Brassaï: The Eye of Paris

By Anne Wilkes Tucker with Richard Howard and Avis Berman

Brassaï: The Eye of Paris By Anne Wilkes Tucker with Richard Howard and Avis Berman

Published on the occasion of the exhibition
Brassaï: The Eye of Paris
This exhibition was organized by The Museum of Fine Arts,
Houston, with funding provided by The Brown Foundation, Inc.,
Houston Endowment Inc., The Wortham Foundation,
and the National Endowment for the Arts, a federal agency.

The Museum of Fine Arts, Houston

Distributed by Harry N. Abrams, Inc.

The Museum of Fine Arts, Houston, Texas
December 6, 1998 – February 28, 1999

The J. Paul Getty Museum, Los Angeles, California
April 13 – July 4, 1999

National Gallery of Art, Washington, D. C.
October 17, 1999 – January 16, 2000

First edition
Library of Congress Cataloging-in-Publication Data
is found at the back of this book.
ISBN 0-81096-380-9 (cloth) / ISBN 0-89090-086-8 (paper)
Front cover: Brassaï, Looking through Pont Marie to Pont Louis-Philippe,
Paris, 1930–32 (catalogue number 23)
Back cover: Brassaï, Pont Neuf, Paris, 1949 (catalogue number 24)

Published on the occasion of the exhibition
Brassaï: The Eye of Paris
This exhibition was organized by The Museum of Fine Arts,
Houston, with funding provided by The Brown Foundation, Inc.,
Houston Endowment Inc., The Wortham Foundation,
and the National Endowment for the Arts, a federal agency.

Distributed by Harry N. Abrams, Inc.

The Museum of Fine Arts, Houston

The Museum of Fine Arts, Houston, Texas
December 6, 1998 – February 28, 1999

The J. Paul Getty Museum, Los Angeles, California
April 13 – July 4, 1999

National Gallery of Art, Washington, D. C.
October 17, 1999 – January 16, 2000

First edition
Library of Congress Cataloging-in-Publication Data
is found at the back of this book.
ISBN 0-81096-380-9 (cloth) / ISBN 0-89090-086-8 (paper)
Front cover: Brassaï, Looking through Pont Marie to Pont Louis-Philippe,
Paris, 1930–32 (catalogue number 23)
Back cover: Brassaï, Pont Neuf, Paris, 1949 (catalogue number 24)

Contents

Lenders to the Exhibition

Mr. Stuart Alexander

Anonymous lenders

The Art Institute of Chicago

Dan Berley

The Jack S. Blanton Museum of Art, The University of Texas at Austin

Madame Gilberte Brassaï

Mr. and Mrs. Arnaud Brunel

Mr. Andrew Cahan: Bookseller, Ltd.

Camera Works, New York

The Cleveland Museum of Art

Collection de la Communauté française de Belgique en dépôt au Musée de la Photographie à Charleroi

Jacqueline and Milton Esterow

The J. Paul Getty Museum, Los Angeles

Gilman Paper Company Collection, New York

Howard Greenberg Gallery, New York

Ydessa Hendeles Art Foundation, Toronto

Estate of Robert Herman

Edwynn Houk Gallery, New York

Ms. Deborah Irmas

Michael and Jeanne Klein

Mr. James Edward Maloney and Ms. Beverly Ann Young

Marlborough Gallery, New York

The Menil Collection, Houston

The Metropolitan Museum of Art, New York

Ornella and Robert Morrow

Musée Carnavalet, Paris

Museum Folkwang, Essen

Museum of Fine Arts, Boston

The Museum of Fine Arts, Houston

The Museum of Modern Art, New York

Museum voor Fotografie, Antwerp

National Gallery of Art, Washington, D. C.

National Museum of American History,
Smithsonian Institution, Washington, D. C.

Susan Patricof

Mr. Sylvio Perlstein

Nicholas J. Pritzker

Private collection

Harry Ransom Humanities Research Center,
The University of Texas at Austin

The Alvin Rush Family

San Francisco Museum of Modern Art

Mr. Jean-Michel Skira

Stockeregg Gallery, Zurich

Monsieur Roger Thérond

Thomas Walther

Wallace S. Wilson

Figure 1 André Villers, French, born 1930. Brassaï's Eyes, 1981.

Yokohama Museum of Art

15 3/8 x 11 3/16 inches (39.1 x 28.4 cm). The Museum of Fine Arts, Houston, gift of the artist, 98.21.

Ms. Virginia Zabriskie

Zeit-Foto Salon, Tokyo

Musée Carnavalet, Paris

Museum Folkwang, Essen

Museum of Fine Arts, Boston

The Museum of Fine Arts, Houston

The Museum of Modern Art, New York

Museum voor Fotografie, Antwerp

National Gallery of Art, Washington, D.C.

National Museum of American History,
Smithsonian Institution, Washington, D.C.

Susan Patricof

Mr. Sylvio Perlstein

Nicholas J. Pritzker

Private collection

Harry Ransom Humanities Research Center,
The University of Texas at Austin

The Alvin Rush Family

San Francisco Museum of Modern Art

Mr. Jean-Michel Skira

Stockeregg Gallery, Zurich

Monsieur Roger Thérond

Thomas Walther

Wallace S. Wilson

figure 1 André Villers, French, born 1930. Brassaï's Eyes, 1981.

Yokohama Museum of Art

15 3/8 x 11 3/16 inches (39.1 x 28.4 cm). The Museum of Fine Arts, Houston, gift of the artist, 98.21.

Ms. Virginia Zabriskie

Zeit-Foto Salon, Tokyo

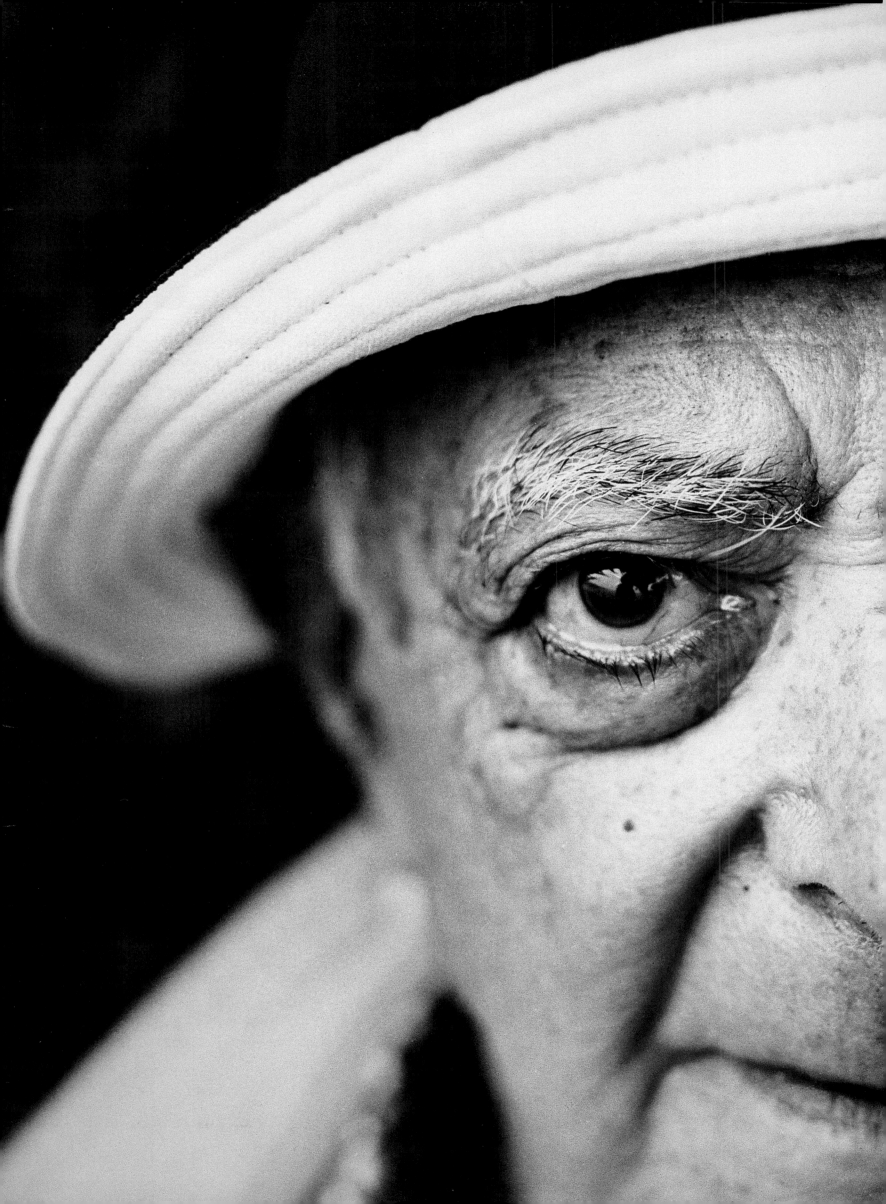

Foreword A day in the life of Brassaï must have been an unforgettable adventure. His interests ranged from grand monuments to graffiti, from high life to low life, from street toughs and police to workers and intellectuals, from elegant shop windows to popular advertising signs — anything that registered the broad drama of life itself. During the day and late into the night, Brassaï was propelled by a work ethic that would have stunned his friend Picasso. Like Picasso, he brought a vigorous interpretation to the mundane and the everyday as well as a critical, penetrating eye to the grand and the fashionable.

In this first retrospective of Brassaï's photographs, we meet a man whose lifetime achievement is far more significant than has been described before. Brassaï was a philosopher, an intellectual who reveled in discussion, and a reader/writer whose passion for great literature was admired by anyone who knew him. Brassaï's artistry can be described as his ability to combine popular and intellectual pursuits into a world of beauty that on one level was literal and literary, and on another level transcended any particular time or location. His photographs objectify our visual experience by fixing his subjects firmly on film, but they also animate these subjects with life and atmosphere, imparting a new reality. At their best, his prints heighten the presence of his subjects, making them seem more real than our everyday experiences. How often has one seen firsthand the Parisian monuments that Brassaï photographed, only to be amazed at how he captured their essences through photography and made them instantly recognizable?

As Brassaï walked the streets of Paris or other locations, he was in pursuit of mystery. His photographs provoke questions that require the viewer to search for answers: What is behind that door or at the top of the stairs? Who wrote or chiseled the graffiti? Why? What made geniuses such as Giacometti or Picasso or Henry Miller tick? Do the personalities and motivations of menial laborers and high-society patrons really differ? How can we get past the perceived barrier of wealth and the often intimidating elements of style to understand the fundamentals of human existence?

The Brassaï mysteries go on forever. And, as revealed in this exhibition and accompanying catalogue, Brassaï gives us the opportunity to see the world with a detective's eye.

Peter C. Marzio
Director
The Museum of Fine Arts, Houston

Acknowledgments

I first met Brassaï in 1973 at the opening of his exhibition at Lee Witkin's gallery in New York City; it was a meeting of some consequence to me. The catalogue from Brassaï's 1968 retrospective at the Museum of Modern Art was one of the photography books I viewed most frequently. Brassaï and I met again in Paris ten years later through the courtesy of Virginia Zabriskie. She introduced me to Madame Gilberte Brassaï, who invited my husband and me to meet Brassaï for tea in their apartment on Easter afternoon. We were under strict instructions to stay for an hour only. As Brassaï spoke no English and we spoke little French, we could anticipate easily keeping our promise. But we all spoke the language of photography. He pulled out albums and snatched boxes of photographs from the middle of chest-high stacks. Gilberte Brassaï translated some questions and answers, but mostly we looked in wonderment at the works demonstrating the wealth of his rich career. I purchased one picture for the Museum of Fine Arts, Houston, and mentioned our hopes of organizing an exhibition of his work.

Through subsequent letters we resolved that the show should be organized jointly by the Art Institute of Chicago and the Museum of Fine Arts, Houston, with David Travis and I serving as curators. Brassai died July 7, 1984, before we could begin to work on the project. In 1985, we resumed our discussions with Madame Brassaï. Shortly thereafter, the Metropolitan Museum of Art and curator Maria Morris Hambourg joined the project. In the intervening thirteen years, the responsibility for the project has been shared by many variant combinations of co-organizers, but finally, the exhibition has been organized solely by Houston.

Throughout those thirteen years, I have worked closely with Gilberte Brassaï, who has devoted herself to preserving and promoting her husband's works. This project is indebted to her enormous assistance. Although I am prohibited from citing anything that I learned from the Brassaï Archives in Paris, I did have the privilege of looking at photographs, sculpture, drawings, contact sheets, and articles. This access, along with Madame Brassaï's comprehensive knowledge, greatly enhanced my understanding of Brassaï's work and career. Also, Madame Brassaï has enabled the Museum of Fine Arts, Houston, to acquire a major collection of Brassaï's work, including photography, sculpture, drawings, and books, some of which she donated to the permanent collection. She also donated a Dior ensemble made of fabric designed by Brassaï. Finally, she graciously selected one hundred of the one hundred forty pictures in the exhibition that we could reproduce in this catalogue. I would also like to thank Madame Brassaï's assistants, Stuart Alexander and Elisabeth Perolini, for their support.

This project could not have been realized without the unfailing support of the trustees of the Museum of Fine Arts, Houston, and the institution's director, Peter C. Marzio. Museum projects do not usually span decades; the trustees' and the director's faith in the successful completion of the exhibition and catalogue was exceptional. I particularly want to thank the members of my Photography Accessions Subcommittee; their spiritual and tangible assistance has been sustaining.

The exhibition received both planning and implementation grants from the National Endowment for the Arts, a federal agency. Other funders include The Brown Foundation, Inc.; Houston Endowment Inc.; The Wortham Foundation; Louisa Stude Sarofim; Anchorage Foundation of Texas; Mr. and Mrs. Robert L. Clarke; Florence J. Gould Foundation; Air Liquide America Corporation; Stanford and Joan Alexander Foundation; Consulat Général de France à Houston; Corporate Partners of the Museum of Fine Arts, Houston; Gay Block and Malka Drucker; Eve France; Mr. and Mrs. Alfred C. Glassell, Jr.; Max and Isabell Smith Herzstein; Mr. and Mrs. Alexander K. McLanahan; Macey and Harry Reasoner; and Alice C. Simkins. The following individuals have contributed funds toward the purchase of art by Brassaï or have donated works by Brassaï to the museum's collection: Joan and Stanford Alexander, Jane and Raphael Bernstein and the Prospero Foundation, Gay Block and Malka Drucker, Anne Bushman, Allan Chasanoff, Howard Greenberg, John Hansen Building Investments, George S. Heyer, Jr., Alain and Françoise Paviot, Max and Isabell Smith Herzstein, Mr. and Mrs. Alexander K. McLanahan, Joan Morgenstern, Mr. and Mrs. S. I. Morris, Mr. and Mrs. Joe Mundy, Photo Forum, Macey and Harry Reasoner, Louisa Stude Sarofim, Alice C. Simkins, and Isabel and Wallace Wilson.

I also received a grant from the J. Paul Getty Research Institute for the History of Art and the Humanities to spend a month using its valuable archives and library, and I would like to express appreciation to the institute and its staff.

The exhibition itinerary includes the J. Paul Getty Museum and the National Gallery of Art. We are grateful to these institutions and their staffs, especially to my counterparts, Weston Naef and Sarah Greenough.

A research project of this depth owes whatever success is achieved to the generosity of many scholars and institutions. While the Houston museum is ultimately the exhibition's organizer, I am greatly indebted to my colleagues David Travis and Maria Morris Hambourg. Both Mr. Travis and Ms. Hambourg have been passionate scholars of French photography throughout their careers. Ms. Hambourg worked in the Brassaï Archives for one intense summer and interviewed many of Brassaï's colleagues and friends. Both curators have generously shared their research and their wisdom, and their institutions have lent important works to the exhibition. The three of us would also like to thank those individuals who were interviewed by Ms. Hambourg and occasionally by Ms. Hambourg and Mr. Travis: Jacqueline Delaunay-Belleville, Robert Doisneau, Daria Gamsaragan, Roger Grenier, Raymond Grosset, Stanley Hayter, Jacques Hérold, Roger Klein, Boris Kochno, Roméo Martinez, Roszi Medina, Alfred Perlès, Carlo Rim, Madame Gilberte Robbe, Elizabeth Savitry, and Alexandre Trauner. Frank and Bita Dobo were interviewed by both Ms. Hambourg and myself, as well as by Kim Sichel. Anyone writing about Brassaï must be indebted to Ms. Sichel. I have benefited greatly from her essay published in the 1989 Musée Carnavalet exhibition catalogue of Brassaï's work, as well as from her doctoral dissertation, Photographs of Paris, 1928–1934: Brassaï, André Kertész, Germaine Krull and Man Ray, and also from an unpublished article, based on the Carnavalet essay, titled "Brassaï and Paris de nuit: From Surrealist to Detective." In addition to these contributions, she graciously shared other research, her time, and good judgment.

12

I worked with the following individuals and institutions, many of whom are lenders to the exhibition, but all of whom graciously opened their collections and/or their research archives for study. Others shared their personal insights about Brassaï and his career. In Austria, Monika Faber, Museum Moderner Kunst, Vienna. In Australia, Gael Newton and Kate Davidson, National Gallery of Australia. In Belgium, Georges Vercheval, Musée de la Photographie à Charleroi; Patrice Dartevelle, Ministère de la Communauté française de Belgique; Sylvio Perlstein, Antwerp; and Pool Andries, Museum voor Fotografie, Antwerp. In Canada, Louise Désy and Marie-Agnès Benoit, Canadian Center for Architecture, Montreal; Ann Thomas, National Gallery of Canada, Ottawa; Ydessa Hendeles, Toronto; Jane Corkin, Toronto; and Jeff Wall, Vancouver. In Paris, Philippe Arbaizar, Bibliothèque Nationale de France; Anne Baldassari, Musée Picasso; Christian Bouqueret, Association pour la Recherche et la Diffusion de la Photographie; Mr. and Mrs. Arnaud Brunel; Anne Cartier-Bresson, Atelier de Restauration et de Conservation des Photographies; Michèle Chomette, Galerie Michèle Chomette; Xavier Demange; Viviane Esders; Serge Hambourg; Françoise Heilbrun, Musée d'Orsay; Jean-Luc Monterosso, Maison Européenne de la Photographie; Pierre Gassmann; Gérard Lévy; Alain and Françoise Paviot, Galerie Paviot; Petros Petropoulos, Première Heure; Françoise Reynaud, Musée Carnavalet; Alain Sayag, Musée National d'Art Moderne, Centre Georges Pompidou; and Roger Thérond; and in Mougins, Mr. and Mrs. André Villers.

In Germany, Ute Eskildsen and Robert Knodt, Museum Folkwang, Essen; Rudolf Kicken, Galerie Rudolf Kicken, Cologne; Dr. Marianne Bieuer-Thielmann and Thomas von Taschitzki, Museum Ludwig, Cologne; Dr. and Mrs. Herbert Molderings, Cologne; and Wolfgang Wittrock, Wolfgang Wittrock Kunsthandel, Düsseldorf. In Holland, Hripsime Visser, Stedelijk Museum, Amsterdam. In Hungary, Karoly Kincses and Magda Kolta, Magyar Fotogràfiai Múzeum, Kecskemèt; and in Budapest, Csaba Nagy and Dr. Praznovsky Mihaly, Petöfi Irodalmi Múzeum; Eva Bajkay, Józsefné Zigó, and Enikö Róka, Magyar Nemzeti Galléria. In Israel, Nili Goren and Rona Sela, Tel Aviv Museum of Art.

In Japan, Hiromi Nakamura, Tokyo Metropolitan Museum of Photography; Shino Kuraishi, Yasuhide Shimbata, and Hideko Numata, Yokohama Museum of Art; Etsuro Ishihara, Zeit-Foto Salon, Tokyo; Yasoo Hattori; Hiroji Tanaka; and Torin Boyd and Naomi Iszkura. In Mexico, Robert Littman, Fundación Cultural Telivisa. In Romania, Andor Horváth, Cluj; and Mr. and Mrs. Kálmán Halász, Eva Lendvay, Waldemar Máttis-Teutsch, and Mr. and Mrs. Alexander Wotsch, all of Brassó. In Switzerland, Jean-Michel Skira, Geneva; and Nicholas Éber, Kaspar Fleischman, Stockeregg Gallery, Walter Frey, Dr. Ch. Hoffman, and Michael Ringier, all of Zurich.

In the United States, Clifford Ackley and Anne Havinga, Museum of Fine Arts, Boston; Tom Bamberger, Milwaukee Art Museum; Andrew Cahan, Chapel Hill, North Carolina; Dennis Kiel, Cincinnati Art Museum; Thomas Hinson, Cleveland Museum of Art; Mary Galvin, The Detroit Institute of Arts; Stefan Lorant; Sandra Phillips and Doug Nickel, San Francisco Museum of Modern Art; Nancy Lutz, Terrance Pitts, and Amy Rule, Center for Creative Photography, University of Arizona, Tucson; Michael Sachs; Karen Sinsheimer, Santa Barbara Museum of Art; and Maggie Weston, Weston Gallery, Carmel. In Austin, Roy Flukinger, Harry Ransom Humanities Research Center, The University of Texas at Austin; Mr. and Mrs. Robert Herman; and Jonathan Bober, The Jack S. Blanton Museum of Art, The University of Texas. In Chicago, David Travis, Colin Westerbeck, Sylvia Wolf, Jim Iska, and Liz Siegel, Art Institute of Chicago; the staff in the Visual and Performing Arts Division, Chicago Public Library; and Nicholas J. Pritzker. In Houston, John Cleary, John Cleary Gallery; Mickey and Jeanne Klein; Elizabeth Lunning and Julie Bakke, Menil Collection; James Edward Maloney and Beverly Ann Young, and Mike and Mickey Marvins. In Los Angeles, Stephen Cohen and Chloe R. Ziegler, Stephen Cohen Gallery; Deborah Irmas; Weston Naef, Gordon Baldwin, and Julian Cox, and Kate Ware, The J. Paul Getty Museum and the staff of the J. Paul Getty Research Institute for the History of Art and the Humanities; Mrs. Ervin Marton; and Robert Sobiezek and Tim Wride, Los Angeles County Museum of Art. In New York City, Stuart

Alexander; Pierre Apraxine, Gilman Paper Company Collection; Jack Banning and Adam Boxer, Ubu Gallery; Dan Berley; Frank and Bita Dobo; Jacqueline and Milton Esterow; Howard Greenberg, Howard Greenberg Gallery; Michael Hoffman, Aperture; Edwynn Houk, Edwynn Houk Gallery; Harry Lunn, Lunn Gallery; Peter MacGill, PaceWildensteinMacGill; Kim Schmidt, Marlborough Gallery; Ornella and Robert Morrow; Peter Galassi, Susan Kismaric, and Virginia Dodier, Museum of Modern Art; Susan Patricof; Kay Reese; Joyce Pomeroy Schwartz; Ben Sonnenberg; Howard Stein; Thomas Walther; and Virginia Zabriskie and Ricardo Sardenberg, Zabriskie Gallery. In Washington, D. C., Sarah Greenough, National Gallery of Art; Michelle Delaney and David Haberstich, National Museum of American History, Smithsonian Institution, and Ronald Steel.

T. S. Eliot once wrote that "Between the conception and the creation . . . Falls the Shadow," and it is my experience that such shadows can be very deep when producing an exhibition catalogue. The success of this one is indebted to Diane Lovejoy, publications director at the Museum of Fine Arts, Houston; she has the exceptional talent to administer a large department and still edit manuscripts with rare insight, accuracy, and sympathy. I would also like to thank Hillery Hugg and Michelle Nichols for further editing assistance. Richard Howard contributed his vast knowledge of French literature to his perspective of Brassaï as a writer. Avis Berman brought to our attention the aspects of her interview with Brassaï that have not been published previously. Anita Meyer and her firm, plus design inc., designed the book with great style and sympathy for Brassaï's art as well as respecting my particular vision of his work and career.

I would like to thank Celeste Roberts-Lewis, curatorial assistant, for her contributions to the bibliography, exhibition history, and catalogue of the exhibition, and most especially for developing the structure of the bibliography. Since Brassaï's talents extended to so many fields, we wanted scholars who were interested in only a particular aspect of the artist's career to be able to easily locate the relevant materials related to specific topics. Ms. Roberts-Lewis also supervised the gathering of as complete a set of books and articles by and on Brassaï as we could manage. Kathleen Ottervik became my curatorial assistant and immediately assumed the job of completing the bibliography, exhibition history, and catalogue of the exhibition and has done so by fact checking around the globe. The thoroughness of these documents has been her responsibility. The members of the staff of the photography department at the Museum of Fine Arts, Houston, have been dauntless and indulgent: Maggie Olvey, Mark Petr, Harlow Tighe, and Eric Davis are the other curatorial assistants who have worked on the project through the years. Lana McBride managed faultlessly the project budgets, my appointments, and my travel. Others who assisted on the bibliography include Holly Anderson, Beth Block, Bari Herzstein, Betsy Mullins, Payam Sharifi, Ruth Buchanan, and Rose Ann Osmanian. Mr. Sharifi's analysis of Brassaï's books and his comparisons of different language editions was particularly helpful.

We would have been lost without the unfailing assistance of Jacqui Allen in the museum's Hirsch Library. Others who greatly assisted our research include Gail Alexander, Paris; Stuart Alexander, New York; Peter Badge, Berlin; Christian Phéline, Paris; the staff of the Berg Collection, New York Public Library; Gerald Auten, Dartmouth College; William Camfield, Rice University; David Chandler and Elizabeth Kilburn, The Photographer's Gallery, London; Ted Dalziel, National Gallery of Art, Washington, D. C.; Diana Franssen, Library, Stedelijk van Abbe Museum, Eindhoven, The Netherlands; Emily Godbey, Chicago; Maya Ishiwata, Tokyo; Robert L. Kirschenbaum, Pacific Press Service, Tokyo;

Ryuichi Kaneko; Cornelia Knight, Maren Mainenti, and Jenny Tobias, Museum of Modern Art, New York; Takako Matsuda, Tokyo; Jörg Meissner, Bochum, Germany; Jeffrey Mifflin, Massachusetts Institute of Technology; Alistair Robinson, London; Kimsey Sorensen, Frye Art Museum, Seattle; Nancy Swallow, Worcester Art Museum; Phillipa Tawn, Arcade Publishing; Dina E. Uliana, Museu de Arte Contemporânea, Saõ Paulo, Brazil; Deborah Willis, Center for African American History and Culture, Washington, D. C.; and Mary Wolliver in the Ryerson and Burnham Library, the Art Institute of Chicago. Special thanks go to Becky Simmons, George Eastman House, Rochester. For legal assistance, I would like to thank Vinson & Elkins L. L. P., particularly Leslie Clark, Andrew G. DiNovo, and Vincent S. Moreland.

The Museum of Fine Arts, Houston, worked closely with editor Susan Bielstein of the University of Chicago Press to publish the English edition of Brassaï's Letters to My Parents. Ms. Bielstein was also an attentive and sympathetically critical reader of my essay. Parts of my essay were first published in the essay written for Letters and in a review for the magazine On Paper. I thank both publishers, as well as those who have invited me over the years to lecture on Brassaï, for the opportunity to work out various opinions and ideas in those publications and presentations.

Whatever my talents may be, foreign languages are not among them. I would never trust my own translations, and without the aid of the following individuals I would not have managed this research: for Hungarian—Enikö Róka, Barna Kantor, Eva Lendvay, and Ilona Kölcsei; for Russian—Margarita Tupitsyn; for French—Britt Chemla, Kathleen Ottervik, Celeste Roberts-Lewis, Payam Sharifi, Harlow Tighe, and Corporate Language Service, a division of ALS International Translation and Interpreting Specialists.

An exhibition of this size involves every department in the museum. One can't list the entire staff, but the particular efforts of certain individuals not mentioned previously must be acknowledged: Gwendolyn H. Goffe, Finance and Administration; Debra Breckeen, Richard Hinson, and Kelley Loftus, Preparations; Charles Carroll and Thomas Chingos, Registrar; Jack Eby, Design; Margaret Mims, Education; Misty Moye, Rights and Reproductions; Wynne Phelan, Conservation; Margaret Skidmore and Barbara Michels, Development; Anne-Louise Schaffer, Art of Africa, Oceania, and the Americas; Marty Stein, Freed Image Library; Frances Carter Stephens, Public Relations; Karen Vetter, Exhibitions; and Lea Whittington, Hirsch Library. I want to also acknowledge the dedication and skills of Nancy Reinhold, who assisted in the conservation of many of the works in the exhibition. We also appreciated the consultation of the photography conservators Constance McCabe, the National Gallery of Art, and Marc Harnly, the J. Paul Getty Museum.

The research for this project was also aided by friends who supported it and me in many ways, including free lodging on research trips provided by Jane Corkin, Eve France, Marge Goldwater, Robert Heinecken and Joyce Neimanus, Mary and Weston Naef, Frances Murray and Harold Jones, and Jim and Linda Stone. Finally, I would like to thank the members of my family who bore the ups and downs of this project with absolute support as well as endearing silence about the sacrifices for which they had not volunteered.

Anne Wilkes Tucker
The Gus and Lyndall Wortham Curator of Photography
The Museum of Fine Arts, Houston

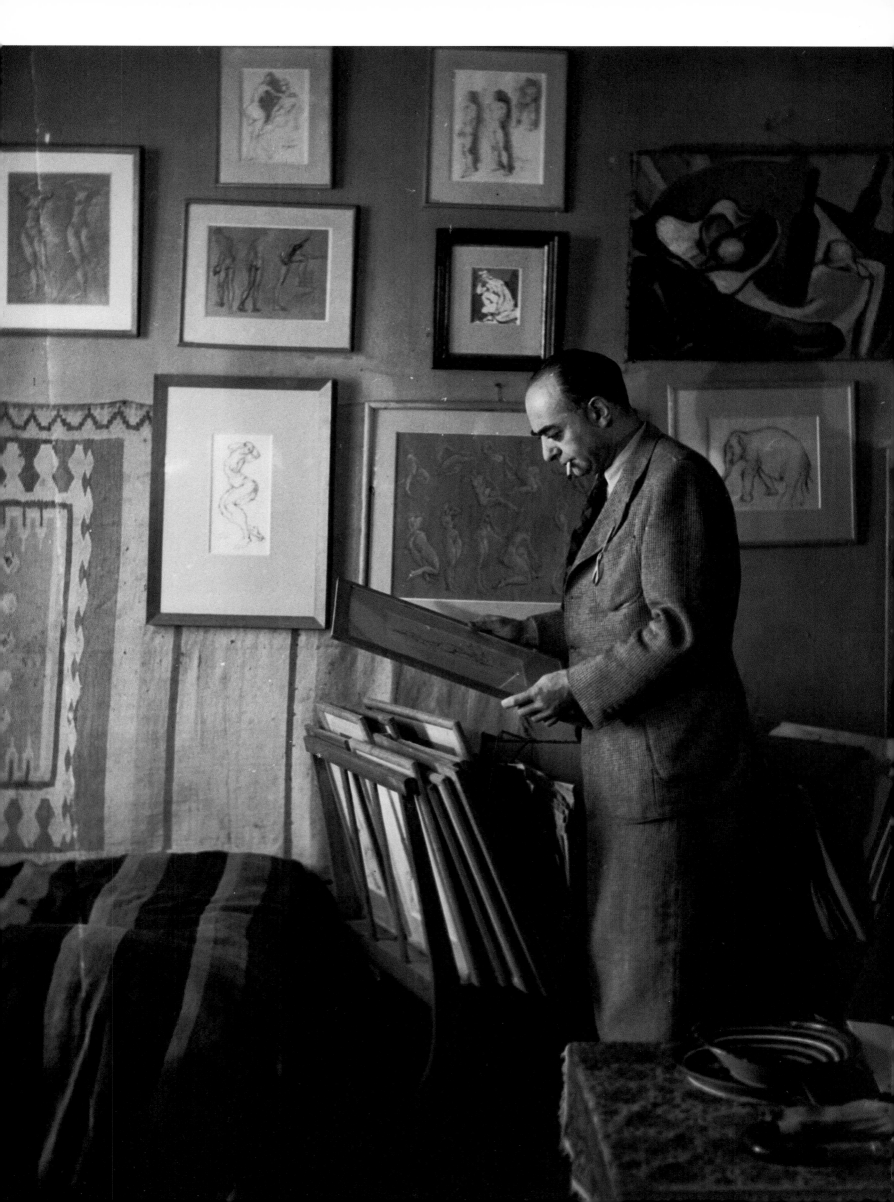

Brassaï: Man of the World Anne Wilkes Tucker

In December 1932, Brassaï published a slim volume of sixty-four photographs titled Paris de nuit (Paris by Night). Critically acclaimed, this volume of Brassaï's works garnered international recognition and secured for Brassaï a permanent place in the history of photography. While this status was inadequate to Brassaï's intellectual ambitions, the book's success was a more than adequate beginning to his distinguished career as a photographer, author, sculptor, draftsman, and filmmaker. Over the next five decades, Brassaï would publish sixteen books and hundreds of articles, participate in countless exhibitions, see his art acquired by the world's most prestigious museums, and win many awards and honors. He is best known for the photographs of Paris at night that he produced between 1930 and 1934, but the full extent and complexity of his accomplishments are little known and the interlocking relationships between all aspects of his work are misunderstood. The photographs of Paris at night, however significant, represent only a fragment of a much greater vision that the artist pursued with deliberation.

Brassaï aspired to an illustrious tradition, one that he laid out clearly in the introduction to his 1949 book, Camera in Paris.[1] He eschewed classification as a photographer because the term was too broad and too open to misinterpretation. His introduction carefully explains all that might normally fall under the rubric "photographer" that did not apply to him. His photographs do not deal with publicity, sport, fashion, science, news, or travel. He is not an amateur who, for lack of technical skill, cannot express his ideas or communicate them with "form and authority."[2] He is not an "Artistic" photographer, "interested in view-points from awkward angles . . . or the 'picturesque,'" or experimental processes. Instead, Brassaï places himself within a broader context and identifies with Constantin Guys, a draftsman-chronicler of London during the reign of Queen Victoria and of Paris in the Second Empire. Guys was immortalized by the essayist and poet Charles Baudelaire in his essay "Le Peintre de la vie moderne" (The Painter of Modern Life).[3] Writing of himself in the third person, Brassaï observes, "His secret ambitions were found to have so much in common with those of Constantin Guys — this 'universal man.' Here we are on the trail of a genealogy reaching back far into the past; a trail which this man, with the desire of knowing more about his own vocation, will follow hotly. He will find that he is exploring a great family of minds, the members of which, all intent on reality, breathe it in, probe it with eyes and hands. These are the men who, from time to time, awaken painting from the torpor of convention by administering to it a whiff of fresh air from the street. A secret demon drives them on to take hold of life wherever it can be found, to snatch the fleeting image of their time. Nature for them is not merely a pretext for expressing their dreams or for making works of art; their whole curiosity is turned towards the myriad facets of human existence. With Goethe they consider, 'the world is more fraught with genius than themselves.'"[4] figure 2 Ervin Marton, Hungarian, 1912–68. Untitled [Brassaï standing in his apartment], 1948. 9 5/16 x 7 1/16 inches (23.7 x 18 cm). The Museum of Fine Arts, Houston, museum purchase with funds provided by Anne Bushman, 96.805.

Brassaï then traces his genealogy as an artist to a "great family of minds," by discussing painters who were the archetypal "reporters of life," including Rembrandt, Goya, Daumier, Hokusai, Degas, and Toulouse-Lautrec.[5] He honors these great artist-chroniclers because the world and its multiplicity of forms intoxicate them. He relishes Hokusai's self-portrait "with a paintbrush between his teeth, one held in each hand and by both feet, frenziedly attempting to express his emotion in the presence of living forms."[6] He emphasizes that their art was the "art of things seen," and that they are not so much artists as men of the world, who, as Baudelaire wrote, "understand the world and its mysterious springs of action . . . [They want] to know, to understand, to appreciate everything that happens on the surface of our planet."[7] ("Man of the world" is an important phrase for Brassaï, as will be discussed later in this essay; see "Society," below.)

Returning to his discussion of photography, Brassaï questions whether he is being presumptuous to claim such esteemed ancestors. No, he reasons, for it "is not enough for the artist of to-day to express the meaning of our age; he must express it in the modern medium. Our generation can only recognize itself completely in images expressed in the new languages of our century. Hence the power of prestige of the cinema and of photography. The great respect in which oil-painting is held, for example, is due to its former glory and not to the part it plays in modern life."[8] Brassaï is not declaring that the expressive potential of painting is exhausted. He is saying that photographers have inherited a mantle disdained by contemporary painters. But, he warns, the photographer must understand his exalted mission. "He must be fully aware of the overwhelming legacy which has fallen to him and of the heavy burden he must shoulder in our age. With the film man, the photographer is the only survivor, the sole inheritor of that great family of artists of which we have spoken."[9] In conclusion, he writes, "A thousand strands attach this man to the family of the great draftsmen, his respect for his subject, amounting almost to religious veneration; the keenness of his powers of observation; his patience and hawk-like speed in swooping on his prey; his impulsiveness; his preference for the human race and his indifference to mere 'nature'; his love of the transient; his sense of the magic beneath the surface of reality; his spurning of color and the enjoyment he derives from the restraint and sobriety of black upon white; and, finally his desire to get beyond the anecdotal and to promote his subjects to the dignity of types."[10] The phrase "dignity of types" intimates the forethought that would characterize Brassaï's art in all of the media he employed. His legacy is to chronicle the era in which he lived, "to breathe it in, probe it with eyes and hands."

Brassaï's birthplace, Brassó, is nestled between the arc joining the Transylvanian Alps and Carpathian Mountains. Located on a site that had been crucial to economic, military, and political interests since the Roman Empire, Brassó was prospering at the time of Brassaï's birth as the regional center of the Austrian-Hapsburg Empire's eastern boundary. Merchandise and resources flowing between the Near East and northern Europe were channeled through the mountain pass above Brassó.[11] Its prosperity was further enriched by the thickly wooded mountains that flank two sides and the rich plains of grain that stretch west toward Budapest. The town's geographic position also made it ethnically diverse. The major ethnicities were Hungarian, German, and Romanian, each almost equally represented, with the addition of a few other minorities. The citizens of Brassó were proud of their cultural heritage and Brassó's centuries-old status as the dominant town in the region.

Sitting in their cluttered apartment in Brassó, an elderly couple reminisces about their classmate Gyula Halász, who later would be known to the world by his pseudonym, Brassaï, meaning "from Brassó."[12] Josefine Wotsch remembers that Brassaï was handsome, very athletic, and "a good dancer." Closing her eyes, she drifts back to the "Hungarian culture balls" of her youth, when she floated in a long dress to the waltzes of the fading Austro-Hungarian Empire. Her husband remembers little about Brassaï except that he was witty and always drew in class. Alexander Wotsch prefers talking about Brassaï's father, who taught French and Hungarian at the local gymnasium. "He was our most sympathetic teacher. But if you hadn't done your homework," he said, "you could always distract him by asking about Paris. He would sit on the corner of his desk and discuss French culture and his life in Paris."[13]

Mr. Halász, Sr., was a serious reader, collected rare books, and wrote for Hungarian literary magazines and newspapers. His passion for culture encouraged two of his three sons to pursue careers in the arts.[14] Brassaï's younger brother, Kálmán, was a successful architect in Brassó. One presumes Paris was discussed as readily at the dinner table as it was in the classroom. Brassaï remembers his father as someone who adored "Paris and the book-sellers along the Seine, Sarah Bernhardt and the club dancers, the eighteenth century, the French encyclopedists and moralists."[15] Writing his autobiography in his nineties, Mr. Halász devoted a chapter to Paris and vividly professed his love of French literature and art.[16] He and his wife first introduced their sons to Paris in 1903–4, when Mr. Halász took classes at the Sorbonne. Impressions of those early years would later affect both Brassaï's photography and his writing.[17] When Brassaï returned to Paris twenty years later, he became one of the greatest chroniclers of Parisian life and art. The father was well aware and proud of his influence on his famous son's vision of Paris, and wrote in his autobiography that Brassaï had seen Paris through his father's glasses.[18]

After completing his secondary education, Brassaï served in the Austro-Hungarian cavalry between 1917 and 1918. He then briefly attended the Academy of Fine Arts in Budapest and may have shared a room with the Expressionist painter János Máttis-Teutsch.[19] Also from Brassó, but fifteen years Brassaï's senior, Máttis-Teutsch was the major artistic influence on Brassaï at that time. Having exhibited at the National Galerie in Budapest as early as 1906, and at Berlin's Galerie Sturm in 1918, Máttis-Teutsch was already an integral member of the avant-garde scene to which Brassaï aspired. From 1909 to 1913, the dominant Hungarian painters formed a group called "The Eight."[20] Later, between 1916 and 1919, the most influential Hungarian artists, including Máttis-Teutsch, were members of the MA Group, which was named for the internationally distinguished avant-garde periodical MA. The magazine's editor and the group's spokesman was Lajos Kassák, who also directed the MA art gallery. As a serious art student, Brassaï would have read MA and probably Kassák's early publications. In 1917, while still a teenager in the army, one of Brassaï's first bold acts was to show Kassák a play for a ballet that he had written. Kassák had just devoted a special issue of MA to the composer Béla Bartók, whose critically acclaimed ballet The Wooden Prince had premiered recently in Budapest. Upon Kassák's recommendation, Brassaï submitted his ballet to Bartók, who, Brassaï remembered, was "friendly and promised to read the draft. Now I believe that it was poor, but it allowed me to meet Bartók, that wonderful person, whom I had a chance to see several more times later in Paris."[21]

Life in Budapest changed radically in October 1918 when the bloodless "bourgeois revolution" erupted. Hungary detached itself from Austria and the Austro-Hungarian monarchy and established its own government independent of Vienna. Count Mihály Károlyi, a liberal member of one of Hungary's wealthiest and most aristocratic families, became president of the new democratic republic.[22] But the social and political problems he inherited were too great; the newly formed political parties could not form a working coalition. Six months later, the Communist party gained control and the Hungarian Soviet Republic was declared under a new president, Béla Kun. As in the U.S.S.R., artists supporting the Red cause were active members of the new Hungarian government. The painter Georg Lukács was appointed the people's commissar for culture and public education; other members of "The Eight" and of the MA Group assumed roles at the National Galerie, at the art school in Budapest, and on various government committees. Brassaï was moved by these extraordinary events. As his father reports in his memoirs, Brassaï wrote home from Budapest, "The winds of revolution have reached the drawing teacher's school. The whole school is in a turmoil, demanding reform. This reform would not be the kind I had in mind, but it will be sufficient for the time being."[23] This must have occurred in 1919, because the Red Republic, declared in March, was forced to yield in August to a consortium of armies, composed of Czechs advancing from the north, Serbians and French from the south, and Romanians from the east. To defend Budapest, Brassaï joined the Hungarian Red army. He was captured by the Romanians, contracted typhus while a prisoner, and was freed as a result of his father's intervention.[24]

Many members of the Hungarian avant-garde fled to Berlin or Vienna rather than to Paris because Hungary and France had been enemies, both in World War I and in the recent crushing of the Red revolution. The new Hungarian government, under the conservative nationalist Admiral Miklós Horthy, proved so repressive that other artists and intellectuals who were not politically involved soon emigrated as well. Horthy remained in power until World War II, preventing a revival of the extraordinary intellectual life that had characterized Budapest in the decades before and after 1900.[25] This massive exodus of intellectuals created a valuable network of colleagues and employers throughout Europe and the United States on which Brassaï would draw for the rest of his life.[26]

Brassaï, however, first returned to Brassó, where he remained until another political event erupted with devastating consequences. In 1920, the Treaty of Trianon between the victorious countries in World War I gave Transylvania to Romania and presented other portions of western Hungary to Slovakia, leaving Hungary with only thirteen of its sixty-three original departments (or states). Although designated as a Romanian citizen, Brassaï would never publicly acknowledge it, preferring instead to say he was Hungarian by birth or that he was born in Transylvania. (He became a French citizen in 1947.)

The influence of Hungarian culture on Brassaï's early art is difficult to measure because his earliest paintings and drawings are lost.[27] Our only gauge is his own account, and Brassaï wrote and spoke little about aesthetic and political events in Hungary or their influence except in letters to his parents. He mentioned an eight-to-ten-year period in which he fell completely under the powerful influence of Máttis-Teutsch's Expressionist paintings, concluding, therefore, that his early works were not really his own. His drawings in Germany were influenced by other members of the Hungarian avant garde (see "Nudes," below) and by philosophies encountered during his studies in Germany. figure 3 János Máttis-Teutsch, Hungarian, 1884–1960. Landscape Composition/Rhythm, n.d. Linoleumcut on paper. 6 1/2 x 6 9/16 inches (16.5 x 16.7 cm). Hungarian National Gallery, Graphics Collection, G. 89.36.

21

Germany In December 1920, Brassaï and several friends made the arduous journey from Brassó to Berlin, traveling through Czechoslovakia instead of Hungary. The sixteen months Brassaï spent in Berlin were important, because he began his career as a journalist, nurtured his ideas and his art, initiated lifelong friendships, and discovered the work of the German poet Johann Wolfgang von Goethe.

In March 1921, Brassaï first mentioned to his parents his deepening friendship with Lajos Tihanyi. It is likely, however, that they met shortly after Brassaï's arrival in Berlin, or knew each other from Budapest. Brassaï would certainly have known of Tihanyi, who was a prominent artist and a colorful character. His father owned the elegant and famous Balaton Café in Budapest. Stricken deaf from meningitis at age eleven, Tihanyi, according to their mutual friend Frank Dobo, "understood and, in the deaf person's inarticulate way, learned to speak four languages, Hungarian, German, French and English. [He was also] very well informed, with a strong passion for cooking. Being invited to dinner by him was always a privilege."[28] Although there was a fourteen-year age difference between the two men, they complemented and assisted each other in many ways. As Brassaï wrote, Tihanyi "turns to me with his day-to-day affairs and problems. When he goes somewhere he takes me as his interpreter. . . . I also stand to gain from this, since I have gotten acquainted with several artists, collectors and critics this way."[29]

Among the artists Brassaï met in Berlin were László Moholy-Nagy, Oskar Kokoschka, and Vassily Kandinsky. Moholy, like Tihanyi, was a member of Kassák's MA group, which had transferred its activities to Vienna after the Hungarian revolution. Brassaï met Kokoschka during an exhibition opening in Berlin, and when they met again in Paris, in 1931, "Kokoschka remembered me," wrote Brassaï, "and I was welcomed with open arms."[30] Kandinsky and his wife were among a group of Russian painters — Ivan Puni, Mikhail Larionov and his wife, Natalia Goncharova — with whom Brassaï attended concerts in Berlin.[31] Brassaï remembered, "We heard recent works of Béla Bartók, Stravinsky, Schoenberg, and Bach in transcriptions by Busconi, interpreted by young composers such as George Antheil, who also performed their own works. Intimate concerts followed by passionate debates."[32]

Much more important than the social interchanges between Tihanyi and Brassaï were their discussions about art and philosophy. In 1922, Brassaï wrote his parents that Tihanyi had helped him through a "severe crisis," the discovery of Johann Wolfgang von Goethe. The great German poet and dramatist became one of Brassaï's intellectual anchors; the French novelist Marcel Proust was the other.[33] Brassaï continued to read and reread Goethe throughout his life, along with the works of the German philosophers Oswald Spengler and Friedrich Wilhelm Nietzsche, both of whom he also first encountered while a student in Germany.[34] A portrait of Goethe hung in Brassaï's apartment in Paris. Brassaï's conversations, published interviews, and all subsequent essays quote Goethe unfailingly and draw parallels between Goethe's life and his own, especially the transition from a romantic to a classical sensibility.[35] Brassaï also drew parallels between Goethe's friendship with Frau Charlotte von Stein and his own friendship with Madame Delaunay-Belleville (Madame D.-B. in all of Brassaï's texts; see "Society," below).[36] Finally, Brassaï also perceived a corollary between the maturation of Proust's and Goethe's youthful heroes in their novels and his own development as revealed in letters to his parents.

In issue 3-4 of the Surrealist magazine Le Minotaure, Brassaï is one of a dozen artists and writers asked the question, "What has been the most essential encounter of your life?" He responded that his encounter with Goethe had been "fatal,"[37] by which he meant the death of his "self" as a romantic subject. Rather than reflect the world in the mirror of his own temperament, Brassaï concluded "the world is richer than I."[38] He sought to achieve Goethe's particular objectivity, which combines a feeling for the essential with a profound understanding of, and even a submission to, the object. In interviews given throughout his life, Brassaï stated that after long observation and contemplation he had been able "to raise himself to the level of the object."[39] Once Brassaï began to photograph, he applied Goethe's ideas to both his system of working and his approach to individual images. Like Goethe, he sought to make distinct images of individuals who, nevertheless, were discernible types. Because Brassaï succeeded so well in conveying the specificity of an individual, his interest in categories and symbolic representation has not been appreciated fully. As a result, assessments of his work fail to apprehend its complexity and ambition.

With the lessons absorbed from Goethe, Brassaï evolved a style that can be described as poetic realism or objective poetry, with the emphasis on objectivity. The writer Henry Miller best understood Brassaï's blend of realism and poetry.[40] In his essay "The Eye of Paris," written in 1932, only a year after they met, Miller described Brassaï's capacity to bring "attributes of the marvelous" to ordinary objects.[41] Miller observed that, when Brassaï looked at an ordinary object, such as a chicken bone, he "transferred his whole personality to it in looking at it; he transmitted to an insignificant phenomenon the fullness of his knowledge of life, the experience acquired from looking at millions of other objects and participating in the wisdom which their relationships one to another inspired." Next, as if quoting Brassaï quoting Goethe, Miller wrote, "The desire which Brassaï so strongly evinces, a desire not to tamper with the object, but regard it as it is, was this not provoked by a profound humility, a respect and reverence for the object itself? The more the man detached from his view of life, from the objects and identities that make life, all intrusion of individual will and ego, the more readily and easily he entered into the multitudinous identities which ordinarily remain alien and closed to us. By depersonalizing himself, as it were, he was enabled to discover his personality everywhere in everything." Later, in Brassaï's introduction to his own book of conversation/verse, Paroles en l'air (Empty Words) (see "Books," below), he selected the following passage by Miller to describe a particular kind of artist who portrays "characters in their own light: without a commentary, explanation, any psychological analysis; without depicting their contexts, their outward appearances; with no stage directions. . . . He lends [only] his pen, his ability, his life experience."[42] This approach, explained Brassaï, was the spirit in which he recorded the conversations in Paroles en l'air as well as took his photographs. Reproducing the conversations from memory employed his capacity to truly hear (and to remember) and making photographs depended on the acuity of his vision.

While in Berlin, Brassaï received an allowance from his parents, which was given on the condition that he supplement those funds with whatever income he could earn as a correspondent. This stipulation was influenced by the fact that Brassaï's father had worked as a reporter in his youth and continued to contribute articles to journals throughout his life. While in Germany, Brassaï wrote for Hungarian-language newspapers and literary magazines in Transylvania. In his introduction to his book Brassaï: Letters to My Parents, he cast aspersions on his early articles by admitting he wrote about subjects of which he knew little or nothing, and even manufactured interviews and copied others' articles to submit under his own name. He also wrote articles that others submitted under their names. Some of the articles were unsigned or signed only with initials. All of these factors make it difficult, if not impossible, to trace his early writing career. While in Germany Brassaï wrote about Albert Einstein and his theory of relativity, the Prussian elections, and the criminal trials of Hungarian counterfeiters working in Berlin, in addition to covering art, music, and theater. Later, in Paris, the political and scientific topics receded, and he focused increasingly on culture and the arts. But throughout his career, the range of his writing indicates that Brassaï was alert, practical, and industrious.

In the midst of his activity as a journalist, Brassaï briefly, and only intermittently, attended classes at the Akademische Hochschule, Berlin-Charottenburg. Eventually he confessed his irregular attendance to his parents and justified himself by saying that the academy had little to teach him. "One may learn to draw at the academy," he wrote, "but one cannot learn art."[43] Instead, he drew in independent studios with hired models. However, Brassaï remained officially enrolled at the Akademische to avoid the Romanian military draft and to receive his diploma. After a year and a half, German inflation was eroding his allowance and earnings, and Brassaï felt that he had absorbed all that Berlin had to offer. He returned home to Brassó in the late spring of 1922.

Paris In late January or early February 1924, Brassaï arrived in Paris, where he would live for the rest of his life, never returning to Brassó, even for a visit.[44] For the next five years, experiencing the joys of life in Paris and establishing sources of income took precedence over the production of art. Brassaï abandoned painting entirely, and neglected drawing for more than a decade. He concentrated on establishing clientele that included the largest newspapers and magazines in Germany, as well as French, Dutch, English, and U. S. periodicals. To complement his writing, he added caricatures[45] and built a collection of old photographs and postcards that he sold to art dealers, editors, and artists as well as to his regular publishing clientele. Slowly Brassaï met and formed friendships with an extraordinary range of intellectuals engaged in all the arts and of myriad nationalities.

He came to know Paris intimately by walking from one district to the other, and by reading books on French culture and history. Wandering was an experience that each newcomer to Paris relished. Immediately after Brassaï's arrival, Tihanyi acknowledged to their mutual friend, Edmund Mihàlyi, "Halász is here; he came two weeks ago. He is walking in the city without direction. I am through that period, but spring makes me start again."[46] Living la vie de noctambule (the life of a nightwalker), Brassaï wrote that his first five years were "rich but unproductive."[47] He walked alone, and with friends, many of whom were writers, including Raymond Queneau and Jacques Prévert, and, later, in the 1930s, Henry Miller and Léon-Paul Fargue, "the pedestrian of Paris."[48] In Brassaï's books on Henry Miller, Brassaï's own enchanted, early meanderings infuse his insights into Miller's own rambling initiation to Paris. Similarly, Miller wrote that Brassaï was "a wanderer like myself who seeks no goal except to search perpetually."[49] Brassaï's letters to his parents, observed editor Andor Horváth, "document life before fame, specifically of Brassaï, but generally of the artists in twentieth-century Europe — how art and artist are born. In the hallway to Parnassus doubt is as real as starvation, and the youthful, wolfish appetite longs not only for the fame to come but also for love, life and all the magic of Paris."[50]

Brassaï's exploration of Paris is frequently linked to the nineteeth-century Parisian tradition of flânerie, the activity of strolling and looking, that is carried out by the flâneur. Many French writers, including Victor Hugo and Honoré de Balzac, created heroes who were flâneurs, but the tradition is most closely associated with the poet Charles Baudelaire, and most especially with his essay "Le Peintre de la vie moderne."[51] This is the essay about the draftsman Constantin Guys with whom Brassaï so closely identified in his introduction to his 1949 book. The essay makes an important distinction. A flâneur is more than a wanderer, wrote Baudelaire. He is a philosopher, an observer, and a painter of modernity who "makes it his business to extract from fashion whatever element it may contain of poetry within history, to distill the eternal from the transitory."[52] Thus, for his first six years, Brassaï was a wanderer, but only what Baudelaire called a "mere flâneur," because he was not yet producing works that revealed the knowledge he had gained. Brassaï's early years in Paris were essentially research for his life's work.

Fortunately for Brassaï, when he was seeking employment as a journalist in the second half of the 1920s, magazines and illustrated newspapers were experiencing the greatest period of expansion in their history. Although weekly newspapers illustrated with drawings had existed in Germany since the latter part of the nineteenth century, advances in printing techniques after World War I enabled the papers to utilize photography. In the Weimar period (1918–32), Germany was the leading center of influential newspapers and magazines. In particular, certain periodicals introduced innovative juxtapositions of photographs with texts, resulting in the birth of modern photojournalism (see "Magazines," below).[53] By the late 1920s, every major city in Germany, and political organizations ranging from the Communists to the Nazis published illustrated magazines. The Münchner Illustrierte Presse had a circulation of 500,000; the combined circulation of the German illustrated weeklies surpassed five million, creating an enormous weekly appetite for photographs and stories. The weeklies enjoyed their greatest success from 1928 to 1933, the five-year period before the Nazis came to power, and the same interval during which Brassaï established his career, first as a writer and then as a photographer.[54]

Writing freelance articles yielded an irregular cash flow, and Brassaï was often on the verge of semi-starvation and of losing his accommodations. He was no stranger to pawn shops. Surely his parents were distressed to receive his letters that were filled with details of his deprivations and financial instability. For instance, during a trip to Nice in 1926, there were days when he survived by eating discarded fruit. He achieved financial stability only after the publication of his book Paris de nuit.

Although Brassaï moved frequently during his first few years in Paris, he always lived on the Left Bank of the Seine, near the heart of Parisian artistic life, and not far from the rue Monge, where he had lived with his parents in 1903.[55] In 1928, he settled into the Hôtel des Terrasses, 74, rue de la Glacière, across from the Métro stop on Boulevard Auguste-Blanqui. The hotel was described as a "catch-all for foreigners."[56] Among the Hungarians who lived there were Lajos Tihanyi; Frank Dobo; George Dobo (unrelated to Frank), an ethnographer; Vincent Korda, a painter and, later, a set designer; Heinrich Neugeboren, a musician and composer from Brassó; and Gyula Zilzer, a painter from Budapest.[57] Other residents included the German watercolorist and painter Hans Reichel (see "Portraits," below) and Michel Seuphor from Antwerp, who was well connected in art circles when he first arrived in Paris in 1925 because he had already published Het Overzicht, an avant-garde art review in Belgium.[58] Through the magazine, Seuphor knew Tihanyi and Zilzer as well as Piet Mondrian, Theo van Doesberg, Fernand Léger, and Sonia and Robert Delaunay. The wide variety of the residents' professions and nationalities assured an equally broad and diverse group of visitors to the hotel and its bistro; among them, French writers Robert Desnos and Raymond Queneau, the Belgian poet Henri Michaux, and the American Henry Miller, all of whom became Brassaï's friends.

Among the residents' nightly pursuits was chess, which Frank Dobo said they would play in the hotel's bistro until it closed at 1:00 a.m., and then carry the boards to someone's room. Brassaï, he said, was a good player, but Dobo could not remember any specifics about his game.[59] One may speculate that in chess, as in photography, Brassaï was a strategist in planning his moves in advance and a tactician when in play. His ability to anticipate and visualize his opponent's potential actions gave him an advantage, and then he could adroitly maneuver his way through whatever situation was at hand.[60]

Paris, Night It was disingenuous of Brassaï to write, "Up to my thirtieth year I did not know what a camera was." But good storytellers often deviate from the truth to improve their story.[61] Brassaï may have found it more engaging to say that he discovered photography in 1929 and only three years later produced a watershed book, and more charming to relate how watching his friend André Kertész make a long night exposure on Pont Neuf inspired him to buy a camera the next day.[62] In fact, Brassaï wrote his parents as early as January 1925 that a "lady photographer . . . comes with me everywhere I want her to and takes pictures."[63] Later that month, Brassaï wrote that he "had a small network, two women photographers and several French photographers who send me their photos automatically."[64] Frank Dobo and his wife, Bita, believe that one of the women photographers was Ergy Landau, a Hungarian photographer who moved to Paris in 1923 and opened a studio.[65] One can only speculate about the identity of the other woman photographer.[66]

By December 1925, Paul Medina, an Austrian writer and a friend of Brassaï's, had introduced him to a Mr. Gaudenz, the director of a German picture agency for whom he procured photographs. Gaudenz wanted Brassaï to obtain images of general interest to German readers, to supply specific pictures for commissioned articles, and, preferably, to learn to photograph so that he could provide the pictures himself. Until Brassaï began to photograph in 1929, he hired others to record situations that Brassaï set up, ranging "from a cease-fire wagon to me jumping clear of a car on the rue de Rivoli."[67] Curator David Travis has located a picture by Maurice Tabard that credits mise en scène (direction) by J. [Jean] d'Erleich, another pseudonym that Brassaï assumed.[68] Therefore, besides the evening described with Kertész, there were many opportunities to watch other photographers work on location and in their darkrooms. Before Brassaï ever became a photographer, he had prepared himself in three important ways. He had thought about which photographs would sell and then tested his ideas in the marketplace. He had mentally composed photographs and directed others to take them. And, as an observant man, he had assimilated technical information and developed an awareness of different photographic styles from watching other photographers work.

figure 4 Brassaï Photographing the Parisian Night on Boulevard Saint-Jacques with his 6 x 9 Voigtländer, 1931–32 (catalogue number 1) © Gilberte Brassaï

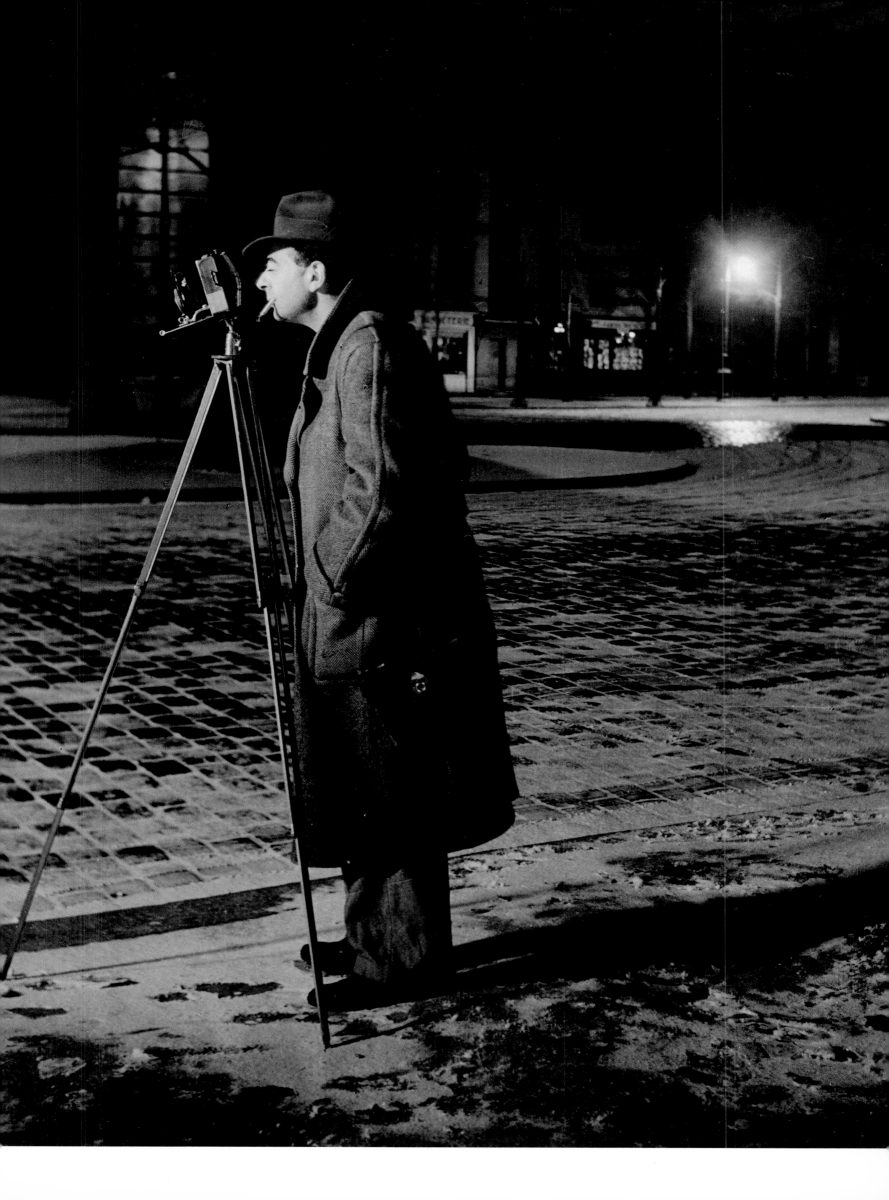

To embrace photography, Brassaï had to overcome a strong aversion to the medium, which, typical of him, he explained through an anecdote: "How I became interested in photography reminds me of a story Isadora Duncan once told me. She was in love with an extremely wealthy man she called Lohengrin. He hired for her an accomplished pianist who played perfectly as an accompanist to her dances but whom she detested. His face drove her to such distraction that she had a screen placed between them when she practiced. Her disaffection grew steadily worse. One day they found themselves in a carriage sitting opposite each other, face to face; there was no avoiding him. It was a rough, curving road. The carriage came to an abrupt stop and she was catapulted into his arms. She said to me, 'I stayed there; I understood it was to be the greatest love of my life.' . . . Brassaï ended the story, 'So too with me and the camera. I once detested her.'"[69]

His initial lack of respect for photography as well as for journalism is also the root of his choosing the pseudonym Brassaï. He wrote to his parents in early 1924 that he had begun to sign articles Gyula Brassaï because he "had to create a separate being" to assume responsibility for the superficial opinions in his articles.[70] "I never write what I think," he declared. Years later, he told Gyula Illyés, "I wanted to immortalize my family name, Halász, solely with my paintings. I needed the name Brassaï for earning a living. In the beginning I made a very clear distinction between the two."[71] In the early thirties, he dropped his first name and became simply Brassaï in both his professional and personal lives. As the years passed, he must have been struck by the irony of "saving" his given name, only to have it utterly consumed by the pseudonym.

There is no agreement as to how and when Brassaï acquired his first camera. Numerous authors have written that Kertész lent Brassaï a camera. Brassaï told interviewers in 1975 that a woman lent him a camera.[72] Still later, he told Avis Berman that his landlord cosigned for a camera that Brassaï purchased.[73] Paul Medina said he lent Brassaï the money, and Dobo thinks that is likely.[74] Whatever the source of the funds and whether or not the camera he purchased on credit was his first camera, by late December 1929, Brassaï had acquired a camera and begun to photograph.[75]

Much has been written — by Brassaï, Kertész, and others — on the role Kertész played in the development of Brassaï's early technical knowledge and his choice of subject matter. Born in Budapest in 1894, Kertész purchased his first camera in 1912. He arrived in Paris in September 1925, and met Brassaï soon thereafter. Having been a serious photographer for more than a decade, Kertész quickly established himself with the weekly illustrated magazines that were being founded throughout Europe (see "Magazines," below). His work was readily accepted in the art community as well. Kertész had a solo show at Au Sacre du Printemps Gallery in Paris in 1927, and he was included in international photography salons in Paris, Brussels, Rotterdam, Prague, Essen, and other cities. Given Kertész's success as well as the "Hungarian connection" that he shared with Brassaï, it is logical that they would work together as photographer and writer. The exact nature of their relationship is impossible to determine, given that Brassaï's accounts changed over the years. Kertész accused Brassaï of stealing his technique and his ideas,[76] and their friends, depending upon their loyalties, have added to the variations.[77] Kertész had been making night pictures since the early twenties in Hungary, and Brassaï did learn from him. Given that Brassaï's and Kertész's styles, output, and ambitions are so different, it is nonsensical to say that Brassaï's pictures are only imitations, as Kertész claimed in an interview in the late seventies.[78] The most far-reaching claims are late-life entrenchments, which belied, and eventually ruptured, what had been a close friendship. Through at least the early sixties, the men sent each other copies of their books, warmly inscribed.[79] In 1963, Brassaï wrote that, from Kertész, "I discovered how much this 'spiritless and soulless mechanism,' this 'technical process,' had enriched man's means of expression."[80] This undisputed lesson was perhaps their most important exchange.

Brassaï's explanation about why he began to photograph has never varied. Perhaps Gyula Brassaï the journalist never wrote what he thought, but Brassaï the photographer was initially driven by his love of Paris. He had a vision of Paris at night that could only be expressed with photographs. In an interview with Gyula Illyés, he declared, "I could no longer hold the pictures in me; I had absorbed so many, mainly during my nocturnal wanderings. I had to express them in a different, and more direct, form than the one afforded by the paint brush."[81]

For six years Brassaï walked the length of Paris, nurturing a vision that encompassed an ambitious range of subjects. He surveyed the majority of the historical churches and monuments in the heart of Paris, an expanse loosely defined at its four corners by the Arc de Triomphe, the Luxembourg Gardens, the Place de la Bastille, and Basilique du Sacré-Coeur. He photographed colonnaded squares and darkened facades, and looked through fences and gates into deserted parks and cemeteries. He walked north to the Saint-Lazare train station, and then east to the industrial canals of Saint-Martin, Saint-Ourcq, and Saint-Denis, where towering cranes pierced the hazy night sky. He walked both sides of the Seine between the Eiffel Tower and the Austerlitz train station, and photographed from multiple perspectives and in all seasons and weather (catalogue numbers 22, 23, and 24). He descended onto the damp quays along the river and into Métro stations. He ascended to record skylines punctuated by chimney pots, long boulevards crowded with cars, and sidewalks bustling with pedestrians and cafe tables (catalogue number 10). He photographed both fashionable and popular nocturnal entertainments, as well as some that were base diversions. His photograph of the wall of Santé Prison served to remind viewers of the presence of crime, while "ladies of the night" connoted the omnipresence of desire. The more knowledgeable a viewer is about Paris, the more he or she can understand the considerable breadth and intelligence of Brassaï's vision.

Brassaï was aware that Paris was in transition between the era of the Belle Époque and that of the Modern Age, and that much of what he photographed was on the cusp of disappearing. Christian Bouqueret identified Brassaï as "the first photographer of electricity, of a new world where night is no longer night and where light brutally and loudly bursts forth while everyone sleeps, making things visible where before there was only speculation."[82] Actually the first electric street lamp was installed in Paris in 1920 and the first electric traffic light in 1923. Therefore, Paris was still in the process of converting from gas to electric light when Brassaï began to photograph. Although Brassaï reported to his parents that trams, gaslights, and horses had nearly disappeared from Parisian streets by 1928–30, one of his well-known photographs is of the nightly ritual of lighting gas lamps (catalogue number 12).[83] He also photographed the white-gloved policemen who, before traffic lights were installed, directed traffic from wooden islands raised in the intersections. Electrification allowed the city of Paris to bathe its important buildings and sculptures in light, giving them a prominence at night that is often lost in the day. In daylight, the monuments must compete for attention with the less significant entities that are also plainly visible, whereas, at night, the competing clutter is lost in the shadows. Even in a park closed and locked for the evening, the important sculptures are radiantly lit, and therefore visible from outside the park fence, as in Entrance to the Luxembourg Garden, Paris (1932). (Since Brassaï had so thoroughly documented the "City of Light" in the thirties, he was all the more acutely sensitive to the effects of the blackout on Paris during the war years. Thus, he photographed the Saint-Germain-des-Prés church visible only in silhouette and the usually festive Café des Deux-Magots shrouded according to wartime regulations [catalogue number 13].)

Throughout the twenties and thirties, every metropolis was photographed at night. Other photographers made single pictures, or series focused on a single subject, similar to those photographed by Brassaï, but no one photographed a city at night with Brassaï's peculiar blend of system and poetry. The electrification of cities brought forth photographers in every city to record illuminated marquees, often using multiple exposures to emphasize the cacophony of neon messages. Berenice Abbott photographed down onto New York City's twinkling buildings as though one were gazing up at the stars, not down on the city. Alfred Stieglitz concentrated on the vertical thrust of skyscrapers backlit by a faintly glowing horizon. In Germany, Eric Salomon hunted images in famous political and social gatherings, and Felix H. Man captured the gaiety of beer halls. Josef Sudek recorded how nocturnal lighting heightened considerably the romantic beauty of Prague's Baroque architecture.[84] Similar to Brassaï's work, Bill Brandt's series on London at night was about "love, carousing, and vice" as well as high society.[85] Working in Paris, André Kertész photographed deserted plazas and streets as well as working-class dance halls. Marcel Bovis relished shafts of light breaking across darkened spaces, and also haunted circuses and street fairs. Some photographers, including Abbott and Stieglitz, continued to work with large-format cameras.[86] Others switched to the new cameras — Leica, Ermanox, Voigtländer — which were more portable and required less light to make an exposure. What Brassaï uniquely established was how hauntingly rich the night could be for a photographer. Others did not manage the same breadth in their approach. With the publication of his book Paris de nuit, Brassaï claimed night as his subject, and simultaneously legitimized night photography for others in a previously unimagined way.

In his first two years of photographing at night, Brassaï focused on exterior views. With the exception of pictures made inside certain well-known public institutions — Bal Tabarin, Médrano Circus, the Opéra — he did not capture interior scenes, and rarely photographed people. When he did include persons, they are usually seen from a distance and primarily served to humanize the larger scene. Workers are the only figures who appear in the pictures' foregrounds, yet they, too, are included primarily as types, with little individuation. Brassaï was consciously gathering "types" for his survey of Paris. He photographed members of the most elite social class as well as night-scavenging ragpickers, the lowest-ranking members of the demimonde. His subjects included other inhabitants of the night: lovers, beggars, and cycling police, as well as loiterers waiting out the night in a cafe or on a bench. The extreme diversity of subjects subtly inserted issues of economics and social class into his project, but he never proclaimed his political views. His intention was to enlighten us and to arouse a response, not to conduct a campaign.

Beyond the ambitious scope of his project, Brassaï's individual images manifest his distinctive vision. The historic edifices are only occasionally approached frontally with their facades gloriously bathed in light, as a tourist might see them. Instead, he often took a nontraditional view. For instance, he photographed Notre-Dame Cathedral from its darkened rear aspect, and also, from the river level, looking up past the vine-covered embankment. In one of his photographs of the Arc de Triomphe, a small train blocks the lower corner of the arch, an event he perceived as a "nightly rendezvous of dignity and impudence."[87] He photographed the stage of the Folies-Bergère from the catwalks, and the peristyle of the Bourse du Commerce with sleeping clochards receding down the arcade (catalogue number 7).

Brassaï's exterior views of the Parisian night are complex compositions. He often employed a strong recessional thrust in which the subjects in the foreground and those in the distant background are equally important to our understanding of the picture's content. His pictures reflect how objects and structures from different periods and of diverse historical importance supply context to one another as they coexist in richly layered proximity. For instance, by looking through the arch of one bridge to the succession of bridges farther along the Seine — a device he used repeatedly — he established the vital presence of bridges in the city as well as their various architectural styles. The bridges are the staples that seam together the Right and Left Banks. Brassaï photographed every bridge from Pont de Grenelle to Pont de Bercy, the central stretch of river spanned by a bridge every three hundred meters. The visual, historic, economic, and chauvinistic importance of each bridge is inestimable, but usually, their importance is not on a conscious level. They are too ingrained in the city's daily routine. Brassaï's varied and inventive approaches serve to awaken viewers from "the torpor of convention." He photographed Pont Neuf, the oldest bridge, with the most frequency and variety; it was both one of his first, and one of his last, subjects (catalogue numbers 4 and 24).

Another compositional device was to situate decorative or functional elements in front of venerable monuments. For instance, in one of his photographs of the Place de la Concorde, the richly detailed sculptures of the river gods that circle the two central fountains contrast in myriad visual ways with the stark Egyptian obelisk towering between the fountains. In the distance, on the edge of the square, are two grand eighteenth-century mansions, one of which houses both the Hôtel Crillon and the Automobile Club de France. (Brassaï also photographed the obelisk and fountains from the club's balcony.) While most tourist guides take the same standard approach of including in one picture all three central elements — the fountains, the obelisk, and the mansions — Brassaï managed to build a composition with only those three elements, eliminating cars, pedestrians, roadways, and other distractions from the central structures. Thus, he reduced his image of the Place de la Concorde to its essence. He also employed the fountains' water spouts and the light refracted through the water, simultaneously to unite the composition and to add a touch of the marvelous.

33

Reflections are another element that often played an important visual role, especially in his views of the river. Subjects that are already ill-defined in the dim light of evening gain ghostly doubles in the water, and pinpoints of light stretch into wavering wands (catalogue number 24). The movement of boats as well as of the flowing water add additional ghostly effects, as in Looking through Pont Marie to Pont Louis-Philippe, Paris (1930–32) (catalogue number 23). These images evoke the sensation of a waking dream. This is a twilight world that comes into being at night, wrote Paul Morand, "a world of shifting forms, of false perspectives, phantom planes."[88]

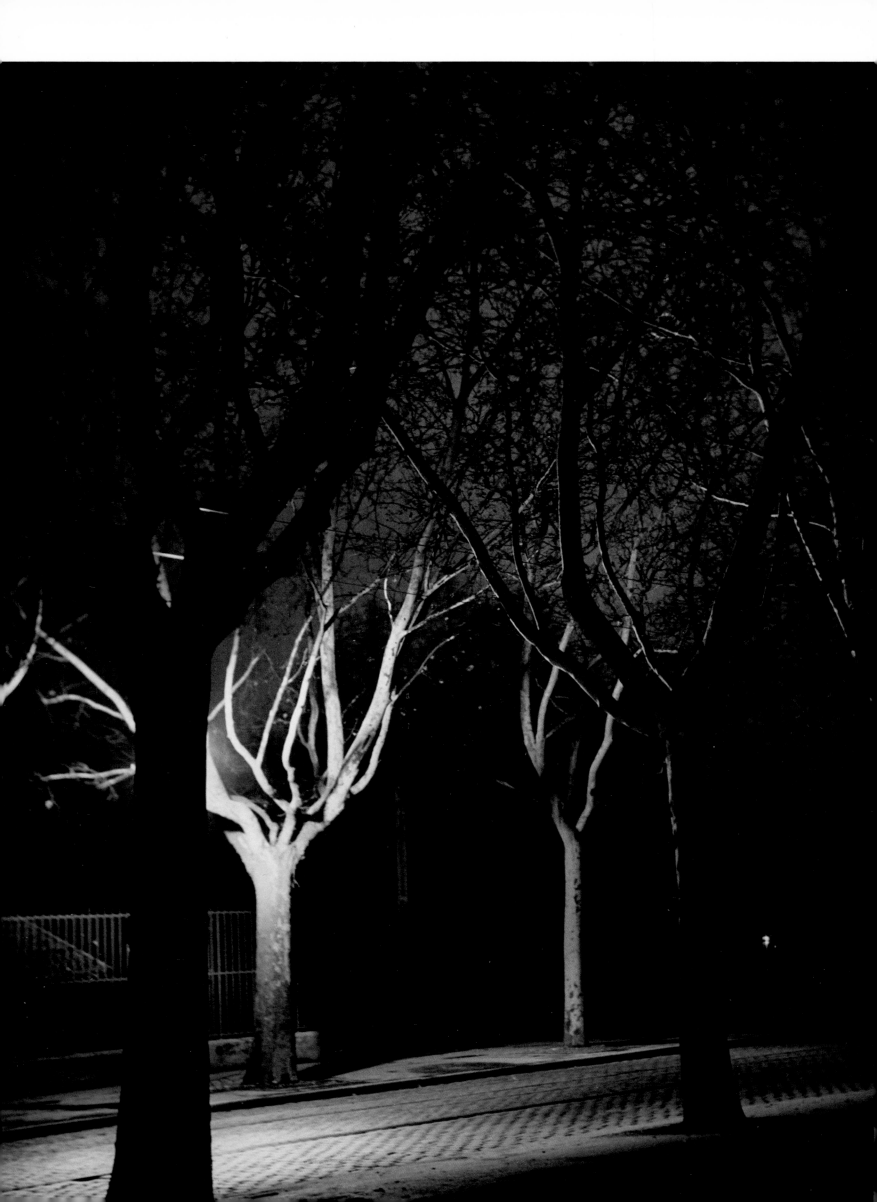

Brassaï used shadows as skillfully, and as playfully, as he used light to construct his nighttime pictures. Looking through a park fence at night was another subject that Brassaï approached from various viewpoints and in different seasons, and he was often struck by the "phantasmal chequerwork of shadows" cast by the fence posts.[89] In the first plate in Paris de nuit, he excluded the fence itself and focused instead on the interlacing shadows that recede toward the sculpture in the distance. Conversely, in a photograph of the Luxembourg Gardens, the fence itself is the dominant feature. The shadows lie across the snow, casting dark patterns in contrast to the lightness of the ground and the light reflected off the surface of the fence posts. A fence and its shadows are also pivotal elements in Brassaï's photograph of Montmartre Cemetery (plate 31 in Paris de nuit). The deep shadows heighten the unearthly aspects of the cemetery. In another photograph, the shadowy forms of trees that are cast onto the Santé Prison wall appear as sentinels lining the prison's perimeter, but they also seem to dissolve the wall where the shadows fall, contradicting our sense of its being solid and impenetrable. Shadows in other photographs appear to be anthropomorphic spirits, such as the ghoulish profile projected by the protruding edges of a corner pillar on a Métro station wall. Thus, Brassaï's photographs embody two components of French culture. The illuminated monuments, sculpture, and architecture portrayed in his photographs reveal France's splendid and ordered civilization; the shadows and reflections release the worlds of the imagination and desire that are equally important in France's cultural history.

Once Brassaï had assembled a portfolio of about one hundred pictures, he took a selection to a magazine editor — probably Lucien Vogel — who in turn referred him to Charles Peignot, the editor of the luxuriously printed magazine Arts et Métiers Graphiques.[90] Peignot's immediate response to the photographs of Paris at night was favorable. He had been looking for a photographer to prepare such a book, so he quickly offered Brassaï a contract. As Brassaï wrote to his parents, "I've managed, with my first book, to grab the best publishing house, and, if Peignot's predictions are fulfilled, the book itself will be a great success in terms of both the photographs and the presentation."[91] Having signed the contract in November 1931, Brassaï worked unceasingly for the next four months to make new photographs for the book; for most of this period, he worked at night and slept through the day. By December, he reported that half the book had been assembled. As he worked, his technical skills increased, and he steadily raised his critical standards. "I could almost say," he wrote, "that as the material grew . . . the number of chosen pictures decreased."[92] By April, he announced that the selection of photographs had been completed.

For a young, relatively unpublished photographer, Brassaï had a great deal of input in the book, but certainly not absolute control. There was a period when Peignot thought about adding the work of other photographers. Brassaï reported with glee to his parents that the new works that Peignot commissioned did not measure up to the standards set by Brassaï.[93] Peignot also insisted that Brassaï add a photograph of blooming chestnut trees to accommodate what they thought would be a springtime release of the book. Brassaï obviously didn't see the design for the book's cover

figure 5 Quay Bercy, Trees near the Wine Market, Paris, 1932–33. 11 15/16 x 9 13/16 inches (30.3 x 24.9 cm). The Museum of Fine Arts, Houston, museum purchase, 94.376.

before its publication, because he hated the use of red ink for the title and credits on the cover. He extracted promises that after the first thousand copies the type would instead be printed in white or silver ink, a change that never occurred. Also, Brassaï was initially pleased with the selection of the eminent writer Paul Morand to contribute the foreword, but was furious when Morand's status was seemingly elevated to that of being the book's author. Morand received top billing on the book's cover and his name was set in a typeface almost twice as large as that for Brassaï's name. In fact, the editor, Jean Bernier, received billing as prominent as Brassaï's. Finally, regarding matters of control, Peignot had possession of Brassaï's negatives for the sixty-four photographs in the book; they were rediscovered in the attic of the publisher Flammarion in Paris by Kim Sichel in 1983.[94]

Paris de nuit is a beautiful book in nontraditional terms. Using the gravure printing process, the publisher succeeded in matching the rich, saturated blacks and sparkling whites of Brassaï's prints. Also, like Brassaï's photographs, the images are printed to the edges of the page. It is annoying that holes were punched through the inside edges of the images to accommodate the spiral wire binding. On the other hand, this particular form of binding allows the book to lie flat, and parts of the image are not lost in the gutter of each spread. The way the pages abut allowed the designer to carefully match the graphic elements in the adjoining pictures of each double-page spread. For instance, the line formed by the outside edge of a road continues to become the base of a building on the facing page. The arch of a bridge becomes the circular wall of a circus ring in another spread. In a third pairing, the semicircular runway on which young women dance over the heads of the audience at the Opéra ball is transformed on the next page into the grand stair and arches in the Opéra's lobby. Similarly, the book's end pages are diptychs of the patterns of Parisian cobblestones; the patterns match exactly across the gutter (catalogue number 5). It is unknown who was responsible for sequencing the book's pictures. Brassaï's wife, Gilberte, told Sichel in 1984 that Peignot and Bernier probably determined the layout and choice of images.[95] However, in 1932, Brassaï had written to his parents that Peignot, Bernier, and Morand agreed that by delaying the book for Brassaï to make more photographs they would gain "in the beauty and unity of the book."[96] This implies that all four men were actively involved in various aspects of decision making. Whoever controlled the layout, as the critic Colin Westerbeck observed, a strong graphic instinct prevailed and the unifying graphic order is the book's dominant quality.[97]

In his foreword, Morand ignored the graphic aspect and the literal order of the pictures. Instead, he discussed the pictures in the order in which one might encounter the subjects while walking through Paris. As Sichel points out, Morand's promenade "is inspired by the tradition of flâneurs from Baudelaire to Breton, and he organizes the city around his particular rambling walk."[98] Appointing himself as the viewer's escort for the evening, Morand began by observing the night workers one might see: the baker, the cesspool scavengers, the prostitutes, and the police. He traversed from Montmartre to Montparnasse and back to the Seine, where he watched dockhands unload barges. Then he proceeded to the market at Les Halles, which is also the destination for the contents of the barge. After noting what was still open and what was closed by 1:00 a.m., Morand kept walking between 3:00 and 5:00, when "Paris sleeps, really sleeps."[99] No trains stirred, he proclaimed. Not a soul was in sight, except clochards. Finally, he returned home, and just before drifting to sleep, he heard the rattle of milk-cans. Brassaï's photograph of the milkman is the book's last image, which is one of the few concessions made to establishing a progressive time frame in the book's layout. Sometimes Morand mentioned pictures by Brassaï that are not actually in the book, such as Brassaï's views of Sacré-Coeur, cafés on Boulevard Montparnasse, cinema theaters, and the Comédie Française. This implies that he may have written his text before the picture selection was final. One gets the impression that he wrote

with a stack of pictures beside him and merely used them as cues to formulate his imaginary journey, which he then embellished with details gleaned from a lifetime of being a Parisian. More than one reviewer commented that the photographs far surpass the text. The newspaper Le Temps stated, "When the name of Paul Morand will be long forgotten, Brassaï's photographs will still be living and precious documents."[100] A writer named Waverley Lewis Root, who may have actually been Brassaï's friend Alfred Perlès using a pseudonym, cribbed almost this exact phrase in his article in the Paris edition of the Chicago Tribune.[101]

Response to the book was immediate, widespread, and almost universally favorable. Reviews appeared throughout Europe and in the U. S., Japan, and South America.[102] No artist could wish for a stronger beginning to his career. In an article titled "La Ville photogénique," the author commented that most pictures of Paris were documentary without reflecting the conceptions of the artist or the soul of the poet. The exception to this was Paris de nuit, in which the poetic material revealed the virtuosity of the artist who movingly worked with chiaroscuro.[103] Many reviewers referred to Brassaï as the "poète des nuits" (poet of the night). Jacques Guenne described him as the poet who "unveiled in the shadows and in the rain slices of our hectic life."[104] An indication of Brassaï's rapid rise to prominence is that soon after the book's publication, a very short review for a group exhibition mentioned only a few photographers. Brassaï is one of those named; the review also isolated his individual works for comment.

Besides reviews, various publications featured portfolios of Brassaï's night photographs. Although Brassaï did not have access to the negatives for the images in Paris de nuit, he published variant images of those subjects and other photographs made for the book project, but excluded from the final selection for the book. In Paris, he published portfolios in newspapers and magazines as diverse as L'Intransigeant, Les Nouvelles littéraires, Vu, and L'Instantané. This was also the beginning of his association with various English and U. S. publications. The Weekly Illustrated ran ten pictures in the article "Midnight in Paris" in 1934. Lilliput published five photographs in August 1938, and Picture Post featured twenty-two images in a four-page spread in 1939.[105] The book's success also led to Brassaï's first interview. He boasted to his parents, "My maiden interview, conducted by an American journalist named Miss Watterson, came out a few days ago; her interview about me and my work appeared in several American newspapers."[106] (While it is unknown which American publications ran the interview, it was also published in Prague and in Brassó.) He went on to say that he didn't have a suitable picture of himself to give her for the article, and this may have provoked him to take his self-portrait on Boulevard Saint-Jacques (catalogue number 1). The book also led to exhibitions of Brassaï's work, although he had begun to exhibit well before its publication. He was included in Photographes d'aujourd'hui (Today's Photographers) in Paris in 1931 and exhibited six photographs in Modern European Photographers at the Julien Levy Gallery in New York in 1932.[107]

Paris de nuit was republished in French, English, and Japanese editions in 1987.[108] Nine years before, Brassaï had published a book titled Le Paris secret des années 30/The Secret Paris of the 30s that featured the pictures he made immediately after those in Paris de nuit (see "Secret Paris," below). Although the photographs in these books differ in their subject matter, their composition, and their tendency to be either exterior views (Paris de nuit) or interior settings (Secret Paris), many historians and reviewers have written about the photographs in the two books as though they were interchangeable and from only one series, not two distinct projects. Writers have also cited photographs that appear only in Secret Paris as having been published in Paris de nuit. Other reviewers have focused almost solely on the nine — out of sixty-four — photographs of the demimonde that are included in Paris de nuit, while downplaying the importance of the photographs of architecture and monuments, and virtually dismissing the photographs of other segments of society. For instance, Kim Sichel wrote about Paris de nuit, "Several of its plates depict the city's bourgeois nightlife. . . . Workers like newspaper printers are also represented. Its overall focus, however, points to the underside of Parisian society."[109] Partly, Brassaï's own talent is to blame for the confusion. His ability to engage the underworld subjects, and portray them without pity or disdain, makes them available to viewers in such an appealing way. Plus, Brassaï, alone among photographers, achieved almost comprehensive access to the underworld. But focusing primarily on his more exotic subjects has distorted our understanding of the work and of Brassaï's intentions.

Brassaï began to make the photographs for The Secret Paris of the 30s
while finishing Paris de nuit. Initially titled Paris intime (Secret Paris), the
new series was an extraordinary set of photographs about prohibited
love and the Parisian underworld. The places that Brassaï photographed
ranged from still-existing entertainment institutions to private dens of
momentary pleasure, including circuses, street fairs, working-class dance
halls, bordellos, theaters, opium dens, homosexuals' bars, and artists' galas.
The people whom Brassaï included in Secret Paris — performers, revelers,
clochards, gangsters, and prostitutes — were drawn together in his eyes
by their status as outcasts, a status that has always fascinated artists
and writers. Brassaï also photographed their antagonists in this ongoing
drama, the police, who were called hirondelles, or swallows, for the
billowing capes they wore as part of their uniforms. Works by Brassaï's
favorite authors — Stendhal, Dostoevsky, Proust, and Nietzsche — fueled
his fascination, as did a series by artists who focused on Parisian
nightlife, including Toulouse-Lautrec, Degas, and Picasso.[110] Other
photographers worked many of the same haunts.[111] The nighttime pleasure
halls of homosexuals and the interiors of bordellos were the subjects that
Brassaï first introduced to the world of serious artistic and documentary
photography. His goal was not only to make great individual pictures, and
even a salable story or two, but to produce a cohesive project, which was
itself part of a grander plan. From the beginning, Brassaï intended the
project to become a well-printed book, a sequel to Paris de nuit, with a
serious introductory essay by the novelist Pierre MacOrlan.[112]

Many of the subjects depicted in Secret Paris Brassaï had encountered
during his first days in the city. Naturally, he gravitated first to
Montparnasse, the famous arrondissement (district) that dominated the
art world between the wars. In 1924, a day after his arrival, Brassaï heard
Kiki sing her "dirty songs that offended no one" at Le Jockey, located
only a few blocks from the Hôtel des Écoles where he was staying.[113] This
hotel was a famous "first stop" because of its proximity to the major cafés
and restaurants where newly arrived artists could count on meeting and
making friends. Tihanyi, Tristan Tzara, Man Ray, and Henry Miller are
only a few of the artists and writers who stayed there.[114] For most
immigrants, their second stop was the Café du Dôme, where the tables
spilling out onto the broad sidewalk became the artists' "living room and
office." Café de la Rotonde, Le Select, and La Coupole were also popular
meeting places. The four cafés were all within one block of the
intersection of the Boulevard du Montparnasse and Boulevard Raspail, the
crossroads and heart of Montparnasse.[115] Brassaï wrote of the many times
that he and Henry Miller, "broke and weary, would sit at the Dôme or the
Rotonde, order a café crème and a sandwich, then wait for deliverance:
that friend who would happen by and cover the tab for you."[116] Sometimes
they would sit all day. Sculptor Daria Gamsaragan remembers the neat
stacks of café crème saucers accumulating while we "rearranged the
world."[117] According to Pierre Gassmann, "If someone asked to join you, it
meant they had money to pay."[118]

Looking for subjects for Paris intime, Brassaï was guided by his love of books by Proust and other French writers. He sought out Paris's obvious monuments as well as the establishments not publicized in tourists' guides that were nevertheless legendary, such as the bordello frequented by Prince Edward of England. Brassaï went to the great brothels and theaters to photograph their lavish, and sometimes exotic, interiors.[119] He encountered other institutions on his routine paths through Montparnasse. Both the brothel Le Sphinx and the lesbian bar Le Monocle were located on the Boulevard Edgar-Quinet, just a short walk down the rue Delambre from the Café du Dôme. Finishing their evenings-on-the-town at dawn, Brassaï and his friends would go to Les Halles for fresh onion soup. There, they would see the broad-shouldered workers and loosely clothed prostitutes also finishing their "day." Accompanied by other artists and friends, Brassaï attended street fairs, circuses, clubs, and artists' balls. Calling on the mental images that he had collected from those early wanderings about Paris and from his reading, Brassaï sought to make photographs that conveyed the essence of his experiences and learning.

Writing about Brassaï's photographs, Helmut Gernsheim referred to Brassaï's "'candid' pictures of Parisians in unguarded moments."[120] Gernsheim is one of many historians who have assumed incorrectly that Brassaï's sitters did not participate in making the pictures. Especially when working indoors, Brassaï had a technique for taking pictures in which his subject knew that he or she was being photographed, but not exactly when. Brassaï said, "I involve them in a certain manner. Due to the situation, there is something like complicity. For the delicate subjects that I photographed, I had to be familiar with the people and it was difficult at that time. I didn't have a lot of money and I had to make friends and buy drinks. Technically, also, it was difficult. I couldn't become invisible. . . . I had to invent a technique so that people . . . never knew when I was going to take their picture, or when they knew, I didn't take it."[121] Having selected a subject — occasionally making an appointment with a particular sitter — he set up his camera and tripod, and placed his assistant with the flash over to one side. Such activity was unlikely to go unnoticed, and certainly not after the first picture, because Brassaï used magnesium flash powder.[122] Powder explosions are brilliant, noisy, and odorous. (These offensive aspects of magnesium flash led Picasso to nickname Brassaï "The Terrorist."[123]) But Brassaï preferred magnesium powder because it produced shadows with less contrast than single-source bulbs. He further softened the tendency of magnesium flash to create strong shadows by using a square of canvas as a reflector and by relying on the bistro mirrors then in fashion to disperse the light.[124] Once set up, he waited for life to resume. When ready, he signaled his assistant to set off the flash and then exposed his negative.[125] Thus, he succeeded in making pictures that look unposed but were actually thoughtfully composed.

In describing his compositional goals, Brassaï explained that he worked toward a feeling of balance and he hated "snaps" where everything was "pell mell."[126] He might have been speaking of photographs by the American Weegee, whose subject matter overlaps somewhat with Brassaï's, but whose style is the opposite. In comparing their work, Colin Westerbeck described Brassaï's work as being "imbued with an element of formalism, or at least of balanced composition. . . . His vision worked by centripetal force, pulling everything in the frame together, unifying the society in which he lived. Weegee's vision was explosive, blowing the world apart. . . . The force in his pictures is centrifugal. The best of them are sheer chaos."[127] Nothing about Brassaï's work was left to chance. In comparing Brassaï's work with that of another of his contemporaries, Pierre Gassmann noted, "Cartier-Bresson was a pickpocket who hunted compositions. Brassaï knew where he was going and what he would photograph."[128]

Anticipating the action was often crucial to Brassaï in making formal, well-composed pictures that nevertheless seem to be "grabbed" in an instant. Research was essential at places like the circus, said Alexandre Trauner, where Brassaï "couldn't use the flash because of the animals. . . . He knew the moments when there was a tiny pause, a slowing down, and took the pictures at that moment."[129] In Médrano Circus, Boulevard Rochechouart, Paris (1930–32) (catalogue number 32), Brassaï records the performers and animals waiting at the ring's entrance. Counting on our anticipation of the performance, he captures the "about to be." In this case, he had conducted his research the night before when he accompanied Picasso, his wife, Olga Koklova, and their son, Paulo, to the circus. Picasso's fascination with the stunt riders that night resulted in the series of paintings Variations sur le cirque (Variations on the Circus).[130]

Even without Brassaï's commentary, we can determine that his pictures were often staged. Variant poses exist of many famous images. In one print of Lovers in a Small Cafe, Place d'Italie, Paris (1932–33) (see Secret Paris), the woman is seated in the corner of the booth, and the man's back is to the camera. The positions are reversed in the second version.[131] In Secret Paris, Brassaï published front (catalogue number 39) and back views of the plump streetwalker, and a third pose shows her leaning against a light pole. There are many views of the young woman with the large spit curl whom he photographed in a music hall on the rue de Lappe. Two images of her wearing the same outfit are published in Secret Paris, and others can be found in public and private collections. In each picture, she is in a different location and/or shown with different women and men. In all of these examples, Brassaï had a particular picture, or a particular type of picture, in mind for his grand survey of Parisian life.

Sometimes Brassaï approached an idea from different perspectives. For instance, in 1931–32 and 1937, he took variant versions of a backlit figure staring at mannequins and lingerie in a shop window (figures 6 and 7). In the earlier image, a man daydreams before preening mannequins in lacy corsets; in the later view, a heavyset woman contemplates the cinching strictures of girdles. The pictures are similarly structured, but their meanings could shift significantly depending on our presumptions about the gazer's gender. We might presume that this man's musings more closely parallel those of another man, who is similarly posed, looking at magazines with racy titles, such as Scandale, displayed in the window of a sex shop.[132] But such a presumption could be wrong, as we have been instructed by contemporary theorists on gender-based readings of art. Interpretations of Brassaï's photographs vary widely, and usually we can only speculate about his own reading of an image. We know only that on these and numerous other occasions, Brassaï found the act of window gazing visually and symbolically rich.

figure 6 Shop Window, Paris, 1931–32 (catalogue number 30) © Gilberte Brassaï

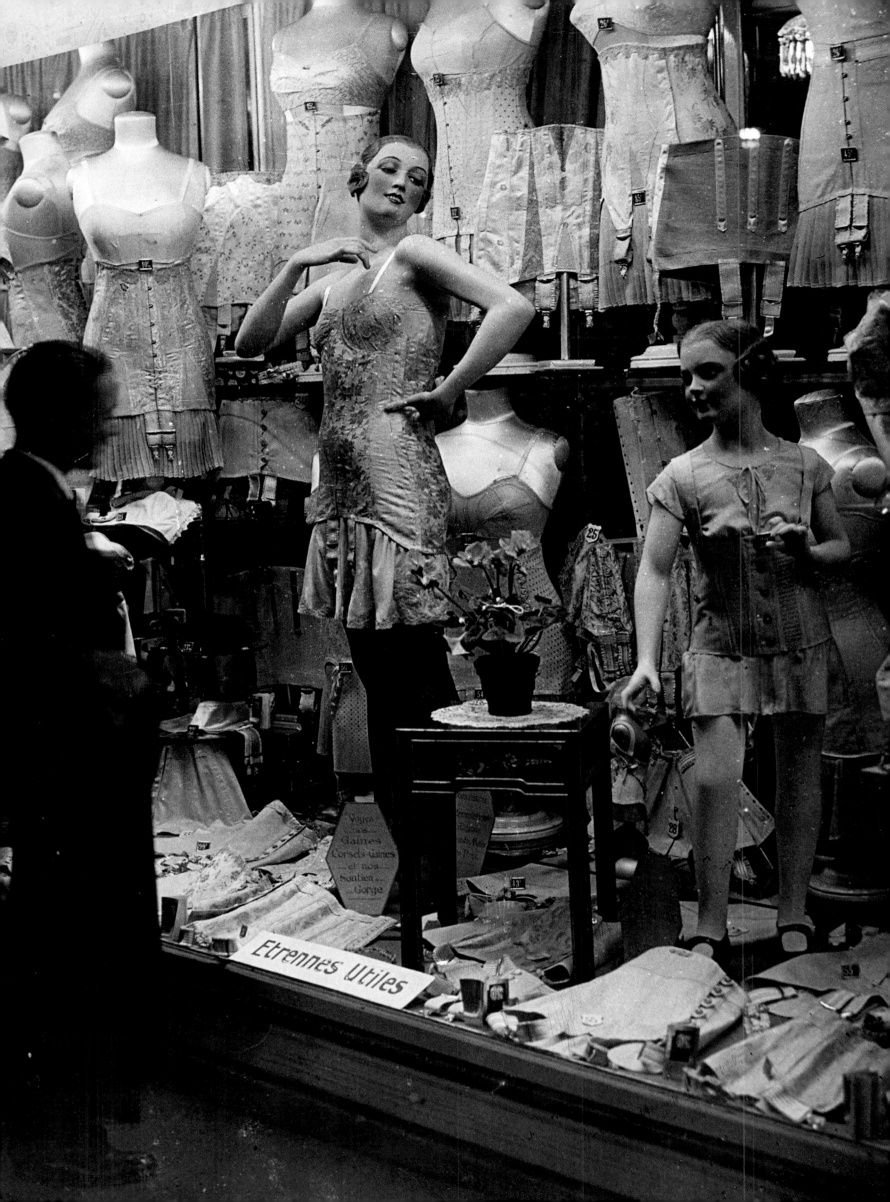

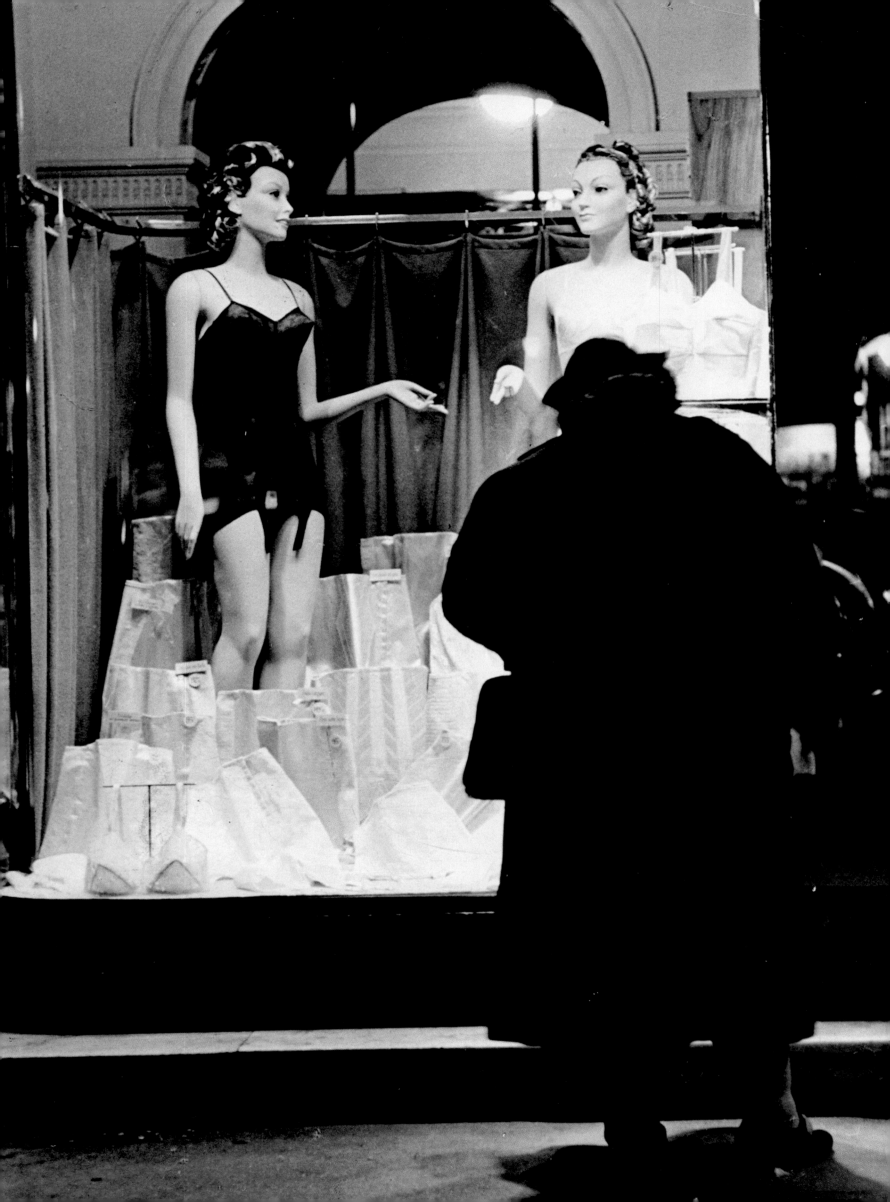

When Brassaï had an idea for a picture that he could not "find," he staged it. Frank Dobo, among others, acknowledged serving as a subject.[133] He was the male lover on the bench in plate 24 of Paris de nuit. The female was Janet Fukushima, the sister of Dobo's sister-in-law. Fukushima was also the subject of the photograph included in Dalí's collage Le Phénomène de l'extase (The Phenomenon of Ecstasy), 1933.[134] Dobo further identified Brassaï as the man exiting the pissoir in plate 11 of Paris de nuit and as the clochard on the ground under the Métro in plate 47. Brassaï, said Dobo, put people in his pictures "to make the photographs livelier."[135] Since photographing in bordellos was illegal, Brassaï posed a friend as the male in most of the pictures he took at "Suzy's" bordello. His friend was seen first approaching the door, then, in Introductions at Suzy's, Paris (c. 1932) (catalogue number 42), making his selection from the three disrobed women standing in front of him. He was also seen lying on the bed with a prostitute, dressing while the prostitute washed herself on the bidet (catalogue number 41), and adjusting his tie in the mirror of the armoire.[136] Most of the pictures published in Secret Paris were initiated by Brassaï. But magazines commissioned other pictures in the series, especially those accompanying dubious "police stories" in Scandale, Détective, and Paris-Magazine. These illustrations constitute some of Brassaï's most obviously staged pictures. In one issue of Paris-Magazine, the not-very-convincing "dead man" is Brassaï himself.[137] Dobo remembered he and Brassaï trying to persuade a Chinese waiter to pose in a photograph for Détective. Brassaï promised to photograph the man from the back so he would not be recognized, but the man declined, saying, "Not even from the front."

The man who posed for Brassaï at Suzy's was a friend whose last name was Kiss, which is how everyone addressed him. He was an electrician who had recently immigrated to Paris from Arad in Transylvania. When Brassaï photographed in tough neighborhoods, he also employed Kiss as a bodyguard, because he was physically well qualified for the job. Kiss once casually set down a briefcase full of exercise weights that Dobo could not lift. "Ironically," said Dobo, "Kiss means small in Hungarian."[138] Brassaï needed protection, because while some of his subjects were friends who acted out roles for his photographs, other subjects were actual members of the demimonde who were to be feared. The historian Xavier Demange has identified the larger woman in Lesbian Couple at Le Monocle, Paris (1932) (catalogue number 46) as Violette Moriss, a French weight-lifting champion, nicknamed "discus thrower of the cut breasts" because she had had a double mastectomy. Before the war, she killed a man during an argument in her home; during the war, she collaborated with the German Gestapo and was allowed to torture female prisoners. The Resistance assassinated her in 1944.[139]

To enter the abodes of outcasts, Brassaï relied on members of the demimonde he knew to introduce him to others in the underworld. He also employed forms of bribery that included buying drinks and giving sitters prints of their photographs. He acknowledged using both "trickery and diplomacy" to win their cooperation.[140] But bribes, tricks, and trust did not always succeed. Brassaï's negatives were stolen one night, and, on another, his cameras were broken. He was threatened, chased, and pickpocketed. He endured these perils as an inherent part of the project, challenges to be mastered akin to the formidable technical feats that were required in these particular settings. Another reason for Brassaï's success in negotiating these situations, explained the printmaker Stanley Hayter, was "his enormous human appreciation for people under extreme circumstances. They had a feeling of acceptance from him. He felt neither judgment or fear. He could get along with chimney sweeps or royalty."[141] figure 7 Shop Window, Paris, 1937. 9 1/4 x 6 7/8 inches (23.5 x 17.5 cm). Collection of Michael and Jeanne Klein. © Gilberte Brassaï

For Brassaï, the fact that these pictures were not candid did not make them "untrue." He considered his photographs to be unsuccessful only if they were unconvincing. His attitude was similar to that of a novelist or filmmaker who is seeking to create convincing characters in a fictional situation. In assessing Brassaï's ability to create significant and credible pictures, one must acknowledge his ongoing relationship with film and filmmakers, their influence on his style, and his influence on theirs. When Brassaï lived at the Hôtel des Terrasses, one of the other residents was Vincent Korda, a Hungarian painter who became a set designer for his famous older brother, Alexander Korda. The elder Korda directed films in Hungary, Germany, Hollywood, and France before settling in England, where he was eventually knighted for his contribution to British cinema. In 1932, just as Brassaï was completing Paris de nuit, Alexander Korda convinced him to join the crew for the film Les Dames de chez Maxime (The Women of Maxime's) as a still photographer. The job was a profitable, absorbing, ten-hour-a-day experience, and Brassaï realized too late that devoting several months to the film, just after his book was published, seriously interfered with his career as a photographer. He did not have time to contribute to his regular newspaper and magazine assignments, he did not fulfill a contract he had signed to make a book on Provence, and he did not deliver the prints requested by the New York art dealer Julien Levy for an exhibition devoted to Brassaï's work. (Having canceled his first solo exhibition in the U. S., he would have to wait until 1954 for the next opportunity.)[142] Nor did Korda's film conform to Brassaï's concept of a good film, because, as he wrote his parents, the company was "too rich to produce good films rather than merely entertaining ones."[143] Working on the film, Brassaï was given a very good camera and learned a great deal about directing, lighting, staging, and motion-picture cameras. But ultimately, as Alexandre Trauner observed, being a film's set photographer bored Brassaï, although "he could have easily made a living with it."[144]

Trauner was part of a group that offered more intellectual stimulation and exchange for Brassaï. He met Brassaï in December 1929 at the Café du Dôme's "Hungarian table." A painter recently emigrated from Budapest, Trauner would shortly begin his career as an Academy Award-winning cinema art director.[145] Between 1937 and 1946, he worked with French director Marcel Carné and the screenwriter and poet Jacques Prévert on six films that were unsurpassed in thirties France and are regarded as the creative force behind the development of poetic realism in French cinema.[146] Brassaï was also close friends with Prévert and his brother, Pierre, who began to make films together in 1928.[147] Another friend, the actor-producer Marcel Duhamel, shared a house with Prévert and the painter Yves Tanguy in 1925, although Brassaï did not meet them until later.[148]

Brassaï's photographs definitely influenced Les Portes de la nuit (1946), the last film collaboration of Carné, Prévert, and Trauner.[149] Prévert's script was based on his own ballet Le Rendez-vous, a collaboration with Roland Petit and Boris Kochno's ballet company, which had been performed the previous year (see "Ballet and Theatre," below). Brassaï created the sets for the ballet and was consulted on the set design for the film.[150] Trauner acknowledged that he told Philippe Agostini, the director of photography for Les Portes, that "we wanted an atmosphere like those in Brassaï's photographs, but usually [the influence] wasn't that conscious."[151]

It is possible that Brassaï's views of lovers, bistros, and misty nights influenced other movies by Carné, Prévert, and Trauner — especially those films set in Paris between dusk and dawn, such as Le Quai des brumes (1938) and Le Jour se lève (1939). A very conscious balance between realism and poetry was a key trait in Brassaï's photographs as well as the Carné-Prévert-Trauner films. Fidelity to life was balanced by attention to poetic atmosphere and artistic invention. Trauner was famous for designing studio sets that were faithful to specific locations, but simplified. Merely decorative details were removed, and other items were added that helped the audience grasp the characters' psychology. Of course, Brassaï's staging was always "on location," but "props" such as glasses and other table detritus shift or disappear between pictures taken of the same subject. Edouard Jaguer observed that Brassaï's sequence of photographs titled A Man Dies in the Street, Paris (1932) (catalogue number 110 a-d) is produced "in the same style of 'poetic realism' as Le Jour se lève," but the photographs predate the film. All of Brassaï's friends were familiar with his work.

As in any community of friends, influence flows both ways, but the filmmakers' impact on Brassaï is more difficult to pinpoint. Although Prévert and Trauner did not begin to collaborate with Carné until the mid-thirties, they began to make films around the same time that Brassaï began to photograph, and close to the time they all met. During the years Brassaï was photographing Secret Paris, Prévert wrote three feature-length films and an avant-garde short film for his brother.[152] Among close friends, there would have been serious discussions about film and its particular qualities and problems.[153] Some film issues were pertinent to still photography; others were useful later when Brassaï made his own, award-winning film (see "Cinema and Filmmaking," below).[154]

Film language certainly appears in his writing of the early thirties; for instance, in the article "Techniques of Night Photography," published in January 1933, he wrote, "At night, a city becomes its own decor, studio-like, recomposed in papier mâché. The overhead lights are out, the projectors set on movable platforms are unplugged."[155] He then explained that by watching studio cameramen use large, blank boards between offending lights and the camera, he learned to use trees and other naturally occurring obstructions to block street lights in his night pictures. He also admitted, in his first published interview, to studying Russian films by Sergei Eisenstein.[156] Another cinematic influence on Brassaï's work is perceived by Marja Warehime, who draws a parallel between the order of the photographs in the book Secret Paris and the structure of a narrative film. She observes that in the first chapter of the book, Brassaï climbs to the top of Notre-Dame, which "serves as the equivalent of a cinematic establishing shot by providing a gargoyle's view of the city from the tower of Notre-Dame. From here the reader descends the two hundred-some steps from the tower, following Brassaï into the streets and then into the closed and secret places evoked by the title."[157] The narrative is further developed in the frontispiece image of a street lamp being lit, and then, in the final photograph, of another lamp being extinguished, signifying the beginning and the end of the night.

Ultimately the influence of filmmakers on Brassaï's work was less a matter of "they-did-this-and-then-he-did-that," and more a function of film becoming an intimate component of Brassaï's life. He could not have avoided its influence, nor did he want to. As Brassaï told one interviewer, "It is not without interest to ponder the medium with which people concern themselves during a given century. Each has its own means of expression, as for example miniatures in the middle ages. Today we live in the age of photography and film."[158]

Whenever there was a break in the Korda film, and when production was finally over, Brassaï turned his energies again to his project on the demimonde. The clients for the Secret Paris photographs tended to be a certain class of magazines, including Allô Paris, Paris-Magazine, Ici-Paris, Paris-Sex-Appeal, Vive Paris, Scandale, Séduction, Pour Lire à Deux, and Détective. Brassaï published in many of these magazines; at one point, he wrote his parents that Paris-Magazine was his major client.[159] During the thirties, Paris-Magazine was a much more noteworthy magazine than the others that published similar articles and illustrations. Christian Bouqueret has written extensively on the "presse particulier" in his book Des Années folles aux années noires: La Nouvelle Vision Photographique en France, 1920–1940

(New Vision Photography in France, 1920–1940).[160] Of these magazines, he wrote, "The most important was Paris-Magazine, which, at its height, sold more than 150,000 copies (as many as L'Illustration) and with which the most important photographers of the time were associated: Jean Moral, Gaston Paris, Brassaï, Roger Schall and Louis Caillaud contributed to most issues, while André Kertész, Germaine Krull, Roger Parry, [André] Verneuil, Ergy Landau, Lorelle Aban, Nora Dumas, Rogi André, Jacques Lemare, Ma Wa (Willi Maywald), [Martin] Munkácsi, [André] Steiner and many foreign photographers . . . also contributed regularly. Renowned writers did not hesitate to put their name in the magazine. . . . This magazine . . . developed a policy of illustration resolutely modern, addressed all genres, and appealed to all the large agencies (Rapho, Keystone, World Press, Globe Alliance Photo, etc.). The reduced format with good reproductions was a principal support of the New Photography [style] and the new photographers were assured good revenues."[161]

Brassaï's association with Paris-Magazine ultimately undermined his intentions to publish a serious book using the images in his project Secret Paris. Instead, a slim volume of forty-eight pages and forty-six halftone reproductions was published in 1935 under the title Voluptés de Paris (Sensual Pleasures of Paris).[162] Like Paris de nuit, the publication was spiral bound, but in plastic, not wire, and its binders broke easily. Instead of including a serious text by a respected author, the book contained brief introductory remarks that read like an advertisement for naughty Paris: "City of games and of joys, paradise of desires, capital of Adventure! . . . Paris, where one can dare anything, desire anything, satisfy anything! . . . Take all you want, Ladies and Gentlemen! There is enough for everyone in Paris' great bazaar of the sensual pleasures." As Marja Warehime observes, the book "sensationalized even the most innocent of the photographs. If few of the photographs were completely innocent, they were rarely explicitly erotic."[163] Brassaï condemned the book's emphasis solely on whatever titillating aspects his photographs contained. He also disliked the poor quality of the reproductions, the binding, and the text.[164] In fact, Brassaï hated Voluptés de Paris, claiming it was published without his permission, and excluded the book from his list of publications.[165]

According to Alexandre Trauner, "a man named Vidal," who published Paris-Magazine, also owned various shops, including Librairie de la Lune and Librairie Diana-Slip, which sold lingerie, magazines, books, and photographs.[166] According to Warehime, Vidal was also the publisher of Scandale, "la review des affaires criminelles," in which Brassaï published his photographs. Vidal must have also owned Librairie du Ponceau, a sex-book shop on rue de Ponceau, because its address was the same as that given for the publisher of both Paris-Magazine and Voluptés de Paris.[167]

Brassaï would also have objected to the blatant advertisement for one of the publisher's sex shops that was inserted in the center of Voluptés de Paris. The double-page spread in Voluptés consists of two pictures by Brassaï. On the left-hand page is an evocative photograph of a man looking in the window of a book shop; on the right side, a young woman is seen standing on a stool to reach books on the top shelf of a bookcase. The caption below the photographs redirects our perception of the images from a potentially rich reading into the limited range of an advertisement. It reads, "The famous 'libraire de la lune' offers unpublished curiosities to collectors."[168] The pose of the young woman echoes similar poses repeated in every photographic ad for any shop owned by Vidal, although in other photographs, the woman shows more "leg." Later in the book, the publisher included a picture, also by Brassaï, of a man photographing a topless woman in sheer underpants; the model is surrounded by large studio lights. This picture may have been taken at Studio de la Lune, which, according to contemporary advertisements, was next door to Librairie de la Lune and sold "très rares" film and photographic series that the shop's owner promised to send with discretion to foreign purchasers. It is possible that the photograph Nude (1931–32) (catalogue number 84) was part of a series initially commissioned by Vidal, or, at least, was made taking advantage of the opportunity to photograph the young women who posed in that studio.

Having purchased for his magazine a wide range of Brassaï's pictures, Vidal was able to publish Voluptés de Paris without asking for Brassaï's permission. Maybe Brassaï had submitted the maquette for the book to Vidal, and maybe Brassaï thought Vidal would publish a serious book. Ultimately Voluptés lacks the substance of other books that Brassaï published, therefore, it is unlikely that this book was published with his cooperation. Brassaï intended Secret Paris to be "a book on the 'lower depths' of Paris, a sort of document on customs and morals."[169] Validating his assurance to his parents that "the book won't lose its relevance for many years," Brassaï published The Secret Paris of the 30s forty years after he took the pictures.[170] By then, the world of the demimonde was history, and its few surviving establishments served tourists more than real practitioners of love and vice. In the text for each chapter, Brassaï situated the subjects of his pictures in a historical context selected as much from the world of literature as from actual events. All of Brassaï's friends acknowledge that he was a marvelous raconteur, a talent that emerged in his text for Secret Paris. His "ear" for dialogue enriched his accounts of the Human Gorilla and his wife, "Loïe Fuller," and of the beggar and his "Cro-Magnon wife, Doudou." Brassaï's sympathy for their situations and the lively details that he recounted fleshed out their photographic portraits.[171] When Brassaï wrote about street-fair performers, he discussed the great Parisian fairs that, for decades, moved predictably from one neighborhood to the next. The description of one beggar's life served as the introduction for a brief history of the Parisian clochards dating from the Middle Ages to the present. Photographs of the music halls on the rue de Lappe lead to descriptions of the dress, language, music, and behavioral codes of the gangsters and their women. The prostitutes near Les Halles prompted Brassaï to invoke the writing of Giovanni Boccaccio, whose Decameron was "one of the most risqué books ever written."[172] Brassaï's chapter on bordellos discussed their price structures and the services available. For "hotels" serving the noble and wealthy, Brassaï recounted in detail their varying themes and practices as well as their celebrity customers during the era when the bordellos were licensed and inspected by the city. Throughout the text, he quoted his beloved Proust.

Much of the text laments the "sanitizing" of Paris in the name of progress. The disappearance of the clochards, he wrote, "will erase from Parisian folklore one of the delectable things that went to make up its charm." The public urinals, or vespasiennes, he claimed, were as much a legitimate part of the Parisian landscape as were Morris Columns, newspaper kiosks, and the Art Nouveau Métro entrances. But after World War II, the Paris Municipal Council and the National Assembly were "seized with a fever of morality and virtue." They removed the urinals, closed the brothels, and cracked down on the clochards. The activities they sought to ban all continued in clandestine forms; Paris was only outwardly sanitized. To Brassaï's mind, for Paris to lose the distinctive character of its backstreets and great neighborhoods constituted a grave loss, with little gain.[173]

Careful students of Brassaï's work are led by him, and by the nature of his work, to the literature of Charles Baudelaire. As curator Manuel Borja-Villel observed, it "is not depravity but the incessant repetition of desire" that they both explored.[174] Andor Horváth extends this perception to include "not only human life in extremis but also the beauty of ugliness, poverty, cheap pleasure, and perversion. Thus, does the Brassaï of secret nocturnal Paris resemble Baudelaire: he draws beauty from ugliness, but without the tension that informs Baudelaire's rebellion: to the contrary, Brassaï's scenes are suffused with a kind of serenity."[175] Throughout Secret Paris, Brassaï set his photographs in a historical, not a contemporary context. There are no citations of authors, such as Miller or Céline, whose works are contemporary with Brassaï's photographs, but whose texts also deal with poverty and desire. In fact, neither of Brassaï's two books that are devoted to the works and life of Miller focus on Miller's ribaldry and the explicit eroticism in his writing. Miller's pleasure in living with abandon and in uninhibited excess held no fascination for Brassaï. Instead, Brassaï gravitated to instances in life in which prohibitions and desires are confronted, channeled, released, modified, and compounded.

Magazines A charming, witty man, Brassaï was accepted with pleasure in many Parisian circles, which, if diagrammed, would resemble the interlocking Olympic rings. Among his coterie were Hungarian compatriots, the Surrealists and ex-Surrealists, Picasso and company, Henry Miller and friends, artists living at the Hôtel des Terrasses, and other writers, poets, and photographers.[176] Drive, talent, luck, and personal contacts all play a role in the competitive world of publishing, and Brassaï understood the necessity of both ability and contacts to secure jobs. "Here one's life is taken up by never-ending activities," he wrote his parents, "making contacts for immediate and instant goals . . . Every man can be of use."[177] This commentary does not mean that his friendships were not true and loyal; the letters to his parents are laced with caring details about his friends. But he understood that friendships were integral to business. For instance, the critic-turned-editor Tériade invited Brassaï to participate in Le Minotaure and, later, Verve.[178] Many of the friends Brassaï first met at the "Hungarian table" at the Café du Dôme also became collaborators, employers, or employees.

Brassaï also understood that "make the picture" and "sell the picture" are part of the never-ending cycle in the life of a working photographer. He was good at both the creative and the administrative sides of his business, but, like others, he found that the time required to market his pictures, or his ideas for pictures, substantially diminished the time available to make them. The logical solution was joining a picture agency, so that he could concentrate on making his photographs. He needed an agent whom editors knew and trusted, and who had a good eye for salable pictures. Brassaï chose Charles Rado, a fellow Hungarian who worked in France from 1933 to 1940, and then escaped Vichy France for New York.[179] After the war, Rado stayed in New York as the United States representative for Rapho, the photographic agency he had founded. Although Brassaï worked infrequently with its Paris branch after World War II, Rado continued to represent Brassaï in the U. S. until 1966.[180]

Christian Bouqueret has identified Rapho as the premier French photography agency that managed archives of independent photographers, such as Brassaï, Bill Brandt, and Robert Doisneau.[181] Rado brought to Paris his prior experience and contacts from directing the Press-Cliché agency in Berlin. Agencies such as Rapho and Alliance Photo in France, Press-Cliché and Simon Guttmann's Dephot in Berlin, and Black Star in New York were a logical consequence of the rapid growth of the illustrated press in Europe and the U. S. and its increasing demand for more pictures.[182] The agencies also satisfied the photographers' increasing need to have agents market their work. Agencies offered editors a choice of single pictures or complete photo stories from their archives, or they pitched photographers for stories that the photographers, agents, or editors conceived.

As discussed above, Brassaï began to photograph soon after the birth of modern photojournalism. The emergence of powerful and inventive magazine editors and art directors was another major corollary to the rise of the weekly illustrated magazines. Shifting from stiffly composed photographs arranged amid the text in predictable grids, magazines began to run sequences, or "picture stories," achieved by editors selecting, cropping, and arranging photographs to form narratives. Inventive art directors devised lively new graphic styles to merge photographs and text. Sometimes photographs were tilted on their axes. Double-page spreads were treated as one visual unit across which words and images could dance. In an issue of the German newspaper AIZ, a pole vaulter appeared to be leaping over the article's title and across the spread. The text, often short, was written to complement the photographs as often as the photographs were commissioned to illustrate the text. Many of these magazines were tabloid size, a larger format allowing the vivid integration of photographs and text.

Brassaï worked with many of the great magazine editors and art directors, both before and after World War II, including Florent Fels (Voilà), Stefan Lorant,[183] Charles Peignot (Arts et Métiers Graphiques and Photo-Ciné-Graphie), Carmel Snow and Alexey Brodovitch (Harper's Bazaar), E. Tériade (Le Minotaure and Verve), and Lucien Vogel, Carlo Rim, and Alexander Liberman (Vu).[184] Published weekly from 1928 to 1940 and owned by Vogel (until 1936), Vu was perhaps the major magazine in France between the wars that published first-rate contemporary photography on a regular basis.[185] Many photographs now recognized as landmarks in the history of the medium were first published in Vu, including those by André Kertész, Germaine Krull, Eli Lotar, Isle Bing, Man Ray, and Maurice Tabard. Vu was modeled on German counterparts, such as Berliner Illustrierte Zeitung, Münchner Illustrierte Presse, and Arbieter Illustrierte Zeitung, which also liberally used photographs in intelligent ways. But Vogel, curator Sandra Phillips proposed, "improved the appearance of the German model and produced a magazine of style and flair. He was interested in a more extensive use of photography, . . . [and] . . . sensed not only the narrative and informational use of photographs, apprehended by the Germans, but also their decorative, lyric and humorous potential."[186] Whenever possible, photographers would sell a story to a French periodical, such as Vu, Voilà, or Regard, and then sell the same story to Münchner Illustrierte Presse, Das Illustrierte Presse (Frankfurt), or any one of the many other illustrated weeklies in other countries.

Trying to understand Brassaï's photographs by looking at only one or two of the magazines in which he published is akin to imagining an elephant by listening only to the blind man holding its trunk. The same picture, or series of pictures, was often accompanied by different texts, and one's perception of the photographs can shift according to the text and the context in which they appear. For instance, in 1932 Brassaï made a series of nine photographs from his window at the Hôtel des Terrasses of a dead man on the sidewalk (catalogue number 110 a-d). Selections from the series were published in Vu (1932), Picture Post (1938), Labyrinthe (1946), and his monograph published by Éditions Neuf (1952).[187] Founded a decade apart, Vu and Picture Post were both weekly magazines about the current events in their home countries of France and England, respectively; each had a liberal dose of world news, fashion, science, travel, sports, and the arts. Labyrinthe was a monthly literary and arts newspaper launched by publisher Albert Skira soon after France was liberated in 1944. Unlike Vu or Picture Post or the other weekly illustrated publications, Labyrinthe featured more text than pictures, poetry as well as prose, and as many reproductions of paintings as photographs. In the same issue of Labyrinthe that published Brassaï's article "A Man Lies Dead in the Street," the other authors and artists featured included Simone de Beauvoir, Henri Michaux, Ernest Hemingway, Goethe, and Toulouse-Lautrec. Although historically Labyrinthe and Skira were linked to the Surrealist circle, the publication featured a much more diverse list of eminent contributors than its predecessor, Le Minotaure. Thus Labyrinthe offered an intellectual context that Brassaï desired for his work. Unfortunately, Brassaï's series on the dead man was labeled "reportage photographs" and published in Labyrinthe without any additional commentary. The texts in the other two publications were closer to the serious tone and substance preferred by Brassaï, even if the editorial direction of the magazines was more oriented toward current events. Poetic in structure and content, the texts accompanying Brassaï's photographs in Vu and Picture Post both speculate about the life and character of the dead man. The anonymous writer for Picture Post plays to the linear narrative aspect of the pictures, but the author's style doesn't display the elegance and richer imagination of Fanny Clar, author for Vu.[188] Clar's text plumbs for causes, consequences, and the human responses evoked by death.

The situation is reversed in the two articles published with Brassaï's photographs of people sleeping. First published in the magazine Coronet in a 1938 portfolio titled "Fatigue," the minimal captions accompanying Brassaï's photographs were prosaic. Sleeping Machinist at the Folies-Bergère, Paris (1932–33) (catalogue number 29) was titled "Labor Lost," and Sleeping Tramp in Marseilles (c. 1935) (catalogue number 125) was captioned "Faute de mieux" (For Lack of Better). When Brassaï published his photographs of a group of eight nappers as "Le Sommeil" (Slumber) in Labyrinthe in 1945, he wrote the text himself. He began noting gravity's constant scheme to topple us, and everything else that dares to rise. Animals, he observed, wisely remain on all fours; man, neither wise nor careful, in an outburst of megalomania, frees his arms from servitude. But man is defeated daily and must spend more than one-third of his already ephemeral existence banished from himself. It is the struggle between high and low, vertical and horizontal. "Alas! The rising tide of inertia and torpor overwhelm him . . . This concludes with the complete leveling of the entire proud hierarchy: the king of creation is no more than a deflated goatskin that snores." Thus a stolen nap in one periodical becomes a fated, recurring human defeat in another. Mere illustration in one publication becomes poetry in another.

Occasionally Brassaï's photographs were so distinctly poetic that the captions published with specific ones were nearly identical in magazines that addressed widely different audiences. In 1945, Brassaï photographed fine sculpture that had been removed from public view during the war and stored for safety near mounds of coal in the cellar of Saint-Nicolas-des-Champs church (catalogue number 97). Brassaï relished the visual discord between the brilliant, white marble figures and their dusty, jumbled environment. He further enjoyed the incongruity of sculpture from vastly different eras and carved in diverse styles stored in close proximity. Finally, he noted that the statues embodied religious and historical values that were incompatible. First published as "L'Agonie des Anges" (Death Throes of Angels) in Labyrinthe, and in the same month as "Les Caves de Saint-Sulpice" in Quadrige, the series was subsequently sold to Lilliput and Harper's Bazaar.[189] In the text for Labyrinthe, Brassaï connects the human suffering of World War II with the religious suffering symbolized in some of the statues. "The epic past merges with the tragedy of our days," he writes, "the legendary past is mixed with the horrible present." He compares the figures of Mary and Joseph praying over the empty space where the Christ child should lie to a bereaved couple weeping for a child lost in bombing rubble. Guardian angels are too wrapped in their own splints; "no one is under the protection of their wings." Brassaï enjoys most that "alone among the saints and martyrs, Voltaire maintains his smiling serenity.[190] This demolisher of the Church is here only to enjoy in dying a mischievous delight in trespassing beneath the rubble of a church!" The other two periodicals rephrased and expanded Brassaï's ideas, maintaining the poetic allusions of his text.

51

Brassaï had the least control over his pictures and their interpretation when they were published individually rather than as a narrative or related portfolio. Coronet and Lilliput were popular "pocket" magazines of photographic illustrations, cartoons, brief articles, and short stories. Both magazines, which were modest in trim size (approximately 8 x 5.5 inches), published many of Brassaï's photographs as full-page illustrations.[191] Lilliput was famous for its humorously pointed, but sometimes lame, pairings of photographs across a double-page spread. For example, Brassaï's photograph of a large, placid cow was paired with an image of the sequin-sheathed backside of Mae West; his picture of the famous Parisian hairdresser Antoine playing a mammoth organ was juxtaposed with a photograph of Dr. Joseph Goebbels, the Nazi propaganda minister, playing another organ; and his photograph of a cat with phosphorescent eyes (catalogue number 123) complements the single luminous gaze of a full moon rising over a lake, also by Brassaï.[192] Even Brassaï's seemingly most surreal photograph, that of a potato with animated tendrils suspended in ambiguous space by threads, is reduced from great poetry to banality when juxtaposed with a stag whose antlers parallel the myriad directions of the potato's tendrils.[193]

Thus, perception of Brassaï's photographs was shaped by the imagination, or the lack thereof, in the accompanying captions and texts, and by the publisher's mission. It is likely that Brassaï was confident that his pictures could endure these and many more, though equally different, approaches. An important point to which Brassaï continually returned in his writings and interviews is that his photographs have a long shelf life because they are not the kind of magazine pictures that are tied to current events, nor do they need captions to explain them. In both subject and composition, Brassaï sought to make timeless pictures with richly layered references to cultural and historical matters. The complexity of his photographs elicited multiple interpretations from writers of different aesthetic and political persuasions, and each subsequent generation has evolved its own reinterpretations. Books came closest to giving Brassaï the control over text, sequencing, and presentation that he desired. In late life, when his international reputation granted him the control he desired, he wrote the text and selected the pictures himself, taking the responsibility for the context for the work.

As a young man, Brassaï discovered that being a perfectionist and being practical were incompatible. While he preferred to see his work published in magazines directed toward cultivated readers, he also needed to earn a living, and thus accepted sales of his work where he found them. For a couple of years in the mid-thirties, Brassaï was very serious about his career as a magazine photographer. Between 1935 and 1937, he hired Kiss and another photographer, Emile Savitry, to assist him. The variety of magazines in which he published between the wars was prodigious. The range encompassed most of the illustrated weeklies; the hair stylist magazines Votre Beauté and Coiffure de Paris;[194] the fashion magazines Vogue, Harper's Bazaar, and Le Jardin des Modes; the Surrealist and ex-Surrealist periodicals Le Minotaure and Bifur; photography publications Photo-Ciné-Graphie and La Revue de la Photographie; and the sex-story and police-story reviews discussed above in the section "Secret Paris." After years of needing his parents' financial assistance, Brassaï took great pride in writing to them about his remunerative success. On the other hand, he also yearned for his prior "penniless freedom and friendless solitude." He justified his commercial careerism by writing, "I'll soon be able to earn a lot of money and be freer than ever."[195]

A year and a half later, Brassaï changed course again. "Business and fame are getting to be too much for me," he told his parents in August 1937. "In recent weeks I handed in my resignation to Coiffure de Paris and I gave notice to my two useless colleagues (Savitry and Kiss)."[196] While bragging that his income nevertheless had doubled through Rado's sales of his pictures to Coronet and to advertising agencies, he wrote to his parents that "photography is no longer a labor of love for me and I'm going to give it up as soon as possible."[197] He wouldn't give up photography for another twenty-five years, and then his reasons were more related to his health than to a loss of affection for the medium. The year 1939 was one of transition for Brassaï. There were great personal losses. Tihanyi died.[198] Because of their Austrian and German citizenship, Paul Medina and his wife were deported. Frank Dobo immigrated to New York. The musician Heinrich Neugeboren moved to Nice. It was a time of terrific political and social tension. Hitler's troops had entered the Rhineland in March 1936 and the Popular Front party was elected to a majority in France in May of that year, only to fall a year later. Spain was in the throes of civil war. In April 1937, General Franco bombed the village of Guernica and leveled it during weekly market. Picasso painted Guernica for the Spanish pavilion at the International Exposition of Arts and Technologies, which opened in Paris that summer. Anti-Semitism was on the rise in France. According to Pierre Gassmann, even La Rotonde, haven to intellectuals and artists, posted the sign: "Dogs and Jews not welcome."[199]

In 1983, Brassaï explained to an interviewer that he struggled against photography in the late 1930s because he feared losing his identity as an artist. Rather than forsake photography completely, he abandoned his career as a professional photographer who would accept assignments of no personal interest. Henceforth, Brassaï became more cautious. In 1937, Tériade's beautiful magazine Verve began publication in Paris, giving Brassaï important new and engaging assignments. The first issue includes more than a dozen of his photographs of the work of Henri Matisse and of Aristide Maillol, as well as their portraits. The same year Brassaï also began his formal relationship with the U. S. magazine Harper's Bazaar, a relationship that lasted more than two decades. His work was included in the historic exhibition and catalogue Photography 1839–1937, curated by Beaumont Newhall for the Museum of Modern Art in New York, and was awarded a gold medal at an exhibition held in Budapest on the centenary of the birth of Louis Jacques Mandé Daguerre. Brassaï began to draw again (catalogue numbers 86 and 87), continued to work on his photographs of graffiti (see "Graffiti," below), and concentrated on a relatively new photographic series on high society, which would find a ready market with Lorant at Picture Post as well as with Harper's Bazaar.

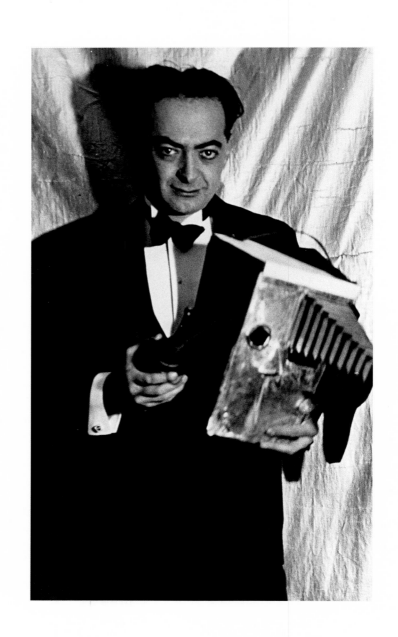

Brassaï nurtured an avid curiosity about high society long before he began his association with Harper's Bazaar. Some of his most vivid childhood memories included watching the comings and goings of wealthy people and royalty in Paris (see Berman, page 146). And his curiosity about fashionable society plays a prominent role in his correspondence with his parents. For example, at the end of his report on an aunt's visit to Berlin in 1921, he relishes the opportunity her visit gave "to have a glance at Berlin's profiteering society and see all the extravagance."[200] In those days, he writes, "I was prompted by an irresistible curiosity to explore the mysteries of 'the world,' know its secrets, its manners, its customs."[201]

The Parisian world of high society was as closely guarded as that of the demimonde; both required the proper introductions. Many immigrants have written about their inability to make friends with any native-born Frenchman, much less someone of aristocratic birth. "I would make it my business to 'crash' the portals of society," Henry Miller commented to Frank Dobo in 1933, "just to have a glimpse of that life which the French deny us foreigners by erecting their Chinese walls of cafes. . . . There are infinite possibilities here if only one is thrown into the right set — the so-called 'smart' set."[202] In 1924, only ten months after his arrival, Brassaï was fortunate to meet Madame Marianne Delaunay-Belleville (Madame D.-B. in all of Brassaï's texts), whose family produced handmade cars.[203] He described her as a highly intelligent and erudite woman. She painted, wrote poetry, and authored a book on Tristan and Isolde from the point of view of an old woman who had heard the true story, but Madame Delaunay-Belleville's finest accomplishments were as a pianist. She gave frequent concerts, sometimes accompanied by Silvio Floresco, a Romanian violinist and pianist, who introduced her to Brassaï when she was forty-six and he was twenty-five.[204] She was also a member of the French aristocracy.[205] In Brassaï's introduction to his book Brassaï: Letters to My Parents, he refers to her as his Léda, or his Frau von Stein. Léda (Mrs. Adél Brüll) was a lover and patron of Endre Ady, one of Hungary's greatest poets;[206] Charlotte von Stein, to whom Goethe was completely devoted, was the wife of a German court official. She taught Goethe the graces of society and engaged his imagination, intellect, and desire while insisting on a relationship governed by decorum and conventional virtue. Whether Brassaï's exact relationship with Madame D.-B. was closer to that symbolized by Léda or Frau von Stein remains unknown, except through speculation. Jacqueline Delaunay-Belleville, Madame D.-B.'s daughter, described Brassaï as her "foster brother."[207] Having read Brassaï's letters to Madame D.-B., curator Maria Morris Hambourg described them as "true friends" whose letters evidenced great honesty and encouragement for one another's endeavors. figure 8 Self-Portrait, Hôtel des Terrasses, Paris, c. 1935. 12 x 9 3/8 inches (30.5 x 23.8 cm). Courtesy of John Cleary Gallery, Houston. © Gilberte Brassaï

In his introduction to Letters, Brassaï credits Madame D.-B. with his "insights into that mysterious universe they call 'the world' . . . A man of the world, a woman of the world." "It took me a long time to understand the meaning of those expressions." he wrote. "Wealth in itself did not allow access to aristocratic circles. . . . The plutocracy had access to 'the world' only if their wealth was accompanied by a refinement of taste, life-style, and artistic thought."[208] He also notes that in Proust's time, the aristocracy of the Saint-Germain district constituted the center of "the world," setting the standard for social life. After World War I, Olivier Bernier observed, Paris "was more glamorous than ever, and . . . it was clear to all that Paris, always brilliant, was once again the center of the world" [italics mine].[209] In Fireworks at Dusk, his book on Paris between the world wars, Bernier concentrates on the intermingling of society and the arts, and on members of the nobility known for bringing their great names and fortunes to patronage. The comte and comtesse Etienne de Beaumont were friends of Picasso's and sponsored first-rate concerts; the vicomte Charles and vicomtesse Marie-Laure de Noailles subsidized Luis Buñuel's first films.[210] The de Noailleses were not the comte Mathieu and comtesse Anna de Noailles of Proust's intimate circle, but the de Beaumonts were the same couple that Proust knew, and having personal acquaintance with them was invaluable to Brassaï when he wrote his book on Proust. Like Proust, Brassaï attended some of their famous balls and celebrated dinners, although Brassaï and Proust never attended the same parties, since Proust died in 1922. Throughout the 1920s, Brassaï's letters teem with countesses, marquises, and princes whom he meets in Mme D.-B.'s company, including the de Noailleses and the de Beaumonts.[211] Madame D.-B. gave him the access and introductions to "the world," but, much more important, taught him how to act, dress, and speak properly to the aristocrats of French society, ensuring that he would be accepted and invited again to their evening parties and outings.

By 1927, Brassaï was bragging that, "if I wanted a society career it would be wide open to me,"[212] but he was losing his fascination for "the world" as a lifestyle. The most intense phase of his friendship with Madame D.-B. did not last past 1930,[213] but her tutelage allowed him to photograph high society through the 1950s. In 1935, he wrote to his parents, "Besides the underworld and night life, I am now photographing high life . . . with the same passion, because all walks of life interest me equally. Now that a perfect whole is slowly emerging from the pictures I develop day after day (light and shadow, front stairs and back stairs, the 500 franc banquet and the cesspit), I have to admit that I must truly be what an American writer, Henry Miller, called me: 'the eye of Paris.' "[214]

In fact, Brassaï had been photographing society since the beginning of his career. Five of the sixty-four photographs in Paris de nuit are of high society. Plate 53 depicts couples dressed in evening attire, seen through a car's windows. Two photographs were made at the Paris Opéra, one at the deluxe Hôtel Crillon and one at the Pavillon d'Armenonoille in the Bois de Boulogne. Another early picture shows a top-hatted gentleman reading a newspaper at Longchamp racetrack in 1932. The photograph was later reproduced in an article titled "Élégance Stable," on men's fashions at Longchamp.[215] The photographer Germaine Krull noted in her book that this racetrack had for a long time "been the place where fashionable tailors show their creations for the first time."[216]

The decision, in 1935, to photograph elegance and wealth might surprise anyone who remembers that Europe was in political turmoil and that the Great Depression had occurred six years before. But these events had little effect on "the world" in Paris. Although it was now difficult for even fully employed French workers to survive on their diminished pay, Bernier reported that some of the most brilliant balls of the decade were given in 1935.[217] He later described in considerable detail a ball given in 1936 by the prince and princess de Fancigny-Lucinge, whom Brassaï knew through Madame D.-B. At their "Bal des Valses" (Ball of the Waltzes), the theme of the dance chosen to open the ball was "Waltz of the Millions," danced by a couple dressed in bank notes and gold coins.[218] Until the German troops arrived, there was much for Brassaï to photograph, and some of his finest pictures of high society were made between 1934 and 1938.

Some of the pictures were meant to serve as reports of new developments in entertaining. Brassaï's photographs of evening parties held under great tents at Longchamp followed the introduction of nighttime races in 1934. According to Bernier, at the conclusion of these new races "a very grand supper [was] served in a vast tent for which Daisy Fellowes suggested forcefully that light dresses and big hats were in order."[219] The midnight fête of Longchamp was repeated annually and became what Picture Post described as the "most glamorous of all social events in the world's most glamorous city." "Racing by floodlight, dining by moonlight, dancing by the flicker and flare of gigantic fireworks are only some of the entertainment offered to the élite of the most fastidious pleasure-seekers in the world," declared the text accompanying Brassaï's photographs.[220] Figures 9 and 10 are of the midnight fêtes in 1936 and 1938. During the dinner in 1938, Brassaï captured a woman at one table, and a man seated nearby, each of whom reacted to being photographed (catalogue number 58). She was disconcerted; he coolly adjusted his bow tie. Such self-conscious acts are rare in Brassaï's photographs, but the woman's gesture called attention to her elaborate little evening hat and her jewelry, thus emphasizing her fashion finery. Brassaï's flash caught the sparkle in her ring, her hat, and the crystal. During the fireworks display, rather than use a flash, Brassaï allowed the people being photographed to move. Therefore, in his photographs, they appear ghostly as the fireworks seem to shoot through them (catalogue number 57). figure 9 Evening at Longchamp Racetrack, Paris, 1936 (catalogue number 57) © Gilberte Brassaï figure 10 Evening at Longchamp Racetrack, Paris, August 1938 (catalogue number 58) © Gilberte Brassaï

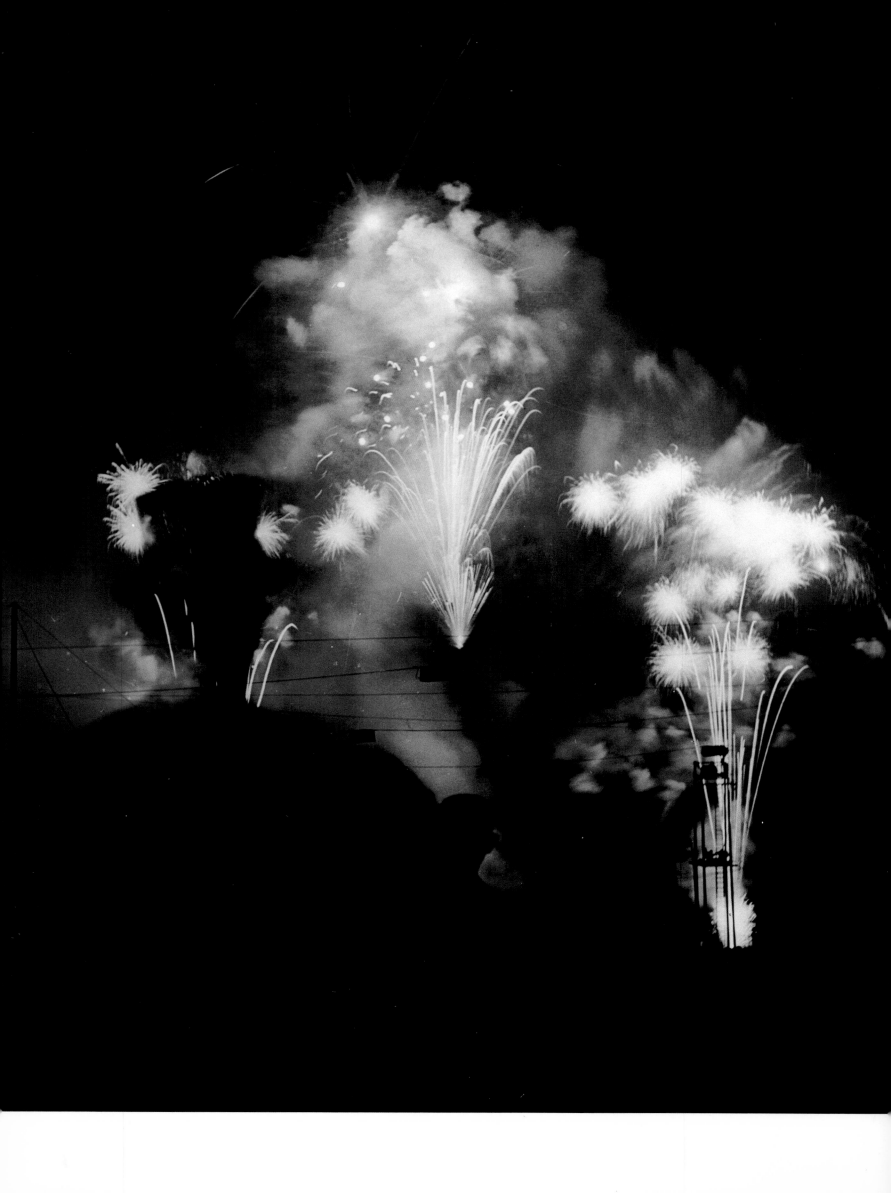

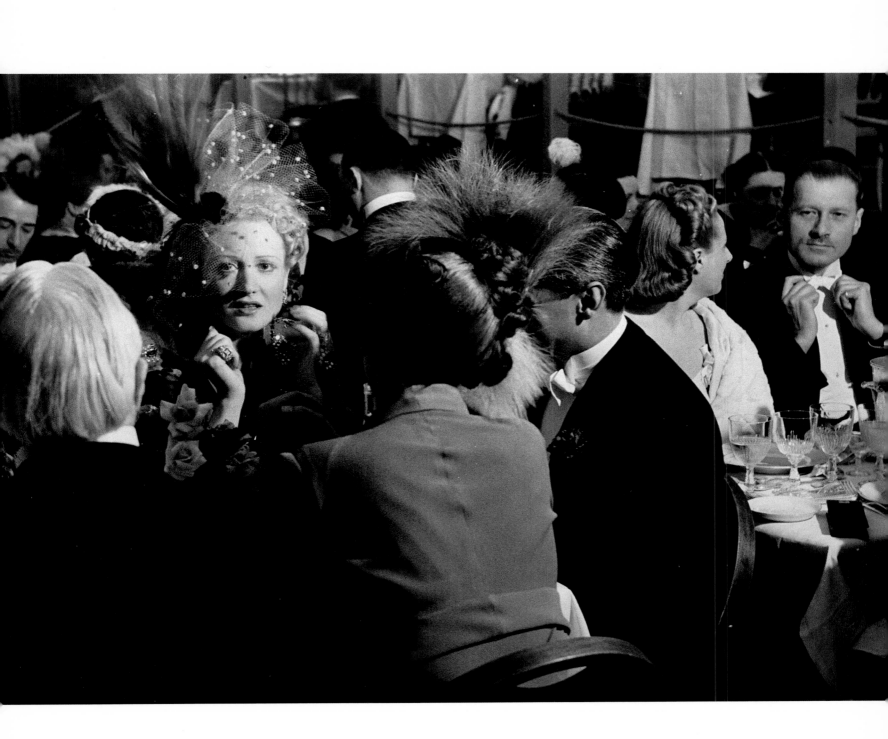

As a child, Brassaï had watched the parade of carriages up and down the Champs-Elysées. As an adult, he explored their various destinations in the Bois de Boulogne. Under Baron Haussmann, lakes had been cleaned, racetracks built, trees planted along wide allées (avenues lined with trees), and cafés opened in the chalets. Although the elegant restaurant Le Pré Catelan was not mentioned by name by Proust, it was fashionable in his, and in Brassaï's, time, as it is today. With rooms designed to open into the park, and its open-air patios, the Pré Catelan was a popular site for masked balls, one of which Brassaï photographed in 1946.[221] His subjects that evening included the vicomtesse de Noailles, the painter Léonore Fini, the princess Troubetzkoï, and the comtesse Jean de Polignac. Brassaï also photographed Lady Diana Cooper, wife of the British ambassador, seated with Christian Bérard, the painter and set designer for plays, ballets, and lavish parties (catalogue number 60). Bébé, as he was known to friends, shared an apartment with his longtime friend and collaborator Boris Kochno, with whom Brassaï had worked on a ballet the previous year. Another attendee at the ball, Madame Jacques Costet, wore a prewar-style dress, updated with gathered satin at the waist (catalogue number 61). In Brassaï's photograph, she is alluringly beautiful and statuesque.

If one wants to photograph high society, certain sites are inevitable, especially the Paris Opéra. Designed by Charles Garnier at the height of the Second Empire, the Opéra's lavish façade, grand staircase, and gilt balconies were fine subjects as well as sumptuous backdrops for those who attended the opera (catalogue number 56). Brassaï's parents had taken him to the street in front of the Opéra so that they could watch the arrivals and departures of royalty. So, in 1935, Brassaï returned to the Opéra's steps to make his first photograph for Harper's Bazaar. As he wrote his parents, Harper's was "the biggest American fashion magazine, the rival of Vogue," and for Harper's, he staged a formal couple descending the exterior stairs.[222] Given Brassaï's love of ballet, it is not surprising that he also photographed the Opéra's ballet troupe, before and after their performances and at rehearsal (catalogue numbers 53 and 54). For Harper's Bazaar, he photographed the "ballet rats" (children in the corps de ballet), as well.

Working for Harper's Bazaar gave Brassaï access to private parties and aristocratic homes. Commissioned by the magazine, he photographed Château d'Anet, Château Légier, Château Mouton-Rothschild, and the sherry vineyards and home of the Domecq family in Jerez de la Frontera, Spain.[223] Brassaï also attended the Directoire Ball in the gardens of the Palais Royal and photographed at Maxim's restaurant on the eve of its fifty-sixth anniversary celebration.[224] Just before the war, Brassaï photographed a soirée at Helena Rubinstein's apartment on the Île Saint-Louis (catalogue number 59). In the foreground of Brassaï's photograph, Misia Sert is sitting on the floor. She was one of the leading figures in the intellectual and artistic world of Proust's Paris, and someone with whom Proust corresponded. Rubinstein's profile is barely visible behind the figure of the Spanish fashion designer Antonio Canovas del Castillo. The fashion and perfume designer Gabrielle "Coco" Chanel leans back to speak to the dancer and choreographer Serge Lifar. In his book on Proust, Brassaï cited how Misia Sert once used a photograph of her husband's lover as the basis for remodeling Sert's own dress and hair to resemble that of her rival, and how Proust modeled a scene between three of his characters on Sert's vain attempt to resecure her husband's affection.[225] The impresario Sergei Diaghilev, for whom Lifar first danced, was also a part of Proust's world. When Brassaï wrote about these members of the high-fashion world of Proust and Diaghilev, he added his personal observations as well as those gleaned from books. By then, Brassaï regarded himself as a "man of the world," at ease in these settings; it is apparent from his images that the elite whom he photographed were as accepting of his presence as were the habitués of the lower-class dance halls. But how different are the sharply cool expressions of the upper class when compared with the open flirting and vamping of the molls with their pimps and customers in Secret Paris. Only Bijou and the madam at Suzy's appear as shrewdly appraising and as cautious of joy as the society denizens.

That Brassaï intended his grand survey of Paris to include a book on fashionable society is confirmed in his interview with Paul Hill and Tom Cooper. "My future publications will verify," he said, ". . . that my inquiry was not limited to underground Paris or to the Paris night, but included many other aspects of the city and other social classes as well."[226] Although he never published the book of society photographs that he had intended to title Paris Élégant, his last book, published posthumously in 1997, examined photography's influence on Proust. Brassaï wrote about Proust's elaborate schemes to acquire photographs and of the pains people took, sometimes in vain, to have flattering portraits made of themselves. Gathering instances from Proust's books and letters, Brassaï observed that Proust occasionally focused his feelings on photographs, using them as surrogate replacements for the people portrayed in the images. Brassaï cited instances in which a character in Proust's epic novel uses a photograph as an icon to alleviate wounded love, or even employs a photograph to deliver an insult. Brassaï presented these acts as being motivated by desires and obsessions that were often sublimated or transferred to the photographs. As noted above, some of the people mentioned in Brassaï's book are those he photographed at Parisian soirées. What more would he have written about those people and events had he completed the society book? What historical and literary traditions would he have invoked to give the images historical continuity, as he had done in the text of Secret Paris? If Secret Paris was about license and breaking prohibition, we can only regret all the more that Brassaï never wrote the text to accompany his photographs about the elaborate rituals and coded prohibitions of "the world."

At the same time Brassaï was concentrating on his society pictures, the English photographer Bill Brandt was finishing his book The English at Home (1936), in which photographs of the British upper crust are juxtaposed with photographs of people immersed in lives of poverty. This book was followed by A Night in London (1938), which offered similar comparisons. Brandt's photographs of garden parties, cricket matches, horse-racing afternoons, and evenings at the theater parallel Brassaï's records of fireworks displays, afternoons on the Longchamp racetrack, and evenings at the opera. Both men relied partially on their magazine work for some of the access they enjoyed to exclusive social gatherings, and partially employed their personal contacts for entry into upper-class interiors.[227] There are many additional connections that have not been previously recognized. According to Gilberte Brassaï, her husband met Brandt in the 1930s in Paris.[228] Brandt's first wife was Hungarian, which may have been the source of the two photographers' connection, although they also shared numerous friends in the Parisian art community. Their friendship was based on great mutual respect,[229] as well as on biographical and professional similarities.[230] For instance, when they were in their twenties, each artist was estranged from the country of his childhood.[231] Each man immigrated permanently to the country about which he had heard much spoken during childhood and each became a great chronicler of his adopted nation. Each produced books on that country's capital, presenting it in cross-section — poverty and plenty, night and day, iconic monuments and shabby suburbs — but neither worked in a traditional documentary style. Consciously avoiding anecdotal renditions, each sought to take photographs that were symbolic of their time.

They anatomized Paris and London, respectively, breaking them down into their constituent recognizable categories. Their outsider status enabled them to observe their individual cities with detached humor as well as with acute observational skills. Brassaï was less judgmental and lacked Brandt's early predilection for making comparisons between the social classes. Brandt was laconic and wrote almost nothing about his aesthetic philosophy or personal background. Brassaï was a raconteur and a prolific writer. The great differences in their personalities and aesthetic styles, as well as between the countries in which they settled, made for great differences in their pictures, but they were similar in the ways they worked.[232] Each carefully selected his sites, organized his subjects when necessary, and directed friends and family members in pictures that could only be achieved by staging the event. Both preferred to visit a place or person, or, at least, to be well informed about the subject, before taking the actual photograph. Both men also acknowledged the influence of contemporary films on their work.[233]

Brassaï and Brandt worked for many of the same magazines, including Lilliput, Picture Post, and Harper's Bazaar, owing some of their finest portraits to commissions from Harper's Bazaar. Each preferred to make portraits in the sitter's natural surroundings, avoiding fleeting or affected expressions by waiting until the sitter was distracted by work or contemplation. While Brassaï was more likely than Brandt to initiate his own projects, the range, if not the quantity, of their subjects was quite parallel.[234] Besides photographing Paris and London, respectively, each photographed other regions of his adopted country as well as the major artists and writers inhabiting it. Each photographer also produced an extensive series of nudes, and each took the most overt liberties with his subject matter when photographing nudes. Fascinated by the bizarre ways that wind and wave carve stone, each was interested in what Brandt called "the brooding fantasy hidden in stones."[235] Brassaï and Brandt were inclined to photograph mannequins and sculpture, an interest that led each artist independently to the fantastic sculpture at the Villa Orsini in Bomarzo, Italy. After World War II, each began to make sculpture. Brassaï worked with stones; Brandt made assemblages using natural found elements, including feathers, driftwood, bark, seaweed, and shells. Toward the end of their careers, both briefly made color photographs.

Brandt's and Brassaï's photographs had more in common with each other than with works by their contemporaries, such as Kertész and Cartier-Bresson, whose pictures depended on the photographers' lightning reflexes to capture a decisive or lyrical moment. As novelist Cyril Connolly observed of Brandt's photographs, "the meditative and reflective side of his nature gains control."[236] Brassaï and Brandt sought to make pictures in which time is transfixed. This quality of standing outside of time was vital to making their work appear "sur-real." Both photographers had ties with the Surrealists, and they published work in Le Minotaure and Verve, although neither Brassaï nor Brandt officially joined the Surrealist group. Each photographer had the capacity to find an element of the fantastic in something quite ordinary, and few artists used shadows more evocatively. The aspect of invention and staging in their work shifts it from being a straight record of reality to being what critic Charles Hagen identified as "emotionally urgent inner landscapes" imposed on the world around them.[237] Often those inner landscapes were skillful compilations of imagined and remembered experiences that each artist sought to capture or recapture.

Unlike today's photographers who readily show their directorial hands, Brandt and Brassaï concealed this aspect of their work. Their pictures do not appear to be staged, certainly not to the extent that they were, and the two men never wrote or spoke in interviews about using friends as models. Both photographers insisted that their primary desire was to capture the essence of things. As Brandt observed, "We look at a thing and believe we have seen it. And yet what we see is often only what our prejudices tell us to expect to see or what our past experience tells us should be seen, or what our desire wants to see. Very rarely are we able to free our minds of thoughts and emotions, and just see for the simple pleasure of seeing. And so long as we fail to do this, so long will the essence of things be hidden from us."[238] In similar terms, Henry Miller described Brassaï's approach in his famous essay "The Eye of Paris." "Brassaï," wrote Miller, "has that rare gift which so many artists despise — normal vision. He has no need to distort or deform, no need to lie or to preach. He would not alter the living arrangement of the world by one iota; he sees the world precisely as it is and as few men in the world see it because seldom do we encounter a human being endowed with normal vision."

Only after Brandt's and Brassaï's deaths have we learned that both photographers made pictures that conformed to images they preconceived, but were nevertheless based on their life's experiences. As Brassaï explained his approach to historian Nancy Newhall: "The object is absolutely inimitable; the question is always to find that sole translation that will be valid in another language. And now, immediately, there is the difficulty of being faithful to the object, the fear of betraying it (for all literal translation is treason), which obliges us to recreate it or reinvent it. The compelling pursuit of resemblance, or representation (whatever may be said about it today) leads us far, much farther than 'free' imagination or invention. . . . How to capture them, how retain them with form? Not being a stenographer, nor a recording machine, my course seems clear; to cast the living thing into an immutable form . . . In a word, I invent nothing, I imagine everything."[239] Both Brassaï and Brandt succeeded where they wanted to succeed in the task of anchoring their images in the world of objects, each drawing on his rich imagination to give his photographs a sense of timeless and immutable form.

Brassaï did not have a portrait studio, use banks of artificial lighting, or employ fanciful props or a team of assistants. His portraits lack the elegantly manufactured drama of images by George Hurrell, George Platt Lynes, Edward Steichen, or George Hoyningen-Huene.[240] Rather, Brassaï's subjects are situated in their everyday environments — at a desk or easel, or in a favorite bistro. They are neither consciously posed nor captured off guard. In an interview on Paris Radio, Brassaï once said, "When I do a picture of someone I like to render the immobility of the face — of the person thrown back on his own inner solitude. The mobility of the face is always an accident. . . . But I hunt for what is permanent."[241] His style gives the viewer a sense of enormous privilege. As critic Andy Grundberg observed, "Brassaï managed to penetrate the public facade of French avant-garde life, showing Bonnard, Braque, Dalí, Giacometti, Matisse, Picasso and others in relaxed and sometimes private moments. One example, his 1939 picture of Matisse drawing a nude (catalogue number 66), is both a record of a remarkable artist at work and a photograph of such unpretentious, seemingly spontaneous composition that it seems we are peering in at Matisse through the most transparent of windows."[242]

Brassaï was also known for exposing very few negatives in a sitting. For instance, he took only one or two shots when photographing Thomas Mann and Picasso, although both subjects were important professional assignments. Lawrence Durrell described his own sitting for Brassaï as being bewitchingly simple, and quotes Brassaï as saying, "Yes, I only take one or two or three pictures of a subject, unless I get carried away; I find it concentrates one more to shoot less. Of course it's chancy; when you shoot a lot you stand a better chance, but then you are subjecting yourself to the law of accident — if accident has a law. I prefer to try and if necessary fail. When I succeed, however, . . . I feel that I have really made it myself, that picture, not won it in a lottery."[243] The brevity of the sitting was also partially motivated by Brassaï's respect for the sitter's available time. He could successfully work with speed because he had already envisioned the results. He arrived for the sitting knowing what the person had accomplished, what might best characterize the subject, and how technically to achieve the portrait he desired to make. In this way, Brassaï's pictures were just as "created" as more elaborate studio portraits. For Andor Horváth, Brassaï's skill elevated the portraits he produced beyond any notion of their being documentary records. "Brassaï had a talent for discovering or for producing a moment, a real event invented," said Horváth. "They are the same as creating human images in any other medium. It is the same as Titian composing a human face. Finally, it is the same."[244]

Rather than photograph film stars, politicians, or society mavens for his magazine work, Brassaï preferred sitters chosen for their talents and selected from an elite pool — artists, writers, musicians, and occasionally, aristocrats. But he made striking portraits long before the elite of the art world became a part of his professional staple. He brought the same skills to The Dean of the Porters, Les Halles Market, Paris (1935) (catalogue number 27) as he did to Matisse and His Model at the Villa d'Alésia, Paris (1939) (catalogue number 66). They are equally "portraits." Both works are typical of Brassaï's method of using the setting as well as the sitter's pose and expression to direct our perceptions. Both the "Dean" and Matisse appear relaxed in Brassaï's presence. Stanley Hayter remarked that Brassaï "could get on with anybody and could go almost anywhere."[245] Whether famous artists or anonymous laborers, Brassaï's subjects are revealed as worthy of our interests, and very human. He honors, but does not flatter.

Some of Brassaï's best portraits are of friends, such as Hans Reichel, Henry Miller, and Henri Michaux. Miller and Brassaï met in late 1930 or early 1931 through Tihanyi, whom Miller met on his first trip to Paris in 1928. The portrait of Miller standing in Brassaï's doorway at the Hôtel des Terrasses (catalogue number 71) parallels Brassaï's written memories of Miller's "mandarin smile" and "rosy face emerging from a rumpled raincoat: the pouting, full lower lip, eyes the color of the sea."[246] They shared a love of Paris, and believed that they had come to artistic maturity by living there en marge (on the fringes of society) in their first years of immigration. The editor Carlo Rim thought that Brassaï's book on Miller was stupendous in the way it conveyed "the grand intimacy of misery and poverty."[247] Both men were prodigious readers with fine memories for the arcane. Much of what Brassaï wrote about Miller applied equally to himself, such as, "Henry was an indefatigable walker, as absorbent as a sponge, and infinitely curious about people and things. Everything he observed was recorded for future use — faces, movements, gestures, odors, passions, sins."[248] Miller concurred. "In cher Halász," he wrote Frank Dobo, "I find a counterpart to myself, I find a man whose curiosity is inexhaustible, a wanderer like myself who seeks no goal except to search perpetually."[249] They wandered about Paris together and Miller sent lists to Dobo of places that he thought Brassaï should photograph, including the entire thirteenth arrondissement. The lists were probably superfluous to Brassaï's already vast knowledge of Paris and served more to illuminate Miller's own recent discoveries.

Both Miller and Brassaï met the German watercolorist and painter Hans Reichel at the Hôtel des Terrasses. Miller wrote an essay, "The Cosmological Eye," as a tribute to their friendship and Reichel's role as his watercolor instructor. (Miller continued to make watercolors throughout his life.) Reichel's career suffered because his style was close to that of the more famous Paul Klee, and real success for Reichel came only after his death in 1958. He was described as a charming raconteur and a ferocious drunk, a trait that alienated many friends, but Brassaï wrote in his own memorial tribute, "If the angel was marvelous, the demon was passionate and that was whom I preferred."[250] Brassaï's portrait of Reichel is unlike any other photograph published of Reichel and is best described by Brassaï himself: "His face, while still young, was marked with the imprint of an undetermined sadness. . . . It reminded me of Beethoven's mask framed by sharply demarcated cheeks, sensitive lips and nostrils, eyes so tender that their heavy eyelids seemed to turn away from the world and a broad forehead furrowed with deep wrinkles unrolling in successive waves on mobile eyebrows, which were practically faun-like."[251]

Given his association with Surrealist publications, it is not surprising that Brassaï photographed many of the writers and artists associated with the movement. In fact, in 1931 Tériade suggested that Brassaï should begin photographing French artists in their studios and publish the series in a book. Later, Tériade commissioned and published many of Brassaï's portraits in his magazines. Brassaï dedicated his 1982 book, The Artists of My Life, to Alexey Brodovitch and Carmel Snow because Harper's Bazaar had also commissioned and published so many of his photographs. But Brassaï also warmly acknowledged his debt to Tériade in the introduction to his book.

Among the Surrealists whom Brassaï photographed at various times was Salvador Dalí (catalogue number 67). They first met in 1932 at Picasso's studio on the rue de la Boétie. Dalí struck Brassaï as "young and handsome, with an emaciated face and pale olive complexion, and he sported a small mustache. His large moonstruck eyes glittered with intelligence, with a strange fire, and his long gypsy's hair was slick with brilliantine."[252] The mustache was not yet the style that became Dalí's trademark, long and pointed upward; the posture and costume were not yet those of a clown provocateur. Brassaï liked Dalí's humor and "untrammeled imagination," and for a while they saw each other frequently and collaborated on several articles for Le Minotaure (see "Surrealism," below). Although Brassaï and Dalí did not remain close, neither did they experience the complete split that alienated Dalí from most of his early supporters. Brassaï and Gilberte visited Dalí and his wife, Gala, in Spain in 1955 to photograph them for an article published a year later in Harper's Bazaar.

Brassaï's portraits of writers and musicians are less well known because they have not yet been published collectively in a book. Many of the portraits of writers were first seen in Labyrinthe (Albert Camus, Jacques Prévert, Pierre Reverdy, and Henri Michaux) and in Harper's Bazaar (Samuel Beckett, Eugène Ionesco, Janet Flanner, and Thomas Mann). As with the portraits of painters and sculptors, some writers were strangers, or nodding acquaintances of Brassaï's whom he photographed on commission, but many were friends. He met Henri Michaux in January 1925, and they became lifelong friends. Frank Dobo introduced Brassaï to the French poet and novelist Raymond Queneau, who became an editor at Gallimard, the publisher of Brassaï's books on Picasso and Miller as well as of The Secret Paris of the 30s. Picasso introduced Brassaï to the poet Pierre Reverdy, whose fits of temper, like Hans Reichel's, appealed to Brassaï. He met Jacques Prévert just as Prévert, Robert Desnos, and others were being expelled from the Surrealist group by André Breton. Through his friendship with Henry Miller, Brassaï came to know Alfred Perlès, Lawrence Durrell, and Anaïs Nin. Through his association with Le Minotaure, he met the poets Paul Éluard, Breton, and Léon-Paul Fargue. Fargue (catalogue number 69) became one of his nightwalking partners, although it is more accurate to say that Brassaï was the one who joined "the pedestrian of Paris" on his nocturnal strolls. However romantic those walks may seem now, their inconveniences and discomforts did not justify for everyone the rewards of the adventure. "One night," Roger Grenier remembered Brassaï reporting, "Fargue had invited a third companion, Edmond Jaloux. However, he, surrounded by the fog, stomping through the mud, appreciated little the charm of these deserted streets and did not hesitate to take leave."[253] In approximately 1932–33, Brassaï photographed Fargue sitting on a bench, one smoking cigarette stub in his fingers and another ground into the dirt at his feet. Dressed in a hat, overcoat, and vest, he was insulated from the night chill. Apparently, they were joined that evening by Le Minotaure's publisher, Albert Skira, for his family owns a version of the portrait that includes Skira. For Fargue's article, "Pigeondre," published in Le Minotaure in 1934, Brassaï also photographed Fargue's hand holding that of the writer Louise de Vilmorin.[254]

After World War II, many of Brassaï's finest portraits are of prominent writers associated with Existentialism, either through their development of Existentialist ideas or because their literary work shared an affinity with Existentialist philosophy. Brassaï also photographed artists associated with Existentialism due to their contacts with various writers, who, in turn, had contributed introductions to exhibition catalogues of the artists' works. The writers that Brassaï photographed included Simone de Beauvoir, Jean-Paul Sartre, Albert Camus, Samuel Beckett, and Jean Genêt (catalogue number 72). He photographed both Alberto Giacometti and Germaine Richier, and their works for Harper's Bazaar. Brassaï also accepted Richier's commission to photograph much of her sculpture.[255] Brassaï photographed Giacometti over the last three decades of the sculptor's life, the first time for Le Minotaure in 1932 when Giacometti was still a Surrealist. In the forties Giacometti began to develop the elongated figures with tiny heads for which he is best known; Sartre was one of several Existentialists who wrote introductions for Giacometti's exhibition catalogues as well as articles in Labyrinthe. The portrait Alberto Giacometti (1948) (catalogue number 65) was part of a series done for Harper's Bazaar in 1948, after Giacometti had begun to fashion his now famous sculptures, but three years before they were first exhibited in Paris. Sitting in his notoriously cluttered studio with his distinctive heads and torsos sketched directly on the wall behind him, Giacometti holds the plaster model of a hand and arm skewered on a stand. The whiteness of the plaster separates it from the modulated tones of the portrait as though the model were a drawing scratched through the photographic emulsion to the paper support. The irregular surface of the armature is as ragged as a torn edge. The armature's gauntness echoes Giacometti's own. Brassaï's last photographs of Giacometti, made a year before Giacometti's death, were published in Harper's Bazaar in 1967.

Germaine Richier was slightly younger than Brassaï.[256] She came to Paris a year after Brassaï and completed her studies before beginning a successful career as a classical sculptor of the female nude and portrait busts. During World War II, she developed her mature style while she waited out the war in Zurich, joining a small circle of sculptors that included her friend Giacometti. Her human forms became contorted monsters, hybrids that were part human and part plant, animal, or insect. Brassaï respected much of Richier's late work, referring to her "unsurpassingly beautiful" 1956 retrospective. He also admired her "strength of soul, her capacity for work, [and] her courage in her struggle."[257] In his portrait of her, she stands firmly immobile. Her gaze is unflinching, but almost melancholy. Her strong hands can manage the etching press before her; yet their tense grip hints at the sense of entrapment that pervades the strange human forms in her late work. In fashion-conscious Paris, reviewers of her work were also inclined to cite her plain, practical, and unfeminine working attire. Virtually unknown in the United States, she was a respected and influential figure in postwar sculpture in Europe, especially in France and England.

Half of Brassaï's assignments from Harper's Bazaar were to make portraits. The topics for many of the stories were suggested by Brassaï; others were initiated by Carmel Snow, who recognized Brassaï as an obvious choice to photograph artists and writers, not only for his talent, but also for his easy access to most of his sitters. This was his world. If he did not know his subjects personally, they certainly knew of him.

When they met, Picasso was almost fifty and Brassaï was thirty-two. Over the next four decades, Picasso was the subject of Brassaï's most extensive, fully developed, and complex portrait of an artist and his work. In the first likeness, taken for Le Minotaure in 1932, Picasso stood before Henri Rousseau's painting Yadwigha, which was part of Picasso's considerable collection of other artists' works. Brassaï commented on his "gray suit with a double-breasted jacket, its pockets stretched out of shape, its lapels spotted" and on his eyes, which had "a curious ability to open very wide, revealing the whites all around the pupils, reflecting the light like a bolt of lightning."[258] Of course, Brassaï's own eyes were the first feature anyone noticed, for they, likewise, were large and seemed to absorb everything simultaneously. However moved or anxious Brassaï may have been to meet and photograph Picasso — for this was before the publication of Paris de nuit and the establishment of Brassaï's reputation as a photographer — none of his portraits of Picasso casts a heroic figure. Picasso is fierce, proud, commanding, and appraising, but also disheveled, manly, and human.

The first issue of Le Minotaure was to be devoted to Picasso's sculpture, and Brassaï was employed to photograph the pieces at Picasso's Boisgeloup château in Normandy. At Boisgeloup he saw for the first time Picasso's imprint in plaster of his own right hand, "a fleshy palm, the hill of Venus bursting with sensuality, a headstrong thumb, fingers so tightly matched against each other that not the smallest ray of light could pass between them."[259] Brassaï admired the sculpture, but did not have an opportunity to photograph it until 1943, after the plaster version had been cast in bronze (catalogue number 77). The sculpture is so vividly realistic that its status as an inanimate object is evident in Brassaï's photograph only because he included a small part of the sculpture's base at the bottom edge of his image. But the most startling discoveries for Brassaï at Boisgeloup were the sculptures inspired by Picasso's new model, Marie-Thérèse Walter, including "an almost classic head, with the straight line of the forehead flowing unbroken into the line of the nose . . . the eyes like globes" (catalogue number 74).[260] On a table crowded with sculptures of various sizes, Brassaï centers the head and uses contrasting light and shadow to separate its profile from the undulating forms around it, turning clutter to intention. Later, in discussing his methods with Picasso, Brassaï explained his simple principle that "the lighted parts . . . should be lighter than the background, and the shaded parts, darker."[261] This practice is contrary to that of putting a light statue against a dark background and a dark statue against a light one, practices that flatten the dimensionality of sculptures and rob them of animation.

In 1939, Brassaï photographed Picasso again for Life magazine. Rather than take only one or two photographs of Picasso, as was his usual approach to a magazine assignment, Brassaï worked in the mode generally preferred by Life, and therefore known as "a day in the Life" approach. He followed Picasso through his daily routine: lunch at the Brasserie Lipp, coffee at the Café de Flore, and visiting with guests in Picasso's studio on rue des Grands-Augustins. Here, Brassaï made the famous portrait of Picasso seated beside an enormous, potbellied stove with crenulated sides. Wearing the same (or an identical) gray suit, and a similar dark sweater vest that he had worn in Brassaï's portrait six years earlier, Picasso appears every bit the "man of the world." Despite the extensive range of Brassaï's photographs, Life used only one photograph (of paint cans on the studio floor) that had actually been made in 1932.[262]

In September 1943, as the Allies began achieving hard-fought victories in parts of Africa and Italy, Picasso asked Brassaï to photograph his sculpture for a forthcoming book. Besides coping with the ever-present clutter in Picasso's various studios, Brassaï wrote that his biggest problem was working in the cold of Picasso's unheated studio. (No one could get coal in wartime Paris.) Brassaï photographed Picasso's existing sculpture, then began to work with Picasso's newest pieces. Picasso worked through November to finish a series of large-scale statues, and then started on smaller-scale bronzes and figurines, finishing the project in June 1944. Les Éditions du Chêne, the publisher of Picasso's book, went bankrupt and could not issue it until 1949. With an introduction by Daniel-Henry Kahnweiler, two hundred plates of Brassaï's photographs, and sixteen by other photographers, the book was issued in a high-quality edition. The book's cover featured Brassaï's photograph of Picasso's sculpture of his fleshy right hand. Among the other sculptures illustrated in the book is Picasso's bronze Death's Head (c. 1944) (catalogue number 78), which Brassaï described as "a monumental, petrified head with vacant orbits of eyes, a nose that has been eaten away, and lips erased by time."[263] Death's Head is a key sculpture of the postwar period, one that the Existentialists embraced as a rich embodiment of their philosophy. Also, with its gouged eyes and eviscerated nose, the skull reflects the deep interest Brassaï and Picasso shared in carved graffiti.

Asked if his friendship with Picasso had influenced his work, Brassaï responded, "With reference to my purely photographic work, I do not think so. But my association with Picasso, his example, and his curiosity were always an extraordinary stimulus for me."[264] Part of that stimulus was also the extraordinary array of people whom Brassaï met through Picasso. One can only speculate about more specific influences. For instance, in 1932 Picasso picked up one of Brassaï's negatives and etched a drawing into it. Brassaï acknowledged that Picasso's act instigated Brassaï's own Transmutations series in which he etched into a group of his negatives of nudes (see "Nudes," below).[265] After World War II Brassaï decided to carve figures out of small stones. Was he influenced by seeing the sculptures that Picasso carved from pebbles? Did Picasso's tapestry designs encourage Brassaï to make a series of eight tapestries in the late 1960s and 1970s (see "Graffiti," below)? Certainly Brassaï found sympathy and support for his own positions regarding Surrealism. Like Brassaï, Picasso had many friends who were Surrealists and, though interested in their ideas and practices, Picasso rejected the Surrealist offer for a membership, which required a complete commitment to the movement (see "Surrealism," below).

Brassaï's reaction to the stimulation of being with Picasso and his coterie was to record what Brassaï saw and heard, first in his "photographic" mind, and then on bits of paper. According to Roland Penrose, "In the early days he made notes after conversations and bundled them into a box with no particular thought about their future. It was not in fact until 1960, nearly thirty years after its beginning, that he showed Picasso the box labeled 'Conversations avec Picasso,' and at the suggestion of Picasso himself, the box became a book."[266] Published in more than twelve languages, Conversations avec Picasso (released in England and the United States as Picasso and Company) offers a fascinating entry into Picasso's immediate world and, through astute thumbnail sketches, into the lives of many of those surrounding Picasso in those years — from his ever-present secretary/friend Jaime Sabartés to his art dealer Daniel-Henry Kahnweiler, and all the friends in between: Breton, Matisse, Jean Cocteau, and Paul Éluard, to name a few.[267] We read about Picasso's studios, work habits, guiding philosophies, and wives. And we learn a great deal about Brassaï — his work habits, his fascinations and collecting passions, his photographic philosophy, and his respect for Picasso and his work. The book was, and continues to be, critically well received. At the time of its publication, Le Figaro Littéraire ran a series of full-page excerpts. Picasso's principal biographer, John Russell, called the book "invaluable."[268] It is the source for many quotations at the heart of historians' understanding of Picasso. For instance, in an article titled "Zervos, Picasso and Brassaï, Ethnographers in the Field: A Critical Collaboration," art historian Christopher Green bases his thesis in large part on statements made by Picasso in Brassaï's book.[269] Brassaï continued to keep notes on their encounters and, later, published two more essays on Picasso: a chapter in The Artists of My Life and, on the occasion of Picasso's ninetieth birthday, a long article in The New York Times.

What did Picasso learn perhaps from Brassaï? At one point, Picasso says, "It's curious, isn't it, but it's through your photographs that I can judge my sculptures. When I look at the pictures, I see the work with new 'eyes.'"[270] This was not a new method of working for Picasso. As curator Anne Baldassari fully revealed in her exhibition and book Picasso and Photography: The Dark Mirror, Picasso had been using his own and others' photographs to refresh his view of his works since 1901.[271] We know from Picasso and Company that Picasso valued Brassaï's photographs of the work and of his studio. "I love your photographs," he told Brassaï, "precisely because they are truthful . . . the ones you took at the rue de la Boétie were like a blood-test from which an analysis and diagnosis can be made of what I was at that instant." Since 1928, Picasso had been dating most of his works by day as well as by their year of completion. As Green makes clear in his article, it was very important to Picasso to document his work and his own working habits. Therefore, Picasso valued the fact that Brassaï became one of the best chroniclers of Picasso's creative process, employing consummate skill and insight to best present Picasso's work.

Surrealism

As with other aspects of his life and career, Brassaï's precise relationship with Surrealism has been the subject of myriad speculations. In support of his association with the movement are his friendships with Surrealist and ex-Surrealist artists and poets; his photographic contributions to their magazines and books; and issues and ideas central to both Brassaï and the Surrealists. The primary indicator that the connection between Brassaï and the Surrealists was tenuous is Brassaï's refusal to accept André Breton's invitation to officially join the second-generation Surrealists. Like that of his friend the poet Pierre Reverdy, the vector of Brassaï's career ran parallel to theirs, but it never merged. Brassaï's reverence for the physical world and his admiration of Goethe's philosophy were incompatible with Surrealist tenets, and many of the similarities between his thinking and theirs can be traced to other antecedents. As his life progressed, Brassaï's denial of their influence became increasingly adamant. He told the photographer Tony Ray-Jones in 1970, "For years I worked with them. I did not like surrealism, however, as I was very objective. But they liked my photographs. They found a kind of surrealism in my pictures even though I was objective. . . . I was opposed to their ideas but I was friends with them all anyway."[272] Despite his repeated disclaimers, the topic of participation and influence is important, and the truth is as complex and convoluted as the very issues at the heart of Surrealism. For a decade, Brassaï's association with the Surrealists was too intense and his friendships too numerous for one to dismiss their importance in his artistic development. On the other hand, one should not overemphasize their influence on Brassaï at the risk of disregarding the influence of other ideas and artists.

Brassaï came into contact with Surrealism relatively late in the evolution of the movement. Actually, it was never intended to be an art movement, but a revolt to "change life." Surrealism was announced in 1924 with the publication of André Breton's Surrealist Manifesto. Through various processes — including automatism, hypnotic states, free association, and chance — the Surrealists endeavored to escape the application of reason and to shun any explanation or illumination of the tangible world. More interested in the interior worlds of the subconscious, dreams, ecstasy, and delirium, they sought "a reorganization of the very way the real was conceived."[273] Brassaï did not meet Breton until two years after his Second Surrealist Manifesto was published in December 1929, which was the same year that Breton expelled many of the original Surrealist poets and painters for "heresy." Thus, Brassaï met Breton after what most scholars would agree were the "heroic" years of Surrealism. Among those expelled were Brassaï's friends, the poets Jacques Prévert, Robert Desnos, and Raymond Queneau; indeed, among his closest friends there was no one who was still an active Surrealist.[274] Through his friend Tériade, Brassaï was asked to photograph Picasso for the new publication Le Minotaure. Edited by Tériade and published by the young Swiss Albert Skira, Le Minotaure was recognized as "the most beautiful art review in the world." The magazine evolved in close collaboration with Breton and Paul Éluard.[275] Twelve issues were published between 1933 and 1939; issues one through nine included over 150 photographs by Brassaï. His association with Le Minotaure seems to have ended in 1937, when Tériade left to found Verve, but Brassaï remained a frequent contributor to Skira's brief, postwar publication Labyrinthe and to other Surrealist publications.

When Brassaï was approached by Tériade to take photographs for Le Minotaure, his book Paris de nuit was essentially complete, but not yet published. The opportunity offered by Tériade was more than a job; it was a chance to work with some of the most interesting minds and talents in the Parisian art world, not the least of whom was Picasso. Of the images Brassaï published in Le Minotaure, more than half were portraits of artists or photographs of their studios and their art that were commissioned by the magazine. Of the remaining half — those that have provoked the most discussion in articles and books on Surrealism — most were chosen from Brassaï's inventory, rather than made in response to the Surrealist movement or at the request of the magazine. Like other photographs in Le Minotaure, wrote Dawn Ades, these were not Surrealist photographs, but rather, photographs in the service of Surrealism.[276]

The majority of Brassaï's photographs are concentrated in three issues of Le Minotaure: numbers 1, 3-4, and 7. Primarily devoted to Picasso, issue number 1 is rich with Brassaï's photographs of the artist, his sculptures, and his studios on the rue de la Boétie in Paris and in Boisgeloup near Normandy. At the end of the issue is Maurice Raynal's article "Variété du corps humain," which includes four of Brassaï's photographic nudes (catalogue number 79) as well as drawings by Renoir and Seurat and anonymous nineteenth-century photographs of nudes. In discussing the Surrealistic aspects of these four female nudes by Brassaï, most scholars cite their power as a fetish, that is, "as a substitute object, simultaneously disavowing and commemorating the penis perceived as missing from the maternal body."[277] For Rosalind Krauss, Brassaï's nudes were one of the clearest examples of this collapse of sexual difference and were images "in which the female body and the male organ have each become the sign for each other."[278] The headlessness of his nudes is the other most notable aspect that relates these photographic nudes to Surrealist writing and theory. "Without heads or with reduced heads," wrote Sidra Stich, "the figures no longer offer evidence of their superior human status."[279] Emphasis on the intellectual realm is displaced to the appeal of the corporeal.

Brassaï transformed the nude again in his vertical diptych Ciel Postiche (False Sky, c. 1932–34), which was published in issue number 6 of Le Minotaure. One familiar form (the body) was redrafted into another (a landscape); the difference between the animate and the inanimate blurred. The back and buttocks of a horizontal torso become the earth in the lower print; in the upper print, clouds are evoked by the hips and the torso below the breast. The space between the torsos becomes terrain, water, mountain, or sky, depending on the viewer's reading. Numerous scholars have explored ways to interpret the picture. Their positions are most clearly stated by Dawn Ades, who focused on the "constant exchange" between the picture's elements. "The torso is apparently doubled but in fact reversed," she wrote, "and there is a continuous oscillation up and down from ground to sky, from foreground to distance, from flesh to storm clouds."[280] She found references in the image both to the classic metaphor of woman as nature and to Aristotle's premise that all tangible bodies are constituted of nature's four basic elements. "The image," she continued, "never settles into one reading — the sharp edge of the body against the darker contrast ensuring the equal weight of each part in the two halves." She found Surrealist underpinnings in this fluidity of meanings and in the "doubling" of the body.

When writing about his photographs, Brassaï never quoted any Surrealist text or alluded to Freudian references. Since most of his articles and many of his letters included quotes about his work, this omission is significant. In his book Picasso and Company, he quoted extensively from Picasso's responses to his images of nudes. "He studies some of the nudes in which the female form has been transformed into a landscape," remembered Brassaï. "One contour which outlines the body and at the same time, sketches a relief of hills and valleys interests him greatly. The eye passes directly from the sinuous line of the feminine body to the curving line of the valleys. Picasso remarks that, in some of the pictures, the presence of 'goose-flesh' evokes the skin of an orange, the granulation of stone, or the network formed by waves when they are seen from a distance. One of the attractions of photography is the thought of mingling such similarities, such visual metaphors."[281] Free associating, Brassaï and Picasso continued to playfully trump one another's imaginations, an enterprise similar to various Surrealist games, but also an integral part of the creation of any poetic metaphor. Picasso's and Brassaï's visual associations stopped well short of the provocative line of the nineteenth-century French poet Isidore Ducasse (alias Comte de Lautréamont), and which was an inspiration for the Surrealists: "As beautiful as the chance encounter of a sewing machine and an umbrella on a dissection table." The two artists operated instead within the poetic tradition articulated by their mutual friend Pierre Reverdy, who proposed, "The characteristic of the strong image is that it derives from the spontaneous association of two very distant realities whose relationship is grasped solely by the mind."[282] Picasso and Brassaï formed metaphors that certainly are more rational and visually based than those that would satisfy the Surrealists.

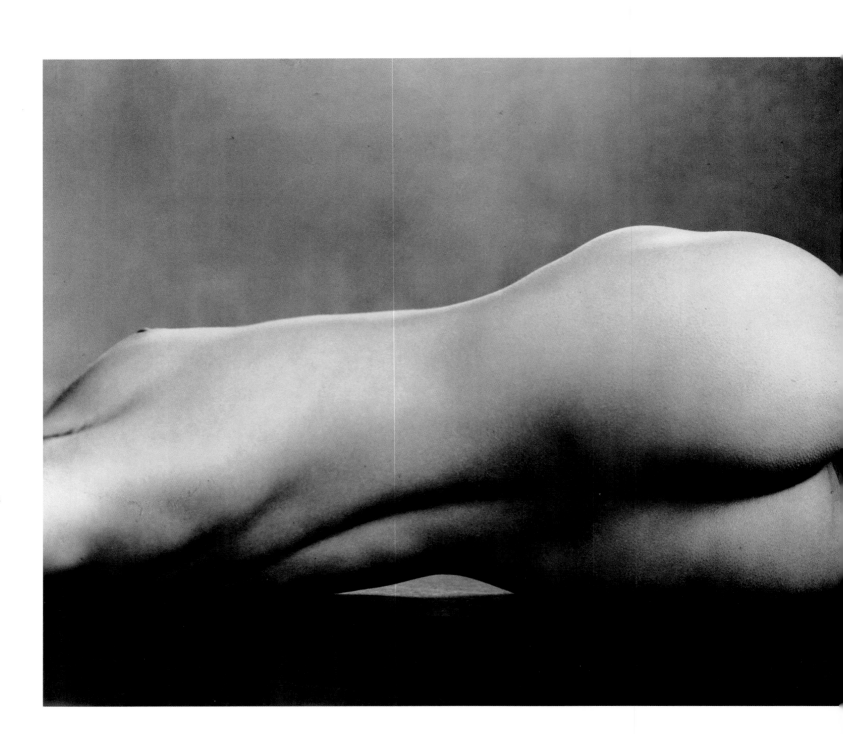

Throughout the 1920s, photographers who were working entirely outside the Surrealist circle consciously explored making realistic photographs that also would suggest entirely different associations.[283] For instance, while working in Mexico, Edward Weston, wrote art historian Mike Weaver, "wanted us to see the object in an imaginative space between the literal and symbolic, the actual and typical, the particular and universal."[284] Weaver then compared Weston's nudes to natural forms, using the same approach that characterized Picasso's and Brassaï's conversation. Comparing Weston's nudes of Bertha Wardell to cypress roots and juniper trees, he observed that "the torque on her ribs and backbone is an analogue of the twist on the tree-trunk that spells vigor." In 1925, seven years before Brassaï's Nude (1931–32) (catalogue number 79), Weston made a similar shoulder-to-buttocks view of a horizontal nude torso that could easily be read as a fetish (figure 11). But while acknowledging the metaphoric base in Weston's work, one is unlikely to apply Surrealist interpretations because Weston's Modernist aesthetic evolved outside the context of and in conflict with French Surrealism. In fact, Weston was aware of Surrealism and adamantly rejected its tenets. If Brassaï's nudes had not been published first in Le Minotaure, one might not look to Surrealism for the meaning of these nudes. But they were published there, underscoring the confusion inherent, and perhaps irresolvable, in Surrealist interpretations of his work and Brassaï's denials of Surrealist influence.

In the series of photographs titled Transmutations, Brassaï physically imposed new images on the now-obliterated original forms. Although the images in Transmutations were never published by the Surrealists, they are frequently discussed as Surrealist examples of transformation. It is also significant that Brassaï's initial images were usually of a female nude. Male erotic fantasies were certainly privileged within Surrealism, and the female nude is ubiquitous in Surrealist works. As critic Hal Foster observed, "One-half, perhaps two-thirds, of the photographs in the exhibition L'Amour fou: Photography and Surrealism are of women."[285] It was an inherent component of the predominantly male Surrealist aesthetic that sexuality — and, for them, its object, woman — were not grounded in what is "natural," but rather, were subject to fantasy and fabrication. When the human body was metamorphosed into another shape or creature, the ensuing confusion of body parts helped undermine established definitions and hierarchies. This disorder, the Surrealists projected, opened the way to the unknown and the unknowable. Thus, the images in Transmutations, even more than the straightforward nudes, lend themselves to inclusion in discussions of Surrealist art. And while Brassaï, in writings about the work, does not admit influence by the Surrealists, his portfolio introduction employs terms and statements associated with Surrealist texts: "sleep-walker," "dislocated parts reorganized into new combinations," "power of desire," "obsession," and "Realism was outweighed by oneirism."[286] Brassaï produced the Transmutations series when he was most engaged with Surrealist artists and writers. For these reasons, his denial of any Surrealist influence is not particularly convincing. figure 11 Edward Weston, American, 1886–1958. Nude, 1925. 7 x 8 1/2 inches (17.8 x 21.5 cm).

Issue number 3-4 of Le Minotaure, published in December 1933, contains Brassaï's photographs of the ateliers of six artists, his article and photographs on graffiti, and three articles by Dalí with components by Brassaï in each. The issue also contains a statement by Brassaï on Goethe. In Picasso and Company, Brassaï recalled that he was immediately attracted to Dalí's "eternally curious mind and his fertile imagination, constantly dreaming up new amusements and surprises."[287] Less than a year after they met, they initiated their collaboration. In his article "De la beauté terrifiante et comestible, de l'architecture modern style," Dalí discerned a "psycho-pathological" quality in turn-of-the-century modern architecture and discusses its expression of "disturbing and inadmissible desires."[288] To illustrate the article, Man Ray traveled to Barcelona to photograph the buildings and sculptures of the Spanish architect Antoni Gaudí and, from prints that he had seen earlier at the Hôtel des Terrasses, Dalí selected four photographs by Brassaï of Hector Guimard's Art Nouveau Métro entrances.[289] As Brassaï framed and lit them, the metal ornaments were transformed to "mimic nature."[290] One became a praying mantis, another a vacant-eyed demon or a phallus. Dalí also asked Brassaï to photograph various Art Nouveau busts, vases, and houses. Preceding the article on Art Nouveau is a photocollage by Dalí, Le Phénomène de l'extase (The Phenomenon of Ecstasy, 1933), comprised of many photographs of women in a state of ecstasy. For the collage's central image, Brassaï convincingly directed Janet Fukushima to dream "in ecstasy." In this stunning photograph, Fukushima lies across the bed, her head slightly reclining over the edge, her hair wild against the pillowcase.[291] Brassaï's image was cropped to just the head in Dalí's collage, and was encircled by much smaller photographs of women from the Salpêtrière Hospital for emotional disorders.[292] The collage also includes Art Nouveau details to connect it to Dalí's article.

Appearing in the same issue is another article by Dalí titled "Sculptures involontaires." The photographs that Brassaï made for this feature resulted from a more active collaboration between Brassaï and Dalí. Brassaï reported, "Dalí would come by to see me and deluge me with suggestions or with his tiny, shakily written notes."[293] The resulting photographs are of "chance" objects such as a coat check receipt or bus and Métro tickets that have been twisted and crumpled in people's fingers, as well as globs of toothpaste and shaving cream squeezed out of a tube onto a plate of glass. These chance creations assume evocative shapes and were presented by Dalí as subconsciously made art. Krauss and others have associated these small sculptures with Georges Bataille's concept informe. As Krauss explains, "For Bataille, informe was the category that would allow all categories to be unthought. . . . Allergic to the notion of definitions, . . . Bataille does not give informe a meaning; rather, he posits for it a job: to undo formal categories, to deny that each thing has its 'proper' form, to imagine meaning as gone shapeless, as though it were a spider or an earthworm crushed underfoot."[294]

Whether Brassaï saw these sculptures as an expression of Georges Bataille's informe is unknown, but unlikely. Brassaï would have been aware of the conflict that was occurring in published articles between Bataille's concept of informe and Breton's concepts of the marvelous and of convulsive beauty. But a collapse of boundaries between reality and the imagination, such as Bataille proposed with the concept informe, would not have appealed to Brassaï. Both "form" and "category" were too much at the heart of his work ethic for him to embrace a concept whereby their distinctions dissolved. He told Henry Miller that he conceived the role of the artist as "endowing the formless with form." He also systematically organized his negatives into subject categories, and then sequenced these categories into chronological order, according to when the negatives were taken.[295] The subject categories continued when he organized his photographs; Nancy Newhall referred to boxes of prints marked "Picasso I, Picasso II, Paris de Jour, Nus, Portraits."[296] The pictures of graffiti were compiled in a series that was divided, in turn, into distinct subseries. Once the subseries were established, Brassaï then looked for images that enriched the established categories. Similarly, all of his monographs concentrate on specific subjects — Paris de nuit, Secret Paris, Graffiti, Les Sculptures de Picasso, The Artists of My Life. Finally, the photographs in his 1963 retrospective at the Bibiliothèque Nationale were installed in groups that were the same as his categorical system.[297] It was antithetical for Brassaï to follow the Surrealist premise that a work of art should arise out of the unforeseen and the unplanned. For him, structure was crucial and illuminating. Brassaï was too delighted by the act of discovering the natural order of the world to impose his own inventions on what he saw.

Brassaï might have been a little more sympathetic with the concept of convulsive beauty, which was Breton's defense against the concept of informe. For Breton, meanings were not to be collapsed (as in informe), but instead blurred so that unexpected associations and dislocations would excite a physical (ecstatic and sexual) sensation. Beauty arose in the process of convulsing reality into its opposite, and he listed three distinct ways by which convulsive beauty was achieved.[298] Still, although Brassaï's photographs were among those used to illustrate the article in which Breton defines convulsive beauty, Brassaï did not share its tenets. However much Brassaï may have enjoyed being stimulated, even shaken, by new concepts, his personal goal was to refresh, not destroy, his mental processes. As he told the interviewer France Béquette, "the 'Surrealism' of my images was nothing other than real being rendered fantastic by vision. I only sought to express reality, because nothing is more surreal. If something no longer amazes us, it is only because habit has made it bland. My ambition was always to see an aspect of everyday life as if discovering it for the first time."[299] Henry Miller understood this when he wrote of Brassaï's capacity to bring "attributes of the marvelous" to ordinary objects.[300] This too was a mission Brassaï seized from Goethe, who extolled the artist's ability to be amazed and ranked amazement as the highest state that a human could attain.[301] In a letter Brassaï wrote to his parents two years before the first Surrealist Manifesto, he noted that most people are not satisfied with amazement, and are like children who, upon seeing their own reflection in a mirror, turn it over to see what lies behind. Paraphrasing Goethe, he wrote, "You are an artist, you are endowed with the ability to be amazed, leave philosophy alone, don't speculate, don't look for the reverse of things, don't keep turning the mirror around, be grateful for being allowed to look into it in the first place."[302]

Nocturnal urban wandering — like automatic writing and drawing, as well as games of chance — was a way for the Surrealists to outwit the rational mind and gain access to the subconscious. As Manuel Borja-Villel perceived, "Night was the natural setting for Surrealist actions; the place where dreams are dreamed and passions awake, crimes are committed and evil lurks."[303] Brassaï's extraordinary project to truly "see" the city of Paris at night, to understand all aspects of the night itself, and to document all of the activities uniquely occurring during the nocturnal hours, was the chief reason that the Surrealists were drawn to his photographs. His ability to transcribe the night with both clarity and a sense of the marvelous served the Surrealists and their publications very well. Issue number 7 of Le Minotaure is unified by the theme "night"; it is the final issue that was rich with Brassaï's photographs, containing seventeen of Brassaï's images of Paris at night and three of winged insects battering against various sources of illumination.[304] Breton specifically requested the inclusion of the photograph of Saint-Jacques Tower, Paris (1932–33) (catalogue number 14) and of two others of Les Halles that recorded sites in his article "La Nuit de Tournesol."[305] The piece explores Breton's nighttime wanderings with a woman with whom he experiences l'amour fou, a transforming love. Charged with his experience of desire, the text requires magically animated images that are still "real." In writing about Breton's essay, Dawn Ades observes, "The city itself, to begin with, held a peculiar place in surrealist thought as a location of the marvelous, the chance encounter, the site of the undirected wanderer in a state of total 'disponibilité,' or availability. It was in the street that significant experiences could occur."[306]

In the late 1960s and 1970s, both the reconsideration of Surrealism and the acceptance of photography as an art form experienced a surge of scholarly and public interest. At first, the books and exhibitions on Surrealism ignored photography's role in the movement, except for the contributions of Man Ray and Hans Bellmer. For instance, in Anna Balakian's 1971 book André Breton: Magus of Surrealism, the photographs in Breton's seminal books Nadja and L'Amour fou go unmentioned. Similarly, in her 1982 book, Dalí and Surrealism, Dawn Ades does not list Brassaï in the index nor mention Brassaï's work in her discussion of the three pieces by Dalí in issue number 3-4 of Le Minotaure, not even while considering the article and photographs that were the most direct collaboration between the two men. She discusses their collective contributions to "Sculptures involontaires" as though they were solely Dalí's creation. Also, Brassaï's four photographs of architectural elements from the Métro entrances that illustrated Dalí's article on Art Nouveau are reproduced in her book with no credit given to Brassaï.[307] Photography was regarded as peripheral in the Surrealist movement by most of the Surrealists themselves and by their historians until 1985, when Rosalind Krauss and Jane Livingston's exhibition L'Amour fou: Photography and Surrealism elevated photography's role in the Surrealist movement and inspired a wealth of subsequent scholarly inquiry.

Efforts to associate Brassaï's photographs with Surrealism are valid, unless one exclusively applies a Surrealist sensibility to his work. Recent investigations have almost consumed the common perception of Brassaï, even though most of his pictures that were published by the Surrealists were also published widely in other kinds of publications with no link to the Surrealist circle. Most of the photographs by other artists that are regularly included in Surrealist exhibitions and publications immediately reveal their embrace of Surrealist values. One cannot look at the reconfigured dolls of Hans Bellmer, the collages of Georges Hugnet and Dora Maar, the rayographs and stagings of Man Ray, the solarized and double-exposure prints of Maurice Tabard, or the special techniques of brulage, or "petrification," developed by Raoul Ubac without perceiving that these photographs do not represent the ordinary course of the visible world. Audiences unfamiliar with Surrealism and the ways in which these works explore dreams, fantasies, chance, and fetish would still discern immediately that these works evoke interior visions. For Brassaï, the context of and captions accompanying his work were pivotal to a reader's perception, and he never applied orthodox Surrealist readings to his photographs.

When Brassaï explains why Picasso should not be considered a Surrealist, despite his long association with the movement, one might substitute Brassaï's name for Picasso's to better understand Brassaï's own position. For instance, he writes, "Unquestionably the Surrealist concept of the mind liberated from all restraint, the audacity of the movement, and its admiration for him stimulated Picasso to 'confront everything that exists with everything that can exist.'"[308] Brassaï was similarly stimulated and flattered by the Surrealists. But, as he wrote about Picasso, "even when he appears to be a thousand leagues from reality, to be taking every liberty he pleases with appearance, even when his work is bathed in an atmosphere of the fantastic or the surreal, a solid realism is at its base."

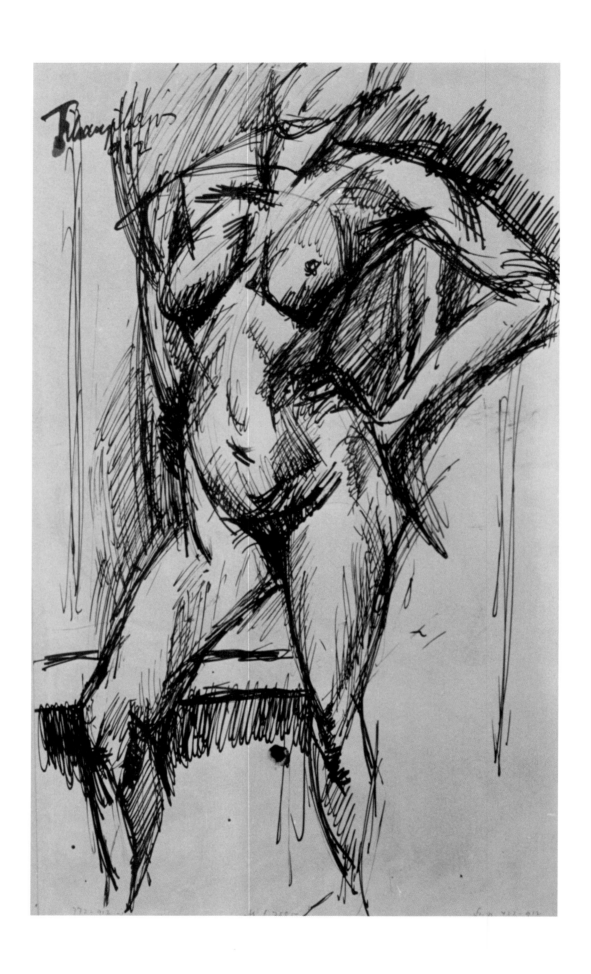

Nudes The female nude was a subject of interest to Brassaï throughout his career, but he addressed the topic with intense concentration during only four specific periods between 1920 and 1970. His investigations of the nude form were conducted in three different media: drawing, photography, and sculpture.

Drawing was part of his academic training in both Budapest and Berlin.[309] The surviving figure studies from the early twenties in Berlin were mostly black crayon sketches of full-length nudes, characterized by firm, slashing, short strokes that define the contours of the body. These works by Brassaï were strongly influenced by artists of the Hungarian avant-garde, especially members of "The Eight," who, in turn, were greatly influenced by Cézanne (figure 12).[310] In Berlin, Brassaï's successes included a gallery exhibition as well as private sales of his drawings.[311] Having ceased drawing and painting once he arrived in Paris, he revived his interest in the media in either the late 1930s or the early 1940s. He usually stated that he resumed sketching only at Picasso's urging during World War II,[312] but the Museum of Fine Arts, Houston, has a crayon study dated 1937 (catalogue number 87). The majority of the published drawings were made in 1944–45.[313] During the Nazi occupation of Paris, Brassaï had no income, little food, and less heat, but he had time, which could account for the extent of his nude studies during the war. During the widespread shortages and hardships of the war, he also drew at the Académie de la Grande-Chaumière because its studios were heated.[314] In Paris, the influence of the Hungarian style diminished. The slashing lines of the early drawings were replaced by firmer, unbroken contours, although he occasionally echoed his primary lines with second and third strokes that were lightly applied (catalogue number 86), or he loosely sketched short rays emanating perpendicularly from one side of the body. Brassaï appears to have worked quickly and with assurance. figure 12 Lajos Tihanyi, Hungarian, 1885–1938. Nude, 1912. Pen and china ink on paper. 13 1/4 x 8 3/16 inches (33.7 x 20.9 cm). Hungarian National Gallery, Graphics Collection, 1912-422.

For the nude studies, he abandoned all pretense of objectivity. In 1921, he wrote to his parents, "My aim is not simply to draw but to reconstruct. I construct a nude as it appears in nature. In my representation, I am freely remolding the shapes, even at the expense of anatomy and proportion if necessary."[315] Whatever the differences in his strokes between the two decades, the nature of the figures is the same. The nude — at least the female nude — as it appeared to him "in nature," was mostly thigh, wide hips, and belly. Each reviewer has noticed the distinctive proportions of the models in his drawings. Nancy Newhall described them as "dynamic and lusty."[316] A notice in Vogue perceived that "most of his studies are of hippy nudes with an indolent looseness of line, a tight core of structure, a caricature — like insistence on the model's special features."[317]

While Brassaï's drawings do not achieve the historic artistic rank of his photographs, reviewers have praised the expressive qualities of his crayon studies. A review in Art News found his early drawings to be "deft, full of élan and erotic."[318] In introducing an exhibition of Brassaï's sculpture and drawings, Gaston Diehl cited historical precedents for these particular female proportions, ranging from the Venus of Willendorf to the Hottentot Venus,[319] but proposed that "The drawings of Brassaï . . . seem to indicate that . . . his faithful attachment to these very distortions (which are so expressive) falls within a formal plan and rhythm, from which he draws astonishing themes of variation. [They are] faithful to the principle which he had formulated early on: 'give movement to the living thing in an immutable form.'"[320]

82

Picasso encouraged Brassaï's renewed focus on drawing, and in May 1945, Picasso instigated an exhibition of Brassaï's sketches at the Galerie Renou et Colle, where Picasso had exhibited his own drawings in the 1930s. In January 1946, Brassaï issued Trente dessins, a portfolio with lithographic reproductions of thirty drawings and a poem by Jacques Prévert that he wrote in response to the drawings. Most of Brassaï's works are of male or female nudes, but his subjects also include a few animals. The poses of the nudes are conventional: standing, seated, horizontal, or one leg raised. The males are as distinguished by their narrow waists and hips as the females are by the exaggerations of their lower torsos. The range of distortions varies from slight to segmentation of the body into a pyramid of oblong spheres. The only facial features included with any specificity are those of a black model whose face was drawn to resemble a tribal mask more than her own flesh. Yet, there is sensuality here. In his accompanying poem, Prévert notices:

and they are beautiful for him	et elles se font belles pour lui
frightening beauties	belles à faire peur
provocative, disturbing and disproportionate	provocantes, inquiétantes et disproportionnées
like a secret desire	comme le désire secret
acknowledged	avoué
undressed.[321]	déshabillé

With the publication of Trente dessins, Brassaï again changed media. That same year he renewed his project of photographing incised graffiti and began to sculpt. Initially, he collected pebbles, worn smooth by the sea or mountain streams, and responded to the dynamic forms he sensed within the stones. Roger Grenier remembered that when Brassaï went to Tarbes to visit Gilberte Brassaï's family, he found the first stones in the Adour River in the foothills of the Pyrenées. Occasionally Brassaï would carve a bird, a human profile, or even a specific portrait, but usually it was a nude (catalogue numbers 88, 90, and 91).[322] Brassaï described the process as "never a feeling of 'invention' or 'creation' but more of 'delivery.'"[323] Grenier attributes Brassaï's recognition of faces and bodies in the stones to the Surrealist concept of transformation or metamorphosis, but certainly every sculptor is to some extent inspired by his materials, and Brassaï had the example of Picasso's carved stones as inspiration for his own sculptural pursuits.

As with his photographs and drawings, Brassaï's sculpted nudes were essentially torsos without heads, or with only minimally suggested heads. Brassaï wrote about the stones he chose having gone through a "metamorphosis of gender."[324] For him, the giant boulders and outcroppings on shore were male. But, he continued, "the blocks which detach themselves, scraped and worn by glaciers, by torrents, by streams, and by the surf, erode and little by little lose their virility and array themselves in the fullness of femaleness. . . . The pebbles suggest the swelling of the belly, the gentle dip of the back, the curve of the hips, the fullness of the rump, the rise of breasts and the shapely curve of the thighs; it is as if the sea, in carving an abundance of fleshy pebbles, wanted to compete with the Aurignacian[325] and Neolithic sculptors — creators of those buxom goddess-mothers. The pebbles thus reunite the male rigidity of rocks and the curves of femininity. From whence also derives the androgynous quality of my sculptures."[326] After reading this passage, one may not be surprised that Brassaï was frustrated by the "Do Not Touch" signs in exhibitions, because, as he said, "sculpture is above all a sensual art." The androgyny to which he refers exists in a few photographs and, more often, in the small sculptures. In works such as Mediterranean Woman I (1964) (catalogue number 91), the female body also distinctly references the male phallus.

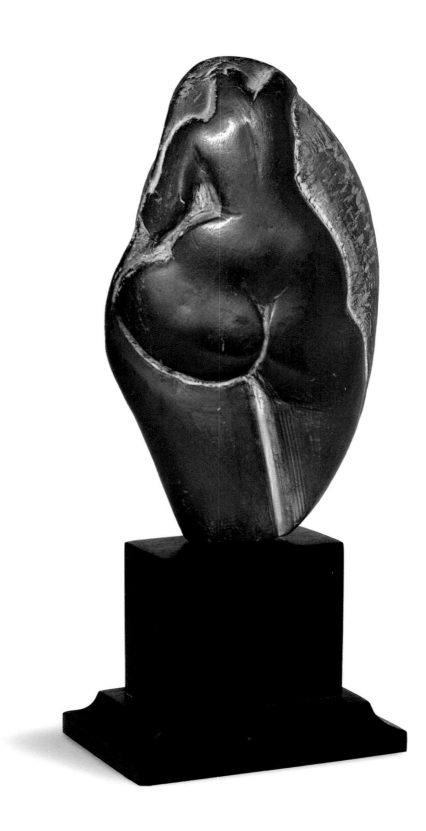

Initially, Brassaï worked with intimately sized stones that could fit in the palm of his hand. Later he worked with increasingly larger pieces of marble, bronze, and other materials "considered more noble," including green-veined serpentine rock, Portuguese rose onyx, Belgian black chalk, and Carrare marble (figure 13).[327] As with previous endeavors, Brassaï was essentially self-taught. The sculptor Daria Gamsaragan said that he asked some technical questions occasionally, but that he was basically "like a sponge and absorbed everything very quickly."[328] Brassaï admitted that his influences were diverse, and emphasized his admiration of Cycladic sculpture. "If I had to choose among all the sculpture of the world," he wrote, "I would unhesitatingly select one of these goddesses of the Cyclades. To me these sculptures from the Aegean Sea — so pure, so stripped of nonessentials — represent the quintessence of the plastic art."[329] He also said that although some critics had compared his sculpture to that of Hans Arp and Constantin Brancusi, he felt closer in spirit to Aristide Maillol.[330] Brassaï did not elaborate on the kinship with Maillol, but he seems to have been eschewing an affinity between his works and the minimalist abstraction in Arp's and Brancusi's sculptures, and responding instead to a shared affection for what Maillol described as women who are "well fleshed, with wide hips and heavy, rounded legs."[331] Brassaï's text on Maillol in The Artists of My Life reveals that they both accepted human desire as a motivating stimulus in their work.

Brassaï exhibited his sculptures alone as well as with his work in other media in solo exhibitions and in various group shows with other sculptors. Gamsaragan remembered that they both exhibited their work in the group shows of the Société des sculpteurs pour les petits objects (Society of sculptors of small objects), and that "all the sculptors agreed that Brassaï's work was good." Brassaï continued to make sculpture through the early seventies, when both the decline of his energy and his preoccupations with photographic exhibitions and with writing books claimed his attention full time.

Brassaï photographed nudes for a relatively short period — from 1931 to 1934 — beginning very soon after he learned to photograph. He told Tony Ray-Jones, "There is no relationship between my photography and my sculpture and drawing except that I like strong form."[332] But his preference for a particular type of model and a low, distorting perspective is the same throughout all three media. As Marcel Natkin observed, "All importance is given to the hips. The small head becomes an accessory. . . . The thighs, which are already exaggerated with a pencil, become enormous in photography."[333] Sometimes the body is lengthened, such that reviewer Waldemar Januszczak observed, "Only Ingres has provided the feminine torso with so many vertebrae, or stretched it so languidly between the neck and the hips."[334] figure 13 Untitled, c. 1940s. Stone sculpture on black marble pedestal. 6 inches (15.2 cm). Collection of Mr. and Mrs. Frank Dobo. © Gilberte Brassaï

Brassaï made three different series of photographic nudes, all of which used female models. There were nudes isolated in a room or studio, women in lingerie, and photographic/drawing combinations. The unmanipulated photographs of nudes range from compositions that isolate the torso from its extremities to more traditional figure studies. The images selected for publication in Le Minotaure in 1933 were those most capable of transforming our perceptions of the human figure, and most open to metaphoric or Surrealistic readings.[335] The female figure is re-presented to resemble something else. As in Brassaï's sculpture, the body metamorphoses, appearing phallic or suggesting facial features (catalogue number 82) (see also "Surrealism," above). These pictures are highly original formal constructions, but Brassaï never transformed his nudes to the extent that their identity is abandoned. He avoids using multiple exposure, solarization, or any other elaborate printing techniques that dissolve or fracture the body, except cliché-verre, discussed below. The nudes in Le Minotaure can be viewed simultaneously as abstractions and as erotically evocative images. In discussing them with Picasso, Brassaï referred to them as having been done in "'roundings,' all curving lines and contours."[336] When these pictures from Le Minotaure have been evaluated by feminist reviewers, they are often criticized because the viewer's relationship is strictly one of gazing, thus reducing the women's status to that of mere objects. However, from Brassaï's perspective, his approach succeeded in transforming his human desires into immutable form.

At the same time that his most distinctive nudes were being reproduced in Le Minotaure, Brassaï was also taking photographs that were more traditional and, perhaps, more commercially motivated. These images were published in risqué magazines, as discussed above in "Secret Paris." After the war, they appeared in the short-lived magazine called Formes,[337] and also in Marcel Natkin's book Nu. In these photographs, the heads of the figures were occasionally shrouded in shadow or cropped by the picture frame, but the women do not appear as dramatically headless as do the nudes in Le Minotaure. The pictures' emphasis shifted away from formal construction and toward sensuality, and were not so distinctively "by Brassaï." His contemporaries — Albert Rudomine, Laure Albin Guillot, André Steiner, Roger Schall, Ergy Landau, and Pierre Boucher — also photographed nudes in studio settings, and their pictures were not radically different from those in this set by Brassaï. Bodies were twisted, not necessarily to transform the viewers' perceptions, but to better reveal the lines of the breast or the rear. Highlights and deep shadows accentuated the models' curvaceous forms and also dramatized the compositions by an escalated tonal range. In Formes, Brassaï's photographs were presented as being "indispensable to artists," but the magazine was confiscated because the photographs were too erotic. By today's standards, they are hardly worth censorship. The women are presented as languid beings, and their frontal poses invite the viewer's scrutiny, but they are hardly provocative. The women were posing too consciously; some look bored. When the face is visible, the rapport and animation that Brassaï had so easily established in his other series is missing. One suspects that Brassaï was only mildly interested in these pictures himself.

In another series (see "Secret Paris," above), the women are naked except for lingerie. These may have been taken for a man named Vidal, who owned the Librairie de la Lune, which sold "naughty" pictures. Whatever the commercial intention of these photographs, they are more than merely titillating. They seem closer in spirit to the prostitute and backstage theatrical pictures in Secret Paris than to Brassaï's other nudes, and the models are more spirited and playful. Some pictures exude a wicked wit, and others reveal a vulnerable sweetness — the difference resides in the design of the lingerie and the model's pose and setting. The bits of lacy fabric animate the figures.

One way to look at these studies is in conjunction with an article Brassaï wrote on Lewis Carroll (pseudonym of the Reverend Charles Lutwidge Dodgson), the English photographer, mathematician, and author of Alice's Adventures in Wonderland and Through the Looking Glass.[338] It was a long article for which Brassaï did considerable research. He quoted freely from Carroll's diaries and letters and was particularly interested in the "violet emotions" that the "child-friends" stirred in Carroll. He described Carroll's plotting to obtain photographs of a child actress; ten years later, Brassaï described in similar terms how Marcel Proust strove to possess certain photographs. Both the Carroll article and the Proust book probe the transference of desire for and obsession with a particular subject into photographs of that subject. "It was photography," wrote Brassaï, "that could act as a substitute for possession."[339] Extremely conscious of his own desires and his capacity to express them, Brassaï was more like Proust than Carroll. What unites these three men are the ways in which simultaneous physical and mental desires served to motivate their work.

In both the article on Carroll and his book on Proust, Brassaï also wrote about the importance of costume. He noticed how Carroll used disguises to create enchanting atmospheres and speculated that Carroll's theatrical enactments were inspired by the photographer's fantasies. Similarly, Brassaï wrote of the importance Proust placed on how one dressed for a portrait, to the extent that Proust considered enlisting in the army as a means of being photographed in uniform. In these texts and in his own pictures, Brassaï understood, as someone in the theater or in cinema would understand, the associative power of costumes. In his other photographs, one also sees a range of evocative apparel: from the excessive jewels on "Bijou" to the split suit on a gay couple, and from the elegant cape on a woman leaving the opera to the black mesh stockings on a nude. Brassaï understood the role of apparel and accessories in projection, deception, and stimulation. By comparison, his traditional nudes are cold, while the ones in which models pose in lingerie convey subtle shades of desire. Appropriately, his title for the lingerie series was Reservé (Private).

In 1934, Brassaï began a series that combined his interests in drawing and photography by employing a process called cliché-verre (literally, glass negative). As art historian Elizabeth Glassman explained, the process is a hybrid of printmaking and photography.[340] From printmaking, specifically from etching, the process borrows the technique of drawing through a coated surface with a sharp tool. The coating usually rests on a transparent surface, such as glass or hardened gelatin. Once the plate is etched, it is used as a photographic negative; light is exposed through the etched areas onto light-sensitive photographic paper. The drawing is recorded as dark lines on the photographic paper. While most artists choose to draw on a plate with an opaque surface, Brassaï used his own negatives of nudes. Thus, he added to the process a second photographic element, that of photographic detail, augmenting reality with invention, or vice versa. When Brassaï began the series, he was unaware that the technique had been introduced in 1841 and had been practiced by such distinguished nineteenth-century artists as Eugène Delacroix, Théodore Rousseau, Jean-Françoise Millet, and Camille Corot, as well as by Man Ray and Max Ernst in the twentieth century.[341] Instead, he maintained that his inspiration was a drawing Picasso made in 1932 by taking one of Brassaï's unexposed glass negative plates and drawing Marie-Thérèse Walter's profile.[342]

As with his drawings, Brassaï's cliché-verres constituted a departure from realistic depiction. As with his sculptures from river rocks, he was inspired by what he found in the photographic image and proceeded then to elaborate on his response. "I cut their flesh," wrote Brassaï of his nudes, "as one carves a block to break loose the figure which it conceals."[343] In 1967, he published twelve of the photographs in the series under the title Transmutations. In the portfolio's introduction, he likened himself to a somnambulist who saw fragments of reality merged with strange visions. The photograph became raw material — the point of departure for mutations based on the existing image in the photograph. Aspects of the female body reminded him of other forms, including vases, musical instruments, fruit, and masks. He then amplified these resemblances through his drawings.[344] Plate 4 in his portfolio, Mandolin Woman (1934–35), fashions the woman into a bulbous musical instrument. Plates 3 and 6 also suggest musical instruments. Plate 12, Street Fair (1934–35), transforms a picture including both a cage of doves and a roulette wheel into the eyes of a bizarre face that Brassaï describes as a Kanaka mask.[345]

The prominent role of tribal masks in this series is not surprising, considering the influence of tribal art on a broad spectrum of Parisian art in the early thirties, but the references may also have been quite personal. Brassaï appears to have owned a small collection of African art. An illustration in Brassaï: Letters to My Parents shows his desk, a number of cliché-verre prints pinned to the wall, and a number of African masks and statues on a shelf. There is also a postcard of a mask from New Guinea pinned near the photographs.[346] The three-dimensional pieces include a piece of folk pottery from Romania, an Ibo head from Nigeria, and another piece apparently of African or Oceanic origin. On the wall is a cliché-verre of the back of a seated nude that employs hatching similar to that used by the Kurumba tribe from Upper Volta.

The image from Transmutations most admired by critics is The Temptation of Saint Anthony (1934–35) (catalogue number 82), because it is the most successful marriage of the properties of drawing and photography. A drawn mask overlays the torso of a reclining nude and most of the remaining surface has been patterned, as in a tribal fabric. All of the figure is obliterated, except the face, one breast, and one thigh. In the Bible, Saint Anthony was tempted by lewd thoughts placed in his mind by the devil. In Brassaï's photograph, Saint Anthony is both a captor and a figment of the nude model's own dream. She, too, is both a captive and a figment of Saint Anthony's imagination. The mask is horrific, yet as curator Marilyn Symmes observed, "The drawing incorporates fragments of the natural female form which remain the objects of worldly temptation."[347] Brassaï similarly described how "by the power of desire, one of [Saint Anthony's] eyes became a woman's breast." Although placed high on her torso, his mouth suggests her vagina, or more specifically, the devouring vagina dentata (toothed vagina).

A portfolio of prints from the Transmutations series was published in 1967, and the prints are different from anything else produced by Brassaï. They are toned brown and printed in a high-contrast style that significantly eliminated large amounts of both photographic and drawn details. The Museum of Fine Arts, Houston, owns two prints of The Temptation of Saint Anthony, one printed in the thirties and one from the portfolio.[348] The portfolio print loses the sensuality of the female's flesh as well as the delicacy of the cross-hatching. The exquisite tension between the drawing and photographic processes is completely lost. Probably, the atypical quality of the portfolio prints arose from an attempt to make them look more like "high art" than traditional photographs. The accompanying promotional material describes the portfolio as "composed of twelve onirological engravings on silver bromide emulsion . . . printed by E. Guillot, master-printer," instead of identifying them as cliché-verre or as photographic prints. One can only speculate whether these decisions about the quality of the prints and the identification of the process was related to Brassaï's ambivalence about being a photographer.

Numerous writers have compared Brassaï's Transmutations to the Distortion series done by André Kertész in 1933. Certainly, both series radically altered the image of the female nude. Kertész posed his models in front of circus mirrors and photographed their stretched and distorted reflections. For both artists, these series are unique examples in their careers of radically manipulating the perception the figures posed before their camera. Although the pictures share subject matter, the series does not establish a special affinity between Kertész and Brassaï, certainly no more than the works bear a relationship to the many other photographs made at the time that were experimenting with distortion and manipulating the female nude. There is no record of either series being inspired or affected by the other.

Arts Visitors to Brassaï's apartment could not resist describing his collection of objects, which Kertész called "spiritually surrealistic."[349] On bookshelves and narrow ledges, objects fought for space: daguerreotypes, hand-painted photographs, primitive paintings, bones, dolls, clay pots, and snapshots. Nancy Newhall considered his collection a "magpie's nest . . . formed by a boundless curiosity and amusement."[350] She observed jumping jacks, playing cards, masks, a statue of Saint Sebastian with holes for arrows into which Brassaï had stuck cigarettes, shells, pharmacists' vases, dried plants, and soap made with the holy spring water at Lourdes. "Even the dull and the conventional," she wrote, were "suddenly transformed by association." If one is familiar only with Brassaï's photographs of Paris, then his personal collections seem unrelated to his photographs. But objects and sculptures were among his favorite subjects and appear in his earliest photographs, as they do in his final images. Brassaï's love for three-dimensional forms was encyclopedic, regardless of their worldly "significance." He photographed an old shoe being used as a planter, the statue of Marshal Ney in Montparnasse, the glove of a suit of armor, scissors, tacks, the constructed fantasies of Count Orsini at Bomarzo, a metal chair in the Tuileries garden, twisted Métro tickets, and most of the three-dimensional works by Picasso and Richier. Applying his talents in equal measure to the utilitarian and the refined, Brassaï photographed fountains, pissoirs, and advertising columns with the same capacity for animation and enlightening context that he brought to Hector Guimard's iron Métro ornaments, the gargoyles of Notre-Dame, the Place Vendôme's column, and the Louvre's Greek sculptures. He categorized found objects and fine art sculpture equally as "Arts."

In his grand portrait of Paris, as well as in his more modest photographic essays on other French regions and foreign countries, Brassaï turned to public sculpture to explore civic values. For his Harper's Bazaar articles on foreign locations, he usually included at least one famous local sculpture. He photographed the Lions of Delos in Greece, saints in Seville, the Bernini fountain in the Piazza Navona in Rome, the giant Christ that looms over Rio de Janeiro, and the statue of Hans Christian Andersen in New York City's Central Park. He knew the cultural importance of each statue and whether there was a historical reason for its location. For instance, Brassaï photographed most of the statues of French queens that encircle the central pond in the Luxembourg Gardens. He knew that the presence of the statues of the French queens in the garden pay tribute to Maria de Médicis, Henry IV's widow, for whom the gardens were originally built. Similarly, in plate 49 of Paris de nuit, Brassaï recorded the sculpted portrait of the duc de Sully, Henri IV's brilliant finance minister, which was erected in front of the National Assembly. Brassaï established the sculpture's location for the viewer by framing the picture so that the building's inscription, "Chambre des Députés" (the name of the parliamentary assembly until it was renamed by the National Assembly in 1946), is included.

Knowing a statue's aesthetic and historical value does not necessarily ensure a memorable photograph. Brassaï's gift was his ability to energize the sculpture. Through Brassaï's lens, the horses in Apollo's Grove at Versailles charge the air with their nips and prancing (catalogue number 98). Brassaï also brought his wicked humor to bear. For example, he captured the fierce face of a giant at the Villa Orsini yawning to discharge the gamekeeper and his dogs (catalogue number 96). Brassaï also photographed the statue of Marshal Ney that stands at the opposite end of the Luxembourg Gardens from where Ney was tried and convicted to die for his allegiance to Napoleon Bonaparte. Ney may have been Napoleon's courageous commander, but Brassaï's photograph of the sculpture ironically merges the heroic past, as embodied in the statue, with the more commercial nature of its present surroundings. Ney's drawn-sword battle pose is reduced to heralding the haven offered by a nearby hotel from the city's dense fog. But, one must also note the haunting beauty of the photograph of Ney. Edouard Jaguer described a "velvety, phosphorescent ashy quality that haloes" the statue. Jaguer referred to the magical light in Brassaï's night photographs as "at once poetic and painterly."[351]

Among the sculptures that most fascinated Brassaï were works often called "outsider art" and carved by men who did not belong to traditional artistic circles. Brassaï was drawn to the "figures colossale et hideuse" that he found at Orsini and Palagonia villas in Italy.[352] In France, he photographed the works of Joseph Ferdinand Cheval, the postman in the village of Hauterives, southeast of Grenoble, and those of l'abbé Fouré, also known as "l'hermite de Rothéneuf," who worked on the French channel coast near Saint Malo.[353] He wrote articles about all of these sites and made photographs that accentuate the wild imagination of the makers. Their nontraditional works are what Bradley Seidman called "waking dream made concrete."[354] At Villa Palagonia, Brassaï delighted in how "every room, object and piece of decoration was calculated to baffle, surprise and disconcert the visitor,"[355] and observed that Goethe had visited and written about the villa in 1787. At Villa Orsini, he concentrated on the outcrops of stone that had been sculpted into various forms: wrestling giants, a soldier from Hannibal's legion whose elephant mangles a Roman opponent, a lion warring against a dragon, and a strange female figure with a planter on her head (catalogue number 95).

Brassaï's appreciation of sculpture and his skill in portraying both artists and their three-dimensional works led to many commissions. Editors and artists alike quickly recognized Brassaï's ability to photograph sculpture in a clean and compelling way. Among the sculptors he photographed (and the years that they posed for him) were Charles Despiau (c. 1932–33), Alberto Giacometti (1932, 1947, 1965),[356] Jacques Lipchitz (1932), Henri Laurens (c. 1932–33, 1946), Aristide Maillol (1932, 1936, 1937), Picasso (1932, 1939, 1943–46), and Germaine Richier (1953, 1955). Different images of these sculptors were published in Le Minotaure, Harper's Bazaar, and Verve, and in Brassaï's own book, The Artists of My Life. In his photographs, the artists' recent and early works coexist in a jumble that nevertheless lets individual pieces breathe. He was particularly gifted at showing a sculpture in situ in the artist's studio, giving the viewer the impression that the work had just been left balanced on a ledge or a makeshift pedestal. Brassaï's lighting looks natural, but could only be calculated and controlled for the distinct effects that were achieved.

Natural elements, such as flowers and cacti, were also among Brassaï's earliest subjects; according to Brassaï, these were the first photographs he ever published.[357] In 1930, he photographed rock crystals that were later published in Le Minotaure. "The mineral world, the product of millions of years, fascinated him as did the glaciers that he sometimes explored in the company of Henri Michaux," wrote Gilberte Brassaï. "'Marvels of creation.' That is the key. Brassaï was convinced that when one had the privilege to witness such marvels of perfection then duty imposed: one must interpret these living beauties."[358] Brassaï was equally drawn to the stone faces carved by nature in the mountains in Les Baux in Provence, where "nature sometimes seems to hold the mirror up to man, reflecting his features back to him."[359] Taken in 1945 and published in both Labyrinthe (1945) and Harper's Bazaar (1958), the photographs highlight anthropomorphic rock profiles carved by wind and rain.[360] Brassaï had multiple interests in these forms. He responded to this landscape so unearthly "that Dante is said to have used it as a setting for his Inferno," with his characteristic passion for carved stone and for the natural world.[361] The unsigned author of the text in Harper's Bazaar, possibly Brassaï, refers to the mythical Greek giant Antaeus, "whose strength depended on his contact with his mother earth, [and who] remained unconquerable until Hercules, by simply lifting him into the air, rendered him powerless." Brassaï, who frequently wrote his parents of his need to flee the city for the mountains or beach, may have identified with this giant deactivated by his separation from nature.

Brassaï used his camera to collect what Nancy Newhall called "the strangeness of the commonplace."[362] Like the Surrealists, Brassaï was fascinated with objects trouvés (found objects), which he loved to pick up in flea markets, or in the street, to fill the shelves in his studio. In 1936–37, Brassaï photographed a loaf of bread baked as a face (catalogue number 93). At the time, he wrote, "What I love, and passionately, is to give to a 'worthless' object a value, by the simple act of discovering it and by the dignity it acquires when welcomed into one's private world. Among all the objects chosen to share my life, I prefer, perhaps, this amazing mask of bread, made for the 6th of January 'Festival of Kings' by a baker from Boulevard Raspail. I've seen few portraits as joyous, as encouraging. It is the spitting image of French life: optimistic in spite of it all, limited to immediate pleasures, egocentric, gourmand."[363] Thus, like the Surrealists, Brassaï felt that bringing his personal attention added value to the object, but when he elaborated on its worth, he also cited its value relative to other objects and to the external world. Similarly, he photographed what he called the "carnal love of matter" found in craftsmen's common arrangements of their goods, including window displays, the pyramidal arrangements of vegetables at Les Halles, and a shoemaker's wall of shoes. He admired these still lifes as little masterpieces of naive art that deserve to be ranked among the greatest French primitives. "This delight in grouping," he continued, "assembling and displaying things for the eye and the senses can be found in French painting from Chardin to Braque and from the Le Nain brothers to the Douanier Rousseau."[364]

Some of his earliest photographs were of small, ordinary objects — shoelaces, paper clips, matches — photographed at close range and enlarged "fourteen times" to appear monumental.[365] Writing about these pictures in 1932, a reporter observed that "before [his] magic lens, the objects which we see and use every day, stop being everyday."[366] Rows of tacks were transformed into a metallic forest. The body and handle of rusty scissors became a torso and legs. A candle flame became a torch. These readings distance his close-ups from similar work done at the same time (and earlier) in Germany by Albert Renger-Patzsch, Hans Finsler, Hein Gorny, and Karl Blossfeldt, among others.[367] The German efforts have become known as "The New Vision," because they were guided by desires "to awaken eyes that do not see." Brassaï would surely have known and perhaps even admired the virtues of Germany's sachlich (objective, factual) photographers. But unlike Brassaï's seductive images,[368] their work has the "aesthetic of the engineer"[369] that discouraged attempts at poetic interpretation. Furthermore, the "Objects of a Grand Scale" and the close-ups of plants and crystals were done before Brassaï met and began working with the Surrealists, including Dalí, and the Surrealists had no priority claim on ambiguous or erotic images. Nor could the tenets of Surrealism compete in Brassaï's mind with the philosophy of his beloved Goethe.

From Goethe's writings on morphology, Brassaï developed his belief that "after long observation and contemplation I have been able to raise myself to the level of the object." Goethe had a particular passion for botany and biology, particularly for morphology, the study of internal and external form, and for the evolution of form. Stating that nature was not created to serve man, Goethe wrote that the "objects will thrust themselves upon him with such force that he, in turn, must feel the obligation to acknowledge their power and pay homage to their effects."[370] The poet denounced as trivial man's "habit of valuing things according to how well they serve his purposes."[371] Goethe's writings on art insist that the arts must closely observe objects and be attuned to all things (not just those of apparent value). Goethe found man's challenge in the living relationships of life, and reveled in what he termed the "potential for infinite growth through constant adaptation of [man's] sensibilities and judgment to new ways of acquiring knowledge and responding with action."[372] But a great artist, observed Goethe, is both nature's master and her slave. He must be accurate. For instance, he must understand and be faithful to the structure of bones.[373] Then, observed Goethe, "when a picture becomes an independent image, [the artist] has freer play, and here he may have recourse to fictions."[374] This balance of observation and interpretation, of analysis and synthesis, of individual and type, was deeply satisfying to Brassaï.

figure 14 Serge Hambourg, French, born 1936. Brassaï's Atelier, 1985. 11 1/2 x 11 1/2 inches (29.2 x 29.2 cm). The Museum of Fine Arts, Houston, museum purchase with funds provided by members of the Photography Accessions Subcommittee in honor of S. I. Morris, 95.203.

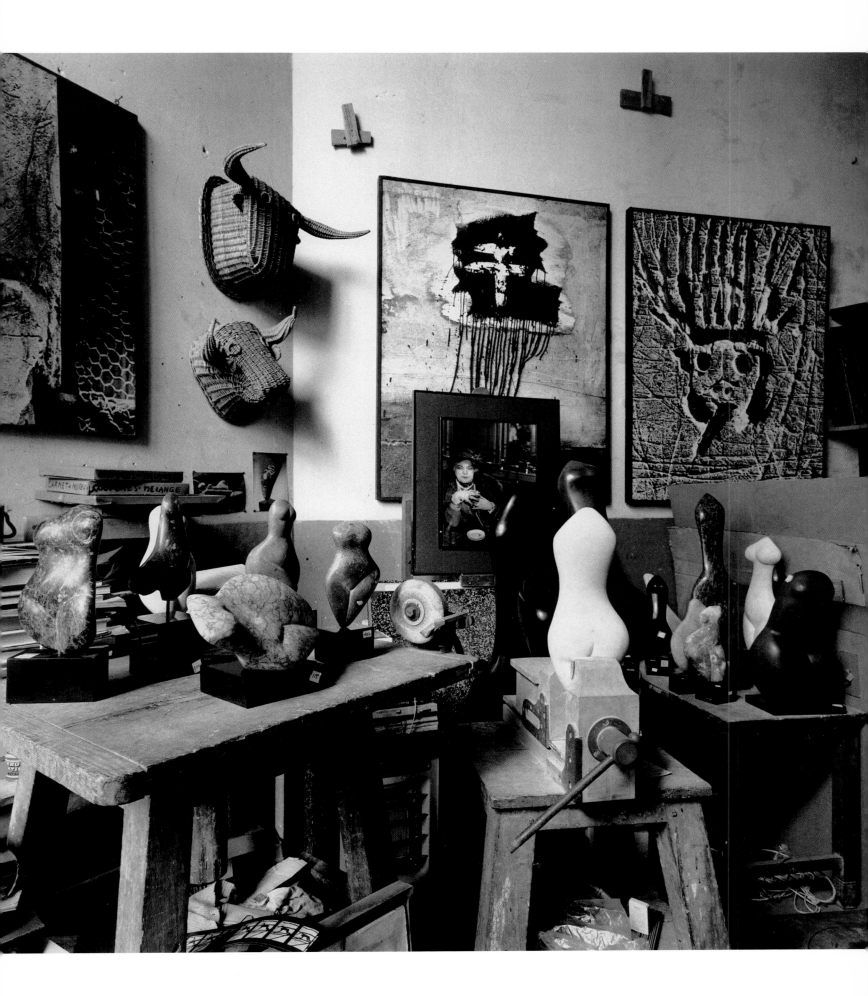

Graffiti In 1961, Brassaï published a photographic book on graffiti. Preferring carved to painted wall markings and photographing primarily in the working-class districts of Paris, he had begun his graffiti series in the early thirties and published the first examples in Le Minotaure in 1933.[375] Working on the series for three decades, Brassaï sometimes rephotographed the same carving years later, after it had been modified by the cumulative impact of time, weather, and different carvers. The graffiti were found images, and Brassaï respected their makers. Yet he claimed their creations for his own art, or rather, picked the graffiti "which my own visual sense could judge to be a formal success."[376] Like the stones he gathered from streams and transformed into sculpted nudes, the carved drawings — however vital in their own right — were transfigured by Brassaï's vision. He created his own works of art through his framing, his lighting, and, ultimately, the quality of his prints. Many other artists have photographed graffiti, but one can recognize Brassaï's images by the way he vividly isolated a single carving and emphasized its individual vigor.

In the text accompanying his photographs, Brassaï addressed the disturbing beauty of the carved graffiti that he preferred. He believed that the rawness of the images was derived as much from the rough-hewn qualities of the deteriorating walls into which the graffiti were typically chiseled as from the crude qualities of the drawings themselves. "The nature of the materials and of the tools can transform art and transfigure thinking itself," he wrote. "From paper to the wall, the childlike expression takes on a sort of gravity, a sort of density. It's because paper submits and the wall commands."[377] Speaking from his own experience, Brassaï described the strenuous effort required to carve stone, noting that breaking down the stone's resistance stripped the image of facile effects, gave it a unity of style, and yielded emotional candor. The deeper the carved lines and natural cracks, the more grave and astringent the image became. He also noted that the properties of the wall — "its fissures, its streaks, its mold" — can suggest resemblances that excite the imagination.[378] Brassaï admired how "dampness, heat, inclement weather, smoke and steam give the walls their patina, cutting, corroding, gouging their reliefs and aging them so quickly that they truly seem to emerge from another era."[379]

Regarding the relevance of graffiti, Brassaï presented two approaches. First, he proposed that the impulse to carve graffiti is latent in everyone, but is schooled out of all but "the naive, the primitive, children, [and] the mad." Disturbed minds offer "such fertile ground [for powerful emotions] that immunity could not be built up by reason, intellectual clarity or the multiple vaccines of education."[380] For graffiti artists, their "canvas" is the wall — birthplace of all revolutions — which attracts those who harbor something for which society can be reproached, and those whose impulses can no longer be repressed. The wall, Brassaï insists, is the most faithful witness to this furtive, stifled psychic ego that otherwise might be condemned to silence.[381]

Second, Brassaï drew a parallel between an individual childhood and that of all mankind. "Like our distant ancestors," he wrote, "the child struggles in the dark; like theirs, his solitude is terrifying and fundamental."[382] He divided man's earliest visual efforts into two opposing segments — private/public, cave/open air, carved/painted — each with fundamental stylistic differences. The art of the cave, Brassaï proposed, is "secret, turned back into itself, [and] offers us, above all, carvings and solitary sculptures. . . . I believe that this same antagonism which opposed the two great currents of prehistoric arts exists at the heart of children's art."[383] He chastised society for exhibiting the art that children make on paper while ignoring their creations on walls. "The wall will always be a depiction, while paper will be movement and storytelling. . . . The divergence of the two 'styles' of cave art does not seem to me to pertain only to prehistoric times. It is inherent in the very nature of art at its origins."[384] Brassaï believed that the "graffiti, the art of the streets, should be displayed alongside the art of the museums. . . . Do they not both contain the same spark of life?"[385] In his article, "Le Procès des Graffiti" (Criticism of Graffiti), he responded to an unidentified critic that graffiti should be accepted as art, even while those who make it are not necessarily artists.

Brassaï also drew parallels between urban graffiti and tribal art from other cultures, believing that graffiti is the contemporary city's "primitive art." He traced his interest in such art to a desire "to discern beneath the carved or painted figures . . . the true being of man, the essence of the human spirit."[386] Brassaï then lamented a tendency to recognize these impulses in other forms from other cultures, but to neglect them at home. As a result of their neglect, much of what he had photographed had been destroyed by urban renewal.

Brassaï was also interested in how graffiti changed over time, and how one could find continuity in carvings from culture to culture and from one historical period to another. He sought out graffiti wherever he traveled. With Picasso, Brassaï discussed the graffiti in the prison at Gisors in Normandie and then photographed the carvings there. He wrote about the graffiti in the grottoes of the Dordogne, along the Nile and the Euphrates Rivers, on the walls in Pompeii and Rome, inside prisons in Istanbul, and on ancient fortresses in France and England.[387] Brassaï delighted in finding carvings "a stone's throw from the Paris Opéra" that mirrored those in ancient sites, such as a bird-headed woman related to the beaked deities of the Assyrians. He compared the caveman's painted bison, studded with arrows, to initialed hearts ravaged by fury, both initiated by the desire for magical powers.

As Brassaï worked, he organized his prints of graffiti into subseries, which later inspired some of his most poetic essays. Into his writing, he folded a lifetime of reading about diverse subjects — art history, paleontology, social history, and psychology. At first Brassaï felt inadequate to the task of discussing fully the many disciplines relevant to graffiti and its history. Later, he accepted that his essays "have no other goal than to inspire and create echoes."[388] The nine subseries of archetypes into which he divided his project later became the chapters in Graffiti. Of these, The Language of the Wall contains his few photographs of painted graffiti, and Propositions of the Wall compiles his photographs of nature's own drawings formed from cracks, peeling surfaces, and abrasions on decaying facades.[389] The photographs of carved images are divided into seven groups titled the Birth of Man, Masks and Visages, Love, Death, Animals, Magic, and Primitive Images. The Birth of Man consists of the most rudimentary carvings of two parallel holes. With or without an accompanying nose and mouth, or an encompassing oval head, two hollows sufficiently indicate eyes and, therefore, "man." Brassaï grouped the addition of an array of mouths, necks, and skulls into Masks and Visages. These first two subseries of carved graffiti contain the plainest images, instigated more by impulse than imagination. Equally simple are the images captured in the Animals subseries. Birds, fish, dogs, wolves, and horses offer mere outlines for recognition. Many of the forms seem to have been suggested by natural breaks in the wall, except for a marvelous carving of a chicken that was chipped from a previous graffito of interlocking hearts. The graffiti illustrated in this catalogue were selected from Brassaï's last two chapters, Magic and Primitive Images. The former includes sorcerers, wizards, devils, ghouls, fairies, satyrs, and fauns. The latter accounts for the most inventive and personal creations in all the series.

Brassaï observed that often carnality and "the absence of love appear on the wall" rather than confessions of intimacy and tenderness.[390] Love was usually signified by initials enclosed by a heart, wounded love by hearts pierced by knives and phallic symbols, and base sexuality by male and female genitalia. Matisse told Brassaï that he was delighted by the graffiti concerned with feminine sexual organs, particularly the "coffee bean" representation. "Do you know the red-light district of Toulon?" he asked Brassaï. "You will find this symbol everywhere on the walls there. And each of the bordellos carries this coffee bean as its emblem."[391] Henry Miller also gravitated toward the most overt sexual images. "I want a world," he wrote, "where the vagina is represented by a crude, honest slit, a world that has feeling for bone and contour, for raw, primary colors, a world that has fear and respect for its animal origins."[392] The absence of male sexual organs, except as they pierce other elements, suggests the predominance of boys among graffiti artists, at least in the graffiti that Brassaï selected.

Of the universally recognized depictions, some are clichés — such as hearts, phalluses, and skulls — but, in the most compelling graffiti, these symbols are rejuvenated by the passion implicit in the clawed-out lines and by the highly imaginative evolutions visible within a single image. Sexual desire, anger, and the need to possess segued into death when the heart became a skull. Graffiti artists would take a heart, add eye sockets, and carve in the sides of the head to create a bold chin and fleshless cheeks; something tender was transformed into something ominous. Hope became menacing. A subsequent carver added crossbones, creating an image that in turn was transformed with the addition of a body. Crossbones added below a head emerged as arms, while crossbones above the head read as horns. In another image, death became a fearsome genie. Childhood minimalists eliminated the skull without sacrificing the power of their images. An "x" with eyes, or just an "x" alone, intimated a bloody sign to guide an assassin. Anonymous carvings located in semipublic places were available to anyone who wished to alter them. Like the game "exquisite corpse," each successive performer added to the whole. But unlike the Surrealist game in which a drawing is begun, and then folded after each contribution to conceal the prior efforts from the next participant, until the drawing is finished, graffiti are always in view and accessible. They are less collective efforts than ongoing repossessions. Brassaï was fascinated by these evolutions of graffiti from the Birth of Man to Masks and Visages, from Love to Death, and from female to male to demon. "The language of the wall," observed Brassaï, "ceaselessly transposes, transmutes images, forming and reforming them, blending them and separating them, disguising and metamorphosing them . . . until they are reduced to hermetic, inaccessible ideograms."[393]

After the 1933 article in Le Minotaure, Brassaï's images of graffiti were not published again until Harper's Bazaar ran a selection of them in 1953. In 1956, Edward Steichen organized an exhibition of Brassaï's graffiti photographs at the Museum of Modern Art in New York that traveled to other venues. The Institute of Contemporary Arts in London organized an exhibition in 1958, accompanied by a modest catalogue with an introduction by Roland Penrose. Subsequent shows, connected with the publication of Graffiti, were held in Milan, Saarbrücken, Rome, and Paris, to name a few locations.[394] As with his other series, the critical response to the images in the book ranged from the anecdotal to the poetic, from silly to deeply engaged observations. Most responses were guided by Brassaï's own text. Having sought "to inspire and create echoes," Brassaï took pleasure in the serious reviews, and was particularly gratified by the critics who accepted the carvings as art, rather than dismissed them as children's curiosities. But he also delighted in those reviewers who seriously disagreed with him, for their thoughtful observations also confirmed the intellectual basis of his efforts.

By 1961 Brassaï had been making his images of graffiti for three decades. During these years, he was guided by aesthetic and philosophical ideas then prevalent in France, ideas that helped his thoughts on the carvings crystallize. Graffiti found its audience with the introduction and ascension of Existentialism and other related doctrines in psychiatry, philosophy, aesthetics, and literature.[395] Brassaï's various texts reveal that he was intimately acquainted with Existentialist books and issues.[396] His essays on graffiti and the works by Existentialists and other contemporary intellectuals reflect shared interests in ethnography, archaeology, and primitivism. Other issues that they analyzed included the importance of the artist's encounter with materials, the search for origins and the idea of "beginning from nothing," images in metamorphosis, and the idea that anguish was a prelude to self-discovery. For instance, at the same time that Brassaï was speculating about the degrees of pain, fear, and emotional instability that motivated graffiti artists, Henri Michaux was proposing that, through pain and other extreme, alienating states, an individual could most effectively break through the protective armor of conventional behavior and thought process to reach intensely personal, primordial mental states.[397] Similar to Brassaï's ideas on the transforming act of digging into stone were the beliefs of the editor and writer Jean Paulhan, who argued that "it was only through wrestling with materials, grappling with the hazardous effects of chance and challenging the independent will of resistant matter, that artists could find a new way forward."[398]

One must also wonder if Brassaï read philosopher Gaston Bachelard's Water and Dreams, published in 1942, in which Bachelard postulated that "this reverie born from the work of kneading [clay or dough] is necessarily linked with a particular will to power, the male joy of penetrating into substance, of feeling the inside of substances."[399] It is possible that Brassaï attended Bachelard's lectures at the Collège de France during the occupation, given that among those reported to be in attendance were Brassaï's friends and acquaintances Raymond Queneau and Paul Éluard. According to historian Sarah Wilson, a distinguished and varied audience of poets, writers, artists, and tramps attended the lectures. The tramps, at least, may have been most interested in the fact that the lecture hall, like the studios where Brassaï sketched, was heated.[400]

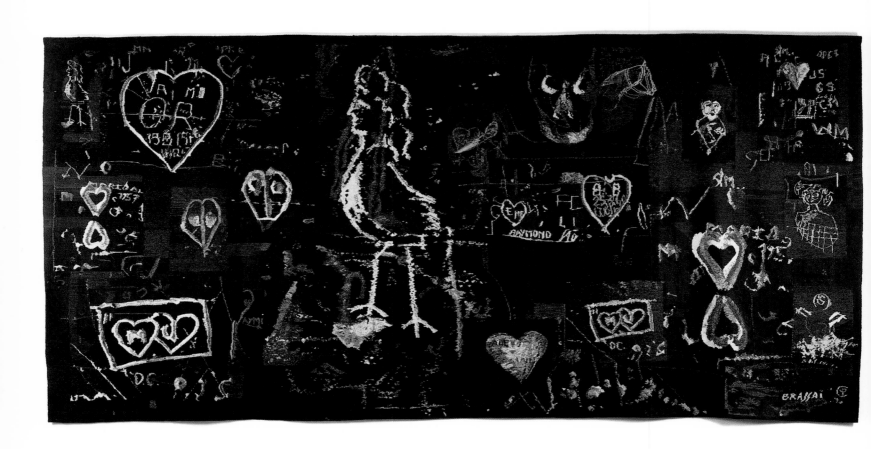

Another relevant parallel to Brassaï's immersion in graffiti was the serious consideration being given to art made by people living on the margins of society. In 1946, a successful public exhibition was held in the Sainte-Anne psychiatric hospital. On view were works by mentally ill patients. Sarah Wilson proposed that this exhibition was, in part, "a deliberate riposte to the campaign against 'degenerate art' by the Nazis."[401] Simultaneously, the painter Jean Dubuffet and others involved in the visual arts began to collect art by people diagnosed as psychotic or considered to be naive outsiders.[402] Dubuffet called the works Art brut and convinced his dealer at Galerie René Drouin to show works from his collection, first in the gallery's basement, and then in its main space in October 1949. In 1950, Sainte-Anne psychiatric hospital presented a much larger exhibition of psychopathological art in conjunction with the first World Congress of Psychiatry. At the same time, the philosopher Maurice Merleau-Ponty addressed the mental states of childhood; several important exhibitions of children's drawings were also mounted.[403] Brassaï's plea to consider wall graffiti as a form of childhood expression equally important as, but vitally different from, children's drawings on paper may have been provoked by the fact that these exhibitions and writings focused exclusively on works on paper.

After the publication of Graffiti, Brassaï was commissioned by the Atelier Yvette Cauquil-Prince, Paris, to design tapestries. "I thought deeply about our every-day wall," he wrote, "about its texture so imbued with humanity, about its magic and its poetry. . . . The very ruggedness of the common wall surely has some affinity with the irregular weaving/stitching of the medieval era — with its restricted range of tones and colouration. I had only to draw from that well-stocked herbarium which I have made for myself during the last 30 years from . . . the walls of Paris."[404] Drawing on the original colors of the walls themselves, each design incorporates numerous but diverse elements from his photographs of graffiti. As Brassaï delighted in reporting to reviewer Viviane Verger, "I returned to the wall what I took from it!"[405] The first tapestry, Graffiti I (figure 15), was exhibited at La Boétie Gallery in New York in 1968, along with Brassaï's photographs, drawings, and sculptures. Brassaï made seven more designs, each with a distinct theme, or a dominant element. Graffiti II: Le Roi Soleil, a tapestry that employs the graffito image of the sun king as its central element (catalogue number 101), represented France in the Lausanne Biennale in June 1971. Two others tapestries whose titles were inspired by the dominant graffito image in each are Le Coeur (1972) and Samourai (1972). At this time, Brassaï's solo exhibitions regularly included tapestries, drawings, sculptures, and photographs. Along with other prominent artists, Brassaï also exhibited his tapestries in group shows held in Paris, London, Brussels, and Menton, France.[406] The tapestries range in size from 52 x 68 inches (130 x 170 cm) to 88 x 125 inches (220 x 320 cm), and vary in color from muted brown to red. Brassaï also made designs for fabric based on his photograph of a butterfly wing. Utilizing this fabric, which was produced by Madame Brossiade Méné, Christian Dior designed a dress and jacket that was reproduced on the cover of Life magazine for its March 26, 1951, issue and was also reproduced in Elle and Harper's Bazaar. The Dior ensemble is now in the permanent collection of the Museum of Fine Arts, Houston.

Brassaï took his first color photographs in the United States in 1957. "The Yankees wanted to see everything through rose-colored glasses," he told an interviewer, "and color, Kodachrome, Technicolor, etc. has hallowed American life with a permanent daily rainbow."[407] Later, Brassaï worked briefly with color in France. He primarily photographed graffiti, but also published a few articles illustrated with color photographs of architectural details (catalogue numbers 108 and 109). Painted rather than carved graffiti were better suited to color materials. These images, which date from the 1950s and 1960s, are more about bold gesture exercised with speed than raging, primitive bitterness forced into stone. They are more about abstraction than about archetypes, yet they expand upon observations Brassaï first made in the subseries The Language of the Wall and Propositions of the Wall. He is as fascinated with the substances that serve as ground for the graffiti as he is with the actual markings themselves. figure 15 Graffiti I, 1969. Flat-weave wool tapestry. 59 x 118 inches (150 x 300 cm). Woven by Yvette Cauquil-Prince, French, born 1928. Collection of Joyce Pomeroy Schwartz. © Gilberte Brassaï

The moment Hitler reoccupied the Rhineland in 1936, many people realized that war was on the horizon. This was especially true of immigrants such as Brassaï, who had been driven from his own country by right-wing politics. On September 3, 1939, France finally declared war on Germany after the Wehrmacht entered Poland, but the French did little beyond mobilizing their army. In May 1940, Holland, Belgium, and Luxembourg fell, and on June 6, the Germans crossed the Somme River in northern France. By the time German forces marched into a practically deserted Paris on June 14, Brassaï, Prévert, and other colleagues had taken the Métro to the end of its southernmost route, then fled farther south on foot. According to photographer Maria Eisner, "They walked, slept in fields or in an abandoned country house, were machine-gunned, got an occasional ride in a car, and eventually arrived in the south of France, exhausted, terrified and miserable like all those who had made the terrible exodus from Paris."[408] Roger Grenier reported that Brassaï managed to get a good story even from this experience. He recounted that as Brassaï headed for the Loire Valley with his friends, they were terrified when stopped by soldiers, only to discover the soldiers were lost and simply wanted to see Brassaï's Michelin guide.[409]

In October, Brassaï returned to Paris after learning from a fellow tenant that the basement of his Paris apartment building, where he had hidden his negatives, was not waterproofed. "The security of a decade's work became more important than my own safety," he later told Peter Pollack.[410] Picasso had returned to Paris on August 25 to remain for the rest of the war, and many, including Brassaï, cited Picasso's decision as a source of their own resolve to endure the occupation in Paris. During the war there were shortages of everything, from food to electricity to medicine. Restaurants were open, but their menus no longer included such staples as coffee. Brassaï photographed Saint-Germain-des-Prés church and the Café des Deux-Magots shrouded in their "mournful wartime look" (catalogue number 13).[411] His apartment was so cold that his pet fish froze and he was forced to build a stiff tent from enlarged exhibition prints to reduce the living area that required heat. Since Brassaï would not work for the Germans, he could not obtain a work permit or publish his pictures. Some financial relief came in September 1943, when Picasso and Les Éditions du Chêne commissioned Brassaï to photograph Picasso's sculpture for a book. John Richardson speculated that Picasso's black-market sources, which helped him secure metal for sculpture, also might have been able to procure film and photographic paper for Brassaï.[412] In Picasso and Company, Brassaï reported that Picasso was also able occasionally to get coal, which allowed Brassaï to work without wearing his hat, scarf, and overcoat.[413]

Staying in Paris was not without danger for Brassaï. Picasso and Company is laced with accounts of friends and acquaintances being captured and deported, of collaborators being murdered by the Resistance, of air raids and a few stray bombs. There were accidental brushes with the invaders. In one such incident, Brassaï dropped his lighter while walking at night and was questioned for the suspicious behavior of crawling around the sidewalk in search of it. In April 1944, he left his apartment, took refuge with friends, and obtained a false identity card, because, as an ex-officer in the Austro-Hungarian calvary and a Romanian citizen, he had been called to serve in the German army. "I preferred desertion," he told Pierre Reverdy.[414] Finally, on August 25, 1944, Paris was liberated, but even on this historic day Brassaï could not escape danger. He was photographing the Liberation from his apartment window when someone below mistook him for a sniper and fired a shot through his window. Brassaï managed to dodge the bullet, which broke his mirror and lodged in his bathroom wall (catalogue number 121).[415]

Also coming to an end was the extraordinary period in Montparnasse that had attracted Brassaï to Paris, the last decades of which he had lived and recorded. The postwar period marked the beginning of a very different phase of Brassaï's life, that of the mature artist. The aesthetic heart of Paris would move to Saint-Germain-des-Prés. Brassaï would keep his apartment in Montparnasse, spend more and more time in the south of France, and travel increasingly to other countries to photograph. While still making new pictures, he would spend more time reconsidering his life and organizing his thoughts and images into books. Brassaï entered a stage in life in which he was esteemed and yet beginning to be marginalized by his age. He was impressively productive, but no longer on the cutting edge. He was a middle-aged man, confronting the pressure of knowing he had more projects in his head than he had time to accomplish.

Paris by Day

Brassaï never published a book titled Paris by Day, but he could have.[416] Almost a quarter of the photographs in Camera in Paris and the Éditions Neuf Brassaï are of the city in its waking hours. In the day, as in the night, Brassaï haunted Paris's parks, walked the Seine and its quays, photographed all of the city's major monuments, and was partial to cats, dogs, and children. As with his nocturnal views, his daytime vision of Paris was heavily influenced by the way the city looked when he had first lived there as a child. For instance, one of his first photographs is of a small boy pushing boats in the Luxembourg pond, just as he had once done.[417]

In March 1924, Brassaï wrote to his parents that he was most interested "in the way Paris lives and moves and how one moves with it today, and not in the way people used to live and move centuries ago. . . . Paris is not a museum . . . it is still very much alive. I often stroll quite indifferently past the greatest works of Rubens and Leonardo da Vinci at the Louvre, but I never tire of the views of the Tuileries, full of children, or the Seine."[418] Actually, much of the Paris that Brassaï photographed was less than a century old; the Paris into which he arrived as a child was still quite new. Many of the parks and bridges, as well as the Opéra, were products of Napoleon III's renovations and "greening programs," introduced in the Second Empire (1852–70). These programs created the Montsouris and Buttes-Chaumont parks, transformed the Bois de Boulogne and the Bois de Vincennes from woods to parklands, and replenished the trees on the avenue des Champs-Elysées and along the Seine, as well as in the Luxembourg and Monceau gardens. Paris's skyline continued to change dramatically during the Third Republic. The Eiffel Tower opened in 1889. Both the Grand Palais and the Petit Palais were built for the 1900 World's Fair, as was the Alexander III bridge that crosses the Seine immediately to the south of the palaces. The Basilique du Sacré-Coeur, which so radically changed the Parisian skyline, was begun in 1876, but not consecrated until 1919. These late-nineteenth-century and early-twentieth-century sites and renovations were the Paris of Brassaï's beloved Proust and of his childhood. Later, this was the Paris impressed on Brassaï's mind when he railed against the changes introduced by tall buildings and cars, especially the new roadways along the Seine.

While one might claim Brassaï as the sole photographer of particular aspects of Paris by night, the distinction is not possible for Paris by day. Germaine Krull and André Kertész were only two of Brassaï's numerous contemporaries who photographed between the world wars. Both Krull and Kertész published books on daytime Paris.[419] Krull's book 100 x Paris was published in 1929 with a trilingual introduction by Florent Fels. As Fels pointed out, Krull's Paris unavoidably embodies history, culture, and charm. It includes the city's great monuments, architecture, and vistas, as well as the raggedy clochards, meat stalls in Les Halles, and bookstalls along the Seine. Thus, Krull and Brassaï photographed many of the same subjects, each with his or her own particular style. Krull's approach to the city was quite cool. She rarely stood closer to her subjects than mid-range, and constructed her pictures using large blocks of form and bold graphic patterns. Her scenes are peopled without being particularly energized by their inhabitants. Her images are about permanence, not action, and about dependable, daily, urban repetition, not eccentricity.

Kertész's approach was lighter and more lyrical than that of either Brassaï or Krull.[420] Shadow and light play delicately across Kertész's scenes. His pictorial constructions inspire thoughts of exquisite lace, and are nevertheless emblematic of modern photographic design. People are often the focus of his pictures; he perceived seemingly irrelevant human gestures as being revelatory: the way a man holds his cane, cleans his toes, rests his head, or reads his book. Grand history was never Kertész's subject. Paris's monuments are by and large on a distant horizon from the human incidents that delighted him.

Brassaï's style existed at a point somewhere between those of Krull and Kertész. Brassaï's pictures were also about permanence and culture, but he, too, relished human gesture and eccentricity. Whereas the riverside bookstall in Krull's photograph is unpeopled, Brassaï focused on Professor Dimier, a member of the prestigious French Institute, scrutinizing the wares (catalogue number 115). Brassaï and Kertész were both wonderful chroniclers of children's delights and torments. For instance, in Balloon Seller, Montsouris Park, Paris (1931–34) (catalogue number 116), Brassaï focused on a child's rapture with his new purchase while the balloon vendor is obscured by his merchandise. More than Krull, both Kertész and Brassaï employed irony and noticed incidents and individuals that were out-of-step with normal routine. Serendipitous events and juxtapositions became the focal points of many of Brassaï's daytime pictures. Glare replaces a newspaper vendor's eyes with blank white orbs (catalogue number 118). A painted cat deflates the presumably serious discussion between policemen on their beat (catalogue number 112). White pedestrian markers, as bold as drumbeats, make a staccato exit, upstage, on the wet rue de Rivoli (catalogue number 117). [421]

In a 1989 review of the Brassaï exhibition at the Musée Carnavalet in Paris, a critic pronounced, "It is Paris by Night that wins hands down over the daytime vision."[422] Her article was riddled with factual errors, but it stated in print a preference universally implied by the disproportionately larger number of articles devoted to Brassaï's nighttime photographs rather than to his documents of daytime life and views, especially since Secret Paris was published in 1976. Even when both the daytime and nighttime series were included in a show, reviewers often concentrated almost exclusively on the "after-hours" images. For example, regarding Brassaï's 1979 retrospective at the Photographer's Gallery in London, most of the exhibition reviews conveyed the impression that the show featured only Brassaï's images of the demimonde. One reviewer mentioned work from Brassaï's other series only to note how perceptions of non-night photographs are altered by their association with the night views. Or, while acknowledging the other pictures, another reviewer observed, "The mantle of all-round photographer slips easily off his shoulders. He's undoubtedly at his best on a foggy night watching Marshal Ney's monument ineffectually waving a sword at the encroaching mists."[423] Similarly, Ian Mayes observed in the Birmingham Post, "He has ranged in time and place capturing a variety of subjects with a totally unaffected warmth and humor. But his pictures of the night-time demimonde of Paris in the thirties . . . add up to a great and compelling achievement."[424]

The uniqueness and breadth of Brassaï's series on Paris by night is partly responsible for the disproportionate preferences for Paris de nuit and Secret Paris just cited. It is an extraordinary series of deeply memorable pictures. But another factor in the current disregard for Brassaï's visions of Paris by day derives from contemporary tastes in art. Modernist, and certainly Postmodernist, theories have been intolerant of pictures that openly express tender sentiment. There has been a tendency to assign all expressions of good-hearted sentiment, however discerning, and examples of maudlin sentimentality to the same dustbin. Social changes in the late 1960s eradicated art-world and magazine appreciation for the kind of sweetness and human sympathy that had evolved in magazine photography from the 1930s through the 1950s. Today, one might call these images "family-value" pictures, but at the time they were regarded as "humanist" photographs.[425] Writing about Edouard Boubat's pictures of the 1940s and 1950s, essayist Patrick Deedes-Vincke described Boubat's particular style, but his analysis could also encompass other works produced by photographers at the same time, including photographs by Brassaï. "While photo-journalism was happy to play on our emotions with scenes of human tragedy," wrote Deedes-Vincke, "Boubat's reportage dealt with places where nothing seemed to happen, where goodness and a certain grace and serenity pervaded."[426] After World War II, the world had seen enough images of devastation and was ready for the more stable, compassionate vision that "humanist" pictures offered, but this "school" of image-making had not originally evolved for this purpose.

Almost all of the daytime Paris pictures exhibited in Brassaï: The Eye of Paris were made before the war, although Brassaï frequently placed these same pictures in magazines after the war. In postwar France, Brassaï's primary competition for assignments came from the generation of photographers born around 1910: Henri Cartier-Bresson, Robert Doisneau, Izis (Israël Bidermanas), René-Jacques, Willy Ronis, and the still younger Edouard Boubat.[427] The photographs by some of these men were influenced by Brassaï's earlier daytime work, images that have not been extensively published in books, but were widely seen in the magazines on which the younger photographers were weaned.[428] Izis, in particular, has acknowledged Brassaï's personal encouragement and influence in making his first book, Paris des rêves (Paris of Dreams).[429] Aspects of the younger men's work from the forties and fifties can be found in many of Brassaï's daytime pictures from the thirties: the ability to see what is beautiful in the everyday world, melancholy streets wet with rain, and, especially, his stylistic approach, "poetic realism." Discussing Brassaï in Photography: A Concise History, but coincidentally describing the postwar humanist style, art historian Ian Jeffrey wrote, "He is a propagandist for what Hannah Arendt, writing in The Human Condition, refers to as petit bonheur, for that happiness which is to be found away from the mainstream of public life."[430]

The presumed apotheosis of this style is Edward Steichen's 1955 exhibition and book, The Family of Man, which sought to display the universality of humankind's experiences and emotions as seen through photography. The exhibition featured images by one hundred and three photographers from sixty-eight countries. Looking closely at The Family of Man can help one understand contemporary reactions to Brassaï's photographs of Paris in its waking hours. Unrelentingly upbeat, the exhibition began with lovers and proceeded through marriage and birth to the many phases of childhood as seen from around the globe. The book continued with photographs of human labor and its rewards. Images of leisure, learning, prayer, war, pestilence, death, and assembly followed. "We two form a multitude," and other such platitudes, accompanied the pictures. The show was an enormous worldwide success; after more than four decades the book is still in print. It was also an exhibition that photographers loved to hate, both for its sentimentality and for Steichen's dictatorial control of its content. He even borrowed the photographers' negatives and determined the size of their prints. His themes and presentation obliterated both subtlety and sophistication. No matter how complex the picture, when it was reproduced with five or six other pictures that shared with it one particular aspect — usually its subject matter — then all of the pictures were reduced to being about that one common denominator, and the audience was prevented from pursuing more subtle avenues of interpretation.

Steichen had a great eye for photographs and utilized some of the medium's greatest images to convey his message. With six pictures in the exhibition, Brassaï was one of only a dozen photographers so richly represented. The selection of Brassaï's images spanned the range of his work, including two photographs from Secret Paris — Two Hoodlums, Place d'Italie, Paris (1931–32), and Lovers' Quarrel, Bal des Quatre Saisons, Paris (1932–33) — and two from southern France — Isère Valley, French Alps (1937) (catalogue number 134) and Christmas Eve Mass, Les Baux, Provence, France (1945) (catalogue number 126). Reproduced full page, Kiss on Swing at a Street Fair (1935–37) (catalogue number 119) was classically typical of the spirit of the exhibition. The darker moods of Secret Paris were reduced to snapshot size; they appear to be Steichen's notation of life's downside in this otherwise joyous ode to man's prevailing spirit.

The reductive nature of The Family of Man might have irritated Brassaï, but its theme about the cycles in human life was a topic that fascinated him. Brassaï wrote often about life's passages and one's organic evolution through birth, growth, maturation, and death. He constantly looked for examples of life's natural stages to photograph. He stated his credo in a one-page résumé distributed by his agent, Charles Rado: "I do not search out the exceptional. I avoid it. I think that everyday life and what happens is the real life. My greatest ambition is to make something new and striking out of the banal and ordinary, to show everyday life in such a way as to make it seem as though it is seen by the spectator for the first time."[431] We have little patience for this approach now. Perhaps in literature, but not in the visual arts. We are too cynical, too "wise," and too jaded, and our approach is too oblique. The forbidden and the dark side thrill us, and we resist taking simple joys seriously. But Brassaï was serious. For him, one side balanced the other; both were part of the grand scale of life and of his work. However much Brassaï delighted in the grotesque, the sexual, and the deviant, he never lost his appreciation for the great variety and challenges found in the ordinary and the daily.

Ballet and Theater

Brassaï had a lifelong interest in the ballet. He once described to Picasso his concept of a ballet to be titled Graffiti, which would blend the innocence of children's games with the primitive drives motivating those who carve into walls. Like Galatea, the symbols in his photographs of graffiti would come alive. The "arrow" would chase the "heart." Skulls and primitive masks would pirouette with "sex."[432] Although neither this nor any of Brassaï's other ideas for ballet scenarios were ever realized, Brassaï did produce sets for three ballets and a play. The most successful collaboration was with Jacques Prévert and Roland Petit, who asked Brassaï to do the sets for the ballet Le Rendez-vous. Boris Kochno and Petit had recently founded the Ballet des Champs-Elysées. Although Kochno remembers meeting Brassaï in Picasso's studio in 1944, it was probably Prévert who suggested the collaboration.[433] Brassaï was approached in May 1945, and the ballet premiered on June 15.[434] Prévert's story, like others that he wrote, involved the inescapable nature of destiny. Brassaï described Prévert's story as "born in hovels and ending in blood, mingling love and death."[435]

Selecting images primarily from his existing negatives, Brassaï created a set for each act. During act one, three larger-than-life panels served as backdrops for the dancers. The photograph on the left panel was the facade of a Place de la Bastille dance hall with the word "BAL" (public dance hall) inscribed over the door. The middle panel was tall and narrow, offering a view of a glowing street light, located at the top of precipitous stone steps. The right panel was taller yet, and featured a photograph of the peeling wall of the Hôtel de la Belle Étoile (Hotel of the Beautiful Star).[436] The panels conveyed, respectively, "pleasure," "city night," and "economic decay." For the second act, Brassaï mounted an enlargement of his famous photograph of the pillar of the elevated Métro where "the black shadow projected on a wall resembles the profile of one of those giant statues from Easter Island."[437] As the story unfolds, the Métro shadow becomes a disturbing specter. For the third act, in which the tragedy comes to its bloody conclusion, Brassaï designed a set based on his photograph of the Pont de Crimée at night, showing the silhouette of the drawbridge as it crosses the dark waters of the Saint-Martin Canal (catalogue number 20). He made the "sinister black wheels and pulleys of the bridge stand out like instruments of torture."[438] "Crime. Crimée," noted the photographer, making a pun between the bridge's name and the ballet's story. Brassaï's pun is sympathetic with Prévert's own rich use of wordplay in his poems and scripts.

In 1947, Raymond Queneau asked Brassaï to design a set for one act of his play En passant, which opened at the Agnès-Capri theater. In 1949, Brassaï worked again for the Ballet des Champs-Elysées, this time designing the sets and costumes for D'Amour et d'eau fraîche (Love and Cool Water), also known as Le Réparateur de Radios (Radio Repairman). The ballet scenario featured a radio repairman courting a girl who worked at a radio station.[439] The principal set was the control room of the station; Brassaï flanked the control room with two large vertical panels onto which he mounted two of his views of Paris. In 1950, Brassaï designed the sets for the ballet Phèdre, produced by the Opéra de Paris (play by poet and playwright Jean Cocteau, music by Georges Auric, and choreography by Serge Lifar).

Cinema and Filmmaking

Brassaï learned about the techniques and concepts of filmmaking in large part from his collaborations with Alexander Korda and Jacques Prévert, and also through contact with other friends in the French film industry. But his experience with film predates those collaborations. As he wrote in "Memories of My Childhood," an essay published in his 1952 monograph, it was on Paris's Grands Boulevards that "I encountered for the first time a young person, barely older than I, and who has since made a way for himself: the Cinema. It was exhibited in windows of some of the department stores, causing crowds to gather and traffic jams."[440] Brassaï was then four or five. The films he describes as riveting him to the sidewalk are by Louis and Auguste Lumière, brothers and inventors of the Cinématographe camera. One of the films that Brassaï saw was Chapeaux à transformations (Transforming Hats), about a dressmaker who rests on a public bench and, while she naps, fairies leap from her hatboxes and dance. Brassaï's early impressions of this film were vivid and lasting.

In 1956, Brassaï completed a twenty-one-minute film on the animals in Vincennes Zoo in southeast Paris. Unlike many movies filmed and directed by photographers, Tant qu'il y aura des bêtes (As Long as There Are Animals) was not a compilation of still photographs strung together. As Brassaï himself admitted, "Certainly, the greatest danger that a photographer faces when attempting to create motion pictures is giving more importance to centering beautiful pictures than to rhythm or movement."[441] Brassaï chose animals as his subjects because, like children, they "dance" rhythmically. The camera followed the graceful movements of giraffes' necks, gibbons swinging from limb to limb, polar bears shaking water from their coats, birds scratching, and hippopotamuses blowing bubbles. The animals run, jump, and leap. In this aspect, the film owed as much to Brassaï's intimacy with ballet as it did to his knowledge of filmmaking. In fact, he referred to the animals as "protagonists in a ballet, a musical ballet, more closely related to a cartoon than to a documentary," and he used the ballet terms "pas de deux" and "pas de trois" to describe the animals' interactions.[442]

Brassaï chose not to include verbal commentary, which he said was too hackneyed in most animal films, and instead commissioned an original score by Louis Bessière. As in Sergei Prokofiev's Peter and the Wolf and Modest Moussorgsky's Pictures at an Exhibition (as orchestrated by Maurice Ravel), the instruments assumed narrative as well as melodic roles.

figure 16 Ervin Marton, Hungarian, 1912–68. Untitled, 1948. 9 x 7 inches (22.9 x 17.8 cm). The Museum of Fine Arts, Houston, gift of an anonymous donor in honor of Gwen Goffe and Leslie Clark, 98.191.

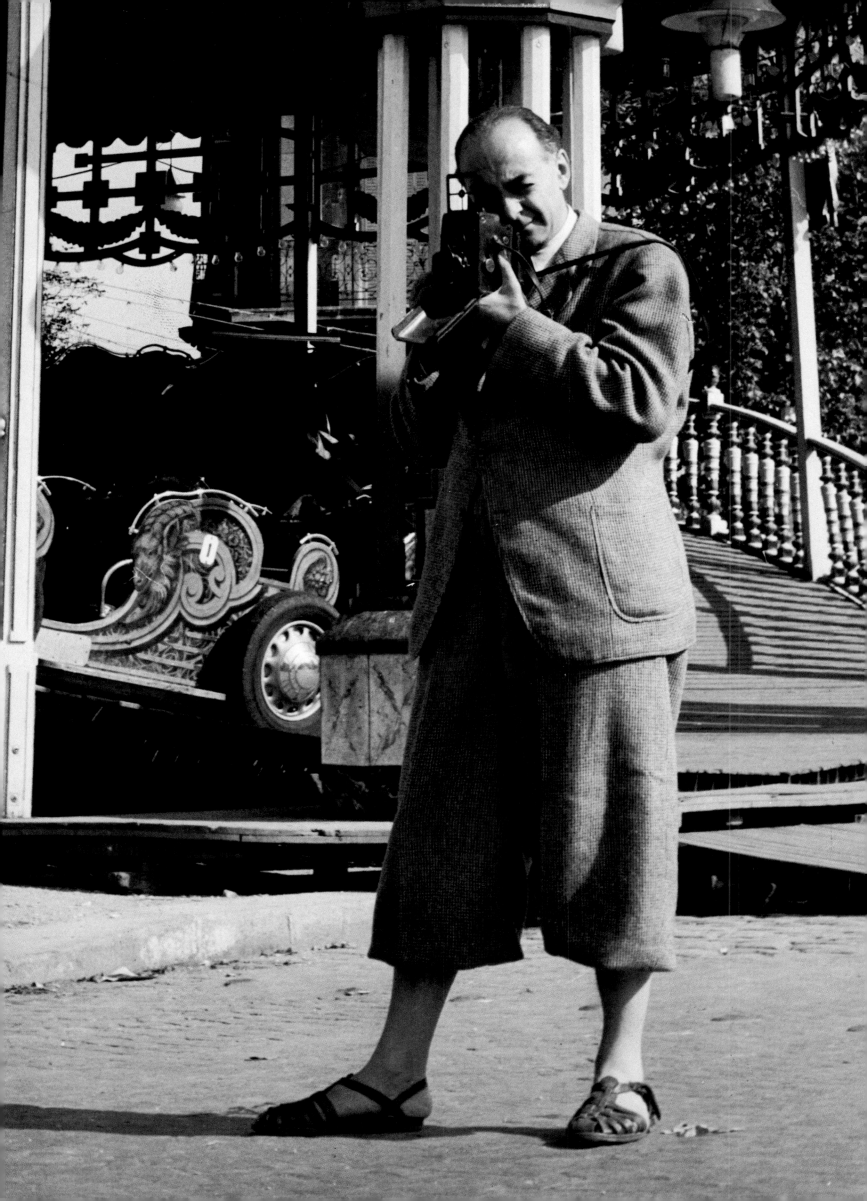

Heavy horns signified the hippopotamuses, and flutes represented the birds. The number of instruments playing often paralleled the number of animals in view. The music so delightfully supported the activity of the film that clearly it was written to accompany the specific actions by the animals. A task made easier, Brassaï admitted, because "when I filmed, I already had in mind, with each draft and sequence, this imaginary melodic arabesque, the only script in the film, to which Bessière gave a very beautiful form. . . . The wonderful array of cinematic images . . . allowed progressions from presto to largo, and from andante to allegro."[443]

To further emphasize the conscious choice of music over words, Brassaï began the film with its only text, "Dieu a donné la parole aux hommes. Il ne l'a pas donnée aux bêtes, dieu merci." (God gave man speech. He did not give it to animals. Thanks be to God.) The film's success was such that it represented France at the 1956 International Festival of Film at Cannes, where it won a special award from the judges, "Mentions aux films de recherche." Intended to praise the film's originality, the award was given at the judges' discretion in a category that they created for this film. Brassaï was pleased with the award, but was equally delighted that the film was greeted with fits of laughter and applause by very diverse audiences. It supported his belief that "an essentially cinematographic film, in which image is not auxiliary to words . . . or a story, but draws its entire force from itself, . . . can successfully appeal to all spectators." His defense of the film and of the stand-alone power of its images could be transposed to an aesthetic statement about his photographs and interpreted as a mild protest directed at years of silly captions being imposed on his photographs. He wrote, "It is incorrect to believe that wealth combined with means definitely enriches expression, that a gesture is improved through explanation, that an eye benefits from what is directed to the ears. To the contrary, pleonasm[444] only makes expression dull. This is why I did not want to afflict my animals with any useless, even harmful commentary. Instead of encouraging the audience's laziness, I wanted the cinematographic image alone to attract its attention."[445]

True to his still photographs, Brassaï made the film in black and white, resisting what he called the "seduction of color." Also, Brassaï carefully distinguished his film from those that focus on the deadly struggles and "latent sadism" in the animal kingdom. Instead, the film was about shared commonalities between animals and humans. He said, "I wanted to show that an elephant's trunk can be as tender as the human hand, that animals experience joy, jealousy, maternal tenderness, and even love, just as we do."[446] With tender humor, one can show more decorously animals (rather than humans) scratching their crotches and engaging in intercourse as well as chewing their food, yawning, licking, and preening. Lovers and Clowns, the simplistic title assigned to versions of the film distributed in Great Britain and the United States, conveyed only the animals' antics without evoking the poetry of the French title or signifying the film's true focus. However, the film was so overtly about humor and sexuality that Brassaï reported, "I sold the movie in 25 countries, all except England who said it was too erotic."[447] The film's real power lay not only in comic documentary, but also in the passages in which Brassaï's eye and technical skills transformed the activities. In one scene, what first appeared to be a strange frog flapping its arms was revealed to be the feet of an upended swan. Besides including a direct view of two gibbons swinging with outstretched limbs across an expanse of water, Brassaï followed their vertiginous watery reflections, as shadowy as a dream. This scene was so breathtaking and memorable that Brassaï referred to the two gibbons, Yoyo and Marie, as his stars.

To some, it might seem odd that Brassaï would make one film and, despite its considerable success, not make another. But Roger Grenier observed, "Whatever Brassaï wanted to do really impassioned him. He was in this way a 'true artist.' For example, he collected stamps with sputniks on them — and very seriously. The various passions he had would come and go often. At one point he would make a film, at another, it would be to construct a silhouette theater."[448] Elsewhere, Grenier observed, if Brassaï "decided to become an embalmer or a member of parliament, that would hardly surprise me. He is always in an alert state, always ready to change and adapt, always searching for new 'avenues' of expression."[449] This all-embracing passion and ability to apply himself to new tasks was very much like Brassaï's father, as Brassaï described the senior Halász in the Brassaï monograph published by Éditions Neuf. Additionally, Brassaï had wanted to prove to himself that he could make a film. That done, there was a long list of other challenges to address.

France, The Riviera, and Abroad

"In the 1940's and 50's," the editor Carlo Rim remembered, "Brassaï became very close to being an official photographer. Everybody knew him. It was his glorious period."[450] He worked primarily for two magazines while selling individual articles to many other publications. He was under contract to Harper's Bazaar, edited by Carmel Snow. Having maintained his friendship and professional respect for Tériade, he also worked steadily for Verve. Both editors let him define and refine his stories, and to select the pictures submitted, to the extent that, in picking a section heading for these pictures in his 1963 retrospective at the Bibliothèque Nationale, Brassaï chose "A Clé des champs." Eschewing the literal meaning, "a key to the fields," he intended an alternative meaning, "given one's freedom." That is the context in which the pictures were made. He and Mrs. Snow met twice a year at a fine Parisian restaurant to discuss the articles for the next six months. Between 1945 and 1960, Brassaï's photographs were published in more than seventy Harper's Bazaar articles, many of which he wrote. They were divided almost evenly between articles on artists, musicians, dancers, and theatrical personalities (see "Portraits," above), and stories about a place or an event. In the late forties and early fifties, Brassaï produced articles primarily on Paris and the southern regions of France — the Midi, Provence, and the Riviera. Later, he traveled throughout southern Europe and to Turkey, Brazil, and the United States.

As we have seen, Brassaï had an intimate relationship with Paris. Day by day, evening after evening, for forty years he systematically explored the city with the leisure of a longtime lover. What did he photograph when working for only a few weeks in a different city or region? He made the same inquiries, and with the same thorough preparation. He asked, "What is most characteristic? Particularly, what characteristics have been associated with this place for centuries?" Typically he focused on pageantry and spectacle and on physical establishments — buildings, statues, terrain — that preserve and project the locale's specific identify. In the Hospice de Beaune, he photographed the nuns in high, starched white coifs serving patients in rooms decorated with fine murals (catalogue number 131); in Bayonne, the festival for the running of the bulls (catalogue number 132); in Les Baux, the traditional offering of the lamb at the Christmas Eve Mass (catalogue number 126); in Seville, the parade of the floats and statues during Holy Week (catalogue number 141); in Rio de Janeiro, a voodoo ceremony (catalogue number 143); and in Turkey, the evening prayers in Suleimaniye Mosque. Occasionally, to make a coherent picture, Brassaï approached a subject knowing that the image he had in mind depended on stopping one aspect of the action at a precise moment. For instance, in his photograph of the Bayonne festival, the figure with outstretched arms became the picture's focus, while the men chasing the bull swirl around that figure. In New Orleans, he waited by a statue of Napoleon until a "Cajun mama" passed by and photographed her just as her skirt snapped back to mirror the fold in Napoleon's jacket (catalogue number 136). Often, the actions that he photographed were basic to the daily rhythms of a locale: an elderly couple at their evening dinner (catalogue number 133), the irregular patchwork of planted fields (catalogue number 134), and two men, one of whom looks remarkably like Picasso in profile, talking on a Spanish street (catalogue number 140).

Frequently, the subject was inert, and it was Brassaï's challenge to perceive its potential as part of the cohesive visual whole, as in the view from Chartres onto the village below (catalogue number 130) or in the photograph of the fish nets drying in the Mediterranean sun in Cannes. Sometimes Brassaï's photographs call to mind other works of art. The Bayonne festival evokes Goya's tapestries, and the shepherd with his lamb at Les Baux nods to El Greco's paintings. Brassaï was not the first, nor the last, photographer to seek out many of these subjects, but he often achieved the most memorable results. Others photographed the annual Christmas Eve ceremony at Saint-Vincent-des Baux, the twelfth-century church. Kertész photographed the medieval hospital at Beaune in 1929, but even Kertész's great champion Roméo Martinez, the editor of Camera magazine, considered Brassaï's image of the nun in a pharmacy one of his greatest pictures, calling it "trés touchant" (very moving).[451]

In 1950, Brassaï made the first of three trips to Spain, where — true to his intense love of three-dimensional objects — he became fascinated with the Festival of the Madonna of Merced, a parade of giant statues in Barcelona.[452] In Seville, he photographed both the festival of Holy Week and the Feria, which followed. During Holy Week, statues on floats and hooded members of religious orders paraded in the streets. For the Feria, women and men donned traditional Spanish costumes and paraded on horseback and in carriages.[453] Typically, Brassaï was drawn to the statues and costumes that best typified the events. He also sought out universally "human" moments, such as that of the men resting from carrying a float (catalogue number 141). His survey includes what one would expect to find in Spain — flamenco dancers, bullfights, and Baroque churches — but he excelled at capturing telling gestures — men's proud stances, anxious girls being fitted in their costumes, and, always, children dashing in and out of the crowds. These photographs were assembled for the book Séville en fête (Fiesta in Seville), which was published in three languages with substantial text and notes by Brassaï, as well as a brief preface by Henri de Montherlant and text by Dominique Aubier. Brassaï also traveled to England and Scotland in 1949, Turkey in 1953, Italy in 1954, Ireland in 1957, Brazil in 1959, and Greece in 1962, but the United States was the only country besides France that seemed to have inspired at least discussions of a book.[454]

On assignment for Holiday magazine, Brassaï came to the States for the first time in 1957. Among other notable events on the trip, he borrowed a Leica from Bita Dobo's father and began to shoot color film with it. "I have always opposed color in photography," he told Peter Pollack, "but at the same time I discovered America, I discovered color."[455] He and his wife, Gilberte, stayed almost three months, visiting New York, Louisiana, and Chicago. In New York City, the emblematic sites and activities that attracted Brassaï included Grand Central Terminal (catalogue number 138), the Brooklyn Bridge, Times Square, Yankee Stadium, and the crowds watching the Easter Parade on Fifth Avenue (catalogue number 137). In Louisiana, he told Frank Dobo that most of what remained of New Orleans's French tradition was artificial, except for the lingerie shops and nightclubs of the French Quarter. Brassaï photographed Napoleon's death mask as well as the statue of Napoleon in the French Quarter. He also sought out Louisiana's French-speaking heritage in the state's fishing communities. Peter Pollack wrote to Helmut Gernsheim that Brassaï "was out in the bayous of Louisiana talking with the Cajuns in their patois, and doing pictures of them as well."[456] Just as she had done when Brassaï photographed graffiti in remote corners of Paris, Gilberte Brassaï drove him to the outlying areas of Louisiana. The Brassaïs also visited Pollack in Chicago, where Brassaï photographed the horse races for Sports Illustrated. They visited the United States four more times, but Brassaï did not add significantly to his American images.[457]

By the mid-sixties, reported Raymond Grosset, the director of Rapho Guillemette Photos agency, the style of editorial photography had changed and new photographers began to secure the jobs Brassaï once could have expected.[458] But, by then, Brassaï had already directed his energies to yet other endeavors.

Books by Brassaï

The photographer George Krause once commented that an aspect of being an older photographer is that "the mind is more subtle, but the knees are gone."[459] Declining health affects everyone as he or she ages, but it is especially inhibiting in professions as physically demanding as photography. Brassaï has variously dated the moment when he ceased to photograph as 1962, when Carmel Snow died, and as 1963, when his retrospective at the Bibliothèque Nationale "declared him dead."[460] Actually, Carmel Snow retired as editor of Harper's Bazaar in 1957 and Brodovitch retired as its art director in 1958. After their departures, Brassaï created only three more stories for Harper's Bazaar. Good storytellers are inclined to find a clear and reasonable moment when a story veers, but the cessation of Brassaï's photographic career was, for many reasons, more gradual. A primary change in his life was his marriage in 1948 to Gilberte-Mercédès Boyer, a beautiful young French woman and watercolorist from Pau, in the southwestern region of France (figure 17). They soon purchased a home in the ancient hill town of Eze, between Nice and Monte Carlo, where they would spend an increasing amount of time each year. As his letters to his parents reveal, Brassaï had been drawn to southern France since he first immigrated to France, but Eze particularly appealed to him because his beloved Nietzsche spent part of his last years in the same region of the Riviera. Brassaï was one of many artists of his generation who, late in his life, found it more productive to remove himself from Paris. Far away from the distractions of lifelong friends and other pleasurable obligations, he could concentrate on long lists of projects he was determined to accomplish in his remaining years. Moving to Eze, and later Beaulieu, accomplished physically what Brassaï had done before for shorter periods. Kertész was one of many to comment on Brassaï's ability to "disappear for three or four weeks at a time, giving no explanation for his mysterious whereabouts."[461] To this statement, Brassaï might have added a quote by Proust, who wrote Léon Daudet, "I am the man who withdrew himself from the world in order to better relive it."[462]

figure 17 Gilberte Brassaï, 1945. 2 1/4 x 1 1/4 inches (5.7 x 3.2 cm). The Museum of Fine Arts, Houston, gift of Gilberte Brassaï, 95.184.1. © Gilberte Brassaï

After World War II, Brassaï spent more time developing his other talents — drawing, sculpture, and, especially, writing. Every book published by Brassaï after the war includes his own text, but does not always feature his photographs. However, he had planned to publish more books of photographs than he did. Asked if the impermanence of magazines bothered him, Brassaï responded, "Yes, but I find that if one can do interesting things, and if you keep the copyright to the photographs, you can make a book out of those photographs afterwards."[463] In interviews, he mentions potential books on society and the United States, and another book on Paris at night; perhaps he would have returned to the books that he mentioned to his family in the thirties: on cacti, on nudes, and on photographic sequences such as A Man Dies in the Street. His first postwar projects were Trente dessins (1946) and Les Sculptures de Picasso (1949). In 1949, he also published Camera in Paris and Histoire de Marie (Marie's Story). The former is a conventional book surveying a photographer at midcareer, except that the foreword is written by Brassaï, rather than by an eminent scholar, and the texts that follow are excerpts from prior articles about Brassaï and his photographs. The selection of photographs is strong, but the book's layout is underwhelming; the juxtapositions selected for double-page spreads seem too obvious — fat butcher/fat prostitute; two policemen and a prostitute/two dancers and a patron; Arc de Triomphe in the distance/Arc de Triomphe in the foreground.

Histoire de Marie is a far more original and interesting publication. Here, said Brassaï, the eye gave its usual place to the ear.[464] He had always been a listener who made notes on what he heard and overheard. As a young student he had written a poem that employed his teachers' remarks in a wicked caricature.[465] He also created a spoof, The Newsless Newspaper, for which the "Responsible and Chief Editor" was "The One Gyula," and the "Irresponsible Editor" was "The Other Gyula." According to Eva Landvay, a Romanian writer and a friend of Brassaï's nephew, the people listed as reporters in these spurious articles and witty asides were his schoolmates and teachers, but Brassaï was clearly the newspaper's sole author.[466] His retentive memory was also employed when he gave a public recital to raise money for his trip to Berlin. According to his father, "My son recited poems of the following authors: Verhaeren, Rimbaud, Wilde, Maeterlinck, Baudelaire, Verlaine, Strindberg, Ady, Dehmel, D'Annunzio, Walt Whitman, Rilke, Ibsen, Arany János, Kosztolányi. He had a great success, and was applauded and congratulated."[467] Thus, we know that from an early age Brassaï was an avid reader of literature and retained key passages, but also that he had an ear for vernacular speech and took pleasure in remembering the most humorous and revealing quotes. This talent fascinated his friends. Robert Doisneau told Maria Morris Hambourg, "Brassaï had perfect recall, absolutely exact."[468] Doisneau recalled one particular evening with Brassaï and Yosuf Karsh when Brassaï "told stories and kept us in stitches until way past midnight."

Brassaï's postwar books rely heavily on his prodigious memory and his acute ear, as evidenced in the books on Picasso and Miller, the conversations recounted in The Artists of My Life, and the beggars' and gangsters' slang in Secret Paris. In Histoire, Brassaï relates the monologue of a taxi driver on Christmas night, and the conversations of his cleaning lady, Marie Mallarmé.[469] Brassaï felt no obligation to literally transcribe their conversations. In fact, the "Marie" in the book may have been a compilation; Frank Dobo thought that she was largely modeled on a maid at the Hôtel des Terrasses. For Brassaï, "The meaning of art is not authenticity, but the expression of authenticity."[470] Henry Miller felt that Brassaï achieved that goal, and in Miller's introduction to Histoire, he praised the "authentic flavor" of Brassaï's story. He concluded that the book also had "the rare virtue of quintessence." "In these few pages," Miller wrote, "Brassaï has squeezed all that is worth telling of the life of a nobody. . . . Each page is a complete chapter from the life story of the dreary drudge whom we shall have with us always. . . . What truth! What revelations!"[471] Miller also wrote Dobo that the book would make a wonderful short movie.[472]

Marie is a simple person who utters hilarious misquotes. Brassaï draws the parallel between his Marie and Proust's Françoise/Céleste. Both Marie and Céleste express themselves very well, not simply in spirit, but in simple spirit. "Born of the people, from a country roughness," Brassaï observed, "they still carry around on their soles the earth of their provinces' corner, keep its nostalgia, breathe from it the air of the Paris tarmac."[473] Brassaï's fascination with Marie derived from the originality of her thoughts, which did not come from books and newspapers, "like Mr. Everybody Else." For Brassaï, this originality was akin to the primordial quality of graffiti or anything else that embodied the intensity of a primitive or of a child. Brassaï then cited Proust's quote that his maid is "more naturally similar to the nature of the elite than most educated people."[474] In 1977, the two conversations in Histoire were included with other "conversations" in Paroles en l'air. Brassaï added "Le Bistro-Tabac" (a conversation overheard in a cafe), "Le Soliloque" (the closing-time ramblings of a derelict in a bar), and two more sections on Marie. Friends and reviewers remembered the laughter provoked when they first read about Marie's misadventures, and used this memory to describe Brassaï as a hilarious raconteur.

Brassaï's friendship with and fondness for the work of Jacques Prévert may have encouraged Brassaï to write and publish the conversations in Histoire. Prévert's film scripts were famous for their transformation of ordinary, banal speech into lyrical street poetry, and for reinvesting clichés with emotional truth. "His characters," wrote film historian Philip Kemp, "speak, not perhaps as the ordinary people of Paris ever do speak, but how they might wish to at their most eloquent. Through subtleties of rhythm, wordplay, and repetition, commonplaces acquire unsuspected resonance."[475] Prévert also published a book titled Paroles, which reproduced one of Brassaï's photographs of graffiti on the cover.[476] Available in a clandestine edition in 1943 and officially published in 1945, Paroles contains two hundred poems, which one critic called "a curious case in the oral tradition."[477] But unlike Brassaï's work, Prévert's poems are not one conversation, nor are they always cast in the voice of a protagonist. Sometimes, Prévert sets the scene with an omnipresent narrator. And his works are closer to being traditional poems with their use of alliteration, some writing in rhyme, and free association of sounds. Prévert does not share Brassaï's obligation to "reality," and the situations and conversations portrayed are at times more overtly invented.

While Brassaï's career as a magazine photographer declined, his status as a fine photographer grew steadily, and he was asked frequently to write about other photographers, and to provide retrospective portfolios of his early work. Another important change in his career were increased sales of his photographs in galleries and the growing recognition of photography by art museums and art book publishers. First in the United States, and later throughout the world, Brassaï exhibited his works in five media — photography, drawing, sculpture, writing, and tapestry — in galleries and museums, often in conjunction with the publication of one of his books. The sale and exhibition of "photographs as fine art" accelerated as magazine opportunities declined. Many of the French magazines for which Brassaï had first worked did not survive the war. Others closed in the following decades. Picture Post died in 1950, Verve in 1960, Coronet in 1961, and Life in 1972. In the seventies, the prices of Brassaï's prints were still low; at the Lunn Gallery in Washington, D. C., Brassaï sold his photographs for $250 each. But the combination of print and book sales compensated for his loss of income from editorial magazines. And, increasingly, magazine articles were about Brassaï. Of nineteen published interviews, only two ran before World War II. Brassaï was also the subject of several radio and television programs and received numerous prestigious awards, including the Chevalier de Legion d'Honneur (Knight of the French Legion of Honor) in 1976, and the first National Grand Prize for Photography in Paris in 1978. He found the attention both gratifying and exhausting, and once accused an interviewer of hounding him. On his eightieth birthday Brassaï told Andor Horváth, "All this honor is a nightmare."[478]

The Influence of Brassaï

It is difficult to ascribe influence in the fine arts. Most artists do not like to discuss the source of their inspirations, especially not among artists of the same or slightly older generations. There are few published accounts of Brassaï's influence. Certain friendships and mutual exchanges have been discussed above. One striking example of influence is a note in the sculptor Henry Moore's journal in 1937 that directs him to "try some drawings in full solidity — see torso photos of Brassaï."[479] Both the American photographer Louis Stettner and the Hungarian photographer János Reismann asked Brassaï to contribute introductions to publications of their work, implying deep respect, if not direct influence. Similarly, Diane Arbus reportedly felt a kinship with Brassaï, although initially she wasn't quite sure why.[480] Her biographer, Patricia Bosworth, suggested that it was Brassaï's and Arbus's mutual desire to photograph "the forbidden."[481] Later, Arbus stated clearly why she loved Brassaï's Paris by Night and Secret Paris photographs. "Brassaï taught me something about obscurity," she told a class, "because for years I've been hipped on clarity. Lately it's been striking me how I really love what I can't see in a photograph. In Brassaï, in Bill Brandt, there is the element of actual physical darkness and it's very thrilling to see darkness again."[482] According to historian Sam Stephenson, W. Eugene Smith's night section in his Pittsburgh essay was influenced by Brassaï's night photographs of Paris,[483] and there was certainly mutual respect between Smith and Brassaï. In a 1974 interview, Brassaï said, "I like a lot of photographers, but especially Eugene Smith," and a print in the Museum of Fine Arts, Houston, of Exotic Garden, Monaco (c. 1945) (catalogue number 128), was a gift from Brassaï to Smith.[484]

Stettner, Reismann, Arbus, and Smith all worked in the tradition of documentary or magazine photography, although Arbus's statement about Brassaï's work admired the reverse of any documentary clarity. Modern-day photographers now look to Brassaï for reasons that depart completely from those that inspired photographers of an earlier generation. The Canadian photographer Jeff Wall says he has always been interested in Brassaï's work because Brassaï "worked with fluidity on the question of what photography could be."[485] Because the question of plausibility has always been important to Wall, he is interested in the way that Brassaï, with very rudimentary equipment, "achieved scenes that would have been missed if he had tried to 'capture' them with no preparation. We can't be sure, ever, where a photograph was fabricated, but 'plausible realism' means a photograph that looks as though it was taken without preparation. That is cinematic and he achieved it."

Brassaï's images have also inspired other photographers' works in fashion and advertising. After Brassaï's photographs of Villa Orsini in Bomarzo appeared in Harper's Bazaar, Richard Avedon, also working for Harper's, photographed models in the monsters' mouths and sitting on their heads, while wearing the latest in sweater fashions. In 1986, the bistro Cafe Luxembourg in New York City ran an advertising campaign that "paid homage" to Brassaï. A representative from the advertising agency explained that after finding models of the right "decadent fleshiness," the women were directed to replicate the poses from Brassaï's Introductions at Suzy's, Paris (c. 1932) (catalogue number 42) and Lovers in a Small Cafe, Place d'Italie, Paris (c. 1932–33).[486] More recently, the painter played by Leonardo Di Caprio in the movie Titanic displayed a drawing that was notably close to Brassaï's photograph of "Bijou."

Ultimately, the question of Brassaï's influence is hard to answer precisely because he worked so assiduously to keep out of his pictures an easily recognizable form of himself and of his photographic style. There are no characteristic quirks, such as Garry Winogrand's reckless horizon lines, László Moholy-Nagy's passion for abstraction and visual play, or Richard Avedon's stark white backgrounds and ragged black borders. Brassaï's skewed humor and pleasure in the grotesque were distinctive, but hard to replicate, and not so unique as to be definitively attributed. Only one of his dominant subjects so lacked precedence that all subsequent essays on that subject might be traced back to him — his photographs of a city at night, particularly a city so rich with destinations for pleasure seekers. There were other subjects that he claimed thoroughly, such as carved graffiti and portraits of French artists in the thirties, but these subjects have not sparked the public imagination such that they and the name Brassaï are inextricably linked in the way that we have wedded Walker Evans and vernacular urban architecture, Dorothea Lange and migrant workers, Edward Weston and Point Lobos, and Robert Frank and the American road. Like Brassaï, all of these photographers have large bodies of diverse work, but are most prominently associated with a narrow segment. First known for his series Paris de nuit, today Brassaï is best known for that same series. But historians and critics still flounder on exactly where to place him in the history of photography and of art. Brassaï was more interested in the latter than the former, which interested him little.

Even the esteemed historian Beaumont Newhall was indecisive about where to situate Brassaï in the various editions of his History of Photography. Newhall kept changing the picture that represented Brassaï and shifting the location of Brassaï's work in the book's text. In the first and second editions, titled respectively Photography 1839–1937 (1937) and Photography: A Short Critical History (1938), Brassaï was mentioned in a broadly defined section titled "Contemporary Photography," which ranged from the cameraless abstractions of Christian Schad to news photographs. Brassaï's image of mountain climbers, The Glacier of Bosson (1936), was placed between works by American photographers using large-format view cameras and works by Europeans using miniature cameras, such as the Leica. Since Brassaï used neither camera and the text focuses on technical evolutions, his work is not discussed. The 1949 edition, The History of Photography from 1839 to the Present Day, reproduced a night view of Pont des Arts in the chapter "The Straight Approach." While Brassaï and Atget are the only Europeans illustrated in this chapter, Newhall again failed to discuss Brassaï's work. The picture's formal elements (receding bridges and lights) are Newhall's key to associating him in this chapter with Ansel Adams, Edward and Brett Weston, Paul Strand, and Charles Sheeler. Among Brassaï's contemporaries who also worked primarily for magazines, W. Eugene Smith was featured in the chapter "For the Printed Page"; Henri Cartier-Bresson and Bill Brandt were represented in "Instant Vision." In the 1964 edition of Newhall's book, Brassaï's photograph was moved into the "Instant Vision" chapter and his work was discussed in a paragraph inserted between text devoted to Brandt and Kertész (who is included in the history for the first time). Newhall chose still another illustration: the eccentric, bejeweled Bijou from the series Secret Paris.

To associate Brassaï's work with "instant vision," Newhall needed a photograph taken with a flash. But in the few sentences permitted, Newhall cites the broad range of Brassaï's photographic work, mentioning specifically those images that do not employ flash — Paris by Night, Graffiti, and "his massive documentation of fellow artists."[487] Finally, in the 1982 edition, although the text is unchanged, Newhall added Giant in the Park of Villa Orsini, Bomarzo, Italy (1952) (catalogue number 96), according Brassaï two illustrations. Newhall never considered Surrealism and its influences relevant to Brassaï's history. Neither does Helmut Gernsheim, who in his history of photography only discussed how Surrealist painting influenced English photographers such as Cecil Beaton.[488] But neither of these histories was published before the exhibition L'Amour fou. Only Newhall's last edition was published after The Secret Paris of the 30s was issued, so the full extent of Brassaï's survey of the night world was unknown to the early historians.

In Looking at Photographs, John Szarkowski's entry on Brassaï was intuitively brilliant, but full of factual errors. Szarkowski mistakenly assigned the subjects of Secret Paris to Paris de nuit and credits Kertész with Brassaï's decision to become a photographer. Yet he characterized Brassaï's intense vision as being "as straightforward as a hammer," and described the Lovers' Quarrel, Bal des Quatre Saisons, Paris (1932) (catalogue number 34) with a poetic blend of speculation and attention to detail worthy of the picture's maker: "The nature of the misunderstanding between the couple in the picture is too serious and too private to speculate about. In any event it is not important whether their relationship was personal or commercial, or both. The photograph is about the bitter and desperate disappointment of private loss."[489] In Photography Until Now, Szarkowski included Paris de nuit among a "handful of books of extraordinary originality and influence" that would fit on a very short shelf.

Beyond the fact that we are still discovering unpublished works that will again shift our understanding of Brassaï's career, part of the difficulty Newhall and subsequent historians have in "placing" Brassaï stems from Brassaï's own ambivalence about the medium. The backbone of Newhall's history is the evolution of the technical process and how each change in photographic equipment led to new aesthetic practices. But Brassaï did not approach photography because he was fascinated with the process or the look of the photographic print. Brassaï cared only for what photography could allow him to do. That is why, having settled on equipment that suited him, he continued to use it well past its antiquation. As Andor Horváth has observed, "He did not become an artist as a photographer, but chose photography as an artist."[490] This statement also explains why he readily shifted from photography to drawing to sculpture to writing to film when he felt one particular medium was better suited to what he had to say. Brassaï does not fit easily into the history of photography in part because he never considered himself a photographer.

Whether one esteems the aspects of Brassaï's works that are Surrealist, documentary, or filmic, the status most widely in acceptance by all admirers is "poet with a camera."[491] The designation aptly conveys the way he constructed his images, element by element. His most consistent devotion was to the physical look of the world. He had a vision and a plan. He had things he wanted to say and looked for ways to say them. Although Brassaï abhorred the outward manifestations of many Modern photographs, such as extreme angles of perspective and proximity, abstraction, tonal reverses, negative and print manipulations, and, most of all, subjectivism, he may have been the supreme Modernist in his devotion to form. Therein lies the irony of his being appropriated by the aesthetics of informe. As with the Surrealists, I think he would have admired the intelligence of contemporary writers such as Rosalind Krauss without embracing their ideas. Brassaï would have understood that, ultimately, the tendency of successive generations to discover current issues in his work is a tribute and signifies that he succeeded in making images that are timeless.

Brassaï is best known for photographing what was secret and infamous. He admired equally what was esteemed, public, and permanent. He sought neither to judge nor to change, but to fathom the living arrangements of the world.

Notes

Frequently cited works are identified by the following abbreviations:

AOML Brassaï: The Artists of My Life
AWT Anne Wilkes Tucker
CIP Camera in Paris
HM:PY Henry Miller: The Paris Years
LTMP Letters to My Parents
MMH Maria Morris Hambourg
Neuf Brassaï, Éditions Neuf
PdN Paris de nuit
Picasso & Co. Picasso and Company
Proust Marcel Proust sous l'emprise de la photographie
Secret Paris The Secret Paris of the 30s
Tàpies Brassaï: Del Surrealism al informalismo

For full details of the works listed above, see bibliography.

1 CIP.

2 CIP, p. 9.

3 Charles-Pierre Baudelaire (French, 1821–1867) originally published the essay in Le Figaro in 1863, the same year he published his essay on Eugène Delacroix. It was preceded by "The Salon of 1859: The Modern Public and Photography," in which he vehemently criticized the public's rush to accept photography as a fine art because it could copy nature. As Beaumont Newhall observed, "His essay is more a criticism of photographers than of photography" (On Photography: A Source Book of Photo History in Facsimile [Watkins Glen, New York: Century House, 1956], p. 104). Brassaï recognizes Baudelaire as "that great enemy of photography," but writes, "In his portrait of Constantin Guys, Baudelaire was in fact anticipating by a century the psychology and physiognomy of the chronicler of the modern age — the photographer." The essay by Baudelaire is published in The Painter of Modern Life and Other Essays by Charles Baudelaire, translated and edited by Jonathan Mayne (London: Phaidon Publishers/Greenwich, Connecticut: New York Graphic Society, 1964), pp. 5-40. For additional views by Brassaï on Baudelaire's views on photography, see Maurice Chapelan's interview with Brassaï, "Baudelaire avait raison: La Photographie n'est pas un art," in Le Figaro Littéraire (Paris) 234 (14 October 1950), p. 1, and Brassaï's article in response, "La photographie n'est pas un art?", in Le Figaro Littéraire (Paris) 235 (21 October 1950), p. 6. These articles led in turn to a symposium at the Société Française de Photographie et de Cinématographie on the topic "La Photographie est-elle un art?" on Thursday, 26 January 1951.

4 CIP, p. 12.

5 Rembrandt van Rijn (Dutch, 1606–1669), Francisco de Goya (Spanish, 1746–1828), Honoré Daumier (French, 1808–1879), Katsushika Hokusai (Japanese, 1760–1849), Edgar Degas (French, 1834–1917), and Henri de Toulouse-Lautrec (French, 1864–1901).

6 CIP, p. 14.

7 CIP, p. 11.

8 CIP, p. 16.

9 CIP, p. 17.

10 CIP, pp. 18-19.

11 The Turkish and Near Eastern rug merchants formed an especially thriving industry in Brassó. The Gothic Black Church (fourteenth century), which dominates the town's center, is filled with extraordinary rugs offered in thanks for safe trading missions, and this early education in rugs fueled Brassaï's lifelong interest in them.

12 Interview with Josefine and Alexander Wotsch by AWT, Brassó, Romania, July 1996.

13 According to his grandson Kálmán Halász, Gyula Halász, Sr.'s first trip to Paris in 1894 was as a student and a newspaper man. He was able to go because a friend with a ticket suddenly could not use it. Mr. Halász had no money, but survived for four months in Paris. One of his accomplishments was an interview with the academic history painter Mihály Munkácsy (Hungarian, 1844–1900), who lived in Paris but had just completed a major mural in Hungary's monumental new Parliament building. Thus the son's journalistic career is also an echo of his father's. Kálmán Halász, interview with AWT, Brassó, Romania, July 1996.

14 The third brother died in World War II.

15 "Souvenirs de mon enfance," in Neuf, unpg.

16 Gyula Halász, "Párizs varázsa" (The Fascination of Paris), in A századik év küszöbén. Emlékek (On the Threshold of the One-Hundredth Year. Memories) (Bucharest: Irodalmi Könyvkiadó [Literary press], 1967). Mostly, he admires figures from the seventeenth and eighteenth centuries, such as the authors Vicomte Francois René de Chateaubriand (1768–1848) and Voltaire (b. François Marie Arouet, 1694–1778), the encyclopedist Denis Diderot (1713–1784), and the dramatists Molière (b. Jean-Baptiste Poquelin, 1622–1673) and Jean Racine (1639–1699).

17 See Avis Berman's interview with Brassaï in this book (pp. 145-53) as well as "Souvenirs de mon enfance" (see note 15).

18 A századik év küszöbén (see note 16), p. 11.

19 For the importance of this relationship, see letters 1, 4, 9, 10, 11, 13, 31, 36, and 37 in LTMP. In letter 11 (23 October 1921, p. 28), Brassaï refers to "the years I lived with Máttis-Teutsch," but this could be a metaphorical reference. Máttis-Teutsch was away from Brassó for most of Brassaï's youth, studying in Budapest, Munich, and Paris between 1901 and 1908, and living in Budapest between 1912 and 1919. Exactly when Brassaï was the older painter's protégé is unknown. Neither Máttis-Teutsch's son nor Nicholas Éber, the primary scholar on the artist's work, was aware that there was any connection or influence.

20 Led by Károly Kernstok (1873–1940), the other members of "The Eight" (Nyolcak) were Róbert Berény (1887–1953), Béla Czóbel (1883–1976), Dezo Czigány (1883–1937), Odon Máfiffy (1878–1959), Dezso Orbán (1884–1986), Bertalan Pór (1880–1964), and Lajos Tihanyi (1885–1938). Originally called "The Seekers" (1909–11), they exhibited as "The Eight" from 1911 to 1913. Berény, Czóbel, Kernstok, Máfiffy, Orbán, and Pór studied painting at the Académie Julian in Paris before joining the group. Czóbel, Czigány, Orbán, Pór, and Tihanyi lived in Paris for periods of various lengths after World War I and, therefore, were in the same circle of Hungarian friends as Brassaï.

21 LTMP, letter 6, 21 May 1921, note 30, p. 252. This early interest in the ballet was sustained by Brassaï. In 1921 he wrote to his parents, asking that they send him the script of his first ballet. He reported that he had finished a new one that he intended to propose to a German company as well as to Bartók (LTMP, letter 6, p. 15). Neither of these early ballets was performed, and their content is unknown. After World War II, he designed the sets for two ballets. See bibliography.

22 Years later Brassaï would write to his father with delight that he saw Mihály Károlyi playing chess with an Armenian medical student at one table in Paris while "next to him the cousin of Queen Zita, a Bourbon-Parma princess who plays chess here [Café Petit Néapolitan] at night was playing with the youngest of her chauffeur sons." Károlyi led the government that overthrew the reign of Queen Zita and her husband, Charles IV of Hungary. Károlyi himself was overthrown a few months later. LTMP, letter 50, 12 July 1926, p. 155.

23 Andor Horváth, "Hallway to Parnassus," LTMP, p. 236.

24 Kálmán Halász, interview with AWT, Brassó, Romania, July 1996. In the father's memoirs, there is a longer account of Brassaï's near-fatal illness and of his father's efforts to free him.

25 For a vivid description of that period, see John Lukacs, Budapest 1900: A Historical Portrait of a City and its Culture (New York: Weidenfeld & Nicolson, 1988); Gyöngy Éri and Zsuzsa Jobbágyi, A Golden Age: Art and Society in Hungary 1896–1914 (London: Corvina/Barbican Art Gallery, 1889); and S. A. Mansbach, Standing in the Tempest: Painters of the Hungarian Avant-Garde 1908–1930 (Cambridge: MIT Press/Santa Barbara Museum of Art, 1991). How extraordinary was that period? Of the six Hungarians who have won a Nobel Prize, five were born in Hungary between 1875 and 1905. For a list of the famous Hungarian emigrants, including Brassaï, see Lukacs, p. 140.

26 More immigrants settled in France in the 1920s than in any other European country and, among photographers, the largest number of immigrants came from Hungary. In addition to Brassaï, the extraordinarily talented Hungarians included André Kertész (1894–1985), Rogi André (life-span dates unknown), Ergy Landau (1896–1967), Emeric Feher (1904–1966), Françoise Kollar (1904–1979), Nora Dumas (b. Nora Telkes de Kelenfold, 1890–1979), Lucien Aigner (b. 1901), Ylla (b. Kamilla Koffler, 1911–1955), Robert Capa (b. André Friedmann, 1913–1954), and Cornell Capa (b. Kornel Friedmann, 1918). For more detailed information, see Annie-Laure Wanaverbecq, "Les photographies étrangers dans la France," Histoire de l'Art 15 (1991), pp. 61-77. I am grateful to Mr. Csaba Nagy of Petöfi Irodalmi Múzeum (Literature Museum) for directing me to this article.

27 The family reports that they were entrusted to someone to bring to Brassaï in Paris, but never arrived. Kálmán Halász, interview with AWT, Brassó, Romania, July 1996.

28 Frank Dobo letter to Kim Sichel, 15 March 1984. Courtesy Dobo and Sichel. Frank Dobo (1908–1998) immigrated to Paris from Budapest in 1928 to work for Paul Winkler, director of Agence Littéraire Internationale, which later became Opera Mundi. He met Brassaï shortly after his arrival, either through Tihanyi or Kertész. He moved to the Hôtel des Terrasses in 1930, staying until he left for London in late 1934. He lived in London for one year, returned to Paris briefly, and then immigrated to New York in 1935. Dobo was also friends with Henry Miller and with Raymond Queneau, whom he introduced to Brassaï. The Dobo/Miller correspondence is in the Berg Collection of the New York Public Library.

29 LTMP, letter 9, 27 July 1921, p. 23.

30 See AOML, p. 68, and LTMP, letter 63, 27 July 1931, p. 184.

31 LTMP, letter 18, 6 March 1924, note 53, p. 254. Puni (1894–1956), Larionov (1881–1964), Goncharova (1881–1962).

32 "Mon ami Hans Reichel," in Hans Reichel 1892–1958 (Paris: Éditions Jeanne Bucher, 1962), pp. 39-50. Also published in Jardin des Arts (Paris) 122 (January 1965), pp. 2-9.

33 Goethe (1749–1832), Proust (1871–1922).

34 Spengler (1880–1936), Nietzsche (1844–1900).

35 Examples of numerous references to Goethe include the following: in Picasso and Company, he compares Picasso and Goethe, citing affinities in "their character, their nature, their loves, their lives" (p. 209), and even in their eyes (p. 23), as well as comparing Françoise Gilot to Goethe's Bettina Brentano (p. 101). In Henry Miller: The Paris Years, he calls upon Goethe's "supercharged creatures" to describe Miller's wife, June (p. 86), and revels in being able to convert Miller into one of Goethe's admirers (pp. 130-34). Regarding Brassaï's evolution from a romantic to a classical sensibility, see "Brassaï: Talking about Photography: An Interview with Tony Ray-Jones," Creative Camera, April 1970, p. 120.

36 "Introduction," LTMP, p. xii.

37 Le Minotaure 3-4, p. 105.

38 "An Interview with Tony Ray-Jones" (see note 35), p. 120.

39 Lecture by Charles Rado to the Photo League, New York City, 1948. Copy in AWT's Photo League files and in the Brassaï Archives, Paris. See also Radu Varia, "De Vorbà cu Brassaï despre fotografia cu arta," Seculol 20 (Bucharest), January 1969, p. 186; "An Interview with Tony Ray-Jones" (see note 35).

40 Miller (1891–1980).

41 "The Eye of Paris," The Wisdom of the Heart (Norfolk, Connecticut: New Directions Books, 1941), p. 177.

42 A portion of this introduction is republished in Tàpies, p. 153, but I have retranslated some words.

43 LTMP, letter 11, 23 October 1921, p. 29.

44 The chronology in Tàpies says January. His first letter to his parents was written in late February (LTMP, letter 17, 29 February 1924, p. 53), and in early March, Tihanyi wrote to their mutual friend Edmund Mihàlyi that Brassaï had been there a few weeks.

45 Brassaï's caricature of Henry Miller, originally published in the Paris edition of the Chicago Tribune in 1931, is reproduced in Alfred Perlès, My Friend Henry Miller (London: Neville Spearman, 1955), p. 53.

46 12 March 1924. In Petöfi Irodalmi Múzeum (Literature Museum) in Budapest.

47 Brassaï, introduction to A Portfolio of Ten Photographs (New York: Witkin-Berley Limited, 1973).

48 When he was actually working on Paris de nuit and Secret Paris, he worked with friends or his assistant/bodyguard.

49 Miller, letter to their mutual friend Frank Dobo, 1933, in the Dobo/Miller Archives of the Berg Collection, New York Public Library.

50 "Hallway to Parnassus," LTMP, p. 229.

51 Hugo (1802–1885), Balzac (1799–1850). In Les Misérables, Hugo wrote, "To wander is human; flâneur is Parisian." Cited in Priscilla Parkhurst Ferguson, "The Flâneur On and Off the Streets of Paris," Flâneur, edited by Keith Tester (London and New York: Routledge, 1994), p. 22.

52 Cited in Bruce Mazlish, "The Flâneur: From Spectator to Representation," Flâneur, p. 49.

53 Tim N. Gidal, Modern Photojournalism (New York: Collier, 1973). See also the two exhibition catalogues: Ute Eskildsen, Fotografie in deutschen Zeitschriften 1924–1933 (Stuttgart: Institut für Auslandsbeiziehungen, 1982), and John Fout, Sandra S. Phillips, Carol Squiers, and Susan Fillin Yeh, Picture Magazines before Life (Woodstock: Catskill Center for Photography, 1982).

54 John Fout, "The Berliner Illustrierte and Photojournalism in Germany, 1929–1935," Picture Magazines before Life (see note 53), p. 1.

55 His early addresses include 1924: Hôtel des Ecoles, rue Delambre, 14e; hotel, rue Dupuytren, 6e. 1925: Max's Hôtel, overlooking Montparnasse cemetery, 6e. 1926: Hôtel du Maine, 64, avenue du Maine, 14e. 1927: apartment on rue Servandoni near Saint-Sulpice, 6e. 1928: Hôtel des Terrasses, 74, rue de la Glacière, 13e. c. 1935: apartment on rue du Faubourg Saint-Jacques, 14e. (Information is from LTMP and from business cards in the collection of Susan Hertzig and Paul M. Hertzmann, San Francisco.) Brassaï was still living at the Hôtel des Terrasses when Miller's Tropic of Cancer was published in September 1934.

56 Madame Gilberte Robbe, the daughter of the hotel's owner, to MMH in Paris, 1985.

57 Zilzer is listed as a resident by Sandra Phillips, but Frank Dobo disagreed (Phillips, "André Kertész: The Years in Paris," André Kertész: Of Paris and New York [Chicago and New York: The Art Institute of Chicago and the Metropolitan Museum of Art, 1986], p. 28. Dobo to MMH, summer 1985).

58 Phillips (see note 57).

59 Dobo to AWT, December 1996.

60 My thanks to master-level player Bill Moore for introducing and explaining the roles of strategy and tactics in chess.

61 "Notes" in Neuf, unpg., and statement repeated in interview for Hungarian edition of Picasso and Company: Beszélgetések Picassóval (Budapest: Corvina, 1968). In the book version of the Hill and Cooper interview, Brassaï says that he had never held a camera until the age of thirty ("Brassaï," in Dialogue with Photography [New York: Farrar, Straus and Giroux, 1979], p. 35). Brassaï preferred to give written, rather than verbal, responses to interviews, and would even later rewrite answers to published interviews. For example, between the interview with Hill and Cooper published in Camera and the version published in the book, there are noticeable changes in some answers. In addition, some questions and answers appear in one and not the other ("Interview with Bernard [sic] Brassaï," Camera [Lucerne] [May 1975]).

62 Nancy Newhall, "Brassaï," in From Adams to Stieglitz: Pioneers of Modern Photography (New York: Aperture, 1989), p. 18.

63 LTMP, letter 30, 18 January 1925, p. 99.

64 LTMP, letter 31, 27 January 1925, p. 103.

65 Interview with AWT, New York City, December 1996. For a biography on Landau and other women photographers of this period, see Christian Bouqueret, Les Femmes Photographes de la Nouvelle Vision en France 1920–1940 (New Vision Female Photographers in France) (Paris: Éditions Marval, 1998), p. 133.

66 Since he distinguished between the two women and the French photographers, perhaps both women were Hungarian. Of the Hungarian women working as photographers in Paris, Nora Dumas and Ylla began their careers in Ergy Landau's studio. It could be Dumas, who began to photograph in 1928, but Ylla did not begin until 1933. Rogi André moved to Paris in 1925 and married André Kertész in 1929, but it is not known when she began to photograph. Later, Brassaï may have worked with the German photographer Germaine Krull, who immigrated to Paris in 1926. She told Christian Bouqueret that Brassaï had been her assistant for two years (Bouqueret, "Métal et Paris de nuit," Des Années folles aux années noires: La Nouvelle Vision photographique en France 1920–1940 [Paris: Éditions Marval, 1997], p. 153, and letter to AWT, 30 June 1998). If Brassaï and Krull ever worked together, neither was sufficiently impressed with the arrangement to ever disclose it in subsequent interviews or writings.

Krull doesn't mention Brassaï in her otherwise detailed memoirs (Kim Sichel to AWT, 2 September 1998, citing Krull's unpublished memoirs, "Click entre deux guerres," located in the Germaine Krull Archive, Museum Folkwang, Essen). Brassaï never discusses Krull or her work, except in an interview published in Culture et Communication, in which he discounts her work, and that of Kertész and Man Ray, as having been influenced by the films of Marcel Carné (France Béquette, "Rencontre avec Brassaï," Culture et Communication 27 [1 May 1980], p. 12). Nor have I located any articles written by Brassaï, illustrated with photographs by Krull.

67 LTMP, letter 41, 19 December 1925, p. 133.

68 Photograph in "Sitkamosi," Vu 60 (8 May 1929).

69 Peter Pollack, "Brassaï's Probing Vision," in The Picture History of Photography: From the Earliest Beginnings to the Present Day (New York: Harry N. Abrams, 1958), p. 405.

70 LTMP, letter 19, 17 March 1924, p. 61.

71 Interview for Hungarian edition of Picasso and Company: Beszélgetések Picassóval (see note 61).

72 Paul Hill and Tom Cooper, "Interview: Bernard [sic] Brassaï" (see note 61), p. 37. Others say that film director Alexander Korda bought a fine camera for Brassaï, but this could not have been his first, because Brassaï began to work for Korda after Paris de nuit was published.

73 See p. 149 in this book.

74 Dobo to MMH, New York, 18 March 1985, and Roszi Medina to MMH, Berlin, 1985.

75 Brassaï told the Romanian art critic Radu Varia that he purchased his first camera on credit ("De Vorbà cu Brassaï despre fotografia cu arta" [see note 39], p. 179). Brassaï also wrote to his parents that he could not pay the bills of exchange he had signed for the camera (LTMP, letter 62, 24 January 1931, p. 182). By 1930, he reported to his parents that he had been taking photographs for a few weeks (LTMP, letter 61, 11 March 1930, p. 181).

76 "Gyula Halász, alias Brassaï, was with me. I gave him a crash course on night photography: what to do, how to do it, and how long the exposures had to be. Later, he started to copy my style in night photography and that, more or less, was the type of work he did for the rest of his life." "On Reading," Dialogues with Kertész 1978–1985, Bela Ugrin, transcripts compiled and edited by Manuela Caravageli Ugrin, © 1985, p. 20. Located at the Getty Research Institute, Research Library, 920024.

77 Camera editor Roméo Martinez said that Kertész was offered the book first, but refused because the conditions were not what he wanted (Interview with MMH, 14 February 1985).

78 Bela Ugrin transcripts (see note 76).

79 Brassaï sent Kertész signed copies of both Histoire de Marie (1949) and the catalogue for his retrospective at the Bibliothèque Nationale (1963). The former is signed, "Pour mon vieil ami André Kertész son vieil ami, Brassaï (For my old friend, André Kertész, his old friend, Brassaï).

80 "My friend André Kertész," Camera (April 1963), p. 7.

81 Interview for Beszélgetések Picassóval (see note 61), as quoted in "Hallway to Parnassus," LTMP, p. 231.

82 "Métal et Paris de nuit," in Des Années folles aux années noires: La Nouvelle Vision photographique en France 1920–1940 (see note 66), p. 153.

83 HM:PY, p. 7.

84 Salomon (German, 1886–1944), Man (German, b. Hans Baumann, 1893), Sudek (Czech, 1896–1976).

85 Colin Westerbeck and Joel Meyerowitz, Bystander: A History of Street Photography (Boston: Bulfinch Press/Little Brown and Company, 1994), p. 184. Brandt (English, b. German, 1904–1983).

86 Bovis (French, b. 1904), Abbott (American, 1898–1991), Stieglitz (American, 1864–1946).

87 Caption for plate 2, PdN.

88 Foreword, Paris by Night (New York: Pantheon Books, 1987), unpg.

89 Caption for plate 1, PdN.

90 The editor who introduced Brassaï to Peignot has been identified variously as Vogel, the owner and an editor of Vu; Carlo Rim, the chief editor of Vu; and Florent Fels, editor of Voilà. Brassaï cited Vogel in a letter to his parents soon after he and Peignot met to discuss the pictures (LTMP, letter 65, 5 November 1931, p. 187). In Neuf, Brassaï said that it was Rim, which Rim confirmed in a 1985 interview with MMH.

91 LTMP, letter 65, p. 188.

92 LTMP, letter 67, 28 March 1932, p. 191.

93 LTMP, letter 68, 1 April 1932, p. 193.

94 The loss of these negatives to his use meant that prints from those sixty-four photographs are very rare. Fortunately for Brassaï, he had made similar versions of many of the images — Santé Prison, Bijou, Folies-Bergère, Place de la Concorde — that he subsequently published to replace the pictures for which he believed the negatives were lost.

95 Kim D. Sichel, Photographs of Paris, 1928–1934: Brassaï, André Kertész, Germaine Krull and Man Ray, University Microfilms International, p. 176, fn. 8.

96 LTMP, letter 67, 28 March 1932, p. 191.

97 "Night Light: Brassaï and Weegee," Artforum 15, no. 4 (October 1976), p. 35.

98 Sichel (see note 95), p. 182.

99 Foreword, Paris by Night (see note 88).

100 Emile Henriot, "Photos de Paris," Le Temps (Paris), 30 January 1933. Quoted in Maria Giovanna Eisner, "Brassaï," Minicam Photography (Cincinnati) (7–8 April 1944), p. 24

101 "Brassaï Makes Photo Record of Nocturnal Paris," Chicago Tribune (Paris edition), 13 March 1933, p. 2.

102 Another indication of the book's popularity and influence are the photographers who sought to imitate the pictures. In Japan, a private collector owns a group of anonymous photographs indicating that the person who originally made them first photographed the pages in Paris de nuit, and then tried to find those same locations in Paris. Dating the photographs by studying the cars and clothing, the pictures appear to have been made before World War II. Since they were found in a Japanese flea market, one might assume that they were made by a Japanese photographer.

103 Jean Vétheuil, "La Ville photogénique," Photo-Ciné-Graphie 21 (November 1934), p. 2.

104 Jacques Guenne, "La Photographie vivante: Les Dix," Art Vivant, March 1936, p. 37: "qui découvre dans l'ombre et dans la pluie les éclats de notre vie trépidante."

105 "Paris by Night," Lilliput 3, no. 2 (August 1938), pp. 147-56. "Paris by Night," Picture Post 2, no. 3 (21 January 1939), pp. 20-27. "Talking Pictures," Coronet, December 1937, pp. 119-27. "Night Workers," Coronet, September 1938, pp. 147- 52. The Picture Post introduction mistakenly proclaims that "Brassaï is now on the staff of Picture Post — the only paper for which he would leave his beloved Paris." That these articles ran four and five years after the publication of the book illustrates the timeless nature of the pictures.

106 Zdenka Watterson, "Der grosse Photo-Reporter von Paris: Ein Besuch im Atelier Brassaï," Prager Presse (Prague), 21 August 1932, p. 6.

107 Librairie-Galerie de la Plume d'Or, Paris, 15 December 1931 – 15 January 1932, and Julien Levy Gallery, 20 February – 11 March 1932. Brassaï exhibited at Levy's as Halász, not Brassaï (Anouncement in the Beaumont and Nancy Newhall Papers, the Getty Research Institute, Research Library, 920060). Brassaï claimed this was the first exhibition of his work and that it contained close-ups of objects (Tom Marotta, "Brassaï: An Interview," Lens [New York] 2:7 [September–October 1977], p. 14). In letter 68, 1 April 1932, Brassaï wrote that the dates of the Levy exhibition were 15 March to 15 April; February to March dates are on the exhibition announcement in the Beaumont and Nancy Newhall Papers, the Getty Research Institute, Research Library, 920060. The exhibition announcement listed the participating photographers as "Peterhans, Man Ray, Miller, Henri, Lerski, Sougez, Tabard, Halász, Umbo, Bing, Lotar, Parry, Kertész, Moholy-Nagy, and Nerllinger."

108 The German edition, published in 1979 by Schirmer/Mosel Verlag, was issued without Brassaï's permission.

109 Sichel (see note 95), p. 189.

110 Stendhal (b. Marie-Henri Beyle, French, 1783–1842), Fyodor Mikhailovich Dostoevsky (Russian, 1821–1881), and Pablo Picasso (Spanish, 1881–1973).

111 Most of Brassaï's contemporaries photographed clochards, night clubs, dance halls, circuses, and street fairs. For instance, the magazine Vu published articles on the nightclub Le bal Nègre in 1928 ("Chez les nègres," Vu 2 [28 March 1928], p. 52) and Germaine Krull's photo-essay on Bal Tabarin in 1930 (Text by Michel Georges-Michel, "Tabarin," Vu 94 [1 January 1930], pp. 10-11). Robert Doisneau also photographed the street-fair dancer "Wanda." Ilse Bing photographed at the Moulin Rouge. André Kertész recorded the working-class dance halls.

112 Poet and novelist Pierre MacOrlan was sympathetic to photography and responsible for some of the most provocative criticism of photography written in France during the late 1920s and early 1930s. Besides numerous articles, he wrote introductions to books by Germaine Krull, Eugène Atget, and André Kertész. Brassaï would have to wait until 1953 to have an article on his work by MacOrlan, who would have been extremely apt for the Secret Paris series because, according to historian Sandra Phillips, "MacOrlan chose the working class and the lower levels of society as subjects for his somewhat grotesque, parablelike stories and poems. He was also interested in outsiders: pirates, vagabonds, and underworld characters . . . MacOrlan was interested in the way photographs can disturb and dislocate, in their power to suggest the frightening or mysterious" (see pp. 36-37 in Phillips, note 57).

113 Kiki (b. Alice Ernestine Prin, 1901–1953). See chapter on Kiki in AOML; see also Billy Klüver and Julie Martin, Kiki's Paris: Artists and Lovers, 1900–1930 (New York: Harry N. Abrams, Inc., 1989), p. 126.

114 Tzara (1896–1963), Man Ray (1890–1976).

115 Café du Dôme and La Rotonde were long established as being sympathetic to artists. Le Select opened in January 1925 and La Coupole in 1927. Le Select was the first café to stay open all night. At the time it opened, Brassaï was living above the café and was forced to move shortly thereafter.

116 HM:PY, pp. 3 and 22.

117 Daria Gamsaragan to MMH, summer 1985.

118 Gassmann to AWT, September 1996.

119 See his chapter "House of Illusion" in Secret Paris.

120 Creative Photography: Aesthetic Trends 1839–1960 (Boston: Boston Book and Art Shop, 1962), p. 233.

121 Tom Marotta and Jean-Claude Gautrand, "Brassaï: A Talk with the Great French Master," Lens (see note 107), p. 10.

122 Many photographers used magnesium flash; Kertész made many pictures with magnesium flash, including Bal Musette (1926) and Ernest (1931) (André Kertész: Sixty Years of Photography, edited by Nicolas Ducrot [New York: Penguin Books, 1978], pp. 107 and 113). But Brassaï may have used magnesium longer than other photographers, because he liked the quality of light. He was still using it during World War II when photographing Picasso's sculpture (Picasso & Co., p. 53).

123 He acquired this nickname when he photographed Picasso's sculpture during World War II (Picasso & Co., p. 53).

124 Alexandre Trauner (1906–1993) to MMH, 1985.

125 Among those who have said they assisted Brassaï are Pierre Gassmann and Alexandre Trauner.

126 George Hughes, "Brassaï Talks to George Hughes," Amateur Photography (London) 138:2 (18 June 1969), p. 12.

127 Colin Westerbeck and Joel Meyerowitz, Bystander: A History of Street Photography (Boston: Bulfinch Press/Little Brown and Company, 1994), p. 339.

128 Gassmann to AWT, September 1996.

129 Alexandre Trauner to MMH, 1985.

130 AOML, p. 170.

131 See Secret Paris, chapter titled "Lovers." According to both Frank Dobo and Gilberte Robbe, the latter of whom is the daughter of the hotel's owner, the man is Kiss. The place is the bistro on the ground floor of the Hôtel des Terrasses (Interviews with MMH, New York and Paris, 1985). It is therefore on the corner of rue de la Glacière and Boulevard Saint-Jacques, about five blocks from the Place d'Italie, which in common discussion was a neighborhood designation as well as a place. The reversed image is reproduced as plate 246 in Sarah Greenough, Joel Snyder, David Travis, and Colin Westerbeck, On the Art of Fixing a Shadow: One Hundred and Fifty Years of Photography (Boston, Washington, D. C., and Chicago: Little Brown and Company, the National Gallery of Art, and the Art Institute of Chicago, 1989), p. 302.

132 Both images including men were published in Voluptés de Paris (unpg.). The woman was published in Camera in Paris, p. 78.

133 Dobo interview with AWT, December 1996.

134 Both the collage and the photograph are reproduced in Tàpies, cover and p. 13.

135 Interview with MMH, New York, 18 March 1985.

136 All reproduced in Secret Paris.

137 Fernand Pouey, "Un Pure," Paris-Magazine (April 1933), p. 212.

138 Dobo to AWT, New York, April 1997.

126

139 Among Mr. Demange's sources of research were articles in L'Aurore, Libération, and France-Soir. He is researching the Paris demimonde for a forthcoming book, Dictionnaire du Demimonde au XXe Siècle. I am grateful to Pierre Apraxine for calling this source to my attention.

140 "Introduction," Secret Paris.

141 Interview with MMH, Paris, 1985.

142 See LTMP: letters 69-76, 12 August–4 December 1932, pp. 195-208. Alfred Stieglitz considered offering Brassaï an exhibition, but decided that his declining health did not permit it. (See Brassaï's article in Camera, January 1969.)

143 LTMP, letter 72, 18 September 1932, p. 201.

144 Interview with MMH, Paris, 30 June 1985. The job also allowed a return favor for a friend. He hired as his assistant Raymond Raynal, son of Maurice Raynal, the art critic for the paper L'Intransigeant. Brassaï writes about Raynal in both Picasso & Co. and AOML, citing particularly the artists and intellectuals he had first met at Raynal's frequent dinner parties.

145 For The Apartment in 1960. He also won three César awards.

146 The films were Drôle de drame (Bizarre, Bizarre, 1937, based on a novel by Storer Clouston); Le Quai des brumes (Port of Shadows, 1938, based on a novel by Pierre MacOrlan); Le Jour se lève (Daybreak, 1939, based on a novel by Jacques Viot); Les Visiteurs du soir (The Devil's Envoys, 1942); Les Enfants du paradis (Children of Paradise, 1945); and Les Portes de la nuit (Gates of the Night, 1946). The last three were with the Hungarian composer Joseph Kosma. Trauner and Carné also collaborated on Hôtel du Nord (1938).

147 Brassaï and Prévert worked together on the ballet Le Rendez-vous (1945). Two of Brassaï's photographs were used as the covers for Prévert's books Paroles (Words, 1943) and Spectacle (1959). Prévert wrote a poem for Brassaï's Trente dessins (Thirty Sketches) (Paris: Éditions Pierre Tisné, 1946).

148 According to the catalogue for his retrospective at the Bibliothèque Nationale (p. 18), Brassaï met Prévert in 1929, after he had been expelled from the Surrealist group. Film historian Edward Baron Turk noted that by then Prévert's preferred haunt was "Les Deux Magots, the cafe at Saint-Germain-des-Prés that served as the unofficial headquarters for heretical Communists, dissident Surrealists, and anticommercial filmmakers" (Child of Paradise: Marcel Carné and the Golden Age of French Cinema [Cambridge: Harvard University Press, 1989], p. 47, but based on a 1936 quote by Roger Leenhardt). In an interview with MMH (Paris, 1985), Roger Grenier identified Duhamel as one of Brassaï's friends.

149 It starred Yves Montand and Nathalie Nattier, and also featured Sylvia Bataille, wife of the Surrealist-ostracized theorist Georges Bataille.

150 See Picasso & Co., pp. 189-90, and Brassaï interview with France Béquette (see note 66). On page 12, he says that Carné consulted with him ten times, but also asserts that he influenced the earlier films.

151 Interview with MMH, Paris, 30 June 1985. See also Picasso & Co., p. 190, footnote.

152 Short: L'Affaire est dans le sac (It's in the bag, 1932); feature length: Claude Autant-Lara's (b. 1901) Ciboulette (Chives, 1933), Marc Allégret's (1900–1973) L'Hôtel du Libre échange (The Hotel of Free Trade, 1934), and Autant-Lara's My Partner Mr. Davis (1936).

153 It's possible, even probable, that Brassaï was reading film articles. For example, in 1932, both Brassaï and Carné wrote of the need to move movies out of the studios and "descend into the streets" — Carné in a published challenge to French cinema and Brassaï in a letter to his parents. (Carné's statement is quoted in Georges Sadoul, Dictionary of Film Makers, translated, edited, and updated by Peter Morris [Berkeley and Los Angeles: University of California Press, 1972], pp. 37-38; LTMP, letter 72, 18 September 1932, p. 201.) Did Brassaï read Carné's call for films to be more interested in Parisian working-class districts? Since he was then working on a film crew and was an insatiable reader, it is plausible that he did.

154 Art historian Marja Warehime has suggested that Brassaï's short apprenticeship with Korda "may in fact have influenced his shift from Paris de nuit, where exterior shots and street views predominated, to a 'Paris intime,' where his photographs focused on the interaction of people in cafés and bars, music halls and bals" (Brassaï: Images of Culture and the Surrealist Observer [Baton Rouge: Louisiana State University Press, 1996], p. 35). Although Brassaï took the majority of the pictures in Secret Paris between 1931 and 1932, before he joined Korda's crew, the important shift in the work from exterior to interior views could have been prompted by his love of the cinema, but, more likely, was necessitated simply by the new subject matter. In his introduction to Secret Paris, Brassaï says that having photographed Paris from the outside, "I wanted to know what went on inside behind the walls, behind the facades . . . I was eager to penetrate this other world, this fringe world" (Secret Paris, unpg.).

155 "Technique de la photographie de nuit," Arts et Métiers Graphiques (Paris) 33 (15 January 1933), reprinted in Tàpies, p. 91.

156 Zdenka Watterson, "Der grosse Photo-Reporter von Paris: Ein Besuch im Atelier Brassaï" (see note 106), p. 6.

157 Images of Culture and the Surrealist Observer (see note 154), p. 115.

158 Marco Misani, "Brassaï: 'we live in the age of photography'. . .," Printletter 8 (March/April 1977), p. 7.

159 "Paris-Magazine, my main source of income," LTMP, letter 78, 7 December 1933, p. 210.

160 He identified "presse particulier" as "les magazine 'légers'" (light or slightly improper), which became of capital importance for photography, not only for the photography of nudes but also for the reportage of spectacles and for photo-illustration. They were numerous and guaranteed lightness, charm, spirit, and love intrigue (see note 66), p. 159.

161 Des Années folles aux années noires (see note 66), p. 159.

162 The year 1934 has been cited as the publication date in recent books (Proust and Tàpies), but in October 1935, Brassaï wrote to his parents, "My second collection, Paris Intime, has been stuck with the publisher. He paid my fee but he has insufficient funds, or so he claims, to publish the book. I have now been given carte blanche to offer the book to any other publisher" (LTMP, letter 80, 17 October 1935, p. 213). It seems unlikely he would have written that if Voluptés had been published. There is further confusion on the number of halftone plates. See note 168.

163 Images of Culture (see note 154), p. 108.

164 AWT telephone interview with Michael Hoffman, 27 May 1998.

165 "Brassaï's Probing Vision," The Picture History of Photography (see note 69), p. 405.

166 Interview with MMH, Paris, 1985. Trauner stressed that the products sold in these shops were hardly pornographic by today's standards, simply typical of Parisian liberality about sex.

167 An earlier address for Paris-Magazine was 227, rue Saint-Denis, which was the same address as that of the magazine Scandale, Revue Mensuelle de Criminologie. According to David Travis, "Pages Folles was a sister publication to the detective rag Scandale and the racy Paris-Magazine."

168 "offre a [sic] certains amateurs des curiosités inédites." The book is very rare, and for unknown reasons, two versions exist. One has thirty-eight halftones and the other has forty-six. I have seen more than one copy of both versions. The picture of the young woman in the interior of the shop and that of the photographer of lingerie are both missing from the smaller edition. Why two versions exists is a mystery. Since the same photographs are always in each, their existence is not happenstance, but why those precise pages? I have yet to see a copy of the larger edition with the binding intact, so perhaps plates were removed to prevent the rings from breaking. The other images that do not appear in the smaller edition are of an elegant couple looking at a statue at the Louvre, a man wrestling a woman onto the ground, a prostitute dancing with her "john," two women standing before a mirrored wall in a bistro, a man adjusting his tie in an armoire mirror, and an opium smoker.

169 Picasso & Co., p. 166.

170 LTMP, letter 80, 17 October 1935, p. 213.

171 Since Secret Paris has no page numbers, I will not try to cite where quotes and photographs are published.

172 Boccaccio (Italian, 1313–1375).

173 Certainly Brassaï's contemporary, Simone de Beauvoir (1908–1986), took an opposing view of the closing of the brothels in her book The Second Sex (1949). She was more inclined to link the closing with the few, slow steps toward equalization of the sexes in France, which included Charles de Gaulle giving French women the right to vote in 1945 in honor of their roles in the Resistance and as workers during the war.

174 Tàpies, p. 17.

175 LTMP, p. 233.

176 Many of those interviewed referred to the "Hungarian table" at the Café du Dôme. Those immigrating to Paris were told, "Go first to the Dôme." Among photographers, Brassaï had friends, but was not part of any group.

177 LTMP, letter 29, 2 December 1924, p. 94.

178 Tériade was born Efstratios Elefteriades, 1897–1983.

179 The chronology published in Tàpies cites Brassaï as beginning to work with Rado in 1935, but it is possible that they began sooner. Because of the Hungarian connection, they would have met soon after Rado arrived in Paris in 1933. Brassaï may even have had contact with Rado's Berlin agency. The first time Rado is mentioned in LTMP is in 1937 (Letter 84, 23 August 1937, p. 220).

180 Brassaï ended the relationship because Rado failed to sell in the U. S. an article Brassaï had written on Picasso (Stefan Lorant interview with AWT, 3 October 1996, Massachusetts, and letter from Lorant to Brassaï, 5 December 1966, Stefan Lorant Collection, 1901–1992, the Getty Research Institute, Research Library, 920024). The final break, however, only confirmed the gradual shift instigated as Brassaï worked less and less for magazines, and spent more time writing his books and concentrating on exhibitions of his drawings, sculpture, and photographs. However, there are letters through the early sixties —to Nancy Newhall and to the Worcester Art Museum, Massachusetts — directing them to use his agent, Charles Rado.

181 Des Années folles aux années noires (see note 66), p. 161. After the war, the Rapho agency became Rapho-Guillumette and continued in Paris under the direction of Raymond Grosset. In 1984, Grosset told MMH that he met Brassaï in 1932–33 through Grosset's Hungarian friends — Ergy Landau, Ylla, and Nora Dumas — but was not in his circle of friends. "After the war," he said, "Brassaï did not need an agency as much. People came to him directly, but he did consign some pictures to us." The chronology in Tàpies says that Brassaï quit working for the Rapho-Grosset [sic] agency in 1947.

182 United by photographer Maria Eisner, members of the photographers' collaborative association Alliance Photo (1934–1940) included René Zuber, Pierre Boucher, Denise Bellon, Emeric Feher, Pierre Verger, and, later, Robert Capa and David Seymour, the latter known as "Chim." See Alliance Photo, essays by Thomas Michael Gunther and Marie de Thézy (Paris: Bibliothèque de la Ville de Paris, 1989).

183 Between 1927 and 1940, the Hungarian Stefan Lorant edited seven magazines in Germany, Hungary, and England, most of which published Brassaï's articles, drawn caricatures, and/or photographs. The magazines were Ufa Magazin (January–June 1927); Bilder Courier (Berlin, 1928–29); Müchner Illustrierte Presse (Munich, 1929–33); Pesti Napol Magazine (1933), Weekly Illustrated (1934), Lilliput (London, 1937–38), and Picture Post (London, 1938–40). Tihanyi and Lorant met at least as early as 1928 (Source: photograph of them in Lorant's home in Berlin, Stefan Lorant Collection, 1901–1922 [see note 180]). Brassaï began to contribute to Münchner Illustrierte Presse in the same year that Lorant became editor. Both Brassaï and Tihanyi had contributed to Bilder Courier as early as 1925.

184 All but Harper's Bazaar were published in Paris. For a full discussion of French magazines, see Christian Bouqueret, Des Années folles aux années noires (see note 66).

185 According to Sandra Phillips, after Vogel left in 1936 and the conservative owners assumed control, "the paper became dully patriotic, not even crediting its photographers." "The French Picture Magazine, Vu," Picture Magazines before Life (see note 53), p. 2.

186 Ibid., p. 2.

187 See bibliography for citations.

188 Stefan Lorant claimed to be the author of the Picture Post text. Lorant to AWT, Massachusetts, 3 October 1996.

189 Labyrinthe 13 (15 October 1945), pp. 8-9; Quadrige, with text by Louis Chéronnet, October 1945, pp. 8-9; "A Sermon in Stone," Lilliput, April 1947, pp. 84-91; "Paris Underground," Harper's Bazaar, December 1945, pp. 84-87.

190 It is Jean-Antoine Houdon's statue of Voltaire.

191 David Smart, head of the Chicago company that published Coronet and Esquire in the United States, was also the initial financial backer of Verve. The editor of Coronet was Arnold Gingrich. Stefan Lorant began Lilliput in June 1937.

192 Cow, Lilliput 1:1 (July 1937), pp. 110-11; cat, 3:6 (December 1938), pp. 708-9; Antoine, 1:6 (December 1937), pp. 1-2; potato, 2:1 (January 1938), pp. 38-39. More famous pairings that did not involve Brassaï's photographs include a raging Hitler and a raging chimp (3:2 [August 1938], pp. 222-23); extreme close-ups of a pear and a pear-shaped face (2:1 [January 1938], pp. 112-13); close-up profiles of a hen and an aristocrat, both with neck ruffles (3:4 [October 1938], pp. 420-21); and an aerial view of six plates of fried eggs with a similar view of six bald men at a circular table (5:3 [September 1939], pp. 256-57).

193 Similarly changed in meaning by its captions is the same pair of pictures — a woman's haircut and a man trimming a tree — published in Lilliput 4:3 (March 1939), pp. 258-59, and in Labyrinthe 14 (November 15, 1945), p. 11.

194 He was under contract to Coiffure de Paris from late 1934 or early 1935 until May 1937.

195 LTMP, letter 81, 5 December 1935, p. 216.

196 LTMP, letter 84, 23 August 1937, p. 221.

197 LTMP, letter 85, 1 December 1937, p. 222. In the same letter, he wrote, "I'm working almost exclusively for English and American papers."

198 Brassaï and fellow Hungarians György Bölöni and Ervin Marton placed Tihanyi's art in storage and continued to pay the rent until 1970, when they donated three hundred works (eighty-four paintings and more than two hundred graphics) to the National Gallery in Budapest after a show at Galerie Entremonde in Paris. There was a retrospective exhibition of the work in Budapest in 1973.

199 Interview with AWT, Paris, September 1996.

200 LTMP, letter 9, 27 July 1921, p. 22.

201 Introduction, LTMP, p. xiii.

202 Letter of 27 July 1933 in the Dobo/Miller Archives of the Berg Collection of the New York Public Library.

203 Permission to divulge Madame D.-B.'s identity was given by her daughter, Jacqueline, to MMH in an interview in Paris on 26 February 1985. Brassaï identifies her husband as a car manufacturer in LTMP, letter 26, 11 October 1924, p. 85, and gives the names of many of her friends and family members. Brassaï's portrait of Madame D.-B. appears in the cloth edition of LTMP between pages 202 and 203 and on page 75 in Brassaï (New York and Greenwich, Connecticut: The Museum of Modern Art and New York Graphic Society, 1968).

204 According to her daughter, when they met, Madame D.-B. was separated from her husband.

205 Although Brassaï never states her or her husband's title, he does mention that her nephew was Count Bourgault de Coudray, in whose home he had attended many dinners and music parties. LTMP, letter 47, 15 April 1926, p. 141.

206 Ady (1877–1919).

207 Madame D.-B. had four children, but lost two sons and a daughter when they were in their twenties and early thirties. Jacqueline told MMH that Brassaï was present in 1927 when the oldest son, Yves, died of a prolonged illness from being gassed in World War I.

208 LTMP, p. xii.

209 Olivier Bernier, Fireworks at Dusk: Paris in the Thirties (Boston: Little Brown and Company, 1993), pp. 3-4.

210 The Comte de Beaumont and Vicomte Charles de Noailles and their parties and collaborations with artists are also mentioned in Man Ray's Self-Portrait (Boston: Little Brown and Company, 1963), pp. 161-68.

211 "It did happen that, having spent the night among workers . . . and vagabonds, roughnecks and streetwalkers," he wrote, "I would be invited the next day to a soirée or masked ball of the aristocracy at the salon of Count Etienne de Beaumont or Vicomtesse Marie-Laure de Noailles" (LTMP, p. xiii).

212 LTMP, letter 53, 5 February 1927, p. 169.

213 Their correspondence continued at least through the early 1940s. She died in 1946. Her daughter Elizabeth is the girl seen in the flower-shop window in plate 33 of Paris de nuit. This photograph would have been taken between 1930 and 1932.

214 LTMP, letter 81, 5 December 1935, p. 215.

215 Vu 476 (28 April, 1937), p. 576. It was a special issue of the magazine devoted to horse-racing and also featured an article on women's fashion, in which Brassaï had a photograph on p. 575. The top-hatted man is also reproduced in section 3 of Neuf.

216 Caption for plate 98, 100 x Paris (Berlin: Verlag der Reihe, 1929), p. xxxi.

217 Fireworks at Dusk (see note 209), p. 7.

218 Ibid., p. 20.

219 Ibid., p. 151.

220 "Midnight Fête at Longchamp," Picture Post 4:4 (29 July 1939), p. 26.

221 "Masked Ball at Pré Catalan," Harper's Bazaar, September 1946, pp. 222-23.

222 LTMP, letter 80, 17 October 1935, p. 213.

223 September 1947, March 1950, January 1954, and December 1956.

224 Harper's Bazaar, August 1937 and July 1949.

225 Proust, p. 71. (An English-language edition of Brassaï's book on Proust is scheduled to be published by the University of Chicago Press.) Also discussed in George D. Painter, Marcel Proust: A Biography (New York: Vintage Book Edition, 1978), vol. 2, p. 161.

226 Dialogue with Photography (New York: Farrar, Straus and Giroux, 1979), p. 40.

227 Brandt's passage into society was provided by his own family. His uncles were bankers, moving in the privileged world of Surrey country houses and London drawing rooms. Regarding Brassaï's access, see "Society," pp. 202-13.

228 GB to AWT, January 1990. The two couples were close friends. She remembered that Brandt had written to her of Brassaï's importance to him, and that Brandt was always sympathetic to her. He asked Sue Davies to write thanks to "Monsieur and Madame Brassaï" in her foreword to the Photographer's Gallery catalogue, which was Gilberte Brassaï's first acknowledgment of her role in Brassaï's career.

229 "Celui-là, c'est un maître!" (That one is a master!), said Brassaï of Brandt to their mutual friend Lawrence Durrell. Preface to Perspective of Nudes (New York: Amphoto, 1961), p. 5.

230 Brassaï's Paris de nuit was published in 1932; Brandt's The English at Home in 1936 and A Night in London in 1938. B. T. Batsford published Brandt's first book and the English edition of Paris de nuit. Arts et Métiers Graphiques published Paris de nuit and the French edition of A Night in London. Batsford arranged Brassaï's first exhibition in London; Arts et Métiers Graphiques arranged Brandt's first exhibition in Paris. Focal Press published Brandt's Camera in London in 1948 and Brassaï's Camera in Paris in 1949. Both photographers were given retrospectives at the Museum of Modern Art in New York in the late 1960s, and both were represented by Marlborough Gallery in the 1970s and early 1980s. Both estates are now represented by Edwynn Houk Gallery in New York. Brandt's first two books followed Brassaï's, and he acknowledged his debt and their friendship by writing a brief introduction to Brassaï's catalogue for the 1979 retrospective at the Photographer's Gallery in London.

231 Brandt was born Hermann Wilhelm Brandt in Hamburg, Germany, to an English father and a German mother. Raised in Germany during World War I, he was traumatized by the stigma of being half-English and by living in Germany while the two countries were at war. At age sixteen he was sent to Switzerland for tuberculosis treatment and he moved to Vienna in 1927. After spending three months in Paris in Man Ray's studio in 1929, he settled in England but traveled extensively throughout 1931–33. At age 20, Brassaï's nationality was changed by treaty from Hungarian to Romanian.

232 They also used similar photographic equipment. Both preferred a Rolleiflex; Brassaï also used a Voigtländer and Brandt a Deardorff view camera as well as a Kodak Wide Angle for photographing nudes.

233 Brandt saw Orson Welles's Citizen Kane (1943) many times and was particularly impressed by the way in which the interiors were photographed. See Michael Hiley, Introduction to Bill Brandt: Nudes 1945–1980 (London: Gordon Fraser, 1982), pp. 7-8.

234 Brandt wrote, "I hardly ever take photographs except on an assignment." "A Photographer's London," Camera in London (London: Focal Press, 1948), reprinted in Bill Brandt: Selected Texts and Bibliography, edited by Nigel Warburton (Oxford, England: Clio Press, 1993), p. 91.

235 "A Photographer's London" (see note 234), p. 85.

236 Introduction to Bill Brandt: Shadow of Light (New York: Viking Press, 1966), p. 8. Connolly (1903–1974).

237 "Bill Brandt's Documentary Fiction," Art Forum 24, no. 1 (September 1985), p. 112, quoted in Nigel Warburton, "Brandt's Pictorialism," in Bill Brandt: Selected Texts and Bibliography (see note 234), p. 13.

238 "A Photographer's London" (see note 234), p. 90.

239 From Adams to Stieglitz (see note 62), p. 17. "I invent nothing, I imagine everything," is a paraphrase of how Proust's biographer, George D. Painter, described Proust's retelling of his life in Remembrance of Things Past. Painter's words were "though he invented nothing, he altered everything" (Marcel Proust: A Biography [see note 225], vol. 1, p. xiii).

240 Hurrell (1905–1992), Lynes (1907–1955), Steichen (1879–1973), and Hoyningen-Huene (1900–1968).

241 Quoted by Lawrence Durrell, untitled essay in Brassaï (New York: The Museum of Modern Art, 1968), pp. 11-12.

242 "Brassaï, Photographer of Paris Nightlife, Dies," The New York Times, 12 July 1984, 14Y.

243 Untitled essay in Brassaï (see note 241), p. 11.

244 Horváth to AWT, Budapest, July 1996.

245 Interview with MMH, Paris, 1985. Hayter also commented on how Brassaï could disappear in a crowd: "You could never see him."

246 HM:PY, pp. 4 and 36; "Notes" in Neuf, unpg.

247 Rim to MMH, 11 February 1985: "grand intimité de misère et de pauvreté." He is referring to Brassaï's book, Henry Miller grandeur nature (Paris: Gallimard, 1975).

248 HM:PY, p. 25.

249 Letter 1933, in the Dobo/Miller Archives of the Berg Collection of the New York Public Library.

250 "Mon ami Hans Reichel" (see note 32), p. 42.

251 Ibid., p. 39.

252 AOML, p. 28.

253 "Brassaï," Le Club Français de la Médaille (Paris) 45 (4th trimester, 1974), p. 54.

254 Le Minotaure 6 (1934), p. 29.

255 Published January 1948 and October 1953, respectively. See bibliography.

256 Richier's dates are 1902–1959.

257 AOML, p. 195. He had ample time to think about the work because he photographed all the sculpture, during a specific period of production, as a professional job for Richier.

258 AOML, p. 156.

259 Picasso & Co., p. 136.

260 Ibid., pp. 18-19.

261 Ibid., p. 54.

262 "Picasso: Spanish Painter's Big Show Tours the Nation," Life, March 1940, p. 56. The article was timed to coincide with Picasso's exhibition at the Museum of Modern Art in New York.

263 Picasso & Co., p. 53.

264 Radu Varia, "De Vorbà cu Brassaï despre fotografia cu arta" (see note 39), p. 184.

265 Picasso & Co., pp. 25-26.

266 Introduction to Picasso & Co., p. xiv.

267 Cocteau (1889–1963), Éluard (1895–1952).

268 Interview with AWT, Houston, 1997.

269 Art Criticism since 1900 (Manchester and New York: Manchester University Press, 1993), pp. 116-39.

270 Picasso & Co., p. 118.

271 "1900–1906 Monochrome as Paradigm," in Picasso and Photography: The Dark Mirror (Paris and Houston: Flammarion and The Museum of Fine Arts, Houston, 1997).

272 "An Interview with Tony Ray-Jones" (see note 35), p. 121.

273 Rosalind Krauss, "Photography in the Service of Surrealism," L'Amour fou: Surrealism (New York and Washington, D. C.: Abbeville Press and Corcoran Gallery of Art, 1985), p. 15.

274 Brassaï is not mentioned in the biographies and autobiographies of the central figures in Surrealism: Breton, Duchamp, Man Ray, Dalí, and so forth.

275 For Brassaï, their participation in such an expensive and inherently elitist publication "brought an end to the 'radical break with the world' and marked the formal entrance of Surrealist art and poetry into the world" (Picasso & Co., p. 12).

276 "Photography and the Surrealist Text," in L'Amour fou (see note 273), p. 187.

277 Abigail Solomon-Godeau, "The Legs of the Countess," in Fetishism as Cultural Discourse, edited by Emily Apter and William Pietz (Ithaca and London: Cornell University Press, 1993), p. 277.

278 "Corpus Delicti," Rosalind Krauss and Jane Livingston in L'Amour fou (see note 273), p. 95.

279 Sidra Stich, Anxious Visions: Surrealist Art (New York and Berkeley: Abbeville Press and University Art Museum, 1990), p. 40.

280 Tàpies, p. 23.

281 Picasso & Co., p. 70.

282 Written six years before Breton's first manifesto and cited in Marcel Raymond, From Baudelaire to Surrealism (London: Methuen & Co., 1970), p. 262.

283 When writing about the series of pictures that he began immediately after World War I, Edward Steichen clearly described his search for symbolic resonance in natural forms. His challenge was to not let either total abstraction or symbolic reference overwhelm the natural forms. Subverting scale was one method of transforming recognition of an object while retaining its actual identity. One photograph of a single apple on a plate was titled An Apple, a Boulder, a Mountain (c. 1921), but the more successful pictures do not need such directive titles to highlight Steichen's intentions. "World War I and Voulangis," in A Life in Photography (London: W. H. Allen, 1963), unpg.

284 "Curves of Art," in EW: 100, Centennial Essays in Honor of Edward Weston (Carmel, California: Friends of Photography, 1986), pp. 85-86.

285 "L'Amour faux," Art in America, January 1986, p. 118.

286 Introduction to Transmutations portfolio.

287 Picasso & Co., p. 36. Yet when Brassaï writes to his parents about the forthcoming issue number 3-4 of Le Minotaure, he mentions the photographs of artists and his article on graffiti, but none of the Dalí collaborations (LTMP, letter 78, 7 December 1933, p. 210).

288 See Le Minotaure (Paris) 3-4 (12 December 1933), pp. 101-2, 105.

289 Gaudí (1852–1926); AOML, p. 34, and Picasso & Co., pp. 35-36.

290 Dawn Ades, "Brassaï in Minotaure," in Tàpies, p. 25.

291 Reproduced on the cover of Tàpies. In the collection of the National Gallery of Canada, Ottawa.

292 The collage was made as an homage to Jean-Martin Charcot (1825–1893), the French psychiatrist and teacher of Freud, on the fiftieth anniversary of his explanation of hysteria.

293 AOML, p. 34. See also note 3 in Tàpies, p. 19.

294 Krauss (see note 273), p. 64.

295 HM:PY, p. 37.

296 "Brassaï," From Adams to Stieglitz (see note 62), p. 17.

297 Catalogue for the exhibition. Guided by his example, this essay and exhibition have been similarly organized.

298 Breton wrote, "Convulsive Beauty will be veiled-erotic, fixed-explosive, magical-circumstantial or will not be." Veiled-erotic were instances of natural mimicry, when one being imitates another or when inorganic matter shapes itself to look like something else.

Fixed-explosive is related to the expiration of movement, and magical-circumstantial occurs when an object becomes an emissary, carrying a message informing the recipient of his own desire. Seven of Brassaï's photographs of crystals, coral, and malachite illustrated veiled-erotic as Breton discusses the involuntary charater of the crystalline beauty in nature. Brassaï's potato with elaborate tendrils was one of the illustrations with discussions of magical-circumstantial. Since the image is titled Magique-Circonstancielle and is obviously a set-up photograph, it may have been taken specifically for Breton. "La beauté sera convulsive," Le Minotaure 5 (1934), pp. 9-16.

299 France Béquette, "Interview with Brassaï," Culture et communication (Paris) 27 (1980), p. 15.

300 "The Eye of Paris" (see note 41), p. 177.

301 LTMP, letter 15, 24 March 1922, p. 46.

302 Ibid.

303 Tàpies, p. 15.

304 Brassaï's photographs had all been made earlier, and some had been published in other magazines.

305 Breton's text was later published as the book L'Amour fou. Photographs by Man Ray, Henri Cartier-Bresson, Dora Maar, and Rogi André were also published as illustrations for the book.

306 Ades, L'Amour fou (see note 273), p. 163.

307 Dalí and Surrealism (New York: Harper & Row, 1982), p. 162. Brassaï is only mentioned in Ades's discussion of Dalí's Art Nouveau article on page 103.

308 Picasso & Co., p. 2.

309 Some of the drawings from Berlin are reproduced in Neuf and in LTMP.

310 For support in this opinion, I am indebted to Dr. Eva Bajkay, director of the graphics department, Magyar Nemzeti Galérie (National Gallery), Budapest. Tihanyi's drawings were viewed at the National Gallery. Neither the drawings by "The Eight" nor those by Brassaï are widely reproduced. See Tihanyi's Figure Study, in The Hungarian Avant-Garde 1914–1933: Selections from the Paul K. Kovesdy Collection (Storrs, Connecticut: William Benton Museum of Art, University of Connecticut, 1987), p. 10; Neuf; and Trente dessins (see note 147). As art historian Kriszthina Passuth has observed, "The effect of Cézanne [on "The Eight"] was perhaps all the more permanent and deep because it offered not only a stylistic and artistic basis in the narrow sense but also a Weltanschauung. Those Hungarian artists who [wanted] to find an external form for their inner tension felt themselves to be much closer to Cézanne's questing painting, striving as it does to reach the heart of the matter." "The International Connections of the Eight and the Activists," The Hungarian Avant-Garde: The Eight and the Activists (London: Arts Council of Great Britain, 1980), p. 20.

311 LTMP, letter 13, 19 December 1921, p. 35. The gallery is unknown.

312 Picasso & Co., pp. 131-32.

313 Trente dessins (see note 147).

314 "Most people go there to get warm," wrote Brassaï, commenting on the great deprivations of the war years and how they lived without heat and on rationed food (Picasso & Co., p. 113).

315 LTMP, letter 11, 23 October 1921, p. 28.

316 "Brassaï," in From Adams to Stieglitz (see note 62), p. 20.

317 "New Art in Paris," Vogue, November 1945, p. 174.

318 M. L., "Brassaï" (review of exhibition at La Boétie), Art News 67, no. 8 (December 1968), p. 15.

319 The Venus of Willendorf is a stone sculpture, c. 25,000–20,000 B. C. The Hottentot Venus was modeled after Saartjie Baartman, a South African woman who was mistakenly thought to be a member of the Hottentot tribe, and the sculpture was publicly exhibited in England and France from 1810 to 1815. Both Venuses were "admired" for their enormous hips and thighs. I am grateful to Deborah Willis for sharing information on the Hottentot Venus from the forthcoming book by Willis and Carla Williams, The Black Female Body in Photography (Philadelphia: Temple University Press, 1999).

320 Preface to Brassaï: sculptures, tapisseries, dessins (Paris: Galerie Verrière, 1972), unpg.

321 See bibliography for citation.

322 One sculpture was titled Picasso and another Ambroise Vollard. They are less portraits than caricatures. Picasso (1947) emphasizes his wide-eyed look and large nose. Ambroise Vollard (1950) is an almost perfectly round flat stone into which Brassaï carved the suggestions of facial features.

323 "Sculptures" (see note 320).

324 "La lettre d'information: Les Oeuvres flottantes de Brassaï," Connaisance des Arts (Paris) 241 (March 1972), pp. 20-21.

325 Aurignac is located in the Haute-Garonne region of France near caves with paleolithic remains, including stone figures and paintings and engravings on the walls of caves.

326 "La lettre d'information: Les Oeuvres flottantes de Brassaï" (see note 324). Parts of this quote are republished in "Sculptures" (see note 320).

327 Viviane Berger, "Brassaï par Brassaï," Jardin des Arts (Paris) 209 (27 March 1972), p. 12.

328 MMH interview with Daria Gamsaragan, summer 1985. Gamsaragan immigrated to Paris in 1925 from Alexandria, Egypt. She studied with Bourdelle and at the Académie de la Grande Chaumière. Her husband was a Hungarian journalist.

329 Picasso & Co., p. 152.

330 Viviane Berger (see note 327), p. 12.

331 AOML, p. 116.

332 Interview, Creative Camera (London), April 1970, p. 121.

333 Marcel Natkin, Le Nu en photographie (Paris: Éditions Mana/Éditions Tiranty, 1949), p. 28. For examples of Brassaï's images of nudes that support Natkin's observation, see the reproductions in Formes.

334 "The Transylvanian and the People of the Night," Arts Guardian (London) (23 November 1979), p. 11.

335 "Variété du corps humain," text by Maurice Raynal, Le Minotaure 1 (15 February 1933), pp. 41-44.

336 Picasso & Co., p. 69; see also note 344.

337 Formes: Le Magazine des Artistes, Peintres et Sculpteurs published three issues in 1950, each with sixteen photographs. No. 1 — Brassaï, No. 2 — Paul Koruna, No. 3 — Ergy Landau.

338 "Carroll the Photographer," in Lewis Carroll: Photos and Letters to His Child Friends (Parma: Franco Maria Ricci, 1975).

339 Ibid., p. 198.

340 "Cliché-verre in the 19th century," Cliché-verre: Hand-Drawn, Light-Printed (Detroit: The Detroit Institute of Arts, 1980), p. 29.

341 Delacroix (French, 1798–1863), Rousseau (French, 1812–1867), Millet (French, 1814–1875), Corot (French, 1796–1875), and Ernst (German, 1891–1976).

342 Picasso & Co., p. 26, and introduction to Transmutations portfolio (Vaucluse, France: Galerie les Contards, 1967), reproduced in Tàpies, p. 201.

343 Introduction to Transmutations, ibid.

344 See discussion with Picasso regarding the series (Picasso & Co., p. 69). Brassaï explains that he had first nicknamed the series arrondissements after the twenty districts of Paris. However, the nickname is a pun because a secondary definition of arrondissement in French is roundness. Brassaï wrote that the nudes were "done entirely in curving lines and contours."

345 He may mean a Kananga mask from the Dogon tribe in Mali. The reference appears in the introduction to the Transmutations portfolio.

346 I would like to thank Anne-Louise Schaeffer, curator of the Art of Africa, Oceania, and the Americas at the Museum of Fine Arts, Houston, who identified these works.

347 Catalogue entry on Brassaï, Cliché-verre (see note 340), p. 129.

348 The museum also has three prints of the image Stripped Woman of Seville (Sevillane Dénuée): one printed in the thirties, one in the fifties or sixties, and one from the portfolio.

349 "My friend, Brassaï," Infinity 15, no. 7 (July 1996), p. 5.

350 "Brassaï," From Adams to Stieglitz (see note 62), p. 17.

351 Edouard Jaguer, "Brassaï and the Eyes of the Wall," in Tàpies, p. 39.

352 Villa Orsini at Bomarzo (c. 1570) and Villa Palagonia near Palermo (c. 1740s). There is no agreement among scholars about the identity of the figures at Bomarzo. Brassaï also photographed the orderly Renaissance gardens and sculpture at Villa Lante near Viterbo (1566–87).

353 Harper's Bazaar, December 1952 and January 1955. Cheval (1836–1924) worked from 1879 to 1912, and Fouré from 1870 to 1910. André Breton wrote about Cheval in both 1932 and 1933.

354 "Ferdinand Cheval: An International Bibliography of Books, Journal Articles, and Television and Motion Picture Documentaries," Vance Bibliographies (Monticello, Illinois) Architecture Series: Bibliography # A 546 (August 1981), p. 1.

355 "La Villa Palagonia, Une curiosité du baroque sicilien," Gazette des Beaux-Arts, September 1962, p. 364.

356 Although the Giacometti photograph is traditionally dated 1948, it must have been taken in 1947 because it appeared in the January 1948 issue of Harper's Bazaar.

357 The New Review (Paris/London/New York) 3 (August–September – October 1931), unpg. The New Review was published from Paris but edited by the American Samuel Putnam and distributed by the Gotham Book Mart in New York. Brassaï's connection to the journal was through his friends Alfred Perlès and Henry Miller, who also contributed to that issue. (See also reference to this article in HM:PY, p. 179.)

358 "A Few Reminiscences of Brassaï," Brassaï: The Eye of Paris (New York: Houk Friedman Gallery, 1993), p. 4.

359 "The Lamb at Midnight," Harper's Bazaar, December 1951, p. 81.

360 "The Faces of Nature," Harper's Bazaar, May 1958, pp. 96-99, and "L'Enfer de Dante retrouvé aux Baux" (Dante's Inferno found at Les Baux), Labyrinthe 6 (March 1945), p. 3.

361 "The Lamb at Midnight" (see note 359).

362 From Adams to Stieglitz (see note 62), p. 20.

363 Unpublished text given to AWT and the Menil Collection by Gilberte Brassaï. "Ce que j'aime, et ça passionnement, c'est de donner à un object sans prix une valeur, par le simple fait de la découverte, par la dignité qu'on lui donne en l'accueillant dans son intimité. Entre tous les objects, élus pour partager ma vie, je préfère peut-être cet étonnant masque en pâte de pain, créé pour le 6 janvier, fête des rois, par un boulanger du Boulevard Raspail. J'ai vu peu de portraits aussi joyeux, aussi encourageants. Il est l'expression même de la vie française, optimiste malgré tout, limitée aux plaisirs immédiats, égocentrique, gourmande. C'est une véritable irradiation de joie, qui se dégage de cet étrange masque."

364 "The Strange Faces of Paris," Réalités (London) 124 (March 1961), p. 18. Jean-Siméon Chardin (1699–1779), Georges Braque (1882–1963), Louis LeNain (1593–1648), Mathieu LeNain (1607–1677), and Henri Rousseau (1844–1910).

365 He achieved this by taking off the top element of a two-element lens (Tom Marotta and Jean-Claude Gautrand, "Brassaï: A Talk with the Great French Master" [see note 107], p. 14).

366 Zdenka Watterson, "Der grosse Photo-Reporter von Paris" (see note 106), p. 6.

367 Blossfeldt's photographs were made between 1890 and 1932.

368 It does not necessarily follow, however, as Manuel J. Borja-Villel assumed, that "Brassaï's plants and objects were generally imbued with an ambiguity and eroticism that could only recall Surrealism, especially that of Dalí" ("Midway between the Récit Poétique and the Expression of the Essential," Tàpies, p. 13). In 1927, Dalí had written passages directly relevant to Brassaï's series "Large-Scale Objects," but Brassaï was unlikely to have read them because they were published in Spanish periodicals. In these, Dalí proclaims, "The possibilites of photography and the cinema reside in that unlimited fantasy which is born of things themselves . . . a piece of sugar can become on the screen larger than an infinite perspective of gigantic buildings" ("Film-art. Fil Antiartistico," Gaceta Literaria [Madrid] 24 [15 December 1927], cited by Ades in L'Amour fou [see note 273], p. 176).

369 See Christopher Phillips, "Resurrecting Vision: The New Photography in Europe between the Wars," The New Vision: Photography between the Wars (New York: The Metropolitan Museum of Art, 1989), pp. 77-95.

370 "The Enterprise Justified," Scientific Studies, edited and translated by Douglas Miller (Princeton, New Jersey: Princeton University Press, 1988), p. 61. This is paraphrased by Brassaï when he wrote repeatedly throughout his career that one must honor the object. For instance, introducing the work of Louis Stettner in 1949, he wrote, "All the domain of reality is [the photographer's], but everywhere, as in a park maintained in a savage state, is this warning, 'It is strictly forbidden to touch anything!' The photographer, by respecting this warning to the letter, takes the side of the defenseless object" (Introduction to 10 Photographs by Louis Stettner [New York and Paris: Two Cities Publications, 1949], unpg.).

371 "Toward a General Comparative Theory," in Scientific Studies (see note 370), p. 53. This is the very opposite of André Breton's primary regard of an object as "an emissary from the external world [that] carries a message informing the recipient of his own desire." For Breton, the object's significance was in the mental act of recognizing the object's message (Krauss, "Photography in the Service of Surrealism," L'Amour fou [see note 273], p. 35).

372 "The Enterprise Justified" (see note 370).

373 Brassaï traced his love of skeletons to Goethe.

374 "Rubens [Goethe to Eckermann, 11 and 18 April 1927]," Goethe on Art, selected, edited, and translated by John Gage (Berkeley and Los Angeles: University of California Press, 1980), p. 205.

375 Dating graffiti is difficult, and individual images are rarely dated. In the Collection de photographies du Musée National d'Art Moderne, the Centre Pompidou dates its graffiti images by Brassaï (which were acquired as part of the Daniel Cordier collection) to between 1935 and 1950. Yet some of them were published in Le Minotaure in 1933. In Les Imaginaires (reprinted in Tàpies, p. 173), Brassaï says he began photographing graffiti in 1930 and that in 1950 he began to keep notes on cards, that he used to return to those sites many years later. In other articles, he listed the beginning for black-and-white graffiti as 1933. He began photographing graffiti in color in the 1960s.

376 "Le Procès des Graffiti," in Graffiti (Paris: Flammarion, 1993), p. 147.

377 Les Imaginaires (Paris: Union Générales d'éditions, 1976), pp. 251-55, republished in Tàpies, p. 173.

378 "Graffiti Parisiennes," XXe Siècle (Paris) 10 (March 1958), p. 21, reprinted in Tàpies, p. 169.

379 Tàpies, p. 170.

380 Ibid., note 378.

381 Brassaï, statement in Graffiti (London: Institute of Contemporary Arts, 1958.)

382 Tàpies, p. 169.

383 Tàpies, pp. 173-74.

384 Tàpies, p. 174.

385 "The Strange Faces of Paris" (see note 364), p. 23.

386 "The Art of the Wall," The Saturday Book, 1958, p. 237.

387 "Walls of Paris," Harper's Bazaar, July 1953, p. 43, and Statement, Institute of Contemporary Arts (see note 381).

388 "Le Procès des Graffiti" (see note 376), p. 143.

389 In 1949, Brassaï published eight photographs and three sections of his prose poems on Marie in Anthologie de la poésie naturelle. His photographs of natural or found poetry include leather shoe patterns whimsically tacked to a wall (catalogue number 94), and a limbless doll hooked to a ledge. Six of the eight photographs are images created by chance: a devil and a lion are evoked by the places in walls with missing plaster, and "phantoms" appear to dance across a row of broken windows. One of these images is in this section and the others are of the same kinds of phenomena.

390 Graffiti (see note 376), p. 99.

391 Picasso & Co., p. 221.

392 Black Spring (New York: Grove Press, 1963), p. 50.

393 Institute of Contemporary Arts, London (see note 381).

394 As reported in the ASMP Bulletin, Charles Rado told the American Society of Magazine Photographers: "The publication of the French edition [of Graffiti] and the simultaneous showing of photographs from Graffiti in a Paris Gallery aroused considerable interest not only in France, but also in Switzerland, Belgium and Holland, as shown by close to 70 magazine and newspaper articles or notices" (ASMP Bulletin [New York: American Society of Magazine Photographers, May 1966], unpg.). See "Exhibitions" in bibliography. There were shows of Graffiti throughout Europe in the late fifties and early sixties.

395 Particularly relevant was the French evolution of German phenomenological theories, especially as developed by Jean-Paul Sartre (1905–1980) and Maurice Merleau-Ponty (1908–1961).

396 For instance, in writing about Germaine Richier, he observed, "At a time when André Malraux's Man's Fate and Albert Camus's Myth of Sisyphus were influencing the way we think — along with the works of Kafka and Samuel Beckett — Germaine Richier's sculpture began to reveal man in all his nakedness, solitary and overwhelmed by an unknowable universe, as though, after the desolation of Hiroshima, the erstwhile lord of creation had become a hunted animal facing a perilous future and weighed down beneath the threat of some ultimate annihilation." AOML, p. 194.

397 "Henri Michaux," in Paris Post War: Art and Existentialism 1945–1955 (London: Tate Gallery, 1993), p. 143.

398 Paulhan (1884–1968). Frances Morris, introduction to Paris Post War, p. 22.

399 As quoted in Sarah Wilson, "Paris Post War: In Search of the Absolute," Paris Post War, p. 33.

400 Ibid., p. 33.

401 Ibid., p. 31.

402 Simultaneous with the positive reception of Brassaï's Graffiti was the burgeoning career of Jean Dubuffet, who held his first exhibition a few months after the Liberation, in October 1944, at the Galerie René Drouin in Paris. In his 1946 show at the gallery, crude schematic images of people were scratched into the dense sticky surfaces of the work. Dubuffet was also looking at the inscriptions and graffiti on walls and became fascinated with the beautiful textures of the worn stone surfaces, as well as with their cracks, fissures, and carvings. In reviewing Brassaï's book, some critics mentioned Dubuffet and some concluded that the sophisticated re-creations "can never attain the same degree of force and authenticity that many of these photographs do" (Quoted by Brassaï in Graffiti [see note 376], p. 144, but only cited as a review in the Times, 29 September 1958).

403 See note 395.

404 Brassaï: sculptures, tapisseries, dessins (see note 320).

405 Viviane Berger (see note 327), p. 12.

406 There were numerous articles published in Jardin des Arts and other magazines in the sixties and seventies on tapestries designed by artists. See also Tapisseries de Notre Temps in bibliography. Picasso, Le Corbusier, Raoul Dufy, Arp, Sonia Delaunay, Picabia, Kandinsky, and Vasarely were just a few of the artists who were commissioned to make tapestries.

407 Radu Varia, "De Vorbà cu Brassaï" (see note 39), p. 183.

408 Eisner (see note 100), p. 76.

409 To MMH, 1985.

410 "Brassaï's Probing Vision," The Picture History of Photography (see note 69), p. 405.

411 Figure 13, Picasso & Co.

412 Interview with AWT, Houston, April 1997.

413 Picasso & Co., p. 109.

414 Picasso & Co., p. 115. In the text he writes "Rumanian army," but this is not correct. Possibly he thought it was too complicated to explain how someone who was then a Romanian citizen had once served in the Austro-Hungarian army.

415 Letter from Gilberte Brassaï to AWT, January 1996.

416 The closest he came to publishing a book of Paris-by-day pictures was contributing thirty-eight photographs to John Russell's book Paris (London: B. T. Batsford Limited, 1960). But most of these photographs are architectural views selected to best illustrate Russell's text.

417 LTMP, letter 61, 11 March 1930, p. 181.

418 LTMP, letter 19, 17 March 1924, p. 59.

419 Others include Mario Bucovich, Paris, text by Paul Morand (Berlin: Albertus-Verlag, 1928); Eugène Atget, Photographe de Paris (Photographer of Paris), essay by Pierre MacOrlan (New York: E. Weyhe Gallery, 1930); Moï Ver (b. Moshe Vorokeichec-Raviv, 1904), Paris, introduction by Fernand Léger (Paris: Éditions Jeanne Walter, 1931); Ilja Ehrenbourg, Moj Pariz (Russia, 1931); Roger Schall (b. 1904), Paris de jour, preface by Jean Cocteau (Paris: Arts et Métiers Graphiques, 1937); René-Jacques (b. René-Giton, 1908), Envoûtement de Paris (Bewitchment of Paris) (Paris: Grasset, 1938).

420 Kertész's books on daytime Paris include Paris Vu, text by Pierre MacOrlan (Paris: Librairie Plon, 1934); Day of Paris (New York: J. J. Augustin, 1945); and J'aime Paris (I Love Paris) (New York: Grossman, 1974).

421 Brassaï's photograph was made in 1937. We can only wonder if it was inspired by the 1935 advertising photograph by André Vigneau of a man standing under an umbrella near receding pedestrian markers. Because the figure and her clothing as well as the exact composition are more interesting, Brassaï's image is a definite improvement on Vigneau's.

422 Amanda Hopkinson, "Just Celebrating: Paris Shows Brassaï, Cartier-Bresson and Lartigue," Creative Camera 6 (1989), p. 29.

423 Waldemar Januszczak, "The Transylvanian" (see note 334), p. 11.

424 "Brassaï at the Photographer's Gallery," Birmingham Post (November 20, 1979).

425 See Marie de Thézy and Claude Nori, La Photographie humaniste: 1930–1960, Histoire d'un mouvement en France (Paris: Contrejour, 1992).

426 Paris: The City and Its Photographers (Boston: Bulfinch Press, 1992), p. 111.

427 Cartier-Bresson (French, b. 1908), Doisneau (French, 1912–1994), Izis (French, 1911–1980), René-Jacques (see note 419), Ronis (French, b. 1910), and Boubat (French, b. 1923).

428 The bibliography in this book inadequately reflects the depth of articles published by Brassaï between 1930 and 1960. Much research remains to be done; magazines must be searched issue by issue and page by page.

429 Paris: The City and Its Photographers (see note 426), p. 112.

430 Photography: A Concise History (New York and Toronto: Oxford University Press, 1981), p. 186.

431 Press release in Kay Reese file. Part of this quote is cited in Jacob Deschin, "Brassaï Looks Back to 1930s," The New York Times 3 November 1968, D.35.

432 Picasso & Co., p. 185.

433 Interview with David Travis and MMH, 7 May 1985, and Picasso & Co., p. 170.

434 The ballet was performed again in Paris in 1949 and toured to other countries. It was revived in 1992. See bibliography.

435 Picasso & Co., p. 180.

436 The hotel wall is from his graffiti subseries, The Propositions of the Wall.

437 Picasso & Co., p. 180.

438 Picasso & Co., p. 176. He implies here that he made the photograph in 1945, but the image was taken between 1932 and 1934.

134

439 Boris Kochno to MMH, 7 May 1985.

440 "Souvenirs de Mon Enfance," in Neuf, unpg.

441 Brassaï, "Tant qu'il y aura des bêtes," Arts: Beaux-Arts, Littérature, Spectacles (Paris) 566 (2–8 May 1956), p. 5.

442 Ibid.

443 Ibid.

444 Pleonasm: the use of more words than those necessary to denote mere sense.

445 "Tant qu'il y aura des bêtes" (see note 441).

446 Ibid.

447 "An Interview with Tony Ray-Jones" (see note 35), p. 121.

448 Interview with MMH, 1985.

449 Roger Grenier, "Brassaï," Le club français de la médaille (Paris) 45 (1974), pp. 52-53.

450 Rim to MMH, Paris, 11 February 1985.

451 Roméo Martinez interview with MMH, Paris, 14 February 1985.

452 Harper's Bazaar, January 1956.

453 "A Ride in Seville," Harper's Bazaar, April 1953, pp. 164-65.

454 Stefan Lorant to AWT, Massachusetts, 3 October 1996.

455 "Brassaï's Probing Vision," in The Picture History of Photography (see note 69), p. 405.

456 Letter from Peter Pollack to Helmut Gernsheim, 27 May 1957, Peter Pollack Papers, 1945–1978, the Getty Research Institute, Research Library, 900283.

457 In 1968 for Brassaï's retrospective at the Museum of Modern Art and a simultaneous exhibition of sculpture, drawings, and tapestries at La Boétie Gallery in New York; in 1973 for the exhibitions in New York and Washington, D. C., plus visits with Ansel Adams and Henry Miller in California; in 1977, when he gave lectures in New York and Boston; and in 1979 for an exhibition and the celebration of his eightieth birthday.

458 Interview with MMH, Paris, 1985.

459 Krause to AWT.

460 A different answer is given to the same question in the published interviews of Paul Hill and Tom Cooper with Brassaï. When the interview was published in Camera magazine (see note 61), Brassaï cited the death of Snow, which was actually in May 1961. When the interview was republished in their book in 1979, he says, "I should have given up photography forever in 1963, after my big exposition at the Bibliothèque Nationale." Roger Grenier thought that Brassaï's "trip to Louisiana in 1957 marked the beginning of the epoch when he began to lose interest in photography." Grenier interview with MMH, Paris, 1985.

461 "My friend, Brassaï," Infinity 15, no. 7 (July 1996), p. 5.

462 Proust, p. 174.

463 "An Interview with Tony Ray-Jones" (see note 35), p. 121.

464 "Notes," in Neuf, unpg.

465 Kálmán Halász to AWT, Brassó, Romania, July 1996.

466 Letter to AWT, 3 November 1997.

467 On the Threshold of the One-Hundredth Year (see note 16).

468 Paris, 11 February 1985.

469 Dobo to MMH, 18 March 1985. Dobo was not acquainted with the maid whose conversations Brassaï said he had recorded.

470 "Notes," in Neuf, unpg.

471 Quoted from the original English manuscript in the Dobo/Miller Archives of the Berg Collection of the New York Public Library.

472 Letter dated November 2 and probably written in 1948. In the Dobo/Miller Archives of the Berg Collection of the New York Public Library.

473 Introduction to Paroles en l'air (Paris: Jean-Claude Simoën, 1977), pp. 11-12.

474 Ibid., p. 13.

475 Entry on Prévert, International Dictionary of Films and Filmmakers, vol. 4: Writers and Production Artists, third edition (London: St. James Press, 1997), p. 668.

476 À la rencontre de Jacques Prévert (Paris: Fondation Maeght, 1987), pp. 37-38.

477 René Bertelé in À la rencontre de Jacques Prévert, p. 37.

478 Horváth to AWT, Budapest, July 1996.

479 John Canaday, "Henry Moore: Drawing as Soliloquy," The New York Times, Sunday, 30 July 1972, p. 17. Canaday is reviewing Henry Moore: Unpublished Drawings, published by Harry N. Abrams. We can only speculate where Moore first saw the photographs, probably in Le Minotaure.

480 Patricia Bosworth, Diane Arbus: A Biography (New York: Alfred A. Knopf, 1984), p. 122.

481 Harper's Bazaar began to publish Diane Arbus's photographs in the early 1960s about the same time as it ceased to publish Brassaï's. Just as Brassaï had enjoyed the support of Carmel Snow and Alexey Brodovitch, Arbus's work was championed by the magazine's new regime, art directors Ruth Ansel and Bea Feitler, and editor Nancy White.

482 Diane Arbus (see note 480), p. 307. We know that Brassaï also admired Arbus's work because when speaking about his belief that serious photographers must have their own subject matter, he included Arbus in a short list of more senior figures. He identified their "peculiar obsessions and types of images," as follows: "[Edward] Weston's is the sand dunes of New Mexico, Ansel Adams's is vast cosmic landscapes; Arbus's is monsters; [and] Atget's the streets of Paris." Hill and Cooper, Dialogue with Photography (see note 61), p. 40.

483 Stephenson to AWT, telephone conversation, August 4, 1998. Based on notes Stephenson found in the Smith Archives at the Center for Creative Photography, University of Arizona, Tucson.

484 Interview with Paul Hill and Tom Cooper (see note 61), p. 37. The interview was conducted in April 1974. The quote on Smith did not reappear when the interview was published in the book Dialogue with Photography.

485 Telephone interview with AWT, 27 May 1998.

486 Lynn Snowden, "Bar Belles Bare All: The Spirit of Brassaï Haunts a Manhattan Bistro," American Photographer (New York), August 1987, p. 80.

487 The History of Photography: From 1839 to the Present Day. Revised and expanded edition (New York: The Museum of Modern Art, 1964), p. 156. The Newhalls met Brassaï in Paris in 1952, looked through a large selection of his work, and selected images for the George Eastman House collection.

488 "The Influence of Surrealism," in Creative Photography (see note 120), pp. 190-95.

489 Looking at Photographs (New York: The Museum of Modern Art, 1973), p. 110.

490 "Hallway to Parnassus," LTMP, p. 231.

491 Manuel J. Borja-Villel, Tàpies, p. 19.

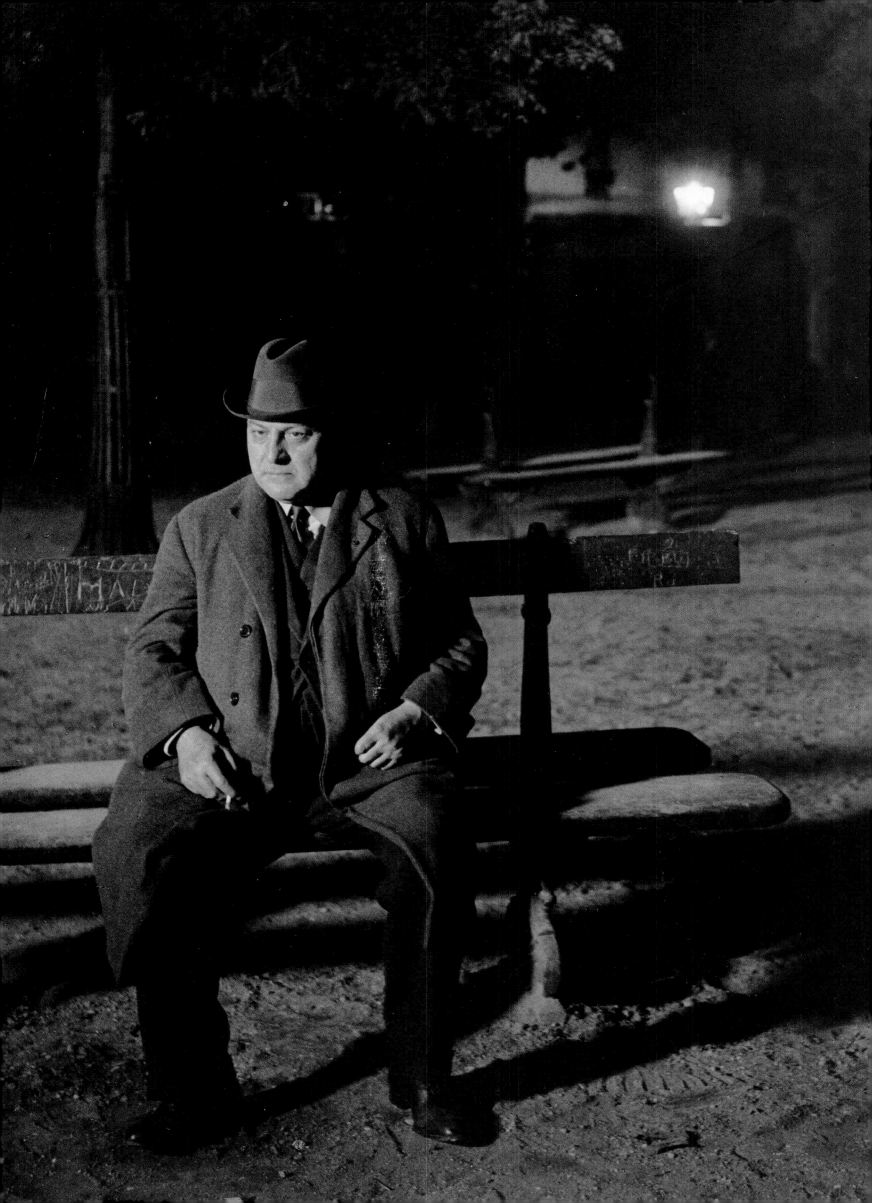

Letters Home

All of us dream, and in contemporary western cultures, all of us write. Our dreams are our art, and our letters — the one mode of writing universally practiced, though hardly perfected — are our literature. Like our dreams, our letters are that expressive form which, once completed — i.e, posted — cannot be revised: they are the product of culture we are most likely to regard as "natural" — not to be corrected, retouched, changed, as we like to say that nature, especially "human nature," does not change. Yet when we read a man's collected letters — even, as in this case, the letters of a very young man — they seem, already, the evidence of culture, something more — or less — than nature. They seem, already, to present the portrait of a member (and perhaps of a victim, too) of a certain culture, but particularly the indication of what spirit (enthusiasm, inertia, aspiration, dismay) possesses the letter-writer, affording the conviction so analogous to Freud's famous dictum about anatomy, that culture is fate.

The father of this particular young man — who is all of twenty-one when he reassures his parents in 1920, upon arriving in Germany from Hungary: "My first impressions are most favorable, and I do not regret for a second that I came here. I guess within a couple of days I will be totally acquainted with Berlin life and can start regular work" — is a teacher of literature, a writer, and the family milieu has prepared young Gyula from the age of five, when he was taken to Paris on a year's villeggiatura, for a life not only sweetened but indeed structured by culture. How pleasant it is to observe that this father is a constant "moral and financial support," as remarked in 1978, ten years after Professor Halász's death (at the age of ninety-seven!); that he actually encouraged his eldest son in his artistic ambitions from the first. The Letters to My Parents, which we may now regard as Brassaï's first book, are therefore charged with a sense of a justifying cultural mission. They are the record of the soul's (and the body's) laboratory.

The only odd — though understandable — thing about them is that the young artist is more likely to mention his relationships with fellow expatriate Hungarians — Sandor (aka Alexander) Korda, for example — rather than with such apparently marginal types as Pierre Reverdy and Henri Michaux, of whom his parents would not have heard. He does not want to scare them off, but here we may note for ourselves the immediate magnetism which draws this as-yet ill-defined intellectual youth to a certain kind of accomplishment in the arts. For Reverdy was perhaps the purest lyrical voice in that astonishing group of poets (Éluard, Aragon, Desnos, Breton himself) who eventually found it expedient to accept the leadership of André Breton in the literary and artistic movement known as Surrealism; and Michaux, though never a popular figure, was both a writer and a graphic artist of evident genius, certainly the greatest Belgian poet since Maeterlinck and one of the most remarkable image-makers of modernity. Friendship with such men — and such friendship was a characteristic of Brassaï's all his life, not just in the enthusiasm of youthful discovery and alliance — has a great deal to do with the photographer's subsequent literary achievement, though such "contacts" are unremarked in his correspondence with his parents, not a matter — yet — for family inspection. figure 18 The Poet Léon-Paul Fargue, the "Pedestrian of Paris," 1932 (catalogue number 69) © Gilberte Brassaï

After two preliminary years in Berlin, where he graduated from the Charottenburg Academy of Fine Art, met Kokoschka, Kandinsky, Moholy-Nagy, and, most important, discovered Goethe (not the Goethe of Werther, but the later, naturalist, world-ordering sage), our hero, for that is how he is conceived by his addressees and by himself, moves on to Paris — it is 1924! — never to return to his hometown of Brassov in Transylvania, though in 1932 he adopts its name and modifies it for his own. Henceforth he will be the Representative.

Exploring Paris and eking out the life of a journalist (in two languages — Hungarian for the articles he sends to Hungarian papers and magazines in Transylvania, German for those regularly published by newspapers in Munich, Essen, and Cologne, and for caricatures sold to a Berlin paper) by taking on whatever employments fortune proposes (for instance, tracking down old photographs and postcards for collectors) in the fashion of Rastignac and Stephen Dedalus, the young outsider is determined to master the French language; according to the French wife he marries twenty-four years later, he studies French grammar and linguistics for the rest of his life; he lives to the age of eighty-five, and for him art is second nature throughout the decades.

138

(One might point out the analogy to the late Rumanian writer E. M. Cioran, Brassaï's contemporary, who indeed made himself a master of this same third language and became by constant study, as he avows, a great modern French rhetorician; Brassaï, I am certain, would have no such claim made for his writings, though it is my conviction that at least three of his many books are of permanent value as writing, and they are written in French.)

The letters home are good-humored, vivid, lucid, and constitute a sort of diagram of how a Young Man from the Provinces determines to conquer the Metropolis. He is wonderfully abetted by his evident capacity for making friends with remarkable people, and in the course of his Parisian discoveries (of which the sustaining ones, I suspect, are in books; Brassaï is a grand reader, marvelously responsive all his life to apparently all of literature in all its forms!) he decides, by 1929, to buy a camera and isolate, from the prolixity of the real, that vision of life which reveals itself to him in the labyrinth of Paris.

It is in these years that the artist Brassaï is formed. Often accompanied on his Baudelairean, even Dickensian prowls through nighttime Paris by Léon-Paul Fargue, already the insomniac poet and urban memorialist, the "ambulator of Paris" who had been a student in Mallarmé's English class and nonetheless, or perhaps for that very reason, remained the most intensely French of modernist poets; and by Raymond Queneau, the novelist and versifier and critic who was to remain a kind of clandestine eminence of French literature until late in life he conquered a flabbergasted public with Zazie in the Métro, that insolent romance whose demotic heroine is a sort of French Lolita; and soon by another expatriate and another urban memorialist, though one with the perspective of Brooklyn instead of the Batignolles, Henry Miller, Brassaï creates his first images of what Baudelaire so canonically defined as the fourmillante cité, cité pleine de rêves; he sets up a darkroom in his Fourteenth-Arondissement hotel where — henceforth invariably — he does his own developing and printing, and becomes what Miller would call "the eye of Paris," though he cannot take more than twenty-four pictures a night because the photographic plates he uses are so bulky.

Until 1930, the young man had rather condescended to photography — if he was to be any kind of artist, it would most likely be a painter, a sculptor perhaps, or even a writer (and indeed Brassaï would succeed in becoming all of these). Photography — though by this time he had met Atget and had accompanied Kertész, a fellow Hungarian, on assignments — was not, to his mind (as it had not been to Baudelaire's, even in the intimacy of Nadar), an art, though it is important to note that Brassaï already shared Goethe's conviction that an artist might, indeed must, be "gradually elevated to the height of objects."

There is a mystery here, one which even these candid, often euphoric letters cannot quite penetrate, as to how Gyula Halász becomes Brassaï, just as there will be a mystery, one which even the masterful visionary of Baudelairean Paris cannot quite penetrate, as to how Brassaï, "the eye of Paris," becomes the author of Paroles en l'air, Les Artistes de ma vie, and Marcel Proust sous l'emprise de la photographie. The two books on Miller and the Conversations avec Picasso, splendid portraits as they are, are not likely to constitute Brassaï as the significant author he will become by writing, in his later years, those ulterior three works. But the importance of mysteries is that they be accepted as mysteries, not degraded to the level of problems or even solutions. I shall assume that my reader knows the quality and value of Brassaï's images (and of his wonderful film Tant qu'il y aura des bêtes), and that it is not my task to account for the appearance, starting with Paris de nuit in 1932, of the continuously produced great photographic work. Since I am going to discuss further the work of the writer, it is perhaps apposite merely to observe how from the start Brassaï's photographic images were cheerfully accompanied by essays from the pens of such contemporary French masters as the polymath novelist, poet, and travel-writer Paul Morand; the poet, novelist, and playwright Henri de Montherlant; and the film-scenarist and poet Jacques Prévert (only the last, demotic lyricist of the Parisian petite-bourgeoisie, was Brassaï's friend who shared his sanguine vision of the lower depths). Contemporary French literature seized upon the new Parisian photographer as one of its own; indeed, the relation of Brassaï to the Surrealist poets, preeminently poets of the postindustrial city, is so complex that it has not yet been argued to a standstill (rather, only set in motion by Rosalind Krauss, whose exhibition of Surrealist photographs at the Renwick Gallery in Washington, D. C., a few years back, was a revelation of the dimensions photography was to assume in the claims, assumptions, and methods of contemporary thought). Enough to say that long before he had reached the Middle of the Journey, Brassaï was acknowledged by the world of letters as by the world of art as a master, and that he had made magisterial accommodations to the world of commerce, arrangements which would assure him, through his transactions with Vollard, with Skira, as with the editors of Verve and of Harper's Bazaar, as with so many others subsequently, an entirely fruitful and prosperous creative life, one of the most attractive our century has to show. Like Balanchine in New York, Brassaï in Paris became one of the marking artists of his age, the two expatriates readily claimed and acclaimed by the world as reliably supreme artificers.

Though I am eager to accord Brassaï's brilliant and copious portraits of Picasso and Miller (those other expatriates, outsiders forever to be associated with the Paris to which they headed with all the force of bullets from Barcelona, from Brooklyn) whatever praise inheres, these days, to such overheard revelations, these volumes are not the literary achievements I want to salute in Brassaï's production. Let me observe merely — merely! — that they are, in the canon of classical journalism, the finest reportorial portrayals since Victor Hugo's Choses vues. Indeed, they are quite comparable, if we read Brassaï's account of his prowls with Miller among the Parisian brothels and then turn to Hugo's account of a midnight visit to Balzac's house to view the novelist's sudden corpse; and perhaps even superior, when we proceed to the more succinct success of Les Artistes de ma vie, a very late work (1982) consisting of the photographs taken, mostly for Harper's Bazaar, of nineteen painters and sculptors in their studios, usually in the process of making art and apparently undisturbed by the photographer's presence and processes (actually there are twenty studies, for Brassaï has included beautiful portraits of Kahnweiler and of Vollard), accompanied by as many essays which make the book something more than another volume of Brassaï photographs. If I were to name a single work of discursive prose identifying the qualities and character of the School of Paris between the wars, it is this book of Brassaï's, with its informal but grave designations, some of considerable length, others brief but always charged with observation, with what Macbeth calls "understood relations," that I would not only choose but would assign to students already so remote from the makings of that great period. As Anne Wilkes Tucker has remarked, "Brassaï (a serious reader of history and philosophy as well as of literature) could just as easily have written The Writers of My Life and accompanied such a volume with equally marvelous photographs. Pity he didn't!" Perhaps in my eagerness to draw attention to the inclusive achievement of Les Artistes de ma vie, I have been less than fair to Brassaï's Conversations avec Picasso; here, it is Brassaï's own skill at becoming part of the furniture, the ambiance of the genius he is "conversant with," which may have dimmed his authentic gifts as a life-limner. Certainly we feel that no other contemporary can make Picasso heard not from a pedestal, not from the bedside, but uniquely from the easel, the workbench, the potter's wheel. But the very exposures in which Picasso has so vigorously cooperated make Brassaï's version of him less spectacular, necessarily, than the kinds of revelation he more trenchantly provides in the cases, or the constructions, of the artists of his life.

140

figure 19 Hans Reichel, Hôtel des Terrasses, Paris, 1931–32 (catalogue number 68)

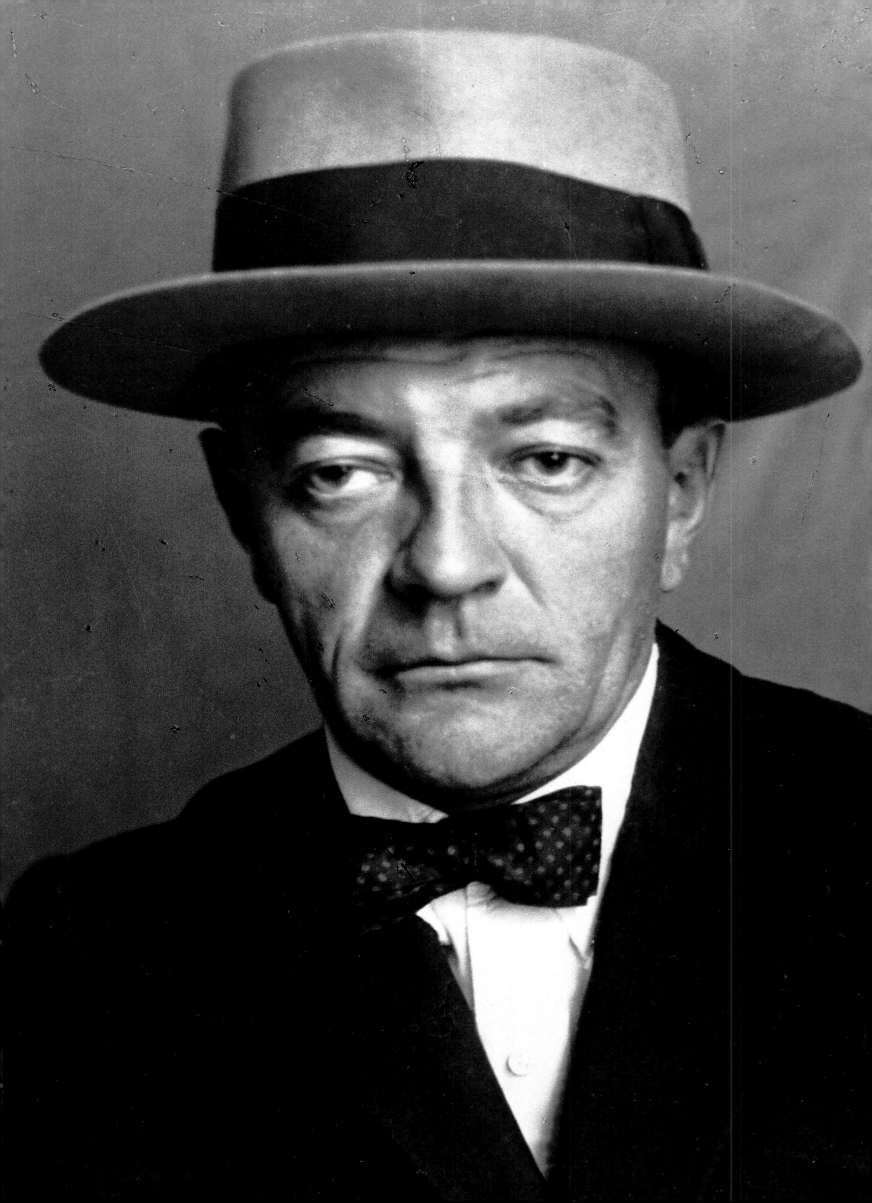

Sometimes, as with the texts on Maillol and Matisse, Brassaï is concerned to correct — properly to focus, one might say — the image of the maker; sometimes he is eager to disinter a buried friend, as in the case of the 1930s portraits-and-text of the forgotten painter Hans Reichel, a companion of Brassaï's earliest time in Paris. Indeed, the intimacy and insight of all the essays is what makes them so much more than reportage, so much more than what we tend to require of journalism: as Brassaï would later remark, it was not a matter of portraying images, but of presenting people in their own light: without any explanation, any psychological analysis, with no stage directions, as it were. This master of lighting is, in his literature, remarkably untheatrical: he is, rather, photographic in spirit, as he puts it in the essay introducing his finest literary texts, Paroles en l'air (1977):

> This "spirit" is not the exclusive property of photography. It existed earlier in the form of the artist's humble attitude toward the world, which was considered greater than his genius. When Goethe, having overcome his youthful romanticism, observed: "I have gradually been elevated to the height of objects," he was no doubt referring to the spirit of photography.

No doubt. And consequently in Paroles en l'air, that extraordinary work of humility, self-effacement, abnegation even, Brassaï offers a handful of recitatives — dramatic monologues, transcriptions of the spoken into the written, literary ventriloquisms — which belong with certain achievements in demotic French culture by Céline, by the contemporary experimental novelist Pierre Guyotat, by Proust himself, of whom more in a moment. These pieces — two uttered en bistrot, the first by a sort of group-consciousness under the Occupation, the second by a drunken clochard at closing-time; one in a taxi by a man demonically possessed by words; and the major piece, "Histoire de Marie" (first published separately with an introduction by Henry Miller), a series of distilled self-revelations by a femme de ménage as harsh, as ignorant, and as eloquent as the Françoise of Proust's A la récherche du temps perdu, and even more at grips with the household bonds of life as they are presented under the Occupation — constitute in their close tracing of voice a special peninsula in the geography of modern French writing. Their accuracy as "character studies," all of which are worthy of the author of "My Last Duchess" and "The Bishop Orders his Tomb" on the one hand (the hand of Demos), and of the author of Claudine and Chéri on the other (the hand of Melpomene) — that accuracy which in its excruciation becomes beauty, is achieved by a focusing of language, a condensation, or as Brassaï puts it, "not a strict copy of reality, but a translation"; Brassaï likes to quote Chekhov as an expression of the spirit of these texts of his, that strangely humble artist who had the greatest pride in a talent that could be conjugated with respect for "the object itself":

> The artist should not judge his characters or what they say, but be only an impartial witness. My role is only to have talent, in other words to know how to distinguish between what is important and what is not, to know how to illuminate my characters and make them speak." These lines by Chekhov express the spirit of photography and express it so well that I would gladly sign my name to them as my own articles of faith. The spirit of photography did not have to wait for Niépce before it could be revealed, but only the invention of photography, its processes, and the photographer's rapport with reality, was able to make visible and intelligible.

It is a splendid article of faith, one that enables us to see why, if not how, Brassaï made himself into the writer he is. But in store for us, in the very last years of the photographer's life, was one further surprise, one ultimate piece of literature, also a consequence of the photographer's dream, which crowns the great edifice of this man's multiple and complex creative energies.

Posthumously published, Marcel Proust sous l'emprise de la photographie (Proust in the Power of Photography) is a lucid analysis of the role of the camera in A la récherche du temps perdu; as Brassaï loses no time in pointing out, Proust's novel is the first great work of literature in which photography and the photograph play a major role, both as a figurant in the text, and as an operator of the text. Notions of cutting, framing, angle, and perspective, and especially the notion of involuntary memory (Proust's Muse) as the latent image to be developed in one's inner darkroom, are here explored with the most diligent concern for the integrity of the narrative itself. As I remarked earlier, Brassaï is a supremely gifted reader, always responsive to text-as-texture, as medium, yet ever alert to the grander consequences of the desire to halt the moment, fixing it forever in that sort of eternity to which Proust found the photograph to be his best guide. In a characteristic gesture of humility and eloquence, Brassaï has produced an invaluable study of Proust and Photography, one which must henceforth be read as closely as those we have so long consulted on Proust and Music, Proust and Philosophy . . . Perhaps the humility is tempered by a certain pride as well, when we observe — as in this closing citation — how readily Brassaï identifies the author of A la récherche with the maker of photographic images:

> Just as the photographer, laden with images he has managed to capture from the visible world, withdraws into the shadows in order to bring them to light, so Proust has elaborated his cloistered work in what he frequently called 'my darkroom'. . . Like Plato's cave, the darkroom of the author of the Search only rarely granted him a direct vision of the world, but thanks to his remarkable visual memory, he could see it all the better, having stored up over the years everything of interest that the world offered to his eyes: flowers, women, girls, boys, steeples, churches, gestures, gazes . . .

A mind as concentrated and loyal as Brassaï's has readily identified what Proust could rescue from distraction, could reprieve only by finding certain repetitions or rhymes in experience. Indeed, Brassaï has discerned in all his works, images, and texts, the scale of values imposed on things by human nature, carried toward some by an innate love and away from others by a quick repulsion. As Santayana put it in 1929, in an early essay on Proust almost as searching as Brassaï's late one, and suggestive of the very qualities we shall find in the literature of this great image-maker, "we could not have asked for a more competent or a more unexpected witness to the fact that life as it flows is so much time wasted, and that nothing can ever be recovered or truly possessed save under the form of eternity which is also, as he reveals to us, the form of art."

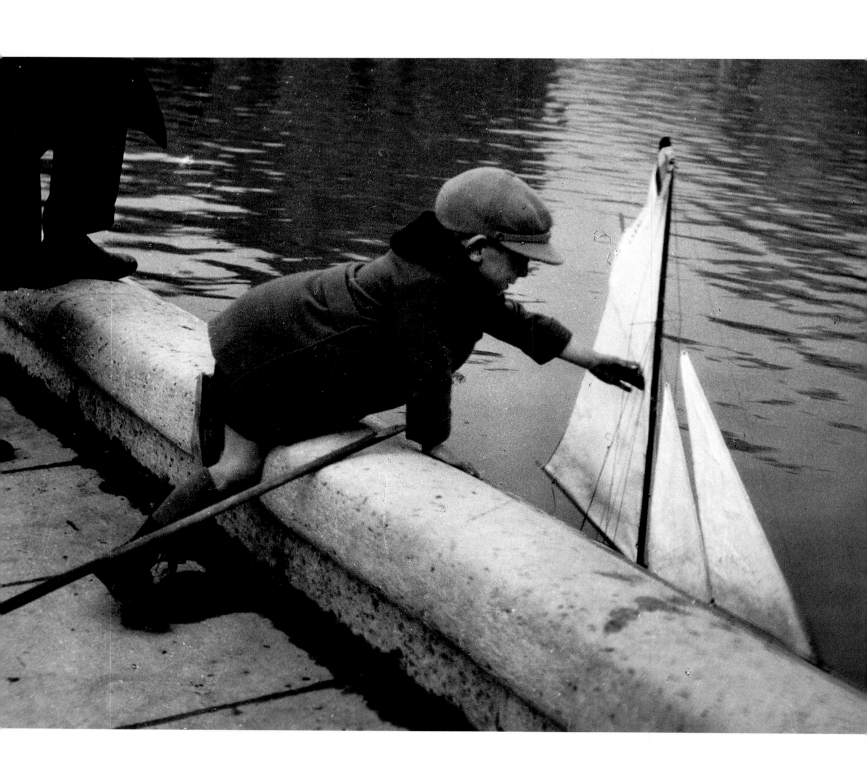

In 1983, I reviewed the English-language version of Brassaï's Les Artistes de ma vie (The Artists of My Life, 1982), for Art News magazine. In June of that year, knowing I was going to France, I sent Brassaï a copy of what I had written, expressed my overall admiration for his work, apprised him of my travel plans, and asked if I might interview him for a profile or other type of article. Brassaï and his wife, Gilberte, liked my review and said that I might pay them a visit, but by the time I got to Paris, they were about to leave for Beaulieu-sur-Mer, the village in the South of France where they would spend part of the year. As I had no fixed agenda, I happily followed them to the Côte d'Azur several days later. The couple received me with great kindness, and Brassaï, perhaps remembering the days when he was a freelance journalist dependent on the good will of others to carry out his assignments, was extraordinarily generous with his time. He spent many hours patiently answering questions, mostly in writing. Afterward, Richard Miller translated Brassaï's responses.

The principal subject of our interview was Paris present and past, particularly the city that Brassaï made a permanent part of our visual imagination. However, a chance allusion I made to early influences and the extent to which photography can be taught led Brassaï to describe, to a greater degree than in any previous commentary, his relationship with his colleague and fellow Hungarian in Paris, the photographer André Kertész (1894–1985). Their rift is famous in photography circles and, to my knowledge, Brassaï's side of the story — disputing claims that Kertész introduced him to photography, lent him a camera, and let him use his darkroom — has not been published before. Brassaï also discussed formal issues that were important to him, but in looking back over these pages what I also found to be of interest was Brassaï's understanding of the similarities between high society and low life, which he anatomized in his photography and writings with the same profusion of visual and literary detail, of lingering sights, smells, sounds, and sensations. It is no wonder that his favorite author was Marcel Proust. Brassaï's limpid yet probing style as both photographer and writer, as well as his gifts as draftsman and sculptor, created a fluidity across disciplines. As a young man, he was writing and painting long before he picked up a camera, and all his life, as is apparent in this interview, he easily drew analogies and uncovered correspondences between one art form and another. Brassaï never mentioned a familiarity with Henry James, but I am positive that he would have agreed with James when he said that "the arts are one, and with the artist the artist communicates."

What, if anything, is left of Brassaï's Paris — its atmosphere, its topography, its people?

Like some of those eleventh- and twelfth-century Romanesque churches that were topped with Gothic towers and spires in the thirteenth or fourteenth centuries and whose interiors were later refurbished during the Renaissance, I carry three quite distinct, superimposed images of Paris in my head — the Paris of the turn of the century, the Paris of 1924, and, finally, the Paris of today.

Around 1903–4, when I was four or five years old, I spent a year in Paris. My father was a professor of Hungarian and French literature, and he had completed a large part of his studies at the Sorbonne. He was also a writer, and in 1903 he was granted a year's sabbatical from teaching to come to Paris. He brought his family with him — my mother, me, and my brother, who was a year younger than I.[1] So I spent an entire year living as a little Parisian in Paris. We lived in the Latin Quarter in a pension near the Panthéon, and while my father attended lectures at the Sorbonne or at the Collège de France, we would wait for him in the Jardin du Luxembourg. My little brother and I, equipped with long poles, would push miniscule boats around on the great round pond, on which a whole flotilla of toy sailing craft would always be drifting to and fro in the breeze — or we would play with diabolos,[2] which were the fashionable toy in those days. figure 20 First Boat, Luxembourg Gardens, Paris, c. 1930. 7 x 9 5/16 inches (17.8 x 23.7 cm). The Museum of Fine Arts, Houston, museum purchase, 94.377. © Gilberte Brassaï

I have so many memories of that 1900 Paris, the Paris of Marcel Proust, of carriages, of men and women dressed in riding habits. Along the Champs-Elysées at that time there wasn't a single café or restaurant, nothing but private mansions and a great flowing river of vehicles coming down from the Avenue du Bois de Boulogne — now the Avenue Foch — through the Etoile and down the Champs-Elysées to the Place de la Concorde and then back up again — and all those cabriolets, calèches, phaetons, tilburys, victorias, and coaches moved to the constant clopping sound of countless horseshoes. Aristocrats, wealthy bourgeoise, "grandes cocottes," all displayed their fortunes in the beauty and elegance of their carriages.

By that same route, from the Place Dauphine to the Elysée Palace, sovereigns on state visits to France would travel through Paris. From a vantage point on the Champs-Elyseés I saw the arrival of King Alfonso XIII. The avenue was a sea of people, and tables, chairs, and even ladders had been rented out to provide a better view of the royal procession. Space at many windows and on balconies lining the route had also been rented at exorbitant prices. From atop a ladder my father had rented for us I saw the open carriage bearing the King of Spain and President Emile Loubet go by, escorted by officers of the Garde Républicaine on horseback. To tell the truth, I only caught a quick glimpse of the great men through the glittering breastplates of their escort, because they went by at considerable speed — those were the days of the anarchist assassinations. As a matter of fact, a few days later, a bomb that had been concealed in a bouquet of flowers was tossed into the royal landau. Oddly enough, that attack did not discourage my parents on another evening from standing among the crowd to watch the king's departure from the Opéra, which was hung with Art Nouveau garlands and lit with thousands of lights. However, since my father never lifted us up until there was really something to be seen, we found the waiting very unpleasant; we were almost smothered among the vast 1900s skirts, and our impatience made us so cranky that my parents decided to take us home. And that evening too, only a few minutes after we had left, there was a bombing. The crowd panicked, many were hurt, children were trampled, and a few people were even killed. When they saw the big newspaper headlines, our parents exclaimed, "The children must have sensed that something was going to happen!"

I can also remember the heavy traffic on the Grands Boulevards, where, in addition to carriages and cabs, there were also omnibuses. To climb the spiral stairway to the open top deck of the omnibus that went from the Madeleine to the Bastille was an endless delight for us. From that dizzying height we could gaze down upon the teeming boulevards and all the different kinds of conveyances. And crossing the street — that was a terrifying experience, because the movements of horse-drawn vehicles were much more unpredictable than those of automobiles. The traffic policemen waved their white sticks to stop the traffic, but there might always be some horse that could disobey and charge into the crowd of pedestrians. One day my brother and I were almost trampled like that as we crossed the Champs-Elysées. Luckily we only lost our stiff black leather caps, which were smashed to bits by the horses' hooves. The lady in the carriage could easily have been the Comtesse de Greffuhle or Comtesse de Chevigné,[3] two of the several models for Proust's Duchesse de Guermantes.

It was also along the Grands Boulevards that I first encountered the cinema, then in its infancy. The movies are almost the same age as I am. You could see them then in the windows of some of the big department stores, and they created real pedestrian traffic jams along the sidewalks. First, there would be a few advertising stills flashed onto the screen, and then suddenly a short film would come on. When I recall how clever and how magical they were, it occurs to me that they might possibly have been the work of the famous illusionist, Georges Méliès.[4] There was one with a milliner carrying some hatboxes, and she would sit on a bench, put down her boxes, and doze off. One of the boxes would then burst open, and fairies would emerge to dance a sarabande. When the milliner slowly awakened, they would return to the box. Whenever we happened upon one of these street movies, it was impossible to tear us away. We would patiently watch all the endless advertising photos and await the film. I remember another one, too, as though it were yesterday, whereas it was really eighty years ago: a bald man bought a salve to make his hair grow. Before going to bed, he shined his shoes and massaged some of the salve into his scalp. But he gets the jars mixed up, and in the morning he wakes up to find his scalp turned as black and shiny as a silk top hat, and his shoes sprouting a luxuriant crop of long hair!

One of the most vivid impressions I have of that year in Paris is of Buffalo Bill's mammoth circus, which was set up at the base of the Eiffel Tower on the Champs-de-Mars.[5] The show was marvellous, but when it was over I had a terrific headache. There were Hungarian csikos on their puszta steeds, American cowboys with lariats, Turks who scaled walls, and Chinese who stood on their shaved heads and rolled huge barrels around with their feet. All the entertainers hollered and fired guns. The noise of the explosions, the galloping horses, and the reek of gunpowder all made my head whirl. The show was far too brutal for a child of my age, and my nerves were jangling. And I also saw Buffalo Bill in the flesh. He fired at bits of coal tossed into the air; he never missed — he hit some of them by aiming through a little pocket mirror and shooting behind his back. The next Sunday we went up the Eiffel Tower and saw the show a second time, but this time from above. From a bird's-eye view the circus was more peaceful, and I was also able to see the herd of bison and follow everything that was going on in all three rings of that vast arena.

That turn-of-the-century Paris was the one in my mind's eye when I returned in 1924 to the heart of Montparnasse, where the Roaring Twenties were in full swing and where they continued to roar until Black Thursday, 1929, after which they slowly fell silent. Of course, I did not find the Paris of my childhood. With the exception of the iceman's cart and the carts of the fruit merchants with their Jaffa oranges, Paris was almost totally empty of horse-drawn vehicles. Top hats had disappeared as well. Some men still wore bowler hats, but most went bareheaded. As for the women, [Paul] Poiret and Gabrielle Chanel — "Coco" — had freed them from the corsets that held their bodies prisoner. And the famous hairdresser, Antoine, had created styles that enabled women to dispense with wearing hats, even in the evenings, for the theater or dinner.

In those days I lived in the heart of Montparnasse, where the two big cafés, the Dôme and the Rotonde, still drew artists from all over the world. At the time I frequented them, however, Picasso no longer came, although he had in the past. This was in February of 1924. I had tried to come to Paris earlier, but Hungary had been at war with France and I had had to wait. That was why I went to Berlin first, instead of going to Paris, and I lived there for two years. Those were the days of the Expressionists, and I became well acquainted with several artists I was later to meet in Paris — Kandinsky and his wife, Oskar Kokoschka, and the Russian painters [Mikhail] Larionov, [Natalia] Goncharova, and Ivan Puni.

In my book Henry Miller grandeur nature (Henry Miller, Life Size), which hasn't been published in the United States, I wrote about the Montparnasse of that period:

> How this corner of Paris, devoid of charm, in no way picturesque, with its dull middle-class apartment houses, became the center of attraction for intellectuals the world over, the breeding-ground for every cultural and social revolution, is a mystery. But it is a fact that during its heyday, the word Montparnasse had such a glowing magic that for years afterwards you could still attend the daily party Paris held just outside the pure Art Nouveau entrance to the Métro at the Vavin stop. Even middle- and upper-class people in search of joy and pleasure were gradually drawn to this zone of euphoria, freedom, nonconformity.[6]

Following the first two cafés, the Dôme and the Rotonde, others soon opened: the Select, where male and female homosexuals congregated, then the Petit Napolitain, and, in 1927 — a great event in the Montparnasse saga — the vast café-brasserie, La Coupole. Soon Montparnassse acquired its first nightclub, Le Jockey, on the Boulevard, where Kiki, chanteuse of extraordinary verve and charm (she was Man Ray's mistress for several years) held forth, and soon became the acknowledged queen of Montparnasse.[7]

But to come back to the look of Paris in 1924, along with the horses and carriages, the omnibuses were gone, too, replaced by trolley-cars that glided along on rails; electricity had begun to replace gas street lamps. Those gas lamps had given off a far lovelier light, one with a tender blue tint, and the light of the electric bulbs was yellower. In those days the districts of Paris had more character, and some of them — Auteuil, Passy, Belleville, Ménilmont — still seemed like villages. But Paris gradually absorbed them all.

Like their neighborhoods, the people also had more personality, and their dress reflected their means of livelihood: there was a special costume for butchers, for confectioners, for bakers. Petty crooks and pimps proudly sported cloth caps and frequented particular streets, like the Rue de Lappe near the Place de la Bastille, or the Rue des Lombards. The police always knew where to look for them.

Paris was still a very lively city in those days. Lower-class dance-halls — bals-musettes, they were called — flourished. There were also huge carnivals, fêtes foraines, and itinerant amusement parks with sideshows, roller-coasters, menageries, shooting galleries, and so on, which moved to a different neighborhood each month and would show up every year back at the same place. The Champs-Elysées was already lined with cafés and movie palaces. The café terraces were always packed. Night life was very active then. However, television has emptied the streets little by little. Theater has come into the home. Paris still had a few of its traditional celebrations then — the Mardi Gras parade, for example, which traversed the Grands Boulevards with flower-decked floats and beautiful girls — one float at Mardi Gras used to be reserved for a huge steer. All of that was gradually ruined by all the automobiles and the heavy traffic they created.

When I arrived in Paris, I had every intention of renting a studio and devoting myself to painting, drawing, and sculpture, but life itself was so interesting that I couldn't make up my mind to go into seclusion with only my own company. For years I led a bohemian life, I lived a nocturnal life, spending my nights in the Montparnasse cafés, meeting people, making friends. When the cafés would close around two or three in the morning, we would go back to someone's apartment or room, or back and forth, hanging out until dawn. It was in crossing the city hundreds of times at night that I discovered the beauties of nocturnal Paris.

Yet contrary to what you may think, pure chance had nothing to do with my taking an interest in photography in February of 1930 at thirty-one years of age, at a time when I had never before held a camera in my hands and even in a way looked down on photography as something almost contemptible and foreign to any artistic expression.[8]

Still, one had to make a living. So I turned to journalism and regularly began submitting articles about Paris to various Hungarian and German newspapers, for in those days my German was fluent. Around this period, 1928–29 and 1930, the first big illustrated magazines were just beginning to appear in the larger German cities, and they paid their contributors much better than newspapers did. Some of these forerunners of Life were the Münchner, Berliner, and Frankfurter Illustrierte. Those paid the most.

These articles had no literary or artistic value. For the most part, they dealt with whatever odd or amusing topics that might entertain the readers of such magazines. For example, I did one on Paris's dog cemetery, which was situated on an island in the Seine; it had tiny tombs for cats and dogs, and it also contained the tombs of a monkey, a lion, and even some chickens whose owners had come to love them and, rather than eat them, had purchased leases for their plots, which cost them a small fortune. All the tombs bore touching inscriptions: "To my beloved Lou-Lou, faithful companion of my life, from her inconsolable mistress." I also had pictures taken of two of the large monuments that grace the cemetery, one erected by Princess Lobanoff to her three departed dogs, and the other the effigy of a Saint Bernard with the inscription: "He saved the life of thirty-two persons and the thirty-third took his."

It wasn't hard for me to find subjects to write about that interested me, but obviously my articles required illustration and I had never had a camera in my hands. I had a kind of aversion to photography and looked upon it as something aside from true art. So for each topic, therefore, I would call upon one photographer or another, telling him the pictures I wanted him to take for me.

Since I was acquainted with André Kertész, an excellent photographer who rapidly made a success in France after his arrival from Budapest, I invited him to collaborate with me on several of these articles. I asked him to make photographs according to my instructions. I shared my fee with him for any articles that were published. Because I have kept these published articles, I have been able to verify that seven of the topics were done with Kertész's collaboration.[9] These appeared in Die Münchner Illustrierte Presse (Munich), Die Kölnische Illustrierte Zeitung (Cologne), and Die Illustrierte (Essen), signed as follows: text by Brassaï, photographs [by] Kertész.[10]

Let me mention just one or two of these half-dozen or so subjects: there was a man in Parisian society who was a great horse fancier and who had had a private circus built on his property in the Rue de la Faisanderie for his private pleasure. It was called the Cirque Molier. Once a year he would give a performance to which he would invite all the great aristocrats. The various acts were performed by barons, counts, and marquises, and all the women who appeared were vice-countesses and even some duchesses. At the Cirque Molier some young high-society ladies even appeared in tableaux vivantes more naked than any nude showgirl at the Folies-Bergère.

Another collaborative article was devoted to the celebrations for the fortieth anniversary of the Eiffel Tower, and it was also published in a French illustrated magazine, Vu, which had just begun to appear.[11] In writing that text, I went into the history of the Eiffel Tower, which had resulted from a contest to "Build a 300-meter-high tower with a metal frame" to serve as the symbolic centerpiece of the 1889 World's Fair. Gustave Eiffel won the competition. However, I found it diverting to compare the various submissions: one of the contestants had proposed a metal elephant some 200 meters high with a 100-meter-high tower on its back. Even Eiffel's proposal was quite different from the tower that was eventually built. Wind-resistance calculations, etc., considerably altered the shape of its curves. I also learned something that is little known: that Eiffel had built a small apartment for himself at the very top of his tower, where he enjoyed relaxing, 300 meters above Paris. There, the monarchs and heads of state who visited the tower were received, and there they would sign the visitors' book while quaffing champagne, bottles of which were stacked on the metal steps of the circular staircase that rose through the room and that had been made into shelves. I also instructed Kertész to photograph this room.

On the second floor of the Eiffel Tower was an amusement-park photographer. Clients stuck their heads through an oval hole in a huge cardboard cutout of the tower with the inscription, "Souvenir of my ascent." Kertész took a picture there of the photographer taking a photograph of me, and that picture was printed along with the French version of my article.

So one can understand the notion that I became a photographer in order to illustrate myself my own articles intended for the German magazines. But that was not at all the case. I have found only four such articles illustrated by my photographs. I regarded my fairly negligible connection with the German magazines as nothing more than a stopgap way to make some money, one I hoped to abandon as soon as possible.

Kertész's pictures played a part in decreasing my own aversion to photography, but — in spite of what has been written[12] — he never lent me a camera and I never worked in his darkroom. I have always recognized, both verbally and in writing, my debt to Kertész and how his photographs stimulated me, so much so that they helped me overcome my initial antipathy toward photography. However, to say that I was his student, as he sometimes asserts, or that I worked in his laboratory, or that he lent me a camera — those are legends . . . for which I myself may in part be responsible. In his introduction to the slim volume devoted to me, published by the Museum of Modern Art, Lawrence Durrell writes, as though quoting my words, that Kertész lent me one of his cameras.[13] Durrell had submitted that text to me, but in the press of time I was unable to read it thoroughly. And in those days my English was shaky, and that is how this error came to remain in the text, an error that I must hereby rectify. First, a woman of my acquaintance lent me a small, nonprofessional camera. Then I bought a Voigtländer 6 x 9 centimeters with a Heliar lens, and since I had little money, I bought it on an installment plan, paying for it over two years. I was renting a room in the Hôtel des Terrasses (at 74 rue de la Glacière, in the thirteenth arrondissement), and the owner of my hotel served as cosigner.

When I began taking photographs, around February 1930, it was not to illustrate the articles I was writing for German magazines, but to fix all the beautiful images of nocturnal Paris that had struck me during my nighttime rambles from Montparnasse to Montmartre. I realized that photography was the only means by which I could achieve what I wanted, so I took it up seriously. In order to acquire a photographic technique I bought books, and in order to develop the negatives and print, I rented another room in my hotel, which I set up as a darkroom. For months and months I shot only nighttime photographs and spent all of nearly every night out, often not returning until daybreak. Gradually I improved my technique, and I learned what the best atmosphere was for night photography. In dry weather the street lamps stood out too harshly against the darkness of the background. On the other hand, a light mist softened them and gave them a kind of halo. I also learned that nighttime pictures were better taken in the autumn or winter, and never in the summer.

I should add that I never took inspiration from Kertész's photos — my ideas were quite different. For that matter, I do not find any similarities in our works, which have quite different characteristics. Let me add another word with regard to Kertész. Once, when we (Gilberte was with me) were debarking from the Île de France, there — among other people — was André Kertész. When I asked him, "How are you?" he replied, "I am dead . . . In the United States . . . nobody knows my name or my work; you are talking to a dead man . . . Let me tell you what has happened to me in this damn country." And he told me that instead of working for Vogue, as his contract had provided, he had been photographing houses and apartments for House and Garden. "Liberman tricked me," he told me. "I've become his slave . . ."[14]

Some years later, in Paris, I ran into Roméo Martinez, the editor-in-chief of Camera magazine, which was published in Switzerland in four languages: French, English, German, and Italian. I told him about the low spirits in which I had found Kertész in New York. Whereupon Martinez said to me, "Brassaï, if you feel like writing an article about Kertész, I will devote a special issue to him." I accepted his proposal with pleasure.

Under the title "Mon ami André Kertész," my article was published in the special issue of Camera in April 1963, with certain changes in my text. I do not exaggerate when I say that that date represents an important, if not decisive, turning point in Kertész's life and career, as he himself has proved by the numerous letters of thanks he wrote to me. Shortly after the publication of that text, he had a show in Venice, organized by Martinez,[15] and another in Paris at the Bibliothèque Nationale in November 1963, and in 1964 [John] Szarkowski also had a show of Kertész as photographer at the Museum of Modern Art in New York.

This great photographer would most likely have been discovered within a few years even without my article, but I do not know how many years — perhaps even, as happens so often, not until after his death. However, talent and character are two different things. Instead of being grateful to me for having resuscitated the self-professed "dead man," Kertész succumbed to an odd jealousy. I telephoned him in New York, but he refused to attend the opening of my show, Secret Paris, in 1976, and also refused to meet me.

I have really allowed myself to go on at undue length in replying to your question, but I cannot get over this behavior of Kertész's, which I regard as a sign either of immense stupidity or of some kind of betrayal, but which, above all, has been a disappointment to me. figure 21 Brent Hannon, American, born 1931. Portrait of Brassaï in Front of His panel at UNESCO, 1958. 5 3/4 x 9 3/4 inches (14.6 x 24.7 cm). The Museum of Fine Arts, Houston, gift of Gilberte Brassaï, 94.354.

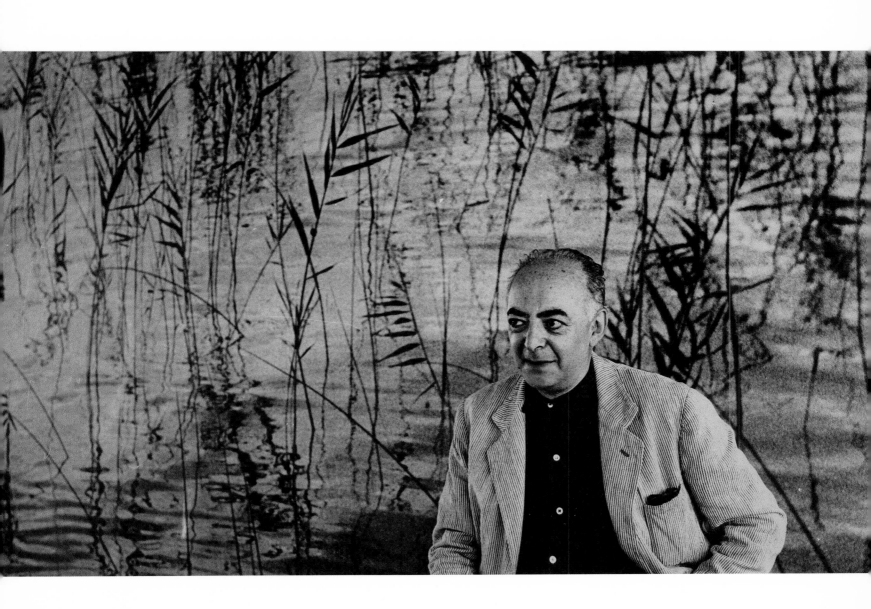

What parts of Paris have remained about the same?

The unbelievable increase in the number of automobiles and the ensuing heavy traffic gradually began to eat away like a cancer at the body of Paris. Cars even prevent people from being able to see the architectural beauties of some parts of Paris — the Place de la Concorde, for example, or the Place Vendôme or the Place des Vosges. To this automobile disease, which is even destroying the banks of the Seine now, since cars can drive on both the left and right banks, I have to add another, no less serious, malady: poured concrete buildings. Some streets have been completely disfigured by these buildings. The Bal Bullier, which was in a way the Moulin Rouge of the Left Bank — a dance-hall where for years artists used to hold huge parties with a parade of nude models and an election of a queen — has been replaced by a huge new building that has totally ruined the harmony of the street. In Paris many similar crimes have been committed, destroying the beauty of so many old streets. Parisians should have preserved the look of their old city and — instead of erecting new, poured-concrete buildings — it would have been better to replace the old with the new, matching buildings, or even to have kept the old façades and rebuilt the interiors. Nor do I think the construction of high-rise towers like Manhattan skyscrapers was a good idea. They don't belong around the Place d'Italie or along the Seine or where the Gare Montparnasse used to be, but outside of town, on the outskirts, at La Défense, for example, where you can have Wall Street-style towers without destroying the surrounding neighborhood. In reply to your question, however, what remains of the Paris of yesterday, I guess, is the parks: the Jardin du Luxembourg and the Tuileries, and a few old streets that have by some miracle escaped the "innovative" architects.

Do you now see Paris in a remote way?

Yes, compared to my childhood memories, and even compared to the Paris of 1924, when I returned.

If you were photographing Paris today, what would you concentrate on?

152

Today I would photograph young people on bicycles or motorcyles — in their round, multicolored helmets they look like Martians.

A few of the young photographers take pictures of Paris today by night, but they do it in color. The ones I have seen do not evoke the atmosphere of Paris at all.

Is there a young photographer in Paris now taking pictures of Paris night life in the same pungent way you did?

No, because the bals-musettes, where the real young toughs used to hang out and dance, have all vanished or have turned into tourist attractions that are included on those "Paris by Night" bus tours. Underworld figures no longer wear cloth caps: they dress like everyone else and patronize the bars on the Champs-Elysées, along the Grands Boulevards or in Montmartre. The police's work of finding criminals or crooks has thus become a great deal more complicated. As for "ladies of easy virtue" who used to hang out in the bals-musettes too, they have abandoned their characteristic hairdos, their spit-curls, and nowadays they too prefer to patronize bars in the more elegant parts of town or to work as call girls.

And life at night has become almost as dangerous in Paris as it is in New York. Many men and women are mugged — women have their purses snatched in the street, in parking garages, in the subway corridors. And many women are being raped in parking garages when they have ventured into one of them alone.

How have your views about the Paris underworld evolved? At the time [in the 1930s], did you find yourself becoming sympathetic to your subjects? How did you judge them?

In order to take pictures in such secret and out-of-the-way surroundings, where people were so suspicious, you had to gain people's trust and make them like you. I always had a lot of respect for them, however they made their money. I even fell in with a gang of crooks who stole my wallet once. That upset me a great deal, particularly because there were important papers in it, but I didn't report it to the police because, after all, stealing was their profession.

Did any of the people who were in the photographs see them and get in touch with you?

Yes — I often gave them photographs to get them to trust me.[16]

When you were a young photographer, did you have any trouble seeing where you were going?

I was never a "young photographer." I took my first pictures around February 1930, six years after my return to Paris, and since I was born in 1899, I was then 31 years old. As I said earlier, I became a photographer in order to fix the nocturnal beauties of Paris, to preserve them.

Do you recall what your first pictures were?

I began by taking pictures at night along the banks of the Seine, the Pont des Arts, with a small, nonprofessional camera that a woman I knew had lent me. Then I bought a German camera, the Voigtländer, with an excellent Heliar lens. It was a glass-plate camera (film had not yet appeared) and it was fairly all purpose, with a double extension that enabled you to photograph small objects as well, and if you removed half the Heliar lens, you could get close-ups of very small objects. Using this capability, in those days I photographed several insides of flowers, the inside of a tulip, for example, the pistil surrounded with pollen globules, or a candle flame or even a large dew drop on a nasturtium leaf.

However, I soon abandoned playing with my camera's capabilities and went back to taking pictures at night. In those days I only photographed scenes of the city asleep — pictures of the Place de la Concorde taken from the terrace of the Hôtel Crillon, the nocturnal aspect of the clipped rows of trees in the Jardins du Luxembourg, many shots of the bridges and trees along the Seine, but no human beings, either indoors or out. I then began to go further afield, to outlying neighborhoods like Belleville or Ménilmontant, and I took pictures by the Canal de l'Ourcq and the Bassin de la Villette, in which that part of town looks just like somewhere in the nordic, Flemish countries.

You reached an extraordinary degree of excellence very early on. How did you do it?

As I have said, I took photography seriously — I bought a lot of books, because it is very important to acquire the photographic technique; it has a great effect on one's own vision. A good photographer does not see a subject, but the photograph he can get of it. In Mozart's head, for example, what his ears heard was not a bird's song, but that song already transformed into musical expression. An amateur without technique is often disappointed when the image he gets is not like the subject he photographed.

When you arrived in Paris in 1924, you came as a journalist, a profession that you said you disliked. But your books show you to be a keen observer who took splendid notes and wrote beautifully. These are primary requirements for a journalist. Therefore, what aspects of journalism conflicted with your personality and ambitions?

To repeat: I worked as a journalist only to earn a living. There is a positive side to having a talent for journalism: you have a curiosity about everything — you're a good observer and can capture whatever is or seems to be interesting. But there is also a negative side — that entails remaining superficial, not going deeply into things. It's because of this superficiality that I did not like journalism as a profession. I never wanted to become a news photographer, or a photojournalist who shoots the surface of things and pursues the ephemeral. There are many good photojournalists who have a sense of what is interesting and their candid shots are newsworthy and the public likes them, but their photographs are still ephemeral because they lack a further gift, that of form. The composition of a photograph is very important, not because of any aesthetic considerations, but because only a picture that is well composed can enter into the memory. Composition is vitally important in a photograph, in the same way that aerodynamics is essential to the design of automobiles or airplanes. My ambition was never to capture interesting things, but to capture things as such, to immobilize them in some immutable, definitive, final way. What characterizes a good photographer is that he has both that journalistic sense (he seizes whatever is interesting in the world) and, at the same time, the sense of form. For me, the criterion of a good photograph is that it be unforgettable.

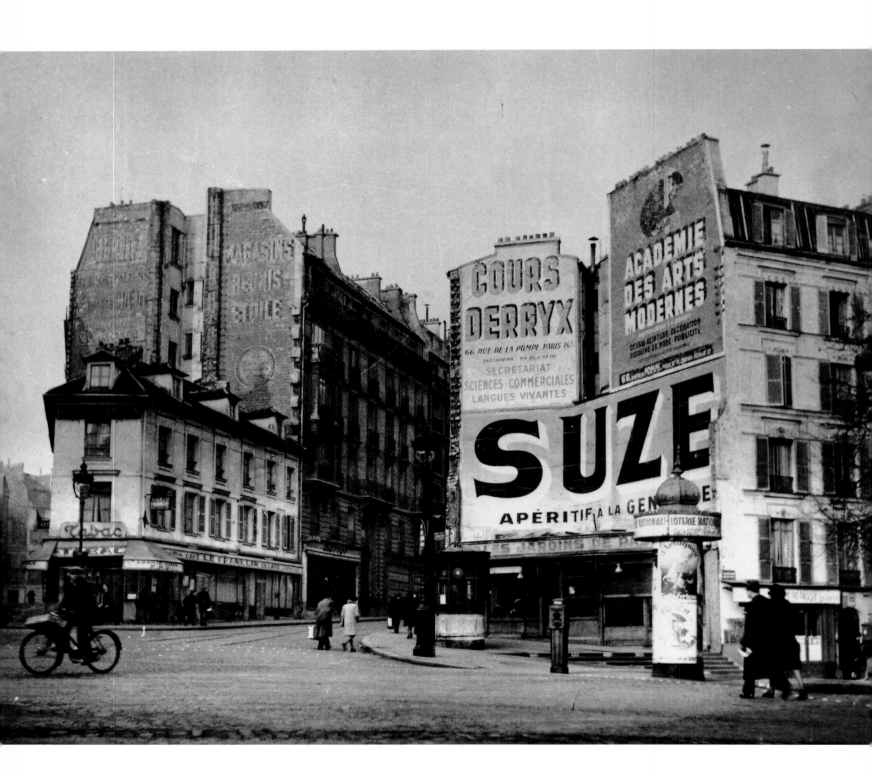

Notes

1 Here, Brassaï is referring to his brother Kálmán because his brother Endre was fourteen years younger than Brassaï.

2 A spool or top that is spun on a cord tied to two sticks, tossed in the air, and then caught again on the cord.

3 Comtesse Élisabeth de Greffulhe (1860–1952) was one of the supreme beauties of her day. As the wife of the immensely rich Comte Henri de Greffulhe and born the Princesse Élisabeth de Caraman-Chimay, who could trace her ancestry to the Merovingian kings of France, she was a queen of Parisian society for decades. Comtesse Laure de Chevigné (1860–1936) was the wife of Comte Adhéaume de Chevigné, a gentleman-in-waiting of the Comte de Chambord, the Bourbon pretender to the throne of France. Her family was distinguished, too. The former Laure de Sade counted among her ancestors Laura, to whom Petrarch wrote his sonnets, and the Marquis de Sade. Both women's looks, bearing, and elegant couture fascinated Proust in his youth, and he would often wait in the streets or attend certain events just to catch a glimpse of them.

4 Brassaï guessed that these short comedies were by Méliès (1861–1938) because Méliès, a professional magician who began making films in 1885, was a pioneer in trick cinematography. He combined illusion, humorous burlesque, and pantomime to treat scenes of fantasy in a playful fashion. However, in the course of her research, Anne Wilkes Tucker discovered that the films were the work of Auguste (1862–1954) and Louis (1864–1948) Lumière, the founders of French cinema.

5 William F. "Buffalo Bill" Cody (1846–1917), scout, Indian fighter, and showman extraordinaire, organized his first touring rodeo spectacle in 1883. In 1887, he took his Wild West show to England, where it was attended by Queen Victoria. In April of 1889, in conjunction with the Exposition Universelle, Cody and his troupe sailed for Paris, for a triumphant engagement of seven months. The show was haunted by artists, including Gauguin, Munch, and Rosa Bonheur. From then on, the Wild West show became an international institution and returned frequently to the French capital.

6 The book was first published in France in 1975 and then issued in the United States in 1995 as Henry Miller: The Paris Years; it was published by Arcade and translated by Timothy Bent. This quotation appears in a slightly different version on p. 9 of the volume.

7 Kiki, whose real name was Alice Prin (1901–1953), was equally legendary as a model and muse; she also painted and wrote her memoirs. Brassaï devoted a chapter to her in The Secret Paris of the 30s (New York: Pantheon Books, 1976, translated by Richard Miller). A more thorough treatment of her life can be found in Billy Klüver and Julie Martin's Kiki's Paris: Artists and Lovers, 1900–1930 (New York: Harry N. Abrams, Inc., 1989).

8 Brassaï has submitted both late 1929 and early 1930 as the beginning of the period when he began to photograph. For a full discussion of this matter, see Tucker essay in this book.

9 For a full citation of these seven articles, see bibliography in this book.

10 Many of these articles were republished in French magazines, and at least one article, celebrating the fortieth anniversary of the Eiffel Tower, was published under another of Brassaï's pseudonyms, Jean d'Erleich. For a detailed discussion of Brassaï's use of pseudonyms, see Tucker essay in this book.

11 Founded by the editor Lucien Vogel, Vu was first published in 1928. It was planned as an exciting pictorial weekly, and it quickly emerged as a showcase for innovative photography. Not only Kertész, but also Brassaï, Man Ray, and Germaine Krull would be published there.

12 Most recently, in the important exhibition catalogue André Kertész: Of Paris and New York (Chicago: The Art Institute of Chicago, 1985), David Travis, in his essay "Kertész and his Contemporaries in Germany and France," wrote that "once or twice [sic] he [Brassaï] and Kertész worked together as a team before Brassaï himself became a photographer. When he did, around 1930, it was Kertész who taught him" (p. 80). In the course of a review ("A Novel's Worth of Complexities in a Single Frame") in The New York Times on March 21, 1993, the photography critic Vicki Goldberg wrote that Kertész lent Brassaï a camera.

13 In his introduction to Brassaï (New York: The Museum of Modern Art, 1968), the catalogue accompanying the photographer's retrospective, Durrell stated that Brassaï wrote of being at a loss about how to capture the powerful images of Paris at night. "My friend André Kertész," Durrell reported Brassaï as writing, "broke the spell by lending me a camera; I followed his advice and his example" (p. 12).

14 The artist and designer Alexander Liberman, whom Kertész first knew in Paris when he was art director of Vu, was appointed art director of House and Garden in 1946. Later, he became the editorial director for all Condé Nast magazines. According to Weston Naef's essay, "André Kertész: The Making of an American Photographer," in André Kertész: Of Paris and New York, Kertész first worked for House and Garden in 1938, but between 1941 and 1944 he did not solicit any magazine assignments. In 1945, he started freelancing for House and Garden, and Naef reports that he "seemed genuinely to enjoy" the assignments he received (p. 117). In 1946, Kertész was offered and accepted a well-paying contract from Liberman to work exclusively for House and Garden, and there is no sense that any trickery or misunderstanding clouded the agreement. Although, as Naef points out, Kertész would have shot a smaller variety of subjects than if he had remained a freelance photographer, the job also let him travel extensively throughout the United States and Europe at the company's expense. Kertész worked for House and Garden until 1962; clearly he elected to renew his contract with the magazine several times. It was only late in his tenure at Condé Nast that Kertész began to complain that he had wasted his life.

15 The IV Mostra Biennale Internazionale della Fotografia, at which Kertész was awarded a gold medal.

16 For a discussion of Brassaï's relations with the inhabitants of the demimonde, see The Secret Paris of the 30s. In the introduction to this book, Brassaï describes the risks involved in frequenting the underworld. He gained its members' trust up to a point, but any intimacy was temporary, strained, and necessarily expedient. His fragile rapport with various criminals was disrupted several times by thugs threatening his life. At least three times, money, cameras, and, early on, a bag full of glass-plate negatives were stolen from him. In another chapter, on the genesis of his famous image La Môme Bijou, Brassaï recalls that after his photographs of the monumental old woman were included as part of Paris de nuit in 1932, she presented herself in the publisher's office and refused to leave until she had been paid for such an "insult." However, as Brassaï concluded, "Thievery for them, photographs for me. What they did was in character. To each his own."

155

figure 21 Intersection of Passy and Tour Streets, Paris, 1940 (catalogue number 113) © Gilberte Brassaï

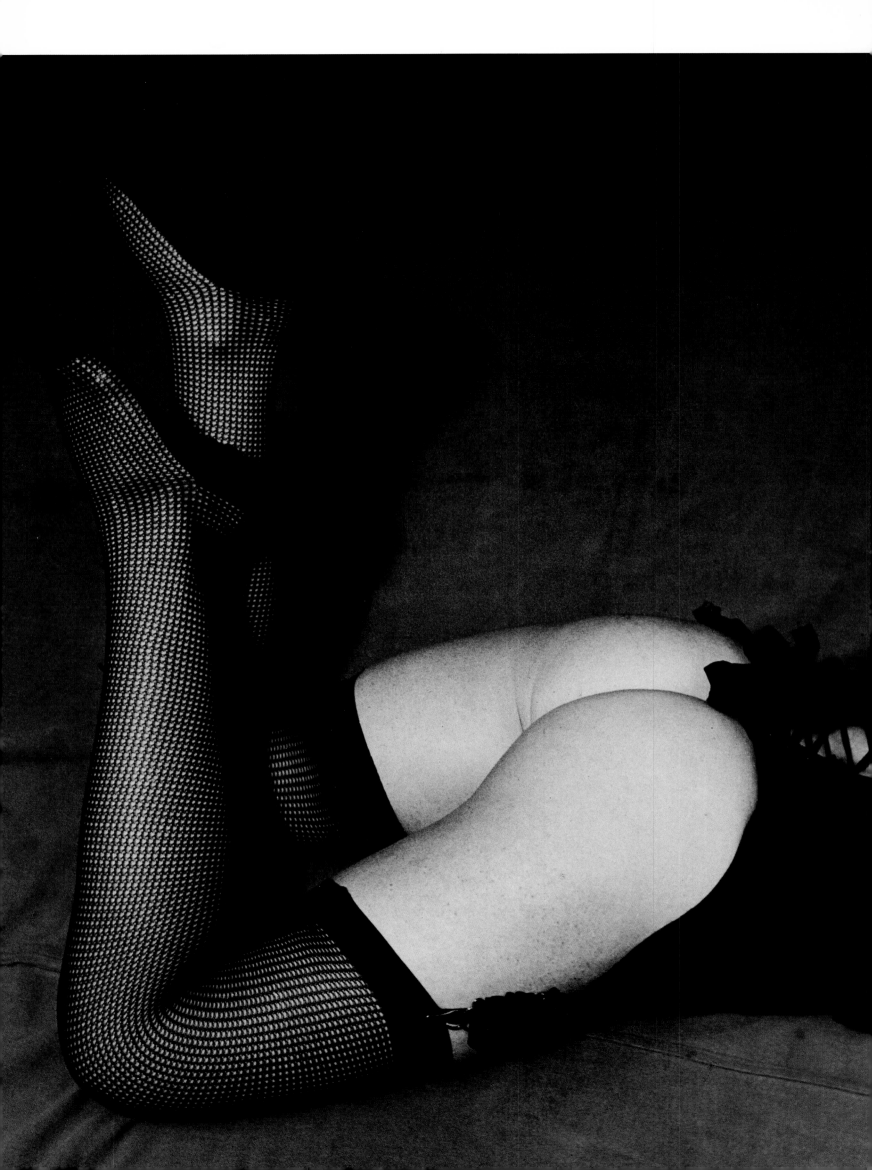

The first camera that Brassaï purchased was not a Leica, as he had first anticipated, but a Voigtländer Bergheil 6 x 9 cm with a Heliar lens.[1] The camera used glass-plate negatives, and Brassaï would carry twenty-four plates on each night's excursion.[2] In 1933, he adapted the Voigtländer to use roll film, and later, he also acquired a Rolleiflex.[3] He acquired a Leica in the late 1950s.

Photographing at night presents unique problems, and Brassaï learned how to master them from the other photographers with whom he worked and from contemporary technical manuals.[4] He also learned from trial and error. His newfound expertise was unique enough for him to publish an article in 1933 on the techniques of night photography. Marcel Natkin cited Brassaï's lighting solutions in his 1934 book on artificial lighting and discussed Brassaï's night photographs in his 1935 book on photographic technique.[5] A particular challenge of photographing at night, when such an extreme tonal range exists, is recording details both in the picture's highlights and in its areas in shadow. To register the scene's descriptive details, Brassaï had to shield his camera lens from the brightest points of lumination while increasing the amount of light reflected into the darkest corners. When recording receding city vistas, Brassaï employed elements from nature, such as trees, to mask bright light sources, such as street lamps (figure 5). "It is a game of patience," wrote Brassaï, "because each time [the photographer] succeeds in hiding four lights, two others appear."[6] He also utilized shiny surfaces, such as mirrors and water, to reflect light. "Fog and rain . . . tend to soften contrasts," he observed. "Steam, as well as wet ground, acts as reflectors and diffuses the light of the lamps in all directions. Therefore, it is necessary to photograph certain subjects in the rain, since it is the rain that makes them 'photogenic.'"[7] Thus evolved Brassaï's propensity to photograph on misty, even pouring, nights, lending a particular poetic atmosphere to much of his work.

Brassaï also employed both long exposures and various kinds of flash to enhance his record of details. Exposure lengths varied from ten minutes for Pont Neuf in Paris (1932) (catalogue number 22) to a few seconds for Entrance, Bal Tabarin, Montmartre, Paris (1930–32) (catalogue number 50). One method of timing the length of his exposures was to smoke a cigarette. If he wanted a long exposure, he chose a Boyard, nicknamed a "Blue," which was a fat cigarette made of less expensive, very strong tobacco that burned slowly. The Gauloise, nicknamed "Jaune" (yellow), was made of a lighter, smoother tobacco that was not as tightly packed. Therefore, the Gauloise was the shorter exposure meter.[8] To record a person at night, Brassaï used a combination of long exposure and flash. The extended exposure would enhance the somber atmosphere of the street and would capture more of the details in the shadows. The flash would secure the figure, which otherwise would be blurred during the long exposure. Brassaï carried his camera on an old wooden tripod, and he used string to establish the distance between his camera and the subject.[9] figure 23 Nude, 1931–32 (catalogue number 84) © Gilberte Brassaï

To process the film and to print the negatives, Brassaï and the photographer Dora Maar briefly shared a darkroom belonging to a third photographer. In the winter of 1930–31, he rented an extra room at the Hôtel des Terrasses and set up his own work space.[10] After he moved to rue Faubourg Saint-Jacques, Brassaï converted the kitchen in his apartment into his darkroom. This darkroom and the equipment he acquired remained his primary developing and printing tools throughout his life. Like Paul Strand and many other photographers of his generation, Brassaï preferred to use the most basic darkroom equipment, acquiring only what was essential to his needs. Photographer Serge Hambourg remembers that Brassaï owned only a metronome, not a timer, that he mixed his chemicals in large wine bottles, and that, by the 1980s, the bellows of Brassaï's enlarger were patched with tape.[11]

Throughout the 1930s and 1940s, Brassaï's prints were generally modest in size (9 x 12 inches/24 x 30 cm), each trimmed to the edge of the image. He primarily printed on single-weight paper and ferrotyped, a process by which a print is glazed to achieve a smooth shiny surface.[12] Newspaper and magazine editors preferred using ferrotyped prints for reproduction because the glossy surfaces reflect a maximum of light and lose a minimum of contrast. Brassaï continued to ferrotype his prints long after the process was no longer required professionally, leading one to think he preferred it aesthetically. In the late 1960s Brassaï responded to the request of his New York art dealer Lee Witkin to cease ferrotyping his prints because Witkin complained that ferrotyped print surfaces scratched too easily in transport and handling.[13] Witkin also requested that Brassaï print on double-weight paper, leave white margins around each print, and sign his work in the lower margin on the front of each print, whereas Brassaï had previously preferred to sign the verso.[14] He also stamped his copyright declaration on the back with a succession of different notices.[15]

Brassaï never felt an obligation to print the full negative of his original image and sometimes printed only a small portion of the whole. The Tokyo Metropolitan Museum of Photography owns three quite different images of a Parisian skyline at night, all taken from the same negative.[16] Brassaï often changed his mind about how to crop a picture, leaving more of the image on the sides or top in different prints. A photograph of The Rue Quincampoix and Its Hôtels de passe (c. 1932, reproduced in the book Secret Paris) that belongs to the George Eastman House Museum is cropped on a slight diagonal from the rectangular negative. The most famous, severe example of cropping is visible in Brassaï's photograph Two Hoodlums, Place d'Italie, Paris (1931–32, also reproduced in Secret Paris), which shows a full view of one man and the right side of a second figure who seems to be standing behind a wall. What appears to be the edge of the wall is actually the edge of the negative. This edge is in the picture's vertical center. The right half of the print that appears to be a length of the wall in deep shadow is actually the photographic paper that has been exposed until it turned black.[17]

Manuel J. Borja-Villel has written, "For Brassaï the photographic print was simply a bridge between the 'image' conceived by the artist and its reproduction in an illustrated magazine or book. Being fetishistic about a vintage Brassaï may prove to be pointless because it is liable to involve over-emphasizing irrelevant features of his work."[18] However, Brassaï's insistence throughout his life that he make his own prints, unlike some of his contemporaries, such as Henri Cartier-Bresson or André Kertész, leads one to conclude that the print as he made it was important to him. Gilberte Brassaï acknowledged, "He loved to control the entire process from the beginning to end."[19] In the mid-1930s, Pierre Gassmann, the director of Pictorial Service, or "Picto" photographic laboratories, lived in the same building as Brassaï and refined his own printing skills by watching Brassaï work. Brassaï was precise and intuitive, said Gassmann. "He would take film out of the hypo, and ease the blacks in the negative to make the whites less dense. He saw his positive prints in the negative before ever printing it."[20] Brassaï allowed another person to print his negatives if the purpose was to make prints larger than 16 x 20 inches (40 x 50 cm), which his darkroom could not accommodate, or to produce the prints for his two photographic portfolios.[21] The large edition of prints required for publishing a portfolio was too strenuous an undertaking for Brassaï to attempt alone.[22] For the portfolio published in 1973 by Lee Witkin and Dan Berley, Brassaï and his publishers were dissatisfied with the prints initially made by the man whom they hired, and Brassaï relegated his assistant to washing and drying the prints.

Notes

Frequently cited works are identified by the following abbreviations:

AWT Anne Wilkes Tucker
LTMP Letters to My Parents
MMH Maria Morris Hambourg
Picasso & Co. Picasso and Company
Tàpies Brassaï: Del Surrealism al informalismo

For full details of the works listed above, see bibliography.

1 The date that Brassaï acquired a camera can be determined by three items of information. On December 4, 1929, Brassaï wrote to his parents, "I want to buy a typewriter to replace the one I'm renting. Then I'll have to buy a Leica camera" (LTMP, letter 60, 4 December 1929, pp. 178-79). The Museum of Fine Arts, Houston, owns a photograph of Pont Neuf that is signed and dated 1929 (catalogue number 4), and, in plate 57 of Paris de nuit, the photograph of the Eiffel Tower records the dates "1889–1929" blazing in lights.

2 He told Charles Rado that the Ilford plates were the most sensitive plates at that time. Rado file, courtesy of Kay Reese.

3 Tom Marotta and Jean-Claude Gautrand, "Brassaï: A Talk with the Great French Master," Lens (September/October 1977), p. 14. It was a Rolleiflex 6 x 6 cm with a 7.5 cm Zeiss Tessar lens. He used those two cameras until 1957; while photographing in the U. S., he borrowed a Leica from Bita Dobo's father and then acquired his own when he returned to France. Henceforth, he primarily used the Leica and the Rollei.

4 For a discussion of popular manuals that address techniques similar to those employed by Brassaï, see Kim D. Sichel, Photographs of Paris, 1928–1934: Brassaï, André Kertész, Germaine Krull and Man Ray (Ann Arbor, Mich.: University Microfilms International), p. 177.

5 "Technique de la photographie de nuit," Arts et Métiers Graphiques (Paris) 33 (15 January 1933), reprinted in Tàpies, p. 91. Marcel Natkin, Lumière artificielle (Éditions Tiranty, Paris, 1934). Marcel Natkin, L'Art de voir en photographie (Éditions Tiranty, Paris, 1935).

6 "Technique de la photographie de nuit," Arts et Métiers Graphiques (Paris) 33 (15 January 1933), reprinted in Tàpies, p. 91.

7 Ibid.

8 Frank Dobo to MMH, New York, 6 August 1985, and Alexandre Trauner to MMH, Paris, 1985.

9 Picasso & Co., p. 53.

10 Maar: Picasso & Co., p. 42; at hotel: LTMP, letter 62, 24 January 1931, p. 183.

11 Serge Hambourg to AWT, Paris, April 1998.

12 Wet prints are pressed into firm contact with a smooth surface and, while drying, the fibers of the gelatin become compressed to form a smooth, glossy print surface. Defects in the print's surface occur if the contact surface is not clean and evenly polished, if it is scratched, if the print is not evenly adhered to the surface, or if the ferrotype surface is either too hot or too cold, causing parts of the prints to lift prematurely. In the early years, Brassaï used his hotel mirror to ferrotype his prints (LTMP, letter 64, 18 September 1931, p. 186).

13 Undated letter, probably after October 1971, because Witkin refers to Brassaï's article on Picasso in The New York Times (Witkin Archives, the Center for Creative Photography, University of Arizona, Tucson).

14 Dan Berley, Witkin's partner in making photographic portfolios, said that they also hired George Tice to tone the prints Brassaï made for the portfolio (To AWT, October 1998).

15 Although there are earlier prints on double-weight paper, or "cartoline," as it is called in Europe, dating from the 1930s, Brassaï used it rarely until much later and never with the white borders until printing for U. S. audiences. There may have been double-weight prints for the show at Robert Schoelkopf Gallery in 1971. Occasionally, Brassaï's signature appears inside the image on the front of the print. Witkin also requested that he put edition numbers on the prints in the portfolio, which Brassaï declined to do because some of his best-selling prints were being reproduced in the portfolio and the edition numbers would be misleading. However, the title page for the Witkin-Berley portfolio announced that it was a "limited edition of fifty." It is unknown why Brassaï later agreed to edition prints for Marlborough Gallery.

16 One print is a horizontal view of the skyline revealing the distant silhouette of the Saint-Jacques Tower. This image is printed using only the upper half of the negative. The other two prints are both vertical views: one from the sky to the lit street and storefronts below, another from the tower to lit windows, but this print excludes the street (Tokyo Metropolitan Museum of Photography accession numbers 20007011, 20007012, and 20007013).

17 A print of the uncropped negative is in the Nicholas Pritzker collection.

18 Tàpies, p. 14.

19 "A Few Reminiscences of Brassaï," Brassaï: The Eye of Paris (New York: Houk Friedman Gallery, 1993), p. 4.

20 Pierre Gassmann to AWT, Paris, September 1996.

21 Transmutations and A Portfolio of Ten Photographs by Brassaï. See bibliography for citations.

22 Jean-Yves Barré assisted with the Witkin-Berley Portfolio, but despite ill health, Brassaï made all the exposures and processed the first stages for each print (Witkin Archives, the Center for Creative Photography, and Dan Berley to AWT, October 1998). Pierre Gassmann said that his laboratory printed the largest enlargements for the Brassaï retrospective held at the Bibliothèque Nationale (Gassmann to AWT, September 1996).

Numbers preceding the titles of Brassaï photographs refer to the catalogue of the exhibition (pages 310-19).

1929

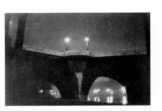

2 Woman in a Coat with an Ermine Collar, Paris 1929

4 Pont Neuf at Night, Paris 1929

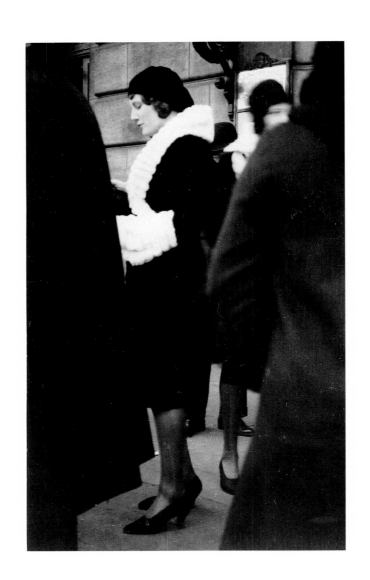

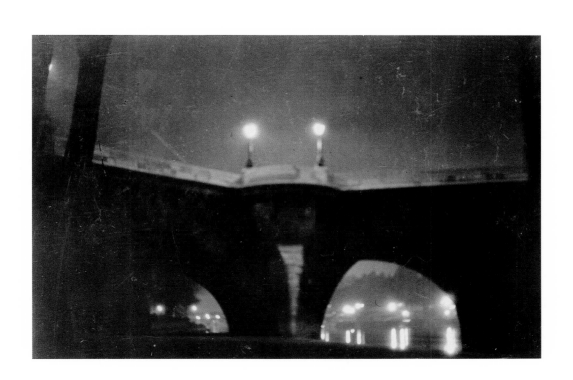

Paris, Night

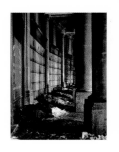

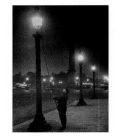

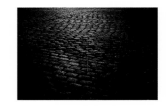

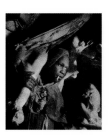

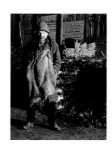

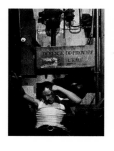

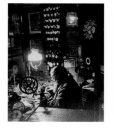

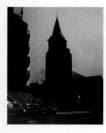

13 Saint-Germain-des-Prés Church, Paris 1939

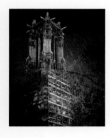

14 Saint-Jacques Tower, Paris 1932–33

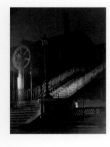

20 Pont de Crimée, Saint Martin Canal, Paris 1932–34

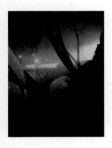

22 Pont Neuf in Paris 1932

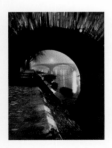

23 Looking through Pont Marie to Pont Louis-Philippe, Paris 1930–32

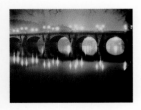

24 Pont Neuf, Paris 1949

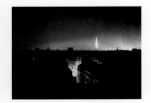

10 Roofs of Paris c. 1930–32

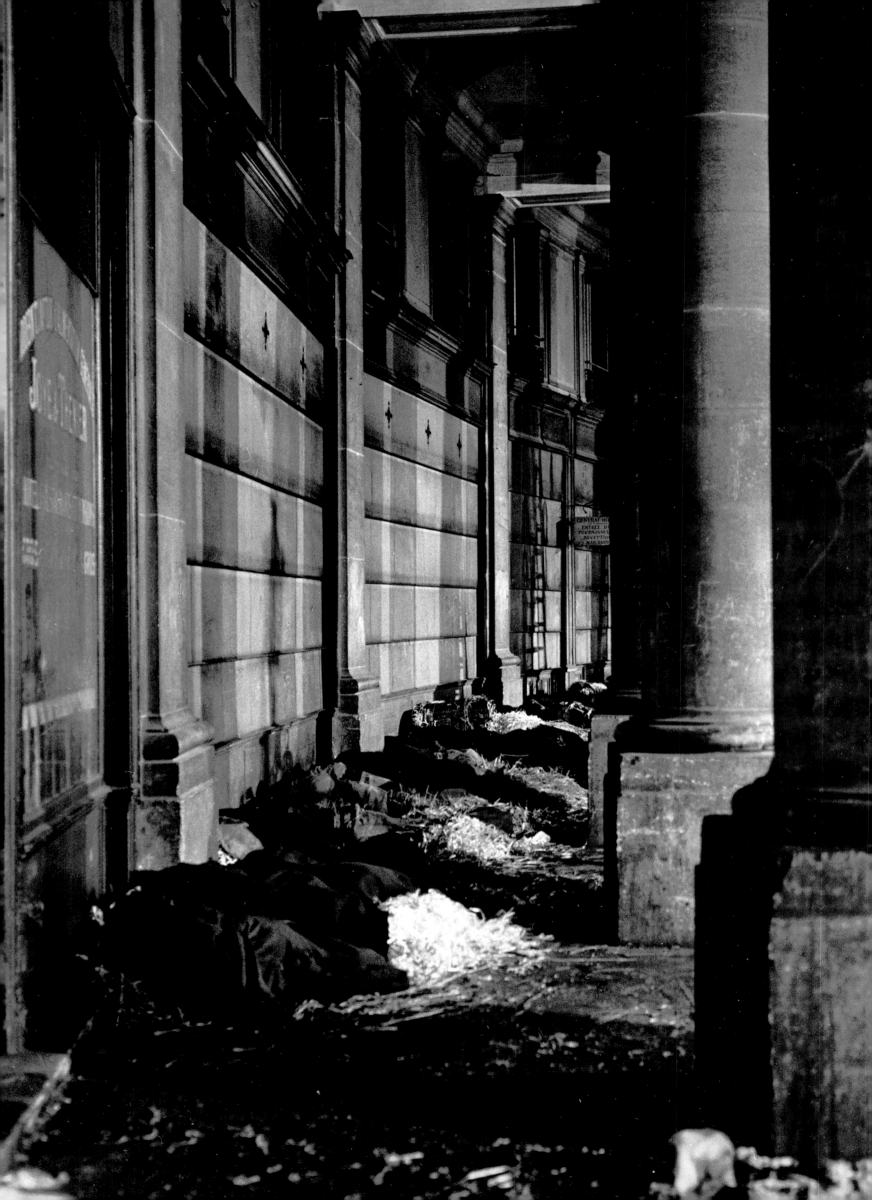

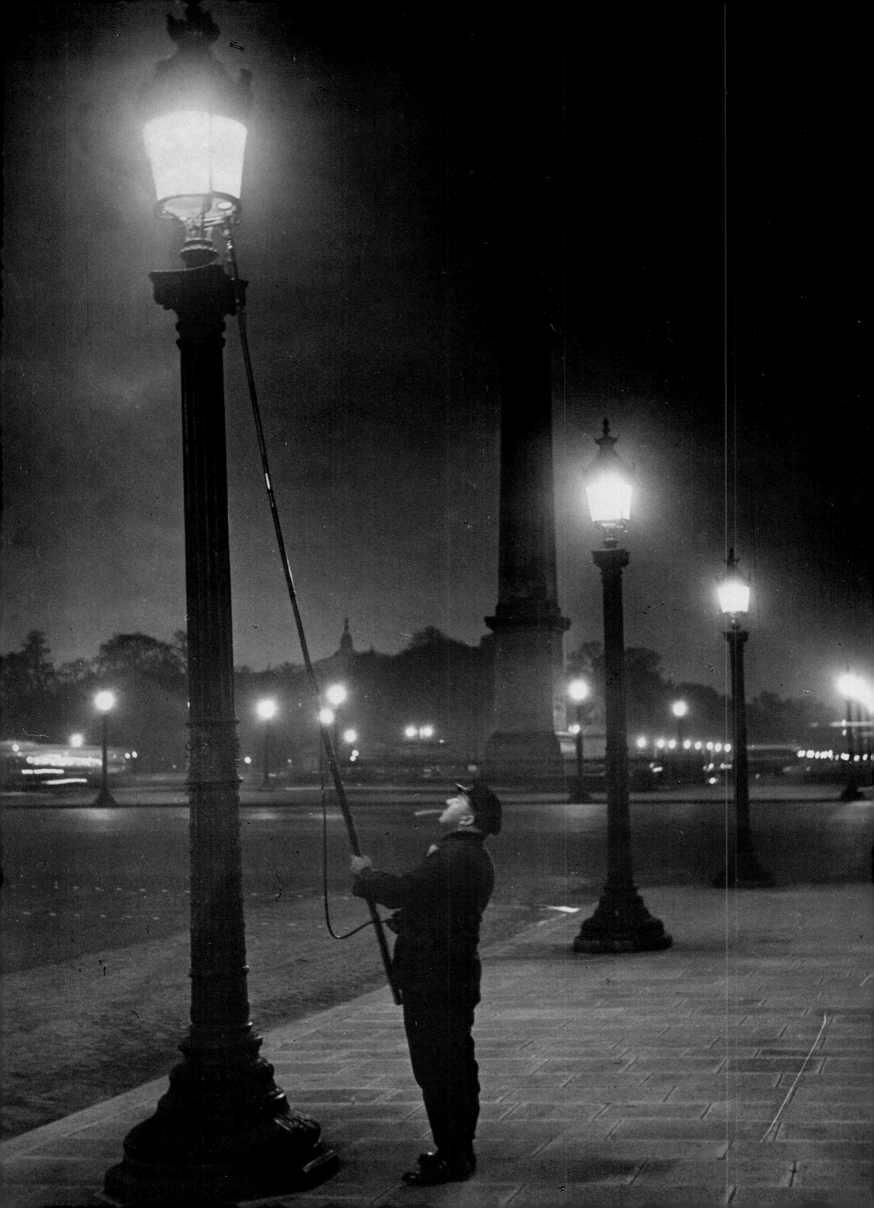

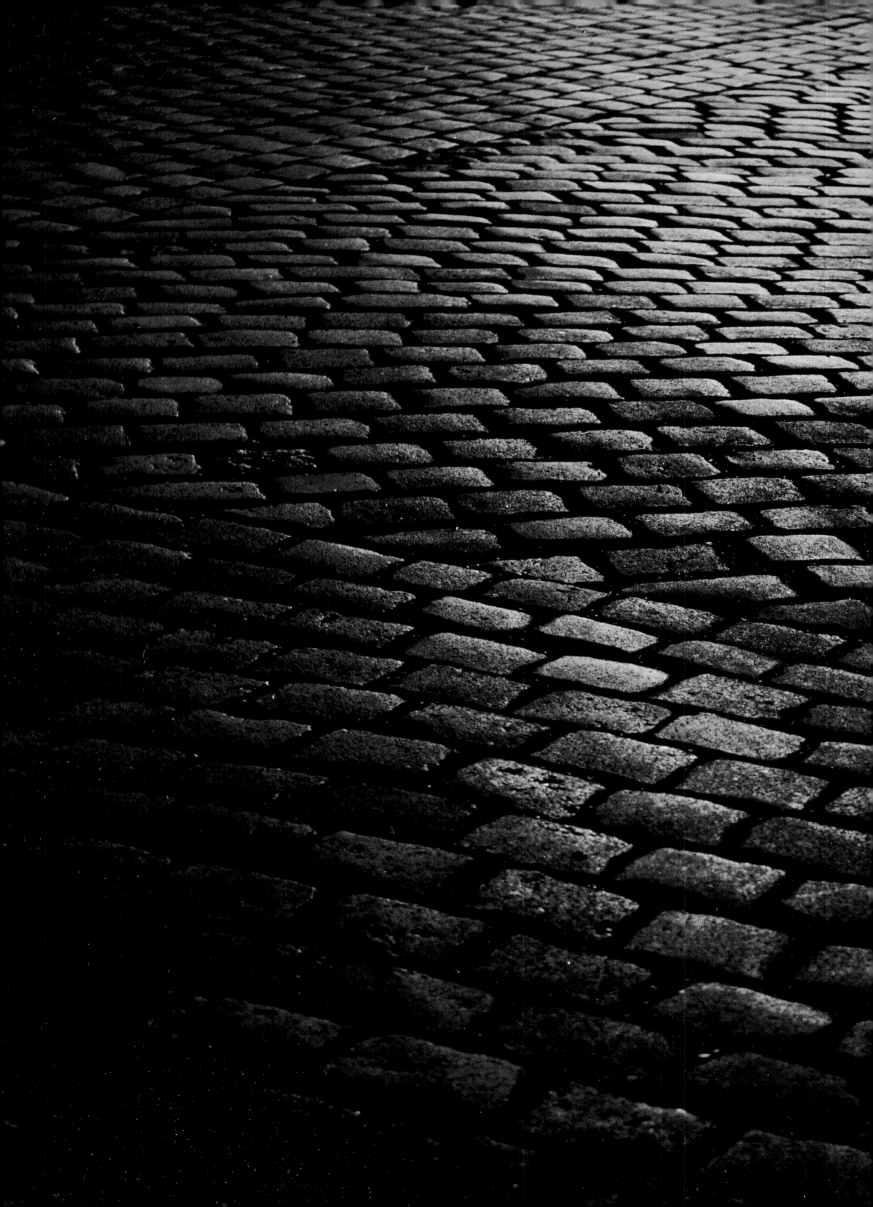

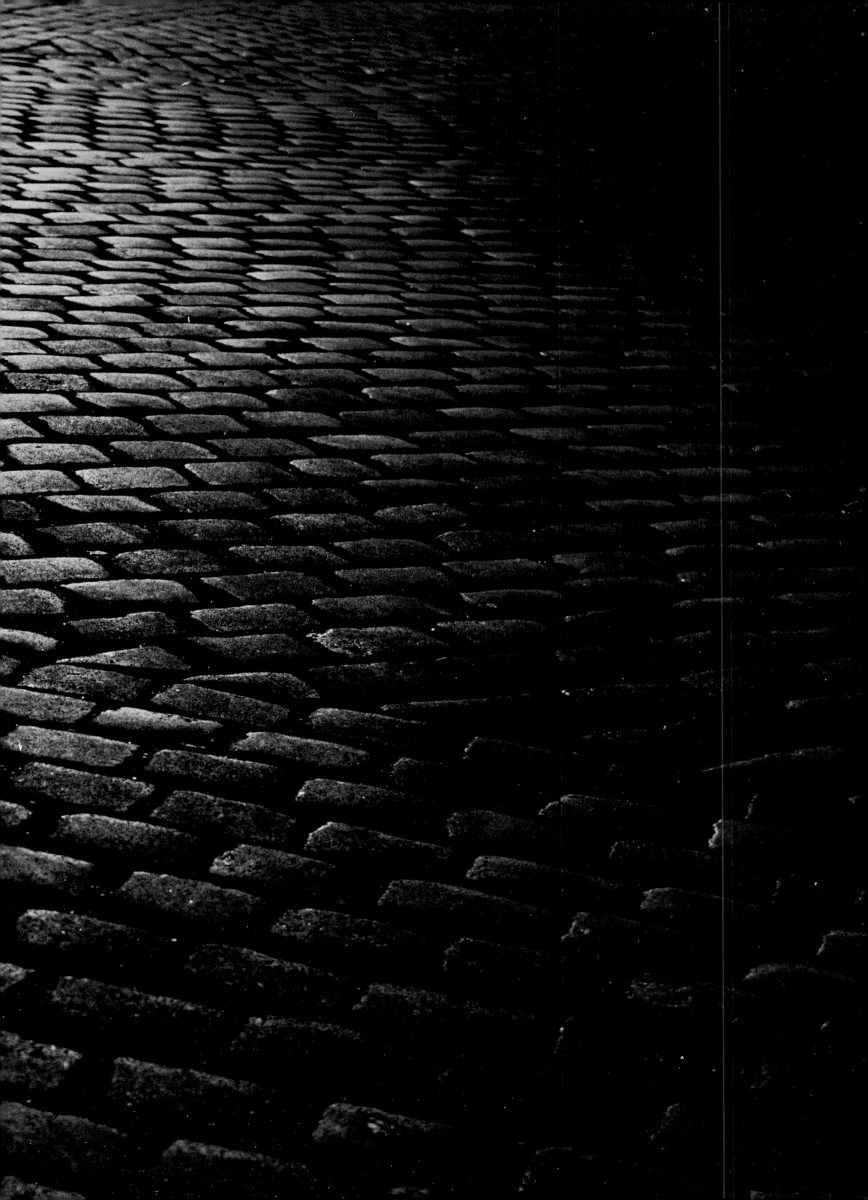

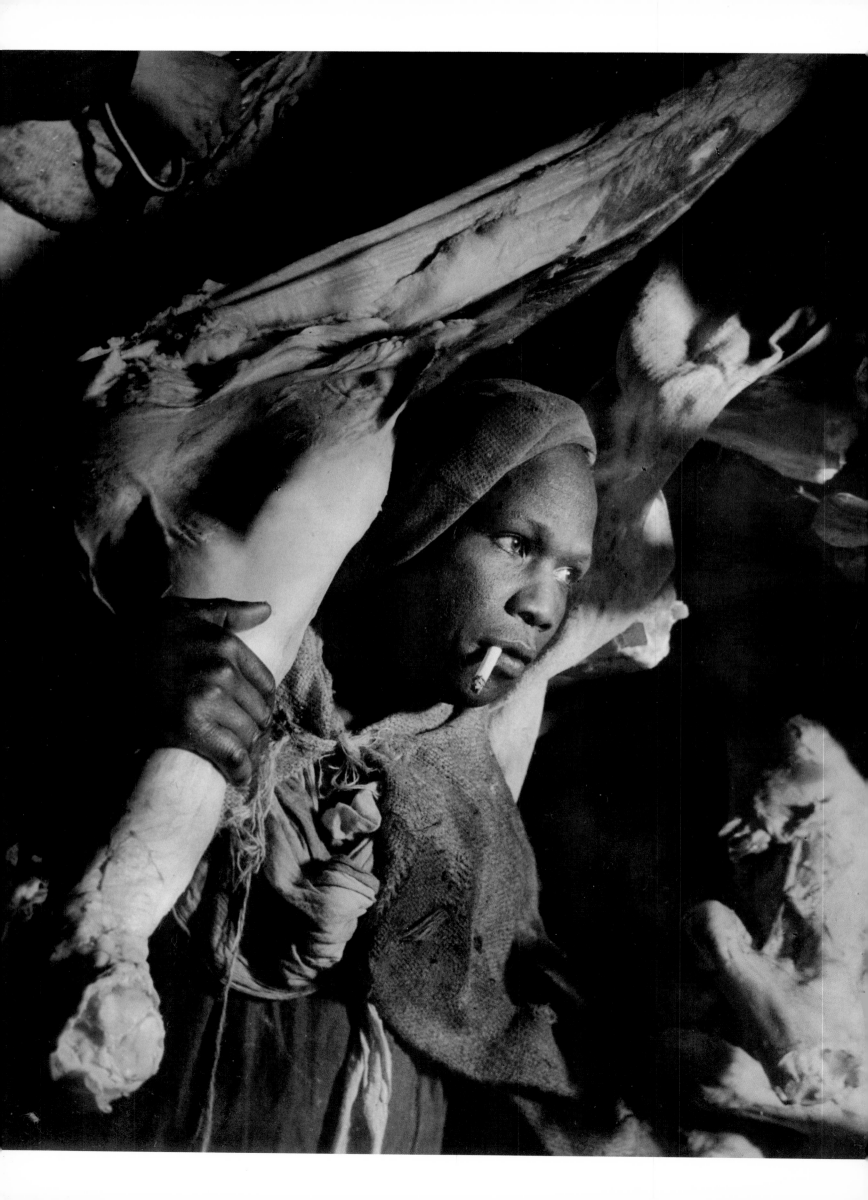

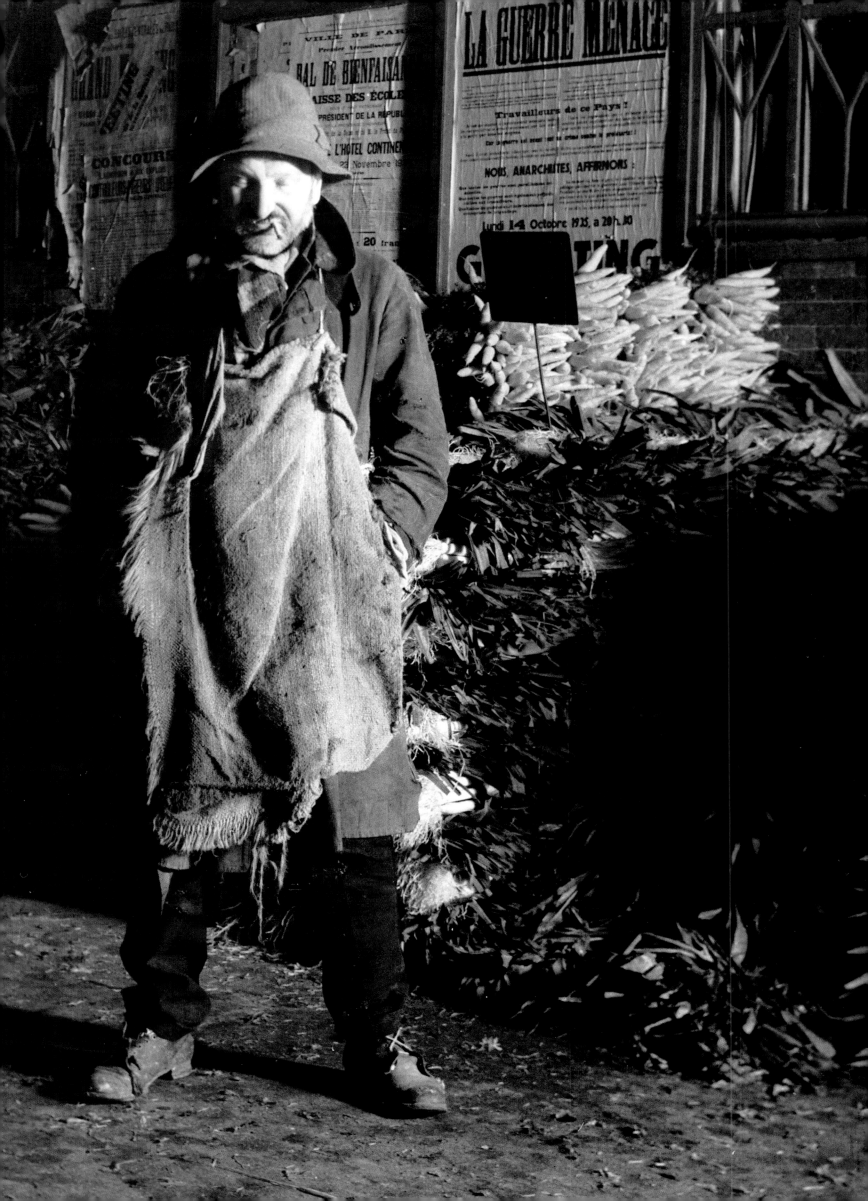

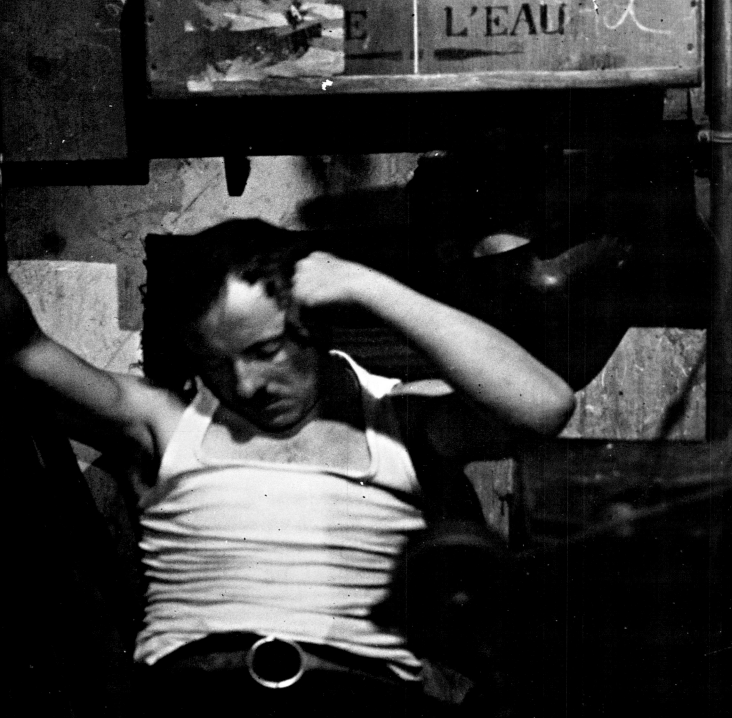

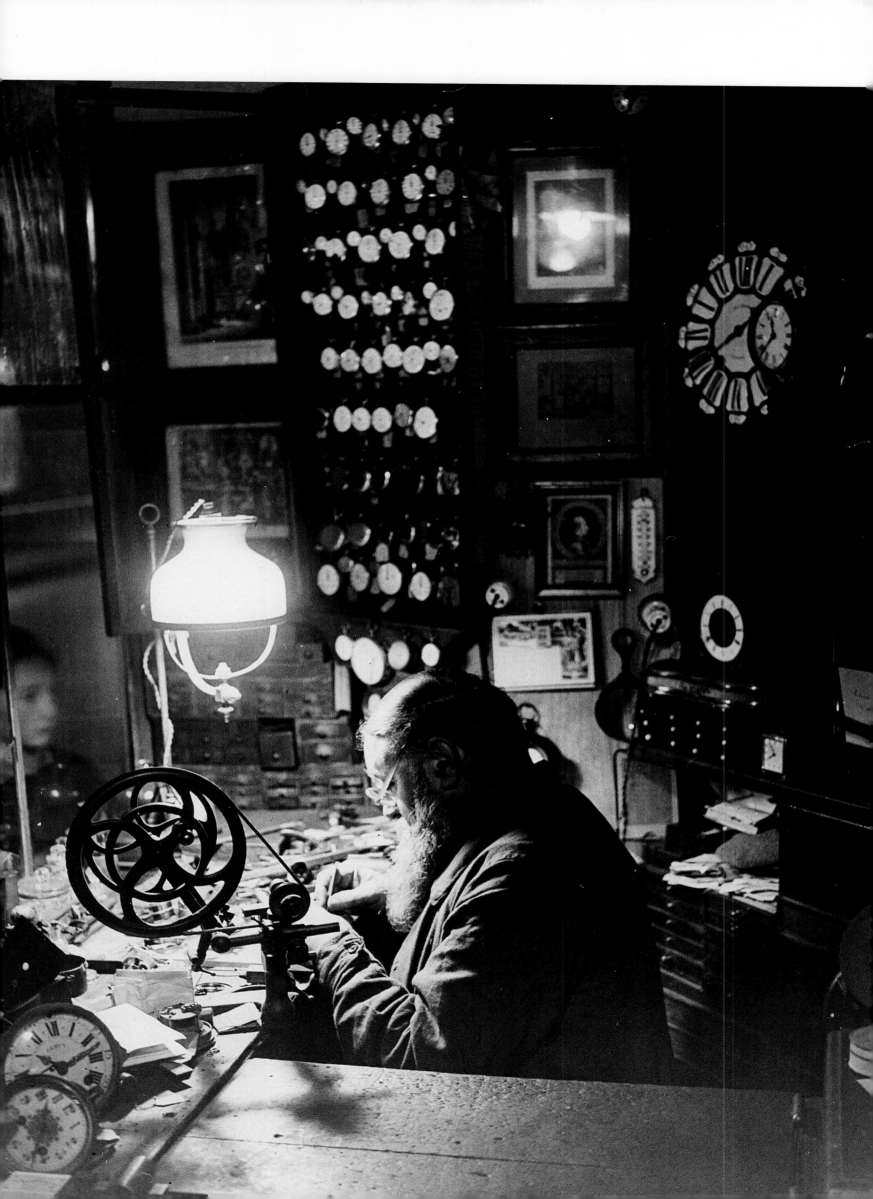

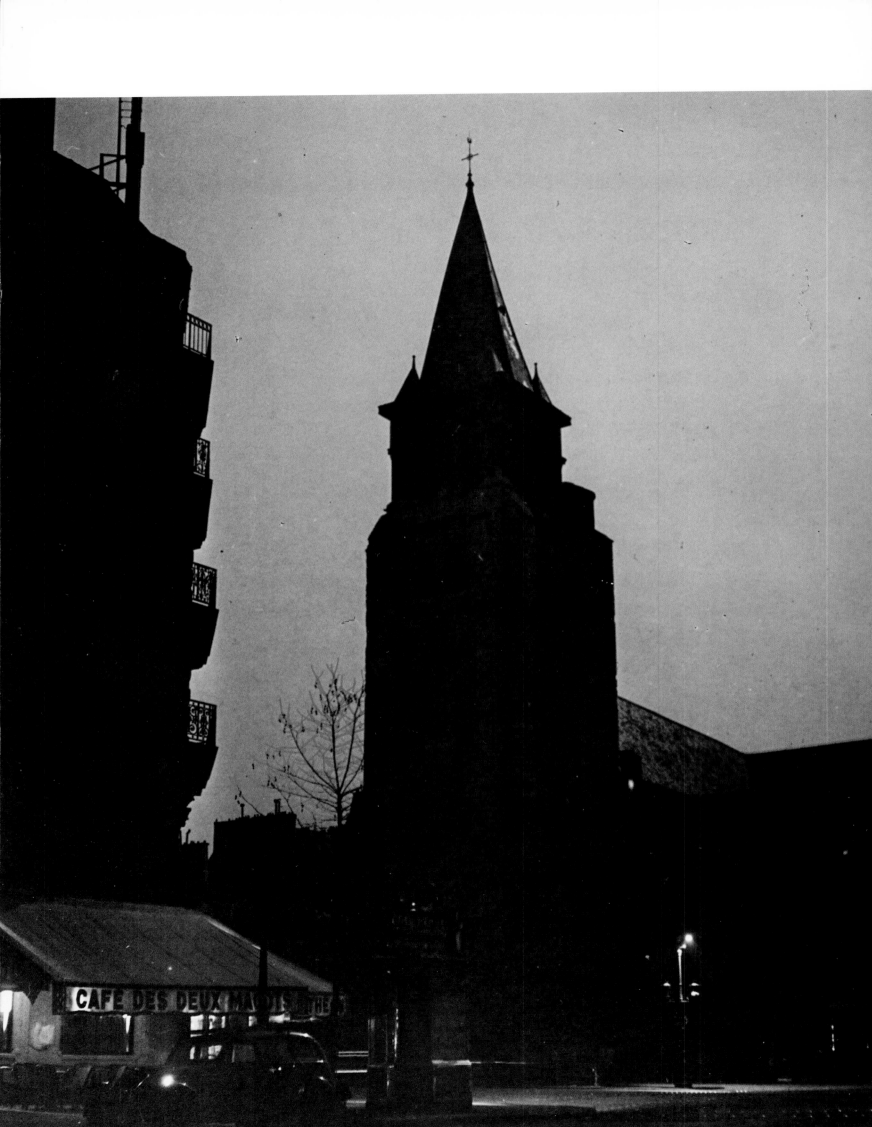

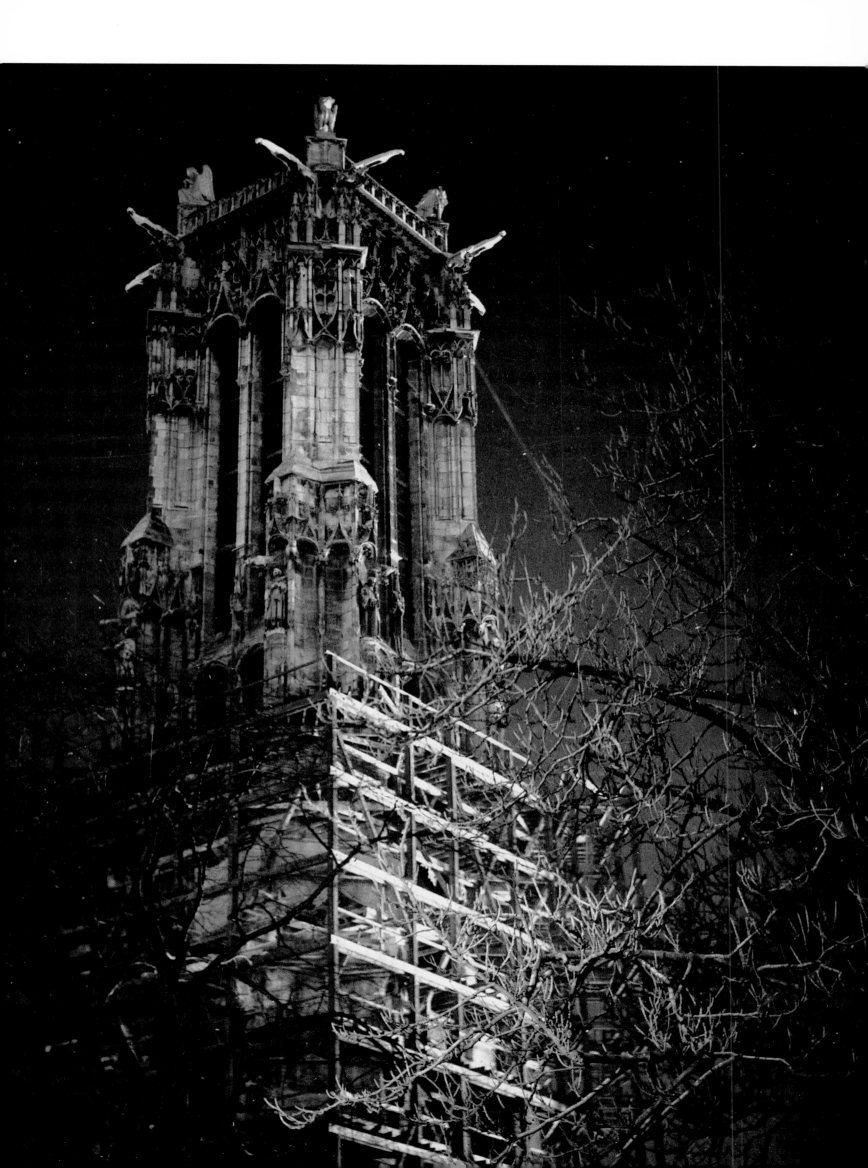

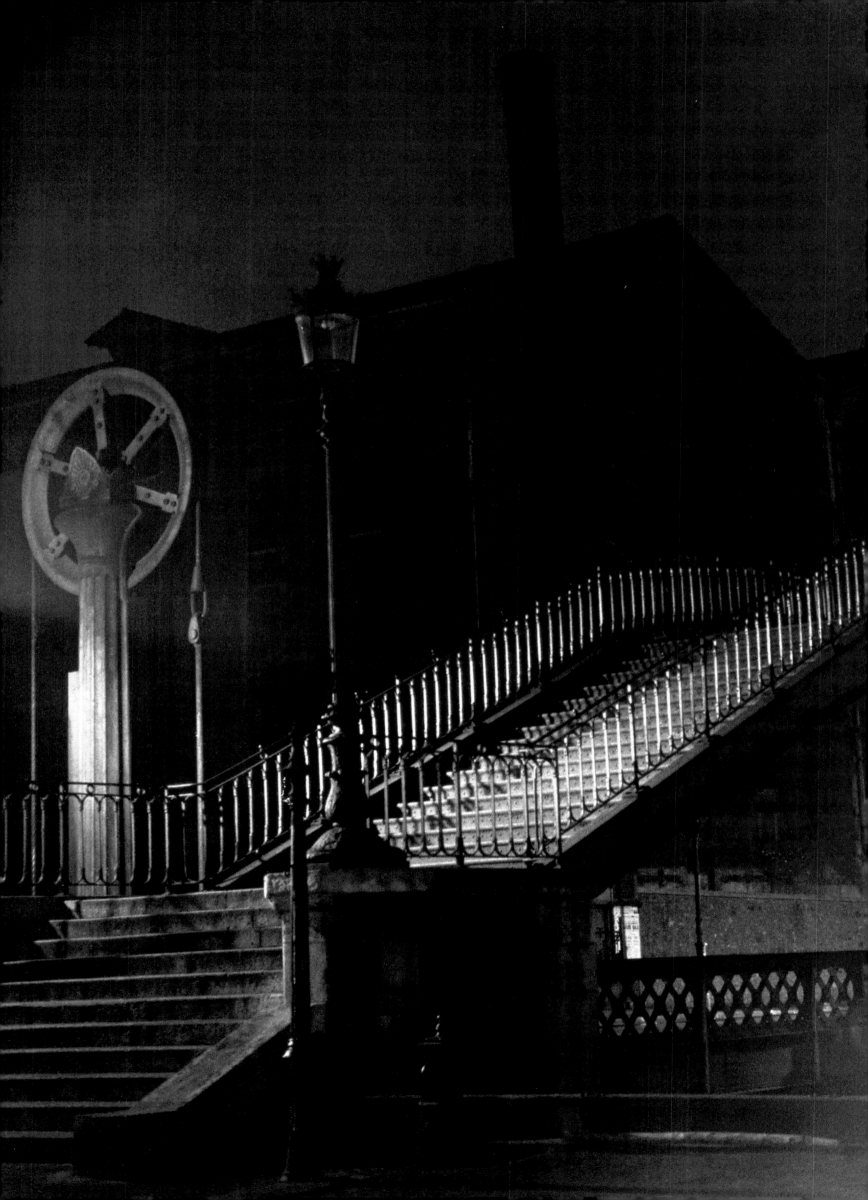

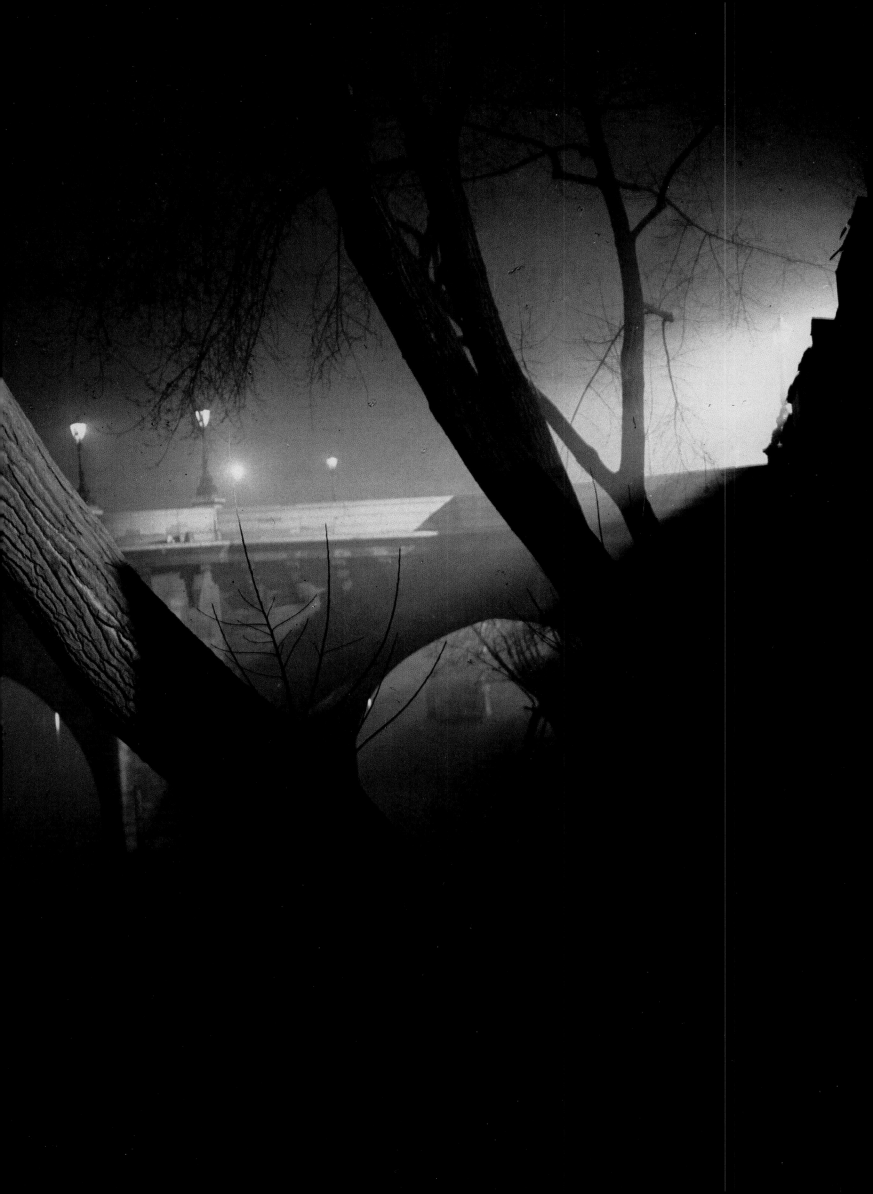

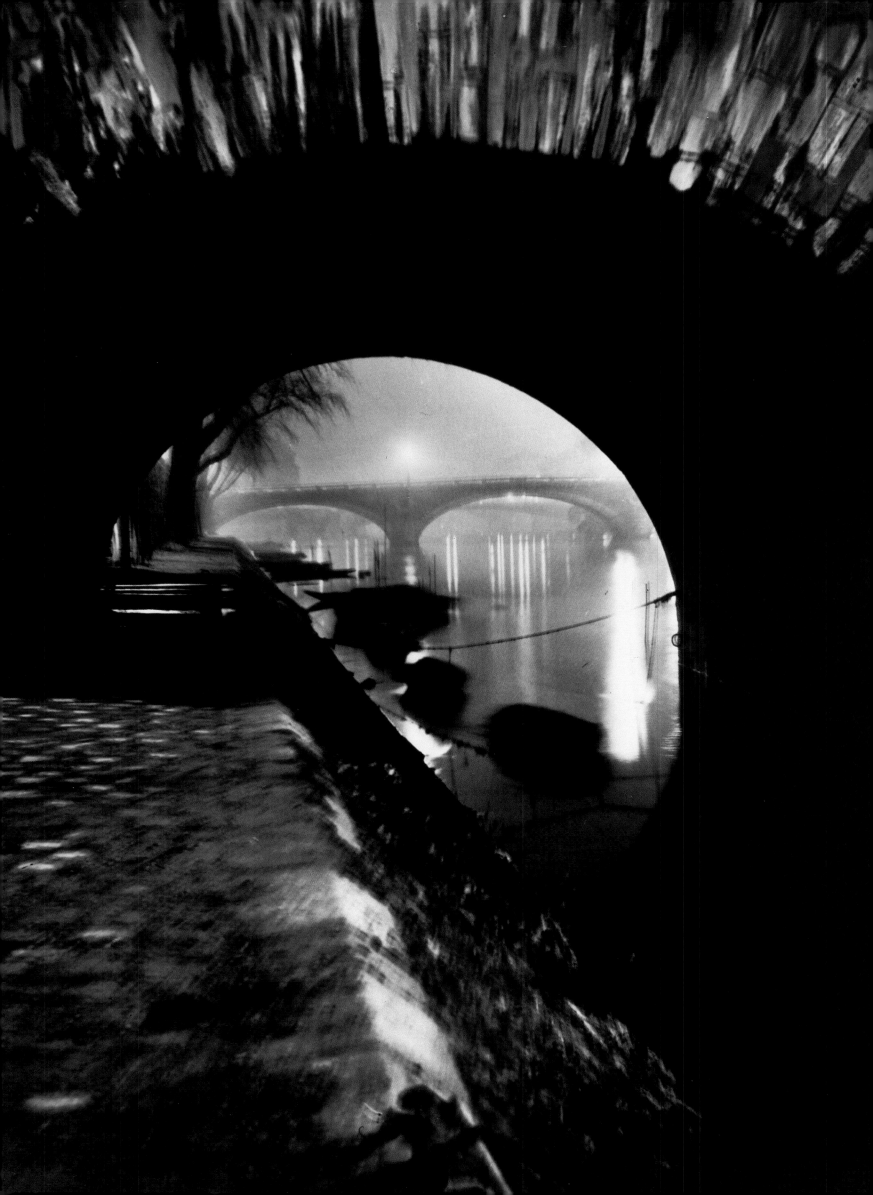

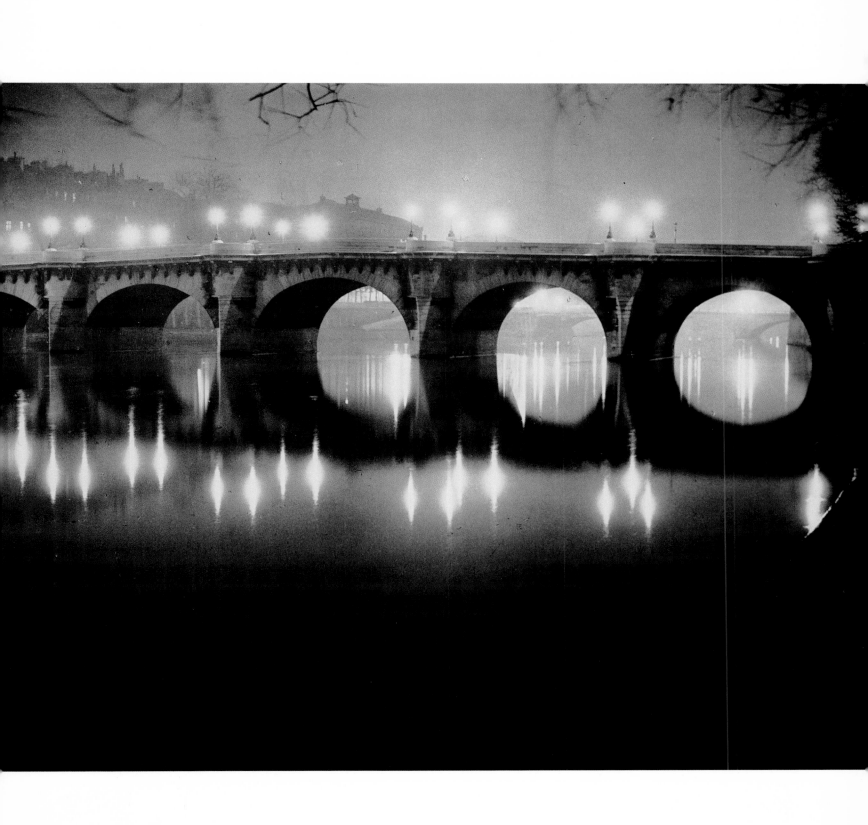

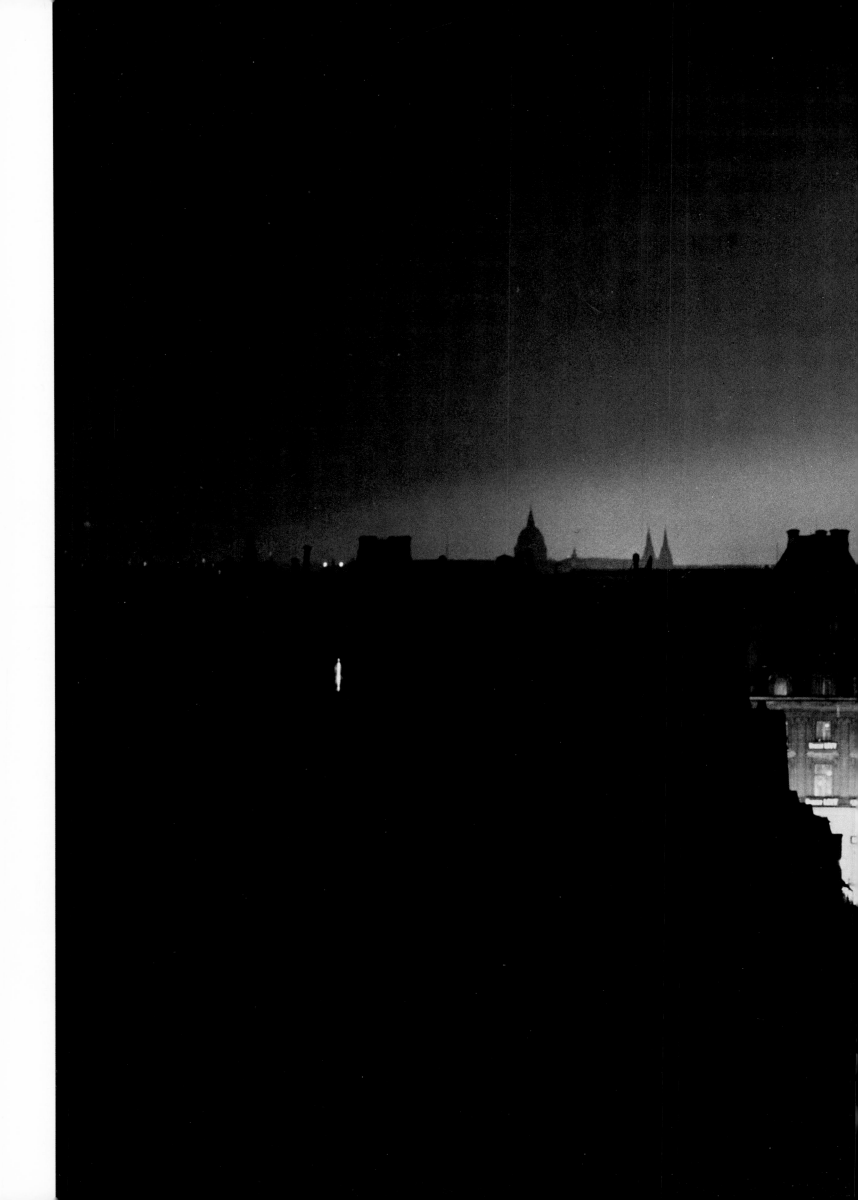

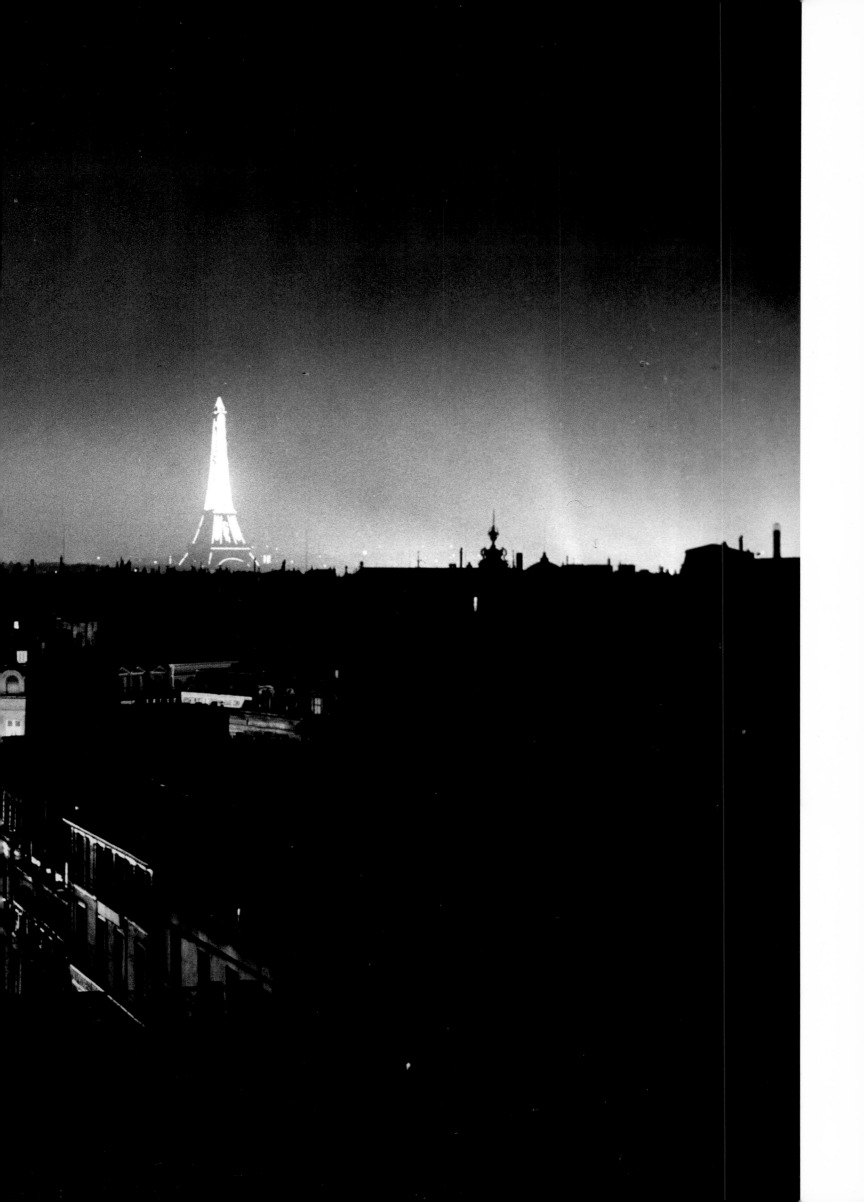

Secret Paris

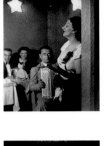

49 Kiki and Her Accordion Player at Cabaret des Fleurs, Montparnasse Boulevard, Paris 1932–33

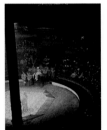

32 Médrano Circus, Boulevard Rochechouart, Paris 1930–32

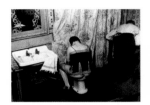

41 Washing Up in a Brothel, Quincampoix Street, Paris c. 1932

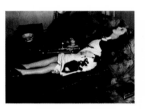

45 Opium Smoker and Cat, Paris c. 1931

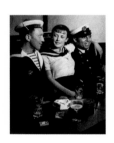

35 Conchita with Sailors, Place d'Italie, Paris c. 1933

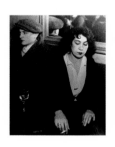

34 Lovers' Quarrel, Bal des Quatre Saisons, Paris 1932

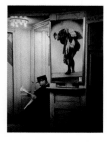

50 Entrance, Bal Tabarin, Montmartre, Paris 1930–32

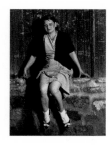

40 Young Prostitute, near the Place d'Italie, Paris c. 1932

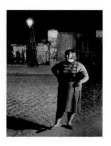

39 Streetwalker, near the Place d'Italie, Paris c. 1932

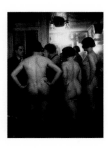

42 Introductions at Suzy's, Paris c. 1932

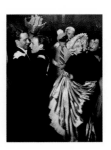

47 Magic-City Dance Hall, Cognacq-Jay Street, Paris c. 1932

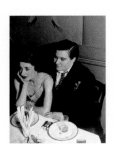

46 Lesbian Couple at Le Monocle, Paris 1932

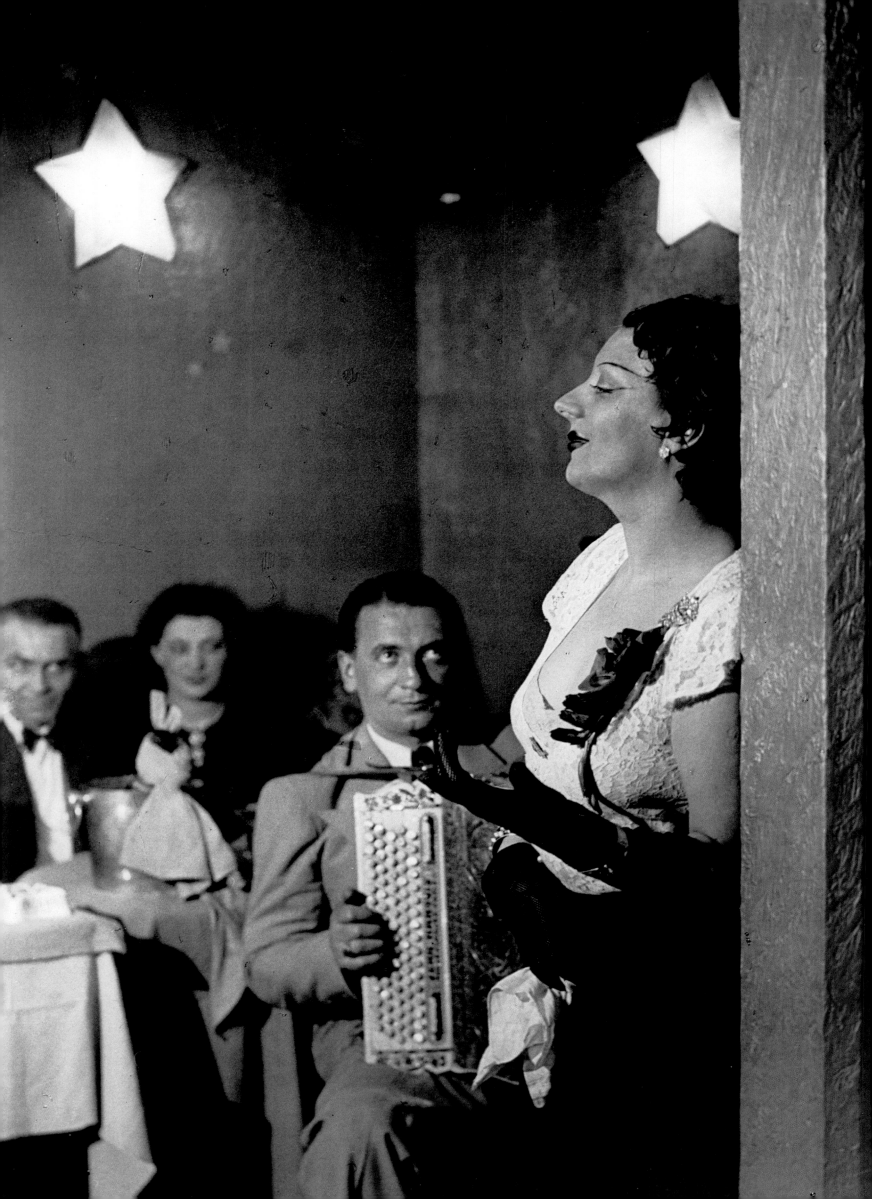

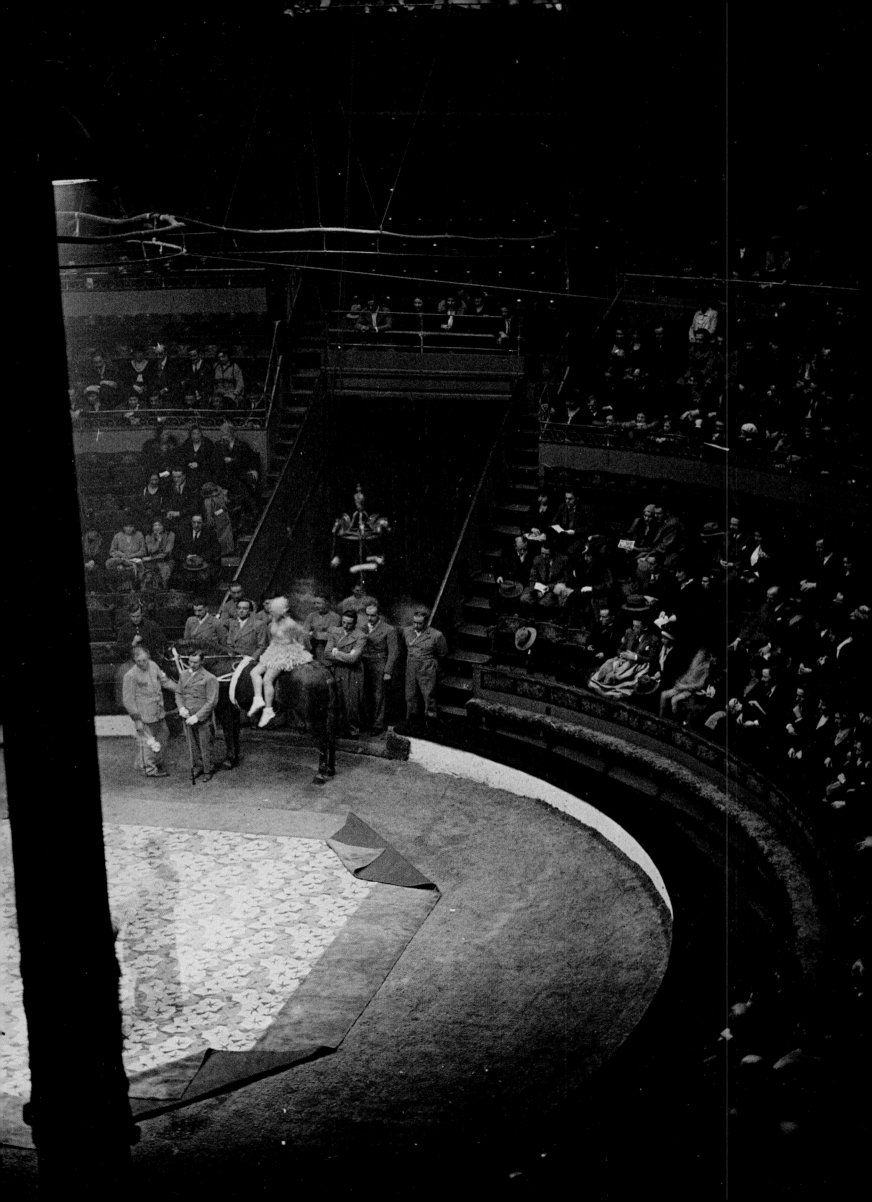

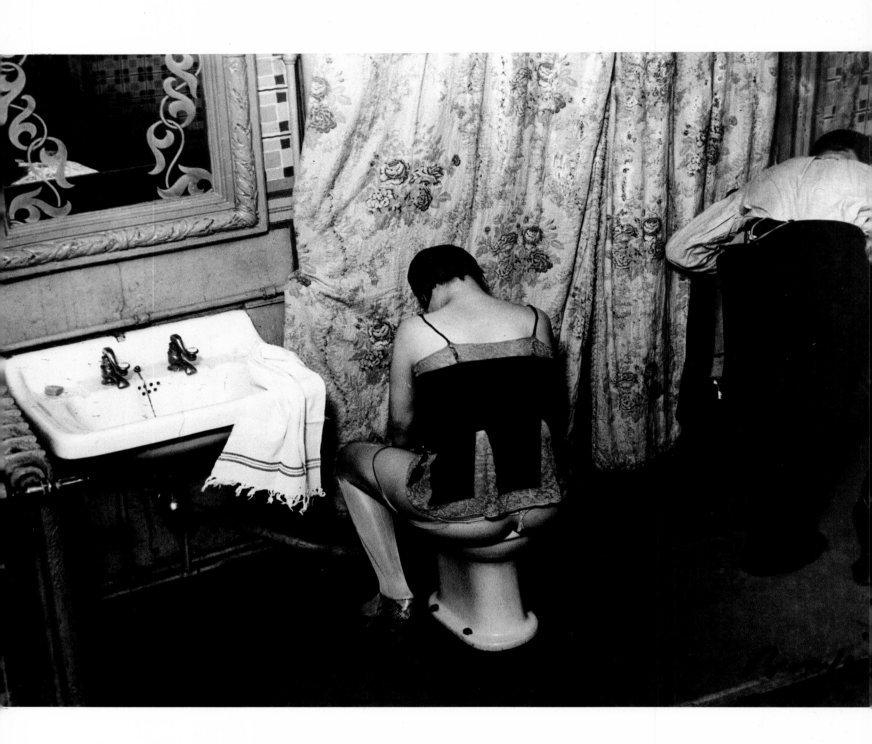

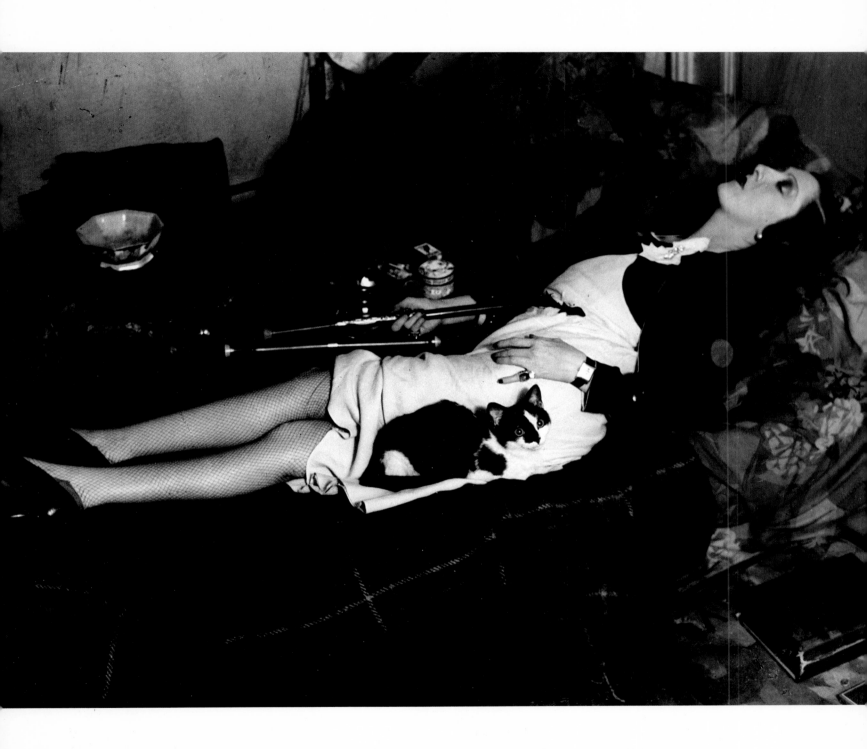

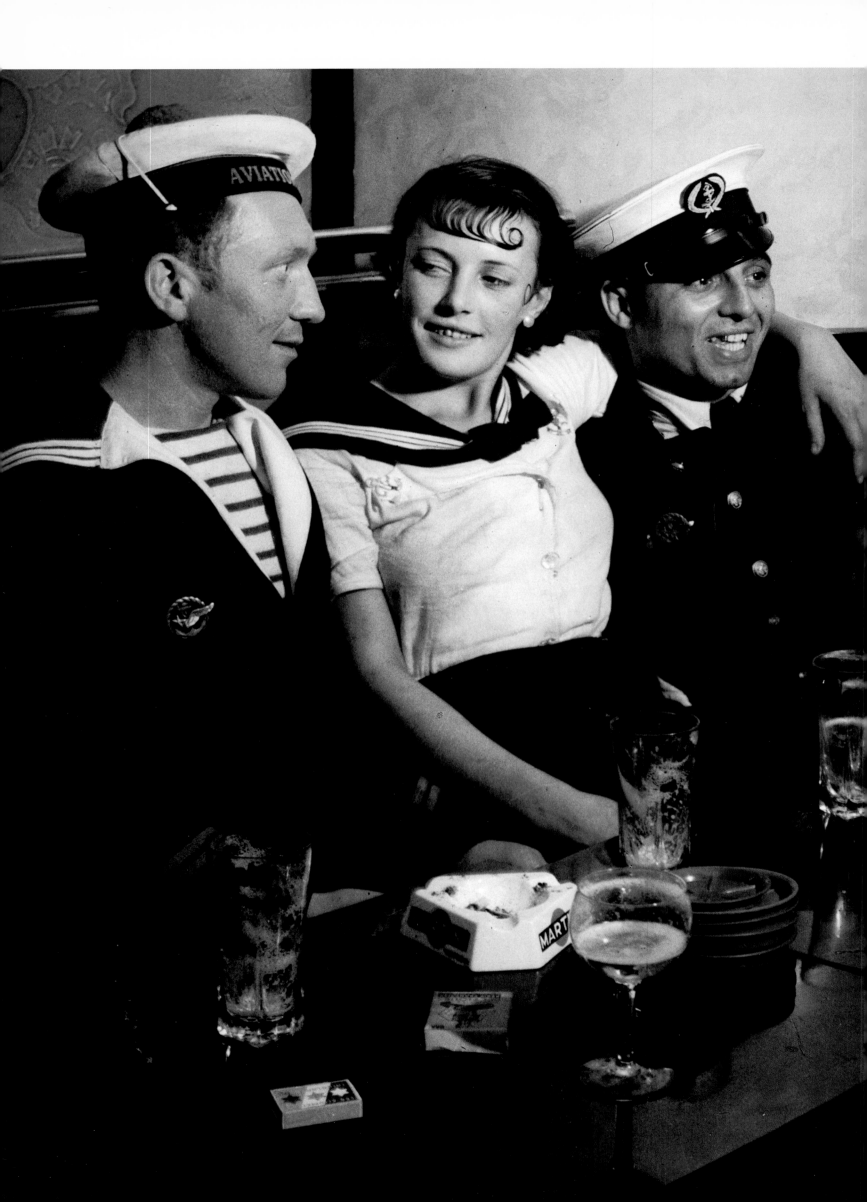

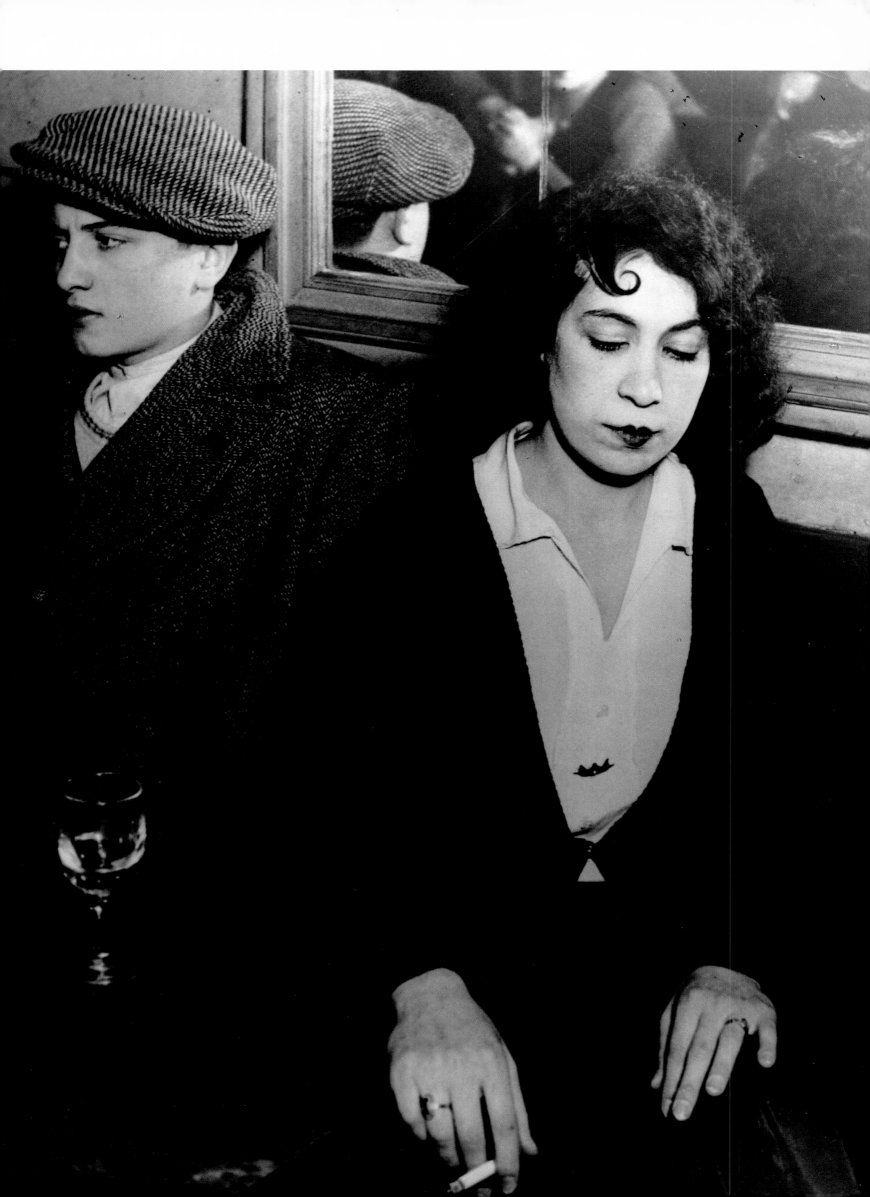

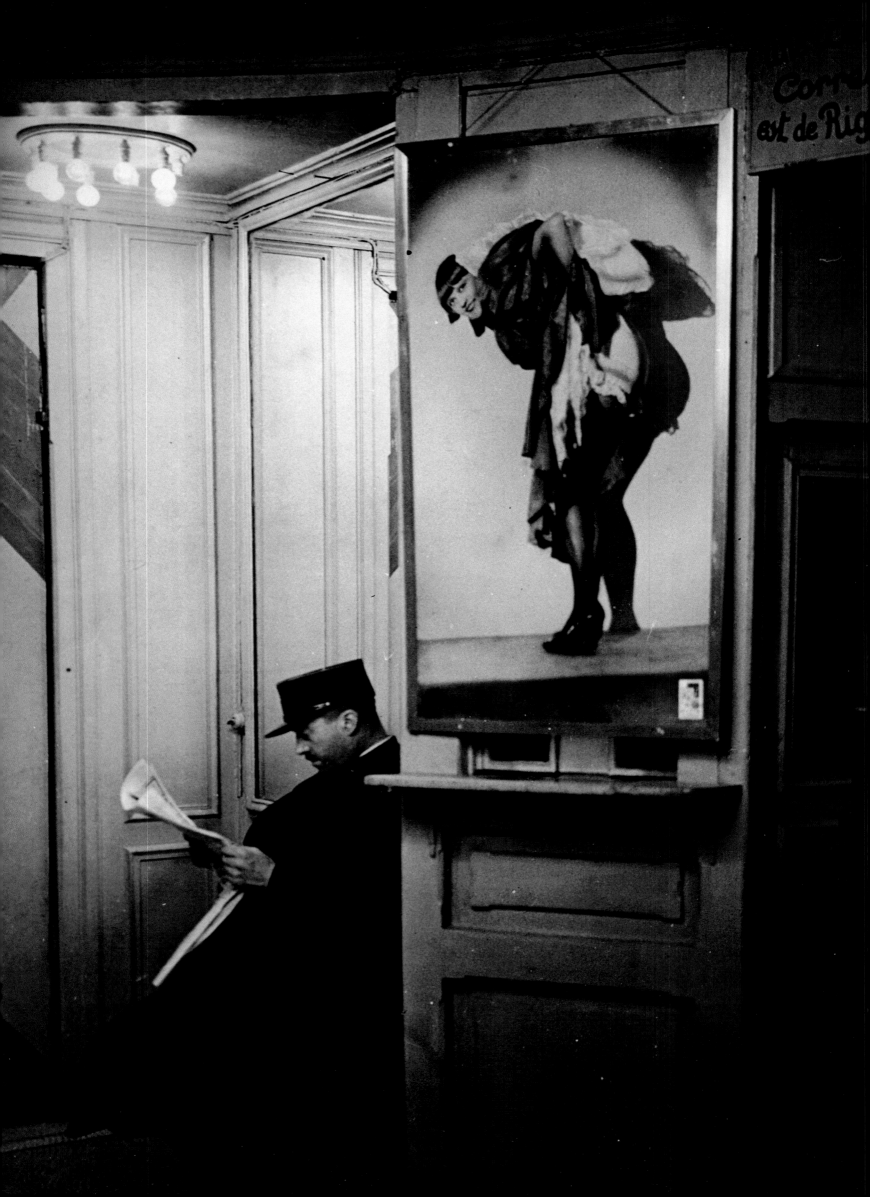

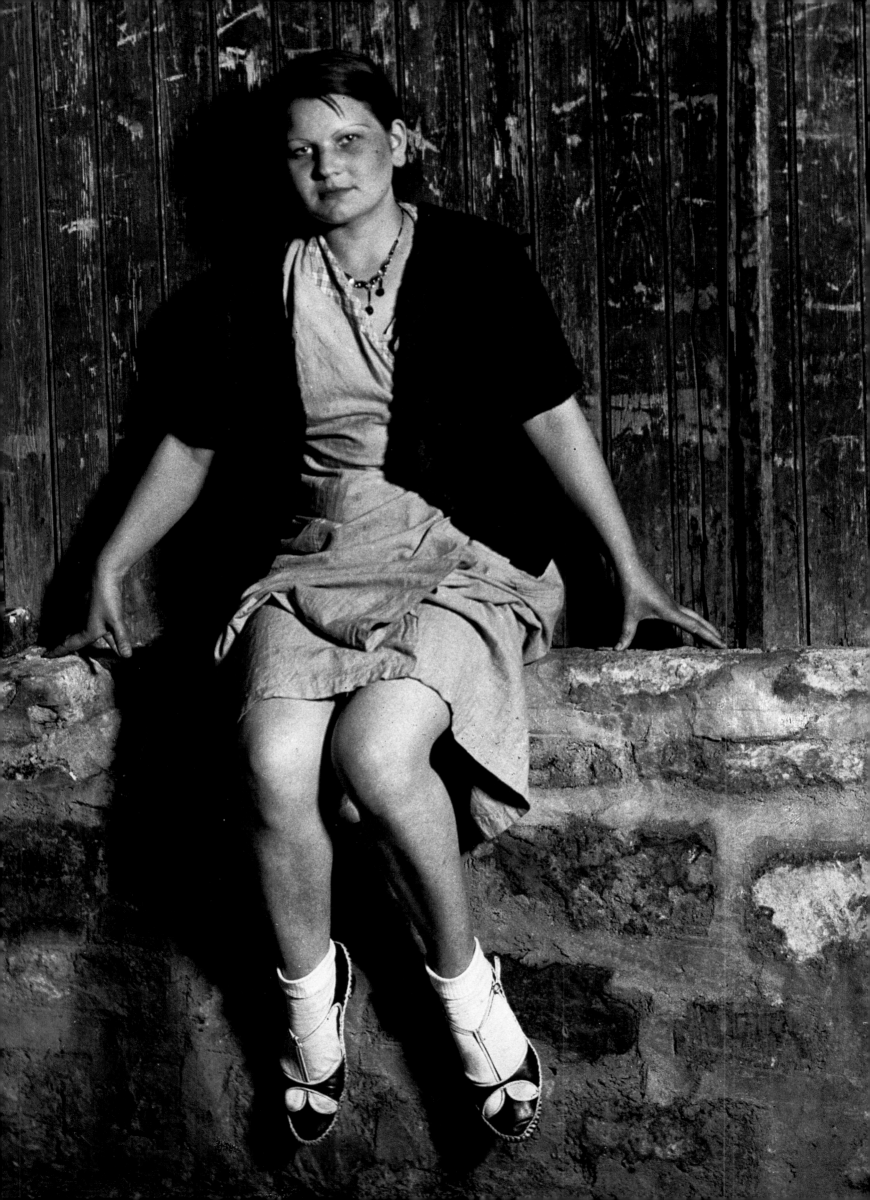

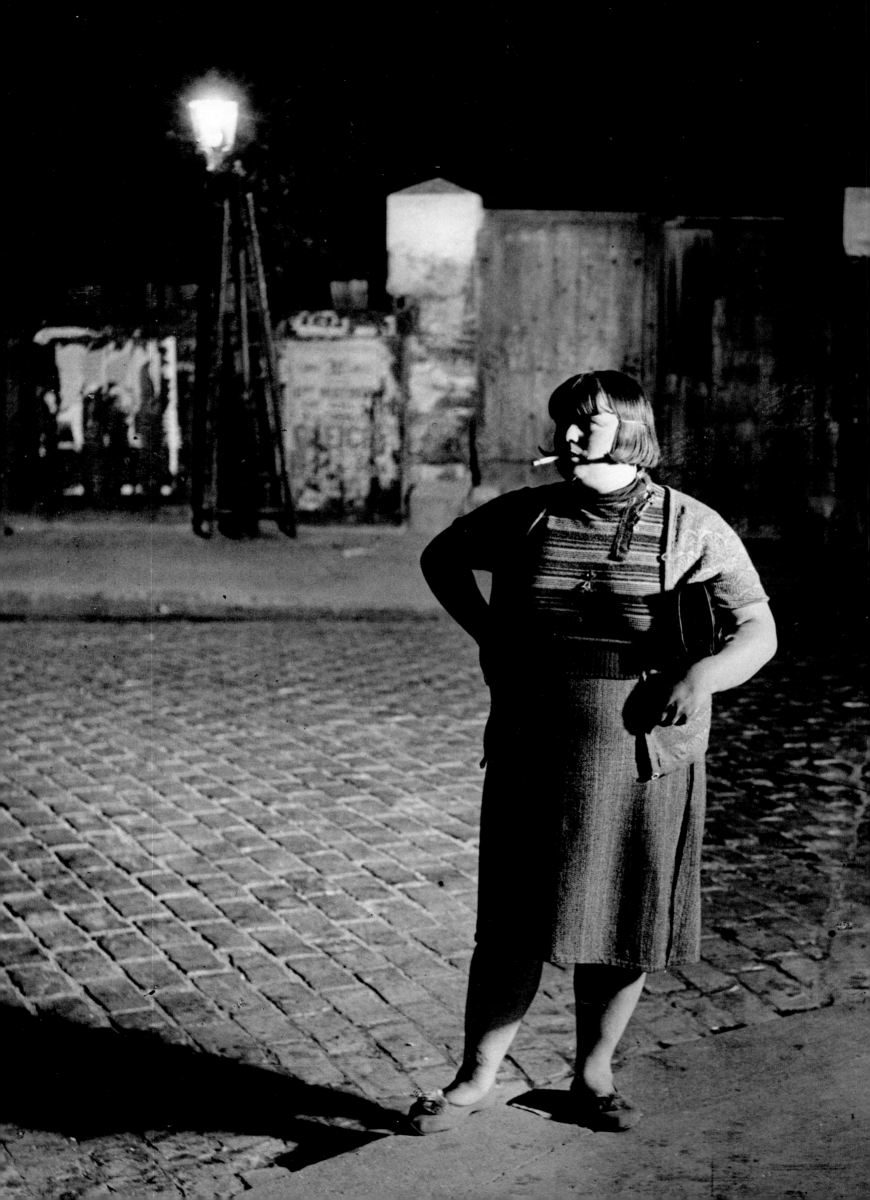

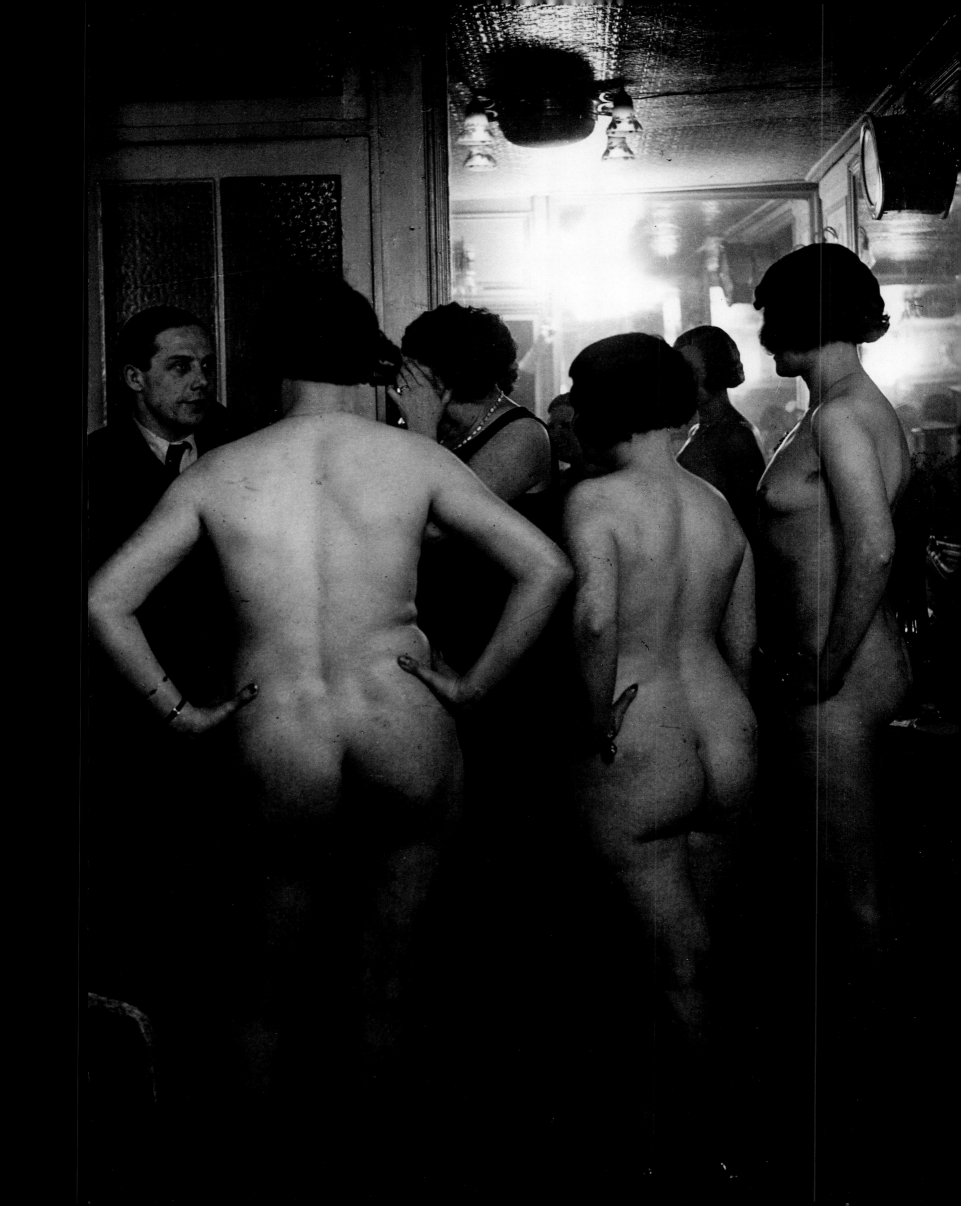

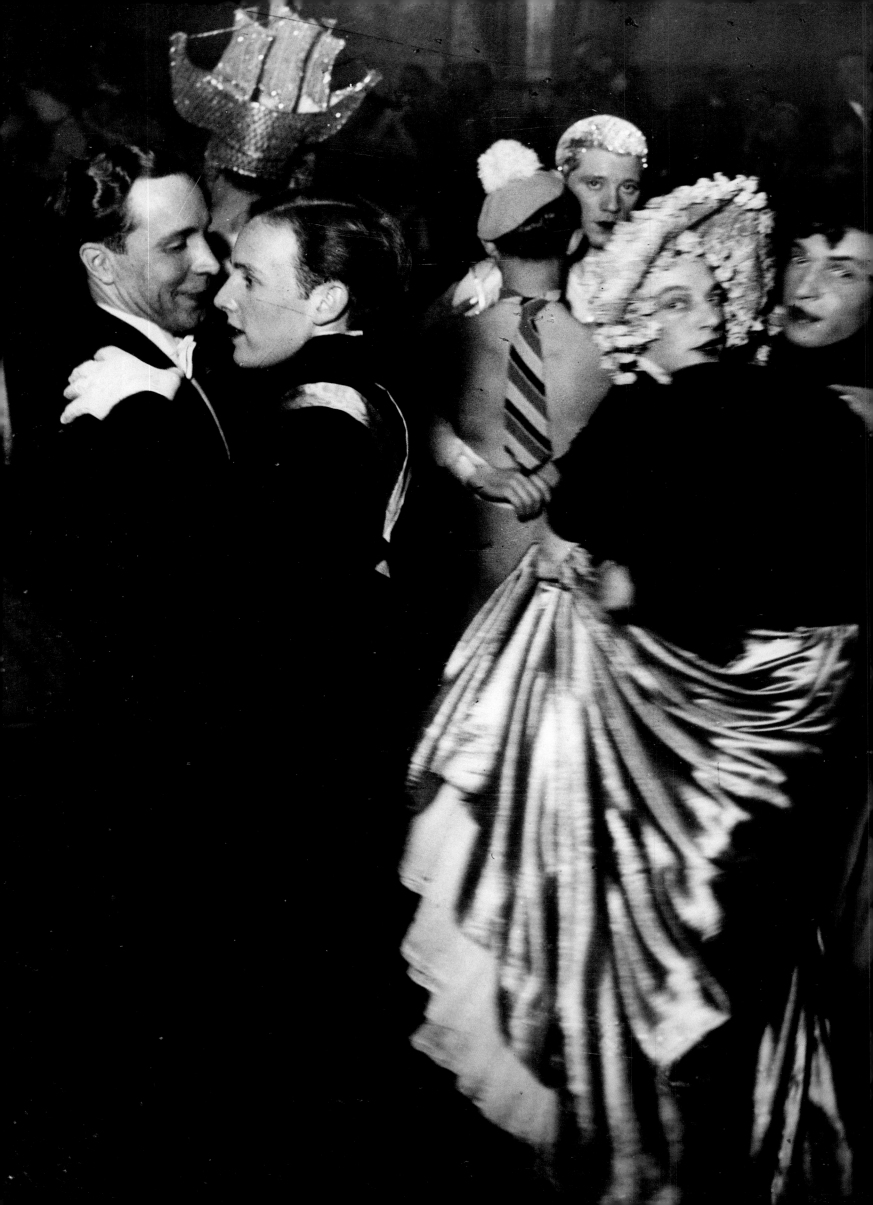

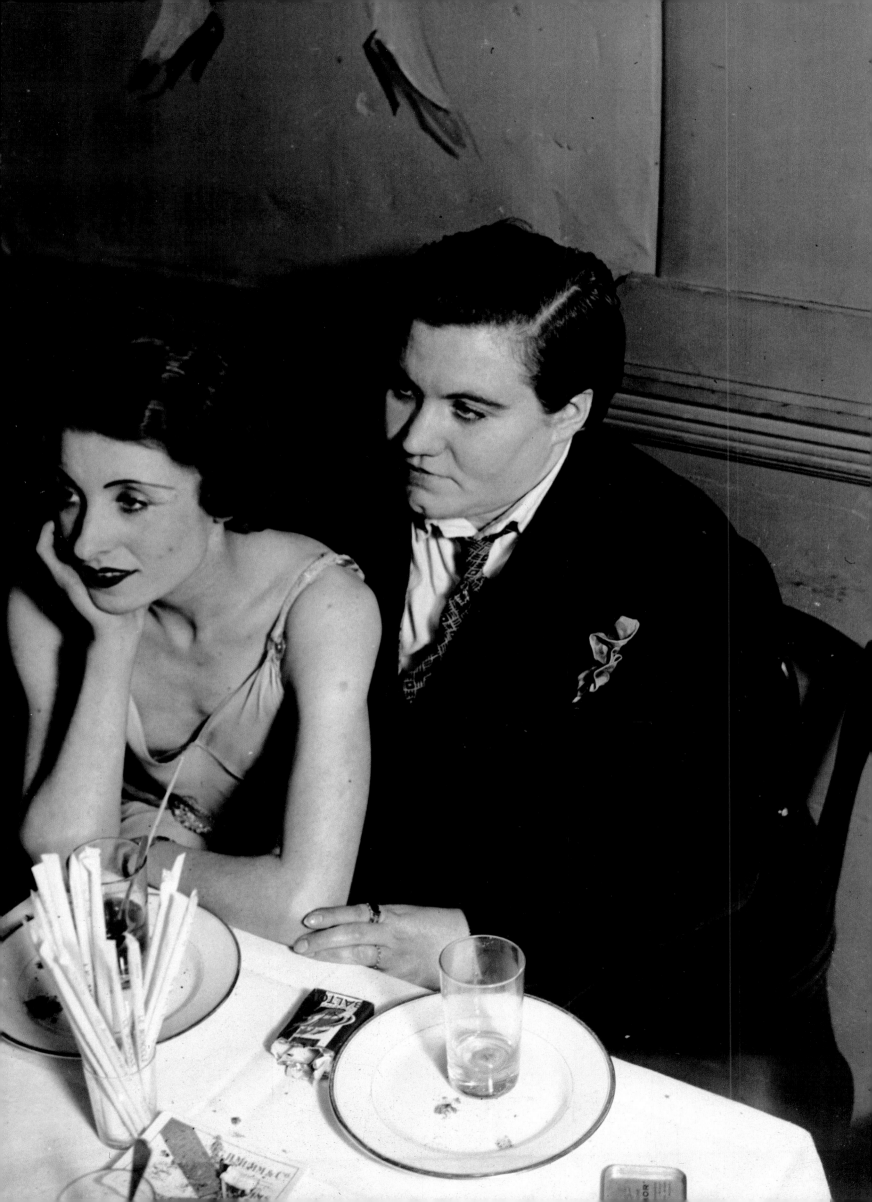

Society

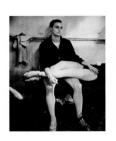

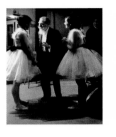

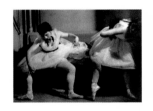

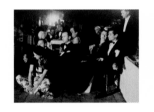

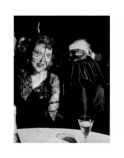

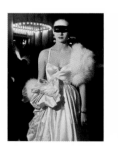

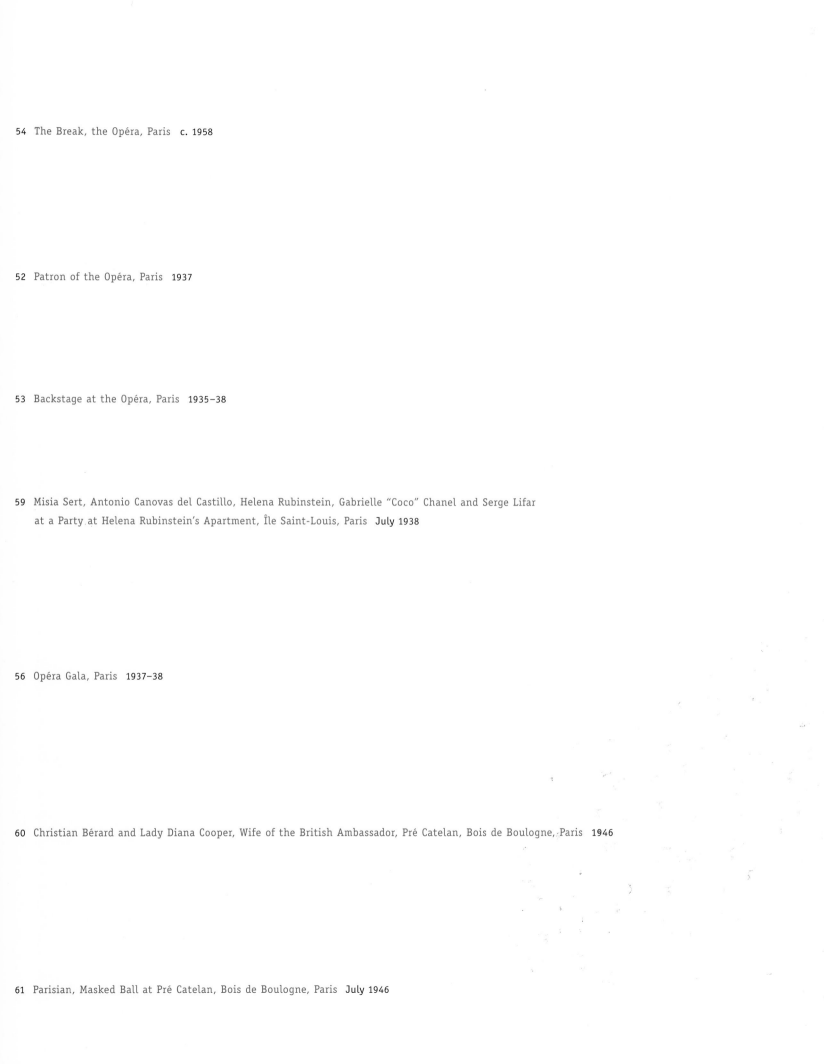

54 The Break, the Opéra, Paris c. 1958

52 Patron of the Opéra, Paris 1937

53 Backstage at the Opéra, Paris 1935–38

59 Misia Sert, Antonio Canovas del Castillo, Helena Rubinstein, Gabrielle "Coco" Chanel and Serge Lifar
 at a Party at Helena Rubinstein's Apartment, Île Saint-Louis, Paris July 1938

56 Opéra Gala, Paris 1937–38

60 Christian Bérard and Lady Diana Cooper, Wife of the British Ambassador, Pré Catelan, Bois de Boulogne, Paris 1946

61 Parisian, Masked Ball at Pré Catelan, Bois de Boulogne, Paris July 1946

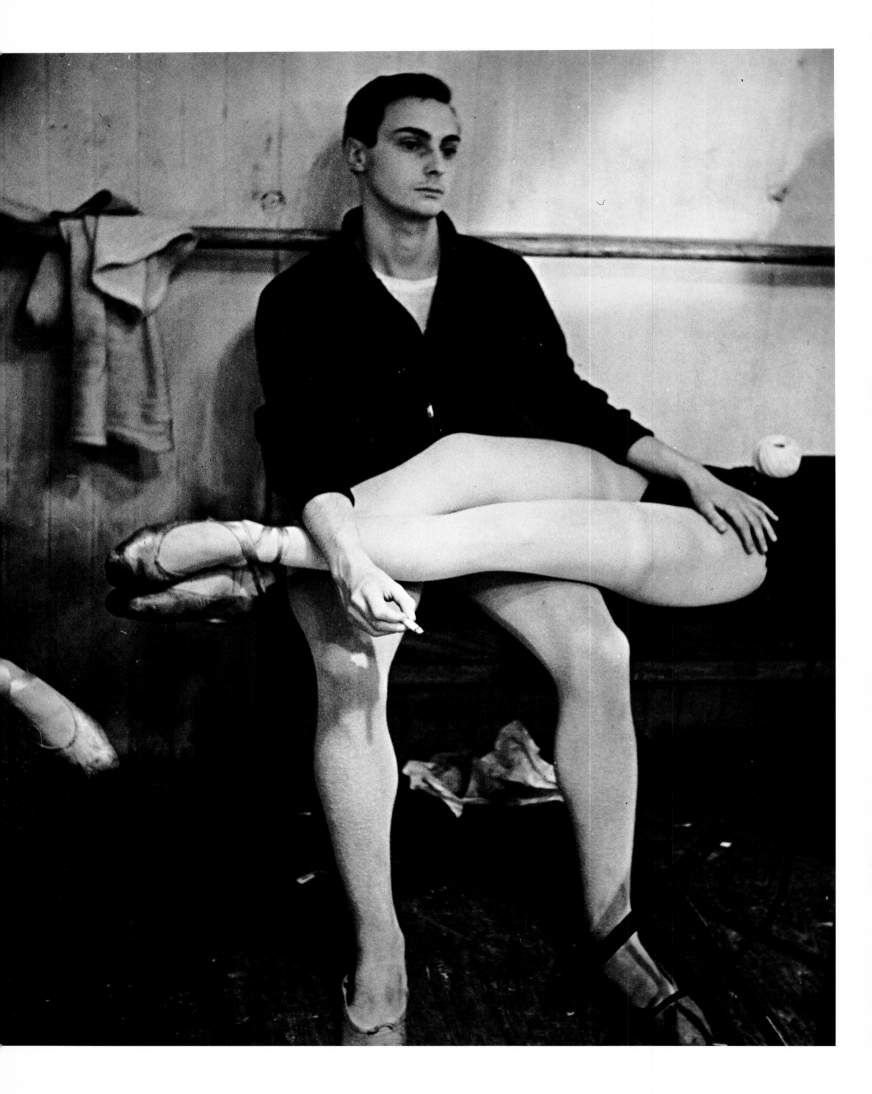

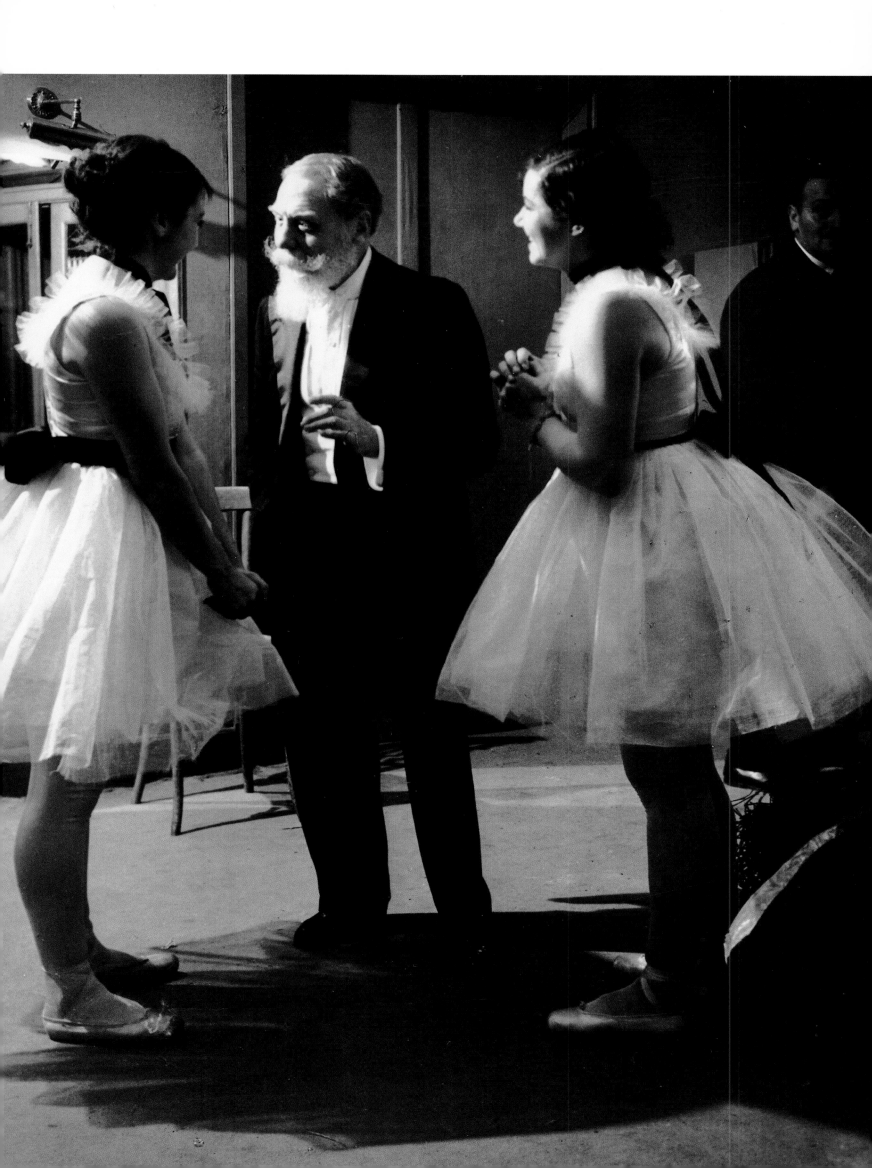

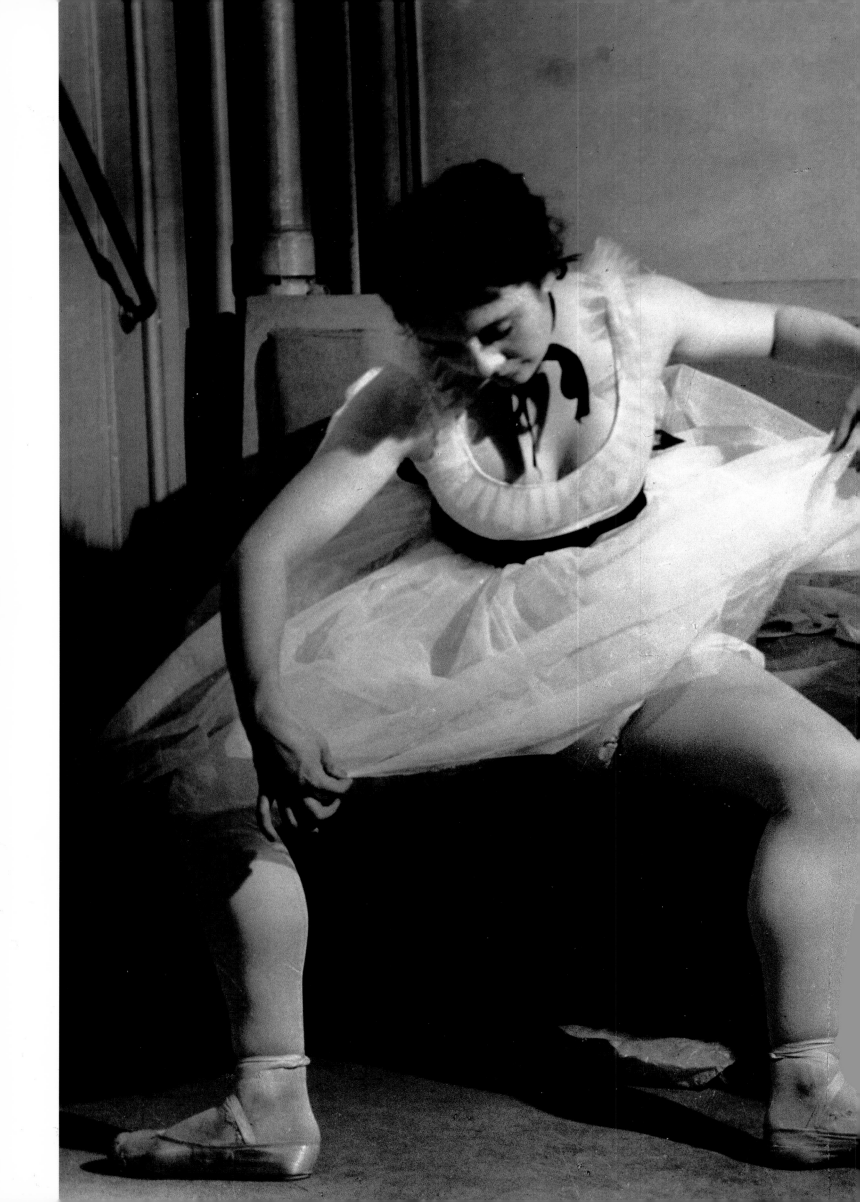

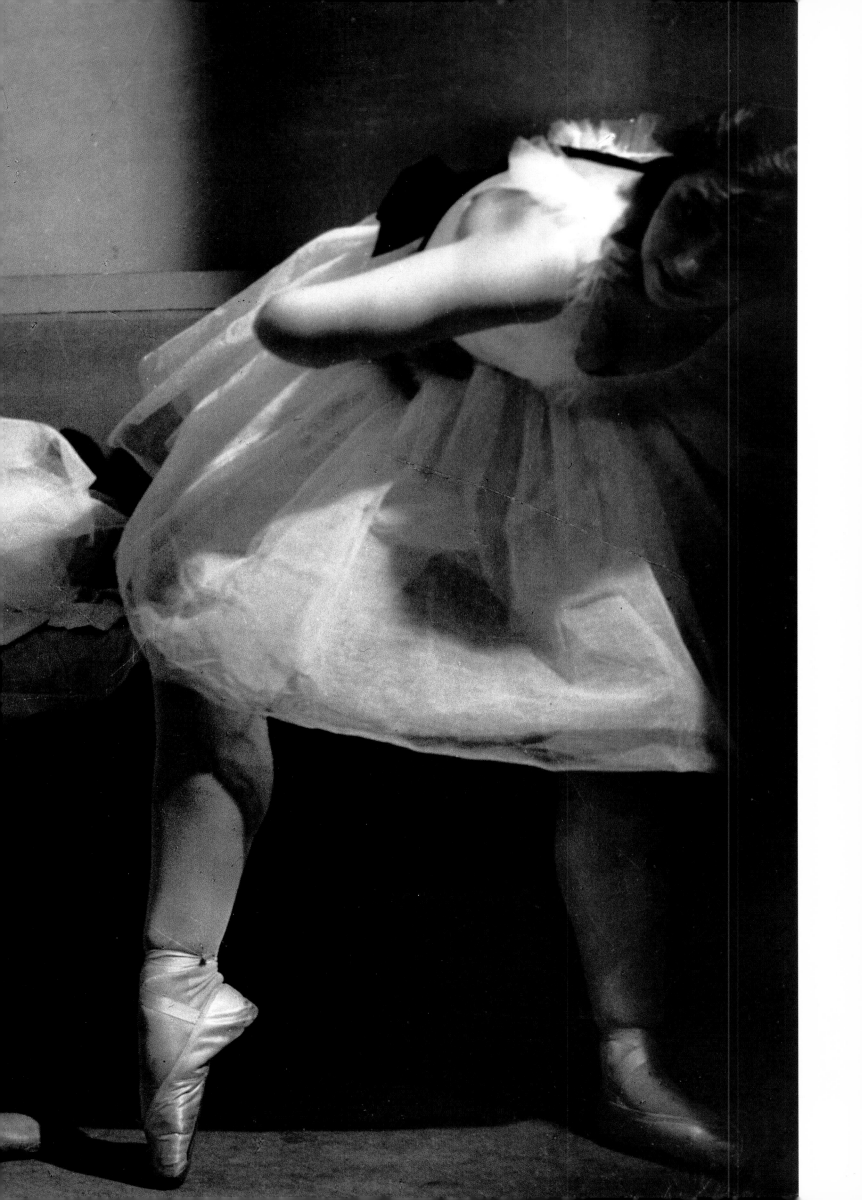

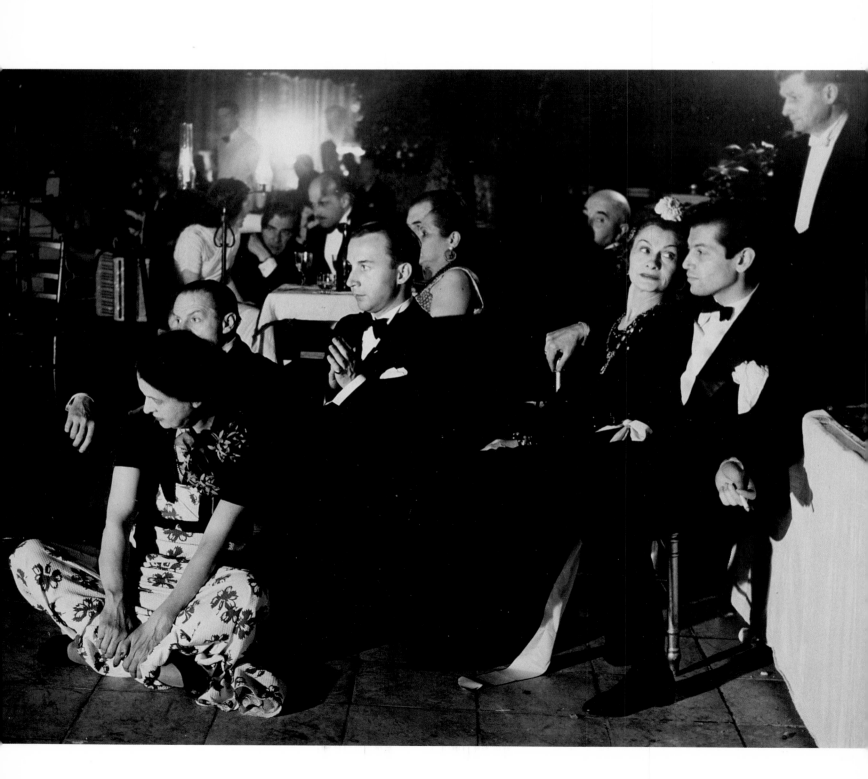

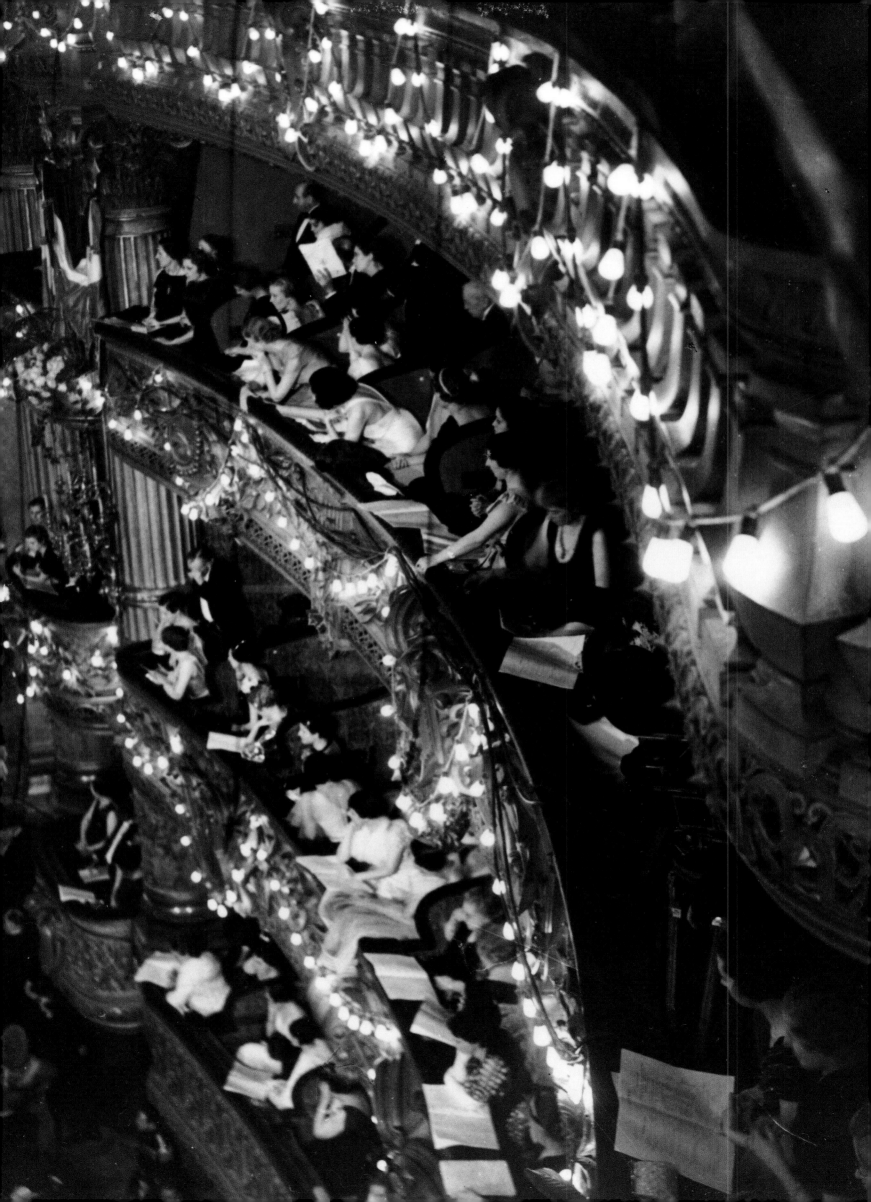

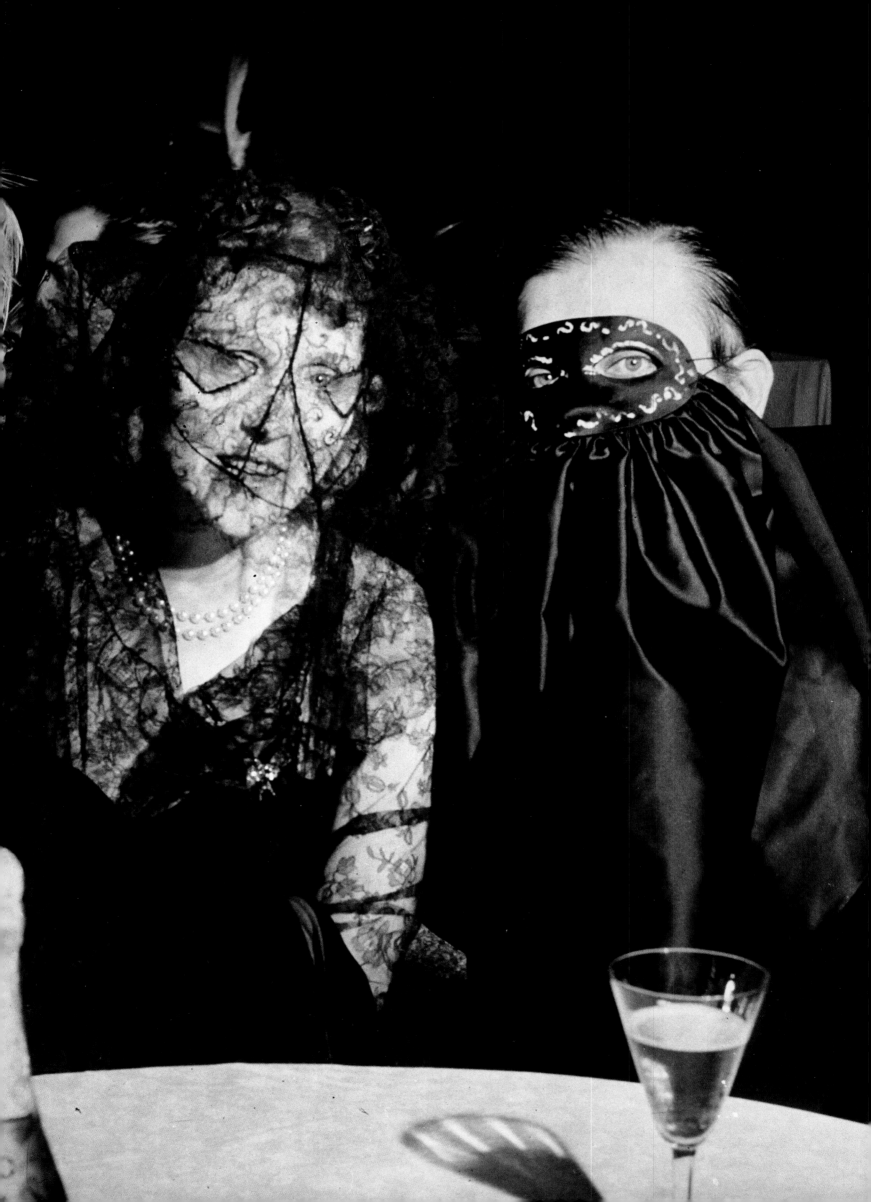

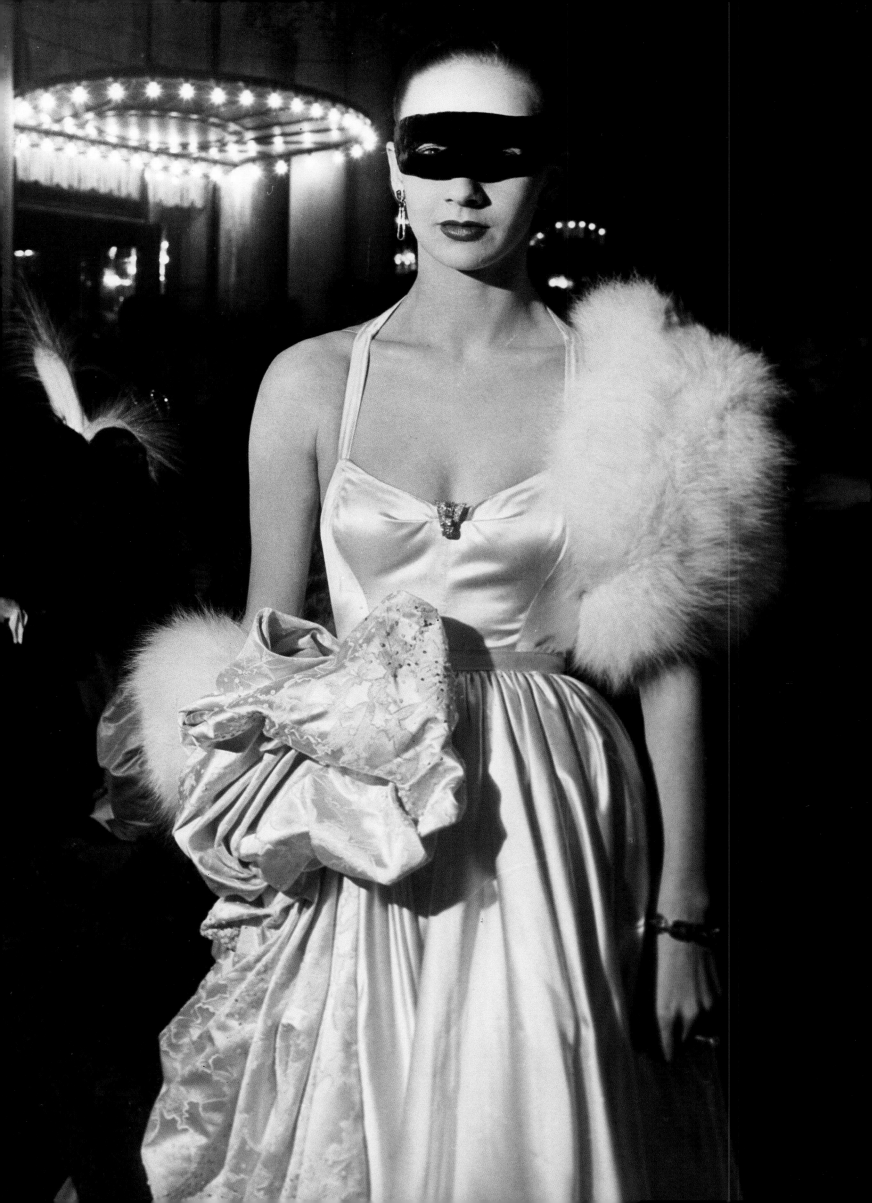

Portraits

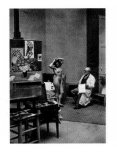

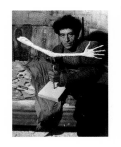

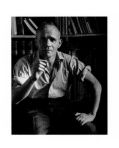

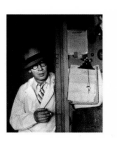

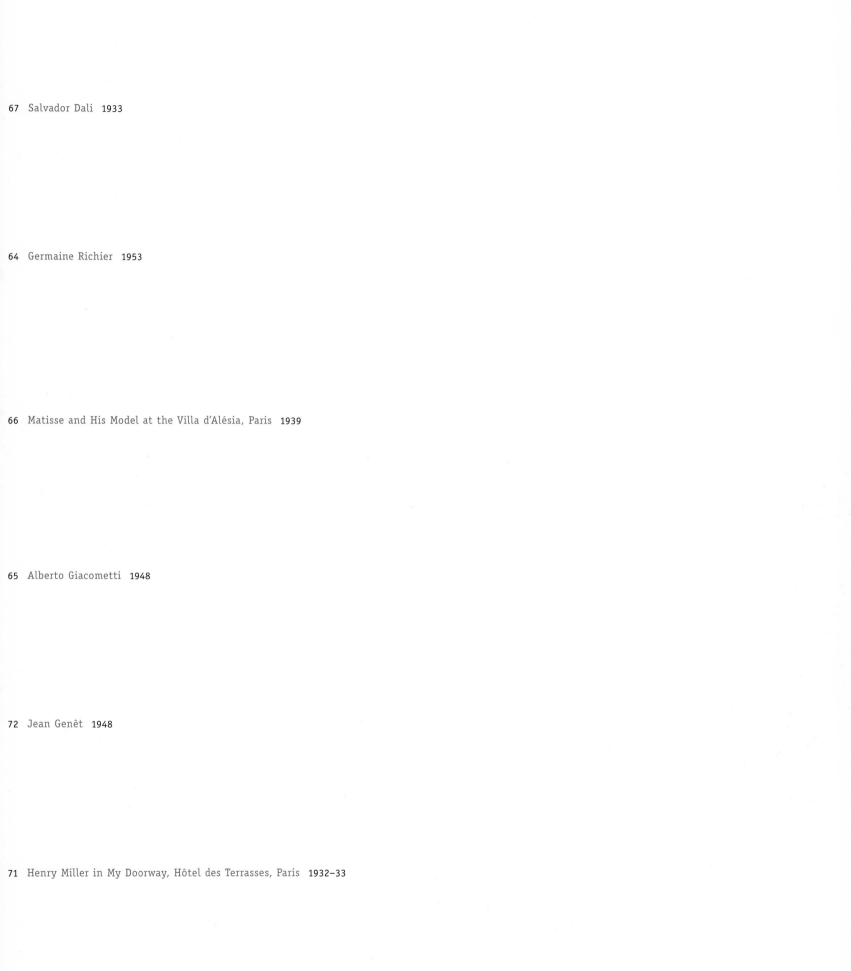

67 Salvador Dali 1933

64 Germaine Richier 1953

66 Matisse and His Model at the Villa d'Alésia, Paris 1939

65 Alberto Giacometti 1948

72 Jean Genêt 1948

71 Henry Miller in My Doorway, Hôtel des Terrasses, Paris 1932–33

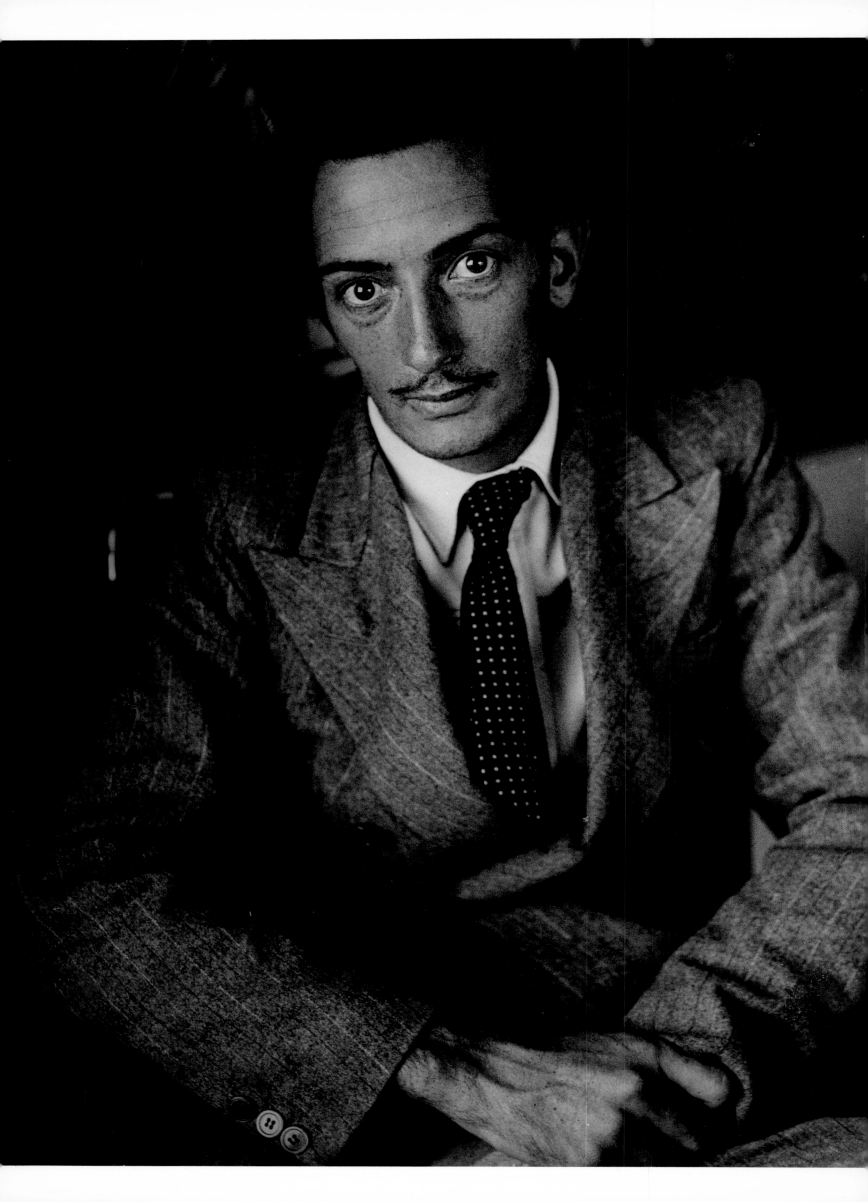

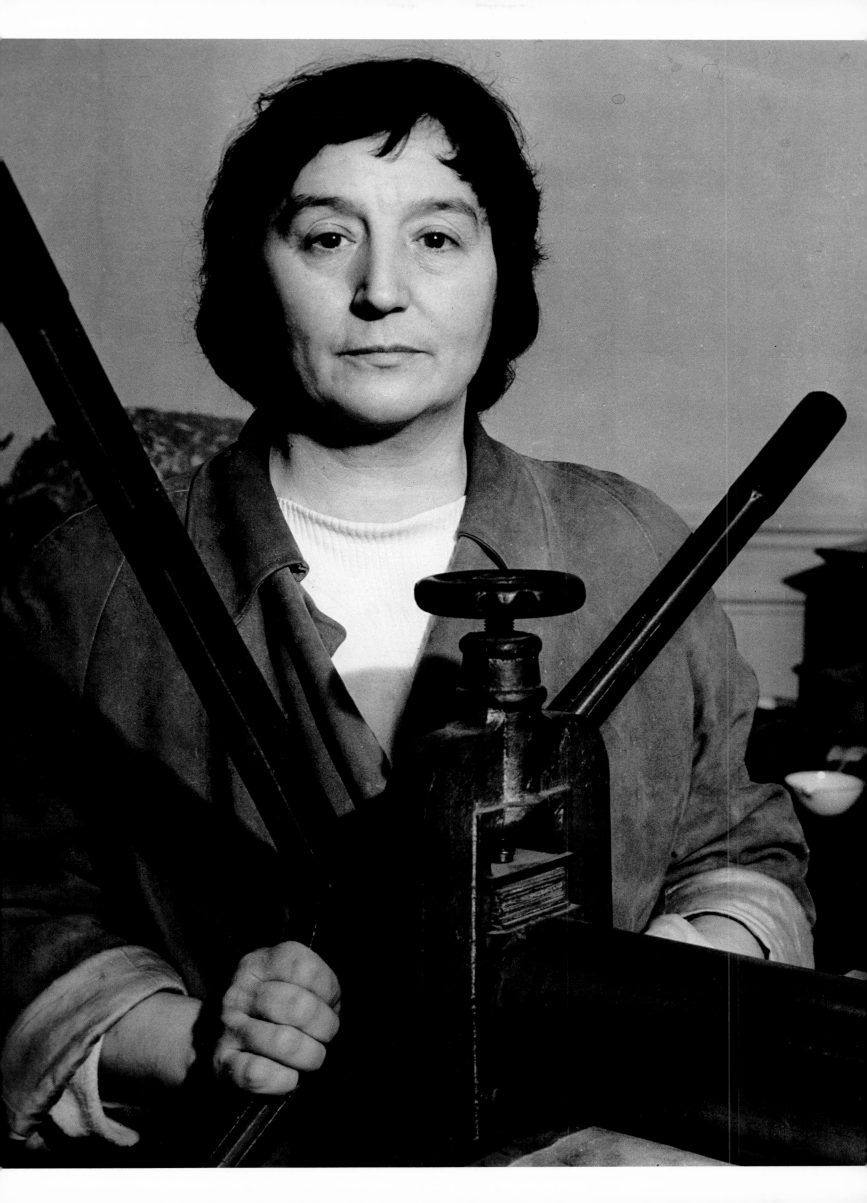

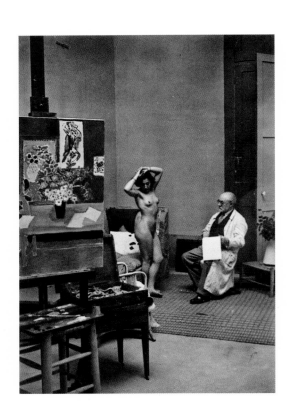

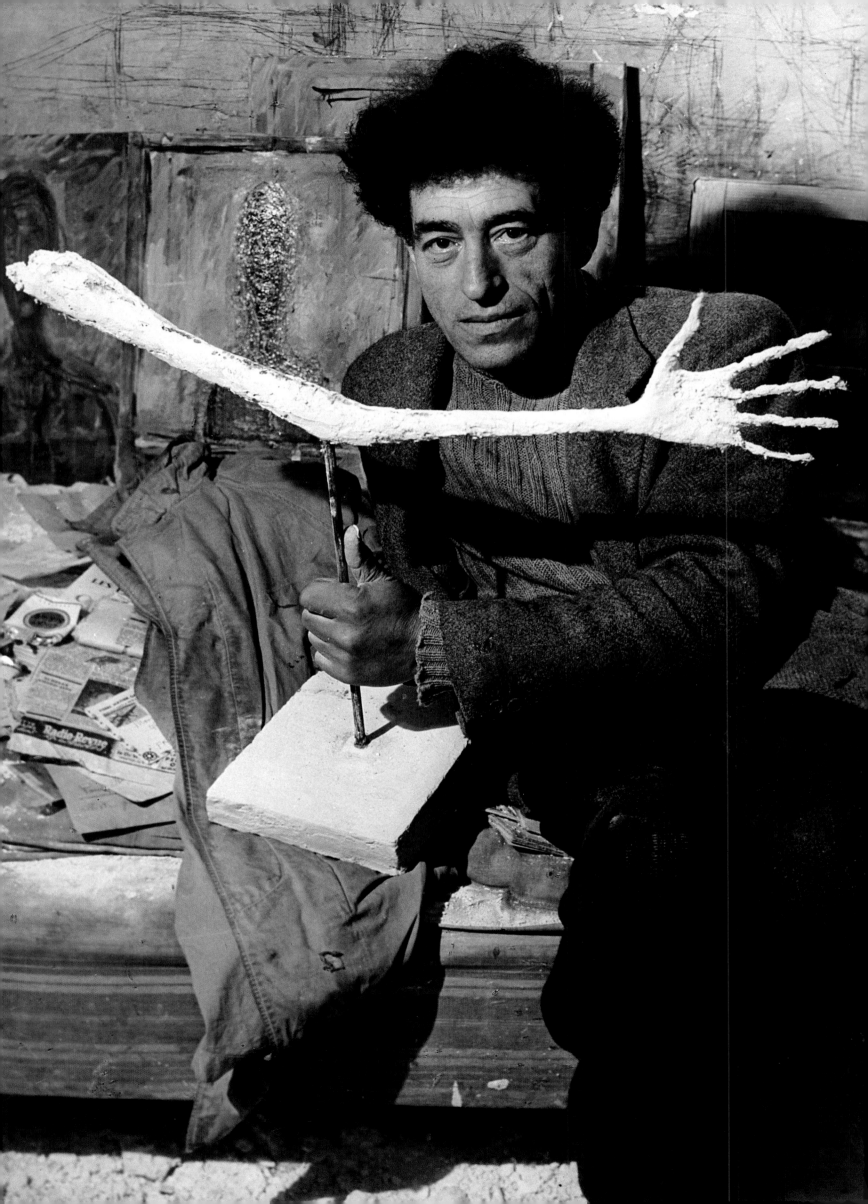

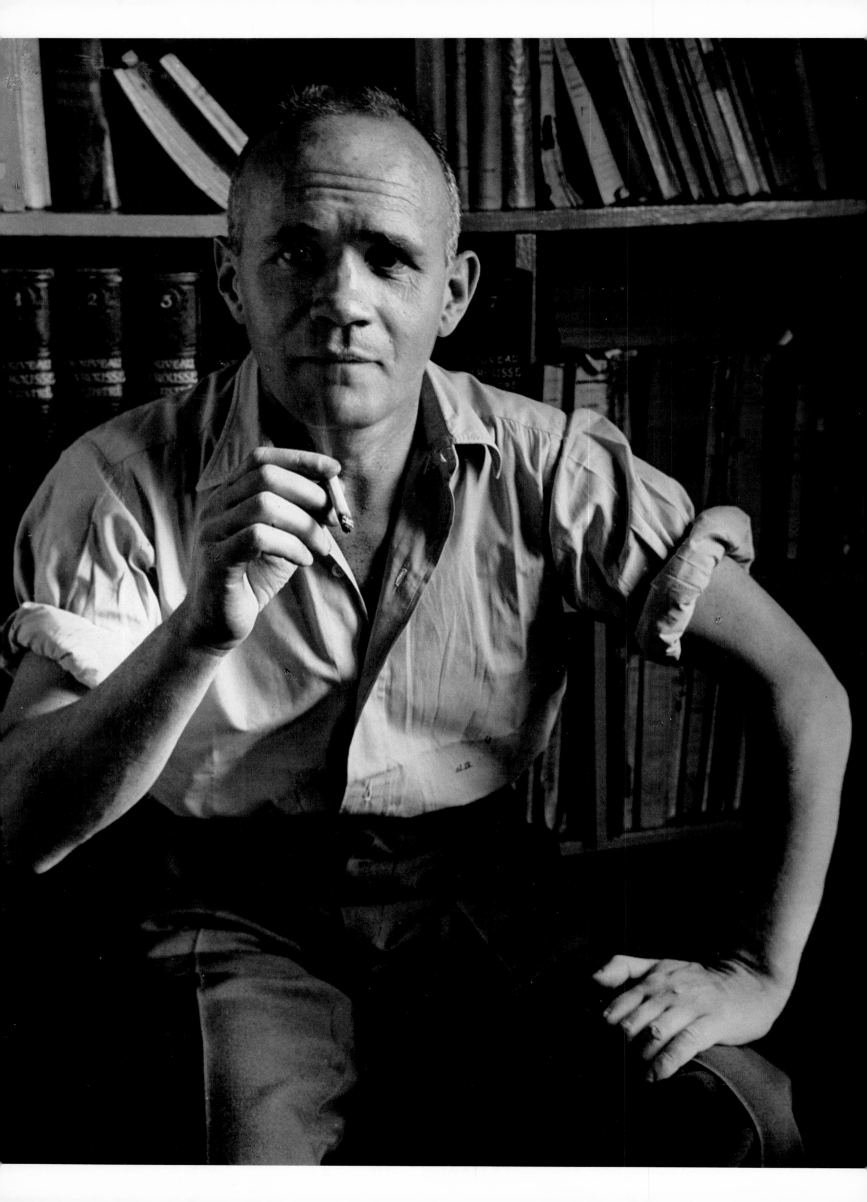

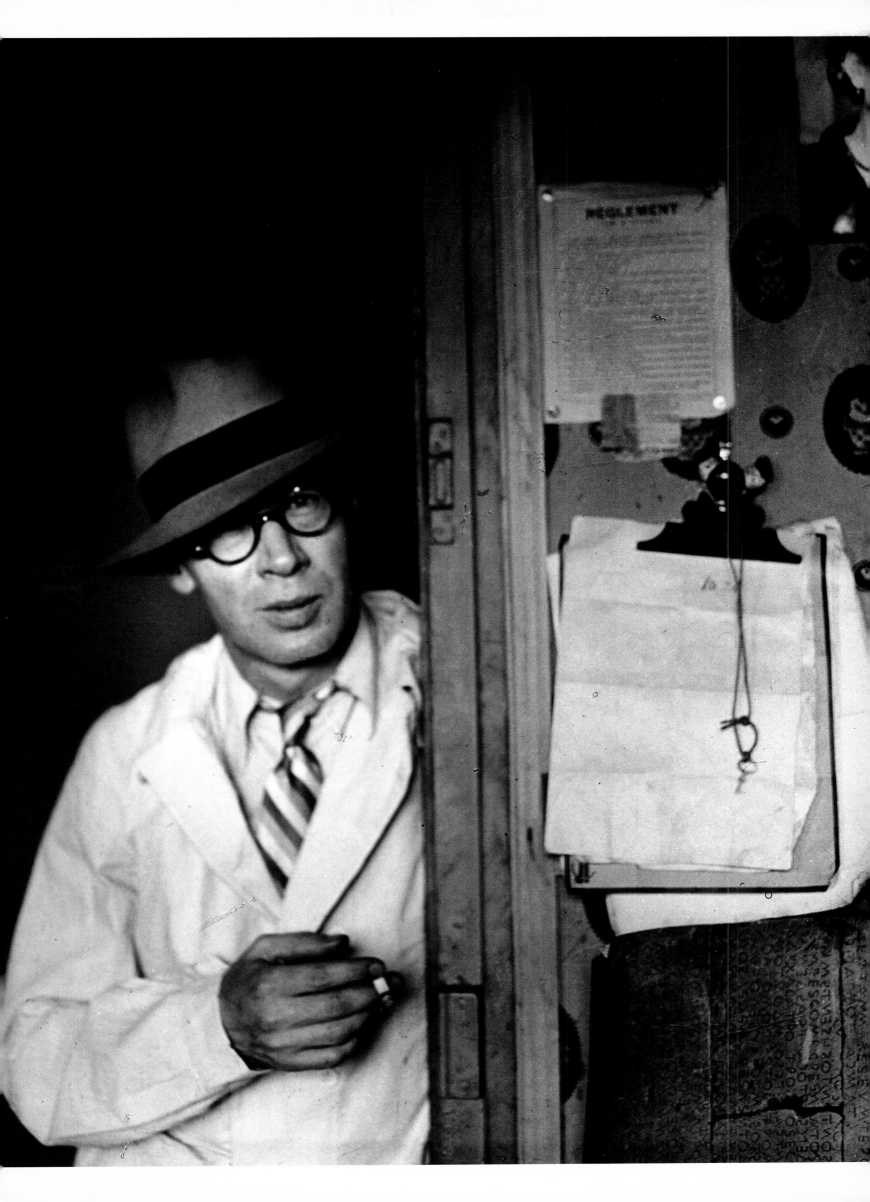

Picasso

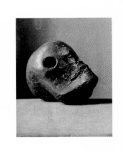

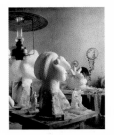

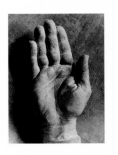

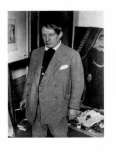

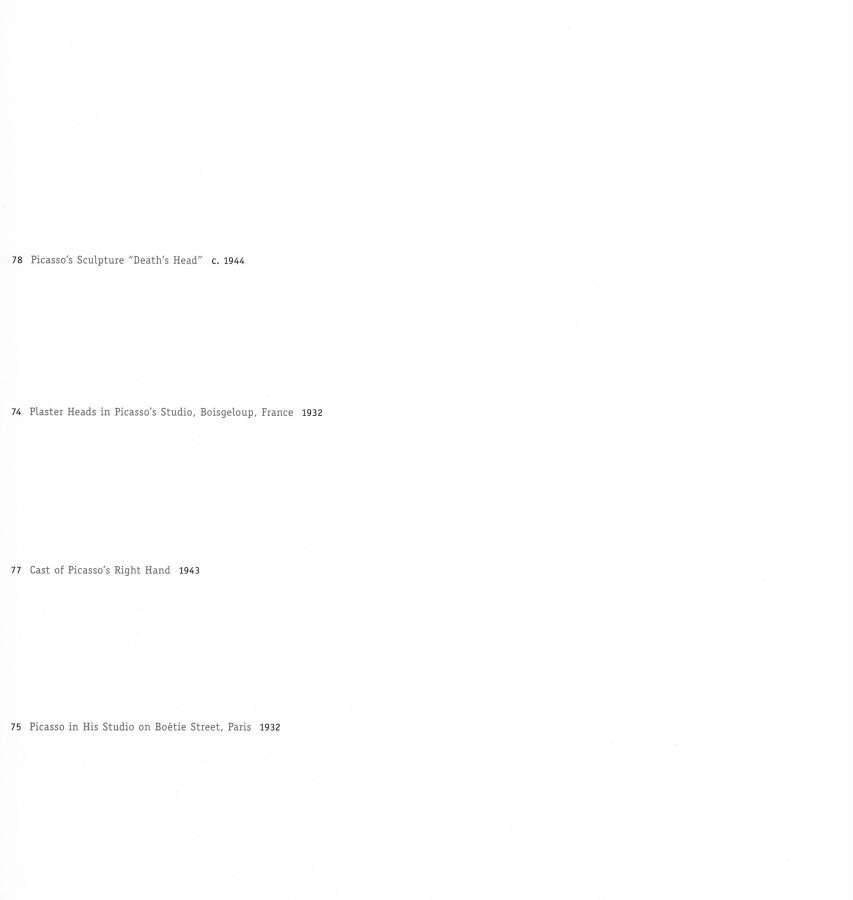

78 Picasso's Sculpture "Death's Head" c. 1944

74 Plaster Heads in Picasso's Studio, Boisgeloup, France 1932

77 Cast of Picasso's Right Hand 1943

75 Picasso in His Studio on Boétie Street, Paris 1932

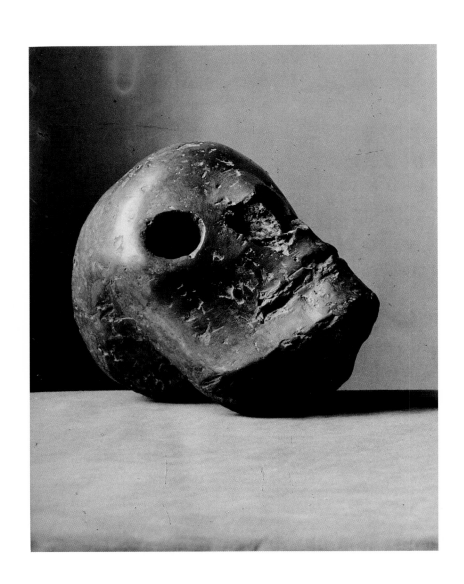

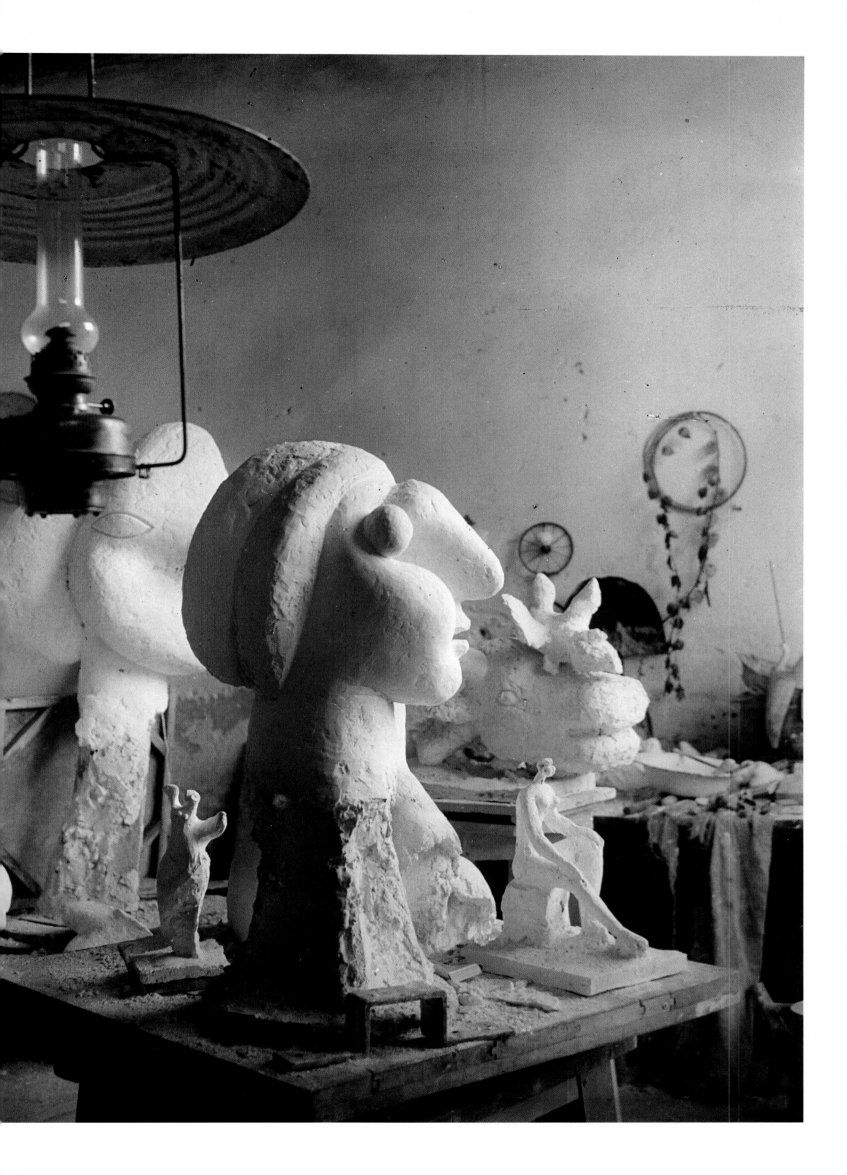

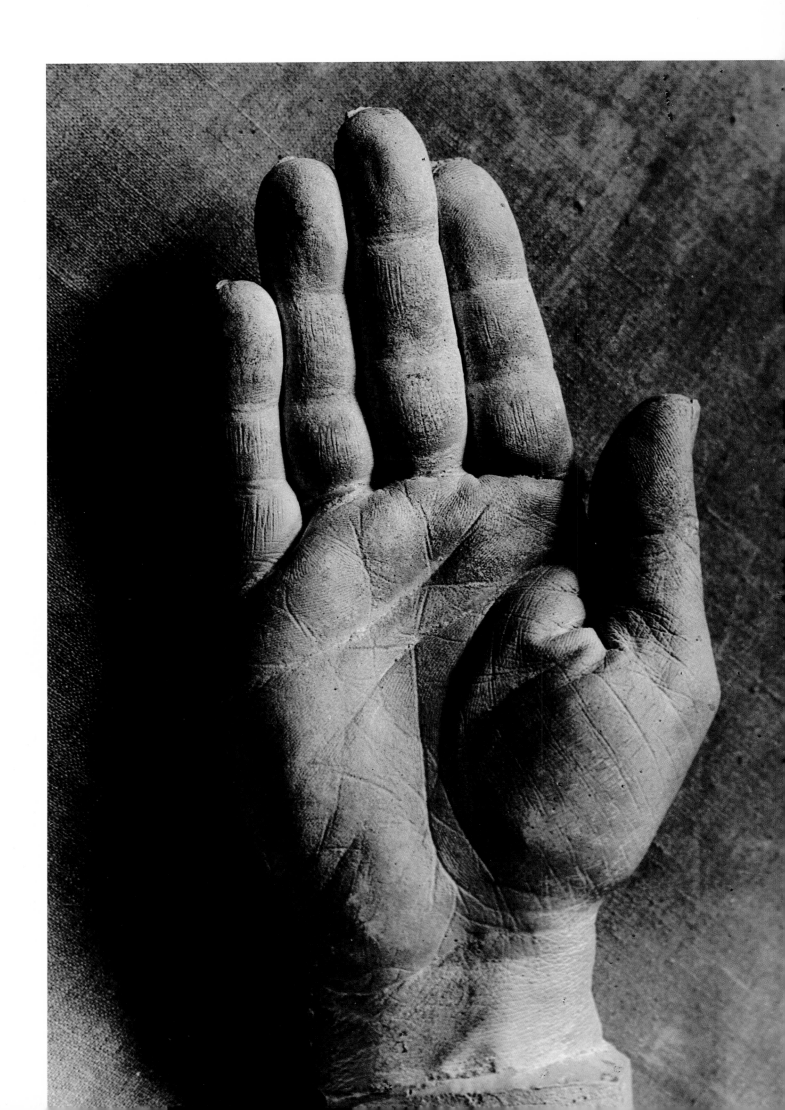

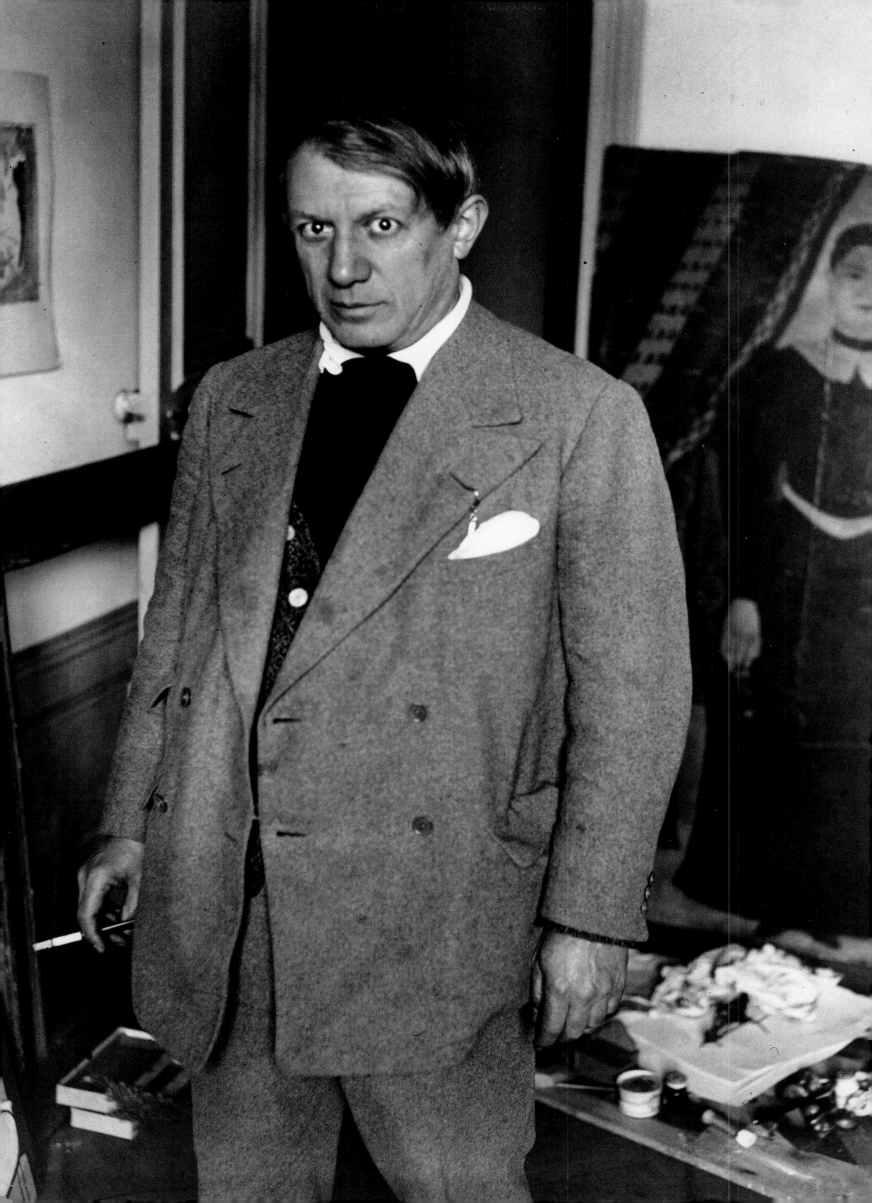

Nudes

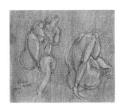

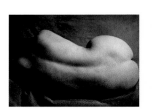

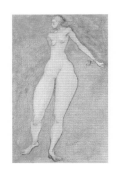

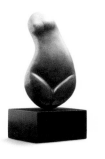

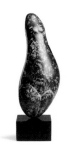

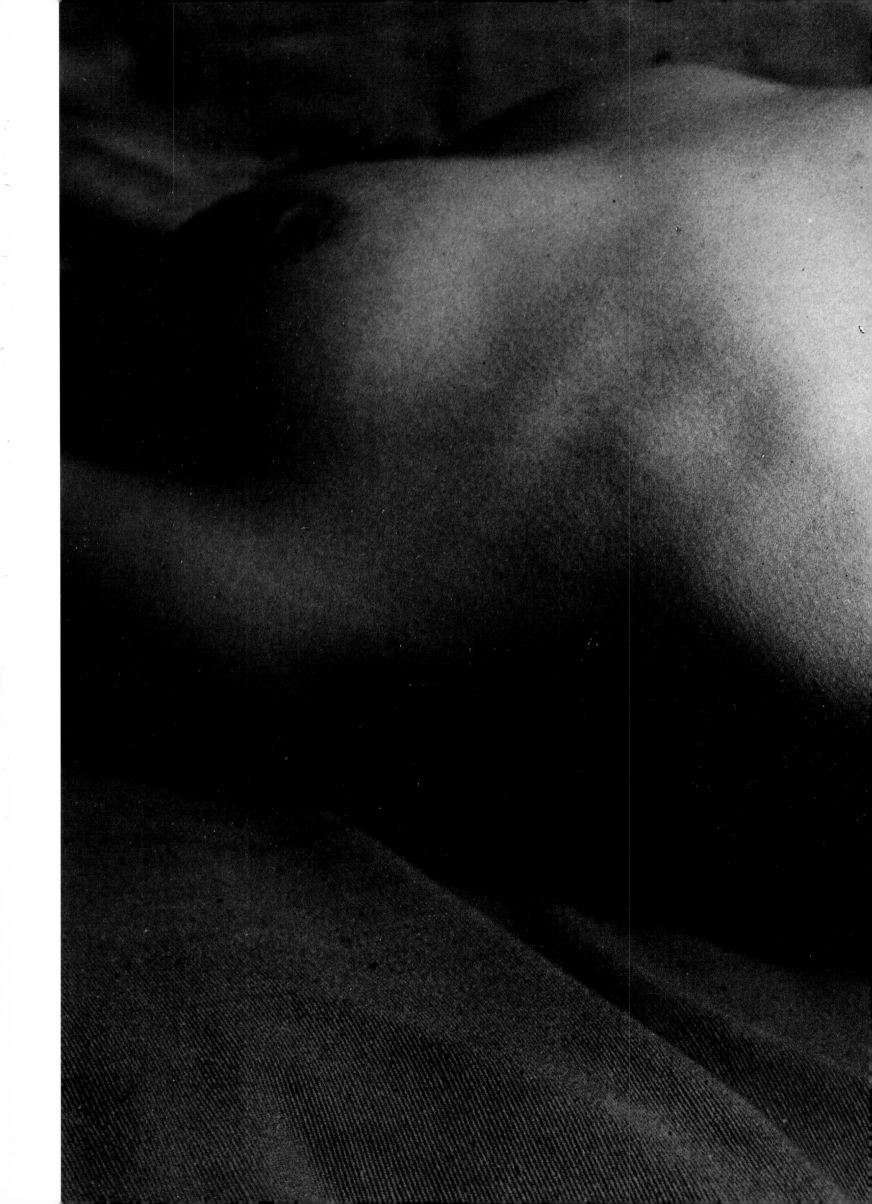

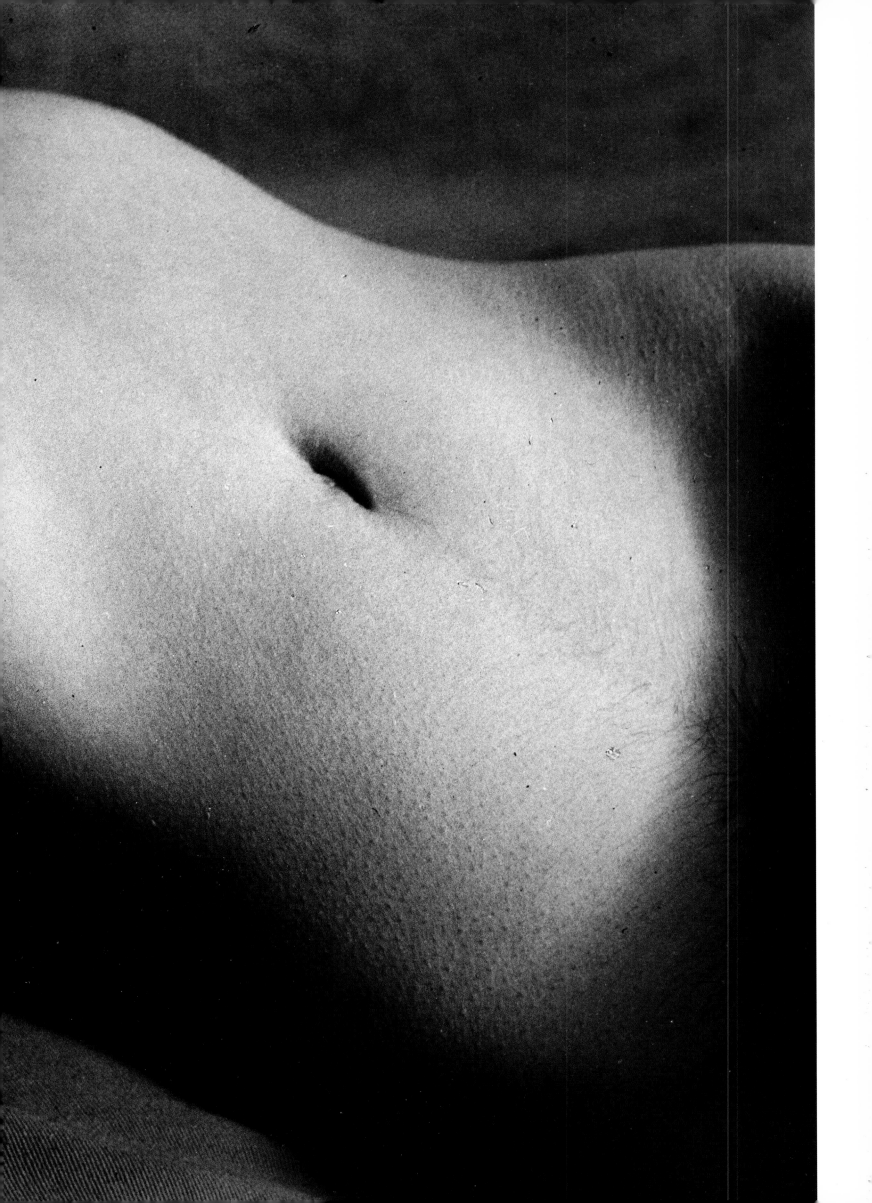

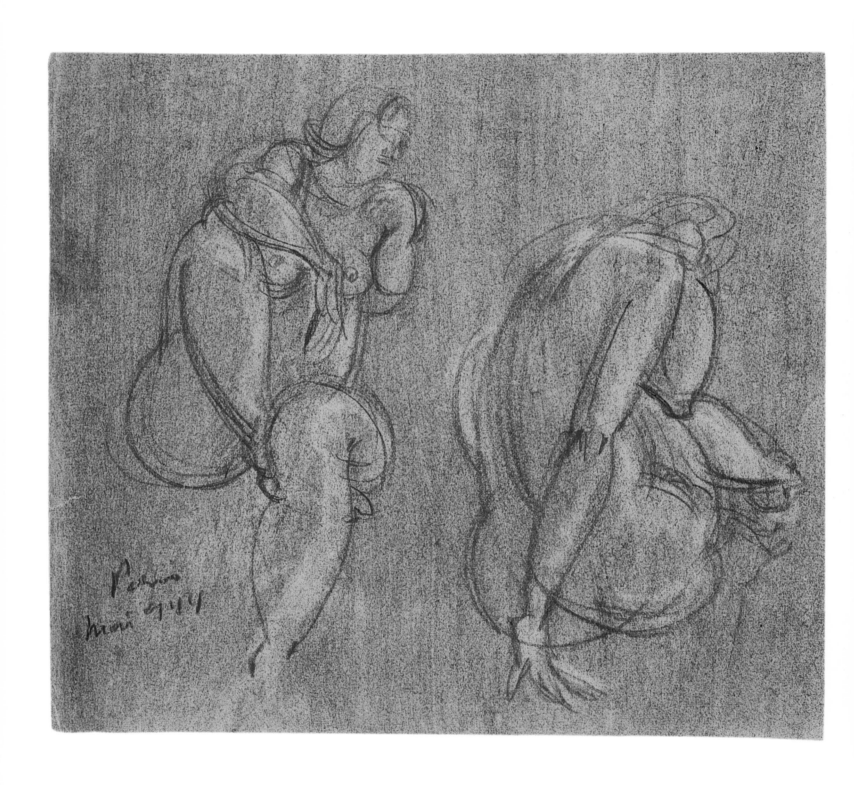

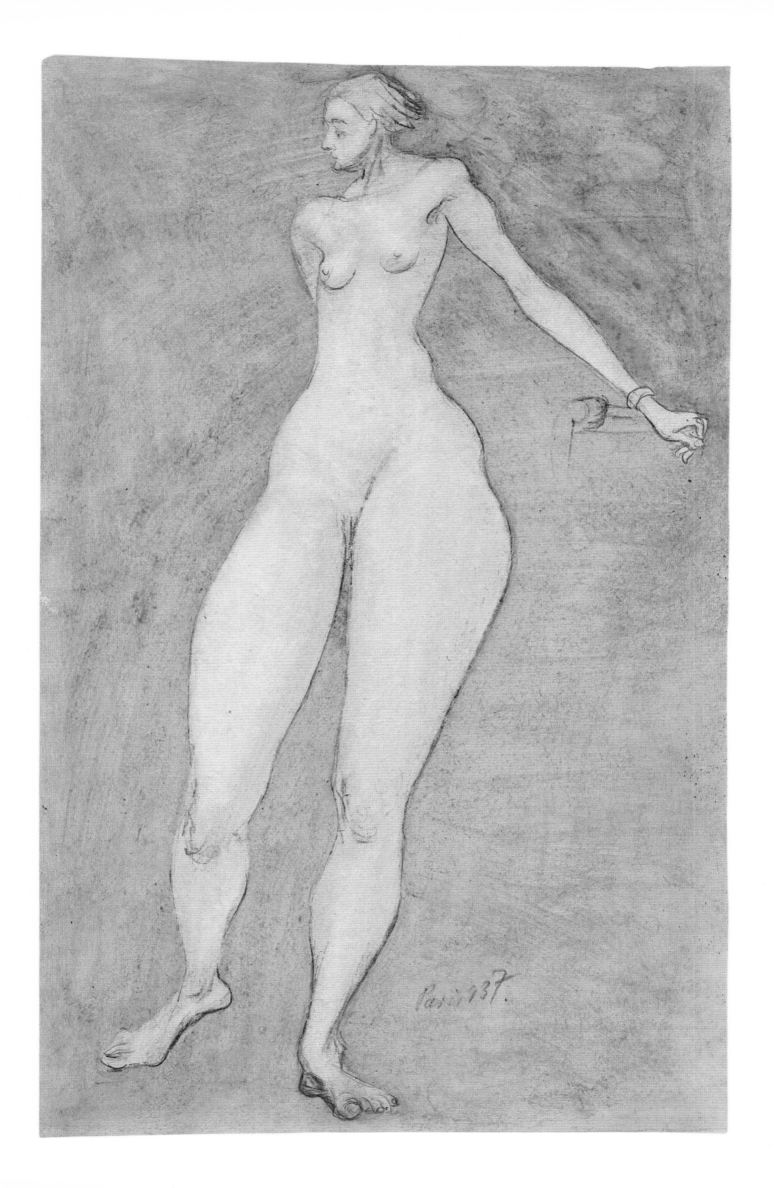

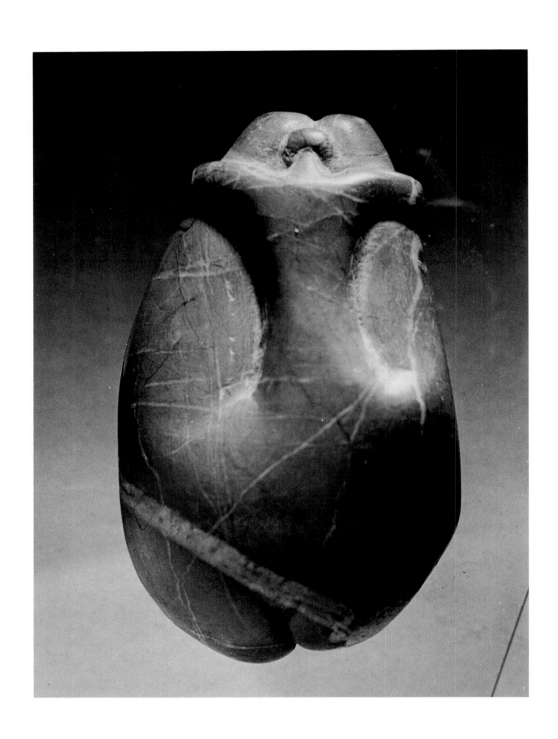

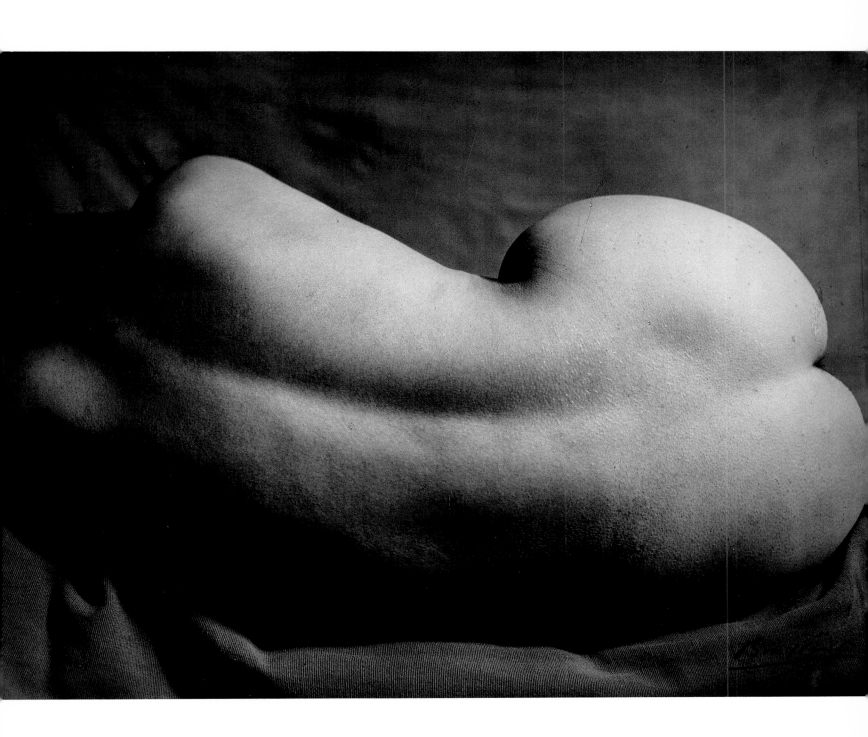

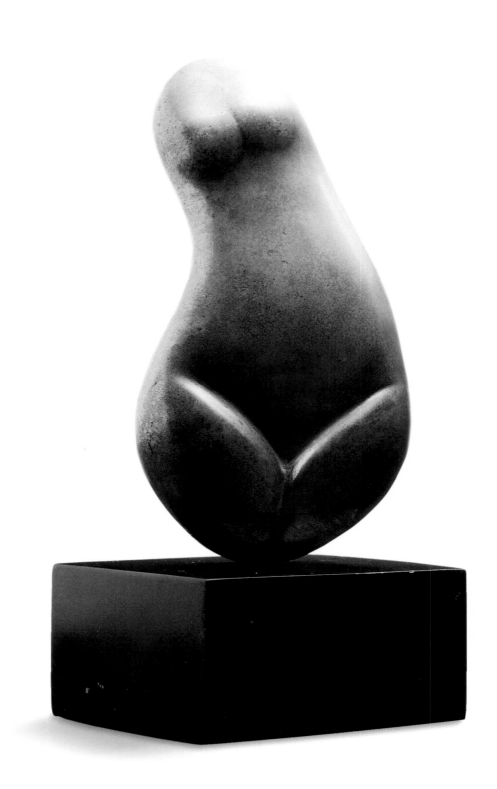

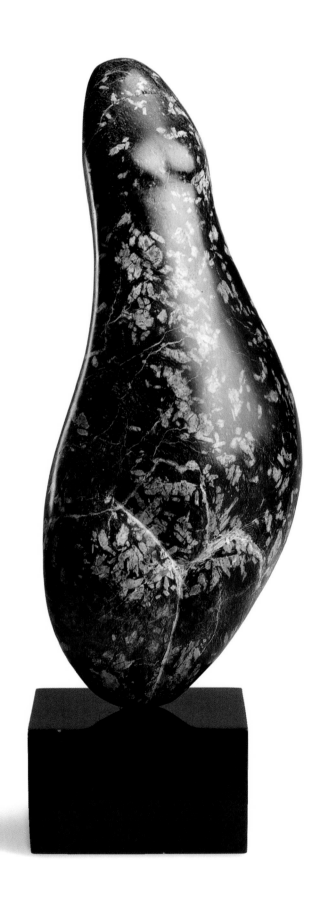

Arts

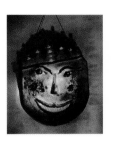

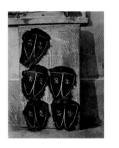

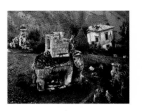

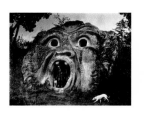

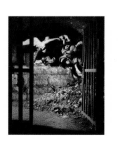

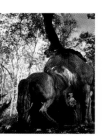

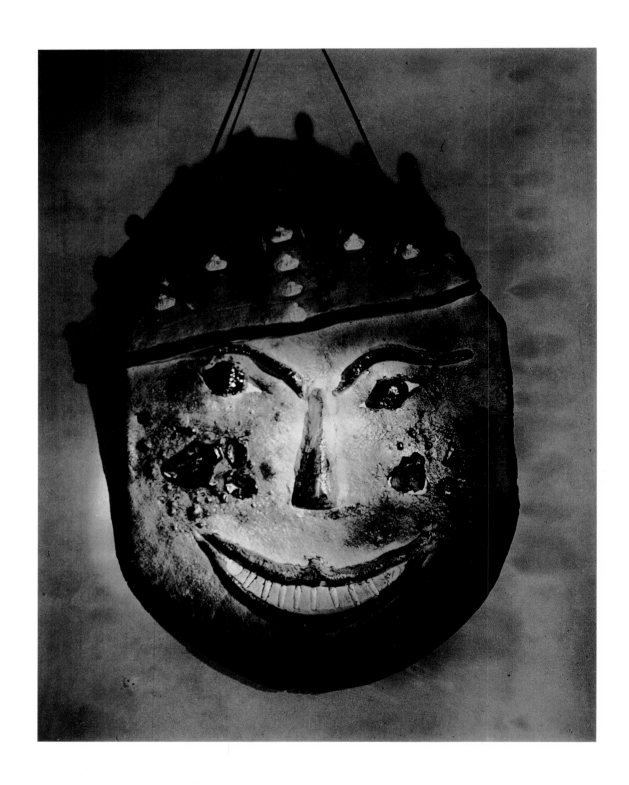

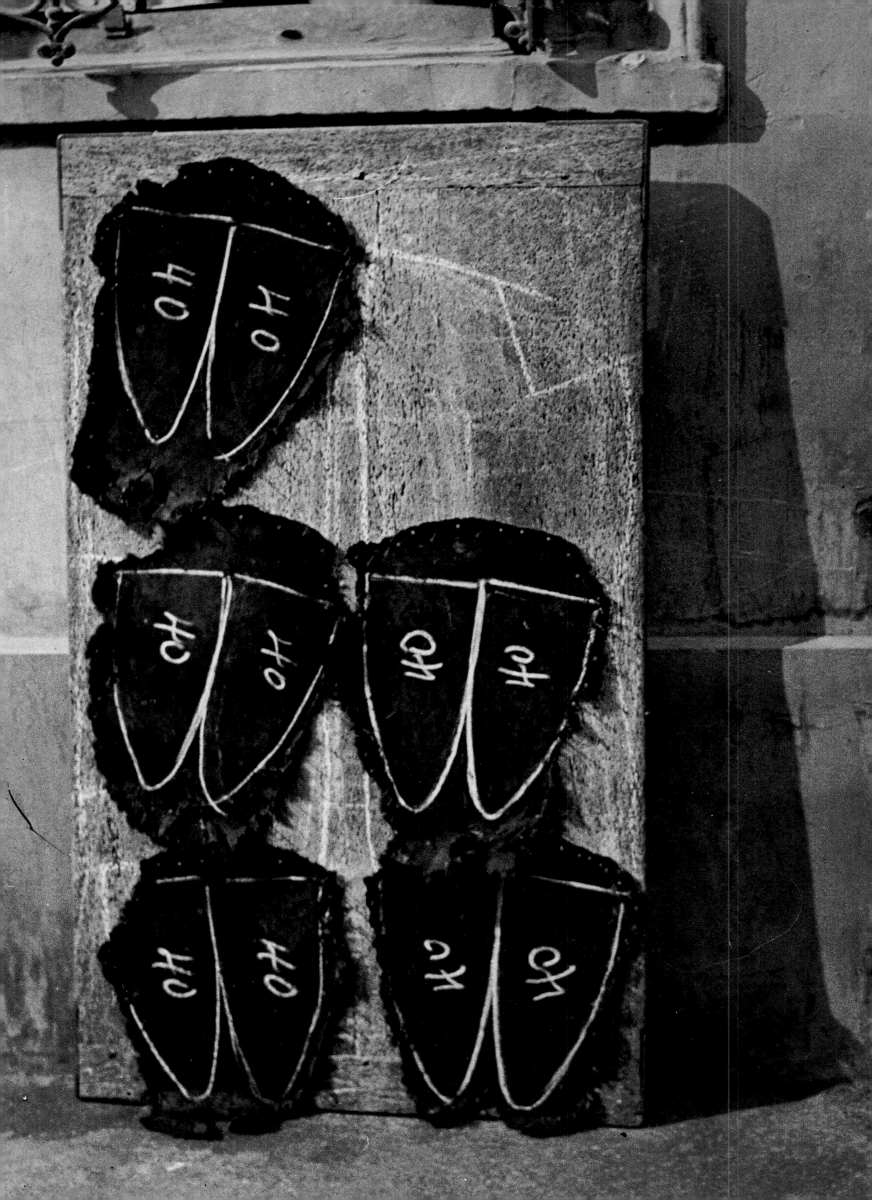

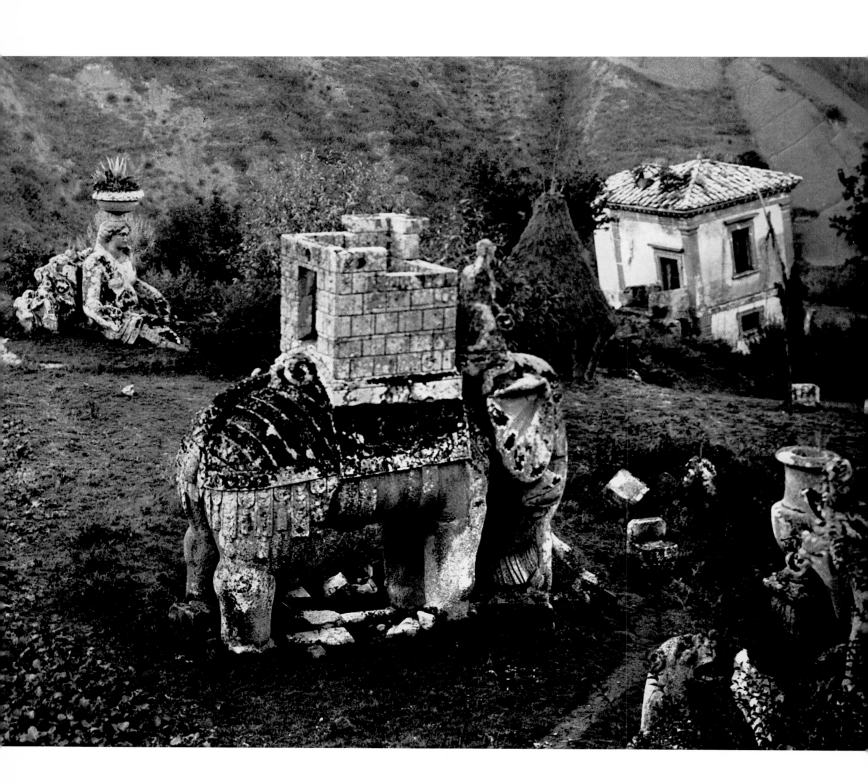

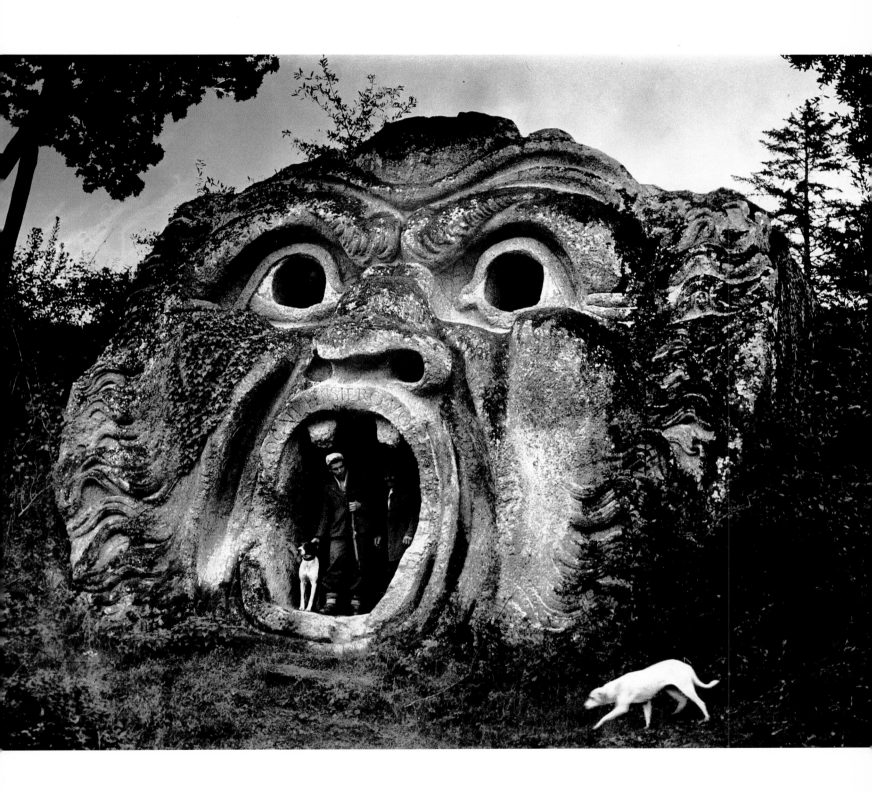

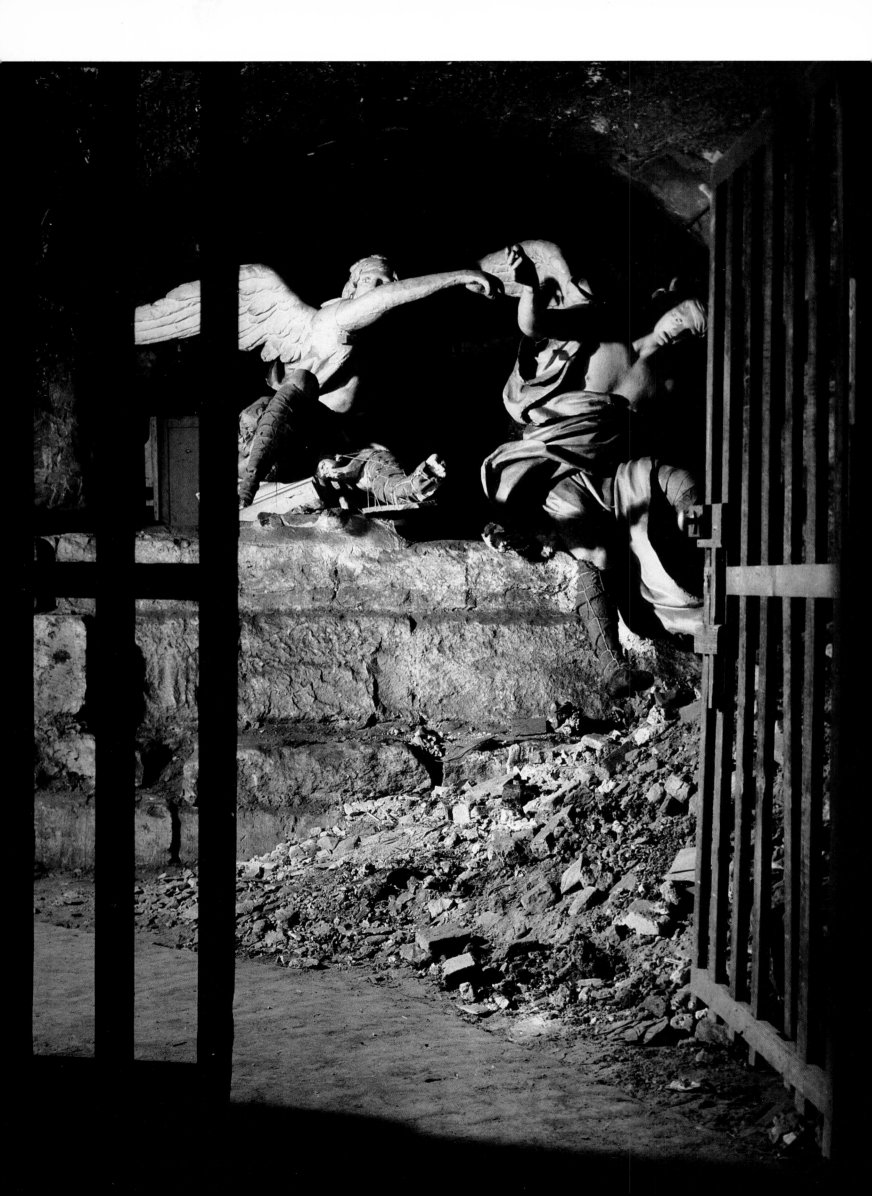

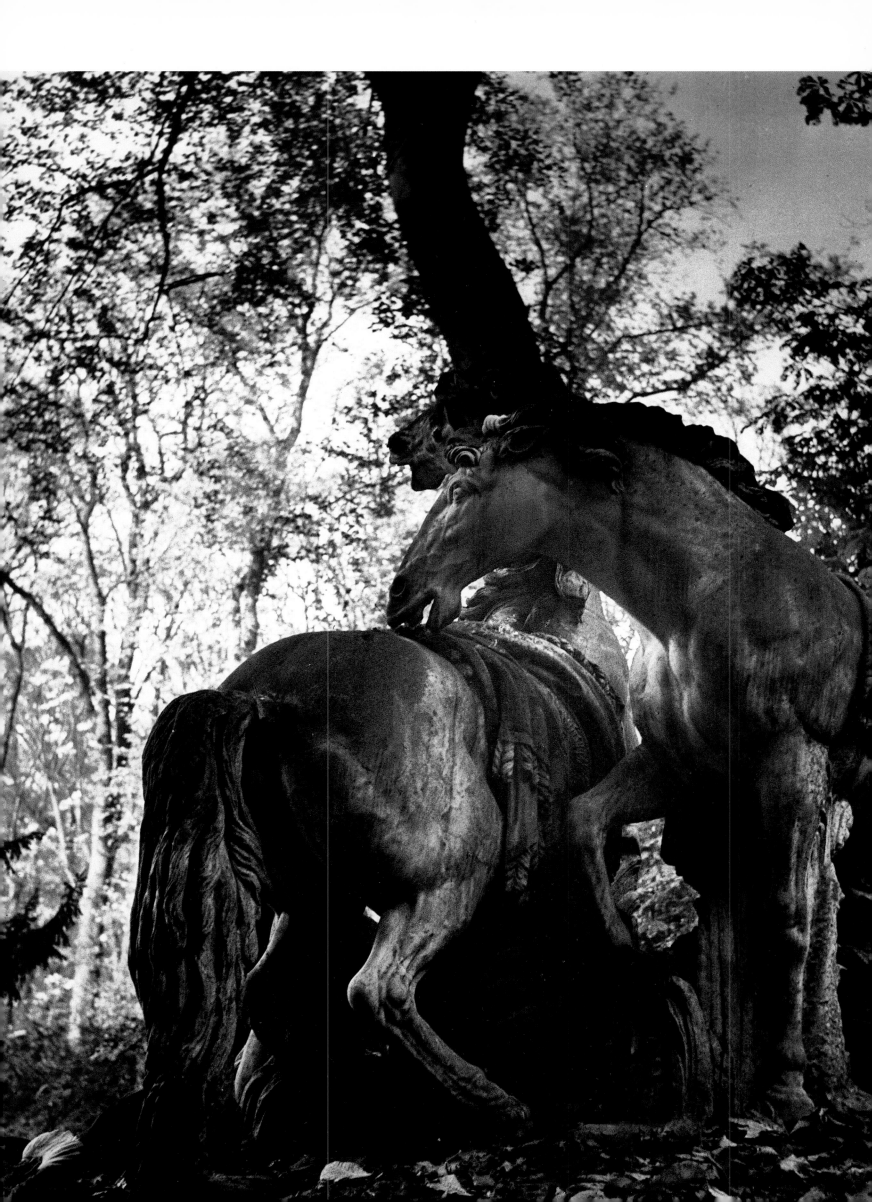

Graffiti

103 Untitled, from the series Graffiti: Primitive Images c. 1931–60

101 The Sun King, City Gate at Saint-Ouen, Paris, 1945–50, from the series Graffiti: Primitive Images c. 1931–60

104 Villa Riberolles, Bagnolet Street, Paris, from the series Graffiti: Primitive Images c. 1931–60

105 The Imp, Belleville, Paris 1952, from the series Graffiti: Magic c. 1931–60

100 Passion, from the series Graffiti: Magic c. 1931–60

106 Swastika 1940–44, from the series Graffiti: Magic c. 1931–60

109 Hommage 1960s, from the series Graffiti c. 1931–60

108 Assassin 1950s, from the series Graffiti c. 1931–60

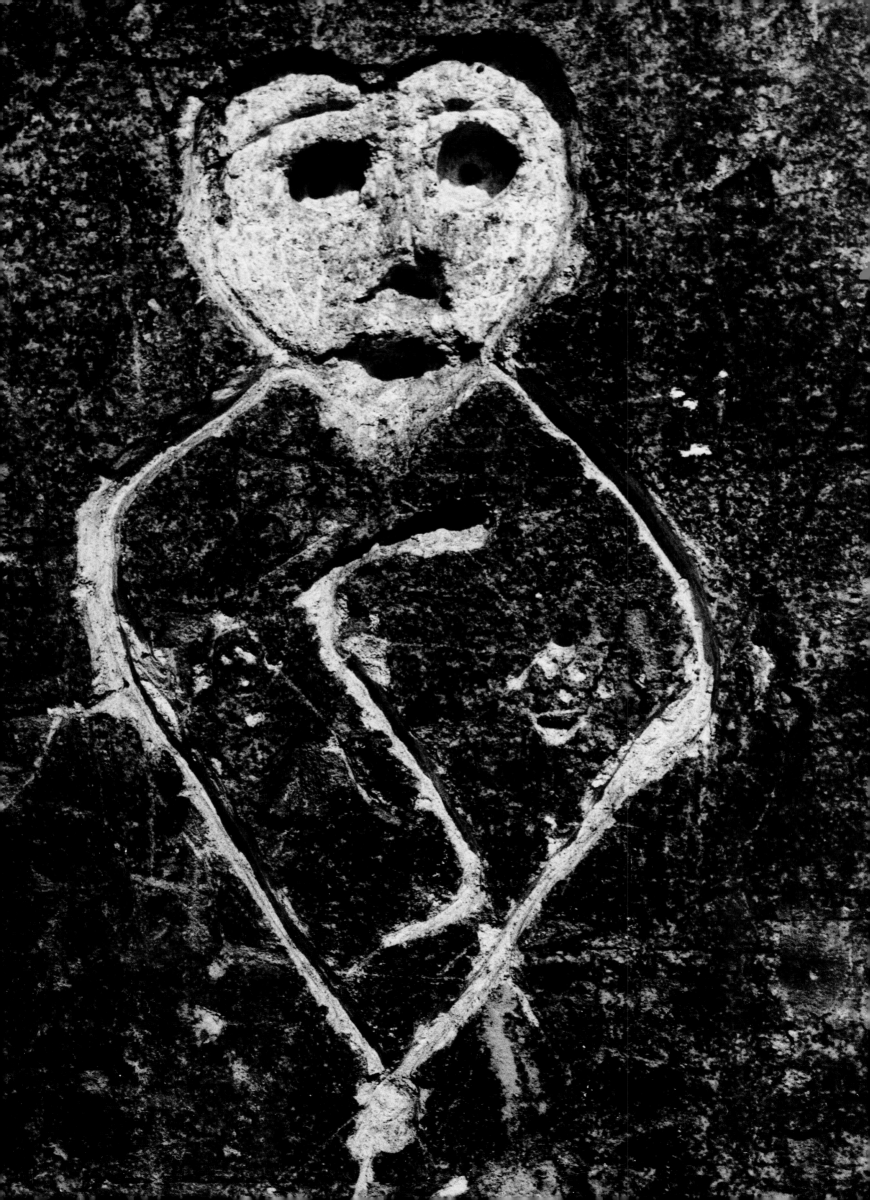

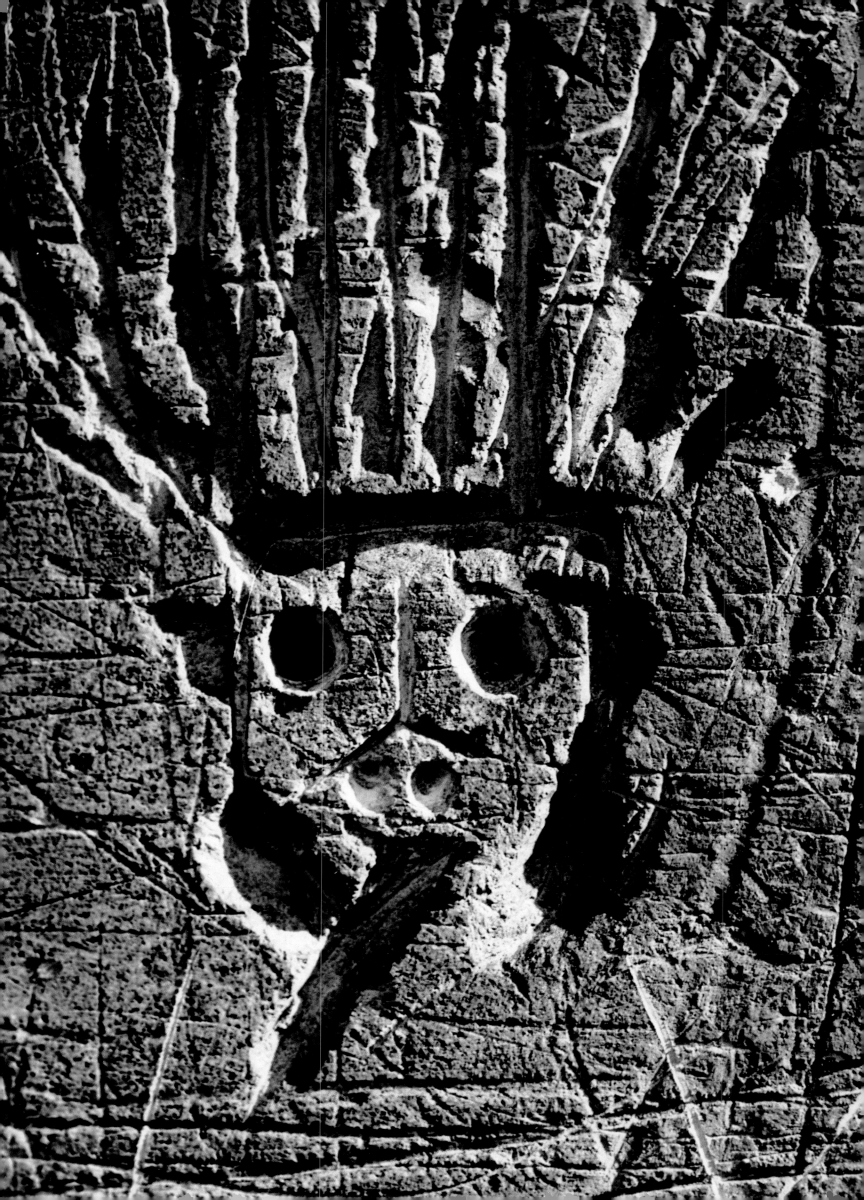

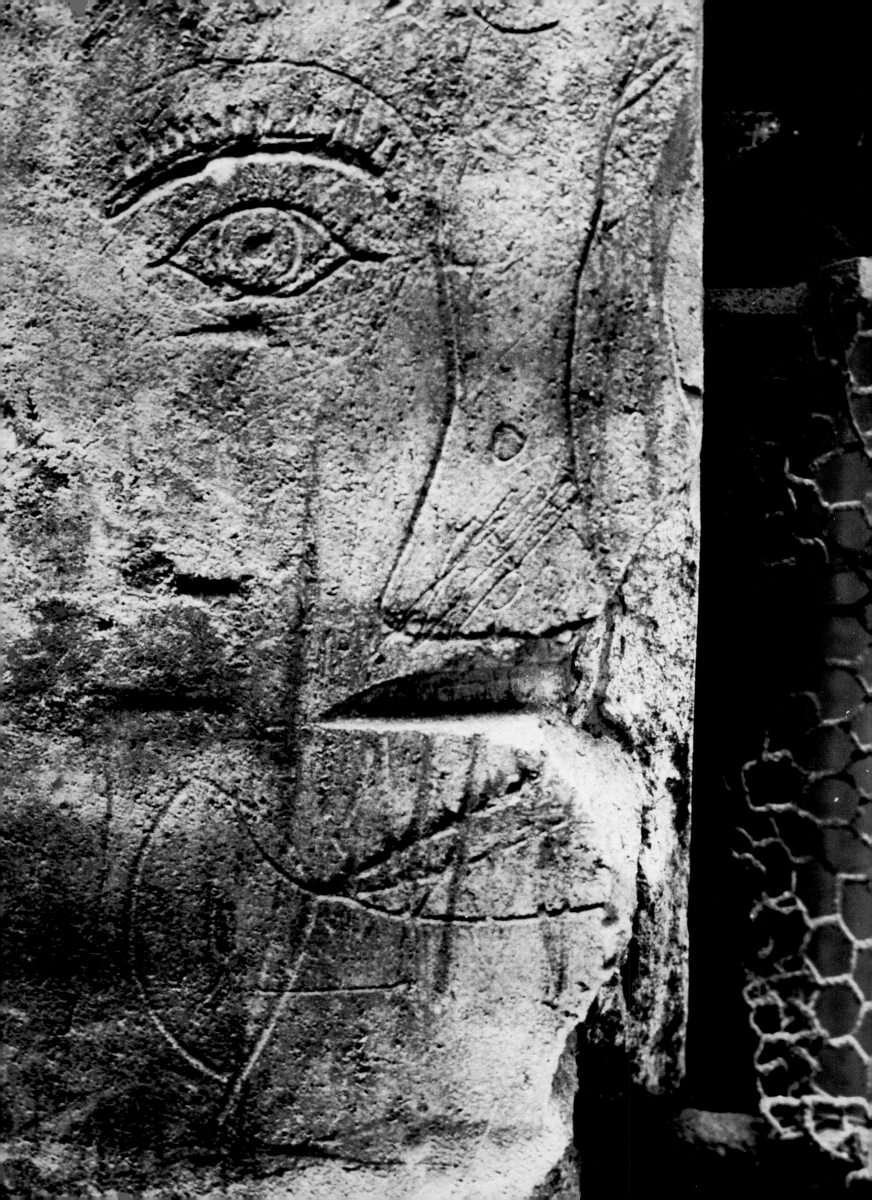

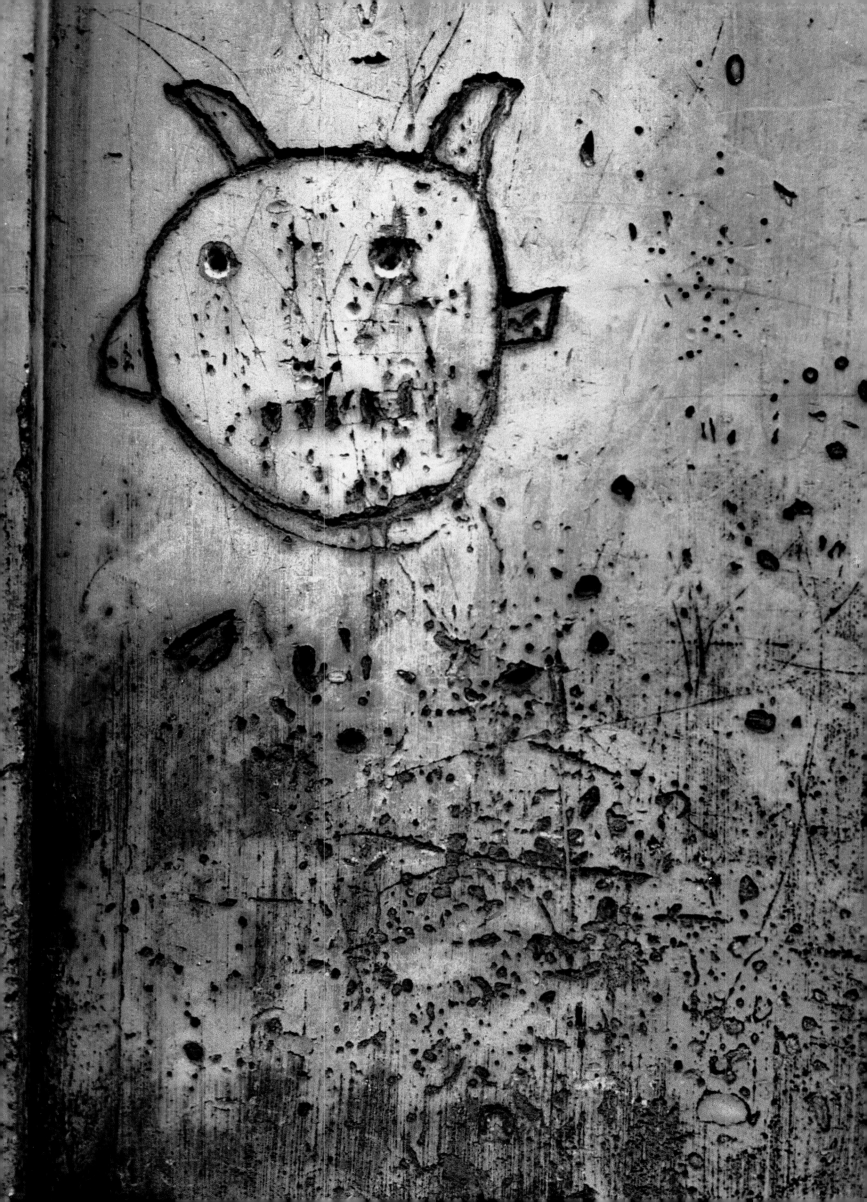

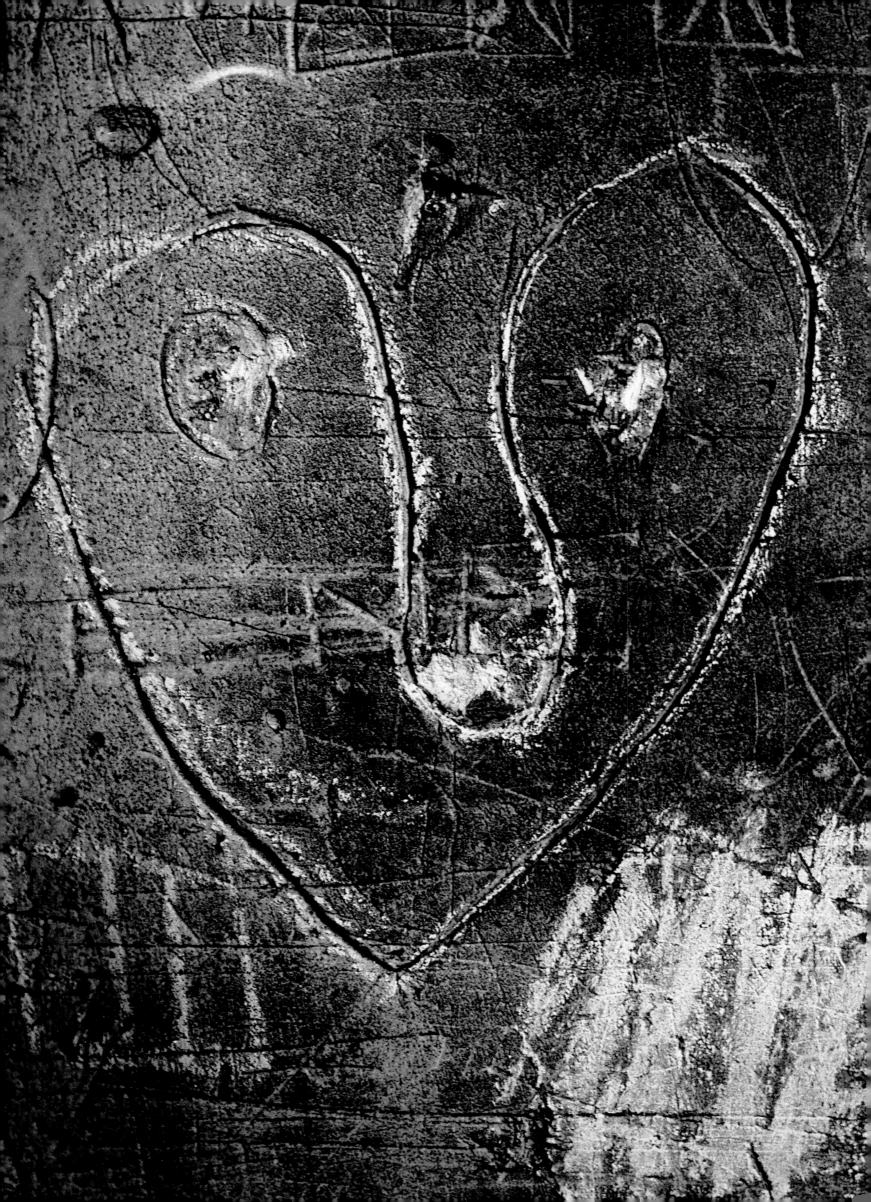

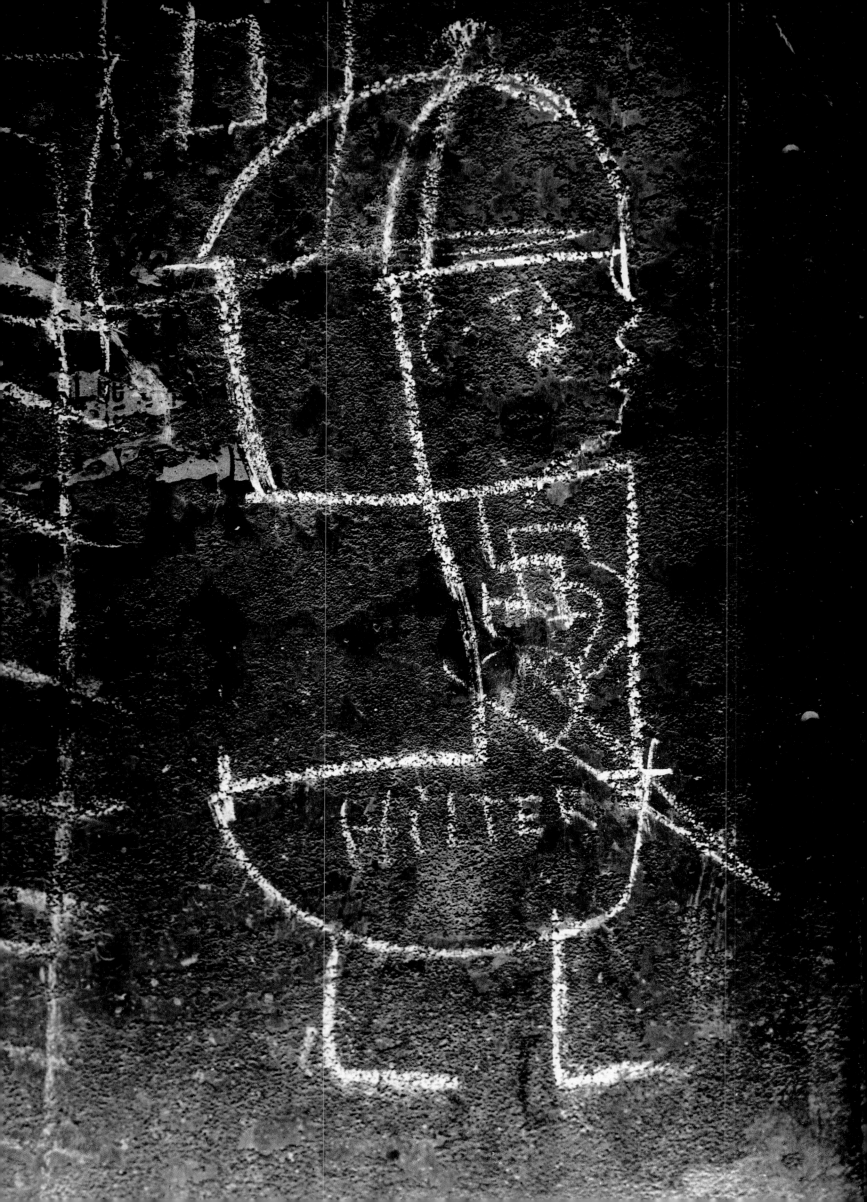

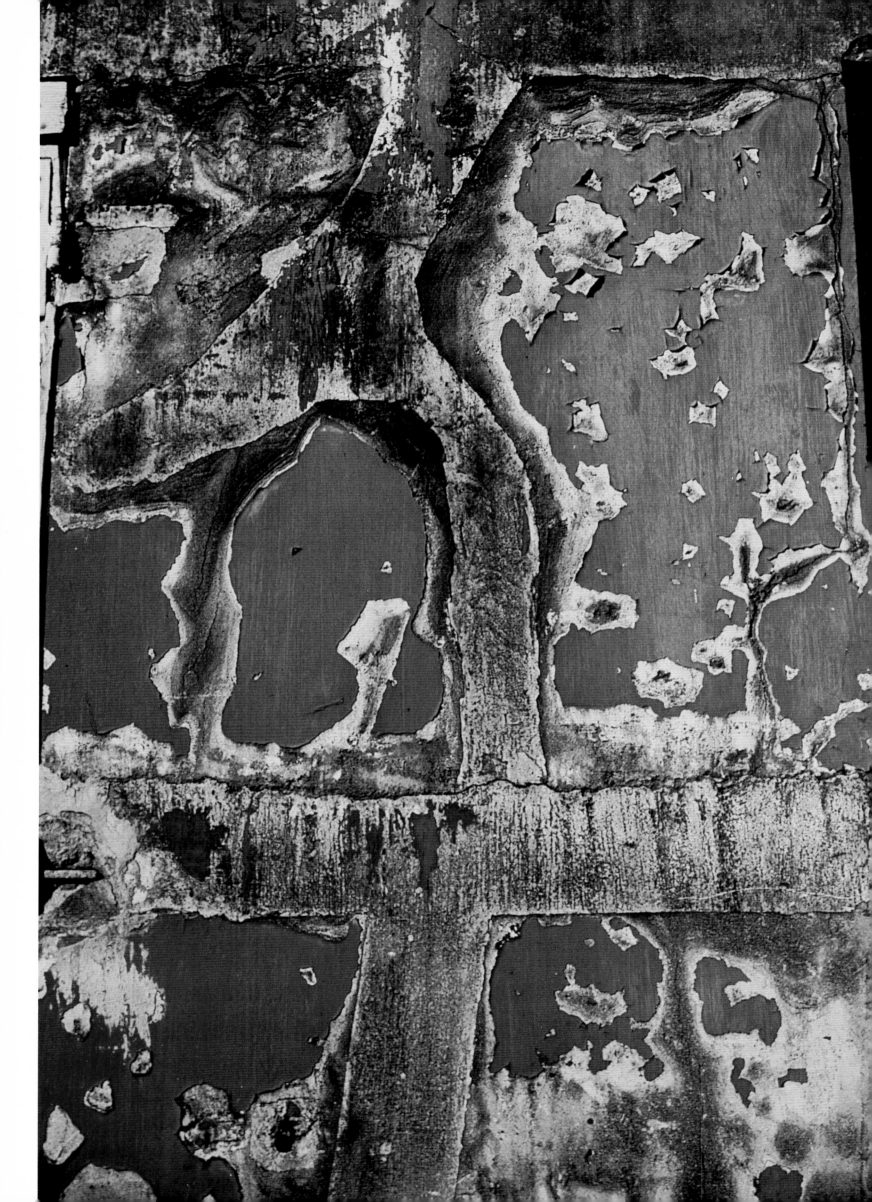

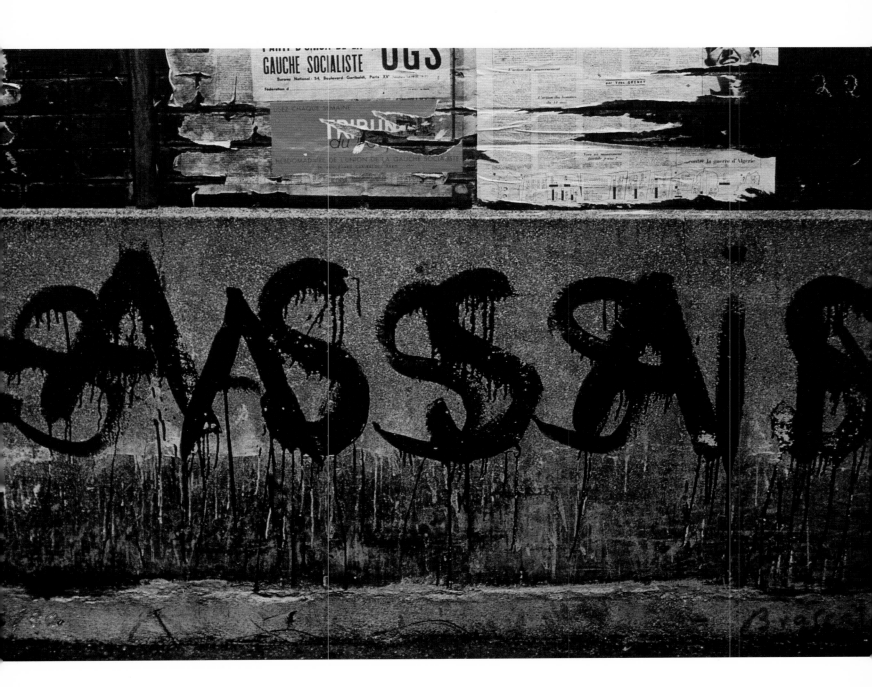

Paris, Day

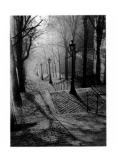

114 Stairs, Montmartre, Paris 1935–36

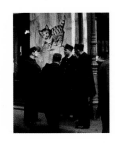

110 a-d A Man Dies in the Street, Paris 1932

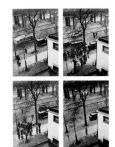

112 Police Outside the "Chat qui Pelote," near Les Halles Market, Paris 1939

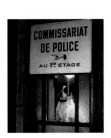

122 Police Station, Paris 1944

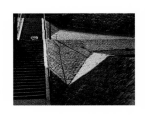

124 Little White Dog, Montmartre, Paris 1932

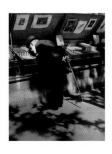

115 Professor Louis Dimier, Member of the Institute, on Quay Voltaire, Paris 1932–33

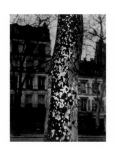

111 Plane Tree, Paris 1945

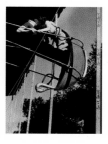

119 Kiss on Swing at a Street Fair 1935–37

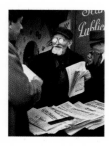

118 My Newspaper Vendor, Place Denfert-Rochereau, Paris 1948

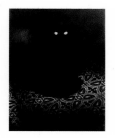

123 Cat with Phosphorescent Eyes 1936

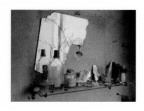

121 Fusillade, Place Saint-Jacques, Paris 25 August 1944

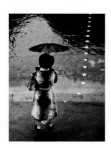

117 Rivoli Street, Paris 1937

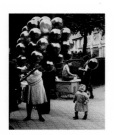

116 Balloon Seller, Montsouris Park, Paris 1931–34

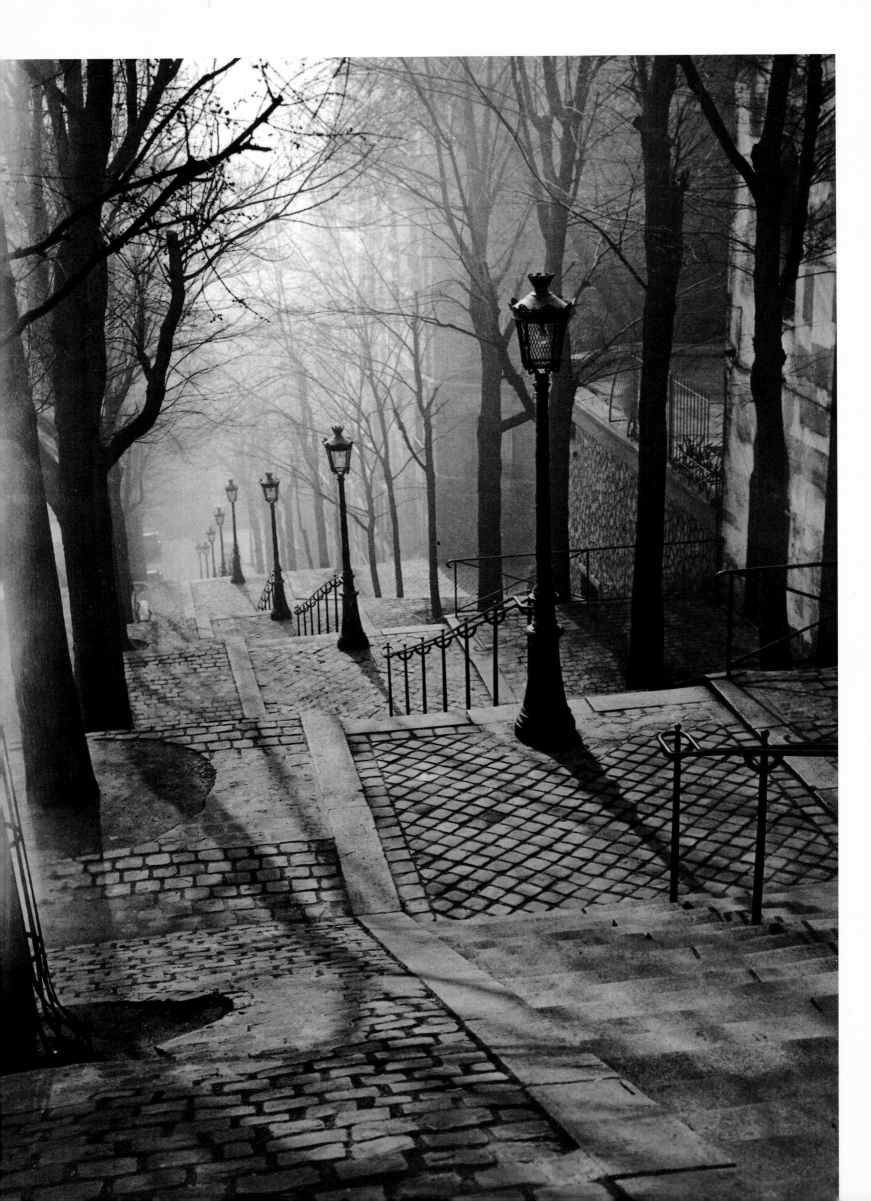

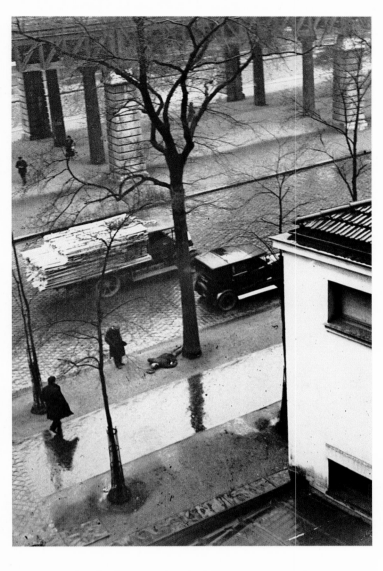
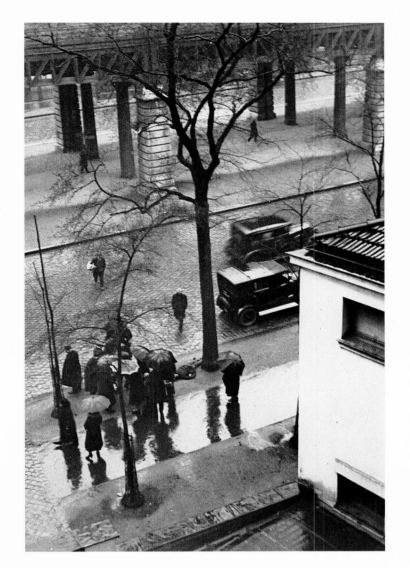
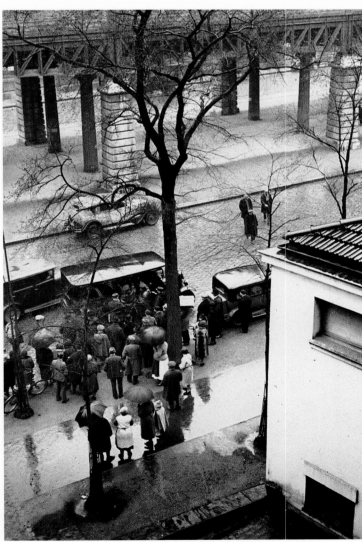
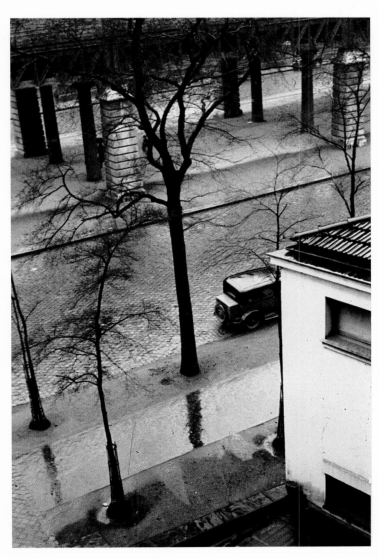

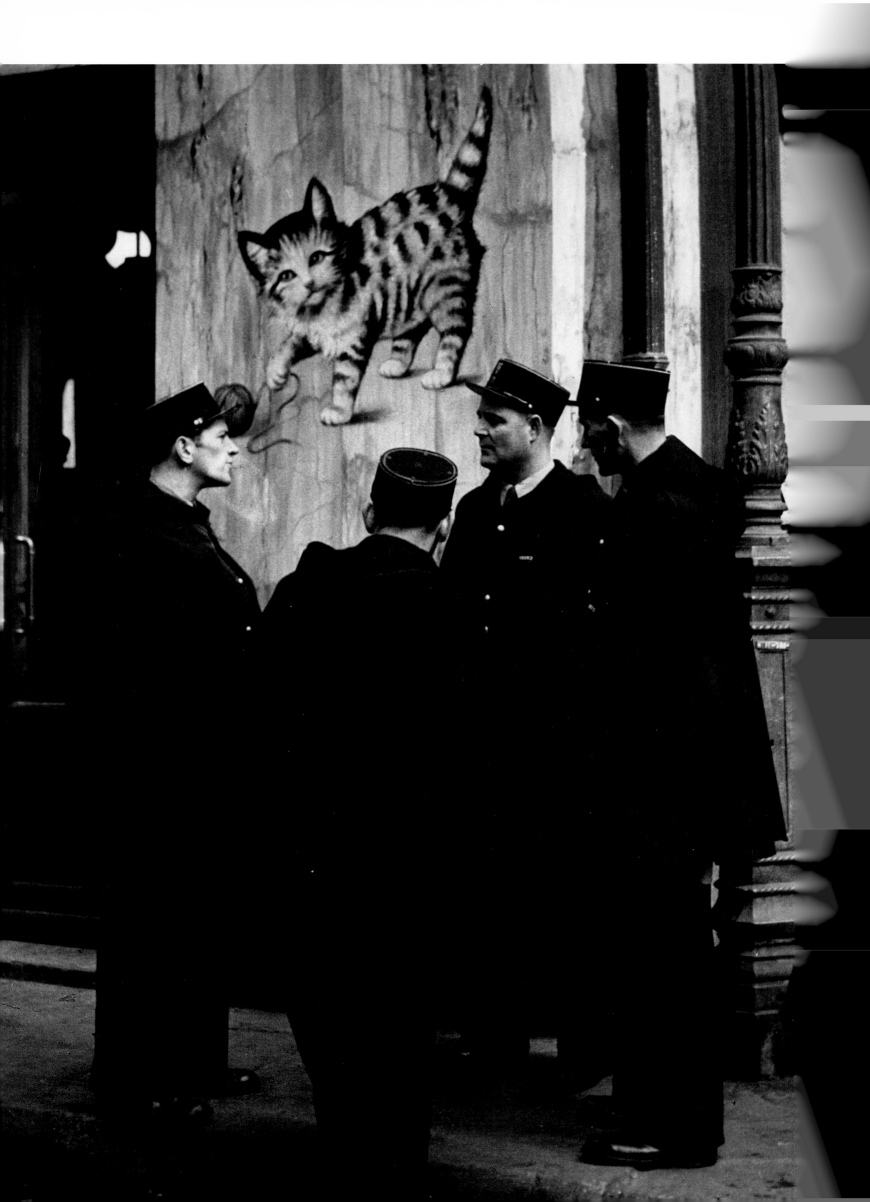

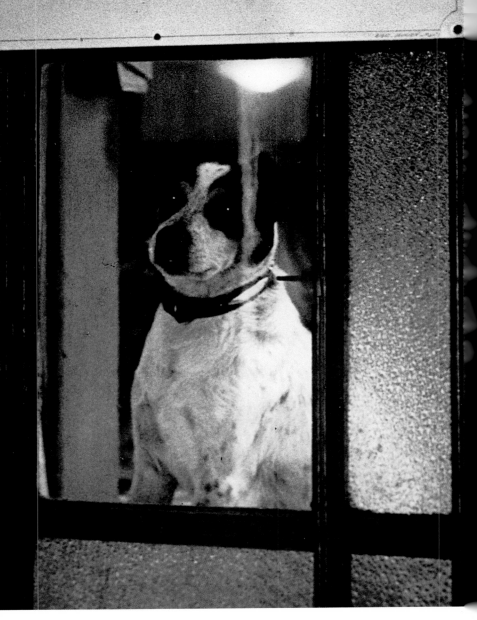

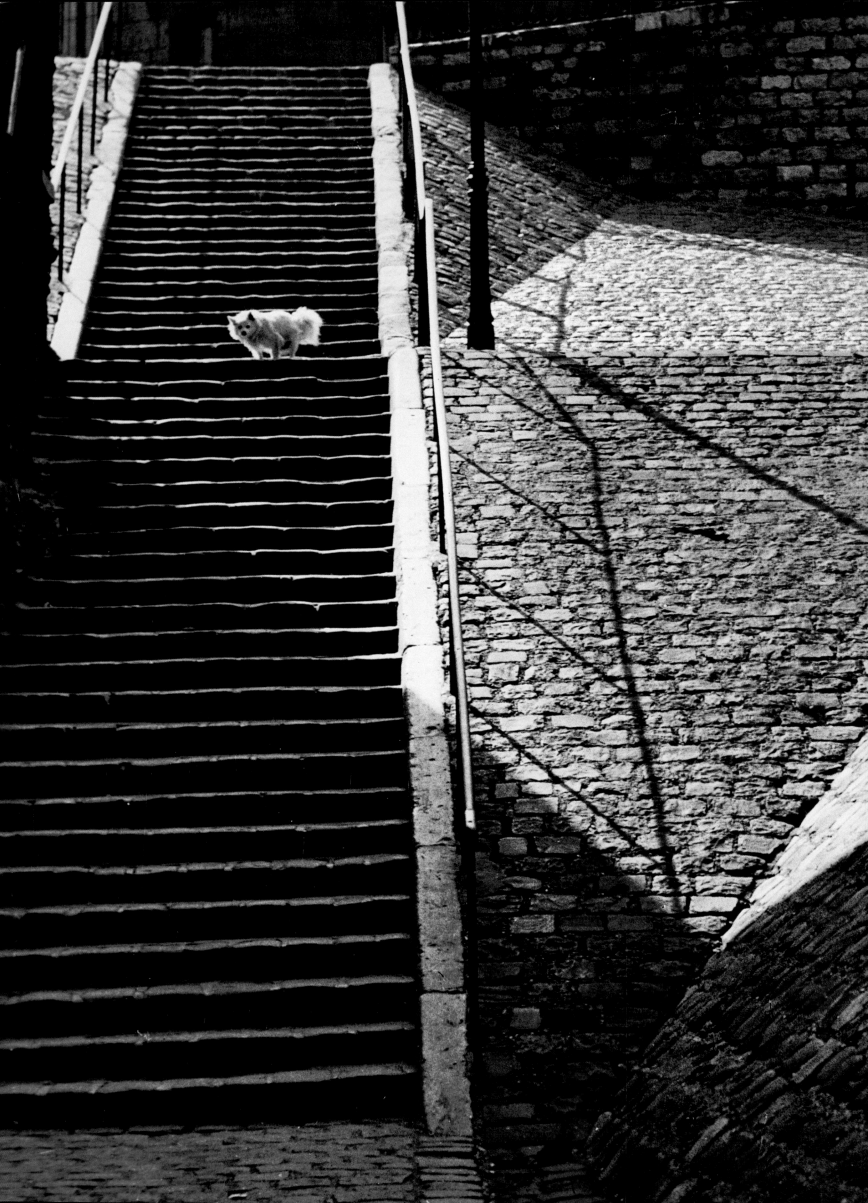

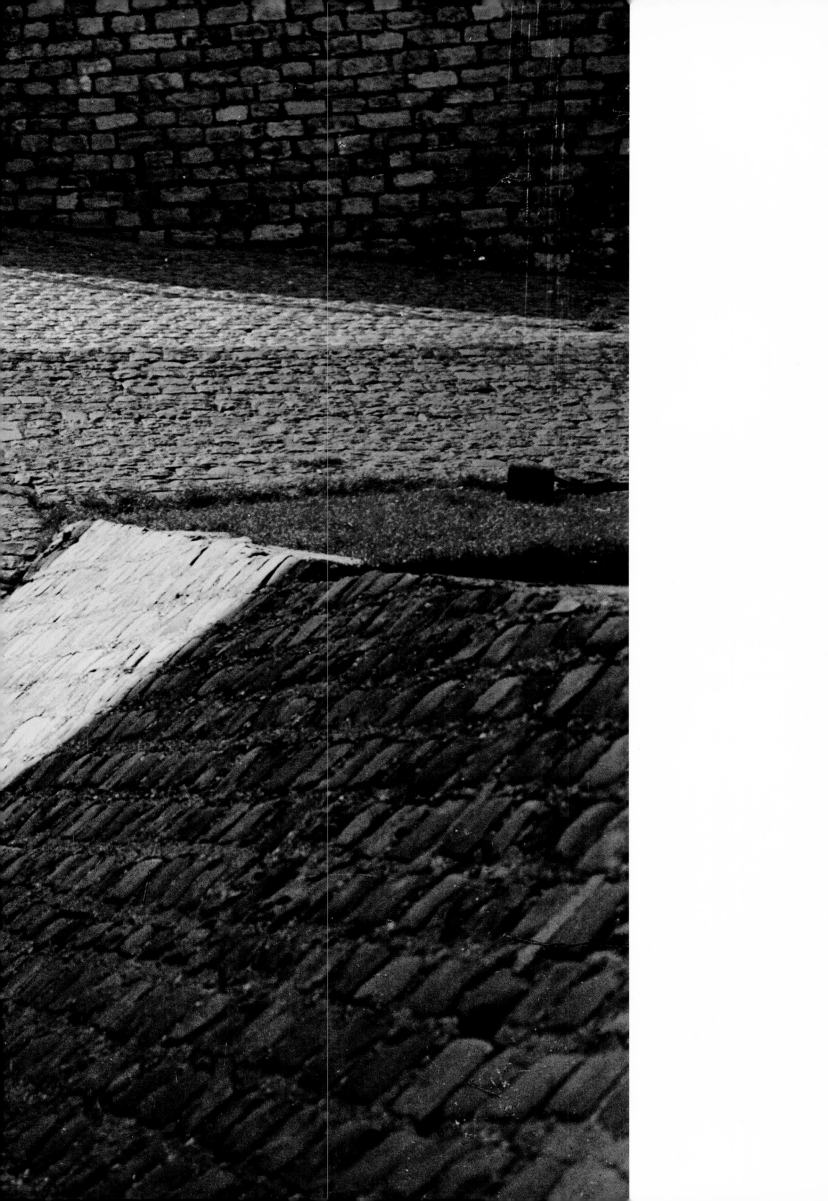

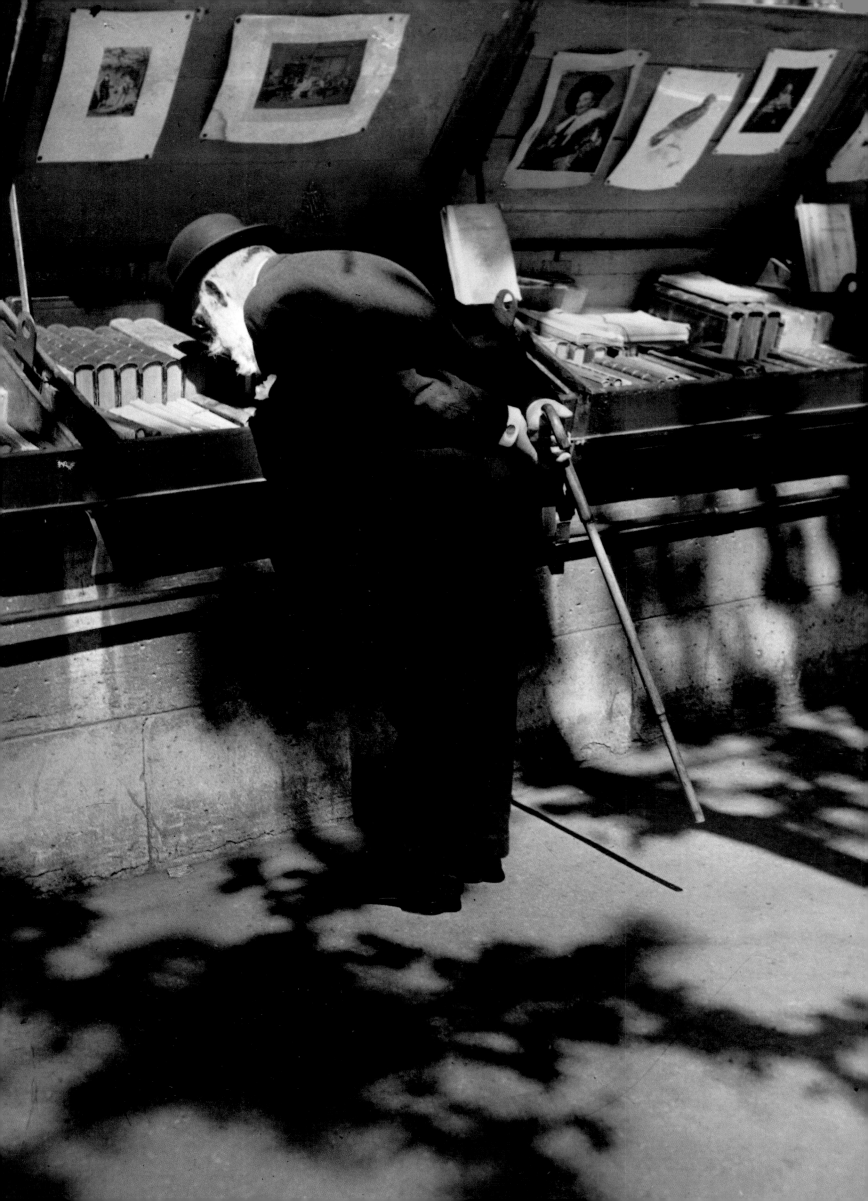

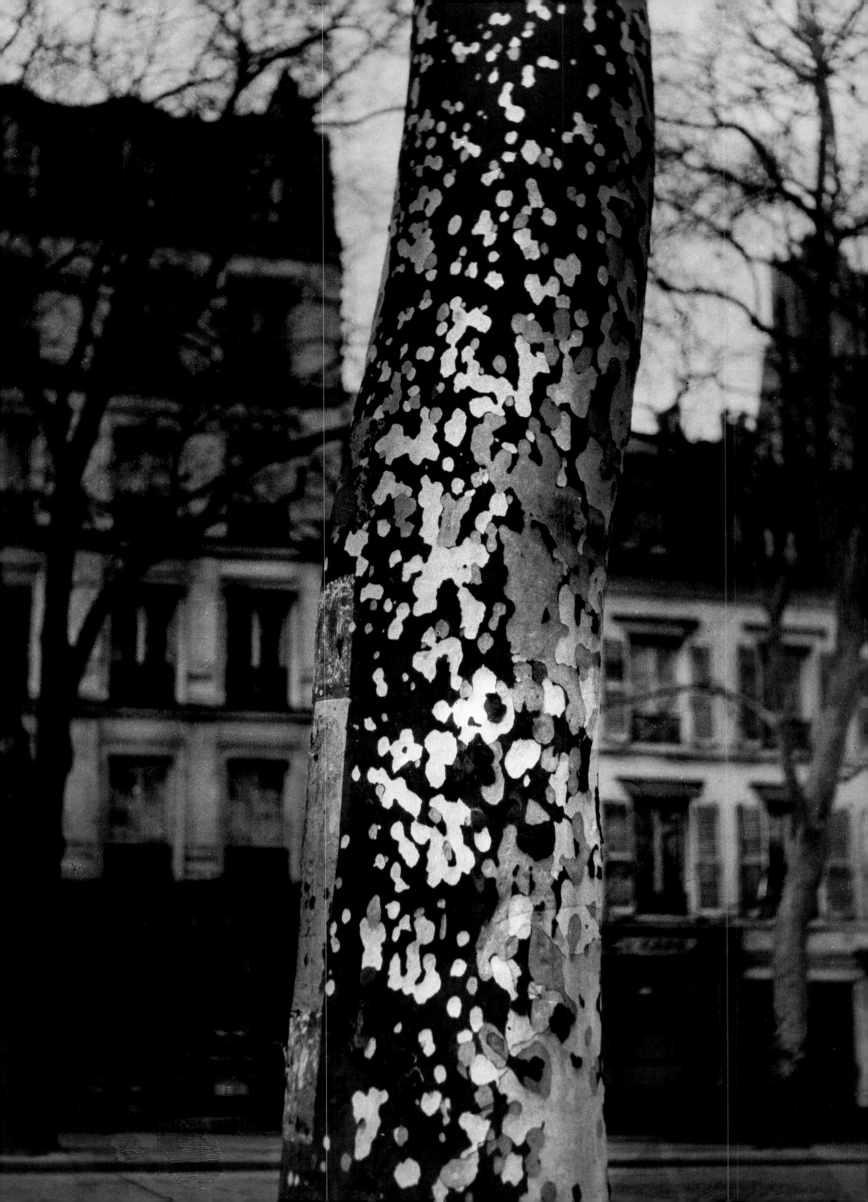

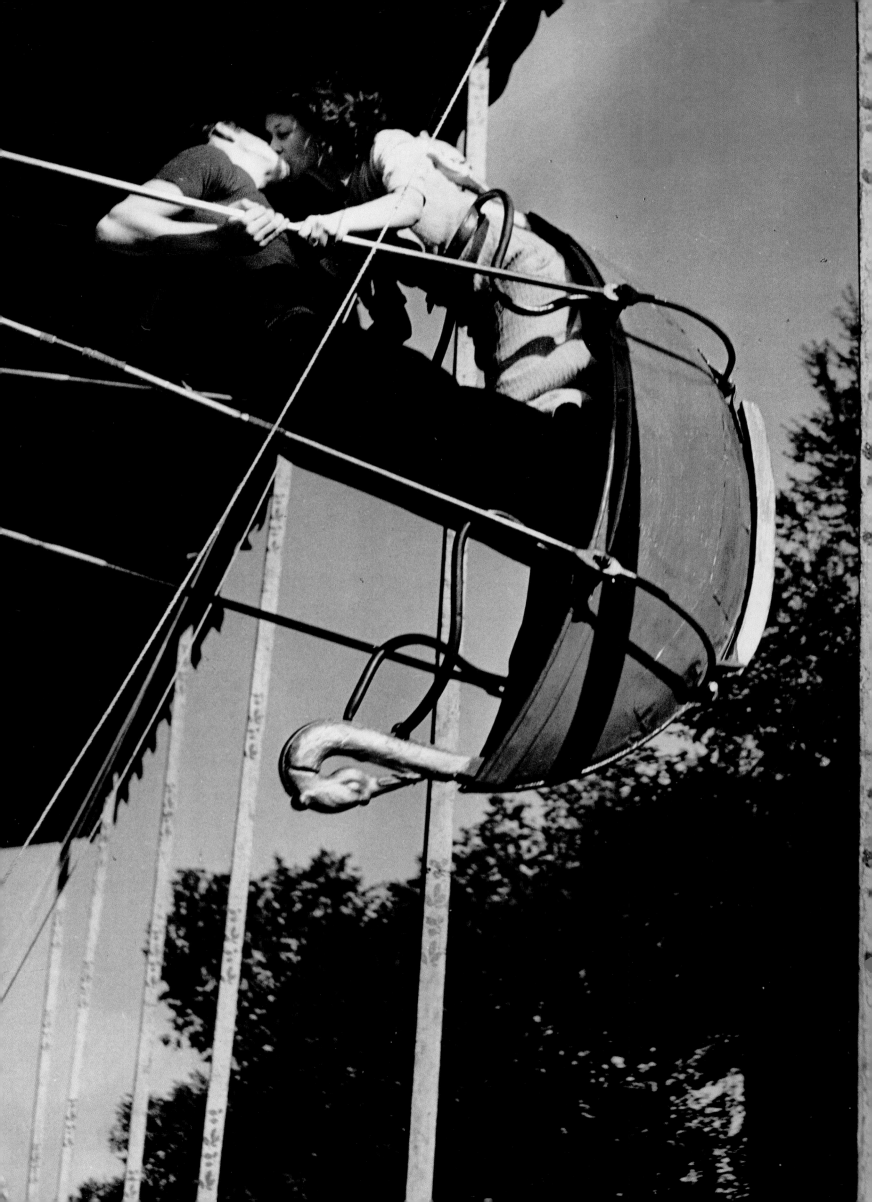

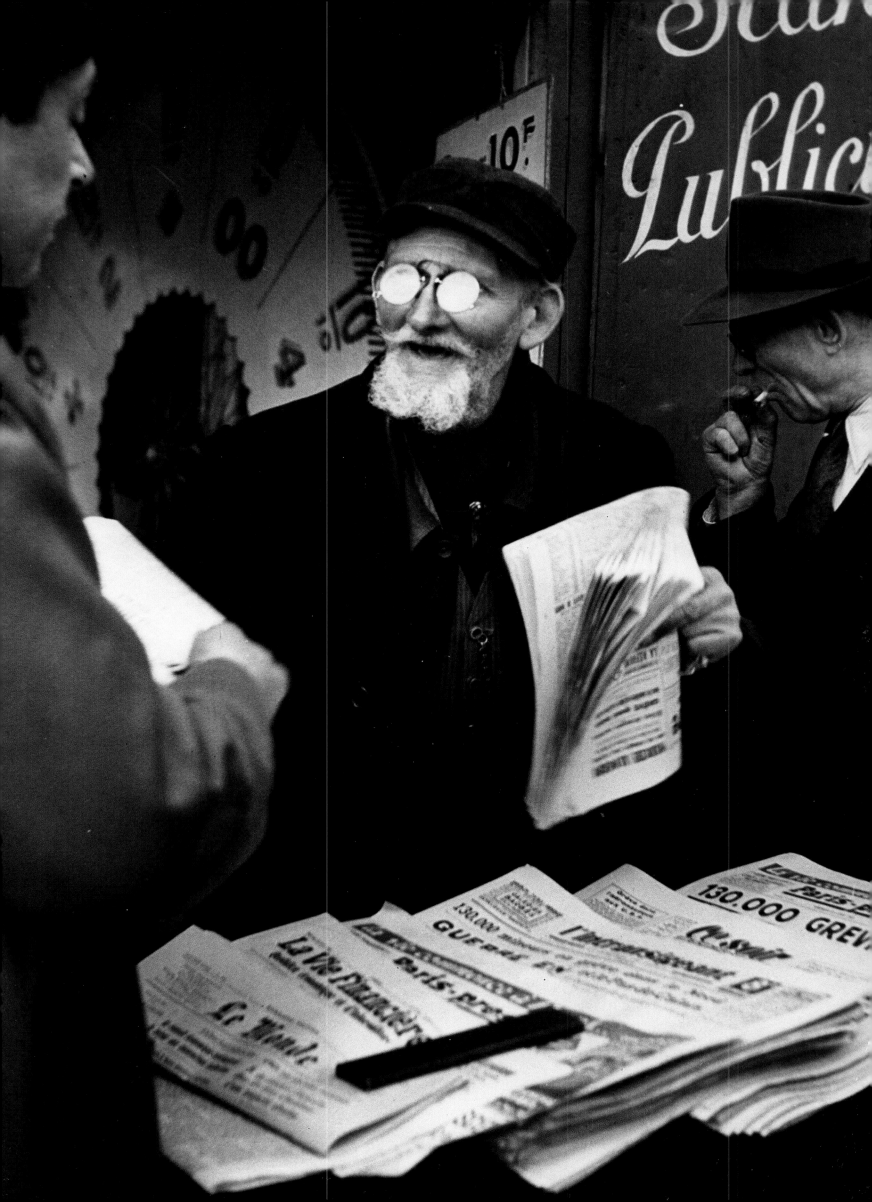

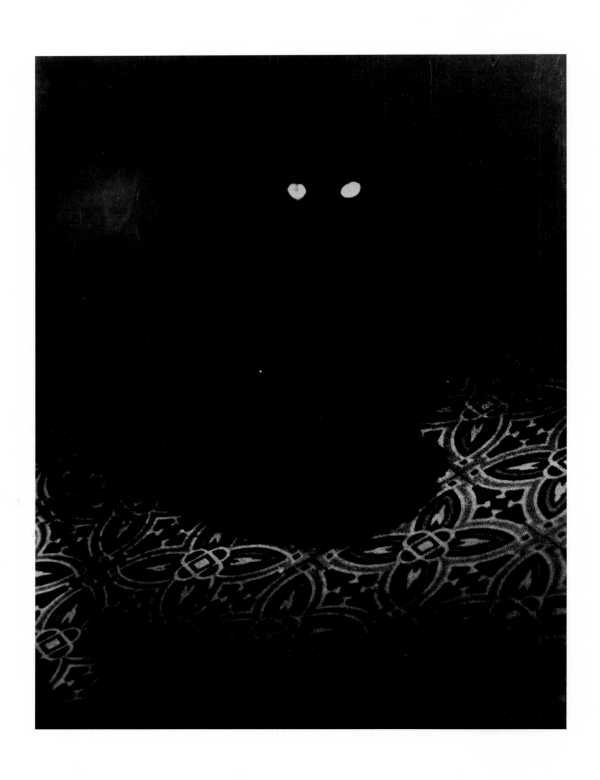

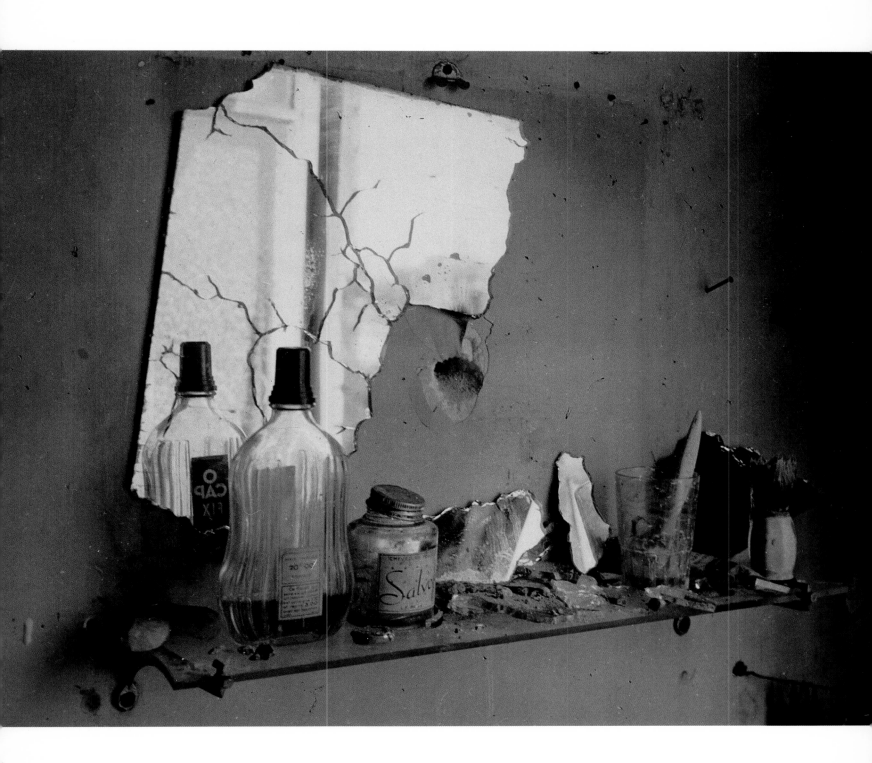

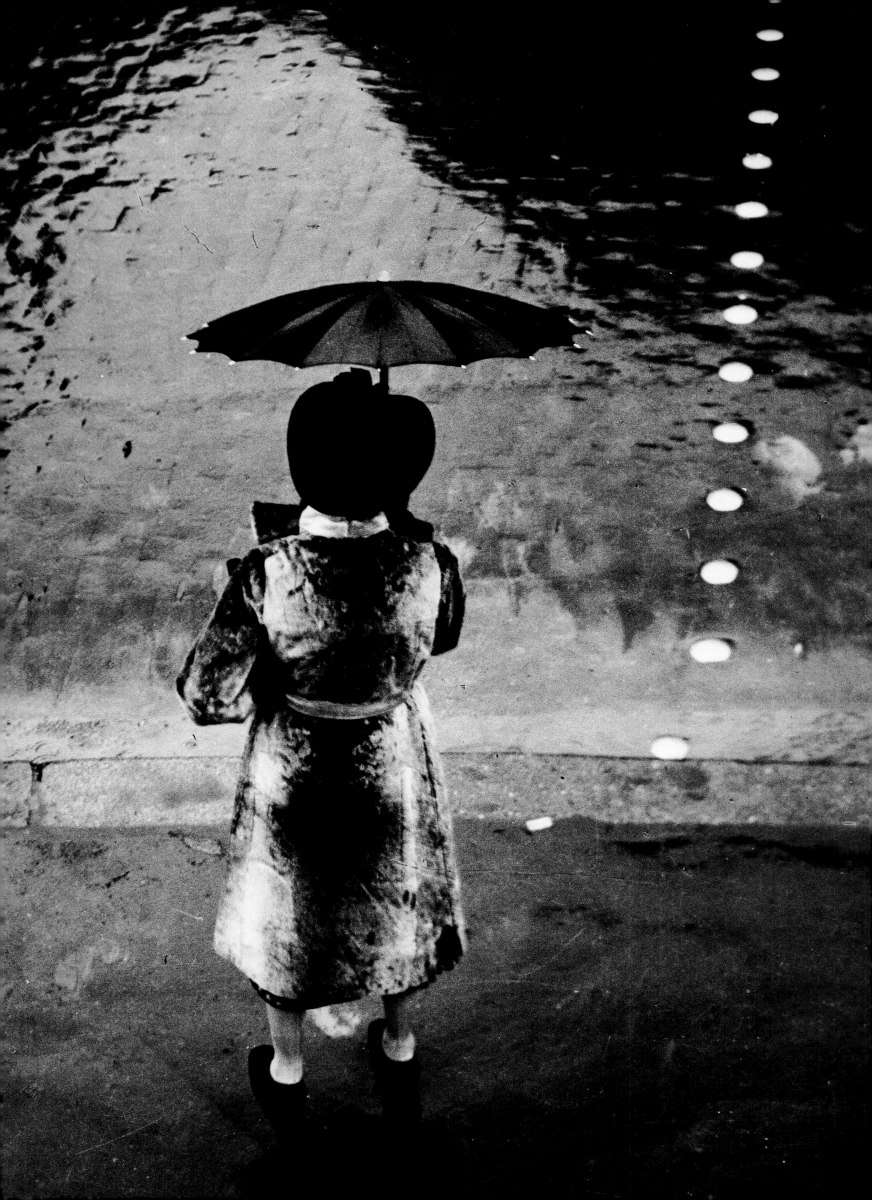

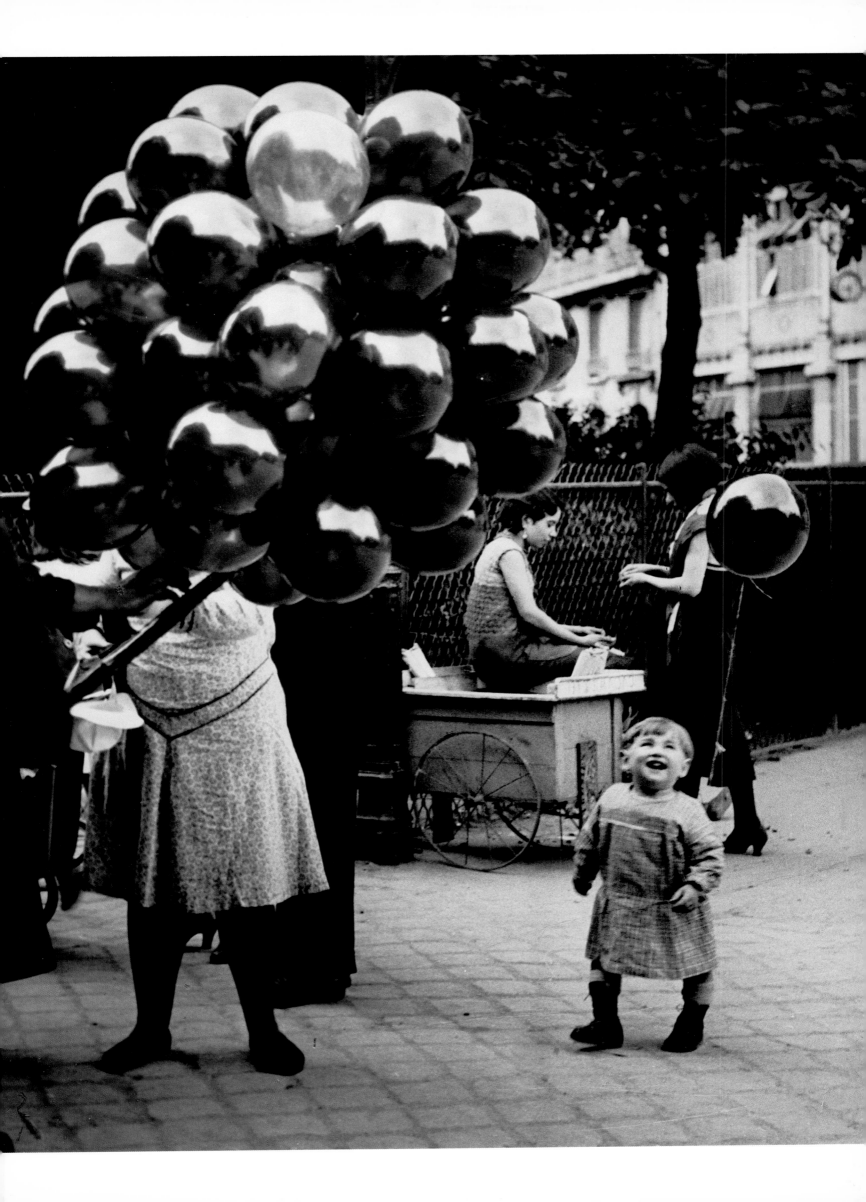

France and the Riviera

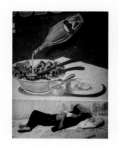

125 Sleeping Tramp in Marseilles c. 1935

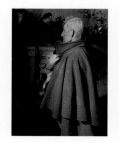

126 Christmas Eve Mass, Les Baux, Provence, France 1945

131 Apothecaries Laboratory, Hospital for the Poor, Hospice de Beaune, France 1951

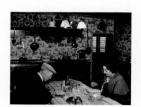

133 Dinner for Two 1936–37

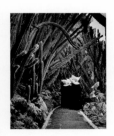

132 Bayonne Festival, France 1949

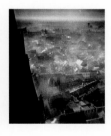

130 Chartres Cathedral in Winter, France 1946

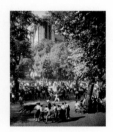

134 Isère Valley, French Alps 1937

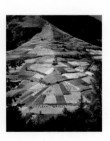

128 Exotic Garden, Monaco c. 1945

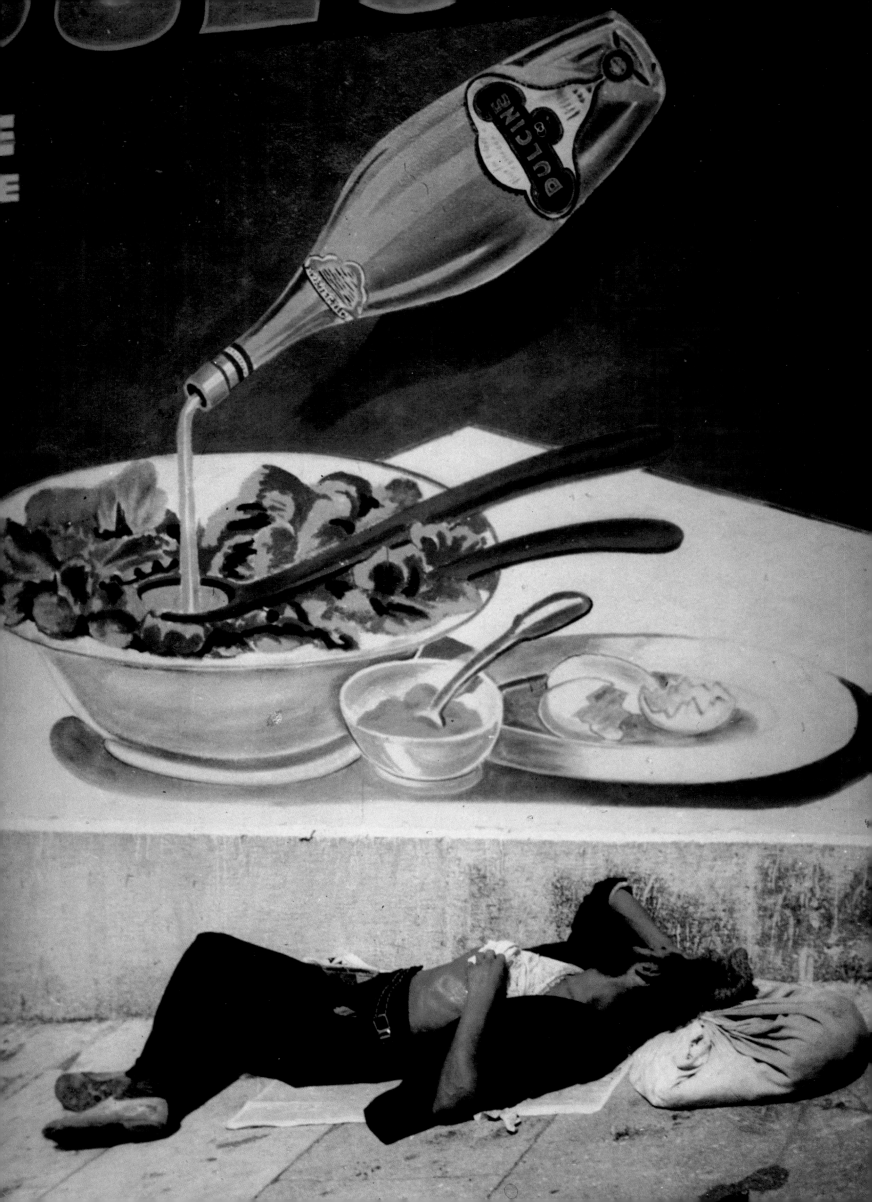

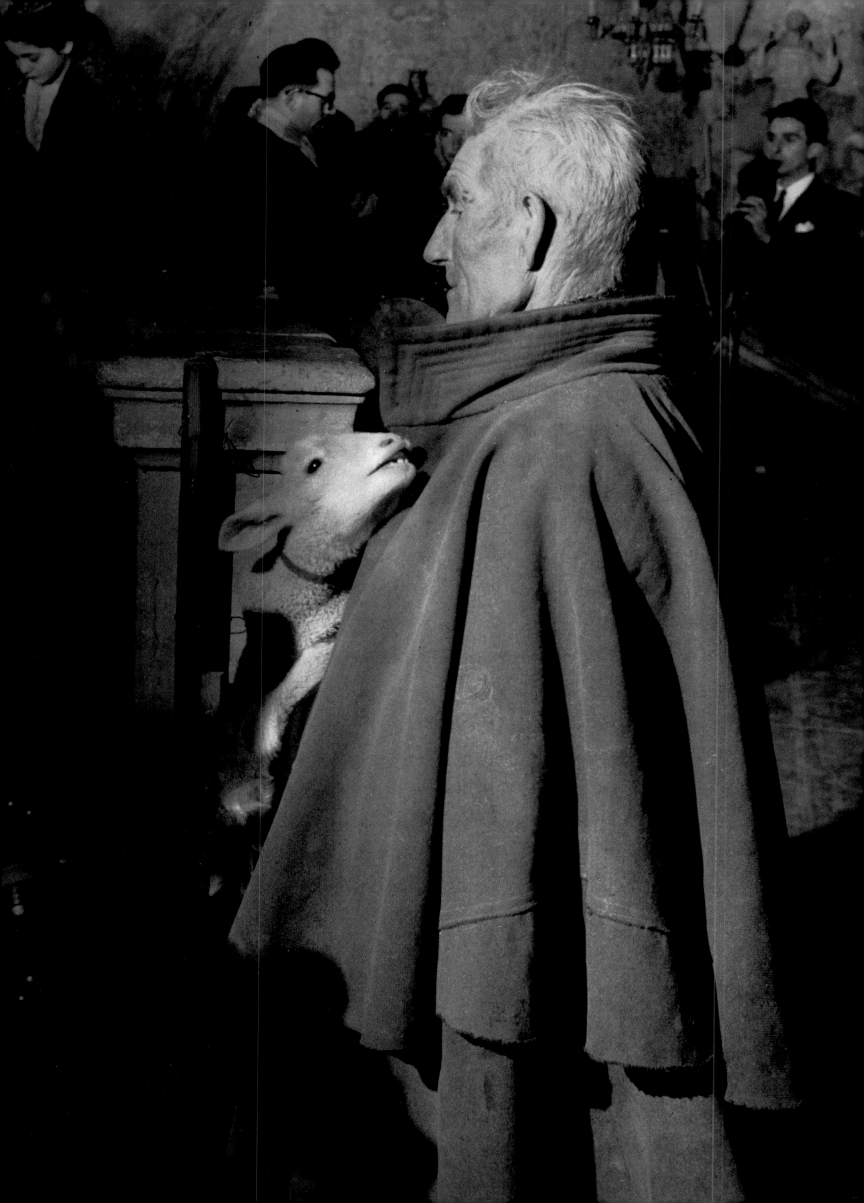

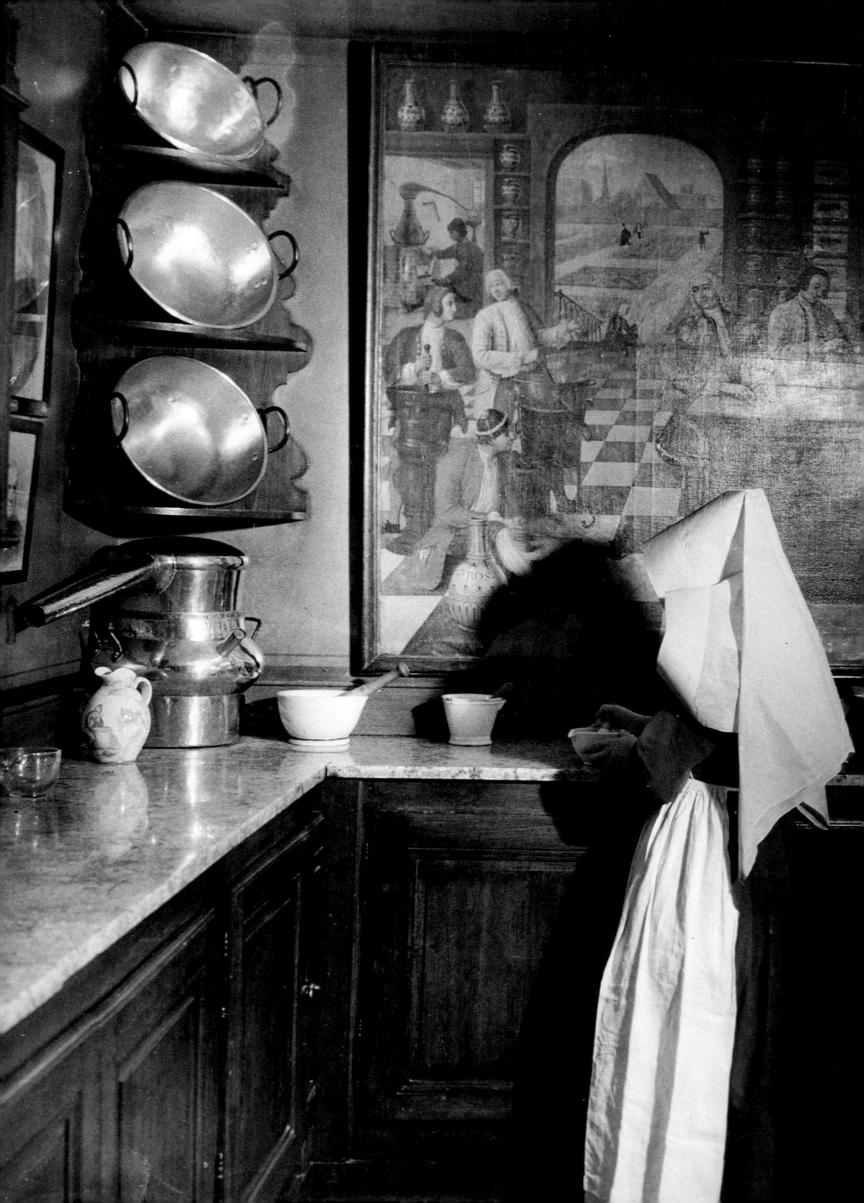

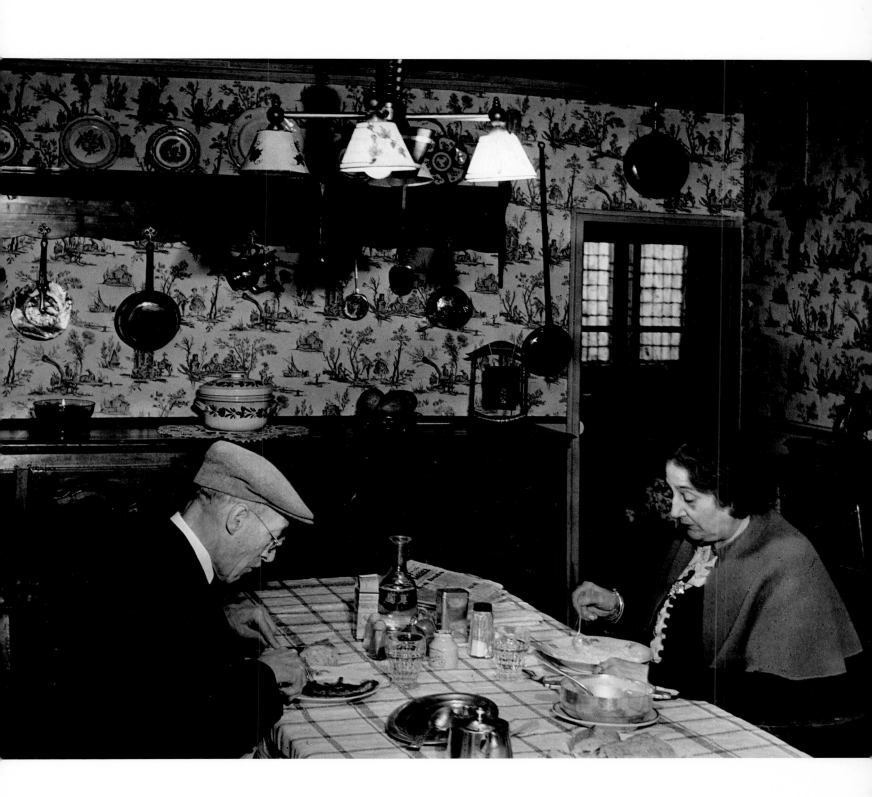

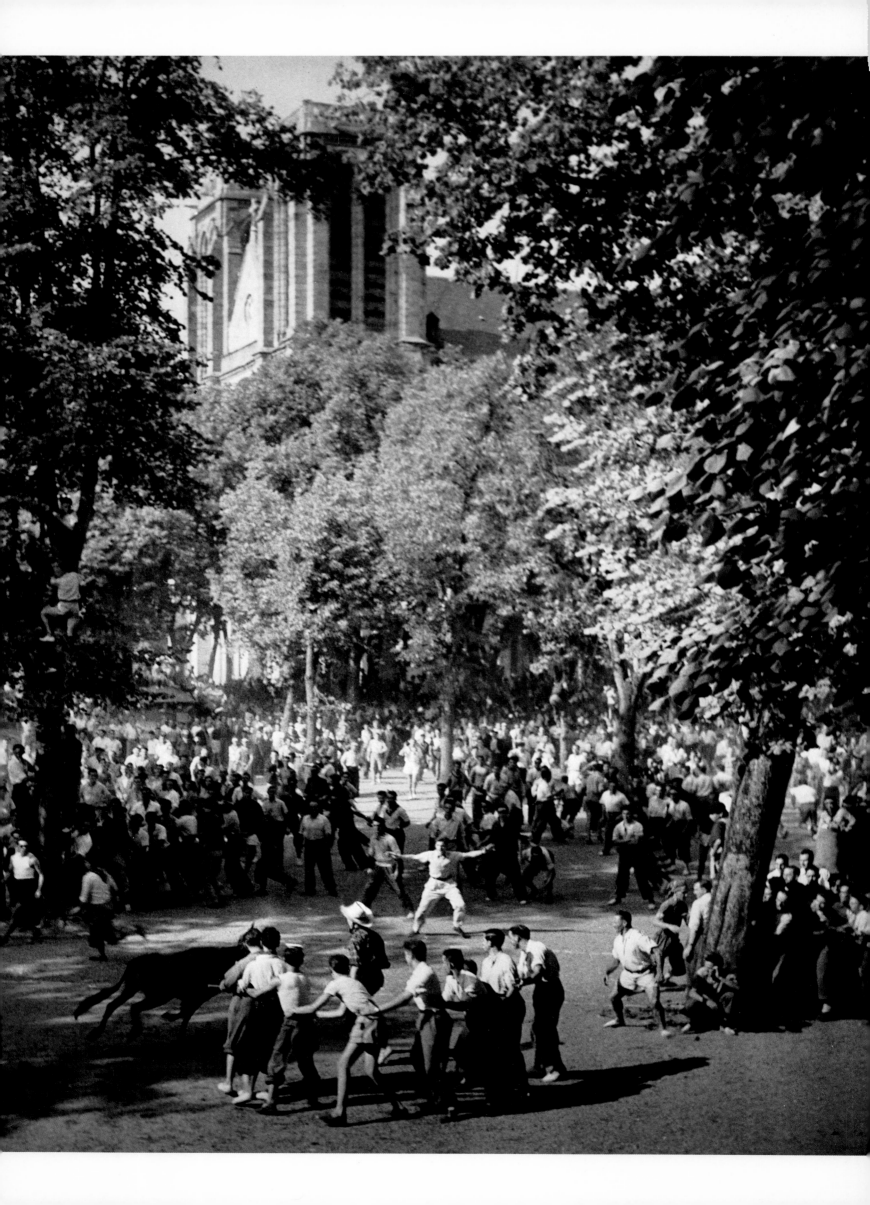

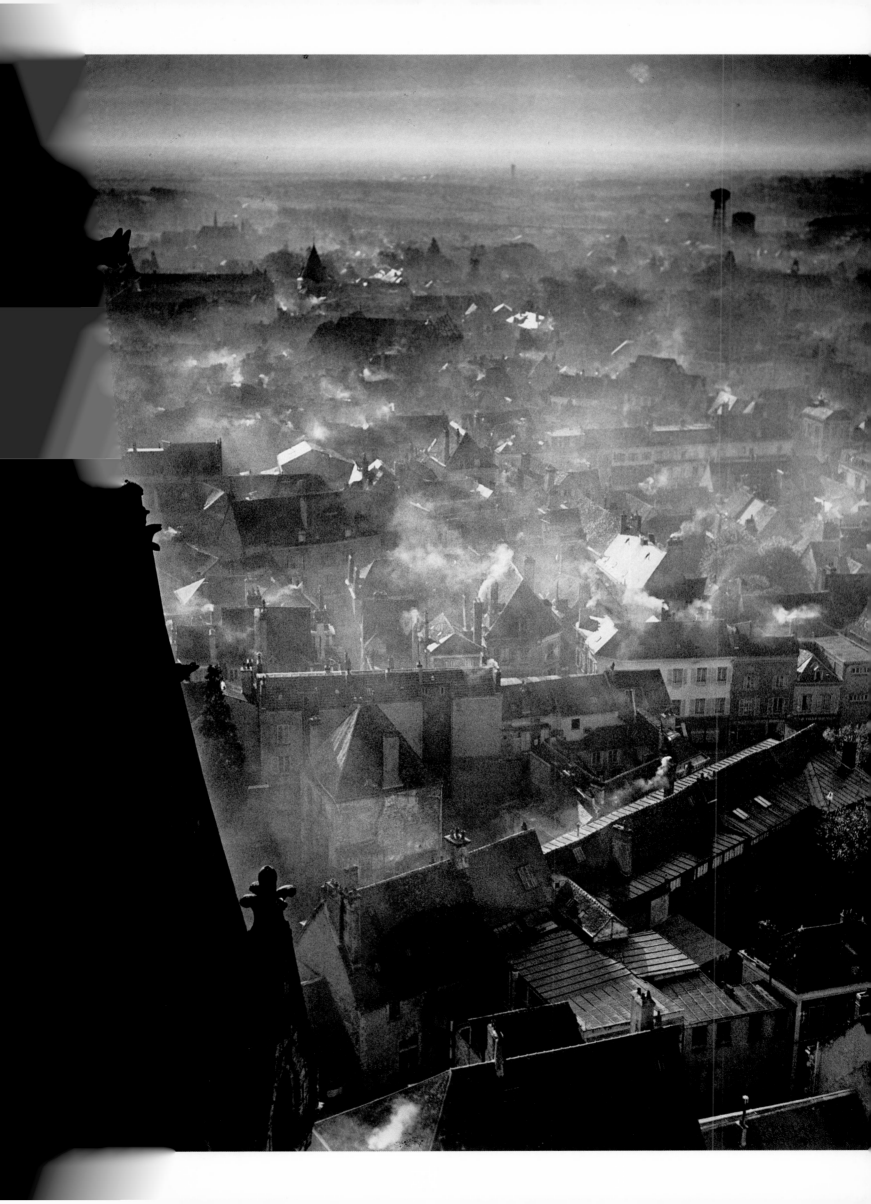

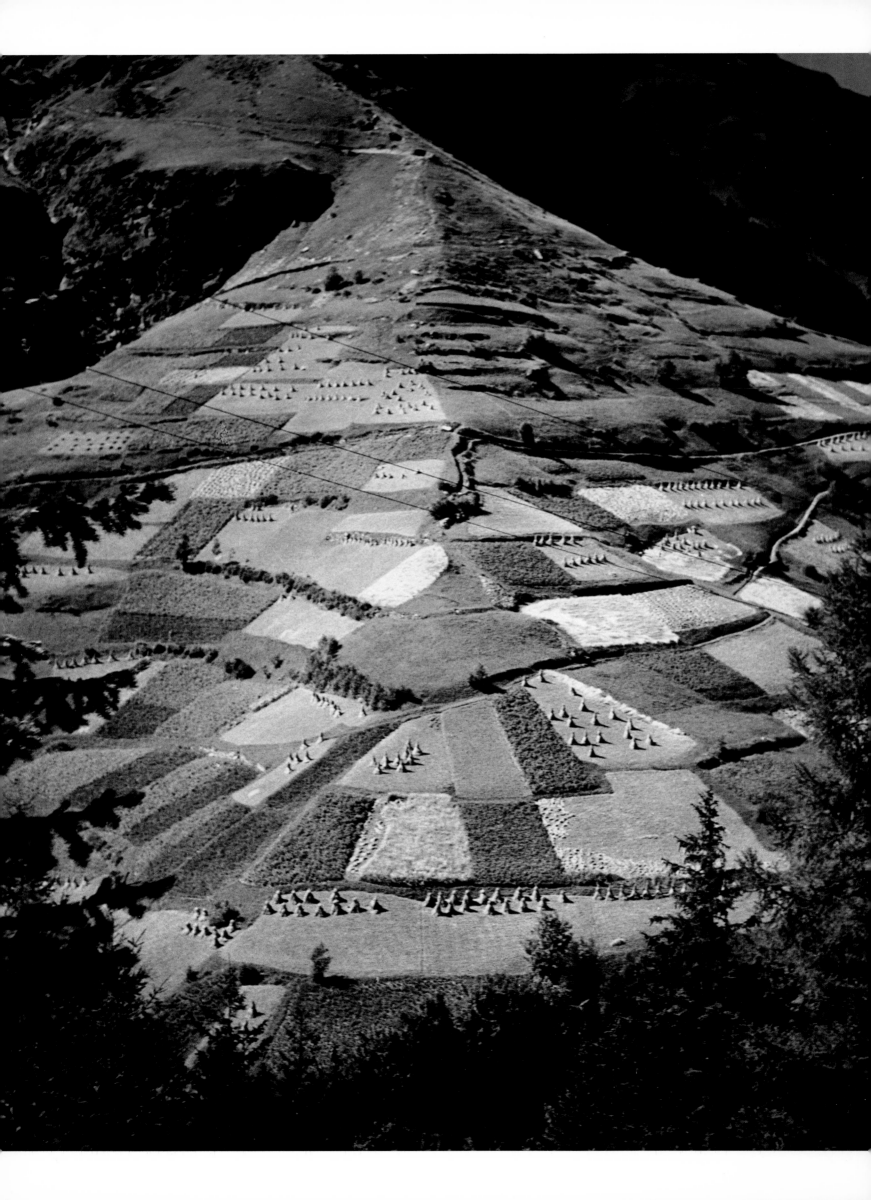

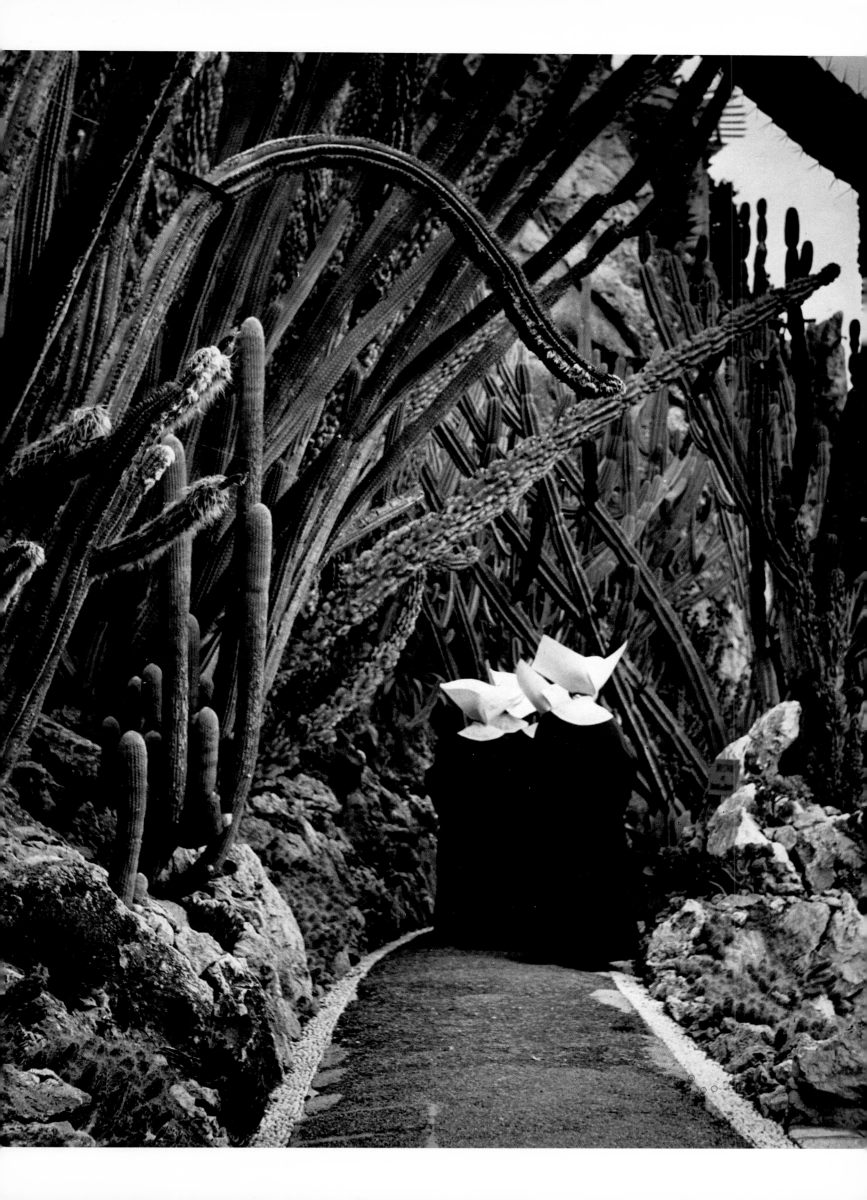

Abroad

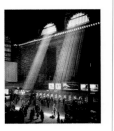

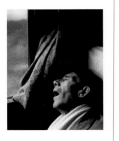

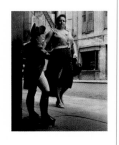

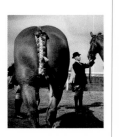

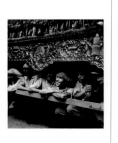

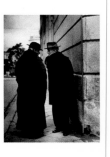

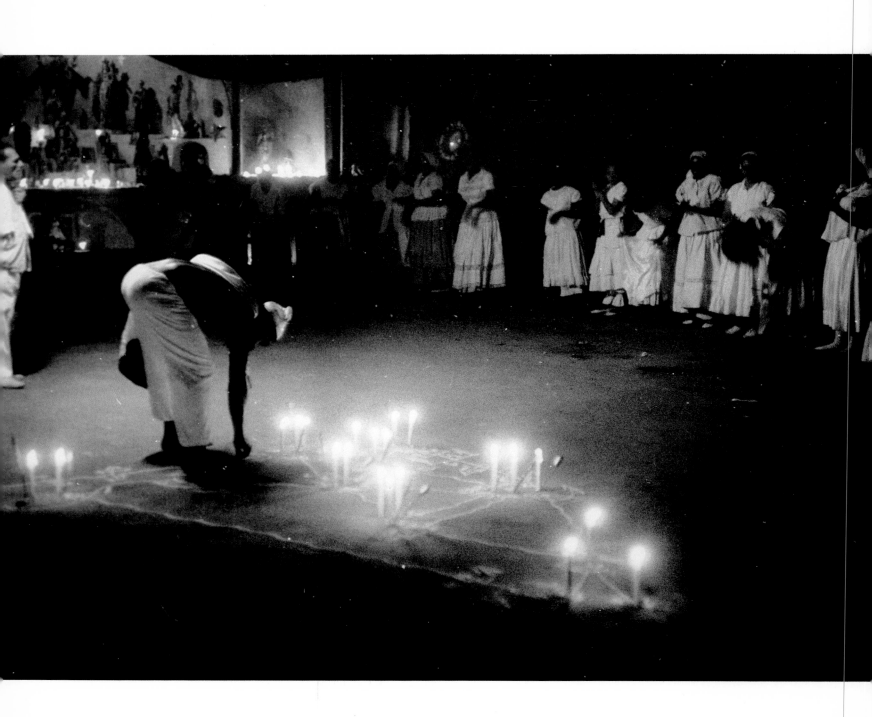

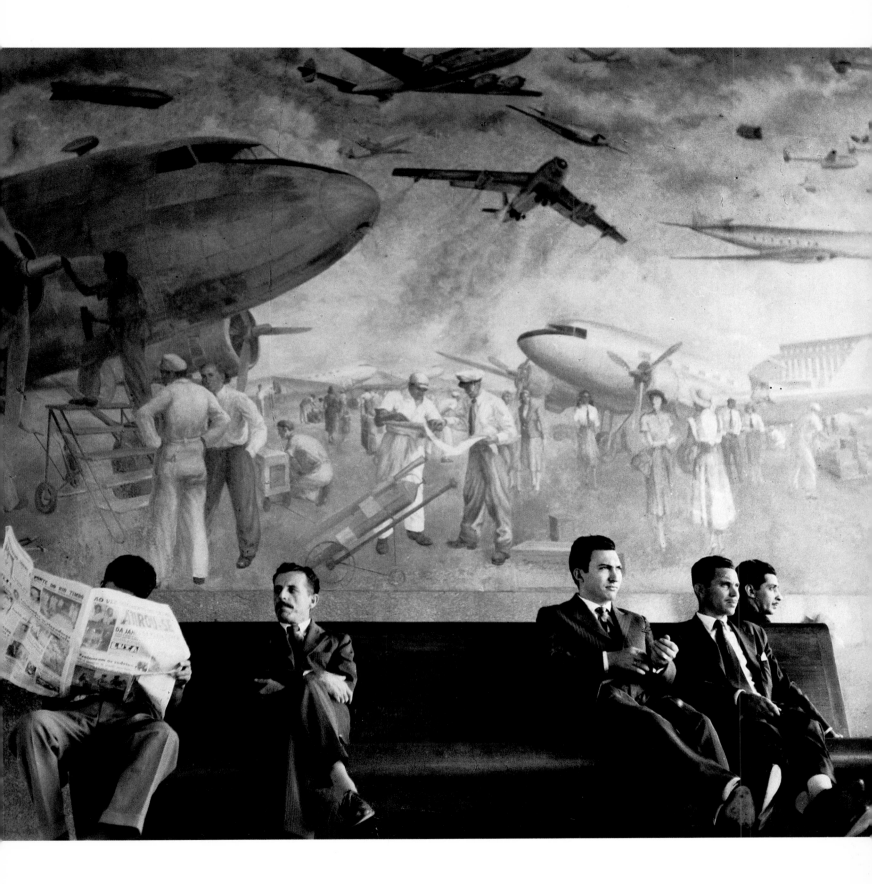

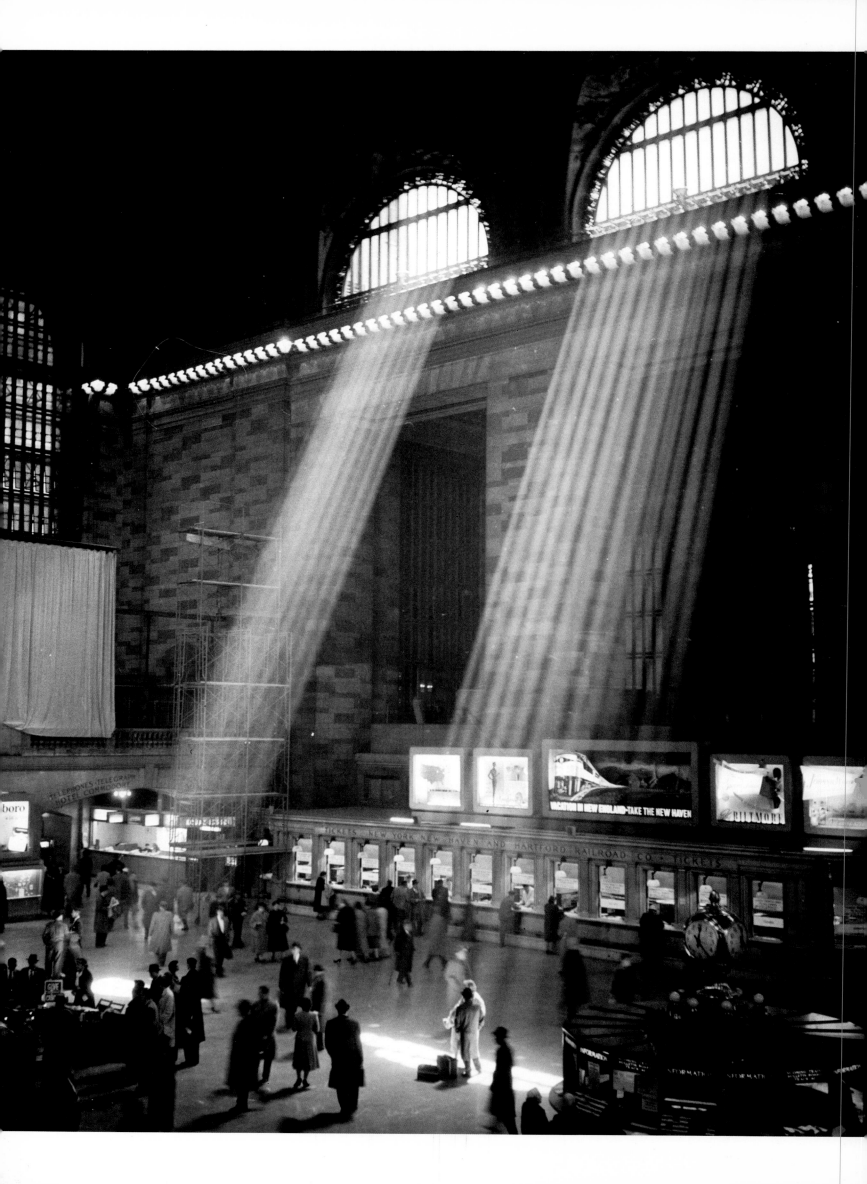

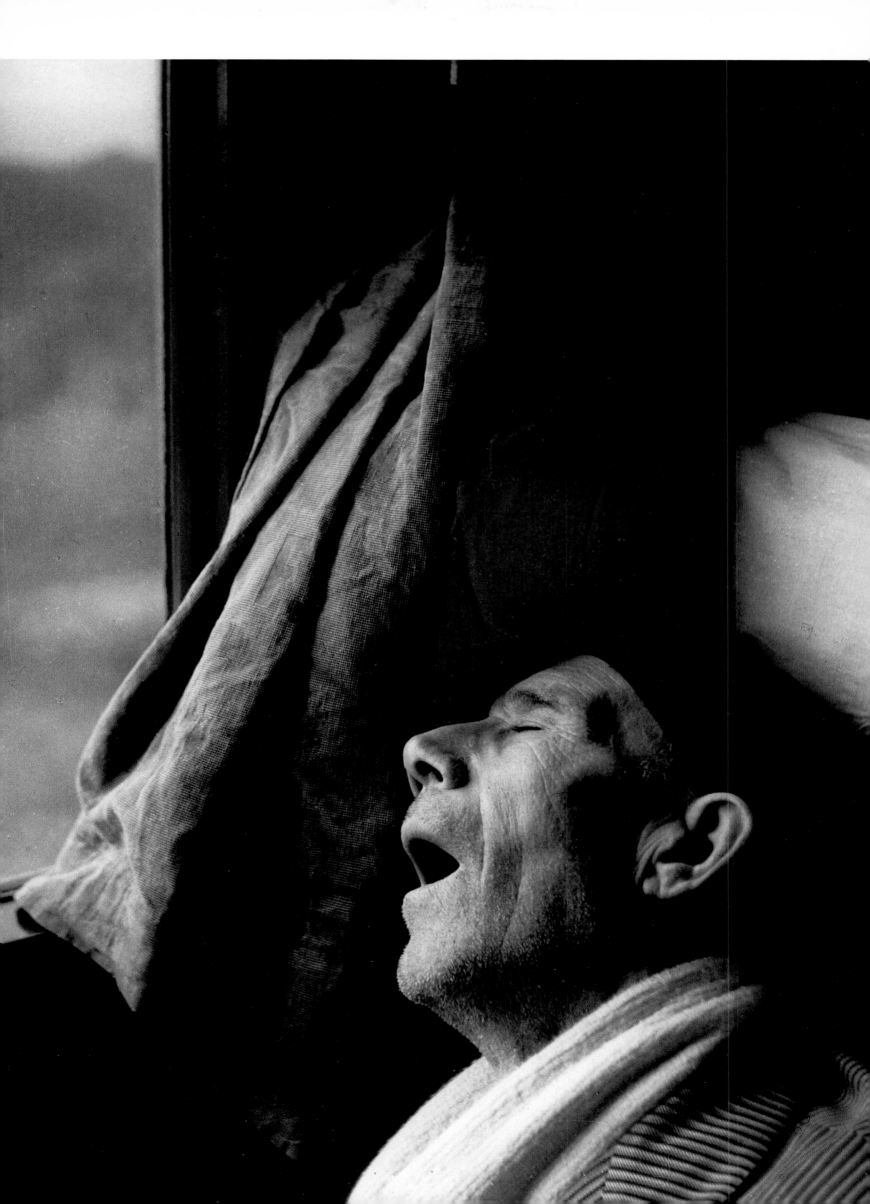

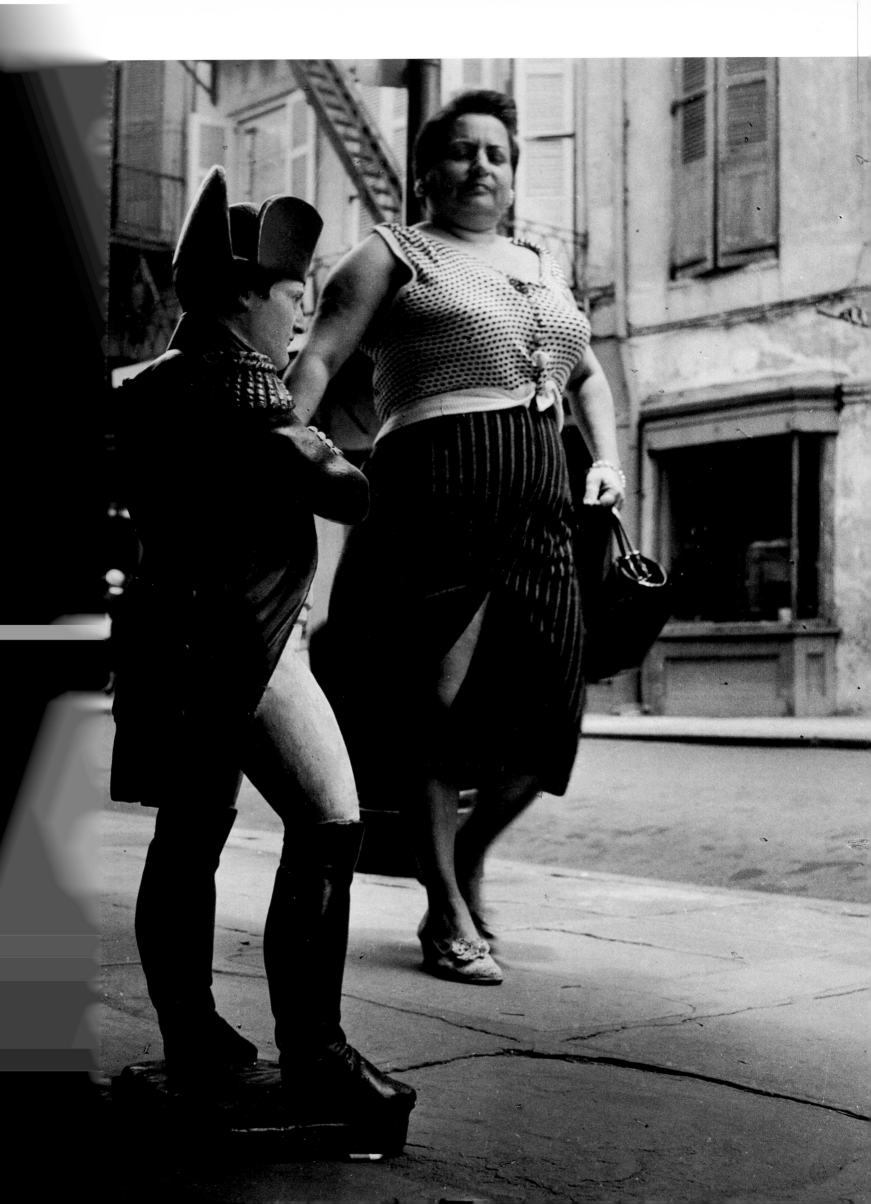

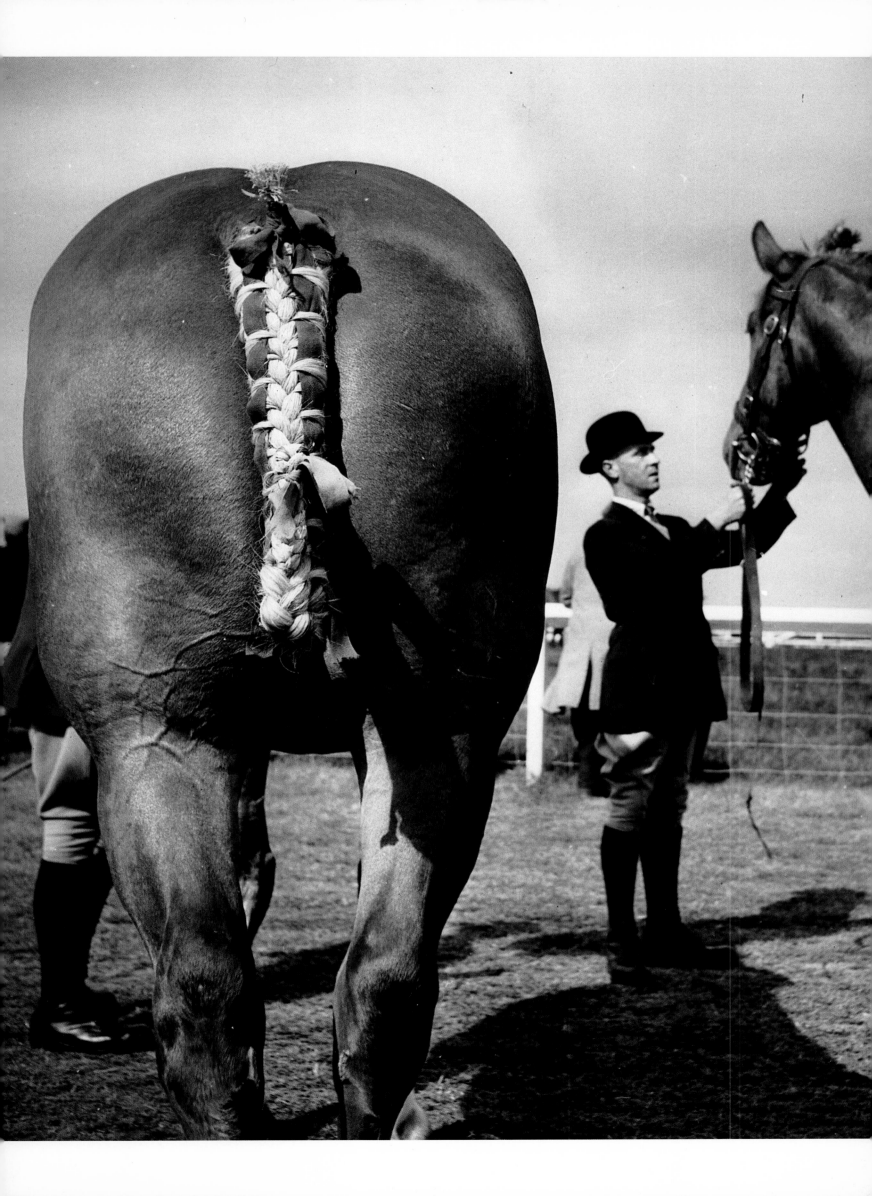

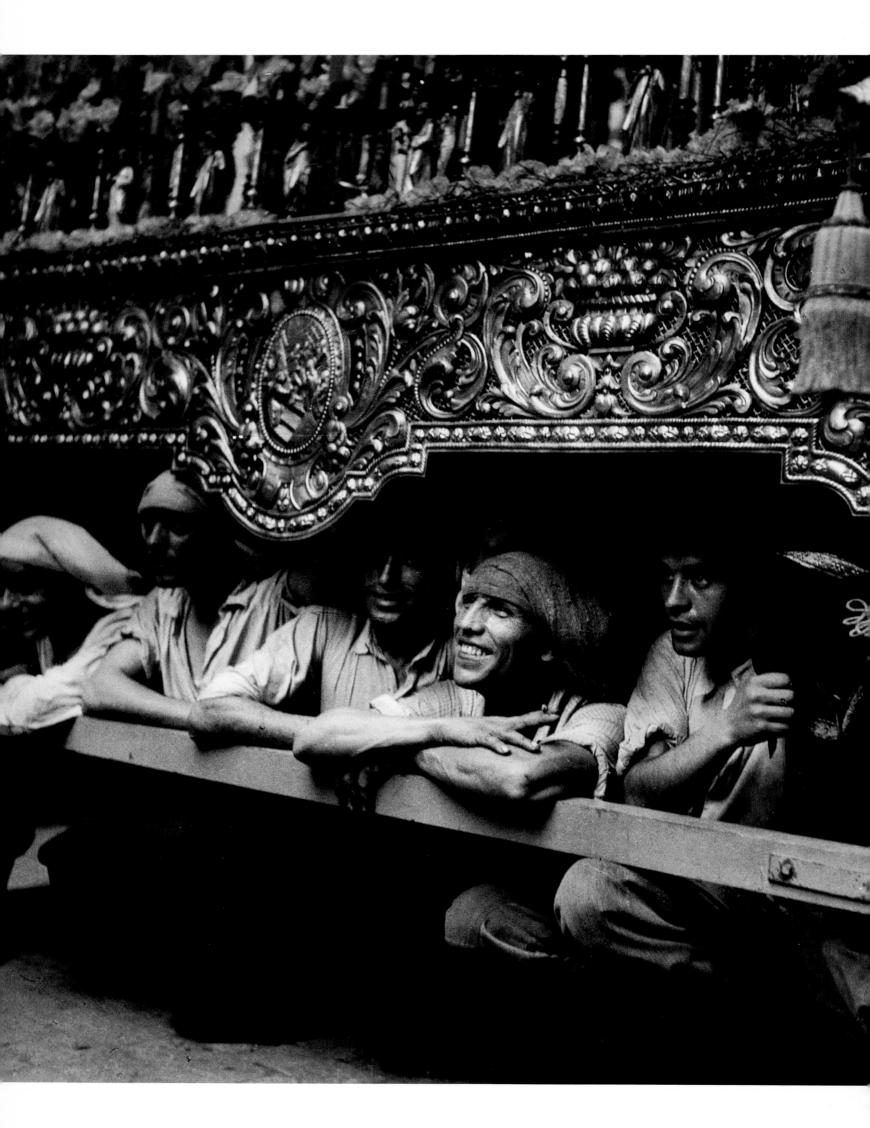

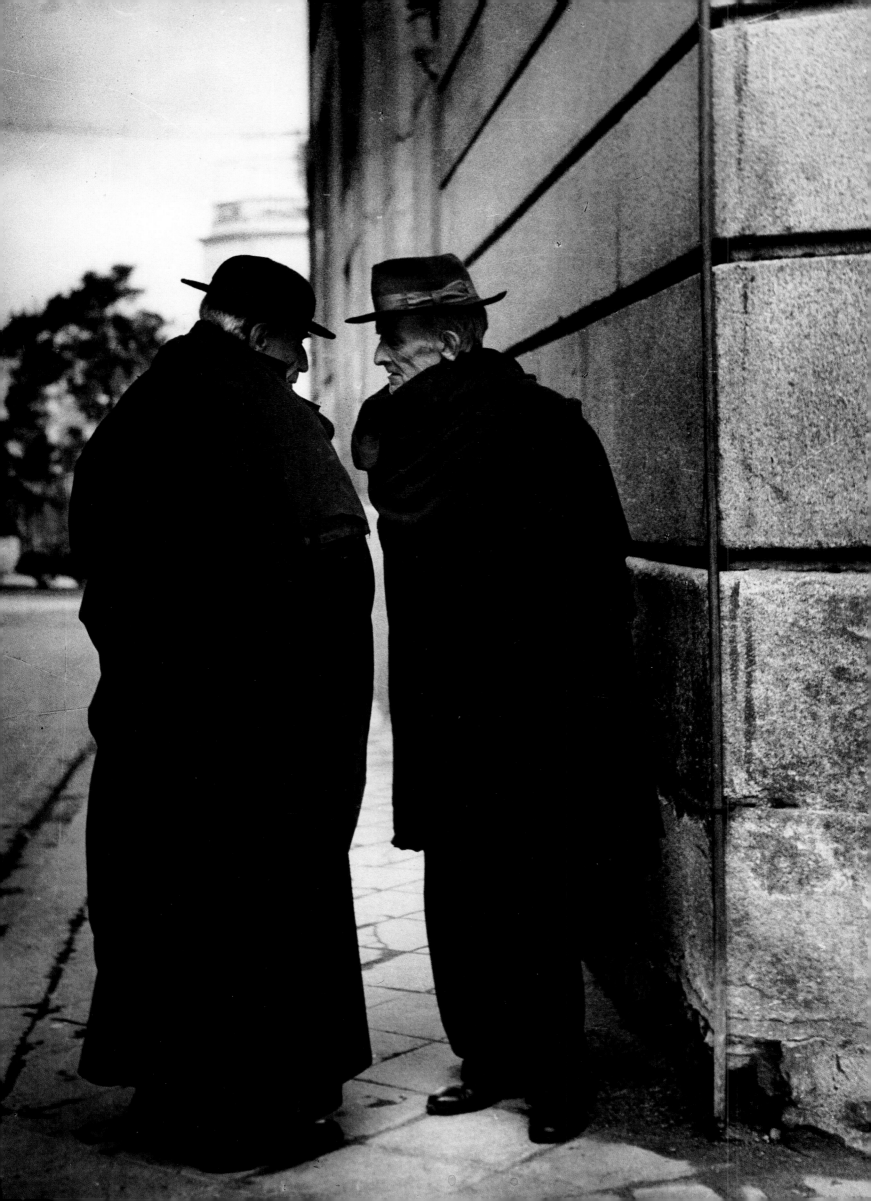

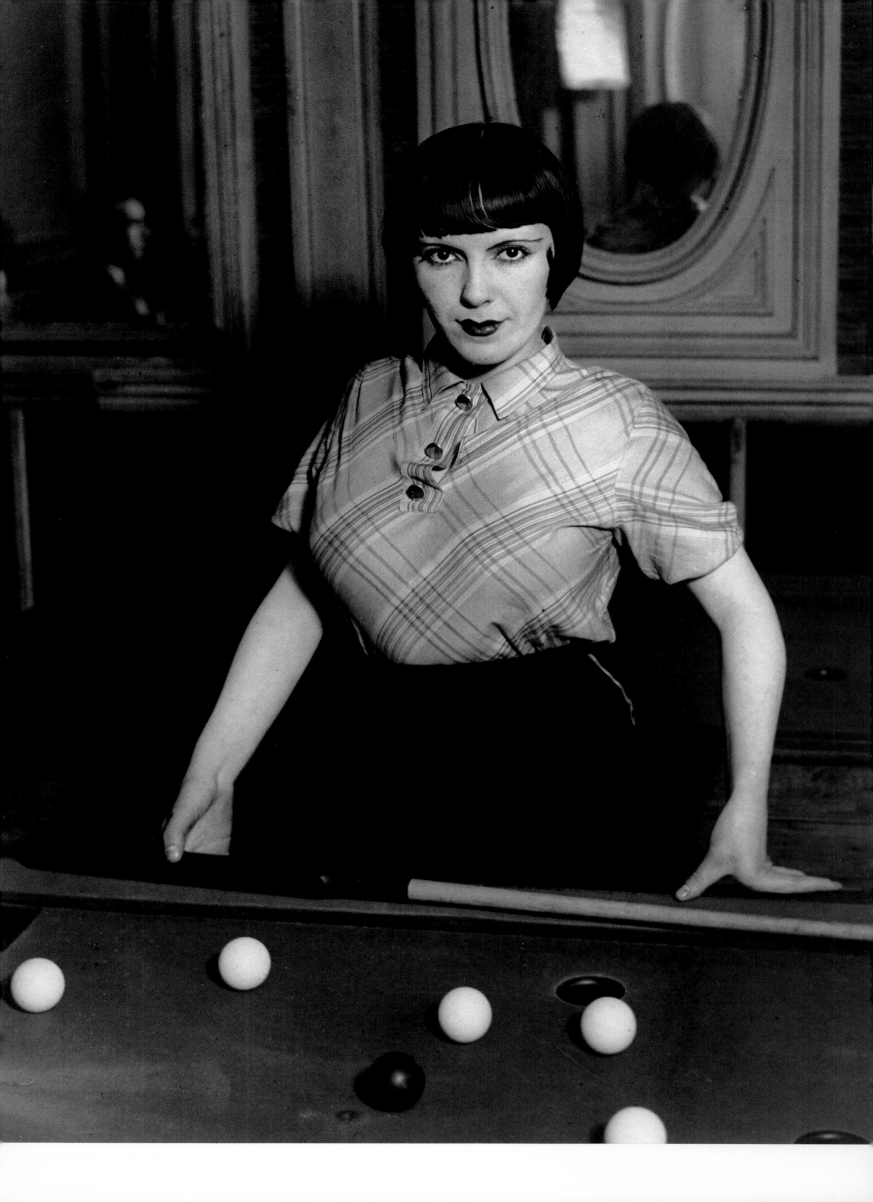

Catalogue of the Exhibition

All photographs, drawings, sculptures, books, and tapestries by Brassaï are © Gilberte Brassaï.

Unless noted, all objects are gelatin silver photographs.

▪ Object reproduced in book.

Self-Portrait

- 1

Brassaï Photographing the Parisian Night on Boulevard
Saint-Jacques with his 6 x 9 Voigtländer 1931–32
11 5/8 x 8 15/16 inches (29.5 x 22.7 cm)
The Metropolitan Museum of Art, New York
Gift of the artist 1980.1029.11

1929

- 2

Woman in a Coat with an Ermine Collar, Paris 1929
5 1/2 x 3 5/16 inches (14 x 8.4 cm)
The Museum of Fine Arts, Houston
Museum purchase with funds provided by Gay Block 94.374

3

Parisian Paving Stones 1929
3 1/2 x 2 9/32 inches (8.9 x 5.8 cm)
The Art Institute of Chicago
Restricted gift of Anstiss and Ronald Krueck in honor of the birth
of Angelica Catherine Evan-Cook 1997.409

- 4

Pont Neuf at Night, Paris 1929
5 7/16 x 3 1/2 inches (13.8 x 8.9 cm)
The Museum of Fine Arts, Houston, museum purchase 94.373

Paris, Night

- 5

Paving Stones, Paris c. 1930–32
Each 9 1/4 x 7 inches (23.5 x 17.8 cm)
Overall 9 1/4 x 14 inches (23.5 x 35.6 cm)
The Museum of Fine Arts, Houston, museum purchase with funds
provided by Louisa Stude Sarofim 94.372.A,.B

6

The Wall of Santé Prison, Boulevard Arago, Paris 1930–32
11 5/8 x 8 5/8 inches (29.5 x 21.9 cm)
The Museum of Modern Art, New York, David H. McAlpin Fund 2531.67

- 7

Tramps Sleeping under the Peristyle of the Bourse
du Commerce, Paris 1930–32
9 1/4 x 6 13/16 inches (23.5 x 17.3 cm)
The Museum of Fine Arts, Houston, museum purchase 94.371

8

Obelisk and Fountains, Place de la Concorde, Paris 1930–32
8 1/2 x 6 3/4 inches (21.6 x 17.2 cm)
Collection of Mr. and Mrs. Arnaud Brunel

9

Statue of Marshall Ney, Paris 1932
9 x 6 3/4 inches (22.9 x 17.2 cm)
Collection of Mr. and Mrs. Arnaud Brunel

- 10

Roofs of Paris c. 1930–32
6 3/4 x 9 inches (17.2 x 22.9 cm)
Collection of Jacqueline and Milton Esterow

11

Champs-Elysées, Paris 1938
11 3/4 x 9 3/32 inches (29.9 x 23.1 cm)
Museum voor Fotografie, Antwerp FP83/25-2

- 12

Lighting the Lamps at Dusk on the Place de la Concorde,
Paris 1932–33
9 x 6 1/2 inches (22.9 x 16.5 cm)
Collection of Mr. and Mrs. Arnaud Brunel

- 13

Saint-Germain-des-Prés Church, Paris 1939
8 3/4 x 6 7/8 inches (22.2 x 17.5 cm)
Collection of Michael and Jeanne Klein

- 14

Saint-Jacques Tower, Paris 1932–33
9 1/4 x 6 3/4 inches (23.5 x 17.2 cm)
The Museum of Fine Arts, Houston, museum purchase 94.375

15

Entrance to the Luxembourg Garden, Paris 1932
15 5/16 x 11 5/8 inches (38.9 x 29.5 cm)
The J. Paul Getty Museum, Los Angeles 86.XM.3.11

16

Observatory Avenue, Paris, Autumn 1934–36
9 3/16 x 12 inches (23.3 x 30.5 cm)
Courtesy of Howard Greenberg Gallery, New York

17

Métro Pillar, Paris c. 1934
14 3/4 x 19 3/16 inches (37.3 x 48.7 cm)
The Museum of Modern Art, New York
David H. McAlpin Fund 2553.67

18

Pont Royal, Paris 1930–32
9 3/8 x 7 inches (23.8 x 17.8 cm)
Courtesy of Camera Works, New York

19

The Eiffel Tower in the Twilight c. 1932
11 11/32 x 8 13/16 inches (28.8 x 22.4 cm)
The Metropolitan Museum of Art, New York
Gift of the artist 1980.1029.4

- 20

Pont de Crimée, Saint Martin Canal, Paris 1932–34
8 3/4 x 6 7/8 inches (22.2 x 17.5 cm)
Collection of Jacqueline and Milton Esterow

21
Pont de Solférino through Pont Royal, Paris c. 1934
15 3/4 x 19 15/16 inches (40 x 50.6 cm)
Musée Carnavalet, Paris Ph 2527

• 22
Pont Neuf in Paris 1932
10 1/32 x 7 7/8 inches (25.5 x 20 cm)
The Cleveland Museum of Art, James Parmelee Fund 1989.93

• 23
Looking through Pont Marie to Pont Louis-Philippe, Paris 1930–32
11 3/8 x 8 1/4 inches (28.9 x 21 cm)
Gilman Paper Company Collection, New York Ph 75.50

• 24
Pont Neuf, Paris 1949
9 1/8 x 11 9/16 inches (23.2 x 29.3 cm)
Collection of James Edward Maloney and Beverly Ann Young

25
Two A.M. at Les Halles Market, Paris 1930–32
9 1/2 x 7 inches (24.1 x 17.8 cm)
Collection of Sylvio Perlstein, Antwerp

• 26
Porter at Les Halles Market, Paris 1935
11 1/4 x 9 inches (28.6 x 22.9 cm)
National Museum of American History, Smithsonian Institution,
Washington, D. C. 69.232.19

• 27
The Dean of the Porters, Les Halles Market, Paris 1935
11 1/4 x 8 1/2 inches (28.6 x 21.6 cm)
Courtesy of Marlborough Gallery, New York

28
The Strongman of Les Halles Market, Paris 1939
11 3/4 x 9 inches (29.9 x 22.9 cm)
The J. Paul Getty Museum, Los Angeles 84.XM.1024.5

• 29
Sleeping Machinist at the Folies-Bergère, Paris 1932–33
9 3/8 x 7 inches (23.8 x 17.8 cm)
The Museum of Fine Arts, Houston, museum purchase 94.383

• 30
Shop Window, Paris 1931–32
9 7/16 x 7 1/16 inches (24 x 18 cm)
The Museum of Fine Arts, Houston, museum purchase 94.379

• 31
Watchmaker, Dauphine Alley, Paris c. 1932–33
9 1/4 x 7 inches (23.5 x 17.8 cm)
The Museum of Fine Arts, Houston
Gift of an anonymous donor in honor of Susan Bielstein 97.705

Secret Paris

• 32
Médrano Circus, Boulevard Rochechouart, Paris 1930–32
8 11/16 x 6 7/8 inches (22.1 x 17.5 cm)
The Museum of Fine Arts, Houston, museum purchase 94.370

33
Backstage at the Folies-Bergère, Paris 1930–32
8 15/16 x 6 7/8 inches (22.7 x 17.5 cm)
Collection of Nicholas J. Pritzker

• 34
Lovers' Quarrel, Bal des Quatre Saisons, Paris 1932
11 x 8 1/2 inches (28 x 21.6 cm)
Ydessa Hendeles Art Foundation, Toronto

• 35
Conchita with Sailors, Place d'Italie, Paris c. 1933
11 9/16 x 9 1/16 inches (29.3 x 23 cm)
Collection of Nicholas J. Pritzker

36
Lovers in a Small Cafe, Place d'Italie, Paris c. 1932–33
7 5/8 x 5 3/4 inches (19.4 x 14.6 cm)
Collection of Ornella and Robert Morrow

37
Two Hoodlums, Place d'Italie, Paris 1931–32
10 3/4 x 7 1/2 inches (27.3 x 19.1 cm)
Collection of Nicholas J. Pritzker

38
The Swallow, Paris 1931–32
15 11/32 x 11 13/32 inches (39 x 29 cm)
Collection de la Communauté française de Belgique en dépôt au
Musée de la Photographie à Charleroi MPC CFB 15.081

• 39
Streetwalker, near the Place d'Italie, Paris c. 1932
11 3/4 x 8 3/8 inches (29.9 x 21.3 cm)
National Gallery of Art, Washington, D. C.
Gift of Madame Gilberte Brassaï 1998.44.1

• 40
Young Prostitute, near the Place d'Italie, Paris c. 1932
9 3/16 x 6 15/16 inches (23.3 x 17.6 cm)
Collection of Stuart Alexander

• 41
Washing Up in a Brothel, Quincampoix Street, Paris c. 1932
8 1/2 x 11 11/16 inches (21.6 x 29.7 cm)
Yokohama Museum of Art 82-PHF-078

• 42
Introductions at Suzy's, Paris c. 1932
9 7/16 x 6 13/16 inches (24 x 17.3 cm)
Collection of Nicholas J. Pritzker

43
Bijou at the Bar de la Lune, Montmartre, Paris 1932
20 x 15 3/4 inches (50.8 x 40 cm)
The Art Institute of Chicago
Peabody Photography Purchase Fund 1955.22

- 44

 Prostitute Playing Snooker, Boulevard Rochechouart,
 Montmartre, Paris c. 1932
 11 3/4 x 8 7/8 inches (29.9 x 22.5 cm)
 The Metropolitan Museum of Art, New York
 Warner Communications Inc. Purchase Fund 1980.1023.9

- 45

 Opium Smoker and Cat, Paris c. 1931
 8 11/16 x 11 3/4 inches (22.1 x 29.8 cm)
 The Museum of Fine Arts, Houston
 Museum purchase with funds provided by Alice C. Simkins 94.382

- 46

 Lesbian Couple at Le Monocle, Paris 1932
 15 x 11 inches (38.1 x 28 cm)
 The Cleveland Museum of Art
 Gift of Mr. and Mrs. Anselm Talalay in honor of Evan Turner 1992.97

- 47

 Magic-City Dance Hall, Cognacq-Jay Street, Paris c. 1932
 9 1/2 x 7 inches (24.1 x 17.8 cm)
 National Gallery of Art, Washington, D. C.
 Gift of the Collectors Committee 1998.52.9

314

48

Two-in-One Suit, Magic-City Dance Hall, Paris c. 1931
11 1/2 x 8 1/2 inches (29.2 x 21.6 cm)
Collection of the Alvin Rush family

- 49

 Kiki and Her Accordion Player at Cabaret des Fleurs,
 Montparnasse Boulevard, Paris 1932–33
 15 1/2 x 11 5/8 inches (39.4 x 29.5 cm)
 The Museum of Modern Art, New York, David H. McAlpin Fund 2547.67

- 50

 Entrance, Bal Tabarin, Montmartre, Paris 1930–32
 9 7/16 x 7 inches (24 x 17.8 cm)
 The Museum of Fine Arts, Houston, museum purchase with funds
 provided by Alice C. Simkins and an anonymous donor 87.206

51

Wanda, Street Carnival, Paris 1951
15 11/32 x 11 1/8 inches (39 x 28.3 cm)
Collection de la Communauté française de Belgique en dépôt au
Musée de la Photographie à Charleroi MPC CFB 15.082

Society

- 52

 Patron of the Opéra, Paris 1937
 11 1/2 x 8 3/4 inches (29.2 x 22.2 cm)
 Gernsheim Collection, Harry Ransom Humanities Research Center,
 The University of Texas at Austin 964:0089:0006

- 53

 Backstage at the Opéra, Paris 1935–38
 9 x 11 1/2 inches (22.9 x 29.2 cm)
 Courtesy of Stockeregg Gallery, Zurich

- 54

 The Break, the Opéra, Paris c. 1958
 11 1/2 x 9 3/8 inches (29.2 x 23.8 cm)
 National Gallery of Art, Washington, D. C., anonymous gift 1998.52.2

55

Leaving the Opéra, Paris October 1935
9 5/16 x 6 7/8 inches (23.6 x 17.5 cm)
Private collection

- 56

 Opéra Gala, Paris 1937–38
 9 1/16 x 6 11/16 inches (23 x 17 cm)
 Musée Carnavalet, Paris Ph 2518

- 57

 Evening at Longchamp Racetrack, Paris 1936
 11 5/8 x 9 1/4 inches (29.5 x 23.5 cm)
 Collection of Thomas Walther, New York

- 58

 Evening at Longchamp Racetrack, Paris August 1938
 7 x 10 inches (17.8 x 25.4 cm)
 The Museum of Fine Arts, Houston, museum purchase with funds
 provided by Louisa Stude Sarofim 94.384

- 59

 Misia Sert, Antonio Canovas del Castillo, Helena Rubinstein,
 Gabrielle "Coco" Chanel and Serge Lifar at a Party at
 Helena Rubinstein's Apartment, Île Saint-Louis, Paris July 1938
 8 15/16 x 11 3/4 inches (22.7 x 29.9 cm)
 The Museum of Fine Arts, Houston, museum purchase with funds
 provided by Mr. and Mrs. Isaac Arnold, Jr. 94.385

- 60

 Christian Bérard and Lady Diana Cooper, Wife of the
 British Ambassador, Pré Catelan, Bois de Boulogne, Paris 1946
 19 3/4 x 15 3/4 inches (50.2 x 40 cm)
 The Menil Collection, Houston 69-17

- 61

 Parisian, Masked Ball at Pré Catelan, Bois de Boulogne,
 Paris July 1946
 11 3/4 x 8 11/16 inches (29.8 x 22.1 cm)
 The Museum of Fine Arts, Houston
 Museum purchase with funds provided by the S. I. Morris Photography
 Endowment Fund in honor of Maria Morris Hambourg 94.386

62

Gala Soirée, Maxim's, Paris 6 May 1949
11 3/4 x 8 15/16 inches (29.9 x 22.7 cm)
Collection of Susan Patricof

63

Longchamp Racetrack, Paris 1932
9 3/16 x 7 inches (23.3 x 17.8 cm)
Private collection

Portraits

■ 64
Germaine Richier 1953
11 3/8 x 8 15/16 inches (28.9 x 22.7 cm)
The Museum of Fine Arts, Houston
Gift of an anonymous donor in honor of Virginia Zabriskie 97.667

■ 65
Alberto Giacometti 1948
11 9/16 x 8 5/8 inches (29.3 x 21.9 cm)
National Gallery of Art, Washington, D. C.
Gift of the Collectors Committee 1998.52.1

■ 66
Matisse and His Model at the Villa d'Alésia, Paris 1939
3 7/8 x 2 11/16 inches (9.8 x 6.8 cm)
The Metropolitan Museum of Art, New York
Ford Motor Company Collection, gift of Ford Motor Company and
John C. Waddell 1987.1100.127

■ 67
Salvador Dalí 1933
11 11/16 x 9 1/4 inches (29.7 x 23.5 cm)
The J. Paul Getty Museum, Los Angeles 84.XM.1024.12

■ 68
Hans Reichel, Hôtel des Terrasses, Paris 1931–32
9 5/16 x 6 7/8 inches (23.7 x 17.5 cm)
The Museum of Fine Arts, Houston, museum purchase 94.387

■ 69
The Poet Léon-Paul Fargue, the "Pedestrian of Paris" 1932
11 11/32 x 10 1/4 inches (28.8 x 26 cm)
The Metropolitan Museum of Art, New York
Warner Communications Inc. Purchase Fund 1980.1023.2

70
Henri Michaux c. 1950
15 11/32 x 11 13/32 inches (39 x 29 cm)
Collection de la Communauté française de Belgique en dépôt au
Musée de la Photographie à Charleroi MPC CFB 15.086

■ 71
Henry Miller in My Doorway, Hôtel des Terrasses, Paris 1932–33
11 7/16 x 8 7/8 inches (29 x 22.5 cm)
National Gallery of Art, Washington, D. C., anonymous gift 1998.52.4

■ 72
Jean Genêt 1948
11 5/16 x 8 15/16 inches (28.7 x 22.7 cm)
National Gallery of Art, Washington, D. C., anonymous gift 1998.52.6

73
Madame Marianne D.-B. 1936
11 9/16 x 9 3/32 inches (29.3 x 23.1 cm)
The Art Institute of Chicago
Restricted gift of Exchange National Bank of Chicago 1974.369

Picasso

■ 74
Plaster Heads in Picasso's Studio, Boisgeloup, France 1932
9 1/16 x 6 7/8 inches (23 x 17.5 cm)
The Museum of Fine Arts, Houston, museum purchase with funds
provided by Isabel B. and Wallace S. Wilson 94.388

■ 75
Picasso in His Studio on Boétie Street, Paris 1932
9 x 6 11/16 inches (22.9 x 17 cm)
The Metropolitan Museum of Art, New York
Purchase, the Horace W. Goldsmith Foundation Gift 1986.1193

76
Picasso in His Studio on Grands-Augustins Street, Paris,
September 1939
11 21/32 x 8 7/16 inches (24.7 x 21.4 cm)
The J. Paul Getty Museum, Los Angeles 84.XM.1024.8

■ 77
Cast of Picasso's Right Hand 1943
11 5/16 x 7 15/16 inches (28.7 x 20.2 cm)
National Gallery of Art, Washington, D. C., anonymous gift 1998.52.3

■ 78
Picasso's Sculpture "Death's Head" c. 1944
8 11/16 x 6 11/16 inches (22 x 17 cm)
Collection of Gilberte Brassaï

Nudes

■ 79
Nude 1931–32
11 1/8 x 16 3/16 inches (28.3 x 41.1 cm)
Courtesy of Zeit-Foto Salon, Tokyo

■ 80
Nude 139 1931–32
8 3/4 x 11 3/4 inches (22.2 x 29.8 cm)
The Museum of Fine Arts, Houston, museum purchase with funds
provided by Isabel B. and Wallace S. Wilson 94.389

81
Artificial Sky c. 1932–34
Vertical diptych
6 7/16 x 9 7/16 inches (16.4 x 24 cm)
6 13/16 x 9 7/16 inches (17.3 x 24 cm)
Collection of Jean-Michel Skira, Switzerland

■ 82
The Temptation of Saint Anthony
From the series Transmutations 1934–35
6 3/4 x 9 inches (17.2 x 22.9 cm)
The Museum of Fine Arts, Houston, museum purchase with funds
provided by Louisa Stude Sarofim 96.651

83
Untitled
From the series Transmutations 1934–35
9 7/16 x 6 15/16 inches (24 x 17.6 cm)
Collection of Virginia Zabriskie, New York

■ 84
Nude 1931–32
11 1/2 x 9 1/16 inches (29.2 x 23 cm)
Ydessa Hendeles Art Foundation, Toronto

85
Nude 1931–32
9 1/4 x 6 1/8 inches (23.5 x 15.6 cm)
Collection of Wallace S. Wilson

■ 86
Nude May 1944
Wax crayon with hand-rubbed highlights on blue paper
8 x 8 5/8 inches (20.3 x 21.9 cm)
The Museum of Fine Arts, Houston, museum purchase 98.13

■ 87
Nude 1937
Wax crayon with graphite, heightened with chalk on paper
12 5/16 x 7 5/8 inches (31.3 x 19.4 cm)
The Museum of Fine Arts, Houston
Museum purchase with funds provided by Max and Isabell Smith
Herzstein in honor of Jane and Raphael Bernstein 98.12

■ 88
The Embrace 1966
Gelatin silver photograph of a sculpture by Brassaï
9 1/4 x 6 11/16 inches (17 x 23.5 cm)
Collection of Gilberte Brassaï

89
Almond Woman 1962
Bronze sculpture on black marble pedestal
Overall 9 1/8 x 2 x 2 inches (23.2 x 5.1 x 5.1 cm)
From the Estate of Robert Herman, on loan to The Jack S. Blanton
Museum of Art, The University of Texas at Austin 16.1989 loan

■ 90
Opulent Nude 1971
Stone sculpture on black marble pedestal
Overall 15 x 5 x 2 13/16 inches (38.1 x 12.7 x 7.1 cm)
Collection of Dan Berley

■ 91
Mediterranean Woman I 1964
Bronze sculpture on black marble pedestal
Overall 6 1/4 x 3 x 2 3/8 inches (15.9 x 7.6 x 6 cm)
The Museum of Fine Arts, Houston, museum purchase with funds
provided by Joan Alexander in honor of Peter and Frances Marzio,
Wynne Phelan, Alison de Lima Greene, and Margaret Skidmore 98.3

Arts

92a
Large-Scale Objects: Thimble c. 1930
8 13/16 x 6 7/8 inches (22.4 x 17.5 cm)

92b
Large-Scale Objects: Matches c. 1930
9 1/16 x 6 11/16 inches (23 x 17 cm)

92c
Large-Scale Objects: Shoelaces c. 1930
9 1/4 x 6 31/32 inches (23.5 x 17.7 cm)
Collection of Jean-Michel Skira, Switzerland

■ 93
Mask of Bread 1936–37
19 3/4 x 15 inches (50.2 x 38.1 cm)
The Menil Collection, Houston F069-14

■ 94
Drying Shoe Leathers 1933
11 3/4 x 8 5/16 inches (29.8 x 21.2 cm)
Museum Folkwang, Essen 546/79

■ 95
General View with the Elephant Statue, Villa Orsini,
Bomarzo, Italy 1952
9 x 11 5/8 inches (22.9 x 29.5 cm)
The Museum of Fine Arts, Houston
Museum purchase with funds provided by the Prospero Foundation,
courtesy of Raphael and Jane Bernstein 95.293

■ 96
Giant in the Park of Villa Orsini, Bomarzo, Italy 1952
15 3/4 x 20 inches (40 x 50.8 cm)
The Menil Collection, Houston F069-11MF

■ 97
Two Seated Angels by Jacques Sarrazin,
Saint-Nicolas-des-Champs Church July 1945
11 1/2 x 8 3/4 inches (29.2 x 22.2 cm)
The Museum of Fine Arts, Houston, museum purchase 98.11

■ 98
The Horses, Grove of Apollo, Versailles, France 1949
11 3/8 x 8 7/8 inches (28.9 x 22.5 cm)
The Museum of Fine Arts, Houston
Museum purchase with funds provided by Anne Bushman in honor of
Elizabeth B. Holton and in memory of George V. Holton 94.391

99
Métro Grill Designed by Hector Guimard, Paris 1932–33
9 x 6 13/16 inches (22.9 x 17.3 cm)
The Museum of Fine Arts, Houston
Museum purchase with funds provided by Anne Bushman and
partial gift of Galerie Alain Paviot 97.173

Graffiti

■ 100
Passion
From the series Graffiti: Magic c. 1931–60
11 7/8 x 9 1/4 inches (30.2 x 23.5 cm)
The Menil Collection, Houston F081-06 MF

101

The Sun King, City Gate at Saint-Ouen, Paris 1945–50

From the series Graffiti: Primitive Images c. 1931–60

11 13/16 x 9 inches (30 x 22.9 cm)

The J. Paul Getty Museum, Los Angeles 84.XM.1024.2

102

Untitled

From the series Graffiti: Birth of Man c. 1931–60

20 x 15 3/4 inches (50.8 x 40 cm)

The Menil Collection, Houston F069-21MF

103

Untitled

From the series Graffiti: Primitive Images c. 1931–60

10 1/2 x 4 1/2 inches (26.6 x 11.5 cm)

Collection of Gilberte Brassaï

104

Villa Riberolles, Bagnolet Street, Paris

From the series Graffiti: Primitive Images c. 1931–60

11 11/16 x 8 7/8 inches (29.7 x 22.5 cm)

The Museum of Fine Arts, Houston, museum purchase 98.9

105

The Imp, Belleville, Paris 1952

From the series Graffiti: Magic c. 1931–60

11 7/16 x 8 11/16 inches (29 x 22.1 cm)

National Gallery of Art, Washington, D. C., anonymous gift 1998.52.5

106

Swastika 1940–44

From the series Graffiti: Magic c. 1931–60

9 3/8 x 6 15/16 inches (23.9 x 17.6 cm)

The J. Paul Getty Museum, Los Angeles 84.XM.1024.9

107

"The political struggle on the wall. General de Gaulle's
Cross of Lorraine, covered over by black paint,
begins to reemerge" 1944–45

From the series Graffiti: The Language of the Wall c. 1931–60

11 x 8 11/16 inches (28 x 22 cm)

The Metropolitan Museum of Art, New York

Gift of the artist 1980.1029.9

108

Assassin 1950s

From the series Graffiti c. 1931–60

Silver dye bleach photograph, printed 1960s

8 1/16 x 11 13/16 inches (20.5 x 30 cm)

Collection of Gilberte Brassaï

109

Hommage 1960s

From the series Graffiti c. 1931–60

Silver dye bleach photograph

10 1/4 x 7 inches (26 x 17.8 cm)

Collection of Gilberte Brassaï

Paris, Day

110a-d

A Man Dies in the Street, Paris 1932

Each 7 x 4 3/4 inches (17.8 x 12.1 cm)

Overall 14 1/8 x 9 7/16 inches (35.9 x 24)

Collection of Michael and Jeanne Klein

111

Plane Tree, Paris 1945

19 5/8 x 13 13/16 inches (49.8 x 35.1 cm)

The Metropolitan Museum of Art, New York

Purchase, Lila Acheson Wallace Gift 1984.1063

112

Police Outside the "Chat qui Pelote," near Les Halles Market,
Paris 1939

11 13/16 x 9 inches (30 x 22.9 cm)

Collection of Gilberte Brassaï

113

Intersection of Passy and Tour Streets, Paris 1940

9 1/2 x 11 7/8 inches (24.1 x 30.2 cm)

Musée Carnavalet, Paris Ph 2519

114

Stairs, Montmartre, Paris 1935–36

13 9/16 x 9 1/2 inches (34.4 x 24.1 cm)

Musée Carnavalet, Paris Ph 2520

115

Professor Louis Dimier, Member of the Institute, on Quay Voltaire,
Paris 1932–33

10 15/16 x 8 1/8 inches (27.8 x 20.6 cm)

Gernsheim Collection, Harry Ransom Humanities Research Center,
The University of Texas at Austin 964:0089:0004

116

Balloon Seller, Montsouris Park, Paris 1931–34

19 5/16 x 15 3/4 inches (49.1 x 40 cm)

The J. Paul Getty Museum, Los Angeles 86.XM.3.9

117

Rivoli Street, Paris 1937

11 11/16 x 9 1/4 inches (29.7 x 23.5 cm)

The J. Paul Getty Museum, Los Angeles 84.XM.1024.21

118

My Newspaper Vendor, Place Denfert-Rochereau, Paris 1948

11 3/16 x 8 1/16 inches (28.4 x 20.5 cm)

The Museum of Fine Arts, Houston, museum purchase 94.380

119

Kiss on Swing at a Street Fair 1935–37

11 23/32 x 9 1/4 inches (29.8 x 23.5 cm)

The J. Paul Getty Museum, Los Angeles 84.XM.1024.18

120

The Manicurist 1931

9 1/4 x 6 7/8 inches (23.4 x 17.5 cm)

Collection of Jean-Michel Skira, Switzerland

121

Fusillade, Place Saint-Jacques, Paris 25 August 1944

6 3/4 x 9 1/16 inches (17.1 x 23 cm)

Museum Folkwang, Essen 1174/87

- 122
Police Station, Paris 1944
10 1/2 x 8 3/4 inches (26.6 x 22.2 cm)
The Museum of Fine Arts, Houston
Museum purchase with funds provided by Joan Morgenstern in honor
of Mark and Joan Silberman 98.1

- 123
Cat with Phosphorescent Eyes 1936
11 7/16 x 8 5/16 inches (29 x 21.1 cm)
The Museum of Fine Arts, Houston, museum purchase 98.8

- 124
Little White Dog, Montmartre, Paris 1932
9 7/16 x 11 13/16 inches (24 x 30 cm)
National Gallery of Art, Washington, D. C., anonymous gift 1998.52.7

France and the Riviera

- 125
Sleeping Tramp in Marseilles c. 1935
9 1/4 x 7 inches (23.5 x 17.8 cm)
Museum of Fine Arts, Boston, Sophie M. Friedman Fund 1986.594

318

- 126
Christmas Eve Mass, Les Baux, Provence, France 1945
15 1/4 x 11 1/2 inches (38.7 x 29.2 cm)
The Museum of Modern Art, New York, purchase 104.59

127
Fish Nets, Cannes, France 1945
19 1/2 x 15 9/16 inches (49.5 x 39.5 cm)
The Roger Thérond Collection, Paris

- 128
Exotic Garden, Monaco c. 1945
11 11/16 x 9 7/16 inches (29.7 x 24 cm)
The Museum of Fine Arts, Houston, museum purchase with funds
provided by museum staff, members of Photo Forum, and partial gift
of the Howard Greenberg Gallery in memory of Joe D. Wheeler 95.300

129
French Riviera 1934
11 9/32 x 9 inches (28.7 x 22.9 cm)
The J. Paul Getty Museum, Los Angeles 84.XM.1024.7

- 130
Chartres Cathedral in Winter, France 1946
19 5/16 x 15 11/16 inches (49.1 x 39.8 cm)
The J. Paul Getty Museum, Los Angeles 86.XM.3.8

- 131
Apothecaries Laboratory, Hospital for the Poor,
Hospice de Beaune, France 1951
15 1/2 x 11 1/2 inches (39.4 x 29.2 cm)
San Francisco Museum of Modern Art
Gift of Louise Dahl-Wolfe in memory of Elizabeth Dahl 79.155

- 132
Bayonne Festival, France 1949
11 7/16 x 9 3/16 inches (29 x 23.3 cm)
Collection of Michael and Jeanne Klein

- 133
Dinner for Two 1936–37
15 3/4 x 20 inches (40 x 50.8 cm)
Anonymous loan

- 134
Isère Valley, French Alps 1937
11 x 9 inches (28 x 22.9 cm)
Courtesy of Edwynn Houk Gallery, New York

Abroad

- 135
On the Train, Rome to Naples 1955
15 3/8 x 11 11/16 inches (39.1 x 29.7 cm)
The J. Paul Getty Museum, Los Angeles 86.XM.3.12

- 136
Napoleon in Front of an Antique Shop, French Quarter,
New Orleans, Louisiana 1957
11 3/4 x 9 3/16 inches (29.8 x 23.3 cm)
The Museum of Fine Arts, Houston
Museum purchase with funds provided by Gay Block 94.390

- 137
Easter Parade, New York 1957
13 x 10 1/4 inches (33 x 26 cm)
Collection of Gilberte Brassaï

- 138
Grand Central Station, New York 1957
11 x 9 1/4 inches (28 x 23.4 cm)
The Art Institute of Chicago, gift of the artist 1983.956

- 139
The Royal Horse Show, Newcastle, England 1959
11 1/8 x 9 1/4 inches (28.3 x 23.5 cm)
The Museum of Fine Arts, Houston
Museum purchase with funds provided by Anne Bushman 98.2

- 140
Conversation, Madrid c. 1950–51
11 5/8 x 8 13/16 inches (29.5 x 22.4 cm)
The J. Paul Getty Museum, Los Angeles 84.XM.1024.22

- 141
Float Porters, Holy Week Festival, Seville, Spain 1951
10 7/16 x 9 1/16 inches (26.5 x 23 cm)
The Museum of Fine Arts, Houston
Museum purchase with funds provided by the Mundy Companies 98.7

- 142
Santos Dumont Airport, Brazil 1960
11 13/16 x 10 3/8 inches (30 x 26.4 cm)
Collection of Gilberte Brassaï

- 143
Macumba, Rio de Janeiro, Brazil 1960
10 13/16 x 15 11/32 inches (27.5 x 39 cm)
Collection of Gilberte Brassaï

Books

144
Paris de nuit
Paris: Arts et Métiers Graphiques 1932
10 x 7 1/2 inches (25.4 x 19.1 cm)
Collection of Deborah Irmas, Los Angeles

145
Voluptés de Paris
Paris: Paris-Publications 1934
10 5/8 x 8 1/4 inches (27 x 21 cm)
Anonymous loan

146
Trente dessins
Paris: Éditions Pierre Tisné 1946
13 x 10 5/16 inches (33 x 26.2 cm)
The Museum of Fine Arts, Houston
Gift of Mr. Alvin S. Romansky 91.1629

147
Histoire de Marie
Paris: Éditions du Point du Jour 1949
6 1/2 x 5 1/8 inches (16.5 x 13 cm)
Title page verso includes a dedication to André Kertész by Brassaï
Anonymous loan

148
Les Sculptures de Picasso
Paris: Éditions du Chêne 1949
12 1/2 x 9 3/4 inches (31.8 x 24.8 cm)
Anonymous loan

149
Camera in Paris
London: The Focal Press 1949
9 7/8 x 7 1/2 inches (25.1 x 19.1 cm)
Anonymous loan

150
Brassaï
Paris: Éditions Neuf 1952
10 3/4 x 8 1/2 inches (27.3 x 21.6 cm)
Anonymous loan

151
Séville en fête
Paris: Éditions Neuf 1954
10 7/8 x 8 1/2 inches (27.6 x 21.6 cm)
Anonymous loan

152
Graffiti
Stuttgart: Belser Verlag 1960
11 1/4 x 9 1/8 inches (28.6 x 23.2 cm)
Anonymous loan

153
Beszélgetések Picassóval
Budapest: Corvina 1968
8 x 6 inches (20.3 x 15.2 cm)
Anonymous loan

Conversations avec Picasso
Paris: Éditions Gallimard 1964
8 x 5 5/8 inches (20.3 x 14.3 cm)
Anonymous loan

Picasso and Company
Garden City, New York: Doubleday 1966
9 1/2 x 6 5/8 inches (24.1 x 16.9 cm)
Anonymous loan

154
Henry Miller grandeur nature
Paris: Éditions Gallimard 1975
8 x 5 1/2 inches (20.3 x 14 cm)
Courtesy of Andrew Cahan: Bookseller, Ltd.

155
Le Paris secret des années 30
Paris: Éditions Gallimard 1976
11 x 8 1/2 inches (28 x 21.6 cm)
Anonymous loan

156
Paroles en l'air
Paris: Jean-Claude Simoën 1977
8 1/4 x 5 1/2 inches (21 x 14 cm)
Anonymous loan

157
Henry Miller rocher heureux
Paris: Éditions Gallimard 1978
8 x 5 1/2 inches (20.3 x 14 cm)
Courtesy of Andrew Cahan: Bookseller, Ltd.

158
Letters to My Parents
Chicago: University of Chicago Press 1997
7 3/4 x 6 1/2 inches (19.7 x 16.5 cm)
Anonymous loan

159
Les Artistes de ma vie
Paris: Denoël 1982
11 1/2 x 9 5/8 inches (29.2 x 24.5 cm)
Anonymous loan

160
Marcel Proust sous l'emprise de la photographie
Paris: Éditions Gallimard 1997
8 x 5 1/2 inches (11.3 x 14 cm)
Anonymous loan

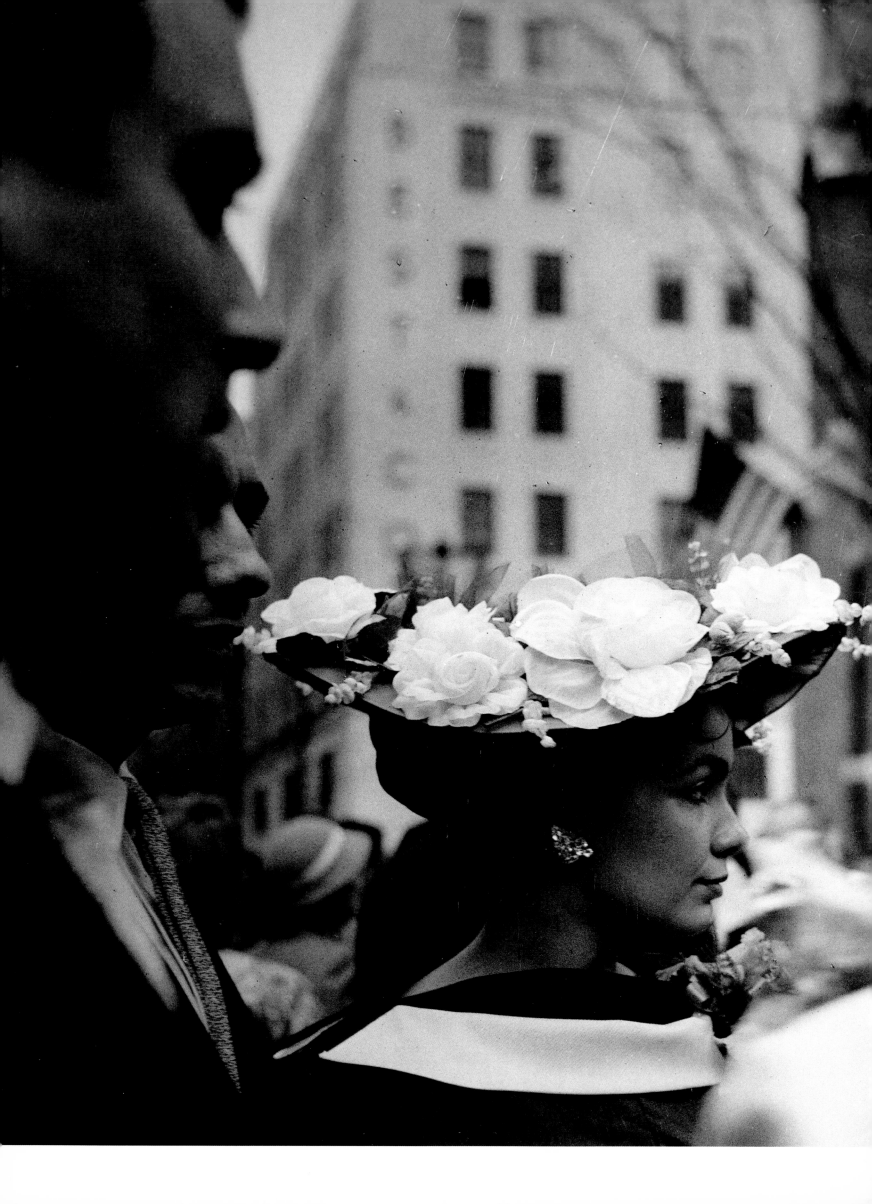

Brassaï Exhibition History

Compiled by Celeste Roberts-Lewis and Kathleen V. Ottervik

- Citations not fully confirmed by the publication date of this book.

figure 25 Easter Parade, New York, 1957 (catalogue number 137) © Gilberte Brassaï

Individual

1933

- Paris de nuit, Galerie Arts et Métiers Graphiques, Paris; Batsford Gallery, London (before June – July) [Catalogue].

1945

Brassaï: Dessins, Galerie Renou et Colle, Paris (13 May – 16 June).

1946

- Photographies parisiennes de Brassaï, Palais des Beaux-Arts, Brussels.

1950

- Brassaï et Paul Grimault, Librairie Cheval Blanc, Paris.

1952

322

- Cent Photographies de Brassaï, Musée des Beaux-Arts, Nancy (4 – 24 December); Interclub, Toulouse (1954) [Catalogue].

Brassaï, Librairie-Galerie La Hune, Paris (26 February) [Booksigning].

1954

Photographs by Brassaï, The Art Institute of Chicago, Chicago (15 November 1954 – 1 January 1955); Walker Art Center, Minneapolis (22 January – 28 February 1955) [Catalogue].

1956

Brassaï, Hansa Gallery, New York (16 April – 5 May).

Language of the Wall: Parisian Graffiti Photographed by Brassaï, The Museum of Modern Art, New York (24 October 1956 – 6 January 1957); Institute of Contemporary Arts, London (25 September – 25 October 1958).

1959

Brassaï: The Eye of Paris, Limelight Gallery, New York (5 – 31 October).

1960

Brassaï, Sculptures-galets, dessins, gravures, Galerie du Pont-Royal, Paris (8 – 23 March).

- Graffiti, Triennale di Milano, Milan (October – November).

1961

- Graffiti, Institut d'Études Françaises, Saarbrücken.
- Brassaï, Festival Hall, London.
- Paris de nuit, Centre Valéry Larbaud, Vichy.

1962

Brassaï: Graffiti, Galerie Daniel Cordier, Paris (11 – 30 January).

- Graffiti, L'Obelisco, Rome (7 April – ?) [Catalogue].

1963

- Brassaï [retrospective], Bibliothèque Nationale, Paris (7 May – 15 June); Résidence du Louvre, Menton, France (August) [Catalogue].

Dizaine de l'Art, Pierre Cardin, Paris (16 – 26 May).

- Graffiti, Maison de la Culture, Caen.

Photographs by Brassaï, Worcester Art Museum, Worcester, Massachusetts (1 June – 3 September).

1964

- Les sculptures de Picasso et les photographies de Brassaï, du livre Conversations avec Picasso, Galerie Madoura, Cannes (22 December – ?).

Graffiti, Staatliche Kunsthalle, Baden-Baden (29 February – 5 April).

Graffiti, Musée du Vieux-Château, Dieppe (24 April – 8 November).

1965

- [Brassaï], Josie Péron, Paris (before 20 May – 15 June).

1966

Brassaï, Kölnischer Kunstverein, Cologne (25 November – 23 December).

1967

Cet homme Brassaï, Galerie Les Contards, Lacoste (7 July – 6 August) [Catalogue].

1968

Brassaï, Sculptures, dessins et gravures, Galerie Lucie Weill au Pont-des-Arts, Paris (8 March – 18 April).

Brassaï [retrospective], The Museum of Modern Art, New York (29 October 1968 – 5 January 1969); Saint Louis Art Museum, Saint Louis (12 February – 16 March 1969); National Gallery of Victoria, Melbourne (3 February – 10 March 1971) and Farmer's Blaxland Gallery, Sidney (2 – 23 April 1971); Auckland City Art Gallery, Auckland (17 May – 13 June 1971), National Art Gallery, Wellington, New Zealand (21 June – 16 July 1971), and Govett-Brewster Art Gallery, New Plymouth, New Zealand (26 July – 8 August 1971); Museo de Arte Moderno "La Tertulia," Cali, Colombia (22 March – 15 April 1973); Museo de Zea, Medellin, Colombia (12 June – 12 July 1973); traveled throughout South America (1973 – 1974) [Catalogue].

Brassaï: Dessins, sculptures, gravures et une tapisserie, La Boétie Gallery, New York (12 – 27 November).

- Brassaï: Picasso und andere Meisterfotos, Staatliche Landesbildstelle, Hamburg (October).

1970

Brassaï, L'Art mural: Trente couleurs inédites, Galerie Rencontre, Paris (7 October – 7 November); Do Not Bend Gallery, London (5 – 30 January 1971).

1971

Brassaï [retrospective], Robert Schoelkopf Gallery, New York (before 26 September – 15 October).

1972

Brassaï [retrospective], Harry Lunn Gallery, Washington, D. C.
(17 February – 5 March).

- Hommage à Henry Miller, Centre Culturel Américain, Paris.

Brassaï: Dessins, sculptures, tapisseries, Galerie Verrière, Paris
(22 March – 30 April); Galerie Verrière, Lyon (1 March – 10 April 1973)
[Catalogue].

1973

Brassaï, Witkin Gallery, New York (13 June – 19 August); Friends of
Photography, Carmel, California (13 October – 18 November); Santa
Barbara Museum of Art, California (5 January – 17 February 1975).

- Brassaï: The Eye of Paris, Corcoran Gallery of Art, Washington, D. C.
(2 June – 15 July) [Circulated by the International Exhibitions
Foundation]; Hopkins Center Art Galleries, Dartmouth College of Art,
Hanover, New Hampshire (1 – 30 September); University of Iowa Museum
of Art, Iowa City, Iowa (15 January – 15 February 1974); ▪ Winnipeg
Art Gallery, Winnipeg, Manitoba (after 15 April – before 4 May 1974);
Charles and Emma Frye Art Museum, Seattle, Washington (4 – 26 June
1974); University Art Museum, University of California, Berkeley
(17 July – 11 August 1974); California State University, Northridge
(9 – 29 September 1974); Hayden Gallery, Massachusetts Institute
of Technology, Cambridge (18 October – 16 November 1974);
Munson-Williams Proctor Institute, Museum of Art, Utica, New York
(12 January – 16 February 1975).

1974

- Brassaï, Wolfgang Wittrock Kunsthandel, Düsseldorf (January).

Brassaï, Musée Réattu, Arles (15 July – 30 September).

- Paris in the 30s, Country Art Gallery, Locust Valley, Jamaica,
Long Island, New York.

1975

Brassaï: The Eye of Paris, Baltimore Museum of Art, Baltimore
(4 – 30 March).

- Brassaï, Gemini Gallery, Palm Beach (11 February – ?).

- Brassaï, French Institute-Alliance Française, New York
(11 February – ? March).

Photographs, Janet Fleischer Gallery, Philadelphia (8 – 30 March).

- Three French Photographers: Atget, Brassaï, Cartier-Bresson,
Allan Frumkin Gallery, Chicago.

- Brassaï et Kertész, Phoenix Gallery, San Francisco
(before 20 December – ?).

1976

- [Brassaï], Lowinsky and Araï Gallery, San Francisco.

- Selections from the series The Secret Paris of the 30s were exhibited
at the following galleries and institutions: Marlborough Gallery,
New York (17 September – 16 October); ▪ Cronblatt Gallery,
Baltimore (1976); Marlborough Gallery, Zurich (7 December 1976
– 29/30 January 1977); Everson Museum, Syracuse, New York
(12 February – 12 March 1977); Halsted 831 Gallery, Birmingham,
Michigan (14 January – 26 February 1977); Foster White Gallery,
Seattle (8 – 28 April); ▪ Hayden Gallery, Massachusetts Institute of
Technology, Cambridge (May 1977); ▪ The Image Gallery, Sarasota
(1977); ▪ Miami Dade Community College, Florida (1977); Neue
Galerie der Stadt, Linz (16 June – 9 July 1977); Galerie Levy,
Hamburg (10 October 1977 – 7 January 1978); ▪ Galerie Arta,
The Hague (1977); Museum voor Moderne Kunst, Arnheim,
Netherlands (2 February – 29 March 1978); Banque Bruxelles
Lambert, Brussels (20 April – 19 May 1978); Galerij Paula Pia,
Antwerp (1 – 30 September 1978); Camera Obscura, Stockholm
(9 January – 17 February 1979).

1979

- Brassaï, Artists and Studios, Marlborough Gallery, New York
(8 September – 6 October); ▪ Gallery 700, Milwaukee (March – before
15 April 1980); Lowinsky and Araï Gallery, San Francisco (15 April
– 31 May 1980); Lowinsky and Araï Gallery, Los Angeles (20 May
– 29 June 1980) [Catalogue].

Brassaï, Zeit-Foto Salon, Tokyo (17 September – 6 October).

- Brassaï: A Major Exhibition, The Photographer's Gallery, London
(9 November – 9 December); ▪ Gallery Newcastle, Newcastle
(December); ▪ Brewery Arts Center, Kendal (January – February 1980);
▪ Stills: The Scottish Photography Group Gallery, Edinburgh
(March 1980); ▪ Tolarno Gallery, Melbourne (? – 24 July 1980);
▪ Salford University, Salford (July 1979) [Catalogue].

Brassaï, Cronin Gallery, Houston (11 November – 9 December 1979).

1980

- Brassaï, Cartier-Bresson, Vintage Prints, Neikrug Gallery, New York
(December 1980 – February 1981).

1981

Brassaï: The Eye of Paris, Edwynn Houk Gallery, Chicago
(2 January – 24 February).

1982

- Brassaï, The Artists of My Life, Marlborough Gallery, London
(15 September – 8 October); ▪ Marlborough Gallery, New York;
▪ Bede Gallery, Jarrow, England.

1984

Hommage à Brassaï, Marlborough Gallery, New York
(13 September – 6 October).

Celebrations, Zabriskie Gallery, New York (13 September – 6 October).

Brassaï, Yurakucho Asahi Gallery, Tokyo (11 – 28 October) [Catalogue].

1985

Brassaï, Galerie Adolf Fényes, Budapest (29 November – 29 December) [Catalogue].

1986

Brassaï, Galerie Municipale du Château d'Eau, Toulouse (1 – 30 April) [Catalogue].

1987

Picasso vu par Brassaï, Musée Picasso, Paris (17 June – 28 September) [Catalogue].

1988

Brassaï: Foto's uit de museumverzameling, Museum voor Fotografie, Antwerp (8 January – 14 February) [Catalogue].

Paris Tendresse, FNAC Forum, Paris (3 November – 31 December); Marseilles (17 January – 25 February 1989) [Catalogue].

Brassaï: Paris le jour, Paris la nuit, Musée Carnavalet, Paris (8 November 1988 – 8 January 1989) [Catalogue].

1990

Brassaï, Printemps, Tokyo (26 April – 15 May); Printemps, Kobe (18 – 30 October) [Catalogue].

1993

Brassaï: The Eye of Paris, Houk Friedman Gallery, New York (5 March – 1 May) [Catalogue].

▪ Brassaï: Del Surrealismo al informalismo, Fundació Antoni Tàpies, Barcelona (14 September – 7 November); Centre National de la Photographie, Hôtel Salomon de Rothschild, Paris (24 February 1994 – 9 May); Rupertinum, Salzburg (29 May – 10 July 1994); Museum Fridericianum, Kassel (2 September – 27 November 1994); Haus der Kunst, Munich (21 January – 26 March 1995); ▪ Museo Nacional Centro de Arte Reina Sofía, Madrid (April – early summer 1995) [Catalogue].

1995

Brassaï [Rehang of Brassaï component of 1951 Five French Photographers exhibition] Centre Georges Pompidou, Paris (1 February – 3 April).

Group

1931

Photographes d'aujourd'hui, Librairie-Galerie de la Plume d'Or, Paris (15 December 1931 – 15 January 1932).

1932

▪ Groupe annuel des photographes, Galerie de la Pléiade.

Modern European Photographers, Julien Levy Gallery, New York (20 February – 11 March).

1933

Groupe annuel des photographes, Galerie de la Pléiade, Paris (3 May – 3 June).

▪ Exposition Internationale de photographie, Palais des Beaux-Arts, Brussels (June – July).

1934

Groupe annuel des photographes, Galerie de la Pléiade, Paris (12 November – 12 December).

▪ Exposition de Photographies, Association Florence Blumenthal, Paris (February).

1935

▪ Formes nues, Galerie Bollard, Paris (before 7 April – May) [Catalogue].

Exposition de photographie, Musée Rath, Geneva (4 – 18 May).

L'Humour et le fantastique par la photographie, Galerie de la Pléiade, Paris (2 – 28 March).

▪ Exposition International photographique du nu esthétique, France-Diffusion, Paris.

Documents de la vie sociale, Association des Ecrivains et Artistes Revolutionaires, Galerie de la Pléiade, Paris (21 May – 21 June).

1936

Exposition internationale de la photographie contemporaine, Musée des Arts Décoratifs, Pavillon de Marsan, Paris (16 January – 1 March) [Catalogue].

Les Dix, ou la photographie vivante, Galerie Leleu, Paris (3 – 12 April).

1937

Photography, 1839–1937, The Museum of Modern Art, New York (17 March – 18 April); Addison Gallery of American Art, Andover, Massachusetts (16 October – 14 November) [Catalogue].

L'Envers des grandes villes, Galerie de la Pléiade, Paris (20 February – 10 March).

▪ Centenaire de Daguerre, Palais des Beaux-Arts, Brussels.

Centenaire de Daguerre, Karolyi Palace, Budapest (23 October – 7 November).

1938

Exposition internationale de photos de neige, Paris
(15 December 1938 – 15 February 1939).

Revue de la Photographie 1938, Galèrie de la Pléiade, Paris
(22 October – 24 November).

1939

- Straalende fransk Foto-Udstilling, Kunstindustriemuseet,
Copenhagen.

Le Visage de la France, Palais des Beaux-Arts, Brussels (1 – 16 July).

1946

D'Ingres à nos jours, Galerie Denise René, Paris
(22 December 1946 – 21 January 1947).

- Première Salon National de la Photographie, Galerie Mansart,
Bibliothèque Nationale, Paris [Brassaï not included in catalogue].

1947

- La photographie française [in association with the French
Embassy], ▪ Karolyi Palace, Budapest (February); ▪ Buenos Aires,
Argentina (July); ▪ Montevideo, Uruguay (September).

- Deuxième Salon National de la Photographie, Galerie Mansart,
Bibliothèque Nationale, Paris (November).

1948

- French Photography Today, Photo League, New York (April 20 – ?).

- Troisième Salon National de la Photographie, Galerie Mansart,
Bibliothèque Nationale, Paris (October).

1949

- Quatrième Salon National de la Photographie, Galerie Mansart,
Bibliothèque Nationale, Paris.

1950

- Cinquième Salon National de la Photographie, Galerie Mansart,
Bibliothèque Nationale, Paris.

Vakfotografie 1950: Internationale Foto Tentoonstelling, Stedelijk
van Abbe Museum, Eindhoven (4 March – 15 April) [Catalogue].

1951

Subjektive Fotografie, Staatliche Schule für Kunst und Handwerk,
Saarbrücken (12 – 29 July) [Catalogue].

Five French Photographers: Brassaï, Cartier-Bresson, Doisneau,
Ronis, Izis, The Museum of Modern Art, New York (19 December 1951
– 21 February 1952).

Cinq photographes: Boubat, Brassaï, Doisneau, Izis, Facchetti,
Librairie-Galerie La Hune, Paris (15 – 28 February).

1952

Welt-Ausstellung der Photographie, 1952, Luzerner Kunsthaus,
Lucerne (15 May – 31 July) [Catalogue].

I Gatti, L'Obelisco, Rome (16 December).

1953

Post-War European Photography, The Museum of Modern Art,
New York (27 May – 2 August).

- Vingt Hommes d'images, Galerie Craven, Paris (before 7 January).

Meister-Photographien aus Frankreich, Institut Français, Innsbruck
(15 February – 15 March).

1954

Great Photographs, Limelight Gallery, New York (1 – 30 December).

1955

The Family of Man, The Museum of Modern Art, New York (25 January
– 8 May); Selected venues include Corcoran Gallery, Washington,
D. C. (30 June – 31 July); Hochschule fur Bildende Kunst, Berlin
(17 September – 9 October); Staedische Lenbach-Galerie, Munich
(19 November – 18 December); Musée National d'Art Moderne, Paris
(26 January – 26 February 1956); Stedelijk Museum, Amsterdam
(23 March – 19 April 1956); Palais des Beaux-Arts, Brussels (23 May
– 1 July 1956); Royal Festival Hall, London (1 – 30 August 1956);
Palazzo Venezia, Rome (1 – 28 November 1956); Kalemegdan Pavilion,
Belgrade (25 January – 22 February 1957); Kunstlerhaus, Vienna
(30 March – 28 April 1957); traveled throughout North America
(1955 – 1957); India (1956 – 1957), Japan (1956 – 1957); Europe
(1956 – 1958); South America (1957); and Africa (1958) [Catalogue].

Four European Photographers at the Detroit Institute of Arts,
Detroit Institute of Arts, Detroit (18 October – 30 December)
[Catalogue].

1957

- Mostra internazionale biennale della fotografia, Sala Napoleonica,
Palazzo Reale, Venice.

1959

Hundert Jahre Photographie 1839–1939 aus der Sammlung
Gernsheim, London, Wallraf-Richartz-Museum, Cologne
(27 June – 16 August).

Photography at Mid-Century: 10th Anniversary Exhibition, George
Eastman House, Rochester, New York (9 November 1959 – January
1960); Museum of Fine Arts, Boston (30 August – 24 September 1961)
[Catalogue does not include Brassaï].

1960

- [Exposition de la photographie française], Banker's Trust Company,
New York.

- Le visage humaine de l'Europe ▪ Hamburg; Palais des Beaux Arts,
Charleroi, Belgium (22 September – 21 October 1962).

1961

Das Naive Bild Der Welt, Staatliche Kunsthalle, Baden-Baden (2 July – 4 September); Historisches Museum, Frankfurt (16 September – 19 October); Kunstverein, Hanover (29 October – 10 December) [Catalogue].

1962

Sculptures contemporaine, Maison de la Culture, Le Havre (6 May – 17 June).

Minotaure, Galerie d'Art de l'Oeil, Paris (23 May – 30 June) [Catalogue].

1963

Creative Photography: 1826 to the Present: An Exhibition from The Gernsheim Collection, Detroit Institute of Arts, Detroit (12 November – 1 December) [Catalogue].

International Photo and Cine Exhibition, Photokina, Cologne (16 – 24 March) [Catalogue].

1964

The Photographer's Eye, The Museum of Modern Art, New York (27 May – 23 August); Columbus Gallery of Fine Arts, Columbus, Ohio (3 – 23 December); Currier Gallery of Art, Manchester, New Hampshire (15 January – 14 February 1965); Rochester Memorial Gallery, Rochester, New York (5 – 26 March 1965); Long Island University (9 – 30 April 1965); Oklahoma Art Center, Oklahoma City (31 May – 21 June 1965); Marion Koogler McNay Art Institute, San Antonio (20 August – 23 September 1965); Dallas Museum of Fine Arts, Dallas (9 – 31 October 1965); St. Edward's University, Austin (9 – 30 November 1965); Cerritos College, Norwalk, California (9 February – 2 March 1966); Cottey College Art Gallery, Nevada, Missouri (25 March – 15 April 1966); Hax Art Gallery, St. Joseph, Missouri (28 April – 19 May 1966); Kenyon College, Gambier, Ohio (16 September – 9 October 1966); Baltimore Museum of Art, Baltimore (24 October – 28 November 1966); Honolulu Academy of Arts, Honolulu (30 July – 24 August 1969); Cultural Center of the Philippines, Manila (25 November – 26 December 1969); American Cultural Center Exhibition Gallery, Madras (15 – 28 May 1970); Stedelijk van Abbemuseum, Eindhoven, The Netherlands (6 November – 13 December 1970); City Museum Bonn, Bonn (22 January – 18 February 1971); Musée des Arts Décoratifs, Lausanne (11 March – 6 April 1971); Kunsthalle Düsseldorf, Düsseldorf (23 April – 23 May 1971); Maison de la Culture, Grenoble (8 June – 15 July 1971); Museum of Art and Industry, Saint-Étienne, France (1 October – 9 November 1971); Amos Andersonin Taidemuseo, Helsinki (25 November 1971 – 2 January 1972); traveled throughout New Zealand (1967), Australia (1968), and India (1970) [Catalogue].

1967

Exposition internationale de photographie: Regard sur la terre des hommes/International Exhibition of photography: The Camera as Witness [photography section of Terre des Hommes: Exposition Internationale des Beaux-Arts/Man and his World/Fine Arts Exhibition, Expo 67], [Organized and presented by the National Gallery of Canada], Montreal (28 April – 27 October) [Catalogue].

Photography in the Twentieth Century, National Gallery of Canada, Ottawa (16 February – 2 April); Memorial Union Art Gallery, University of California, Davis (1 – 30 April 1969); Humbolt State College, Arcata, California (5 – 23 May 1969); Wichita Art Museum, Wichita (1 – 31 July 1969); Baltimore Museum of Art, Baltimore (16 September – 12 October 1969); South Bend Art Center, South Bend, Indiana (1 – 30 November 1969); Civic Center Museum of Philadelphia, Philadelphia (9 January – 8 February 1970); South Dakota State University Audio Visual Center, Brookings (1 – 30 April 1970); Edmonton Art Gallery, Alberta, Canada (18 June – 12 July 1970); University of Kentucky Department of Art, Lexington (1 – 30 September 1970); SUNY Brockport, Art Department, Brockport, New York (20 November – 18 December 1970); Pasadena Art Museum, Pasadena (18 January – 28 February 1971); Tucson Art Center, Tucson (11 March – 11 April 1971); University of Colorado, Fine Arts Department, Boulder (13 October – 10 November 1971); New Jersey State Museum, Trenton (15 November – 15 December 1971) [Catalogue].

1968

[Plastic Arts Triennial, Yugoslavia], Izlobeni Pavillon, Belgrad (12 – 23 November).

Photography as Printmaking, The Museum of Modern Art, New York (19 March – 27 May). Selected venues include Rochester Institute of Technology, Rochester (18 October – 10 November); Allen Memorial Art Museum, Oberlin College, Oberlin, Ohio (25 November – 16 December); Virginia Museum of Fine Arts, Richmond (29 May – 31 August 1969); Detroit Institute of Arts, Detroit (22 December 1969 – 19 January 1970).

1969

Master Photographs from the Collection of the Museum of Modern Art, University of St. Thomas, Houston (15 January – 2 March); Delgado Museum of Art, New Orleans (14 March – 20 April); Southern Methodist University, Dallas (15 June – 13 July); Coe College, Cedar Rapids (15 September – 6 October); Studio 23, Bay City, Michigan (17 November – 8 December); Dulin Gallery of Art, Knoxville (3 – 26 January 1970); Washington University Gallery of Art, St. Louis (13 February – 8 March 1970); Cummer Gallery of Art, Jacksonville, Florida (17 April – 10 May 1970); University of South Florida, Tampa (25 May – 22 June 1970); Toledo Museum of Art, Toledo (4 October – 1 November 1970); Hopkins Center, Dartmouth College, Hanover (15 November – 13 December 1970); Allen Memorial Art Museum, Oberlin College, Oberlin, Ohio (3 – 31 January 1971).

International Sculpture, La Boétie Gallery, New York (6 May – 7 June).

Sculptures de notre temps, Mairie de Pantin, Pantin (23 March – 7 April).

[Expo of sculptures], Galerie Govaerts, Ostende, Belgium (13 July – 15 August).

1970

Photo-Portrait, Gemeentemuseum, The Hague (2 February – 3 May).

• Significant 19th- and 20th-Century Photographs, Robert Schoelkopf Gallery, New York.

1971

Cinquième Biennale internationale de la tapisserie, Musée Cantonal des Beaux-Arts, Lausanne (17 June – 3 October).

1972

- [Exposition de la photo française], Moscow.

Alexey Brodovitch and His Influence, Philadelphia College of Art, Philadelphia (7 April – 2 May) [Catalogue].

- Les Amis parisiens d'Henry Miller, Centre Culturel Américain, Paris, 1972 [Catalogue].

[Exhibition of Transmutations Portfolio], Bibliothèque Nationale, Paris (19 July – 12 August).

1973

A Century of Photographs, Robert Schoelkopf Gallery, New York (19 June – 20 July).

1974

Recent Acquisitions in the Photography Collection, The Art Institute of Chicago, Chicago (16 February – 31 March).

Dixième Biennale International d'Art de Menton, Palais de l'Europe, Menton (1 June – 30 September) [Catalogue].

1975

135 Years of Photography: A Sixth Anniversary Show, Witkin Gallery, New York (5 March – 12 April).

- Three Photographers, Three Cities: Bill Brandt, Brassaï, Berenice Abbott, Marlborough Gallery, New York (18 October – 29 November); • David Mirvish Gallery, Toronto (before 7 – 26 May 1976); • Vision Gallery, Boston (1977). • A Tale of Three Cities, Van Straaten Gallery, Chicago (before 8 March – ? 1977).

Artists by Artists: Photographs, Zabriskie Gallery, New York (2 December 1975 – 3 January 1976).

1976

The Photographer and the Artists, Sidney Janis Gallery, New York (7 February – 6 March) [Catalogue].

- Contemporary Prints, Knoedler Gallery, New York.

- Onzième Biennale International d'Art de Menton, Palais de l'Europe, Menton, France (July – September) [Catalogue].

Photographs from the Julien Levy Collection: Starting with Atget, The Art Institute of Chicago, Chicago (11 December 1976 – 20 February 1977) [Catalogue].

1977

Documenta 6, Museum Fridericianum, Kassel (24 June – 2 October) [Catalogue].

- Ganz-Magav: Kertész, Brassaï, Atget, Cultural Center of Budapest, Hungary.

Appearances, Marlborough Gallery, New York (before 27 February – 12 March).

- Diez Grandes Fotógrafos: Berenice Abbott, Eugène Atget, Diane Arbus, Richard Avedon, Herbert Bayer, Bill Brandt, Brassaï, Robert Frank, Irving Penn, Maurice Tabard, Museo de Arte Contemporaneo, Caracas (August – September) [Catalogue].

20 Monographies, Galerie Zabriskie, Paris (2 August – 3 September).

Künstlerphotographien im XX Jahrhundert, Kestner-Gesellschaft, Hanover (12 August – 18 September) [Catalogue].

Sculpture: A Photographer's Vision, Zabriskie Gallery, New York (13 December 1977 – 14 January 1978).

1978

Images des hommes: 18 photographes Européens, Studio du Passage 44, Brussels (9 September – 8 October); Academie voor Schone Kunsten, Gand (13 – 29 October); Cultureel Centrum, Hasselt (4 – 19 November); Musée du Verre, Charleroi (24 November – 17 December) [Catalogue].

Dada and Surrealism Reviewed, Hayward Gallery, Arts Council of Great Britain, London (11 January – 27 March) [Catalogue].

Photographie française: Le Nouvel esprit 1925–1940, Galerie Zabriskie, Paris (28 November 1978 – 13 January 1979); [France between the Wars: 1925–1940] Zabriskie Gallery, New York (4 December 1979 – 5 January 1980) [Catalogue].

1979

Livres rares et photographies: Paris de nuit, Galerie Zabriskie, Paris (3 July – 22 September) [Catalogue].

- L'École de Paris dans les années 1925–1939, Fondation Nationale de la Photographie, Lyon (? – 14 June).

Photographic Surrealism, The New Gallery of Contemporary Art, Cleveland, Ohio (3 October – 24 November); Dayton Art Institute, Dayton, Ohio (29 February – 13 April 1980); Brooklyn Museum, New York (17 May – 13 July 1980) [Catalogue].

1980

Cliché-verre: Hand-Drawn, Light-Printed: A Survey of the Medium from 1839 to the Present, The Detroit Institute of Arts, Detroit (12 July – 21 August); The Museum of Fine Arts, Houston (11 September – 23 October) [Catalogue].

- Adams, Brassaï, Kertész, Rosenberg Gallery, New York (September).

Das Imaginäre Photo-Museum, Photokina, Cologne (12 – 28 September) [Catalogue].

Les statues de Paris du Musée Bourdelle: de 1940 à nos jours, Musée Bourdelle, Paris (4 November – 1 December).

Les Réalismes, 1919–1939, Centre Georges Pompidou, Paris (17 December 1980 – 20 April 1981); Staatliche Kunsthalle, Berlin (10 May – 30 June 1981) [Catalogue].

1981

Transfixed by Light: Photographs from the Menil Foundation Collection: Selected by Beaumont Newhall, Rice Museum Institute for the Arts, Rice University, Houston (21 March – 24 May) [Catalogue].

Paris-Paris: Créations en France, 1937–1957, Centre Georges Pompidou, Paris (28 May – 2 November) [Catalogue].

La Photographie française: 1970–1980, Galerie Zabriskie, Paris (16 July – 19 September).

1982

Counterparts: Form and Emotion in Photography, The Metropolitan Museum of Art, New York (26 February – 9 May) [Catalogue].

Sculptures/photographies, Galerie Zabriskie, Paris (16 March – 12 May).

Photographes de la Belle Epoque: 1842–1968, Kanagawa Prefectural Museum of Modern Art (21 September – 24 October) [Catalogue].

International Photography, 1920–1980, National Gallery of Australia, Canberra (10 November 1982 – 30 January 1983) [Catalogue].

1983

History of Lensless Photography, Franklin Institute, Philadelphia (18 May – 6 November).

1984

Subjektive Fotografie, San Francisco Museum of Modern Art, San Francisco (8 June – 29 July); Sarah Campbell Blaffer Gallery, The University of Houston, Houston (2 November – 9 December); Museum Folkwang, Essen (16 December 1984 – 10 February 1985); Västerbottens Museum, Umeä (24 February – 31 March 1985); Kulturhuset, Stockholm (19 April – 2 June 1985); Saarland Museum, Saarbrücken (October – November 1985); Palais des Beaux-Arts, Brussels (January 1986) [Catalogue].

The Art of Photography: Past and Present from the Collection of The Art Institute of Chicago, The National Museum of Art, Osaka (6 October – 4 December) [Catalogue].

Dada and Surrealism in Chicago Collections, Museum of Contemporary Art, Chicago (1 December 1984 – 27 January 1985) [Catalogue].

1985

Das Aktfoto: Ansichten vom Körpern im fotografischen Zeitalter. Ästhetik, Geschichte, Ideologie, Stadtmuseum, Munich (1 February – 14 April) [Catalogue].

Paris–New York–Tokyo, Tsukuba Museum of Photography, Tokyo (3 March – 16 September); Miyagi Museum of Art, Tokyo (9 November – 22 December) [Catalogue].

Elementarzeichen: Urformen visueller Information, Staatliche Kunsthalle, Berlin (31 August – 6 October) [Catalogue].

L'Amour fou: Photography and Surrealism, Corcoran Gallery of Art, Washington, D. C. (14 September – 17 November); [Explosante-fixe: photographie et surréalisme], Centre Georges Pompidou, Paris, (15 April – 15 June 1986); Hayward Gallery, London (10 July – 5 October 1986) [Catalogue].

La Nouvelle Photographie en France, Musée Sainte-Croix, Poitiers (7 October – 1 December); Musée Réattu, Arles (19 December 1986 – 8 March 1987); Musée des Beaux-Arts, Carcassonne (25 March – 30 May 1987) [Catalogue].

La Photographie surréaliste avant 1940, Galerie Zabriskie, Paris (26 October – 4 December 1985).

1987

France between the Wars: 1925–1940, Zabriskie Gallery, New York (8 January – 14 February) [Ten-year anniversary exhibition].

Regards sur Minotaure: La Revue à tête de bête, Musée Rath, Geneva (17 October 1987–31 January 1988); Musée d'art moderne de la Ville de Paris (17 March – 29 May 1988) [Catalogue].

L'Oeil du Minotaure: Ubac, Brassaï, Bellmer, Alvarez Bravo, Man Ray, Galerie Sonia Zannettacci, Geneva (1 December 1987 – 31 January 1988) [Catalogue].

1988

Art or Nature: Twentieth Century French Photography, Barbican Art Gallery, London (12 May – 17 July) [Catalogue].

1989

The Art of Photography, 1839–1989, The Museum of Fine Arts, Houston (11 February – 30 April); Australian National Gallery, Canberra (17 June – 27 August); Royal Academy of Arts, London (23 September – 23 December); Sezon Museum of Art, Tokyo (3 March – 1 April 1990) [Catalogue].

Donations Daniel Cordier: Le Regard d'un amateur, Centre Georges Pompidou, Paris (8 November 1989 – 5 March 1990) [Catalogue].

The New Vision: Photography between the World Wars, The Metropolitan Museum of Art, New York (22 September–31 December); San Francisco Museum of Modern Art, San Francisco (28 February – 22 April 1990); Los Angeles County Museum of Art, Los Angeles (10 May – 15 July 1990); The Art Institute of Chicago, Chicago (15 September – 1 December 1990); High Museum of Art, Atlanta (5 February – 28 April 1991); The Museum of Fine Arts, Houston (8 June – 4 August 1991) [Catalogue].

Das innere der Sicht: surrealistische Fotografie der 30er und 40er Jahre, Museum des 20 Jahrhunderts, Vienna (13 April – 21 May) [Catalogue].

1990

Photography until Now, The Museum of Modern Art, New York (14 February – 29 May); Cleveland Museum of Art, Cleveland (27 June – 19 August) [Catalogue].

Anxious Visions: Surrealist Art, University Art Museum, University of California, Berkeley (3 October – 30 December) [Catalogue].

The Past and Present of Photography, National Museum of Modern Art, Tokyo (26 September – 11 November); Kyoto (20 November – 16 December).

L'Écriture griffée: Antonin Artaud, Brassaï, Victor Brauner, Bernard Buffet, Cesar, Jean Dubuffet, Jean Fautrier, Musée d'Art Moderne de Saint-Étienne, France (6 December 1990 – 25 February 1991) [Catalogue].

1991

André Breton: La Beauté convulsive, Centre Georges Pompidou, Paris (23 April – 26 August) [Catalogue].

Picasso visages, Musée Picasso, Paris (16 January – 8 April) [Catalogue].

Sculpter-Photographier, Photographie-Sculpture, Musée du Louvre, Paris (22 – 23 November) [Catalogue].

1992

The Paris of Atget, Man Ray, and Brassaï, Tokyo Metropolitan Museum of Photography (23 October – 8 December) [Catalogue].

Portraits d'une capitale: De Daguerre à William Klein: Collections photographiques du Musée Carnavalet, Paris (30 October 1992 – 10 January 1993) [Catalogue].

1993

Espais existincials: La Mirada apassionada de Daniel Cordier: Una Selección de la donación Daniel Cordier al Musée National d'Art Moderne, Centre Georges Pompidou, Paris, Centre Cultural de la Fundació "la Caixa," Barcelona (16 April – 30 May) [Catalogue].

Yvette Cauquil-Prince Taller de Tapices, Monasterio de Varuela, Zaragoza (10 June – 18 July); Palacio de Sastago, Zaragoza (30 July – 25 August) [Catalogue].

Magicians of Light: Photographs from the Collection of the National Gallery of Canada, National Gallery of Canada, Ottawa (4 June – 6 September).

Paris Post War: Art and Existentialism, 1945–55, Tate Gallery, London (9 June – 5 September) [Catalogue].

1994

Photo dessin, dessin photo: Le Dessin photographique, Espace Van Gogh, Arles (1 April – 30 June) [Catalogue].

Photography: A Surrealist Dream Come True, Harry Ransom Humanities Research Center, The University of Texas at Austin (11 April – 29 July) [Brochure].

Graffiti, Zabriskie Gallery, New York (13 July – 8 September); Galerie Zabriskie, Paris (28 March – 30 May 1995).

Kunst des 20 Jahrhunderts: 20 Jahre Wittrock Kunsthandel: 20 Werke, Wolfgang Wittrock Kunsthandel, Düsseldorf (October).

1995

Les Heures chaudes de Montparnasse, Fondation Electricité de France, Paris (14 April – 23 July) [Catalogue].

• Luz y tiempo: Colección fotografica formada por Manuel Alvarez Bravo para la Fundación Cultural Televisa, A. C., Centro Cultural/Arte Contemporáneo, A. C., Mexico City [Catalogue].

Picasso et la photographie: "À plus grande vitesse que les images," Musée Picasso, Paris (3 October – 31 December) [Catalogue].

1996

L'Informe: mode d'emploi, Centre Georges Pompidou, Paris (22 May – 26 August) [Catalogue].

Legacy of Light: Master Photographs from the Cleveland Museum of Art, Cleveland Museum of Art, Cleveland (24 November 1996 – 2 February 1997) [Catalogue].

1997

Le miroir noir: Picasso, sources photographiques, 1900–1928, Musée Picasso, Paris (12 March – 9 June) [Catalogue].

Picasso and Photography: The Dark Mirror, The Museum of Fine Arts, Houston (16 November 1997 – 1 February 1998).

1998

The Surrealist Vision: Europe and the Americas, Bruce Museum of Arts and Science, Greenwich, Connecticut (17 January – 5 April) [Catalogue].

Brassaï and Company, The Art Institute of Chicago, Chicago (24 January – 17 May).

Brassaï: Paris de nuit, Robert Miller Gallery, New York (14 October – 14 November).

Brassaï: The Eye of Paris, The Museum of Fine Arts, Houston (6 December 1998 – 28 February 1999); The J. Paul Getty Museum, Los Angeles (13 April – 4 July 1999); National Gallery of Art, Washington, D. C. (17 October 1999 – 16 January 2000) [Catalogue].

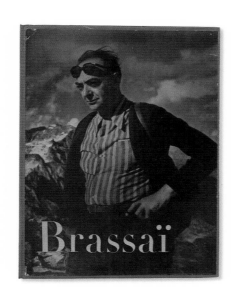

figure 26 Photographs of books by Brassaï

Bibliography

Compiled by Celeste Roberts-Lewis with research assistance by Kathleen V. Ottervik

▪ Citations not fully confirmed by the publication date of this book.

Copies of almost all articles and essays listed below are now housed in the archives of The Museum of Fine Arts, Houston.

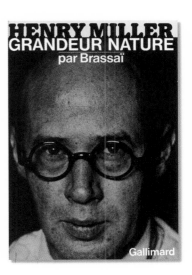

Books by Brassaï

Paris de nuit. Introduction by Paul Morand. Photographs by Brassaï. Paris: Arts et Métiers Graphiques, 1932. French reedition, Paris: Flammarion, 1987. English edition, Paris after Dark: Brassaï, London: Batsford, 1933. German edition, Nachtliches Paris, Munich: Schirmer/Mosel Verlag, 1979. English reedition, London: Thames and Hudson, 1987. American edition, Paris by Night, additional texts by Lawrence Durrell and Henry Miller, New York: Pantheon Books, 1987. Japanese edition, Paris de nuit, Tokyo: Misuzu Shobo, 1987.

Voluptés de Paris. Photographs by Brassaï. Paris: Paris-Publications, 1934. Two editions, identical except one has 38 and the other 46 halftones.

Camera in Paris. Text and photographs by Brassaï. Masters of the Camera Series, edited by A. Kraszna-Krausz. London: The Focal Press, 1949.

Histoire de Marie. Poems by Brassaï. Introduction by Henry Miller. Paris: Éditions du Point du Jour, 1949.

Les Sculptures de Picasso. Text by Daniel-Henry Kahnweiler. Photographs by Brassaï. Paris: Éditions du Chêne, 1949. English edition, The Sculptures of Picasso, London: The Focal Press, 1949.

Brassaï. Includes the texts "L'Oeil de Paris," by Henry Miller, and "Joyeuse Nuit de Noël" and "Souvenirs de mon enfance," by Brassaï. Paris: Éditions Neuf, 1952. Also published in Neuf (Paris), no. 5, special issue devoted to Brassaï (December 1951).

Séville en fête. Preface by Henri de Montherlant. Text by Dominique Aubier. Notes and photographs by Brassaï. Paris: Éditions Neuf, 1954. German edition, Festliches Spanien, Feldafing: Buchheim-Verlag, 1954. English edition, Fiesta in Seville, London: Thames and Hudson, 1956. American edition, New York: The Studio and Thomas Crowell, 1956.

Graffiti. Text and photographs by Brassaï. Stuttgart: Belser Verlag, 1960. French edition, Paris: Éditions du Temps, 1961. French reedited version, preface by Gilberte Brassaï, various excerpts from Brassaï's writings on graffiti, including an unpublished text, "Le Procès des Graffiti," and a poem, Paris: Flammarion, 1993.

Conversations avec Picasso. Text and photographs by Brassaï. Paris: Éditions Gallimard, 1964. French reeditions, 1969, 1987. German edition, Gespräche mit Picasso, Hamburg: Rowolt-Verlag, 1966. Czechoslovakian edition, Rozhovory s Picasso, Bratislav: Tatran, 1966. Spanish edition, Conversaciones con Picasso, Madrid: Aguilar, 1966. American edition, Picasso and Company, preface by Henry Miller, introduction by Roland Penrose, Garden City, New York: Doubleday, 1966. English edition, London: Thames and Hudson, 1967. Hungarian edition, Beszélgetések Picassóval, interview with Brassaï by Gyula Illyés, Budapest: Corvina, 1968. Originally published in Hungarian translation as "Brassaï de vorbà cu Picasso," translated by Radu Varia, Secolul 20 (Bucharest), no. 1 (January 1966): 32-43. Japanese edition, Kataru pikaso, Tokyo: Misuzu Shobo, 1968. Portuguese edition, Conversas com Picasso, Porto: Livravaria Civilizacao, 1971. Romanian edition, Convorbiri cu Picasso, Bucharest: Editura Meridiane, 1975. Polish edition, Warsaw: Panstwowy Instytut Wydawuiczy, 1976. Italian edition, Conversazioni con Picasso, Torino: Umberto Allemandi, [1996]. American reedition, Conversations with Picasso, translated by Jane Marie Todd, preface by Henry Miller, introduction by Pierre Daix, Chicago: University of Chicago Press, 1999. Edition also in Dutch.

Henry Miller grandeur nature. Text and photographs by Brassaï. Paris: Éditions Gallimard, 1975. French reedition, 1997. German edition, Henry Miller Natürliche Grösse, Frankfurt: S. Fischer-Verlag, 1977. Catalan edition, Henry Miller tamano natural, Barcelona: Ediciones del Cotal, 1977. Japanese edition, Tokyo: Misuzu Shobo, 1979. English edition, Henry Miller: The Paris Years, New York: Arcade Publishing, 1995.

Le Paris secret des années 30. Text and photographs by Brassaï. Paris: Éditions Gallimard, 1976. English and American editions, The Secret Paris of the 30s, London: Thames and Hudson; New York: Pantheon Books, 1976. English and American reeditions, 1977, 1983. German edition, Das Geheime Paris: Bilder des dreissiger Jahre, Frankfurt: S. Fischer-Verlag, 1976. Japanese edition, Tokyo: Misuzu Shobo, 1977.

Paroles en l'air. Poems by Brassaï. Paris: Jean-Claude Simoën, 1977.

Henry Miller rocher heureux. Text and photographs by Brassaï. Paris: Éditions Gallimard, 1978. French reedition, 1997. Spanish edition, Henry Miller, duro, solitario y feliz, Barcelona: Ediciones del Cotal, 1979. English-language edition, Chicago: University of Chicago Press, forthcoming.

Elöhívás: Levelek (1920–1940). Text and photographs by Brassaï. Edited with an essay by Andor Horváth. Bucharest: Kriterion Könyvkiadó, 1980. Excerpts of Brassaï's letters originally published in an unedited version as "Fotografálok! Párizsi levelek, 1924–1940," "Fények és fantomok: Párizsi levelek, 1924–1940," "Korda Sándor hajóján: Párizsi levelek, 1924–1940," and "Páriz szeme," A Het (Bucharest), 14, 21, and 28 October and 4 November 1977, respectively; excerpt found on page 8 of each publication. English edition, Brassaï: Letters to My Parents, foreword by Gilberte Brassaï, "Education of a Young Artist," by Anne Wilkes Tucker, Chicago: University of Chicago Press, 1997, sponsored by The Museum of Fine Arts, Houston.

The Artists of My Life. Text and photographs by Brassaï. New York: Viking Press, 1982; London: Thames and Hudson, 1982. American and English reeditions, 1983. French edition, Les Artistes de ma vie, Paris: Denoël, 1982. Japanese edition, Tokyo: Libro Port, 1987.

Marcel Proust sous l'emprise de la photographie. Text and photographs by Brassaï. Paris: Éditions Gallimard, 1997.

Excerpts and Reviews of Books by Brassaï

Excerpts from Paris de nuit (various editions)

"Visages de Paris: La Nuit." L'Intransigeant (Paris), 7 November 1932, 8.

"Paris de nuit." Les Nouvelles Littéraires (Paris), no. 536 (21 January 1933): 1-2.

"Extrait de Paris de Nuit." Photograph by Brassaï. L'Instantané (Paris), February 1933, 30.

Asahi Camera (Tokyo), October 1933, 388-96.

"Paris by Night: Brassaï." Nippon Camera (Tokyo), May 1990, 94-99.

Reviews of Paris de nuit (various editions)

"Visages de Paris: La Nuit." L'Intransigeant (Paris), 7 November 1932, 8.

"Boekaankondigingen: Fransche Letteren." Nieuwe Rotterdamsche Courant, Avonblad (Rotterdam), 29 December 1932, 2.

Finta, Zoltán. "[Paris de nuit]." Brassói Lapók (Brassó), 22 January 1933, 5.

Henriot, Emile. "Photos de Paris." Le Temps (Paris), 30 January 1933, 15.

Bernier, Jean. "Paris de nuit." Vu (Paris), 1 February 1933, 31.

Lévy, René. "Quelques Visions du monde en photographie." Le Monde (Paris), no. 244 (4 February 1933): 6.

Maraï, Sandor. "A Párisi éjszaka [Paris Nights]." Az Ujsag (Budapest), 26 February 1933, page numbers undetermined.

Root, Waverley Lewis. "Brassaï Makes Photo Record of Nocturnal Paris." Chicago Daily Tribune (Paris edition), 13 March 1933, 2.

O., R. "Bibliographie: Livres illustrés." L'Illustration (Paris), no. 4698 (18 March 1933): 18.

- "Paris la nuit." Les Amitiés Franco-Canadiennes (Paris), April 1933, 29.

Vétheuil, Jean. "La Ville photogénique." Photo-Ciné-Graphie (Paris), no. 21 (November 1934): cover, 1-2.

Roche, Denis. "Paris de nuit de Brassaï." Télérama (Paris), no. 1976 (25 November 1987): 18.

Denoyelle, Françoise. "Arts et Métiers Graphiques: Histoires d'images d'une revue de caractères." La Recherche Photographique (Paris), no. 3 (December 1987): 6-17.

Grundberg, Andy. "Photography: Paris by Night." New York Times Book Review, 6 December 1987, 20-21.

Collins, Kathleen. "Photography: Paris by Night." Library Journal (New York) 113 (1 March 1988): 62-63.

Sichel, Kim. "Brassaï Revisited." Views (Boston) 9, no. 4 (summer 1988): 18-19.

Excerpt from Camera in Paris

"[Introduction from Camera in Paris]." Brassaï: Del Surrealismo al informalismo. Exhibition catalogue. Barcelona: Fundació Antoni Tàpies, 1993, 115-19.

Reviews of Camera in Paris

- "Brassaï." Neue Zürcher Zeitung (Zurich), 23 September 1949, page numbers undetermined.

- "Brassaï." Record (London), December 1949, page numbers undetermined.

- "Camera of Paris." Photography (London), December 1949, page numbers undetermined.

"Brassaï, Camera in Paris." New Statesman and Nation (London), 10 December 1949, 709.

Gullers, K. W. "Den Fotografiske Brassaï." Foto (Stockholm), no. 3 (1950): 7-10.

Mannheim, L. Andrew. "Paris Picture-Book." Caméra (Lucerne), no. 2 (February 1950): 90. Published in English, French, and German.

Viola, Wilhelm. "Paris mit der Kamera eingefangen." Der Bund (Bern), no. 152 (31 March 1950): 5.

Excerpts from Histoire de Marie

"Le Procès de Marie." Labyrinthe (Geneva), no. 22-23 (December 1946): 8-9.

"Trois Propos photographies par Brassaï [Marie à Saint-Joseph]." In Anthologie de la poésie naturelle, edited by Camille Bryen and Alain Gheerbrant. Paris: K éditeur, 1949, 120.

"Brassaï: L'Histoire de Marie." Schweizer Journal (Zurich), September – October 1949, 24-25.

Reprint of Histoire de Marie

"Histoire de Marie." In Paroles en l'air. Paris: Jean-Claude Simoën, 1977, 71-150.

Excerpts from Brassaï (Éditions Neuf, 1952)

Nieting, Valentin [Henry Miller]. "L'Oeil de Paris." The Booster (Paris) 2, no. 7 (September 1937): 21-25. Reprinted in The Booster: September 1937 – Easter 1939, New York: Johnson Reprint Corporation; London: Johnson Reprint Company Ltd., 1968, original pagination.

Miller, Henry. "The Eye of Paris," Globe (Milwaukee), November 1937, 45-52.

———. "The Eye of Paris." In Max and the White Phagocytes. Paris: Obelisk Press, 1938, 240-52.

———. "The Eye of Paris." In The Wisdom of the Heart. Norfolk, Connecticut: New Directions Books, 1941, 173-86.

Brassaï. "Amintiri din copilaria mea [Memoirs of My Childhood]," Secolul 20 (Bucharest), no. 8 (August 1966): 157-61.

———. "L'Oeil de Paris." In Brassaï: Foto's uit de museumverzameling. Exhibition catalogue. Antwerp: Museum voor Fotografie, 1988, no pagination.

———. "The Eye of Paris." Partially reprinted in Modern Arts Criticism: A Biographical and Critical Guide to Painters, Sculptors, Photographers and Architects from the Beginning of the Modern Era to the Present, edited by Joann Prosyniuk. vol. 1. Detroit: Gale Research, 1991, 141-43.

Reviews of Brassaï (Éditions Neuf, 1952)

Merester, Guy. "Les photographies de Brassaï aux Éditions Neuf." Combat (Paris), 4 March 1952, 7.

Mallet, Robert. "Brassaï." Le Figaro Littéraire (Paris), no. 307 (8 March 1952): 8.

"Les belles pages." Point de Vue, Images du Monde (Paris), no. 199 (27 March 1952): 35.

Delincé, Robert. "Paris du troisième oeil." Gazette des Lettres (Paris), no. 19 (15 April 1952): 55-57.

S., Ph. "Neuf–No. 5, consacré à Brassaï." Courrier Graphique (Paris), no. 58 (May – June 1952): 74.

"Brassaï." Le Photographe (Paris), 5 July 1952, 262.

Ina, Nobuo. "Brassaï." Asahi Camera (Tokyo), January 1953, 142-43.

Craeybeckx, A. S. H. "Bibliographie." Photorama (Antwerp), no. 11 (November 1953): 327.

Bott, François. "Le Paris nocturne de Brassaï." Le Monde des Livres (Paris), 18 December 1987, 15.

Excerpts from Graffiti (various editions)

"Le Langage du mur." Mercure de France (Paris), no. 1180 (December 1961): 577-81.

"Graffiti." In Les Imaginaires. Paris: Union Générale d'Éditions, 1976, 251-55. Also reprinted in Brassaï: Del Surrealismo al informalismo, exhibition catalogue, Barcelona: Fundació Antoni Tàpies, 1993, 173-74.

"[Introduction by Brassaï from Graffiti]." Espais existencials: La Mirada apassionada de Daniel Cordier. Una Selección de la donación Daniel Cordier al Musée National d'Art Moderne, Centre Georges Pompidou, Paris. Barcelona: Centre Cultural de la Fundacío "La Caixa," 1993, 34-35.

Reviews of Graffiti (various editions)

• Neugass, Fritz. "Graffiti parigini." Photo-Magazin (Milan), no. 7 (July 1959): 24-26.

Schwäbische-Donau-Zeitung (Schwabische Donau), no. 112 (14 May 1960): 25.

"Kratzbilder." Augsburger Allgemeine Litteraturblatt (Augsburg), no. 128 (3 June 1960): 10.

Heissenbüttel, Helmut. "Dokumente unbekannter Hände." Deutsche Zeitung (Cologne), no. 145 (25 – 26 June 1960): 18.

Cogniat, Raymond. "Livres sur l'art: Graffiti." Le Figaro (Paris), 28 December 1961, 9.

Braive, Michel-François. "Les Graffiti de Brassaï et les Nus de Bill Brandt: Deux albums qui sauvent la photo de la banalité." Les Beaux-Arts (Brussels), no. 959 (5 January 1962): 12.

Girod de l'Ain, Bertrand. "Dialogues avec le mur." Le Monde (Paris), no. 5290 (19 January 1962): 8.

Kaneko, Ryuchi. "[Review of Graffiti]." Nippon Camera (Tokyo), November 1983, 127.

Excerpts from Conversations avec Picasso (various editions)

"Picasso parle des Graffiti." In Brassaï: Graffiti. Rome: L'Obelisco, 1962, no pagination.

"Picasso." Harper's Bazaar (New York), no. 3059 (October 1966): 204-5, 274.

"Brassaï: Picassóról [Brassaï Speaks on Picasso]." Translated by Lajos Erdelyi. A Het (Bucharest), 22 October 1971, 9.

Cabanne, Pierre. "Plus vivant que jamais, Picasso: 10 flashes de Brassaï sur Picasso." Lectures pour Tous: Je Sais Tout (Paris), no. 232 (May 1973): 34-37.

"Le Regard de Picasso" and "Picasso et Goethe." Gazette des Beaux-Arts (Paris) 82, no. 1257, special issue on Picasso (October 1973): 229-32.

"[Excerpts from Conversations avec Picasso]." In Dixième Biennale International d'Art de Menton. Exhibition catalogue. Menton: Association Biennale de Menton, 1974.

"Picasso and Company." In Photography in Print: Writings from 1816 to the Present, edited by Vicki Goldberg. New York: Simon and Schuster, 1981, 431.

"Picasso parle des Graffiti." In Graffiti. Paris: Flammarion, 1993, 136-38.

"Paris Post-War: Art and Existentialism, 1945–55." Independent (London), 10 June 1993, 6, and 19 June 1993, 8.

Reviews of Conversations avec Picasso (various editions)

Grenier, Roger. "Brassaï écrivain." Bulletin NRF (Paris), no. 195 (November 1964): inside front cover, 1.

Descargues, Pierre. "Brassaï chez Picasso." Les Lettres Françaises (Paris), 19 – 20 November 1964, 13.

Nourissier, François. "Le Livre de la semaine: Conversations avec Picasso." Les Nouvelles Littéraires (Paris), 26 November 1964, 2.

Revel, Jean-François. "[Review of Conversations avec Picasso]." L'Oeil (Paris), no. 120 (December 1964): 49-50.

Cogniat, Raymond. "Les Arts: Expliquer Picasso." Le Figaro (Paris), no. 6331 (6 January 1965): 9.

Mauriac, Claude. "Picasso écouté et vu par Brassaï." Le Figaro (Paris), no. 6337 (13 January 1965): 20.

Reismann, János. "Beszélgetés Picassóval [Conversations with Picasso]." Tükör (Budapest), 13 June 1965, 18-20.

Bajomi, Lázár Endre. "Brassaï köyve Picassóról [Brassaï on Picasso]." Elet és Irodalom (Budapest), 3 July 1965, 4.

Renoir, Jean. "Gabriel and Lucifer." New York Times Book Review, 20 November 1966, 6-7, 93.

Pollack, Peter. "Eye Witnesses." Book Week (Chicago), 11 December 1966, 4, 13.

Speyer, A. James. "Books Today: A Visit to Paris thru Keen Eyes." Chicago Tribune 120, no. 1 (1 January 1967): sec. 9, p. 5.

Richardson, John. "Picasso at Eighty-five." New York Review of Books 8, no. 6 (6 April 1967): 25-28.

Powell, Anthony. "A Successful Boswell to Picasso." Daily Telegraph (London), 4 May 1967, 22.

Hays, Jill. "Books in Review." U. S. Camera (New York) 30, no. 7 (July 1967): 78.

▪ "The Book Shelf: A Book about Picasso." Wall Street Journal (New York), December 1967, page numbers undetermined.

Hall, Douglas. "[Review of Picasso and Company]." Apollo (London) 89, no. 87 (May 1969): 404-5.

Reviews of Henry Miller: The Paris Years

"[Review of Henry Miller: The Paris Years]." Publishers Weekly (Riverton, New Jersey), 18 September 1995, 120.

Braun, Janice. "Literature: Henry Miller: The Paris Years." Library Journal (New York) 20 (15 October 1995): 61

Green, Michelle. "Ghost at the Banquet: Brassaï Remembers Henry Miller's Nine-Year Sojourn in Paris." New York Times, 26 November 1995, sec. 7, p. 33, col. 1.

Bisbort, Alan. "The Quintessential American Writer in Paris." Advocate (Hartford, Connecticut), 14 March 1996, 22.

Excerpts from Le Paris secret des années 30 (various editions)

Kramer, Hilton. "Brassaï: The High Art of Photographing Low-Life in Paris." New York Times, 19 September 1976, sec. 2, pp. 1, 34.

Huser, France. "Les Minuits de Brassaï." Le Nouvel Observateur (Paris), no. 624 (25 October 1976): 104-5.

"[Excerpt from The Secret Paris of the 30s]." Camera Mainichi (Tokyo), April 1978, 101-8.

"Brassaï: Secret Paris of the 1930s." Camera 35 (New York) 24, no. 3 (March 1979): 60-69, 74.

"Latent Images: La Môme Bijou." American Photographer (New York) 2, no. 5 (May 1979): 14.

"[Excerpt from preface of The Secret Paris of the 30s]." In Modern Arts Criticism: A Biographical and Critical Guide to Painters, Sculptors, Photographers and Architects from the Beginning of the Modern Era to the Present, edited by Joann Prosyniuk. vol. 1. Detroit: Gale Research, 1991, 139-41.

Reviews of Le Paris secret des années 30 (various editions)

Sapin, Louis. "Le Paris interdit des années 30." Paris-Match (Paris), October 1976, 62-65, 67-70.

"Paris by Night Captured by One of France's Greatest Photographers." New York Times Book Review, 24 October 1976, 2.

Blume, Mary. "Brassaï's Secret Paris: Incisive, Funny, Humane." International Herald Tribune (Paris), 23 – 24 October 1976, 14.

Bunnell, Peter C. "The Secret Paris of the 30s." New Republic (Washington, D. C.) 175, no. 19, iss. 3226 (6 November 1976): 24-25.

"Strangers in the Night." Sunday Times Magazine (London), 14 November 1976, 48-61.

▪ Czartoryska, Ursula. "Kronika: Brassaï, wystawa nocnego Paryza lat 30-tych." Fotografia (Warsaw), no. 2 (1977): 51.

▪ S., K. "Khiny." Revue Fotografie (Prague) 21, no. 2 (1977): 78.

"Brassaï: Paris Secret 1930." Photo (Paris), no. 112 (January 1977): 22-33, 78-79.

Leroy, Jean. "Bibliographie Photographique: Brassaï, Paris des années 30." Photo Revue (Paris), January 1977, 46.

"Nouvelles de la photographie." L'Oeil (Paris), no. 258-59 (January – February 1977): 56.

▪ Steinberg, Cobbett. "[Secret Paris 30]." San Francisco Review of Books, February 1977, page numbers undetermined.

▪ "The Secret Paris of the 30s." Photo World (New York), no. 6 (February – March 1977): 74-89.

Voyeux, Martine. "Livres." Zoom (Paris), no. 43 (February/March 1977): 19.

Heron, Liz. "The Real Paris of the Thirties?" Camerawork (London), no. 7 (July 1977): 4-5.

"Brassaï, dans son 'sac à malices': Les portraits inédits de ses amis artistes des années 1930." Photo (Paris), no. 150 (March 1980): 40-47.

Yokoe, Fuminori. "The Secret Paris of the 30s." Camera Mainichi (Tokyo), June 1982, 186-87.

Excerpts from Paroles en l'air

"Zinc en Bois." Arts (Paris), 17 November 1954, 1, 6.

"Le Chauffeur de taxi." Les Lettres Nouvelles (Paris) 4, no. 34 (January 1956): 19-25.

"[Excerpt from Paroles en l'air]." In Brassaï: Del Surrealismo al informalismo. Exhibition catalogue. Barcelona: Fundació Antoni Tàpies, 1993, 153-55.

Reviews of Elöhívás: Levelek (1920–1940) (various editions)

"[Review of Brassaï: Letters to My Parents]." Kirkus Reviews, 1 July 1997.

Hartley, Christine Schwartz. "Dear Mom and Dad: I Love Paris." New York Times Book Review, 28 September 1997, sec. 7, p. 23, col. 4.

Coleman, A. D. "Visual Literacy." Photography in New York International (New York), November – December 1997. Partially reprinted as "Letter from New York, No. 82," Photo Metro (San Francisco) 16, no. 148 (1998): 26-27.

Hamilton, Peter. "The Eye of Paris." Times Literary Supplement (London), no. 4941 (12 December 1997): 36.

Jaeger, Karena. "Brassaï's Letters Offer Little on Photography." Columbus Dispatch (Columbus, Ohio) 127, no. 174 (21 December 1997): 7H.

Pinsent, Richard. "Brassaï: Self-Portrait of the Artist as a Young Man." Art Newspaper (London), 1 January 1998, 20.

"Books in Brief." On Paper: The Journal of Prints, Drawings, and Photographs (New York) 2, no. 4 (March – April 1998): 63.

Reynolds, Siân. "Bohemian Nights." Times Higher Education Supplement (London), no. 1, 327 (10 April 1998): 23.

Weales, Gerald. "Becoming Brassaï." Threepenny Review (Berkeley, California), spring 1998, 21-22.

Excerpt from The Artists of My Life

"Portrait of the Artist." Camera Arts (New York), November 1982, 102.

Reviews of The Artists of My Life (various editions)

Blume, Mary. "Brassaï, among Friends." International Herald Tribune (Paris), no. 31008 (29 October 1982): 7W.

Guibert, Hervé. "Les Artistes de ma vie par Brassaï: Carnet de rendez-vous." Le Monde (Paris), 2 December 1982, 17.

Nuridsany, Michel. "Brassaï, photographe et écrivain." Le Figaro (Paris), 17 December 1982, 25.

Galassi, Susan Grace. "Camera Versus Easel." Nation (New York), 18 December 1982, 662-63.

"[Review of The Artists of My Life]." Choice (Middletown, Connecticut) 20, no. 8 (April 1983): 1120.

Bedient, Calvin. "Photos, Texts and Photo-texts." Art in America (New York) 71, no. 5 (May 1983): 17-21.

Berman, Avis. "Day Labors." Art News (New York) 82, no. 6 (summer 1983): 28.

Reviews of Marcel Proust sous l'emprise de la photographie

Lançon, Phillipe. "La Recherche en chambre noire." Libération (Paris) 2, no. 5115 (30 October 1997): Livres section, 1-3.

Webster, Paul. "Negative Origins in Marcel Proust: A New Study Sees the Camera as Vital to the Writer's Private Life, Literary Invention and Descriptive Technique." Manchester Guardian (London), 17 November 1997, sec. 1, p. 20, col. 7.

Chevrier, Jean-François. "Brassaï à l'écrit." Le Monde des Livres (Paris), 21 November 1997, 1.

Durand, Dominique. "Jours tranquilles à clicher." Le Canard enchainé (Paris), 3 December 1997, 6.

Daix, Pierre. "Brassaï: La Mémoire d'un oeil." Le Figaro Littéraire (Paris), no. 16580 (4 December 1997): 8 [42].

Hughes, Edward. "Proust's Poses." Times Literary Supplement (London), no. 4961 (1 May 1998): 71.

Portfolios by Brassaï

Trente dessins. Drawings by Brassaï. Poem by Jacques Prévert. Paris: Éditions Pierre Tisné, 1946.

Transmutations. Text and portfolio by Brassaï, 1934–35. Lacoste, France: Galerie les Contards, 1967.

A Portfolio of Ten Photographs by Brassaï. Texts by A. D. Coleman and Brassaï. New York: Witkin-Berley Limited, 1973.

Reproductions from Transmutations

"Transmutations." Album (London), no. 8 (September 1970): 24-28.

"Transmutations." In Brassaï: Del Surrealismo al informalismo. Exhibition catalogue. Barcelona: Fundació Antoni Tàpies, 1993, 201-9.

Review of A Portfolio of Ten Photographs by Brassaï

"Portfolio: Brassaï." Photo World (New York), December 1973, 14-16, 106ff.

Stage sets by Brassaï

Le Rendez-vous [three-act ballet]. Artistic direction by Boris Kochno. Ballet by Jacques Prévert. Music by Joseph Kosma. Curtain by Picasso. Costumes by Mayo. Choreography by Roland Petit. Stage sets: Act I, photographic montage of Bal-musette, Bec du gaz, Hôtel de la Belle Étoile; Act II, Pilier de Métro; Act III, Pont de Crimée. Théâtre Sarah Bernhardt, 15 June 1945. Performed throughout the world in the 1940s and again restaged 11 – 15 and 17 – 18 March 1992. Performances by the Ballet de l'Opéra de Paris as one of three ballets produced in the series "Picasso et la Danse," Edmon Colomor, conductor.

En Passant [one-act play]. Play by Raymond Quéneau. Théâtre Agnès Capri, 1947.

D'Amour et d'eau fraîche [also known as Le Réparateur de Radios]. Play by Elsa Triolet. Music by Jean Rivier. Costumes and sets by Brassaï. Choreography by Jean Taras. Ballets des Champs-Elysées, 1949.

Phèdre [three-act ballet]. Ballet by Jean Cocteau. Music by Georges Auric. Choreography by Serge Lifar. Opéra de Paris, 1950.

Reproductions from Le Rendez-vous

Fragment of the poem "Le Rendez-vous," by Jacques Prévert. Preface by Jean Cocteau. Photographs, including Pilier de Métro, by Brassaï. In Soirée de ballets. Paris: Les Éditions du Chêne, 1945.

"Ballet." Scenes from Le Rendez-vous (with stage sets in background) photographed by Brassaï. Harper's Bazaar (New York), no. 2805 (September 1945): 136-37.

Review of stage sets for Le Rendez-vous

- "Bühnenbilder aus Grossfotos." Bauzeitschrift (Saarbrücken), no. 2 (1949): page numbers undetermined.

Film by Brassaï

- Tant qu'il y aura des bêtes [originally known as Divertissement]. 16mm, 21 min. Directed by Brassaï. Produced by Société Franco-Britannique des Films et Télévision, Paris, 1955; English version, Lovers and Clowns, 10 min., 1957.

Review and article about Tant qu'il y aura des bêtes

"Tant qu'il y aura des bêtes." Text by Brassaï. Arts: Beaux-Arts, Littérature, Spectacles (Paris), no. 566 (2 – 8 May 1956): 5.

- "Brassaï Makes a Movie." Popular Photography (New York), April 1957, 84-85, 184-85.

Periodicals that published Brassaï's work

Most articles with only one photograph are not otherwise listed in this bibliography.

Adam (Paris), Art et Médicine (Paris), Arts et Métiers Graphiques (Paris), Bifur (Paris), Caliban (Paris), Cavalcade (Paris), Coiffure de Paris (Paris), Coronet Magazine (Chicago), Détective (Paris), Fémina-Illustration (Paris), Foto-Dienst (Mortsel-Antwerp), Fotorama (Mortsel-Antwerp), France-Illustration (Paris), Harper's Bazaar (New York), Illustrated London News (London), Illustration (Paris), Images du Monde (Paris), L'Instantané (Paris), L'Intransigeant (Paris), Jardin des Modes (Paris), Kodéco (Paris), Labyrinthe (Geneva), Lilliput Magazine (London), Marianne (Paris), Mieux Vivre (Paris), Le Minotaure (Paris), The New Review (Paris), Paris-Magazine (Paris), Paris-Soir (Paris), Photo-Ciné (Paris), Photo-Ciné-Graphie (Paris), Photographie (Paris), Photo-Illustration (Paris), Picture Post (London), Plaisir de France (Paris), Point de Vue (Paris), Pour Lire à Deux (Paris), Quadrige (Paris), Réalités (Paris; London), Regards (Paris), Revue de la Photographie (Paris), Scandale: Revue des Affaires Criminelles (Paris), Sphère (Paris), Sur (Buenos Aires), Votre Beauté (Paris), Verve (Paris), Vu (Paris), Voilà (Paris), Weekly Illustrated (London).

Articles with drawings by Brassaï

"La Vie de Bohème (As Lived on the Left Bank)." Text by Wambly Bald. Drawing by Brassaï. Chicago Daily Tribune (Paris edition), 14 October 1931, 4. Reprinted in My Friend Henry Miller, by Alfred Perlès, London: Neville Spearman, 1955, between pages 52 and 53.

"Begegnung mit Brassaï." Text by René Gröbli. Schweizer Journal (Zurich), September – October 1949, 18-23.

Articles by Brassaï and/or illustrated with photographs by Brassaï

"40 Jahre Eiffelturm." Text by Brassaï. Photographs by André Kertész. Münchner Illustrierte Presse (Munich), no. 19 (12 May 1929): 637. Published in a longer French version as "La Tour a quarante ans," text by Jean d'Erleich [Brassaï], photographs by André Kertész, Vu (Paris), no. 63 (29 May 1929): 431-33.

- "Das deutsche Paris." Text by Brassaï. Photographs by André Kertész. Die Wochenschau (Essen), 1930, page numbers undetermined.

"Die Technik in der Kirche." Text by Brassaï. Photographs by André Kertész. Das Illustrierte Blatt (Frankfurt), no. 12 (27 March 1930): 324.

"Das Heilsarmee-Schiff auf der Seine." Text by Brassaï. Photographs by André Kertész. Münchner Illustrierte Presse (Munich), no. 25 (22 June 1930): 863.

"Kennen-Sie schon Moochi und Broadway?" Text by Brassaï. Photographs by André Kertész. Das Illustrierte Blatt (Frankfurt), no. 27 (9 July 1930): 770.

"Wochenend auf Bäumen." Text by Brassaï. Photographs by André Kertész. Kölnische Illustrierte Zeitung (Cologne), no. 31 (2 August 1930): 949.

"Mr. Molier und sein Privatzirkus." Text by Brassaï. Photographs by André Kertész. Kölnische Illustrierte Zeitung (Cologne), no. 20 (16 May 1931): 580.

"L'Amour à travers les livres." Text by Léon Treich. Photograph by Brassaï. Paris-Magazine (Paris), no. 11 (July 1932): 378-79.

"Un Homme tombe dans la rue." Photographs by Brassaï. Text by Fanny Clar. Vu (Paris), no. 228 (27 July 1932): 1222-23. Also published as "An Everyday Tragedy," text by Stefan Lorant, Picture Post (London) 1, no. 5 (29 October 1938): 29-31, and as "Un Homme meurt dans la rue," Labyrinthe (Geneva), no. 20 (1 June 1946): 16. Labyrinthe version reprinted in Brassaï: Del Surrealismo al informalismo, exhibition catalogue, Barcelona: Fundació Antoni Tàpies, 1993, 18.

"Les Froleurs." Text by Jacques de Brussey. Photographs by Brassaï. Paris-Magazine (Paris), October 1932, 528-31.

"Images latentes." Text by Brassaï. L'Intransigeant (Paris), 15 November 1932, 6. Reprinted in Brassaï: Del Surrealismo al informalismo, exhibition catalogue, Barcelona: Fundació Antoni Tàpies, 1993, 63.

"Technique de la photographie de nuit." Texts and photographs by Brassaï. Arts et Métiers Graphiques (Paris), no. 33 (15 January 1933): 24-27. Also published in Photo-Ciné-Graphie (Paris), January 1934, 2-5. Reprinted in Brassaï: Del Surrealismo al informalismo, Barcelona: Fundació Antoni Tàpies, 1993, 91-92.

"Picasso dans son élément." Text by André Breton. Photographs by Brassaï. Le Minotaure (Paris), no. 1 (15 February 1933): 9-29.

"Variété du corps humain." Text by Maurice Raynal. Photographs by Brassaï and Man Ray. Le Minotaure (Paris), no. 1 (15 February 1933): 41-45.

"Un Pur." Text by Fernand Pouey. Photographs by Brassaï. Paris-Magazine (Paris), April 1933, 209-12.

• "Tableaux en liberté." Text by Georges Ribemont-Dessaignes. Photograph by Brassaï. L'Intransigeant (Paris), 10 April 1933, page numbers undetermined.

"Fleurs domestiques et fleurs sauvages." Text by Maurice Raynal and E. [Efstratios Elefteriades] Tériade. Photograph by Brassaï. L'Intransigeant (Paris), 9 May 1933, 44-45.

"Paris la nuit II: Les Guetteurs de la cité." Text by Marius Larique. Photographs by Brassaï and others. Voilà (Paris), no. 112 (13 May 1933): 8-9.

————. "Paris la nuit IV: Les Travailleurs de la nuit." Photographs by Brassaï and others. Voilà (Paris), no. 114 (27 May 1933): 12-13.

"L'Art et le reste." Text by Roger Vitrac. Photographs by Brassaï. Beaux-Arts (Paris), no. 48 (1 December 1933): 7.

"Du Mur des cavernes au mur d'usine." Text and photographs by Brassaï. Le Minotaure (Paris), no. 3-4 (12 December 1933): 6-7. Reprinted in Graffiti. Paris: Flammarion, 1993, 139.

"Dieu, table, cuvette." Text by Maurice Raynal. Photographs by Brassaï and Brancusi. Le Minotaure (Paris), no. 3-4 (12 December 1933): 39-53.

"Sculptures involontaires." Photographs and text by Brassaï in collaboration with Salvador Dalí. Le Minotaure (Paris), no. 3-4 (12 December 1933): 68. Reprinted in Brassaï: Paris le jour, Paris la nuit, exhibition catalogue, Paris: Musée Carnavalet, 1988, 15, and in Brassaï: Del Surrealismo al informalismo, exhibition catalogue, Barcelona: Fundació Antoni Tàpies, 1993, 72.

"De la Beauté terrifiante et comestible, de l'architecture modern style." Text by Salvador Dalí. Photographs of Barcelona by Man Ray. Photographs of Paris by Brassaï. Le Minotaure (Paris), no. 3-4 (12 December 1933): 69-76.

"Le Phénomène de l'extase." Text by Salvador Dalí. Photographs by Brassaï. Le Minotaure (Paris), no. 3-4 (12 December 1933): 76-77.

"[Response to André Breton's and Paul Éluard's 'Enquête', below]." Text by Brassaï. Le Minotaure (Paris), no. 3-4 (12 December 1933): 101-2, 105.

"Les Coulisses du Music-Hall." Text by Guy Dornand. Photographs by Brassaï and others. Paris-Magazine (Paris), no. 29 (January 1934): 42-48.

"La Beauté sera convulsive." Text by André Breton. Photographs by Man Ray and Brassaï. Le Minotaure (Paris), no. 5 (12 May 1934): 9-16.

"Midnight in Paris." Photographs by Brassaï. Weekly Illustrated (London), 1 December 1934, 14-15. Reprinted in Time-Life Books, eds., Photojournalism, New York: Time-Life Books, 1971, 61.

"Ciel postiche." Photograph by Brassaï. Le Minotaure (Paris), no. 6 (winter [5 December] 1934): 5.

"Souvenirs sur Cézanne." Text by Ambroise Vollard. Photographs by Brassaï. Le Minotaure (Paris), no. 6 (winter [5 December] 1934): 13-16.

"Pigeondre." Text by Léon-Paul Fargue. Photograph by Brassaï. Le Minotaure (Paris), no. 6 (winter [5 December] 1934): 29.

"Apparitions aérodynamiques 'Étres-Objets.'" Text by Salvador Dalí. Photograph by Brassaï. Le Minotaure (Paris), no. 6 (winter [5 December] 1934): 33-34.

"Ce soir." Text by Louise de Vilmorin. Photograph by Brassaï. Le Minotaure (Paris), no. 6 (winter [5 December] 1934): 51.

"Grand Fête de la mode 1934–1935." Photographs by Brassaï. La Coiffure de Paris (Paris), no. 299 (January 1935): 22-27.

"Le Jour est trop court." Text by Young. Photographs by Brassaï. Le Minotaure (Paris), no. 7 (10 June 1935): 22-29.

"Il n'est pas encore trop tard. . . ." Text by Young. Photographs by Brassaï. Le Minotaure (Paris), no. 7 (10 June 1935): 30-31.

"Paris a sept collines aussi, où sont-elles dans la nuit?" Photographs by Brassaï. Le Minotaure (Paris), no. 7 (10 June 1935): 70-71.

"Ravitailleurs de Paris." Text by Madeleine Jacob. Photographs by Brassaï. Vu (Paris), special issue (30 November 1935): 47-49.

"Le Point de vue de la nature." Text by E. [Efstratios Elefteriades] Tériade. Photographs by Brassaï. Arts et Métiers Graphiques (Paris), no. 54 (15 August 1936): 33-36.

"Troglodyte." Photograph by Brassaï. Le Minotaure (Paris), no. 9 (15 October 1936): frontispiece.

"Une Enquête sur la prostitution." Text by Lydia Lambert. Photographs by Brassaï. Regards (Paris), no. 155 (31 December 1936): 8-9.

"Les Petits Rats of the Paris Opera." Unsigned text. Photographs by Brassaï. Harper's Bazaar (New York), no. 2698 (August 1937): 68-69, 114.

"La Symphonie de l'eau et du feu." Text by René Roy. Photographs by Brassaï. Regards (Paris), no. 187 (12 August 1937): 8-9.

"Woman and the Sculptor." Unsigned text. Photographs by Brassaï. Harper's Bazaar (New York), no. 2701 (October 1937): 116-17, 130.

"Henri Matisse's Aviary in His Paris Studio." Photographs by Brassaï. Verve (Paris) 1, no. 1 (December 1937): 13-15.

"Psychologie de l'art." Text by André Malraux. Photographs by Brassaï and others. Verve (Paris) 1, no. 1 (December 1937): 41-64.

"Aristide Maillol, Marley-le-Roi, 1937." Photographs by Brassaï and Erwin Blumenfeld. Verve (Paris) 1, no. 1 (December 1937): 89-104.

"Cathedrals." Photographs by Brassaï. Coronet (Chicago) 3, no. 2 (1 December 1937): 111-19.

"Talking Pictures." Text by B. Gingrich. Photographs by Brassaï. Coronet (Chicago) 3, no. 2 (1 December 1937): 119-27.

"L'Homme qui perd son ombre." Text by Paul Recht. Photograph by Brassaï. Le Minotaure (Paris), no. 11 (spring [15 May] 1938): 66-67 [misnumbered].

"Photographs." Photographs by Brassaï and others. Verve (Paris) 1, no. 2 (spring [March – June] 1938): 105-10.

"Paris by Night." Photographs by Brassaï. Lilliput (London) 3, no. 92 (August 1938): 35-42.

"Night Workers." Photographs by Brassaï. Coronet (Chicago), September 1938, 147-52.

"Fatigue." Photographs by Brassaï. Coronet (Chicago), October 1938, 147-52.

"The Rothchilds [sic] Give a Party." Unsigned text. Photographs by Brassaï. Picture Post (London) 1, no. 10 (3 December 1938): 48-52.

"The Hunt." Photographs by Brassaï. Verve (Paris) 1, no. 4 (fall 1938): 45-47.

"Paris by Night." Photographs by Brassaï. Picture Post (London) 2, no. 3 (21 January 1939): 20-27.

"Love Locked In." Photographs by Brassaï. Picture Post (London) 2, no. 3 (21 January 1939): 32-34.

"King of the Hair-dressers." Text by Antonia White. Photographs by Brassaï. Picture Post (London) 2, no. 10 (11 March 1939): 30-34.

"Painters of Paris." Unsigned text. Photographs by Brassaï. Picture Post (London) 2, no. 13 (1 April 1939): 23-29.

"L'Atelier d'Aristide Maillol." Photograph by Brassaï. Verve (Paris) 2, no. 5-6 ([July – October] 1939): 121.

"Midnight Fête at Longchamp." Text by E. H. Tattersall. Photographs by Brassaï. Picture Post (London) 4, no. 4 (29 July 1939): 26-29.

"A Letter from the Sea." Photographs by Brassaï. Picture Post (London) 4, no. 7 (19 August 1939): 58-59.

"Blackout in Paris." Photographs by Brassaï. Lilliput (London) 6, no. 6 (June 1940): 509-16.

"L'Enfer de Dante retrouvé aux Baux." Photographs by Brassaï. Labyrinthe (Geneva), no. 6 (15 March 1945): 3.

"Saint-Germain-des-Prés." Text by Ch.-A. Cringria. Photographs by Brassaï. Labyrinthe (Geneva), no. 8 (15 May 1945): 1.

"Les Poupées lucides." Text by Claude Aubert. Photograph by Brassaï. Labyrinthe (Geneva), no. 8 (15 May 1945): 4-5.

"Le Peintre et son modèle." Text by Pierre Courthion. Photographs by Brassaï. Labyrinthe (Geneva), no. 8 (15 May 1945): 6-7.

"La Tourterelle et la poupée." Photographs and text by Brassaï. Labyrinthe (Geneva), no. 8 (15 May 1945): 9. Reprinted in Brassaï: Del Surrealismo al informalismo, exhibition catalogue, Barcelona: Fundació Antoni Tàpies, 1993, 147.

"Je ne cherche pas, je trouve." Text by Jacques Mercanton. Photographs by Brassaï. Labyrinthe (Geneva), no. 9 (15 June 1945): 1-3.

"Les Caves de Saint-Sulpice." Text by Louis Chéronnet. Photographs by Brassaï. Quadrige (Paris), no. 3 (October 1945): 23-27.

"L'Agonie des anges." Photographs and text by Brassaï. Labyrinthe (Geneva), no. 13 (15 October 1945): 8-9.

"Le Sommeil." Photographs and text by Brassaï. Labyrinthe (Geneva), no. 14 (15 November 1945): 11. Reprinted in Brassaï: Del Surrealismo al informalismo, exhibition catalogue, Barcelona: Fundació Antoni Tàpies, 1993, 141.

"Paris Underground." Photographs by Brassaï. Harper's Bazaar (New York), December 1945, 84-87.

"La Vraie folle de Chaillot." Text by D. Photograph by Brassaï. Point de Vue (Paris), no. 42 (3 January 1946): 15.

"Picasso." Photographs by Brassaï. Harper's Bazaar (New York), no. 2810 (February 1946): 132-35.

"Braque." Photographs by Brassaï. Harper's Bazaar (New York), no. 2811 (March 1946): 156-57.

"Exorcisme ou prophètie?" Text by Pierre Emmanuel. Photograph by Brassaï. Labyrinthe (Geneva), no. 18 (1 April 1946): 8.

"Le Don indien: Sur La Côte nord-ouest de l'Amerique (Colombie Britannique)." Text by Georges Duthuit. Photograph by Brassaï. Labyrinthe (Geneva), no. 18 (1 April 1946): 9.

"Chants des habitants de la Côte." Text by Lindsay Skinner, translated by Georges Duthuit. Photographs by Brassaï and others. Labyrinthe (Geneva), no. 18 (1 April 1946): 10-11.

"La Toilette." Photographs by Brassaï. Labyrinthe (Geneva), no. 19 (1 May 1946): 1. Reprinted in Brassaï: Del Surrealismo al informalismo, exhibition catalogue, Barcelona: Fundació Antoni Tàpies, 1993, 43.

"Un Poème de Prévert/Un Dessin de Brassaï." Labyrinthe (Geneva), no. 19 (1 May 1946): 9. Reprinted in Brassaï: Del Surrealismo al informalismo, exhibition catalogue, Barcelona: Fundació Antoni Tàpies, 1993, 42.

"Les Chats de Paris." Text by Collete. Photographs by Brassaï. Harper's Bazaar (New York), no. 2814 (June 1946): 90-93.

"Paris Puts on a Season." Photographs by Brassaï. Harper's Bazaar (New York), no. 2817 (September 1946): 222-23.

"Essence of Grasse." Text by Colette de Jouvenel. Photographs by Brassaï. Harper's Bazaar (New York), no. 2818 (October 1946): 282-83, 384, 389-91.

"Le Procès de Marie." Poems and photograph by Brassaï. Labyrinthe (Geneva), no. 22-23 (December 1946): 8-9. Reprinted in Histoire de Marie, poems by Brassaï, introduction by Henry Miller, Paris: Éditions du Point du Jour, 1949.

"A Sermon in Stone." Unsigned text. Photographs by Brassaï. Lilliput (London), April 1947, 85-91.

"The Shop-Keeper's Cat." Unsigned text. Photographs by Brassaï. Lilliput (London), June 1947, 92-97.

"Bonnard." Photographs and text by Brassaï. Harper's Bazaar (New York), no. 2828 (August 1947): 146, 151.

"Le Jardin de Bonnard au Cannet." Photograph by Brassaï. Verve (Paris) 5, no. 17-18 (August 1947): no pagination.

"The Chateau of Anet." Text by Denise Bourdet. Photographs by Brassaï. Harper's Bazaar (New York), no. 2829 (September 1947): 200-203.

"High in the Alps a Dominican Father Has Realized His Dream. . . ." Text by M. A. Courturier. Photographs by Brassaï. Harper's Bazaar (New York), no. 2832 (December 1947): 120-23.

"Giacometti." Unsigned text. Photographs by Brassaï. Harper's Bazaar (New York), no. 2833 (January 1948): 110-13.

"Tihanyi Lajos, 1885–1938." Text by Brassaï. Magyar Szemle (Paris), 13 June 1948, 2.

"Morris Graves at Chartres." Photographs by Brassaï. Harper's Bazaar (New York), no. 2846 (February 1949): 134-35.

"Provence." Unsigned text. Photographs by Brassaï and Willi Maywald. Harper's Bazaar (New York), no. 2850 (June 1949): 58-63.

"Maxim's." Text by George Davis. Photographs by Brassaï and others. Harper's Bazaar (New York), no. 2851 (July 1949): 58-63.

[Special Brassaï issue]. Photographs by Brassaï. Formes: Le Magazine des Artistes Peintres et Sculpteurs (Paris), no. 1 (1950).

"The Grottos of Versailles." Photographs by Brassaï. Harper's Bazaar (New York), no. 2860 (15 March 1950): 36-37.

"Adieu, Frou-Frou." Unsigned text. Photographs by Brassaï. Harper's Bazaar (New York), no. 2860 (15 March 1950): 58-60.

"The Feria in Seville." Text by Sacheverell Sitwell. Photographs by Brassaï. Harper's Bazaar (New York), no. 2864 (July 1950): 34-39.

"Sur le Pont d'Avignon." Text by David Piper. Photographs by Brassaï. Lilliput (London), September 1950, 70-79.

"The Gastronomic Fair at Dijon." Photographs by Brassaï. Harper's Bazaar (New York), no. 2871 (February 1951): 146-49.

"Women of Mercy." Photographs by Brassaï. Harper's Bazaar (New York), no. 2876 (July 1951): 62-65.

"The Photographs of Brassaï." Photographs by Brassaï. Harper's Bazaar (New York), no. 2880 (November 1951): 124-25.

"The Lamb at Midnight." Photographs by Brassaï. Harper's Bazaar (New York), no. 2881 (December 1951): 80-81.

"Roualt's Miserere." Text by Monroe Wheeler. Photographs by Brassaï. Harper's Bazaar (New York), no. 2881 (December 1951): 82-83.

"The Medieval Skyscrapers of San Gimignano." Unsigned text. Photographs by Brassaï. Harper's Bazaar (New York), no. 2892 (November 1952): 120-23.

"Works of Faith." Text by Gouverneur Paulding. Photographs by Brassaï. Harper's Bazaar (New York), no. 2893 (December 1952): 84-87.

"The Mammoth Figures of Bomarzo." Unsigned text. Photographs by Brassaï. Harper's Bazaar (New York), no. 2894 (January 1953): 70-73.

"Les Problèmes de la distribution en France: Fruits et légumes." Text by René Cercler. Photographs by Brassaï. Rapports France-Etats-Unis, no. 70 (January 1953): cover, 34-45.

"Selection from Brassaï (1)." Photographs by Brassaï. Asahi Camera (Tokyo), January 1953, 9-15.

"Selection from Brassaï (2)." Photographs by Brassaï. Asahi Camera (Tokyo), February 1953, 9-15.

"Selection from Brassaï (3)." Photographs by Brassaï. Asahi Camera (Tokyo), July 1953, 11-16.

"Walls of Paris." Unsigned text. Photographs by Brassaï. Harper's Bazaar (New York), no. 2900 (July 1953): 42-45.

"Brassaï." Text by P. Sonthonnax. Photographs by Brassaï. Photo-Monde (Paris), no. 27 (July – August 1953): 20-29. Also published in no. 28 (September 1953): 27, 33.

"Le Corbusier's Radiant City near Marseilles." Text by Peter Blake. Photographs by Brassaï. Harper's Bazaar (New York), no. 2901 (August 1953): 98-101.

"Istanbul on the Golden Horn." Unsigned text. Photographs by Brassaï. Harper's Bazaar (New York), no. 2902 (September 1953): 170-73, 259.

"Germaine Richier: A Great Woman Sculptor." Text by C.S.T. Photographs by Brassaï. Harper's Bazaar (New York), no. 2903 (October 1953): 178-81.

"Château Mouton Rothschild." Text by Philippe de Rothschild. Photographs by Brassaï. Harper's Bazaar (New York), no. 2906 (January 1954): 126-29, 163.

"The Young Guard: Painters in Paris." Text by James Johnson Sweeney. Photographs by Brassaï. Harper's Bazaar (New York), no. 2907 (February 1954): 106-11, 170.

"Henri Laurens: A Personal Tribute by Tériade." Text by E. [Efstratios Elefteriades] Tériade. Photographs by Brassaï. Harper's Bazaar (New York), no. 2913 (August 1954): 114-15.

"Majorca: The Fortunate Island." Text by Robert Graves. Photographs by Brassaï. Harper's Bazaar (New York), no. 2914 (September 1954): 184-89, 272.

"Edgar Varèse ou la musique sidérale." Text by Brassaï. Arts (Paris), 8 – 14 December 1954, 4.

"The Carvings of Rothéneuf." Unsigned text. Photographs by Brassaï. Harper's Bazaar (New York), no. 2918 (January 1955): 112-15.

"The Bigoudens of Brittany." Photographs by Brassaï. Harper's Bazaar (New York), no. 2920 (March 1955): 170-73.

"Giants of Catalonia." Photographs by Brassaï. Harper's Bazaar (New York), no. 2930 (January 1956): 116-19.

"Spain: Dalí's Villa on the Costa Brava." Photographs by Brassaï. Harper's Bazaar (New York), no. 2931 (February 1956): 118-21.

"Monaco: Fantasia Revisited." Photographs by Brassaï. Harper's Bazaar (New York), no. 2934 (May 1956): 84-89.

"The World of Sherry." Text by Alexis Lichine. Photographs by Brassaï. Harper's Bazaar (New York), no. 2941 (December 1956): 90-93, 151.

"Bernard Buffet: Man with the Golden Arm." Unsigned text. Photographs by Brassaï. Harper's Bazaar (New York), no. 2941 (December 1956): 108-11.

"Language of the Wall." Introduction by Edward Steichen. Photographs and texts by Brassaï. U. S. Camera (New York), 1957. Reprinted in U. S. Camera 1958, New York: U. S. Camera Publishing Co., 1957, 6-15, 290, 294. Brassaï's text published in a different translation as "The Art of the Wall," in The Saturday Book, edited by John Hadfield, vol. 18, London: Hutchinson & Co., Ltd., 1958, 236-49. "The Art of the Wall" partially reprinted in Modern Arts Criticism: A Biographical and Critical Guide to Painters, Sculptors, Photographers and Architects from the Beginning of the Modern Era to the Present, edited by Joann Prosyniuk, vol. 1, Detroit: Gale Research, 1991, 138-39.

"Norman Abstract." Photographs by Brassaï. Harper's Bazaar (New York), no. 2947 (June 1957): 74-77.

"Language of the Wall." Photographs by Brassaï. Camera Mainichi (Tokyo), no. 9 (September 1957): 23-27.

"Graffiti parisiens." Photographs and text by Brassaï. XXe Siècle (Paris), no. 10, double issue (March 1958): 21-24. Reprinted in Brassaï: Del Surrealismo al informalismo, exhibition catalogue, Barcelona: Fundació Antoni Tàpies, 1993, 169-70, and in Graffiti, Paris: Flammarion, 1993, 140-41.

"The Faces of Nature." Photographs by Brassaï. Harper's Bazaar (New York), no. 2958 (May 1958): 96-99.

"Conversation with Ionesco." Text by Edouard Roditi. Photographs by Brassaï. Harper's Bazaar (New York), no. 2958 (May 1958): 114-15, 144.

"Le Paris insolite." Photographs with comments by Brassaï. Réalités (Paris), no. 179 (December 1960): 79-85. English version, "The Strange Faces of Paris," Réalités (London), no. 124 (March 1961): 17-23. Each version has a different, unsigned introduction.

"Les Folies du Prince Palagonia: Un Surréalisme baroque en Sicile au XVIIe siècle." Text and photographs by Brassaï. Le Figaro Littéraire (Paris), no. 773 (11 February 1961): 3, 11.

▪ "Brève Histoire de mon établissement à Paris." Text by Brassaï. Panorama (Paris), no. 50 (April 1961): page numbers undetermined.

"Walls of Paris." Photographs by Brassaï. Asahi Camera (Tokyo), no. 4 (April 1961): 27-34.

"J'ai vu vivre Maillol." Text and photographs by Brassaï. Lectures pour Tous: Je Sais Tout (Paris), no. 192 (August 1961): 71-75.

"Graffiti: Le Mur est un confident." Text and photograph by Brassaï. France Observateur (Paris) 16 (16 November 1961): 24.

"Reverdy dans son labyrinthe." Text by Brassaï. Mercure de France (Paris), no. 1181, special issue on Pierre Reverdy (January 1962): 159-68.

"Les Saints et la médecine magique." Planète (Paris), no. 4 (April – May 1962): 50-57.

"Descente aux caves du Louvre." Text and photographs by Brassaï. Connaissance des Arts (Paris), May 1962, 100-105.

"La Villa Palagonia, une curiosité du baroque sicilien." Text and photographs by Brassaï. Gazette des Beaux-Arts (Paris), September 1962, 351-64.

"My Friend André Kertész." Text by Brassaï. Caméra (Lucerne), no. 4 (April 1963): 7-32. Published in English, French, and German.

"L'Amateur de livres." Text and photograph by Brassaï. Lectures pour Tous: Je Sais Tout (Paris), no. 114 (June 1963): 59.

"Dernière Heure." Text and photograph by Brassaï. Lectures pour Tous: Je Sais Tout (Paris), no. 115 (July 1963): 53.

"La concierge de Notre-Dame." Text and photograph by Brassaï. Lectures pour Tous: Je Sais Tout (Paris), no. 116 (August 1963): 11.

"Le clochard de Doudou." Text by Brassaï. Combat (Paris), no. 117 (September 1963): 32.

"Les arbres meurent aussi." Lectures pour Tous: Je Sais Tout (Paris), no. 120 (December 1963): 36-37.

"Verres gravés photographies par Brassaï." Photographs by Brassaï. Architecture de Lumière (Neuilly-sur-Seine), no. 11 (1964): 33-40.

"Les souvenirs du grand photographe Brassaï: Picasso s'explique enfin [part 1 of 3]." Text and photographs by Brassaï. Le Figaro Littéraire (Paris), no. 965 (15 – 21 October 1964): 1, 8-9.

"Trente ans dans l'amitié des peintres et des écrivains: Brassaï raconte [part 2 of 3]." Text and photographs by Brassaï. Le Figaro Littéraire (Paris), no. 966 (22 – 28 October 1964): 10, 21.

"Trente ans dans l'amitié des peintres et des écrivains: Brassaï raconte [part 3 of 3]." Text and photographs by Brassaï. Le Figaro Littéraire (Paris), no. 967 (29 October – 4 November 1964): 20.

"Brassaï: Ma dernière visite à Giacometti." Le Figaro Littéraire (Paris), no. 1031 (20 January 1966): 12, 16.

"[Brassaï raconte la naissance difficile des metamorphoses d'Ovide. Conversation avec Albert Skira sur Picasso]." Bulletin trimestriel des Éditions d'Albert Skira (Geneva), no. 3 (August 1966): 2-3, 5-7, 9-10.

"Quoi de neuf M. Picasso? A 85 ans il continue de nous étonner. Une Interview exclusive recueillie par Brassaï." Le Figaro Littéraire (Paris), 13 October 1966, 1, 9.

"Brassaï: Conversation avec Henry Miller." Text by Brassaï. Synthèses (Brussels), no. 249-50, special issue on Henry Miller (February – March 1967): 38-41.

"Picasso and Photography." Text and photographs by Brassaï. Popular Photography (Chicago) 60, no. 5 (May 1967): 78-80, 142-44.

"My Memories of E. Atget, P. H. Emerson and Alfred Stieglitz." Text and photographs by Brassaï. Caméra (Lucerne) 48, no. 1 (January 1969): 3-13, 21, 27, 37, 43. Published in English, French, and German.

"The Photographic World of János Reismann." Text by Brassaï. Photographs by János Reismann. New Hungarian Quarterly (Budapest) 10, no. 36 (winter 1969): 85-89.

"Reismann, János." Text by Brassaï. Fotomüvészet (Budapest) 1 (1970): 33-37.

"Une Thèse sur les graffiti." Photographs by Brassaï and Clovis Prévost. L'Art vivant (Paris), no. 7 (January 1970): 15-17.

"Tihanyi Lajosról [On Tihanyi]." Text by Brassaï. Elet és Irodalom (Budapest), 11 April 1970, 12.

"Elsa et la danse." Text by Brassaï. Les Lettres Françaises (Paris), no. 1340 (24 – 30 June 1970): 11.

"Choses et autres de Jacques Prévert." Text by Brassaï. Photograph by Robert Doisneau. Vogue (Paris), no. 512 (December 1970 – January 1971): 158-61.

"Picasso 1971." Text and photographs by Brassaï. XXe Siècle: Hommage à Picasso (Paris), special issue on Picasso (1971): 134-36.

"Les Peintres en vedette: En Passant par Mougins." Text and photographs by Brassaï. Le Figaro Littéraire (Paris), no. 1325 (8 October 1971): 1, 7.

"Látogatás Picassónál [Visit at Picasso's]." Text by Brassaï. Elet és Irodalom (Budapest), 23 October 1971, 2.

"L'Indomabile novantenne." Epoca (Milan), no. 1100, special issue on Picasso (24 October 1971): 74-79.

"The Master at 90: Picasso's Great Age Seems Only to Stir Up the Demons Within." Text and photographs by Brassaï. New York Times Magazine, 24 October 1971, 30-31, 96, 98, 100, 102, 103-5.

"La deuxième vie de Kertész." Text by Brassaï. Photo (Paris), no. 90 (March 1975): 65, 71.

"[Review of Genius and Lust: A Journey Through the Major Writings of Henry Miller, by Norman Mailer, New York: Grove Press, 1976]." Text by William H. Gass. Photographs by Brassaï. New York Times Book Review, 24 October 1976, 1-3.

"Man Ray l'hérétique: Les antipodes de la photographie." Text by Brassaï. Photographs by Man Ray. Les Nouvelles Littéraires (Paris), no. 2560 (25 November – 1 December 1976): 32.

"Brassaï: Unpublished Portraits of His Artist Friends from the 1930s." Unsigned text. Photographs by Brassaï. Camera 35 (New York) 25, no. 6 (June 1980): 36-43.

"Zur kritischen Revision der Geschichte der Aktphotographie 1: 'Storyville 1912.'" Text by Richard Hiepe. Photographs by Brassaï and others. Tendenzen (Munich) 23, no. 139 (July – September 1982): 45-51.

"Brassaï." Text by Etsuro Ishihara. Photographs by Brassaï. Nippon Camera (Tokyo), November 1984, 23-30.

"Works of Brassaï." Photographs by Brassaï. Asahi Camera (Tokyo), November 1984, 79-89.

"Objets à grande échelle par Brassaï." Text by François-Marie Banier. Photographs by Brassaï. L'Egoïste (Paris), no. 10 (June 1987): 118-25.

"Roundabout." Text by Kaucylia Brooke. Photographs by Brassaï and others. Exposure (Dallas) 29, no. 2/3 (1994): 48-56.

Books with text and/or photographs by Brassaï

L'Amour fou. Text by André Breton. Photographs by Brassaï and others. Paris: Gallimard, 1937, 18, 58, 75, 93. English edition, Mad Love, Lincoln: University of Nebraska Press, 1987. Partially published as "La Nuit du tournesol." Text by André Breton. Photographs by Brassaï, Le Minotaure (Paris), no. 7 (10 June 1935): 48-55.

"La Photographie, art au service des arts." Text by Jacques Lassaigne. Photograph by Brassaï. In Almanach des Arts: L'Année de l'exposition, by Eugenio d'Ors and Jacques Lassaigne. Paris: Librairie Arthème Fayard, 1937, 115-25.

Paris mon coeur. Edited by Louis Chéronnet and Louis Ferrand. Photographs by Brassaï and others. Paris: Pierre Tisné, 1945; reprint 1950, 17, 21, 32, 34-35, 46-47, 53, 54-55, 71, 80, 86-89, 123, 129.

Soirée de ballets. Preface by Jean Cocteau. Fragment of the poem "Le Rendez-vous," by Jacques Prévert. Photographs by Brassaï. Paris: Les Éditions du Chêne, 1945, no pagination.

"Trois Propos photographies par Brassaï [Marie à Saint-Joseph; Marie à Saint-Louis; Saint-Joseph, c'est pas Saint-Louis]." Poems and photographs by Brassaï. In Anthologie de la poésie naturelle, edited by Camille Bryen and Alain Gheerbrant. Paris: K éditeur, 1949, 119-23.

10 Photographs by Louis Stettner. Exhibition catalogue. Introduction by Brassaï. Paris and New York: Two Cities Publication, 1949, no pagination. Published in English and French. Reprinted as "Louis Stettner," Caméra (Lucerne), December 1949, 377-82, published in English, French, and German.

France aux belles mains. Texts by various authors. Photographs by Brassaï and others. Paris: Éditions Pierre Tisné, 1950.

Sortilèges de Paris. Poems by François Cali. Photographs by Brassaï and others. Paris: Arthaud, 1952.

Quiet Days in Clichy. Text by Henry Miller. Photographs by Brassaï. Paris: Olympia Press, 1956; second edition, 1958. Excerpt published as "Paris la nuit," Evergreen Review (New York) 6, no. 24 (May – June 1962): 12-22. Danish edition, Stille Tage in Clichy, Copenhagen: Hanz Reitzel, 1958. German edition, Stille Tage in Clichy, Hamburg: Rowohlt, 1968; second edition, 1975. Japanese edition, Tokyo: Tuttle and Co., 1968.

Les Rues de Paris. Text by Jean-Paul Clébert. Photographs by Brassaï and others. 2 vols. Paris: Club des Libraires de France, 1958, vol. 1: 32, 51, 69, 80, 81, 86; vol. 2: 125, 134, 157, 163, 168, 176, 180, 186, 187, 194.

Paris. Text by John Russell. Photographs by Brassaï. New York: Viking Press, 1960; London: Batsford, 1960. German edition, Munich: Albert Langen-George Muller, 1960. 42 reproductions by Brassaï appear in first editions only and not in the 1983 reissue published by Harry N. Abrams.

D'Après Paris et Le Piéton de Paris. Text by Léon-Paul Fargue. Photographs by Brassaï and others. Paris: Club des Libraires de France, 1961, no pagination of photographs, 15 by Brassaï. Photos by Brassaï in this edition only.

- Henry Miller in Selbstzeugnissen und Bilddokumenten. Text by Walter Schmiele. Photographs by Brassaï and others. Hamburg: Rowohlt, 1961. Italian edition, Milan: Longanesi, 1963.

"Mon Ami Hans Reichel." Text by Brassaï. In Hans Reichel 1892–1958. Paris: Éditions Jeanne Bucher, 1962, 39-50; in German, 87-95. Also published in Jardin des Arts (Paris), no. 122 (January 1965): 2-9. Excerpts from Hans Reichel 1892–1958 published as "Reichel angélique et démoniaque," text by Henry Miller, Lawrence Durrell, and Brassaï, La Galerie des Arts (Paris), no. 65 (15 February 1969): 16-17. Excerpts published in Hans Reichel, 1892–1958, Paris: Arts et Métiers Graphiques, 1975, catalogue of an exhibition held at the Musée d'Art Moderne de la Ville de Paris, 1975.

Brassaï présente images de "Caméra." Introduction by Brassaï. Paris: Hachette, 1964, 7-9. Reprinted as "Les Choses parlent," Les Nouvelles Littéraires (Paris), no. 1959, special photography issue (18 March 1965): 1, 7.

Lajos Tihanyi. Exhibition catalogue. Paris, 1970. Reprinted in Les Lettres Françaises (Paris), no. 1329 (8 – 14 April 1970): 27-28, includes one photograph by Brassaï.

Le Bambine di Carroll: Foto e lettere di Lewis Carroll a Mary, Alice, Irene, Agnese. . . . Edited by Guido Almansi. Parma: Franco Maria Ricci, 1974. English edition, Lewis Carroll: Photos and Letters to His Child Friends, notes by Brassaï and Helmut Gernsheim, Parma: Franco Maria Ricci, 1975. French edition, Lewis Carroll: Photos et lettres aux petites filles, preface by Jean Gattégno, Parma: Franco Maria Ricci, 1976. German edition, Kinder: Photographien und Briefe von Lewis Carroll an Mary, Alice, Irene, Agnes. . . . Genf, 1976. Previously published as "Lewis Carroll photographe ou l'autre côté du miroir," Cahiers de l'Herne (Paris), no. 17 (December 1971): 99-109, and in Zoom (Paris), no. 11 (March – April 1972): 74-81.

Alexey Brodovitch and His Influence. Short text and photograph by Brassaï. Philadelphia: Philadelphia College of Art, 1972, 18, 19. Excerpts reprinted as "Document Brodovitch," Art Direction: The Magazine of Visual Communication, September 1972, 84-86.

Mario Avati: L'Oeuvre gravé, 1955–1960. Exhibition catalogue. vol. 2. Introduction by Brassaï. Text by Roger Passeron. Paris: La Bibliothèque des Arts, 1973.

Pierre Cordier: Chimigrammes. Exhibition catalogue. Preface by Brassaï. Text by Jean-Claude Lemagny. Chalon-sur-Saône: Musée Nicéphore Niépce, 1980.

Louis Stettner: Early Joys: Photographs from 1947–1972. Introduction by Brassaï. New York: Janet Iffland, 1987, 7-9.

Montparnasse: The Golden Years. Foreword by Bertrand Poirot-Delpech. Photographs by Brassaï and others. Paris: Booking International, 1990, 25, 33, 54, 60.

Je me souviens du 13e arrondissement. Text by Catherine Vialle. Photographs by Brassaï and others. Paris: Éditions Parigramme, 1995, 61, 69, 101, 107, 108.

Interviews and Conferences

Becker, Jonathan. "Brassaï." Interview (New York) 9, no. 10 (1979): 54-57.

Bequette, France. "Rencontre avec Brassaï." Culture et Communication (Paris), no. 27 (1 May 1980): 8-15. Partially reprinted in Les mystères de la chambre noire: Le surréalisme et la photographie, by Edouard Jaguer, Paris: Flammarion, 1982, 216.

Berger, Viviane. "Brassaï par Brassaï." Jardin des Arts (Paris), no. 209 (27 March 1972): 12.

Berman, Avis. "Guest speaker: Brassaï: The Three Faces of Paris." Architectural Digest (Los Angeles) 41, no. 7 (July 1984): 26, 30, 32, 34-35. Partially reprinted in Modern Arts Criticism: A Biographical and Critical Guide to Painters, Sculptors, Photographers and Architects from the Beginning of the Modern Era to the Present, edited by Joann Prosyniuk, vol. 1, Detroit: Gale Research, 1991, 148.

Bonnefoy, Claude. "Les Photographes ne peuvent plus travailler sans électricité: Brassaï." La Vie Électrique (Paris), no. 114 (July – August 1975): 44-46.

Boujut, Michel. "Brassaï." Le Nouveau Photocinéma (Paris), no. 67 (April 1978): 26-27.

Brassaï. "La Photographie n'est pas un art?" Response to Maurice Chapelan, below. Le Figaro Littéraire (Paris), no. 235 (21 October 1950): 6. See also Masclet, Daniel. "Oui, La Photographie est un art!" Le Figaro Littéraire (Paris), no. 236 (28 October 1950): 6. See also "Compte rendu de la Séance Générale du Vendredi 26 Janvier 1951." Bulletin de la Société Française de Photographie et Cinématographie (Paris), no. 2 (February 1951): 35-37, 39-41.

Breton, André, and Paul Eluard. "Enquête." Le Minotaure (Paris), no. 3-4 (12 December 1933): 101-16. Brassaï's response, 101-2, 105.

Chapelan, Maurice. "Baudelaire avait raison: La Photographie n'est pas un art." Le Figaro Littéraire (Paris), no. 234 (14 October 1950): 1. See also Brassaï. "La Photographie n'est pas un art?" Le Figaro Littéraire (Paris), no. 235 (21 October 1950): 6. See also Masclet, Daniel. "Oui, La Photographie est un art!" Le Figaro Littéraire (Paris), no. 236 (28 October 1950): 6. See also "Compte rendu de la Séance Générale du Vendredi 26 Janvier 1951." Bulletin de la Société Française de Photographie et Cinématographie (Paris), no. 2 (February 1951): 35-37, 39-41.

"Compte rendu de la Séance Générale du Vendredi 26 Janvier 1951." Bulletin de la Société Française de Photographie et Cinématographie (Paris), no. 2 (February 1951): 35-37, 39-41. Conference organized in response to Brassaï, Chapelan, and Masclet debate of October 1950.

"[How to make a portrait]." Echo de la Mode (Paris), December 1968, page numbers undetermined.

Esnault, A. "La Photographie est-elle un art? Une Interview de Brassaï." Gazette de Lausanne, no. 299 (18 – 19 December 1954): 17, 21.

Gautrand, Jean-Claude. "Brassaï l'universel." Photo-Revue (Paris), July – August 1974, 357-69. English edition, "Brassaï, the universal," Afterimage (Rochester, New York) 3, no. 3 (September 1975): 6-9.

Hill, Paul, and Thomas Cooper. "Interview Bernard [sic] Brassaï." Caméra (Lucerne), May 1975, 37. Published in English, French, and German. Revised version, "Brassaï," in Dialogue with Photography, New York: Farrar, Straus, and Giroux, 1979, 37-43.

———. "Brassaï." In Dialogue with Photography. New York: Farrar, Straus, and Giroux, 1979, 37-43. Spanish edition, Diálogos con la fotografía, Barcelona: Gustavo Gili, 1980, 42-47. Japanese edition, Tokyo: Shobunsha, 1988, 35-40. Revised reprint of "Interview Bernard [sic] Brassaï," Caméra (Lucerne), May 1975, 37.

Hughes, George. "Brassaï Talks to George Hughes." Amateur Photographer (London) 138, no. 12 (18 June 1969): 8-13.

Marotta, Tom. "Brassaï: An Interview." Lens (New York) 2, no. 7 (September – October 1977): 7-14.

Masclet, Daniel. "Brassaï, l'homme de la foule." Photo-Cinéma (Paris), no. 605 (March 1952): 48-54; Le Photographe (Paris), no. 763 (5 March 1952): 78-79.

———. "Oui, La Photographie est un art!" Response to Brassaï and Maurice Chapelan, above. Le Figaro Littéraire (Paris), no. 236 (28 October 1950): 6. See also "Compte rendu de la Séance Générale du Vendredi 26 Janvier 1951." Bulletin de la Société Française de Photographie et Cinématographie (Paris), no. 2 (February 1951): 35-37, 39-41.

Misani, Marco. "Brassaï: 'We Live in the Age of Photography. . . .'" Printletter (Zurich), no. 8 (March – April 1977): 6-7. Published in English, French, and German.

Pérez Luna, Elizabeth. "La Fotografía: Las Noches de Brassaï." El Nacional (Caracas), 18 September 1977, page numbers undetermined.

Ray-Jones, Tony. "Brassaï Talking about Photography." Creative Camera (London), no. 70 (April 1970): 120-25.

Reissman [sic], János. "Brassaï: Photographer of Night." Miniature Camera World (London) 3, no. 4 (April 1939): 249-52.

Stettner, Louis. "Conversation with Brassaï." Camera 35 (New York) 21, no. 6 (July 1977): 22-23.

Varia, Radu. "De Vorbà cu Brassaï despre fotografia cu arta." Secolul 20 (Bucharest), no. 1 (January 1966): 179-86.

———. "De Vorbà cu Brassaï." Secolul 20 (Bucharest), no. 8 (August 1966): 155-56.

Vinkó, Jósef. "Párizs szeme: Beszélgetés Brassaï [The Eye of Paris: Conversations with Brassaï]." Tukör (Budapest), 2 January 1983, 18-19.

Monographs about Brassaï

Brassaï. Introduction by Roger Grenier. Photo Poche, 28. Paris: Centre National de la Photographie, 1987. English edition, London: Thames and Hudson; New York: Pantheon Books, 1988.

Soucék, Ludvík. Brassaï. Prague: Státní Nakladatelství Krásné Literatury a Uméní, 1962.

Sudre, Jean Pierre. [Brassaï]. Lacoste, 1967. Album of photographs of Brassaï.

Warehime, Marja. Brassaï: Images of Culture and the Surrealist Observer. Baton Rouge: Louisiana State University Press, 1996.

Review of Monographs about Brassaï

Tucker, Anne Wilkes. "Brassaï." Review of Henry Miller: The Paris Years, Brassaï: Del Surrealismo al informalismo, exhibition catalogue, by Manuel J. Borja-Villel, and Brassaï: Images of Culture and the Surrealist Observer, by Marja Warehime. On Paper: The Journal of Prints, Drawings, and Photographs (New York) 1, no. 3 (January – February 1997): 46-48.

Texts about Brassaï in General Works

Abe, Yoshio. "[Filth and Existence: Brassaï]." In [Poetics of a Savage]. Tokyo: Ozawa Shoten, 1982, 130-36.

Auer, Michel, and Michèle Auer. Encyclopédie internationale des photographes de 1839 à nos jours/Photographers Encyclopedia International: 1839 to the Present. vol. 1. Hermance, Switzerland: Éditions Camera Obscura, 1985.

Beaton, Cecil, and Gail Buckland. The Magic Image: The Genius of Photography from 1839 to the Present Day. Boston and London: Little, Brown, & Co., 1975, 149.

Bouqueret, Christian. Des Années folles aux années noires: La Nouvelle Vision photographique en France, 1920–1940. Paris: Éditions Marval, 1997, 5, 17, 63, 64, 74-75, 144, 148, 150, 151, 152, 153, 155, 156, 159, 161, 162, 163, 166, 167, 168, 169, 175, 190, 206, 258-59, 265, 266.

Bourdieu, Pierre, et al. Un Art moyen. Paris: Les Éditions de Minuit, 1965. English edition, "Mechanical Art, Natural Art: Photographic Artists," in Photography: Middle-Brow Art, Cambridge: Polity Press; Stanford: Stanford University Press, 1990, 129-49, especially 144-46.

Braive, Michel-François. The Photograph: A Social History. New York: McGraw-Hill; London: Thames and Hudson, 1966, 38, 44, 358.

Bresson, George. La Photographie Française. Paris: Éditions Braun et Cie., 1936, plate 34.

Browne, Turner, and Elaine Partnow, eds. MacMillan Biographical Encyclopedia of Photographic Artists and Innovators. New York: Macmillan; London: Collier, 1983, 74-75.

Campbell, Bryn, ed. "Brassaï." In World Photography. New York: Ziff-Davis Books, 1981, 202-15. Japanese edition, Tokyo: Kodansha, 1982, 202-7.

Capa, Cornell, ed. The International Center of Photography Encyclopedia of Photography. New York: Crown Publishers, Inc., 1984, 80-81.

Coe, Brian, et al. "Brassaï." In Techniques of the World's Great Photographers. Secaucus, New Jersey: Chartwell Books, 1981.

Coleman, A. D. "Brassaï." In The Grotesque in Photography. New York: Summit Books-Ridge Press, 1977, 166-69.

————. Light Readings: A Photography Critic's Writings, 1968–1978. Oxford: Oxford University Press, 1979, 223-24, 233.

De Paz, Alfredo. L'Immagine fotografica: Storia, estetica, ideologie. Bologna: CLUEB, 1986, 203-10, 218, 268, 271, 277.

Deedes-Vincke, Patrick. "A New Vision and the Montparnasse Set" and "The Magnum Style and Photo-Journalism." In Paris: The City and Its Photographers. Boston: Little, Brown and Company, 1992, 70-100, 101-33, 134.

Ellenzweig, Allen. "Brassaï in Paris." In The Homoerotic Photograph: Male Images from Durieu/Delacroix to Mapplethorpe. New York: Columbia University Press, 1992, 65-75.

Fer, Briony. "Surrealism, Myth and Psychoanalysis: The Role of Psychic Disorder in the Surrealist Aesthetic." In Realism, Rationalism, Surrealism: Art between the Wars, by Briony Fer, David Batchelor, and Paul Wood. New Haven and London: Yale University Press, 1993, 209-20, 229-30.

Foster, Hal. Compulsive Beauty. Cambridge, Massachusetts, and London: MIT Press, 1993, 23, 28, 183-85, 192.

Fougère, Valentine, and Michel Tourlière. Tapisseries de notre temps. Paris: Éditions du Temps, 1969, back cover.

Frizot, Michel. Histoire de voir: De l'Instant à l'imaginaire (1930–1970). Photo Poche, 42. Paris: Centre National de la Photographie, 1989, 18-19.

————, ed. Nouvelle Histoire de la photographie. Paris: Bordas S. A., 1994, 399, 454, 455, 473, 518, 521, 566, 568, 569, 572, 573, 574, 577, 617, 618, 623, 624, 671, 672-73, 674.

Gee, Helen. Limelight: A Greenwich Village Photography Gallery and Coffeehouse in the Fifties. Albuquerque, New Mexico: University of New Mexico Press, 1997, 86, 90, 164, 272.

Gernsheim, Helmut. Creative Photography: Aesthetic Trends, 1839–1960. Boston: Boston Book and Art Shop, 1962, 213, 216, 233.

Green, Christopher. "Zervos, Picasso and Brassaï, Ethnographers in the Field: A Critical Collaboration." In Art Criticism Since 1900, edited by Malcolm Gee. Manchester, England, and New York: Manchester University Press, 1993, 116-39.

Gruber, Fritz, ed. Grosse Photographen unseres Jahrhunderts. Berlin: Deutche Buch-Gemeinschaft, 1964, 84-89. English edition, Great Photographers of Our Century, Dusseldorf: Deutsche Buchgemeinschaft, and Vienna: Econ-Verlag, 1964, 84-90. Japanese edition, Tokyo: Asahi Sonarama, 1979, 99-105. Book originates from the exhibition catalogue section titled "Grosse Photographen dieses Jahrhunderts," in Photokina, vol. 2, Cologne: Messe und Austellungs Gemeinschaft, 1963, 48, texts in English, French, and German.

Grundberg, Andy. "On the Dissecting Table: The Unnatural Coupling of Surrealism and Photography." In The Critical Image: Essays on Contemporary Photography, edited by Carol Squiers. Seattle: Bay Press, 1990, 80-87.

Halász, Sr., Gyula. A századik év küszöbén. Emlékek (On the Threshold of the One-Hundredth Year. Memories). Bucharest: Irodalmi Könyvkiadó, 1967.

Hennessey, William, and Graham Smith. From Ansel Adams to Andy Warhol: Portraits and Self-Portraits from the University of Michigan Museum of Art. Ann Arbor: University of Michigan Museum of Art, 1994, 28-29.

Holme, Bryan, ed. The Gallery of World Photography: The City. vol. 7. Tokyo: Shueisha Publishing Company, 1983, 100, 105, 191.

Jaguer, Edouard. Les Mystères de la chambre noire: Le Surréalisme et la photographie. Paris: Flammarion, 1982, 66-68, 216.

———. Surrealistische Photographie: Zwischen Traum und Wirklichkeit. Cologne: DuMont Buchverlag, 1984, 3, 6, 15, 17, 31, 61, 64, 66, 67, 68, 76, 80, 93, 94, 142, 143, 144, 152, 216, 218.

Jeffrey, Ian, ed. Bill Brandt: Photographs, 1928-1983. London: Thames and Hudson, 1993, 8, 14, 15, 16, 27, 55, 183.

———. Photography: A Concise History. The World of Art series. New York and Toronto: Oxford University Press, 1981, 71, 101, 184-86, 191, 202, 203.

Kahmen, Volker. Fotografie als Kunst. Tubingen: Ernst Wasmuth, 1973. English editions, Photography as Art, London: Studio Vista, 1974; Art History of Photography, New York: Viking Press, 1974.

Kanamaru, Shigene. "Brassaï." In Ashai Camera Series 17. Tokyo: Asahi Shimbun, 1937, 135-36.

———. Photography of the World I: France, Italy. Tokyo: Heibonsha, 1956, 18-20, 37-38.

———. "Document as Art." In Art Photography. Tokyo: Asahi Shimbun, 1970, 117-21. Revised edition, Tokyo: Asahi Shimbun, 1979, 117-25.

———. Mine. Tokyo: Nihon University, 1974, 137, 142, 149-51. Includes "Brassaï," originally published in Asahi Camera (Tokyo) 23, no. 1 (January 1937): 60, 271-72, and "[Brassaï's View of Art]," originally published in Asahi Camera (Tokyo), July 1953, 129-31.

Keim, Jean. "Brassaï, the Eye of Paris." In Moderní Francouská Fotografie. Prague: Editions Nakladatelství, 1966, 44-52.

Krauss, Rosalind. "The Photographic Conditions of Surrealism." In The Originality of the Avant-Garde and Other Modernist Myths. Cambridge: MIT Press, 1988, 87-118. Originally published in October (Cambridge, Massachusetts), no. 19 (fall 1981): 3-34. Also published in French as "Photographie et surréalisme," in Le Photographique: Pour une Théorie des Ecarts, Paris: Macula, 1990, 100-124.

Lécuyer, Raymond. Histoire de la photographie. Paris: Baschet et Cie., 1945, 207, 221.

Lemagny, Jean-Claude. L'Ombre et le temps: Essais sur la photographie comme art. Paris: Éditions Nathan, 1992, 65, 113, 209, 210, 212, 238.

Lemagny, Jean-Claude, and André Rouillé, eds. Histoire de la photographie. Paris: Borda S. A., 1986. English edition, A History of Photography: Social and Cultural Perspectives, Cambridge: Cambridge University Press, 1987, 120, 121-22, 168, 178, 179, 184, 190, 200, chronology.

Lewinski, Jorge. The Naked and the Nude: A History of the Nude in Photographs 1839 to the Present. New York: Harmony Books, 1987, 92-94, 95, 137.

Maddow, Ben. Faces: A Narrative History of the Portrait in Photography. Boston: New York Graphic Society, 1977, 444-49, 484-87, 489, 494.

———. "Nude in a Social Landscape." In Nude: Photographs, 1850-1980, edited by Constance Sullivan. New York: Harper and Row, 1980.

Magyar Portrék: Páris, 1934. Paris: Polyglottes, 1934, no pagination.

Marrey, Bernard. Guide de l'art dans la rue au XXe siècle. Paris: Éditions Ouvrières, 1974, 42, 201.

Mèliusz, Jòzsef. Kàvèhàz Nèlkül. Bucharest: Kriterion, 1977, 181-211.

Miller, Henry. Tropic of Cancer. Paris: Obelisk Press, 1934, 196-98.

Morgan, Willard D., ed. The Encyclopedia of Photography. vol. 3. New York: Greystone Press, 1974, 477-79.

Mousseigne, Alain. "Surréalisme et photographie." In L'art face à la crise, 1929-1939, Travaux, no. 26, Saint-Étienne: Université de Saint-Étienne, 1980, 154-81.

Mrazkova, Daniela. Masters of Photography. New York: Exeter Books, 1987, 35, 99, 113, 114-15, 176.

Naggar, Carole. Dictionnaire des photographes. Paris: Éditions du Seuil, 1982, 62, 64-66, 67, 100, 130, 153, 273, 327, 329, 345, 383, 397, 419.

Natkin, Marcel. Pour Réussir vos photos à la lumière artificielle. Paris: Éditions Tiranty, 1934, 20-23, 62-65, 68-69, 72-77.

———. "Vues nocturnes" and "Divers effets de la perspective." In L'Art de voir en photographie. Paris: Éditions Tiranty, 1935, 38-39, 44-45. English edition, "Night Scenes" and "Various Effects of Perspective," in Photography and the Art of Seeing, London: The Fountain Press, 1935, 38-39, 44-45.

———. "Le Nu réaliste." In Le Nu en photographie. Paris: Mana/Tiranty, 1949, 27-28; plates 8-16.

Newhall, Beaumont. Photography: A Short Critical History. Second edition, revised and amended. New York: The Museum of Modern Art, 1938, 94, 194, plate 57. The History of Photography: From 1839 to the Present Day. Newly revised and rewritten. New York: The Museum of Modern Art, 1949, 164. The History of Photography: From 1839 to the Present Day. Revised and expanded edition. New York: The Museum of Modern Art, 1964, 155-56. Newly revised edition, 1971. Completely revised and expanded edition, 1982, 225, 226. Originally published as the exhibition catalogue Photography, 1839–1937, New York: The Museum of Modern Art, 1937, 112, plate 57. Japanese edition, 1949. French edition, 1964.

Newhall, Nancy. "Brassaï." In From Adams to Stieglitz: Pioneers of Modern Photography. New York: Aperture, 1989, 15-22. Reprint of "Brassaï: Je ne découvre rien, j'imagine tout!" Caméra (Lucerne) 35, no. 5, special issue on Brassaï (May 1956): 185-215, published in English, French, and German. Revised version published as "Brassaï," Untitled 10: Quarterly of the Friends of Photography (Carmel), 1976, 11-16. Reprinted as "Brassaï: I invent nothing, I imagine everything," in Photography: Essays and Images, edited by Beaumont Newhall, New York: The Museum of Modern Art, 1980, 276-81, and in Modern Arts Criticism: A Biographical and Critical Guide to Painters, Sculptors, Photographers and Architects from the Beginning of the Modern Era to the Present, edited by Joann Prosyniuk, vol. 1, Detroit: Gale Research, 1991, 148-50.

- Nori, Claude. La Photographie française des origines à nos jours. Paris: Contrejour, 1978. English edition, "Paris and the Avant-Garde: Brassaï," in French Photography: From Its Origins to the Present, New York: Pantheon Books, 1979, 36, 53-56.

Nuridsany, Michel. "Brassaï." In Contemporary Photographers. London: Macmillan, 1982; second edition, 1988, 117-19; third edition, 1995, 126-29.

Owens, Craig. Beyond Recognition: Representation, Power, and Culture. Berkeley: University of California Press, 1992, 16-30. Originally published as "Photography en Abyme," October (Cambridge, Massachusetts), no. 5 (summer 1978): 73-88.

Phillips, Sandra, David Travis, and Weston J. Naef. André Kertész: Of Paris and New York. Chicago: The Art Institute of Chicago; New York: The Metropolitan Museum of Art; New York and London: Thames and Hudson, 1985, 11, 12, 17, 26, 28, 42, 43, 53 n. 15, 55 n. 51, 66, 76, 79-81, 83, 88, 91 n. 49, 91 n. 50, 100, 102, 106, 268.

Photography: Source and Resource. New York: G. K. Hall and Company, 1973. Revised edition, Index to American Photographic Collections, edited by Andrew H. Eskind. New York: G. K. Hall and Company, 1982. Second revised edition, 1990. Third revised edition, 1995.

Pollack, Peter. "Brassaï's Probing Vision." In The Picture History of Photography: From the Earliest Beginnings to the Present Day. New York: Harry N. Abrams, 1958, 404-17; Italian edition, Storia della fotografia, Milan: A. Garzanti, 1959, 426-39; French edition, Histoire de la photographie, Paris: Hachette, 1961, 406-19; German edition, Die Welt der Photographie, Düsseldorf: Econ-Verlag, 1962, 366-75.

Prosyniuk, Joann, ed. Modern Arts Criticism: A Biographical and Critical Guide to Painters, Sculptors, Photographers and Architects from the Beginning of the Modern Era to the Present. vol. 1. Detroit: Gale Research, 1991, 137-53.

Ramírez, Juan Antonio. "La Ciudad surrealista." In El Surrealismo, edited by Antonio Bonet. Madrid: Cátedra, 1983, 71-90.

Rosenblum, Naomi. A World History of Photography. New York: Abbeville Press, 1984, 483, 484, 486. Revised edition, New York and London: Abbeville Press, 1989. Third edition, New York: Abbeville Press, 1997. French edition, Une histoire mondiale de la photographie, Paris: Abbeville, 1992. French reedition, Éditions Abbeville, 1997.

Schaffner, Ingrid, and Lisa Jacobs, eds. Julien Levy: Portrait of an Art Gallery. Cambridge, Massachusetts, and London: The MIT Press, 1998, 116, 118, 174.

Shigemori, Koen. "[Fantasy of Paris]." In [Camera Eye]. Tokyo: Nichibo-syupannsya, 1974, 105-15.

Sichel, Kim. "Les Photographes étrangers à Paris durant l'entre-deux-guerres." In Le Paris des étrangers depuis un siècle, edited by André Kaspi and Antoine Marès. Paris: Imprimerie Nationale, 1989.

———. Germaine Krull 1897–1985: An International Photographic Eye. Cambridge: MIT Press, 1999. German edition, Munich: Schirmer/Mosel Verlag, forthcoming, 1999.

Sobieszek, Robert. "Addressing the Erotic: Reflections on the Nude Photograph." In Nude: Photographs, 1850–1980, edited by Constance Sullivan. New York: Harper and Row, 1980.

Steichen, Edward. "Photography." In Masters of Modern Art, by Alfred H. Barr, Jr. New York: The Museum of Modern Art, 1954, 195.

347

Stettner, Irving [Louis]. "A Visit to Brassaï." Photo Notes (New York), fall 1948, 9-13. Reprinted in Photo Notes: February 1938 – Spring 1950/Film Front: December 1934 – March 1935, Rochester, New York: Visual Studies Workshop, 1977, original pagination.

Tanaka, Masao. "[Four French Photographers]." In [History of Photography: 120 Years]. Tokyo: Davidsha, 1959, 288-96. Revised edition, [History of Photography: 130 Years], Tokyo: Davidsha, 1970, 206-11.

Tanaka, Masao, and Shiro Kawakami. "Brassaï." In [100 Foreign Photographers]. Tokyo: Davidsha, 1975, 100-101.

Tausk, Petr. Geschichte de Fotografie im 20 Jahrhundert. Cologne: DuMont Buchverlag, 1980. English edition, "Further Development of Surrealist Photography," in Photography in the Twentieth Century, London: Focal Press, 1980, 125-26. Spanish edition, Historia de la fotografia en siglo XX, Barcelona: 1980.

de Thézy, Marie. La Photographie humaniste, 1930–1960: Histoire d'un mouvement en France. Paris: Contrejour, 1992, 15, 16, 17, 18, 19, 23, 28, 34, 35, 36, 47, 48, 49, 51, 52, 54, 57, 61, 63, 64, 65, 69, 151, 153, 155, 163, 179, 226, 229, 232, 233.

Time-Life Books, eds. "Brassaï." In Sixty-eight Photographers. New York: Time-Life Books, 1971: 168-69. Japanese edition, Tokyo: Time-Life International, 1971, 168-69.

————. "Catching the Mood of a City." In Photojournalism. New York: Time-Life Books, 1971, 61. Japanese edition, Tokyo: Time-Life International, 1971, 61, 240.

Van Lier, Henri. "Brassaï (Hongrie-France 1899–1984): Les Chiasmes du lieu." In Histoire photographique de la photographie. Paris: Les Cahiers de la Photographie, 1992, 84-91.

Vinding, Ole. Farlig Fred. Copenhagen: K. E. Hermans Forlag, 1945, 115-18.

Warburton, Nigel, ed. Bill Brandt: Selected Texts and Bibliography. Oxford: Clio Press, 1993, xvii, xix, 14, 15-16, 29, 34, 61, 62, 76, 131, 138, 196.

Westerbeck, Colin, and Joel Meyerowitz. Bystander: A History of Street Photography. Boston: Little, Brown and Company, 1994, 99, 124, 129, 137, 169, 179-82, 184-87, 202-3, 208, 339.

Television Programs about Brassaï

Drot, Jean-Marie. L'Art et les hommes. 48 min. Paris, 3 November 1960.

Bietz, Dr. [Graffiti]. 30 min. Westfunk, Baden-Baden, 2 August 1961.

Brassaï, ou Regard en liberté. 75 min. Paris, 19 December 1969.

▪ Radio-Canada. 60 min. Montreal, 19 February 1970.

Gallot, Claude, and Michele Arnaud. Variances. 50 min. Paris: Institut National de l'Audiovisuel, 28 September 1971.

Excerpt from L'Art et les hommes

Brassaï. Paris: Bibliothèque Nationale, 1963, 15, 20.

Reviews of L'Art et les hommes

Mauriac, François. "Brassaï: Il chasse l'homme avec amour." L'Express (Paris), 10 November 1960, 40. Partially reprinted in Brassaï: Graffiti, Rome: L'Obelisco, 1962, no pagination.

Mourgeon, Jacques. "Brassaï, poète de la photo." Combat (Paris), 5 November 1960, 3.

Siclier, Jacques. "A la Télévision: Brassaï." Le Monde (Paris), 5 November 1960, 13.

Review of Brassaï, ou Regard en liberté

M., J. [Jacques Marquis]. "Brassaï, ou Regard en liberté." Télérama (Paris), no. 1039 (14 December 1969): 51.

Articles about Brassaï in Periodicals

Artner, Alan G. "Brassaï Illuminated Man's Darker Side in Photographs of Paris at Night." Chicago Tribune, 19 August 1984, sec. 13, p. 20.

Bajomi, Lázár Endre. "Párizsi találkozas Brassaï (Meeting Brassaï in Paris)." Magyar Nemzet (Budapest), 29 November 1978, 5.

Bauret, Gabriel. "Artistes et ateliers." Photographies Magazine (Paris), no. 44 (September 1992): 66-77.

Bellony-Rewald, Alice. "Photography in Surrealist Reviews." Art International (Paris), no. 5 (winter 1988): 35-40.

Bergstein, Mary. "The Artist in His Studio: Photography, Art, and the Masculine." Oxford Art Journal (Oxford) 18, no. 2 (1995): 45-58.

"Beszélgetés Reismann Jánossal." Fotomüvészet (Budapest) 1 (1970): 38-40ff.

Borhan, Pierre. "Brassaï: Les affinités immuables." Clichés (Brussels), no. 14 (March 1985): 24-31.

■ "Brassaï." L'Information (Paris), 17 January 1952, page numbers undetermined.

"Brassaï." Photography (London) 17, no. 2 (February 1962): 24-35.

"Brassaï grand prix des Arts et Lettres." Le Photographe (Paris), no. 1357 (February 1979): 6.

"Brassaï: Les Photos inédités et les souvenirs du lauréat du Grand prix national." Photo (Paris), no. 137 (February 1979): 14-21, 86.

"Brassaï und seine Künstler." Art: Das Kunstmagazin (Hamburg), no. 6 (June 1983): 68-79.

"A Bronze for Brassaï, Should It Have Been Gold?" British Journal of Photography (Liverpool; London) 131 (24 August 1984): 885ff.

Buraud, Georges. "Le Masque, médium de la vie." Médecine de France (Paris), no. 1 (1949): 17-20.

Cabanne, Pierre. "Brassaï: J'imagine tout." Arts (Paris), no. 917 (22-28 May 1963): 11.

———. "Brassaï: L'Oeil d'un poète." Lectures pour Tous (Paris), no. 205 (February 1971): 109-13, 115-16.

Calas, André. "Brassaï, le magicien a mis pour nous le monde dans des boîtes." Combat (Paris), 18 July 1949, 2.

———. "Portraitiste de Picasso, de Prévert et de Miller: Brassaï a préféré au pinceau un appareil photographique." Samedi Soir (Paris), no. 356 (26 April – 2 May 1952): 2, 8.

Carné, Marcel. "Descendra-t-il dans la rue?" Photo-Ciné Magazine (Paris), November 1933, 83.

Chevrier, Jean-François. "Degas, Brassaï et Picasso." Photographies (Paris), no. 7 (May 1985): 52-54.

———. "Gilbert Fastenaekens noctambule." Art Press (Paris), no. 96 (October 1985): 15-17.

Chiba, Shigeo. "[Brassaï]." Asahi Camera (Tokyo), special number Paris Photo, 1840–1980 (October 1982): 112-19.

Chonez, Claudine. "Brassaï." Nouvelles Littéraires (Paris), 9 October 1952, 3.

Coursaget, René. "Propos sur la photographie française contemporaine." Photo-France (Paris), no. 6 (June 1951): 13-16.

———. "Les Tendences actuelles de la photographie." Cahier Français de l'Information (Paris), no. 184 (16 July 1951).

De Solier, René. "Cartier-Bresson, Brassaï et autres gens d'images." La Nouvelle Revue Française (Paris), no. 39 (1 March 1956): 543-46.

Drahos, Tom. "Inédit: Paris en 1930 vu par le maître Brassaï." Photo (Paris), no. 22 (July 1969): 24-35, 79.

Dunoyer, Jean-Marie. "Photos imaginaires." Le Monde (Paris), 8 February 1975, 23.

———. "Les Grands Prix nationaux des arts et des lettres: Photographie: Brassaï." Le Monde (Paris), 14 December 1978, 30.

Eisner, Maria Giovanna. "Brassaï." Minicam Photography (Cincinnati), 7 – 8 April 1944, 20-27, 74-76.

■ Esnault, A. "Brassaï, un poète de la photo." Pour Tous (Lausanne), December 1952, page numbers undetermined.

Fleury, Jean-Christian. "Le Paris de Brassaï." Photographies (Paris), no. 56 (March 1994): 60-65.

Ford, Graham. "Brassaï, a Man of Passion." Hot Shoe (London), no. 24 (January 1983): 16-20.

Foresta, Merry. "Art and Photography in the Age of Contact." Aperture (New York), no. 125 (fall 1991): 16-23.

"Frem franska Fotografer." Foto (Stockholm), no. 7 (1949): 16-17, 32-33.

Furse, Katya. "Brassaï at MIT." Plan: Review of the MIT School of Architecture and Planning, no. 8 (fall 1977): 18-19.

Galambos, Ferenc. "Kortársaink: Brassaï (Our Contemporaries: Brassaï)." Látóhatár (Budapest), February 1971, 118-22.

Gallian, Jean. "Brassaï." Photo-Monde (Paris), no. 29 (October 1953): 21-28.

Gautrand, Jean-Claude. "Brassaï–Grand Prix National." Point de Vue, Images du Monde (Paris), nos. 1589 and 1590 (5 and 12 January 1979): 18-19.

Gindertael, R. V. "La Conscience au pied du mur." XXe Siècle (Paris), no. 20 (December 1962): 83-86.

Goldberg, Vicki. "Brassaï, Pushed-Back Hat, Spit-Curl, and Cigarette-in-Mouth." Art News (New York) 91, no. 4 (April 1992): 57-58.

———. "All-Conquering Hungarians, Empire or No." New York Times, 3 December 1995, sec. 2, p. 47.

"Graffiti de Brassaï." L'Art vivant (Paris), no. 7 (January 1970): 17.

Grégory, Claude. "Brassaï: Un Gros Oeil rond." Arts: Beaux-Arts, Littérature, Spectacles (Paris), no. 349 (7 March 1952): 10.

Grenier, Roger. "Hommes: Avec Brassaï." Le Nouvel Observateur (Paris), 19 November 1964, 24.

———. "Brassaï." Le Club Français de la Médaille (Paris), no. 45 (4th trimester 1974): 52-58.

■ ———. "Un Gigante della fotografia. Brassaï, 'l'occhio di Parigi,' compie 80 anni: La Grande Occasione mancata di Venezia 1979." Bolaffiarte (Turin) 10, no. 90 (July 1979): 14-20.

Gröbli, René. "Begegnung mit Brassaï." Schweizer Journal (Zurich), September – October 1949, 18-23.

Guerrin, Michel. "Brassaï: L'Oeil vivant." Le Monde (Paris), 24 February 1994, 1.

———. "Une Oeuvre très convoitée." Le Monde (Paris), 24 February 1994, 12.

Guibert, Hervé. "Entretien avec l'auteur: Un Grand Reportage sur la vie humaine." Le Monde (Paris), December 1982, 17.

Guth, Paul. "La Photographie en 1949, a ses écoles d'art. . . ." Figaro Littéraire (Paris), no. 155 (9 April 1949): 1, 4.

Hajdú, Éva. "Az lefolyó élet mozdíthatatlan formája (The Immutable Form of the Passing of Life). Brassaï fotográfiái." Szabadidö Magazin (Budapest) 4 (April 1987): 16-19.

———. "Kepeibol valami mozdulatan, nagy ero sugarzik (From His Pictures Some Great Immutable Power Shines)." Mozgó Képek (Budapest), August 1987, 18.

Hall, Norman. "Opinion: Giant and Others." Photography (London) 17, no. 2 (February 1962): 5.

Hannon, Brent. "Les Roseaux." Le Courrier de l'Unesco (Paris), no. 2 (November 1958): 8.

Izawa, Kohtaro. "Brassaï: Graffiti parisiens." Nippon Camera (Tokyo), January 1988, 142.

Jolis, Alan. "Vasari Diary: Picasso's Organic Chaos." Art News (New York) 95, no. 8 (September 1996): 31-32.

Kasser, Hans. "Brassaï: Paris as Seen by the Camera." Caméra (Lucerne), no. 9 (September 1949): 259-72. Published in English, French, and German.

Kemp, Wolfgang. "Images of Decay: Photography in the Picturesque Tradition." October (Cambridge, Massachusetts), no. 54 (fall 1990): 103-33, especially 114-16. German version, "Bilder des Verfalls: Die Fotographie in der Tradition des Pittoreken," in Foto-Essays, by Wolfgang Kemp, Munich: Schirmer/Mosel, 1978.

Kertész, André. "Brassaï." Infinity (New York) 15, no. 7 (July 1966): 4-13.

Klein, Roger. "Brassaï . . . Eye of Paris." Photography (Chicago) 1, no. 1 (1947): 42-44, 114, 116.

• Kovács, János. "Párizsi Látogatás Brassaïnál." Korunk (Kolozsvár, Rumania), March 1968, 402-5.

Krauss, Rosalind. "Nightwalkers." Art Journal (New York) 41, no. 1 (spring 1981): 33-38. Partially reprinted in Modern Arts Criticism: A Biographical and Critical Guide to Painters, Sculptors, Photographers and Architects from the Beginning of the Modern Era to the Present, edited by Joann Prosyniuk, vol. 1, Detroit: Gale Research, 1991, 150-52. French version, "Les Noctambules," in Le Photographique: Pour une Théorie des Ecarts, Paris: Macula, 1990, 138-53.

Lahs-Gonzales, Olivia. "Brassaï." The Saint Louis Museum of Art Bulletin 21, no. 4 (spring 1996): 12-13.

Lepage, Jacques. "Brassaï ou l'oeil insatiable." Aujourd'hui (Paris), no. 49 (April 1965): 41.

• Loehwing, David. "Brassaï, eternal amateur." Photography (Los Angeles), 1952, page numbers undetermined.

Loengard, John. "Shooting Past 80: Six Great Photographers Born in the 19th Century Are Still Going Strong." Life (New York) 5, no. 5 (May 1982): 115-26, especially 118-19. Japanese version, "Shooting Past," Asahi Camera (Tokyo), August 1982, 91, 94-95.

Mac Orlan, Peter. "La Photographie et la poésie du monde." Mercure de France (Paris), 1 February 1953, 305-8.

Magala, Slawomir. "Konstrukcja przestrzeni spolecznej w fotografii (Construction of the Social Space in Photography)." Fotografia (Warsaw), no. 15 (1979): 8-9.

Merzeau, Sylvie. "Things in Convulsion: Fantasms and Modernism." La Recherche Photographique (Paris), no. 15 (fall 1993): 16-21.

Metken, Günter. "Paris: Fassaden, Spuren, Bilder/Paris: Façades, Traces, Images." Daidalos (Guetersloh, Germany), no. 6 (15 December 1982): 10-21.

• Michaud, Paul R. "Brassaï at 80." Paris Métro (Paris), 11 September 1976, 7, 8, 18.

"[Minutes from the American Society of Magazine Photographers' 1966 Memorial Awards Ceremony, 25 May, 1966]." ASMP Bulletin (New York), 1966, page numbers undetermined.

Mituyosi, Natsuya. "[Who's Who: Foreign Photographers in the Twentieth Century]." Asahi Camera (Tokyo), January 1978, 319.

• Mortimer, Raymond. "Portrait of a Master." Times (London), 16 April 1967, page numbers undetermined.

Nibuya, Takashi. "Brassaï." Art Vivant 22: Special Report: Le Minotaure (Tokyo), 1986, 86-87.

Nuridsany, Michel. "Brassaï à l'oeil de Paris." Le Figaro (Paris), 9 – 10 October 1976, 15.

Parella, Lou, ed. "Brassaï: Faithful Chronicler of Life." U. S. Camera (New York), February 1955, 77-83.

• Petkanas, Christopher. "Brassaï at 83: I Have Things to Do." Women's Wear Daily (New York), 8 – 15 October 1982, 16-17.

Pia, Pascal. "Américains hors-série." Carrefour (Paris), 26 February 1976, 12-13.

Plécy, Albert. "Le Salon permanent de la photo: Hommes d'images: 12: Brassaï." Point de Vue, Images du Monde (Paris), no. 341 (16 December 1954): 17-19.

———. "Brassaï." Galerie (Paris), no. 98 (November 1970): 81-84.

Plécy, Albert, and Jean-Claude Gautrand. "Le Salon permanent de la photo: Les Grands Maîtres de l'art photographique: Brassaï (I)." Point de Vue, Images du Monde (Paris), 6 September 1974, 18-19.

———. "Le Salon permanent de la photo: Les Grands Maîtres de l'art photographique: Brassaï (II)." Point de Vue, Images du Monde (Paris), 13 September 1974, 18-19.

———. "Le Salon permanent de la photo: Les Grands Maîtres de l'art photographique: Brassaï (III)." Point de Vue, Images du Monde (Paris), 20 September 1974, 18-19.

Pollack, Peter. "Brassaï." Art Photography (Chicago) 8 (October 1956): 4-11, 49.

———. "A Favorite Photograph." Chicago American, 13 January 1957, Pictorial Living Magazine, 2.

Putnam, Jacques. "Graffiti vus par Brassaï." XXe Siècle (Paris), no. 18 (February 1962): supplement.

Quasha, Jill. "The Avant-Garde Eye." Antique Collector (London) 61, no. 9 (September 1990): 110-13.

de R., B. "Brassaï en vente publique." Le Figaro (Paris), 11 March 1994, 25.

Rado, Charles. "2 Paris Photographers." Modern Photography (Cincinnati), February 1950, 50-55, 114.

Robertson, Bryan. "When Paris Looked Like a Photograph by Brassaï." Art Newspaper (London) 4, no. 29 (June 1993): 17.

• Rousseau, François-Olivier. "Je n'éprouvais que du mépris pour la photographie." L'Égoïste (Paris), May 1983, 2.

• Roy, Claude. "Brassaï, les yeux fertiles." Libération (Paris), 2 December 1952, page numbers undetermined.

• Scimé, Giuliana. "Quale erotismo: Brevi note per una storia della fotografia erotica." Zoom (Milan), no. 76 (December 1987 – January 1988): 98-105.

————. "I Maestri della fotografia: Brassaï: Dossier." Progresso Fotografico (Milan), February 1992, special supplement on Brassaï.

Seaver, Richard. "Brassaï: Four Wall Faces, a Folio." Merlin (Paris) 2, no. 2 (autumn 1953): 105-8.

Seres, Attila. "A Fény Városának szerelmesei." Népslabadság (Hungary), 19 July 1995, page numbers undetermined.

• Soucek, Ludwig. "Brassaï aneb cesta od slozitosti. . . ." Suétova Literatura (Czechoslovakia), no. 1 (1962): page numbers undetermined.

Szilágyi, Júlia. "Párizs Szeme – Brassaï." Korunk (Kolozsvár, Romania), no. 12 (1962): 1484-86.

• Thornton, Gene. "Paris: The Photographer's Dream." Réalités (Horsham, Pennsylvania), no. 3 (September – October 1980): 54-63.

Tominaga, Soichi. "[Brassaï]." Camera Mainichi (Tokyo), no. 9 (September 1957): 130.

Vestal, David. "Picture Layout." Photo Techniques (Niles, Illinois), March – April 1998, 14-15.

Vinkó, Jósef. "Korunk lelkiismerete: az emlékirat (Memoirs Are the Conscience of Our Age)." Elet és Irodalom (Budapest), 21 May 1977, 7.

Wanaverbecq, Annie-Laure. "Les Photographes étrangers dans la France de l'entre-deux-geurres." Histoire de l'Art (Paris), no. 15 (1991): 61-77.

Watterson, Zdenka. "Der grosse Photo-Reporter von Paris: Ein Besuch im Atelier Brassaï." Prager Presse (Prague), 21 August 1932, 6. Republished as "Páristól Newyorkig vált ismertté egy Brassóból elindult fiatal magyar müvész," Brassói Lapok (Brassó), 15 September 1932, 3.

Individual Exhibition Catalogues and Brochures
See also Collections of Brassaï Works

Brassaï. Curated and preface by Peter Pollack. Chicago: The Art Institute of Chicago, 1954.

Language of the Wall: Parisian Graffiti Photographed by Brassaï. Preface by Roland Penrose. Essay by Brassaï. London: The Institute of Contemporary Arts, 1958. Essay reprinted in Graffiti, Paris: Flammarion, 1993, 142.

Brassaï: Graffiti. Text by François Mauriac. Rome: L'Obelisco, 1962.

Brassaï. Preface by Julian Cain. Texts by Jean Adhémar and Alex Gambier. Paris: Bibliothèque Nationale, 1963.

Cet Homme Brassaï. Lacoste: Galerie Les Contards, 1967.

Brassaï. Curated and preface by John Szarkowski. Text by Lawrence Durrell. New York: The Museum of Modern Art, 1968. Preface reprinted in "Observing the Mechanical Eye," by Samuel Wagstaff, Art News (New York) 79, no. 4 (April 1980): 71. Durrell essay partially reprinted in "Brassaï," Harper's Bazaar (New York), December 1968, 134, 171.

Brassaï. Sculptures, tapisseries, dessins. Preface by Gaston Diehl. Paris and Lyon: Galerie Verrière, 1972.

Brassaï: A Major Exhibition. Curated and introduction by Sue Davis. Text by Bill Brandt. London: The Photographer's Gallery, 1979.

Brassaï: Artists and Studios. Unsigned text. New York: Marlborough Gallery, 1979.

Brassaï. Texts by Taro Okamoto, Ito Toshiharu, and Ryuichi Kaneko. Tokyo: Asahi Shimbun, 1984.

Brassaï. Text by Pierre Borhan. Budapest: Galerie Adolf Fényes, 1985.

Picasso vu par Brassaï. Curated by Anne Baldassari. Texts by Marie-Laure Bernadac and Jean-François Chevrier. Paris: Musée Picasso, 1987.

Paris tendresse. Text by Patrick Modiano. Paris: Éditions Hoëbeke, 1990. Japanese edition, Tokyo: Libro Port, 1991. Exhibition 1988.

Brassaï: Paris le jour, Paris la nuit. Curated by Françoise Reynaud. Text by Kim Sichel. Paris: Musée Carnavalet, 1988.

Brassaï. Curated and introduction by Robert L. Kirschenbaum. Texts by Brassaï, Taro Okamoto, Koji Shirai, Ryuichi Knecko, and Gilberte Brassaï. Tokyo: Pacific Press Service, 1990.

Brassaï. The Eye of Paris: Vintage Photographs. Curated and preface by Edwynn Houk. Texts by Gilberte Brassaï and David Travis. New York: Houk Friedman Gallery, 1993.

Brassaï: Del Surrealismo al informalismo. Curated and text by Manuel J. Borja-Villel. Additional texts by Dawn Ades, Jean-François Chervrier, and Edouard Jaguer. Barcelona: Fundació Antoni Tàpies, 1993. Includes numerous reprints and excerpts from Brassaï's writings, which are referenced in the entries of the originals. English edition, Brassaï: From Surrealism to Art Informel, Barcelona: Fundació Antoni Tàpies, 1993. German edition, Brassaï: Vom Surrealismus zum Informel, Salzburg: Welz, 1994.

Group Exhibition Catalogues and Brochures

See also Collections of Brassaï Works

Formes nues. Texts by various photographers. Paris: Éditions d'art graphique et photographique, 1935, plates 12-13. In English, French, and German.

Exposition Internationale de la photographie contemporaine. Preface by Abel Bonnard. Text by Potonniée. Paris: Musée des Arts Décoratifs, Pavillon de Marsan, 1936, 14.

Photography, 1839–1937. Curated and text by Beaumont Newhall. New York: The Museum of Modern Art, 1937, 112, plate 57.

Vakfotografie 1950: Internationale Foto Tentoonstelling. Introduction by Arn. Van der Heijden. Text by Martien Coppens. Eindhoven: Stedelijk van Abbe Museum, 1950.

Subjektive Fotografie. Curated and text by Otto Steinert. Saarbücken: Staatliche Schule für Kunst und Handwerk, 1951.

Welt-Ausstellung der Photographie, 1952. Lucerne: Luzerner Kunsthaus, 1952.

The Family of Man. Prologue by Carl Sandburg. Curated and introduction by Edward Steichen. New York: The Museum of Modern Art, 1955. Selected editions include the following: Danish edition, Unge meniger om Vi mennesker, Copenhagen: Aschehoug, 1958. Polish edition, Komentarze do fotografii, Kraków: Wydawn. Literackie, 1962. Thirtieth Anniversary edition, New York: The Museum of Modern Art, 1986. Spanish edition, Las razas humanas: 500 pueblos, como son y donde viven, Barcelona: Editorial Noguer, 1990. Japanese edition, Tokyo: Fuzambo, 1994. Still in print.

Das naïve Bild der Welt. Baden-Baden: Staatliche Kunsthalle, 1961.

Le Minotaure. Text by Jean-François Revel. Paris: L'Oeil, Galerie d'Art, 1962, no pagination. Available in English. Reprinted in L'Oeil (Paris), no. 89 (May 1962): 66-79, 111.

"Grosse Photographen dieses Jahrhunderts." In Photokina. vol. 2. Cologne: Messe und Austellungs Gemeinschaft, 1963, 48. Texts in English, French, and German.

The Photographer's Eye. Curated and text by John Szarkowski. New York: The Museum of Modern Art, 1966.

Exposition internationale de photographie: Regards sur la terre des hommes/International Exhibition of Photography: The Camera as Witness. Toronto: Southam Press, 1967.

Photography in the Twentieth Century. Curated and edited by Nathan Lyons. New York: Horizon Press and The George Eastman House, 1967, 25.

- Les Amis parisiens d'Henry Miller. Paris: Centre Culturel Américaine, 1972.

Dixième Biennale International d'Art de Menton. Menton: Association Biennale de Menton, 1974.

Onzième Biennale Internationale d'Art de Menton. Texts by John Szarkowski and Roger Grenier. Menton: Association Biennale de Menton, 1976.

- The Photographer and the Artists. Curated and preface by Sidney Janis. New York: Sidney Janis, 1976.

Photographs from the Julien Levy Collection: Starting with Atget. Curated and text by David Travis. Chicago: The Art Institute of Chicago, 1976, 30-31.

Documenta 6. vol. 2. Kassel: Museum Fridericianum, 1977, 114-15.

Diez Grandes Fotógrafos: Bernice Abbott, Eugène Atget, Diane Arbus, Richard Avedon, Herbert Bayer, Bill Brandt, Brassaï, Robert Frank, Irving Penn, Maurice Tabard. Caracas: Museo de Arte Contemporaneo, 1977, no pagination.

Künstlerphotographien im XX Jahrhundert. Texts by Lawrence Durrell, Carl-Albrecht Haenlein, Klaus Honnef, Werner Lippert, and Schuldt. Hannover: Kestner-Gesellschaft, 1977, 64-70. Includes "He is far from being an enigmatic figure . . ." by Lawrence Durrell, 226-30.

Dada and Surrealism Reviewed. Curated and text by Dawn Ades. Introduction by David Sylvester. Additional text by Elizabeth Cowling. London: Hayward Gallery, Arts Council of Great Britain, 1978. Includes an essay on Le Minotaure and summaries of each issue, 296.

Images des hommes: 18 photographes Européens. Texts by Max-Pol Fouchet, René Léonard, and M. Van Audenhove. Brussels: Crédit Communal de Belgique, 1978.

- Livres rares et photographies. Curated by Virginia Zabriskie. Paris: Galerie Zabriskie, 1979.

France between the Wars: 1925–1940. Curated by Virginia Zabriskie. New York: Zabriskie Gallery, 1979, no pagination.

Photographic Surrealism. Curated and text by Nancy Hall-Duncan. Cleveland: The New Gallery of Contemporary Art, 1979, 24-25.

Cliché-verre: Hand-Drawn, Light-Printed: A Survey of the Medium from 1839 to the Present. Curated and text by Elizabeth Glassman and Marilyn F. Symmes. Detroit: The Detroit Institute of Arts, 1980, 128-29.

Les Réalismes, 1919–1939. Curated and text by Alain Sayag, 306-9. Paris: Centre Georges Pompidou, 1980.

Das Imaginäre Photo-Museum: Meisterwerke aus 140 Jahren Photographie. Curated and edited by Renate and L. Fritz Gruber. Texts by Helmut Gernsheim, L. Fritz Gruber, Beaumont Newhall, and Jeane Oppenheim. Cologne: Dumont Buchverlag, 1981, 7-16. English edition, The Imaginary Photo Museum: With 457 Photographs from 1836 to the Present, New York: Crown Publishers, 1982, 5 reproductions, no pagination. Exhibition 1980.

Paris-Paris: Créations en France, 1937–1957. Curated and text by Alain Sayag. Paris: Centre Georges Pompidou, 1981, 484-501.

Photographes de la Belle Epoque: 1842–1968. Texts by Alain Jouffroy and Romes Martinez. Kanagawa: Prefectural Museum of Modern Art, 1982, no pagination.

The Art of Photography: Past and Present from the Collection of The Art Institute of Chicago. Curated and text by David Travis. Osaka: The National Museum of Art, 1984.

Subjektive Fotografie. Curated and text by Ute Eskildsen, Robert Knodt, and Christel Liesenfeld. Essen: Museum Folkwang, 1984.

Das Aktfoto: Ansichten vom Körper im fotografischen Zeitalter. Ästhetik, Geschichte, Ideologie. Edited by Michael Koehler. Munich: Stadtmuseum, 1985.

L'Amour fou: Photography and Surrealism. Curated and text by Rosalind Krauss and Jane Livingston. Additional text by Dawn Ades. Includes "Corpus delicti," by Rosalind Krauss, 57-114. New York: Abbeville Press, 1985. French edition, Explosante-fixe: photographie et surréalisme, Paris: Centre Georges Pompidou, 1985. "Corpus delicti" also published in October (Cambridge, Massachusetts), no. 33 (summer 1985): 31-72.

Elementarzeichen: Urformen visueller Information. Berlin: Verlag Frölich & Kaufmann, 1985, 166-70, 187-88.

Paris-New York-Tokyo. Tokyo: Tsukuba Museum of Photography, 1985, 86-87, 90-91.

In the Mind's Eye: Dada and Surrealism. Catalogue of the exhibition Dada and Surrealism in Chicago Collections. Curated and edited by Terry Ann R. Neff. Text by Dawn Ades, Mary Mathews Gedo, Mary Jane Jacob, Rosalind Krauss, Dennis Alan Nawrocki, and Lowery Stokes Sims. Chicago: Museum of Contemporary Art, 1986. Includes "Photography's Exquisite Corpse," by Rosalind E. Krauss, 43-61. Exhibition 1984.

La Nouvelle Photographie en France, 1919–1939. Curated and text by Christian Bouqueret and Blandine Chavanne. Poitiers: Musée de la Ville de Poitiers et la Société des Antiquaires de l'Ouest, 1986.

L'Oeil du Minotaure: Ubac, Brassaï, Bellmer, Alvarez Bravo, Man Ray. Text by Edouard Jaguer. Geneva: Galerie Sonia Zannettacci, 1987.

Regards sur Le Minotaure: La Revue à tête de bête. Curated and text by Claude Gaume. Geneva: Musée Rath, 1987.

20th Century French Photography. Catalogue of the exhibition Art or Nature: Twentieth Century French Photography. Texts by Agnès de Gouvion Saint-Cyr, Jean-Claude Lemagny, and Alain Sayag. London: Trefoil Publications Ltd., 1988, 34-37, 56-57, 122, 137-41, 152.

The Art of Photography, 1839–1989. Curated by Daniel Wolf and Mike Weaver. Edited by Mike Weaver. New Haven and London: Yale University Press, 1989, plates 264-65, 282-87, 452-53. Japanese edition, edited by Koko Yamagishi, Tokyo: Sezon Museum of Art; Libro Port Publishing Co., Ltd., 1990.

Das Innere der Sicht: Surrealistische Fotografie der 30er und 40er Jahr. Curated and text by Monika Faber. Additional text by Antonín Dufek. Vienna: Museum des 20 Jahrhunderts, 1989, 94-95.

Donations Daniel Cordier: Le Regard d'un amateur. Curated and text by Alain Sayag. Paris: Centre Georges Pompidou, 1989.

Photography until Now. Curated and text by John Szarkowski. New York: The Museum of Modern Art, 1989, 219, 221, 287.

Anxious Visions: Surrealist Art. Curated and text by Sidra Stich and essays by James Clifford, Tyler Stovall, and Steven Kovács. New York: Abbeville Press; Berkeley: University Art Museum, 1990, 35, 37, 110, 114, 236, 285.

The Past and the Present of Photography. Tokyo: National Museum of Modern Art, 1990, 73-75.

André Breton: La Beauté convulsive. Paris: Centre Georges Pompidou, 1991.

Picasso visages. Texts by Marie-Laure Bernadac. Paris: Musée Picasso, 1991. English edition, Faces of Picasso, Paris: Éditions de la Réunion des Musées Nationaux, 1991.

The Paris of Atget, Man Ray, and Brassaï. Tokyo: Tokyo Metropolitan Museum of Photography, 1992, 30-53, 130-31. Includes essay by Fuminori Yokoe, 2-6 (Japanese), 7-11 (English).

Portraits d'une capitale: De Daguerre à William Klein: Collections photographiques du Musée Carnavalet. Curated and text by Françoise Reynaud. Additional texts by Dominique Baqué and Anne Cartier-Bresson. Paris: Paris-Musées; Paris Audiovisuel, 1992, 41, 96, 116-17, 124.

L'Écriture griffée: Antonin Artaud, Brassaï, Victor Brauner, Bernard Buffet, César, Jean Dubuffet, Jean Fautrier. Text by Jacques Beuffet. Paris; Saint-Étienne: Réunion des Musées Nationaux; Musée d'Art Moderne de Saint-Étienne, 1993, 34-41.

Espais existencials: La Mirada apassionada de Daniel Cordier. Una Selección de la donación Daniel Cordier al Musée National d'Art Moderne, Centre Georges Pompidou, Paris. Centre Cultural de la Fundacío "La Caixa," Barcelona, 1993, 33, 34, 142, 143. Introduction by Germaine Viatte. In Catalan and Spanish.

Paris Post War: Art and Existentialism 1945–55. Curated and text by Frances Morris. Additional texts by Sarah Wilson, David Mellor, and Vincent Gille. London: Tate Gallery, 1993.

Yvette Cauquil-Prince: Taller de Tapices. Texts by Daniel Alcouffe, Yvette Cauquil-Prince, Amaury Lefebure, François Mathey, Bella Meyer, Jean-Louis Prat, and Michel Bepoix. Zaragoza, Spain: Felix Arilla, 1993.

Sculpter-Photographier, Photographier-Sculpter. Edited by Michel Frizot and Dominique Païni. Musée du Louvre, Paris: Marval, 1993, 67, 91. Exhibition, 1991.

Kunst des 20 Jahrhunderts: 20 Jahre Wittrock Kunsthandel: 20 Werke. Texts by Daniel Bell and Matthias Mansen, John Richardson, Andreas Ruby, and Wilfried Wiegand. Dusseldorf: Wolfgang Wittrock Kunsthandel, [1994], 56-59.

Photo Dessin Dessin Photo: Le Dessin photographique. Texts by Serge Bramly, Alain Sayag, and Agnès de Gouvion Saint-Cyr. Arles: Actes Sud, 1994, 55-63, 93-94.

Les Heures chaudes de Montparnasse. Text by Jean-Marie Drot. Paris: Fondation Electricité de France, 1995, 199-214, 251.

Picasso et la photographie: "À plus grande vitesse que les images." Curated and text by Anne Baldassari. Paris: Éditions de la Réunion des musées nationaux, 1995, 175-89.

L'Informe: Mode d'emploi. Curated and texts by Yves Alain Bois and Rosalind Krauss. Paris: Centre Georges Pompidou, 1996, 33, 76, 106, 140, 142-43, 144, 243. English edition, Formless: A User's Guide, New York: Zone Books, 1997.

Le miroir noir: Picasso, sources photographiques, 1900–1928. Curated and text by Anne Baldassari. Paris: Éditions de la Réunion des musées nationaux, 1997, 250, 252-53, 261.

Picasso and Photography: The Dark Mirror. Curated and text by Anne Baldassari. Translated by Deke Dusinberre. Paris; New York: Flammarion and the Museum of Fine Arts, Houston, 1997, 189-90, 192, 233. Based on three exhibition catalogues by the author: Picasso photographe (1994), Picasso et la photographie (1995), and Le miroir noir (1997). German edition, Picasso und die Photographie, Munich: Schirmer/Mosel, 1997. Italian edition, Picasso e la Fotografia lo specchio nero, Florence: Alinari, 1998. Japanese edition, Picasso et la photographie, Tokyo: Asahi Shimbun, 1998.

The Surrealist Vision: Europe and the Americas. Curated and text by Nancy Hall and Sam Hunter. Greenwich, Connecticut: Bruce Museum of Arts and Science, 1998, 25-26.

Reviews and Previews of Brassaï Exhibitions

Paris de nuit, Batsford Gallery

"Week by Week: Paris by Night." Listener (London), 28 June 1933, 1012, 1035.

"Paris de Nuit." Times (London), no. 46, 485 (1 July 1933): 10.

Groupe annuel des photographes, Galerie de la Pléiade

"L'Exposition du 'Groupe amical des photographes.'" Le Petit Journal (Paris), no. 26, 235 (14 November 1934): 8.

G. "L'Art photographique." L'Intransigeant (Paris), 29 November 1934, 6.

L'Humour et le fantastique par la photographie, Galerie de la Pléiade

Sougez, Emmanuel. "L'Humour et le fantastique par la photographie." Photo-Ciné-Graphie (Paris), no. 26 (8 April 1935): 12-13.

Formes nues, Galerie Bollard

Gilson, Paul. "L'Art photographique: Formes nues." L'Intransigeant (Paris), 7 April 1935, 6.

Documents de la vie sociale, Galerie de la Pléiade

Le Cousin Pons. "Les Arts: L'Art photographique." L'Intransigeant (Paris), 30 May 1935, 4.

Aragon. "Un Salon 'photographique.'" Commune (Paris), no. 22 (June 1935): 1189-92.

Dabit, Eugène. "A Propos d'une exposition." Regards (Paris), 6 June 1935, 11.

"A 'Revolutionary' Exhibition of Life: Paris Photographers Picture Work and Misery." Photography (London), September 1935, 12.

Exposition internationale de la photographie contemporaine, Pavillon de Marsan

"Une Exposition internationale de la photographie." Le Petit Journal (Paris), 17 January 1936, page numbers undetermined.

"Photographie contemporaine." La Liberté (Paris), 17 January 1936, page numbers undetermined.

Gilson, Paul. "La Photographie au Pavillon Marsan." L'Intransigeant (Paris), 20 January 1936, page numbers undetermined.

Moutard-Uldry, Renée. "La Photo au musée." Beaux-Arts (Paris), 24 January 1936, page numbers undetermined.

"La Photo consacrée." Télégramme (Boulogne-sur-Mer), 29 January 1936, page numbers undetermined.

"Vie parisienne: Une Exposition internationale de la photographie au Pavillon de Marsan." Dernières Nouvelles (Strasbourg), 2 February 1936, and Journal de Thann (Thann), 8 February 1936, page numbers undetermined.

Cheronnet, Louis. "La Photographie: Image de la vie: Une Exposition internationale au Pavillon de Marsan." Vu (Paris), no. 412 (5 February 1936): 155-62.

Les Dix, ou La Photographie vivante, Galerie Leleu

Guenne, Jacques. "La Photographie vivante: Les Dix." Review of Pavillon de Marsan exhibition and preview of Galerie Leleu exhibition. L'Art Vivant (Paris), March 1936, 37ff.

"L'Art vivant." Le Bien Public (Dijon), 31 March 1936, page numbers undetermined.

Moutard-Uldry, Renée. "La Photographie: Le Groupe des Dix." Beaux-Arts (Paris), no. 170 (3 April 1936): 3.

Fegdal, Charles. "Les Dix ou la photographie vivante." Semaine à Paris (Paris), no. 723 (3 – 9 April 1936): 55.

L'Envers des grandes villes, Galerie de la Pléiade

Fegdal, Charles. "[Review of L'Envers des Grandes Villes]." Semaine à Paris (Paris), no. 770 (26 February – 4 March 1937): 47.

Le Cousin Pons. "Les Arts." L'Intransigeant (Paris), 5 March 1937, 2.

Lambert, Lydia. "Nuit et jour: L'exposition grandit." Regards (Paris), no. 169 (8 April 1937): 12-13.

Photography, 1839–1937, The Museum of Modern Art (traveling exhibition)

"Les Artistes parisiens à l'Exposition de la Photographie de New York." Presse Publicité (Paris), 25 April 1937, 14.

Brassaï: Dessins, Galerie Renou et Colle

"New Art in Paris." Photograph and Drawing by Brassaï. Unsigned commentary. Vogue (New York), 1 November 1945, 174.

French Photography Today, Photo League

"France through French Cameras." New York Times, 4 April 1948, 16-17.

"[French Photography Today]." Photo Notes (New York), June 1948, 1. Reprinted in Photo Notes: February 1938 – Spring 1950/Film Front: December 1934 – March 1935, Rochester, New York: Visual Studies Workshop, 1977, original pagination.

Newhall, Beaumont. "Chasseurs d'images." Photo Notes (New York), June 1948, 3. Reprinted in Photo Notes: February 1938 – Spring 1950/Film Front: December 1934 – March 1935, Rochester, New York: Visual Studies Workshop, 1977, original pagination.

Stettner, Louis. "French Photography Today." Photo Notes (New York), June 1948, 2. Reprinted in Photo Notes: February 1938 – Spring 1950/Film Front: December 1934 – March 1935, Rochester, New York: Visual Studies Workshop, 1977, original pagination.

Troisième Salon National de la Photographie, Bibliothèque Nationale

"Troisième Salon Nationale de la Photographie." Photo-Cinéma (Paris), no. 566 (December 1948): 8-page insert, no pagination.

Cinquième Salon National de la Photographie, Bibliothèque Nationale

Champigneulle, Bernard. "Le Salon National de la Photographie à la Bibliothèque Nationale." France-Illustration (Paris), no. 263 (28 October 1950): 462-65.

Sixième Salon National de la Photographie, Bibliothèque Nationale

Coursaget, René. "Choses et gens de France: Au Sixième Salon Nationale de la Photographie, Bibliothèque Nationale." Photo-Cinéma (Paris), no. 600 (October 1951): 242-48.

Five French Photographers: Brassaï, Cartier-Bresson, Doisneau, Ronis, Izis, The Museum of Modern Art

Deschin, Jacob. "The Work of French Photographers." New York Times, 23 December 1951, 14.

"Brassaï." In "Four French Photographers." Introduction by Edward Steichen. Photographs by Brassaï. In U. S. Camera 1952. New York: U. S. Camera, 1952, 10-31.

———. "L'Exposition de cinq photographes français à New York." Photo-Cinéma (Paris), no. 606 (April 1952): 80-81.

Vingt Hommes d'images, Gallery Craven

Masclet, Daniel. "Les Maîtres de la caméra: Interviewes expresses." Photo-Cinéma (Paris), no. 615 (January 1953): 1-10.

F., D. "Un Grand Artiste parmi les photographes." Journal de Genève (Geneva), no. 14 (17 – 18 January 1953): 7.

Photographs by Brassaï, The Art Institute of Chicago (traveling exhibition)

▪ "One-Man Photo Show." Chicago Sun-Times, 15 November 1954, page numbers undetermined.

Shapiro, Karl. "Brassaï: Poetic Focus on France." Review of Walker Art Center exhibition. Art News (New York) 53, no. 10 (February 1955): 46-47, 69-70. Reprinted in Modern Arts Criticism: A Biographical and Critical Guide to Painters, Sculptors, Photographers and Architects from the Beginning of the Modern Era to the Present, edited by Joann Prosyniuk, vol. 1, Detroit: Gale Research, 1991, 143-44.

The Family of Man, The Museum of Modern Art (traveling exhibition)

▪ Kramer, Hilton. "Exhibiting the Family of Man." Commentary, October 1955, page numbers undetermined.

Brassaï, Hansa Gallery

T., P. "Brassaï." Art News (New York) 55, no. 3 (May 1956): 57.

Language of the Wall, The Museum of Modern Art (traveling exhibition)

Deschin, Jacob. "Brassaï Pictures: Scribblings on Walls Subject of New Show." New York Times, 28 October 1956, 19.

"Brassaï présente les graffiti de Paris au Musée de New York." Parisien Libéré (Paris), 5 November 1956, 6.

Roberts, Colette. "Images et Signes: Graffiti de Brassaï." France-Amérique (New York), no. 191 (11 November 1956): 15.

"Brassaï." New Yorker 32, no. 40 (24 November 1956): 44-45.

Braive, Michel-François. "Photo 22 x 56." Combat (Paris), 27 December 1956, 3.

▪ Skogholm, Carl Werner. "Cave Art in the Street." Politiken (Copenhagen), 14 December 1957, page numbers undetermined.

"Brassaï Photographs the Wall Drawings of Paris." Times (London), 29 September 1958, 6.

Butcher, George. Art News and Review (London), 11 October 1958, 10.

Melville, Robert. "London." Review of Institute of Contemporary Arts exhibition. Arts (New York) 33, no. 2 (November 1958): 19, 21.

Brassaï: Graffiti, Galerie Daniel Cordier

▪ Ashbery, John. "Photos Rival Paintings in Paris Shows." New York Herald Tribune (Paris), 24 January 1962, 6.

Mellquist, Jerome. "A Paris Letter." Apollo (London) 76, no. 1 (March 1962): 68-70, especially 69.

Graffiti, L'Obelisco, Rome

▪ Rinaldini, Angelo. "I Graffiti di Brassaï." Il Mondo (Rome), 12 May 1962, page numbers undetermined.

Brassaï, Bibliothèque Nationale (traveling exhibition)

Descargues, Pierre. "Brassaï célébré à la Nationale." Tribune de Lausanne (Lausanne), 5 May 1963, 6.

Girod de l'Ain, Bertrand. "Brassaï et Paris la nuit." Le Monde (Paris), 10 May 1963, 14.

Plécy, Albert. "Le Salon permanent de la photo: Brassaï." Point de Vue, Images du Monde (Paris), no. 779 (17 May 1963): 18-19.

Valogne, Catherine. "Un Photographe à la Nationale: Brassaï." Les Lettres Françaises (Paris), 30 May 1963, 11.

Masclet, Daniel. "Le Cas Brassaï." Le Photographe (Paris), no. 87 (20 June 1963): 316.

"Brassaï fixe le monde depuis trente ans." Nice-Matin (Marseilles), 3 August 1963, page numbers undetermined.

Bomy, Jean. "La Photographie est un art: Brassaï." Nice-Matin (Marseilles), no. 5839 (10 August 1963): 9.

[Brassaï], Josie Péron

Mora, Edith. "Brassaï: L'Oeil et la Main." Nouvelles Littéraires (Paris), no. 1968 (20 May 1965): 2.

Brassaï, The Museum of Modern Art (traveling exhibition)

Deschin, Jacob. "Brassaï Looks Back to 1930s." New York Times, 3 November 1968, D35.

Coleman, A. D. "Latent Image." Village Voice (New York) 14, no. 5 (14 November 1968): 16.

▪ Gruen, John. "Brassaï, Paris in the Shadows." New York Magazine, 18 November 1968, 19.

"Brassaï: Early Master of the Underground." Modern Photography (Cincinnati), December 1968, 48-49.

T., N. "Brassaï: Toute la réalité." La Presse (Montreal), 4 January 1969, page numbers undetermined.

Brassaï: Dessins, sculptures, gravures, et une tapisserie, La Boétie Gallery

L., M. "Brassaï." Art News (New York) 67, no. 8 (December 1968): 15.

Brassaï, L'Art mural: Trente couleurs inédites,
Galerie Rencontre (traveling exhibition)

Gauthier, Maximilien. "Brassaï au pied du mur." Les Nouvelles
Littéraires (Paris), no. 2247 (15 October 1970): 11.

Bouret, Jean. "Sept jours avec la peinture: Mardi-Mercredi." Les
Lettres Françaises (Paris), no. 1356 (21 – 27 October 1970): 32.

Deschaumes, Jacques. "De Botticelli à Brassaï." Revue des Deux
Mondes (Paris), November 1970, 477.

Grenier, Roger. "Les Murs de Brassaï." La Quinzaine Littéraire
(Paris), no. 105 (1 – 15 November 1970): 18.

Keim, Jean. "Des Expositions: Brassaï." Photo-Ciné Revue
(Paris), December 1970, 53, 538.

Cinquième Biennale internationale de la tapisserie,
Musée Cantonal des Beaux-Arts

Elgar, Frank. "Peu de tapisseries dans une prolifération
d'extravangances et de futilités." Carrefour (Paris), June
1971, 15.

Boudaille, Georges. Les Lettres Françaises (Paris), no. 1392,
30 June – 6 July 1971, 24-25.

Kohler, Arnold. "À Lausanne, triomphe de la nouvelle tapisserie."
Tribune de Genève (Geneva), no. 149 (30 June 1971): 17.

Imbourg, Pierre. "Des Tapisseries qui n'en sont pas." L'Amateur
d'Art (Paris), no. 479-80 (July – August 1971): 11.

Lerrant, Jean-Jacques. "A La Cinquième Biennale de Lausanne:
La Tapisserie en pleine liberté créatrice, devient objet et
environnement." Le Progrès Dimanche (Lyon), no. 950 (4 July
1971): 14.

Grand, P. M. "Les chances du meilleur à la biennale de Lausanne."
Le Monde (Paris), 7 July 1971, 11.

Brassaï, **Robert Schoelkopf Gallery**

Coleman, A. D. "Brassaï Uncovers the Hidden Life." New York
Times, 26 September 1971, 31.

Gruen, John. "Master of All Masters." New York Magazine 4,
no. 41 (11 October 1971): 69.

Brassaï, **Lunn Gallery**

Tamashiro, Sam. "Photos by Brassaï." Washington Post,
29 February 1972.

Lewis, Jo Ann. "Brassaï's World: Lasting Images of Paris."
Evening Star (Washington, D. C.), no. 62 (2 March 1972): 10.

Brassaï: Dessins, sculptures, tapisseries,
Galerie Verrière (traveling exhibition)

Lévêque, Jean-Jacques. "L'Oeil de Brassaï." La Galerie (Paris),
March 1972, 24-25.

"La lettre d'information: Les Oeuvres flottantes de Brassaï."
Connaissance des Arts (Paris), no. 241 (March 1972): 20-21.

Bouret, Jean. "Sept jours avec la peinture: Vendredi-Samedi."
Les Lettres Françaises (Paris), no. 1428 (22 – 28 March 1972): 32.

Lévêque, Jean-Jacques. "Une Riche Semaine." Le Nouveau
Journal (Paris), 25 March 1972, 19.

Crespelle, J.-P. "La Photo a mené Brassaï à la tapisserie et à la
sculpture." France-Soir (Paris), 31 March 1972, 7.

Daleveze, Jean. "Polie par l'onde." Les Nouvelles Littéraires
(Paris), no. 2323 (3 – 10 April 1972): 22.

Diehl, Gaston. "Brassaï." XXe Siècle (Paris), no. 38 (June 1972):
67-71.

Deroudille, René. "Brelan d'as: Brassaï, Albers et Maxime Darnaud."
Dernière Heure Lyonnaise (Lyon), no. 8793 (19 March 1973): 7.

————. "Expositions: Brassaï." Le Tout Lyon et le
Moniteur Judiciaire (Lyon), no. 1680 (19 March 1973): 5.

Lerrant, Jean-Jacques. "Les Expositions: Brassaï." Le Progrès
(Lyon), no. 38, 909 (19 March 1973): 11.

Brassaï: The Eye of Paris, **Corcoran Gallery of Art
(traveling exhibition)**

Richard, Paul. "Brassaï: 'The Eye of Paris.'" Review of Corcoran
Gallery exhibition. Washington Post, 2 June 1973, B1, B7, col. 5.

Kamienski, Jan. "Brassaï's Photography Persuasive." Review of
Winnipeg Art Gallery exhibition. Winnipeg Tribune, 4 May 1974,
page numbers undetermined.

Murray, Joan. "The Eye of Paris." Review of University Art
Museum, Berkeley exhibition. Artweek (Oakland, California) 5,
no. 26 (27 July 1974): 11-12.

"The Eye of Paris." Review of Hayden Gallery, Massachusetts
Institute of Technology exhibition. The Harvard Crimson
(Cambridge, Massachusetts), 26 October 1974, page numbers
undetermined.

Rossell, Deac. "Brassaï's Paris Featured in Retrospective." Boston
Globe, 15 November 1974, page numbers undetermined.

Brassaï, Wolfgang Wittrock Kunsthandel

Wiegand, Wilfried. "Die Botschaft der Mauren: Fotografien von Brassaï in Düsseldorf." Frankfurter Allgemeine Zeitung (Frankfurt), 29 January 1974, 20. Reprinted in Kunst des 20 Jahrhunderts: 20 Jahre Wittrock Kunsthandel: 20 Werke, Dusseldorf: Wolfgang Wittrock Kunsthandel, [1994], 57.

Brassaï, Musée Réattu

Grenier, Roger. "Les Nuits de Brassaï." Vu (Paris), no. 3 (September 1974): 8-10.

Three Cities: Bill Brandt, Brassaï, Berenice Abbott, Marlborough Gallery

Deschin, Jacob. "Abbott, Brandt, Brassaï at Marlborough." Photo Reporter (New York) 5, no. 11 (November 1975): 5.

Brassaï and Kertész, Phoenix Gallery

Murray, Joan. "Brassaï and Kertész." Artweek (Oakland, California) 6, no. 44 (20 December 1975): 13.

The Secret Paris of the Thirties, Marlborough Gallery

Deschin, Jacob. "Brassaï at Marlborough." Photo Reporter (New York) 6, no. 9 (September 1976): 1, 2.

Kramer, Hilton. "Brassaï: The High Art of Photographing Low-Life in Paris." New York Times, 19 September 1976, sec. 2, pp. 1, 34.

Stevens, Nancy. "Brassaï Made Pictures of Love and Amazement." Village Voice (New York) 21, no. 39 (27 September 1976): 92-93.

Deschin, Jacob. "Brassaï Unveils Parisian Night Life in the 1930s." Photo Reporter (New York) 6, no. 10 (October 1976): 7.

Urdang, Beth. "Brassaï." Arts Magazine (New York) 51, no. 2 (October 1976): 7.

Davis, Douglas. "Two Visionaries." Newsweek (Dayton, Ohio; New York) 88, no. 16 (18 October 1976): 109-13.

Huser, France. "Les Minuits de Brassaï." Le Nouvel Observateur (Paris), no. 624 (25 October 1976): 104-5.

Patton, Phil. "Brassaï at Marlborough." Art in America (New York) 64, no. 6 (November – December 1976): 117-18.

Normile, Irka. "Parisian Pleasures: The Secret Paris of the 30s." Afterimage (Rochester, New York), December 1976, 12-13.

Westerbeck, Colin L., Jr. "Night Light: Brassaï and Weegee." Artforum (New York) 15, no. 4 (December 1976): 34-45. Partially reprinted in Modern Arts Criticism: A Biographical and Critical Guide to Painters, Sculptors, Photographers and Architects from the Beginning of the Modern Era to the Present, edited by Joann Prosyniuk, vol. 1, Detroit: Gale Research, 1991, 144-47. Also published in Photography in Print: Writings from 1816 to the Present, edited by Vicki Goldberg, New York: Simon and Schuster, 1, 404-19.

"Vie des arts: Galeries: Zurich." L'Oeil (Paris), no. 258-59 (January – February 1977): 55.

A Tale of Three Cities, Van Straaten Gallery

Elliot, David. "Abbott, Brandt and Brassaï: City Visions." Chicago Daily News, no. 57 (8 March 1977): 17.

Appearances, Marlborough Gallery

Thornton, Gene. "The Changing Faces of Portraiture." New York Times, 27 February 1977, 26.

Photographie française: Le nouvel esprit 1925–1940, Galerie Zabriskie

Laude, André. "La Photographie française de 1925 à 1940." Nouvelles Littéraires (Paris), no. 2666 (21–28 December 1978): 28.

[Brassaï], Akron Art Institute

- Kravitz, Lee. "Brassaï Photographs." Dialogue (Ontario), May – June 1979, 17-20.

Brassaï: Artists and Studios, Marlborough Gallery

Kramer, Hilton. "Three Masters of the Photo in Review." New York Times, 7 September 1979, sec. 3, pp. 1, 26.

French-Frazier, Nina. "New York Exhibitions: Brassaï." Art International (Lugano) 23, no. 8 (December 1979): 36-37.

Brassaï, The Photographer's Gallery (traveling exhibition)

Senn, Peter. "The Dark Side of a City." Daily Mirror (London), 9 November 1979, 6.

Feaver, William. "The Eye of Brassaï." Observer Magazine (London), 11 November 1979, 82-85, 87, 89.

Mayes, Ian. "Brassaï." Birmingham Post (Birmingham, England), 20 November 1979, page numbers undetermined.

Januszcsak, Waldemar. "The Transylvanian and the People of the Night." Arts Guardian (London), 23 November 1979, 11.

McEwan, John. "Octogenarian." Spectator (London), 24 November 1979, 25.

Nuridsany, Michel. "Brassaï: Le Toulouse-Lautrec de la photo." Le Figaro (Paris), 28 November 1979, 28.

Nurnberg, Walter. "Viewed: Brassaï at the Photographer's Gallery." British Journal of Photography (Liverpool; London) 126, no. 6229 (14 December 1979): 1208-9.

Evans, Tom. "Photography." Art and Artists (London) 14, no. 9, iss. 166 (January 1980): 26-31.

Reed, David. "Brassaï's Paris." Afterimage (Rochester, New York) 7, no. 7 (February 1980): 14.

Brassaï, Zeit-Foto Salon

Kuwabara, Kineo. "Photo Exhibition Reviews." Nippon Camera (Tokyo), December 1979, 134-35.

Brassaï: The Eye of Paris, Edwynn Houk Gallery

Lukitsch, Joanne M. "Reviews in Brief: Chicago: Brassaï: The Eye of Paris." New Art Examiner (Chicago: Midwest Edition) 8, no. 6 (March 1981): 17.

Photographes de la Belle Epoque: 1842–1968, Kanagawa Prefectural Museum of Modern Art

"[Review of Photographes de la Belle Epoque exhibition]." Asahi Camera (Tokyo), December 1982, 178.

The Artists of My Life, Marlborough Gallery

Spalding, Frances. Arts Review (London) 34, no. 20 (24 September 1982): 479.

Ellis, Ainslie. "Artists and Photographers." British Journal of Photography (Liverpool; London) 129, no. 6, 378 (29 October 1982): 1158-62.

Hommage à Brassaï, Marlborough Gallery, and Celebrations, Zabriskie Gallery

Grundberg, Andy. "Brassaï Explored More Than the Seedy Life of Paris." New York Times, 23 September 1984, H31.

L'Amour fou: Photography and Surrealism, Corcoran Gallery of Art (traveling exhibition)

Foster, Hal. "L'Amour faux." Art in America (New York) 74, no. 1 (January 1986): 116-28.

Borhan, Pierre. "La Chambre noire." Review of Centre Georges Pompidou exhibition. Beaux-Arts Magazine (Paris), no. 35 (May 1986): 62-67.

Horning, Ron. "An Argument with History." Aperture (New York), no. 103 (summer 1986): 2-7.

Picasso vu par Brassaï, Musée Picasso

"Picasso vu par Brassaï." La Revue du Louvre et des Musées de France (Paris) 37, no. 3 (1987): 222-23.

Pittolo, Véronique. "Picasso sous l'oeil de Brassaï." Beaux-Arts Magazine (Paris), no. 49 (September 1987): 66-69.

Soós, Magda. "Ahogyan Brassaï látta." Elet és Irodalom (Budapest), 15 January 1988, 4.

The New Vision: Photography between the World Wars, The Metropolitan Museum of Art (traveling exhibition)

Hambourg, Maria Morris. "Photography between the Wars: Selections from the Ford Motor Company Collection." Metropolitan Museum of Art Bulletin (New York) 45, no. 4 (spring 1988): 1-56.

Brassaï: Paris le jour, Paris la nuit, Musée Carnavalet, and Paris tendresse, FNAC Forum

Roegiers, Patrick. "Brassaï, la puissance des ténèbres." Le Monde (Paris), supplement no. 13607 (27 October 1988): 1. Also published in L'Oeil Multiple, by Patrick Roegiers, Paris: Éditions la Manufacture, 1992, 82-84.

Hopkinson, Amanda. "Just Celebrating: Paris Shows Brassaï, Cartier-Bresson and Lartigue." Review of Musée Carnavalet exhibition only. Creative Camera (Manchester), no. 6 (1989): 28-31.

Photography until Now, The Museum of Modern Art (traveling exhibition)

Solomon-Godeau, Abigail. "Mandarin Modernism: 'Photography until Now.'" Art in America (New York) 78, no. 12 (December 1990): 140-49, 183.

Brassaï: The Eye of Paris, Houk Friedman Gallery

Goldberg, Vicki. "A Novel's Worth of Complexities in a Single Frame." New York Times 142, no. 49, 277 (21 March 1993): sec. 2, pp. 35-36.

"Photography: Devil's Advocate." New Yorker, 22 March 1993, 20.

Brassaï: Del Surrealismo al informalismo, Fundació Antoni Tàpies (traveling exhibition)

Sand, Michel, and Simon Watney. "Nightlife: Son . . . et Lumière." Artforum International (Paris) 32, no. 6 (February 1994): 15-17.

Guerrin, Michel. "Brassaï relu et corrigé." Le Monde (Paris), 24 February 1994, 12.

Borhan, Pierre. "Brassaï: Paysages de femmes." Review of Centre National de la Photographie exhibition. Beaux-Arts Magazine (Paris), no. 121 (March 1994): 80-85, 133-34. English summary.

Ollier, Brigitte. "Brassaï, le ton de son Paris." Review of Centre National de la Photographie exhibition. Libération (Paris), 17 March 1994, 49.

Marin, Juan. Review of Centre National de la Photographie exhibition. Goya (Madrid), no. 240 (May/June 1994): 365.

"A szurrealizmustol az informelig." Uj Magyarorszag (Budapest), 21 January 1995, page numbers undetermined.

Brassaï, Centre Georges Pompidou

Pittolo, Véronique. "Le Regard tendre de Brassaï." Beaux-Arts Magazine (Paris), no. 132 (March 1995): 120.

Gett, Trevor. "As Bold as Brassaï." British Journal of Photography (Liverpool; London) 142 (1 March 1995): 12-13.

Brassaï: Paris de Nuit, Robert Miller Gallery, New York

Alexander, Stuart. "Brassaï: Paris de Nuit." Katalog (Odense) 11, no. 1 (spring 1999): 68.

Brassaï: The Eye of Paris, The Museum of Fine Arts, Houston (traveling exhibition)

A., G. "Brassaï: The Eye of Paris." Artforum (New York) 37, no. 1 (September 1998): 48.

Goodheart, Adam. "Night Visionary." ArtNews (New York) 97, no. 8 (September 1998): 141.

Lendvay, Éva. "A százéves Brassaï (Brassaï Centennial)." Korunk (Cluj), October 1998, page numbers undetermined.

"[Preview of Brassaï: The Eye of Paris]." Travel & Leisure (New York), October 1998, page number undetermined.

Meyer, Pucci. "Muse on Museums." New York Post, 24 November 1998, page number undetermined.

Russell, John. "Memories of Paris and of One Who Saw It as It Was." New York Times, 29 November 1998, sec. 2, pp. 43-44.

Dean, Nancy A. "Brassaï's Photos of Paris on Display." Houston Chronicle, 30 November 1998, 20A.

Dykstra, Jean. "[Preview of Brassaï: The Eye of Paris]." Art & Auction (New York) 21, no. 7 (30 November – 13 December 1998): 66.

"Brassaï: Los ojos de París." Foto (Madrid), no. 192 (December 1998): 34-40.

"The December Almanac: Arts & Letters." Atlantic Monthly (Boston) 282, no. 6 (December 1998): 24.

Goldberg, Vicki. "Paris Belongs to Brassaï." Vanity Fair (New York), no. 460 (December 1998): 164, 168, 170-72, 176, 178-81.

"L'Occhio di Parigi: Brassaï in Retrospettiva." Photo (Milan; Italian edition of American Photo), no. 22 (December 1998): 6-7.

"Paris by Night." Condé Nast Traveler, December 1998, 68.

"'El Ojo de Paris,' Retrospectiva del Fotógrafo Brassaï." La Voz (Houston), 2 December 1998, 6.

"Viewpoint." New York Times, 3 December 1998, page number undetermined.

Johnson, Patricia C. "Visions of an Oracle: Brassaï's Images Reveal Artist's Pursuit of Perfect Truth." Houston Chronicle, 6 December 1998, Zest section, 2, 14-15, 32.

Neilson, C. A. "Display of Noted Photographer's Works Opens at MFA." Village News/Southwest News (Houston), 8 December 1998, 5.

Kalil, Susie. "Nuit Prowler." Houston Press 10, no. 53 (31 December 1998 – 6 January 1999): 47-48.

"Brassaï: The Eye of Paris at the Museum of Fine Arts, Houston." Art Now Gallery Guide (Southwest edition), January 1999, 28-30.

Halpert, Peter Hay. "The World of Brassaï: A Monumental Exhibition Highlights a Hallmark Artist." American Photo (New York) 10, no. 1 (January/February 1999): 18, 32.

"Journey into Night." Polo (Gaithersburg, Maryland) 24 (January/February 1999): 26-27.

Hixson, George. "Arts Wednesday: In the Oui Small Hours." Sidewalk Houston. http://houston.sidewalk.com/arts/wednesday (6 January 1999).

Schaernack, Christian. "Das magische Auge der Kamera: Brassaï-Retrospektive in Houston." Handelsblatt (Düsseldorf), 12 January 1999, 47.

Holliday, Taylor. "Brassaï: Seeing Paris His Way." Wall Street Journal (New York) 103, no. 10 (15 January 1999): W12.

Lacayo, Richard. "The Night Watchman." Time Magazine (New York) 153, no. 2 (18 January 1999): 83-84.

Collections of Brassaï Works

Some of which are also exhibition catalogues

Acquisitions, 1975–1977. Compiled by Sharon Denton. Tucson, Arizona: Center for Creative Photography, University of Arizona, 1980, 7. See also "Acquisitions: July – December 1982," Archive (Tucson), no. 20 (July 1984): 79.

Brassaï. Curated and text by Jean Dieuzaide. Toulouse: Galerie Municipale du Château d'Eau, 1986.

Brassaï: Foto's uit de museumverzameling. Curated and text by Pool Andries. Antwerp: Museum voor Fotografie, 1988.

Catalogue of Collections, Yokohama Museum of Art. vol. 2 [Photographs]. Tokyo: Yokohama Museum of Art, 1989, 120-21, 179.

Catalogue of Photography: The Cleveland Museum of Art. Curated and text by Tom E. Hinson. Cleveland: The Cleveland Museum of Art, 1996, 108-10, 420-21.

Collection de photographies du Musée National d'Art Moderne: Photographies, 1905–1948. Curated and text by Annick Lionel-Marie. Paris: Éditions du Centre Pompidou, 1996, 77-129.

Counterparts: Form and Emotion in Photographs. New York: The Metropolitan Museum of Art, 1982, cover, 9, 26-27, 34, 36, 52, 78-79, 82-83, 114-15, 150-51.

Diverse Images: Photographs from the New Orleans Museum of Art. Introduction by Tina Freeman. Garden City, New York: Amphoto, 1979, 124.

Four European Photographers at the Detroit Institute of Arts. Detroit: Detroit Institute of Arts, 1955. See also "Four European Photographers," by William A. McGonagle, in Bulletin of the Detroit Institute of Arts 35, no. 4 (1955–56): 98-100.

International Photography, 1920–1980. Text by Isobel Crombie, Helen Ennis, Martyn Jolly, and Ian North. Canberra: Australian National Gallery, 1982, 66-68, 139.

Luz y tiempo: Coleccíon fotografica formada por Manuel Alvarez Bravo para la Fundación Cultural Televisa, A. C. Introduction by Roberto R. Littman. vol. 1 of 3. Mexico City: Centro Cultural/Arte Contemporáneo, A. C., 1995, 161-79.

Magicians of Light: Photographs from the Collection of the National Gallery of Canada. Curated and text by James Borcoman. Ottawa: National Gallery of Canada, 1993, 178-79, 268.

Masterpieces of Photography: From the George Eastman House Collection. Curated and text by Robert A. Sobieszek. New York: Abbeville Press, 1985, 270-71, 443.

Naef, Weston. Counterparts: Form and Emotion in Photographs. The Metropolitan Museum of Art, New York: E. P. Dutton, 1982, cover, 9, 26-27, 34, 36, 52, 78-79, 82-83, 114-15, 150-51.

———. J. Paul Getty Museum: Handbook of the Photographs Collection. Malibu, California: J. Paul Getty Museum, 1995, 200-201.

The New Vision: Photography between the World Wars: Ford Motor Company Collection at the Metropolitan Museum of Art. Curated and text by Maria Morris Hambourg and additional text by Christopher Phillips. New York: The Metropolitan Museum of Art, 1989.

100 x Photo: 100 Photographs from the Collections of the Stedelijk Museum, Amsterdam. Introduction by Hripsimé Visser. Bussum: Thoth Publishers, 1996, 80, 118, 122, 156.

La Photographie du vingtième siècle: Museum Ludwig, Cologne. Text by Marianne Bieger-Thielemann. Cologne: Benedikt Taschen Verlag, 1996, 80-83.

Photographs from the Collection of the Gilman Paper Company. Curated and text by Pierre Apraxine. New York: White Oak Press, 1985, 15, 472.

"Photography," by Edward Steichen. In Masters of Modern Art, by Alfred H. Barr, Jr. New York: The Museum of Modern Art, 1954, 195.

"Photography: Recent Acquisitions." Text by Tom E. Hinson. Bulletin of the Cleveland Museum of Art 62, no. 2 (February 1975): 36-46.

Photography in the Twentieth Century. Curated and text by Nathan Lyons. New York: Horizon Press and The George Eastman House, 1967, 25.

Portraits d'une capitale: De Daguerre à William Klein: Collections photographiques du Musée Carnavalet. Paris: Paris-Musées; Paris Audiovisuel, 1992, 41, 124.

Sammlung Gruber: Photographie des 20 Jahrhunderts. Cologne: Museum Ludwig, 1984, 166, 198-99.

Szarkowski, John. Looking at Photography: 100 Pictures from the Collection of the Museum of Modern Art. New York: The Museum of Modern Art, 1973, 110.

"Thomas Walther." Aperture (New York), no. 124, special issue: Connoisseurs and Collections (summer 1991): 56-67, especially 67.

Transfixed by Light: Photographs from the Menil Foundation Collection: Selected by Beaumont Newhall. Curated by Kathryn Davidson and Elizabeth Glassman. Houston: Menil Foundation, 1981.

Obituaries

Caujolle, Christian. "L'Oeil de Brassaï s'est fermé." Libération (Paris), 12 July 1984, 24-25.

———. "Brassaï." Beaux-Arts Magazine (Paris) 17 (October 1984): 60-65.

Ferney, Fédéric. "Un Sociologue de la nuit." Le Nouvel Observateur (Paris), no. 1028 (20 July 1984): 54.

Grundberg, Andy. "Brassaï, Photographer of Paris Nightlife, Dies." New York Times, 12 July 1984, 14Y.

Guibert, Hervé. "Mort de Brassaï." Le Monde (Paris), 12 July 1984, 28.

Holborn, Mark. "Brassaï, 1899–1984." Aperture (New York), no. 97 (winter 1984): 2.

Kuramochi, Kazue. "From Paris." Asahi Camera (Tokyo), September 1984, 186-87.

McNay, Michael. "Brassaï: A Tribute." Manchester Guardian Weekly (London), 22 July 1984, 6.

Moorman, Margaret. "Brassaï, 1889–1984." Art News (New York) 83, no. 8 (October 1984): 13.

"[Obituary]." Afterimage (Rochester, New York) 12, no. 3 (October 1984): 4.

"[Obituary]." Art in America (New York) 72, no. 8 (September 1984): 247-48.

"Brassaï Dies." British Journal of Photography (Liverpool; London) 131 (20 July 1984): 745.

Index

This index includes the major parts of the book, but not such supplementary sections as the foreword, acknowledgments, notes, catalogue of the exhibition, exhibition history, and bibliography. Numbers in gray type refer to pages with illustrations.

362

364

Photographic Credits

Library of Congress Cataloging-in-Publication Data

Tucker, Anne.

 Brassaï: the eye of Paris/by Anne Wilkes Tucker with Richard Howard and Avis Berman. — 1st ed.

 p. cm.

 Published on the occasion of an exhibition held at the Museum of Fine Arts, Houston, Dec. 6, 1998 – Feb. 28, 1999, at the J. Paul Getty Museum, Los Angeles, Apr. 13 – July 4, 1999, and at the National Gallery of Art, Washington, D. C., Oct. 17, 1999 – Jan. 16, 2000.

 Includes bibliographical references (p.)

 ISBN 0-81096-380-9. — ISBN 0-89090-086-8 (pbk.)

 1. Photography, Artistic Exhibitions. 2. Brassaï, 1899 – Exhibitions. I. Brassaï, 1899 – . II. Howard, Richard, 1929 – . III. Berman, Avis. IV. Museum of Fine Arts, Houston. V. J. Paul Getty Museum. VI. National Gallery of Art (U. S.) VII. Title.

TR647.B73 1999

779' .092 — dc21 99-26961

 CIP

The book was designed by
Anita Meyer, Kristin Hughes, and Vivian Law
plus design inc., Boston
production managed
by Pinpoint Incorporated, Boston
typeset in
Officina Serif, Officina Sans, and Didot
13,000 copies were printed on
Gmund Havanna Cohiba 91 lb text,
Gilbert Clearfold White heavy,
and Consolidated Reflections Gloss 90 lb text
by W.E. Andrews Company,
Bedford, Massachusetts and bound
with binders board and
Champion Kromekote C1S 6 pt cover
by The Riverside Group, Rochester, New York.